THE
GENIUS OF
AMERICAN
PAINTING

THE GENIUS OF AMERICAN PAINTING

EDITOR JOHN WILMERDING

Contributors

R. PETER MOOZ
JOHN WILMERDING
RICHARD J. BOYLE
IRMA B. JAFFE
HARRY RAND
DORE ASHTON

WILLIAM MORROW & COMPANY, INC. NEW YORK

CONTENTS

List of Illustrations

LIST OF ILLUSTRATIONS

LIST OF ILLUSTRATIONS

LIST OF ILLUSTRATIONS

INTRODUCTION

The approximately three hundred years of American painting reveal a periodic dependence on parent European traditions and a continually developing national identity that is distinctly indigenous. It is not startling that the art of a country discovered and settled largely by Europeans should reflect styles of painting and forms of building that derived from the great colonial cultures of Europe in the New World, namely the English, Dutch, and Spanish. Consequently, the commonplace observation about American art, that it is polarized between revolution and tradition, has an undeniable ring of truth. Alternately rejecting and imitating European styles, American painting has gradually but unmistakably defined its own special character.

Similarly, a serious and self-confident body of critical and scholarly writing about American art has also, relatively recently, begun to emerge. To be sure, Dunlap's and Tuckerman's nineteenth-century histories do provide important first-hand source material.[1] They were followed at the beginning of the twentieth century by the first thorough retrospective surveys, such as Lorado Taft's on American sculpture and Samuel Isham's on painting.[2] But the most notable and sustained efforts at critical writing in American art history began little more than twenty-five years ago – Oliver Larkin's *Art and Life in America* first appeared in 1949 – at about the same time as the culmination of Abstract Expressionism. In fact, it was widely held by both native and foreign historians that this was the first art movement that could truly be called American in initiative and influence. Not surprisingly, that attitude (which remained apologetic for the most part about earlier, more provincial American art) was to be a partial stimulus for the fresh interest in the character and development of American art. Ironically, the Abstract Expressionist movement owed much to the European Surrealists who emigrated to the United States in the 1930s and 1940s. Since that time American writers have become less inhibited and more confident of the qualities and values of earlier native art. The Pop Art movement of the later 1950s and early 1960s appears to have encouraged a new awareness of both nineteenth-century realist painting and folk art. Happily, a more thoughtful and balanced view of both past and current American art is now emerging.

The consciousness of Europe surfaces in varying intensities throughout the history of American art – a consciousness that was directly related to America's own idea of its independence. For example, the motivation behind much of American landscape painting in the first half of the nineteenth century was the effort to create images that would define the raw, fresh wilderness of the New World in contrast to the aged and decaying civilizations of Europe. Occasionally, however, such optimistic assertions masked a strain of defensiveness, manifested in the number of artists who effectively became expatriates in Europe. Notable, of course, were John Singleton Copley and Benjamin West in the eighteenth century, and James A. M. Whistler, John Singer Sargent, and Mary Cassatt in the nineteenth; not to mention the attractions of Düsseldorf in the 1850s for George Caleb Bingham, Eastman Johnson, and Albert Bierstadt, and Munich in the 1870s for Chase and Duveneck.

At times the American borrowings from European prototypes were obviously imitative, as for example, John Vanderlyn's reliance on David's Neo-Classicism for a number of his figures and compositions. More explicitly, his *Ariadne* is directly taken from the Renaissance tradition of sleeping Venuses by Giorgione and Titian, although he did attempt to Americanize the setting, it was said, by faithfully rendering indigenous flowers and shrubs in the landscape setting. Another derivative period occurred with American Impressionism at the end of the nineteenth

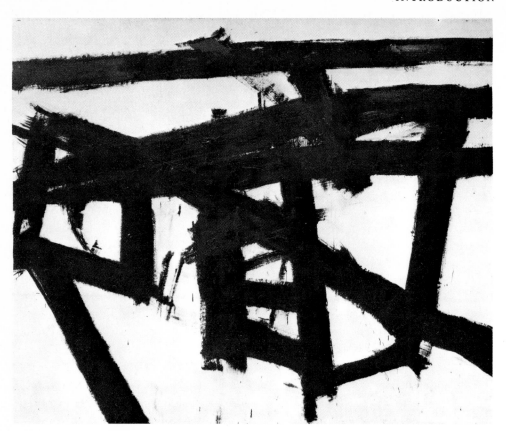

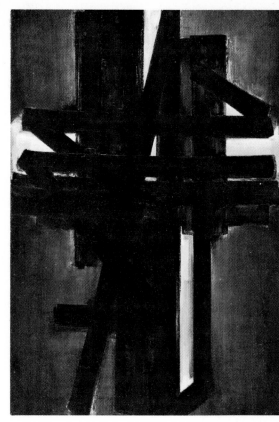

century, which for the most part imitated the French movement without ever fully understanding it. The style and the manner were readily adaptable to similar romantic subjects in the hands of Twachtman, Robinson, Weir, Hassam, and others, but they never seemed concerned with grasping the fundamental intellectual or optical theories of Impressionism. As such, this group produced several charming and appealing pictures, although usually lacking in power of originality.

The same problem underlies much of the American response to Cubism following the Armory Show of 1913. Again misunderstanding of the original accounts for this. The shock of seeing avant-garde European art on such a scale for the first time was bound to be unsettling for the American artist, critic, and public alike. Unfortunately, only examples of Cubism's early phases could be shown, and many of the examples were by peripheral figures like Severini and Gleizes rather than the primary innovators, Braque and Picasso. As a result, the most important movement in early twentieth-century painting received a somewhat distorted initial showing in the United States. Americans attempted to adapt the lessons of Cubism as best they could, whether it was the Precisionism of Sheeler and Demuth or the decorative Expressionism of Hartley and Davis. But few American painters could do more than use the style in a derivative way. And one, John Marin, appears to have developed an artistic schizophrenia when he relied too strongly on Cubist techniques, creating images that could not resolve themselves either as representations or abstractions.

At certain times American painters developed highly personal styles almost entirely on their own. While holding only minimal regard for contemporary European expressions, such artists as Homer, Ryder, and Eakins created paintings with surprising parallels abroad. For example, Homer's realism shares much in common with Courbet's.[3] Eakins' fascination with photography and his profound psychological understanding of his sitters compare favorably with the similar interests of Degas. It was typical of Ryder to have made at least four sea voyages to Europe in

Above, left FRANZ KLINE
Mahoning, 1956
New York
Collection of the Whitney Museum of American Art

Above PIERRE SOULAGES
Painting, 1953
New York
Solomon R. Guggenheim Museum

14

his lifetime, not to see the museums or the countries on the other side of the Atlantic, but to experience the sun and moon on infinite expanses of water. His moonlight marines thus became highly personal and metaphorical voyages of life, symbolic expressions that were at once individual and universal – not unlike the colorful and subjective works of Gauguin and Van Gogh. Although their work does reflect the larger currents of Victorian materialism and romanticism, these three American masters developed as painters largely unaffected by foreign influences.

Of those cases in which American artists created distinctively original statements Abstract Expressionism is certainly the best known. Drawing on that celebration of pure inner impulse and spontaneity present in Surrealism of the 1930s, Pollock and Kline particularly broke new ground in their paintings of the late 1940s and early 1950s. They completely liberated color and line from representational functions, and redefined the nature of pictorial space and composition. There is something especially American, too, in the brash energies of their broad, arm's length brushstrokes, which may be distinguished from the more self-contained and orthodox Expressionism of either Georges Mathieu or Pierre Soulages in France.[4]

Another, more recently recognized American style occurs in Luminist painting of the mid-nineteenth century. In the landscapes of many American artists between 1855 and 1875 light and space came to play special roles in defining man's relation to nature. By contrast to the expressionist use of light in Turner's painting or the optical sensations recorded semi-scientifically by the French Impressionists, the special effects of sunlight often took on a metaphysical meaning for American painters. Light frequently became a vehicle for contemplation of nature's power and mystery. The low horizons and deep thrusts of space common in the landscapes of the early 1860s by Martin Johnson Heade, Fitz Hugh Lane, and Frederic E. Church enhanced the sought for mood of contemplation and reverie.[5]

Geography has been crucial to the American experience from the beginning. The idea of the New World has long had an appeal; the seemingly endless expanse attracted early explorers like John White and Jacques Le Moyne in the sixteenth century. By the early nineteenth century an inland wonder like Niagara Falls had become a symbol of the New World's natural power and vastness. In the first half of the century alone, between John Trumbull's version in 1807 and Frederic Church's in 1857, countless minor and major figures came to paint there.

As the eastern part of the United States became relatively settled, explorers and artists alike began to search westward for new wilderness. George Caleb Bingham's painting of *The Emigration of Daniel Boone* at mid-century is another image of discovery. Boone and his company stride aggressively and positively forward through the dense landscape toward the spectator. The very composition of the artist suggests a directness and self-confidence that was characteristic of American attitudes about their geography.

Essentially, the American artist was typical in viewing his landscape with a paradoxical mixture of awe and fear. As artists like Bierstadt and Moran moved into the Far West to paint, Church and Heade to South America, or James Hamilton and William Bradford to the Arctic, they continued to view these new wilderness landscapes as possessing both a terrible and beautiful attraction. Constantly, in his views of the prairies and the Rocky Mountains, Bierstadt juxtaposed verdant valleys with parched desert, cool running streams and torrential waterfalls, vast expanses of lateral space and soaring mountains, images of serenity and of violence. It is not surprising to read recent accounts of the first American flights to the moon, whose desolate surface has been similarly described by the astronauts as mysteriously fearful and beautiful at the same time. The combined fear and awe of the unknown seem always to have captured the American imagination.

Certainly the property of scale has much to do with this sense of discovery

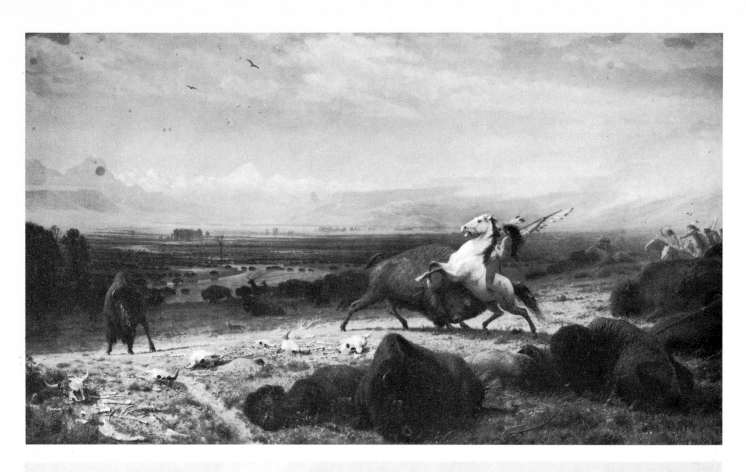

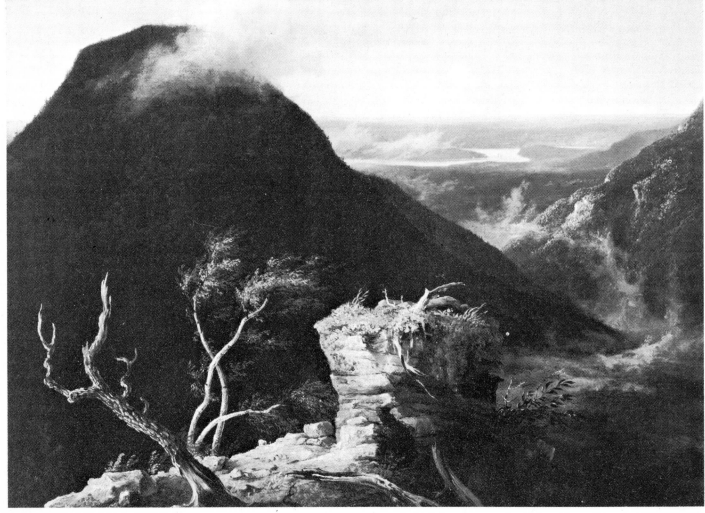

ALBERT BIERSTADT, *The Last of the Buffalo*. Washington, D.C., Collection of the Corcoran Gallery of Art.
THOMAS COLE, *Sunny Morning on the Hudson River*.
Boston, Massachusetts, Museum of Fine Arts, M. and M. Karolik Collection.

towards always new landscapes. In part, nineteenth-century artists like Church and Bierstadt sought to paint on ever larger canvases in some effort to render appropriately the physical and metaphysical dimensions of their subjects as they experienced them. What results in an environmental scale in their work has a twentieth-century equivalent in the large-sized, environmental canvases of the Abstract Expressionists and many Pop artists. James Rosenquist's *F-111* is a modern version of Church's *Niagara*.

The other side of immense scale and its implied endless bounty is waste, and this too has emerged as an all too apparent aspect of the American scene. One of the reasons America is now facing an ecological crisis is because of its long-held romantic view that its frontiers were forever new and limitless. While many were quick to point out today's obvious political and military parallels to this attitude, one can readily find similar expressions of thought in nineteenth-century concepts like the Monroe Doctrine and Manifest Destiny. Bierstadt's series on *The Last of the Buffalo* provides an eloquent pictorial equivalent. There strewn across a serenely spacious landscape are the corpses and skulls of indiscriminately slaughtered animals. A nature of abundance is also a context for powerful and destructive energies. The illusion of plenty continues to haunt the American character. The iconography of obsolescence informs Warhol's repeated Campbell Soup cans or Coca-Cola bottles and Chamberlain's car bumper junk sculpture.

A sense of violence recurs in different ways through much of American art, from Copley's *Watson and the Shark* in the eighteenth century to John Vanderlyn's *Death of Jane McCrea* in the nineteenth and George Bellows' *Both Members of this Club* in the twentieth. One aspect of this theme is manifested in the periodic delight artists have taken in treating subjects of exercise and the out-of-doors, the most familiar being Eakins' rowing scenes and Homer's Adirondacks watercolors. Defined another way, this appears as a mere rawness and energy, related to the preoccupation with newness discussed above. For example, today's obsession with youth has its extension in much of Pop Art's aggressive imagery. Natural forces are implicit in the ever-present blasted tree trunks of Thomas Cole's landscapes, just as physical tensions and energies are objectified in Franz Kline's Abstract Expressionist canvases. In fact, his clashing contrasts of line and plane, dark and light, figuration and non-figuration, all struggling within and against the framing edges, make a telling comparison with relatively restrained and contained forms of his French counterpart Pierre Soulages' works. Jackson Pollock's bodily gestures are equally distinct from the superficially similar paintings by Georges Mathieu, whose images ultimately remain framed, even balanced, within his pictorial space.

If images of discovery and violence reveal a central quality of the American experience, so too does the idea of factuality. Several recent writers have talked of the importance to American painters of grasping the physical presence of things.[6] Americans tend to be a practical people, and for the most part would prefer to deal with fact over idea. The concrete, the tangible, and the immediately present are basic characteristics of still lifes by the Peale family, the genre scenes of Mount and Bingham, the portraits of Copley and Eakins, and the *trompe l'oeil* paintings of Harnett and Peto.

A close look at two portraits, by Ingres and Copley respectively, will give some idea of the American preference for physicality. The great French Neo-Classicist's painting of *Mme Moitessier* is one of his most exquisite portraits of women done at the peak of his career. An ample figure, she fills much of the composition, both in the frontal pose presented to the viewer as well as in the mirror image behind. This sense of amplitude largely derives from Ingres' unmatched abilities at rendering surface materials and textures, whether the soft delicacy of the skin, the lucid clarity of the mirror surface, and shiny edges of the background picture frame, or

17

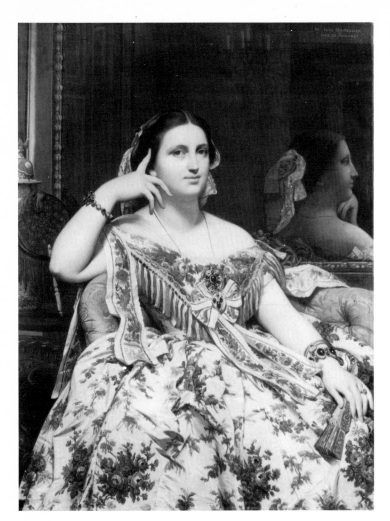

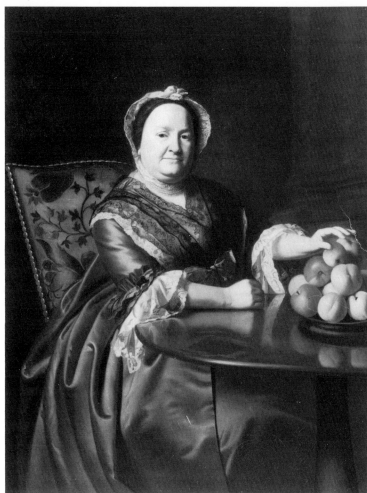

the palpable bulging of the chair and bright floral patterns of the sitter's dress. Yet in so describing this picture, one soon discovers Ingres' special love of pure form, color, and line. Although this painting remains very much a portrait, rendering presumably an accurate likeness, the artist's primary interests are formal. That is, the eye is invited to indulge in the harmonious color arrangement: the strongest and sharpest colors are in the foreground and on the figure or her clothing, repeated less intensely and clear as the eye moves out to the edges or background of the composition. Likewise, much of the physical, three-dimensional sense of the lower torso is lost beneath the dazzling patterns of the dress which assume a life of their own on the surface of the painting. Ingres further plays off the curving lines of the figure and chair, which culminate in the arms, shoulders, and face of Mme Moitessier, against the rectilinear planes of the background picture, mirror, and wall surface. He also arbitrarily adjusts the mirror image itself, moving it from its logical position directly behind the sitter to the right side of the composition and turning it in profile so as to contrast with the frontal image in the foreground. All of these refinements illustrate how important the elements of pictorial design were to Ingres, even at the sacrifice of certain aspects of physical reality.

This is not to say that Copley's portrait of *Mrs Ezekiel Goldthwait* is any less lacking in contrasting textures and shapes. He too delights the eye as well as the sense of touch with a variety of lustrous surfaces, such as the table top, dress, stuffed chair, face and arms, and the bowl of fruit. There is a corresponding range of subtle color tonalities, primarily blue-greens and reddish browns, which together help to unify the figure and the setting. Like Ingres, Copley illuminates the face and hands most

Above, left JEAN AUGUSTE DOMINIQUE INGRES, *Mme Moitessier.*
London, National Gallery.
Above JOHN SINGLETON COPLEY, *Mrs Ezekiel Goldthwait.*
Boston, Massachusetts, Museum of Fine Arts.

strongly, drawing attention foremost to the center foreground of the composition, and carefully controls the decreasing amount of light on the table top, dress, chair-back, and column behind. Copley is equally attentive to the play of similar shapes. Here it is the repetition of spherical and circular forms throughout the picture: table, fruit and dish, arms and lace cuffs, chair and column, and of course Mrs Goldthwait's face, chin, bead necklace, hairline and bonnet.

But there are finally subtle differences between the two pictures which are important to recognize. The formal harmonies of bulging shapes in Copley's portrait all aim to make the physical presence of the sitter as palpable as possible. Copley's real effort is to use them for better revealing the nature of her character and position. In fact, the amplitude and ripeness that he so obviously suggests here directly reflect Mrs Goldthwait's procreative instincts: she had fourteen children and was known for her flourishing gardens. Thus Copley's aim is ultimately different from Ingres'. Where the latter is willing to have his forms assume a life of their own, the American painter never fully permits pictorial design to subordinate or obscure the concrete appearance of objects or figures. To this end Copley retains the sense of weight and volume in his sitter, as well as the clear recession, however shallow, into the background. The diagonal placement of the shoulders and the projecting plane of the table top are characteristic details aiding in definition of this spatial ambience. By contrast, Mme Moitessier's floral dress loses much of its sense of volume and tends to spread out two-dimensionally across the lower half of the picture plane. Like-wise, the background wall is brought up to the picture surface through details such as the cropped picture frame at the left, yet paradoxically at the same time its physical solidity is given a formal ambiguity by being a mirror. (In fact, the use of the mirror has long been a part of the French artist's play between degrees of reality and the formal extensions of space it implies, from Ingres to Degas to Picasso.)

We may make another profitable comparison between the work of Martin Johnson Heade and Claude Monet. Both artists pursued a series of haystack paintings which explored a special kind of landscape under different conditions of light. But Monet's Impressionist canvases move toward the integration of foreground and background, the dissolution of form into a matrix of light and color accents, and the gradual flattening of spatial recession. On the other hand, Heade refined and strengthened the haystack shapes through an almost mathematical series of charcoal drawings. In the final oils foreground details are often de-emphasized or eliminated in order to draw the eye's attention directly across the spatial expanse to the horizon. The hay-stacks stand as solidly conceived and rendered volumes in an ultra-clarified three-dimensional space. Heade's attention to formal organization – the perfected symmetries of the haystack silhouettes, their rounded volumes set off against the curving lines of receding salt-marsh streams or tree lines on the horizon – is ultimately for the purpose of revealing nature's timeless order and inner harmony. Monet and the Impressionists cultivated the quick, spontaneous sketch; Heade and the American Luminist painters sought the calculations of finish in both technique and effect. For Monet the aim was to capture the moment, for Heade the durable beyond time.

Frequently, Homer's work of the mid-1860s has been compared to the paintings of Monet and Boudin done about the same time. Yet all of Homer's croquet scenes were done before his trip to Paris in 1869, and there is no concrete evidence of Homer being influenced by European painting at that time. (It is probable that he saw something of recent French painting during his visit.) More clearly, Homer and his contemporaries at home and abroad were responding to similar subjects with parallel instincts. Artists on both sides of the Atlantic were attracted to the fashion-able coastal resorts to record the newly discovered delights of the working class in leisure hours and pursuits. Although American and French painters alike also shared an interest in bright *plein-air* light effects, there are again essential differences.

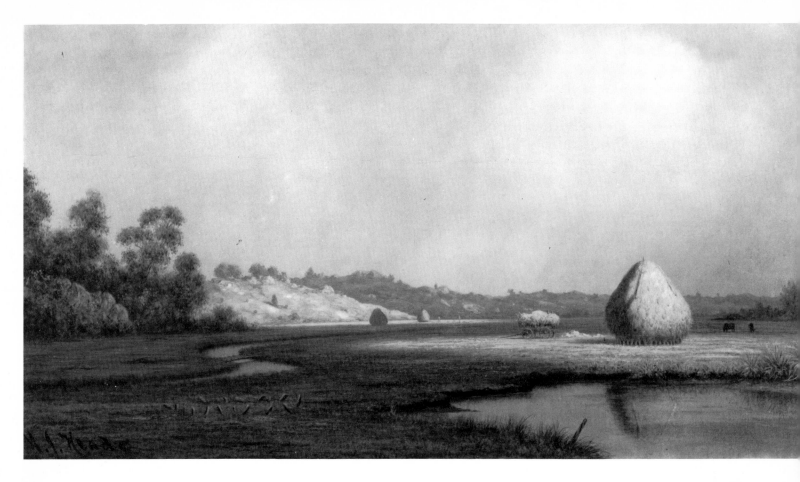

Above MARTIN JOHNSON HEADE, *Salt Marshes, Newport, Rhode Island.*
Boston, Massachusetts, Museum of Fine Arts, M. and M. Karolik Collection.
Right CLAUDE MONET, *Haystack at Sunset near Giverny.*
Boston, Massachusetts, Museum of Fine Arts, Bequest of Robert J. Edwards in memory of his mother, Juliana Cheney Edwards.

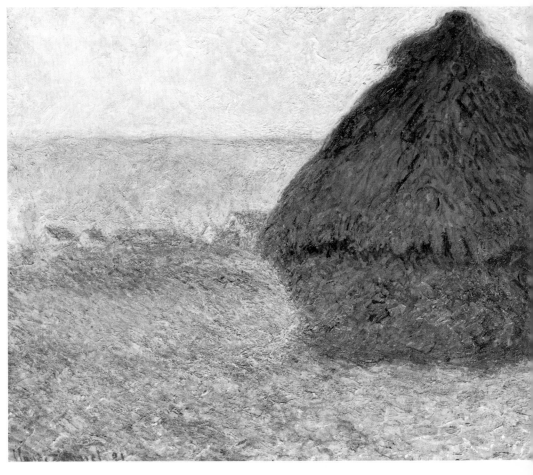

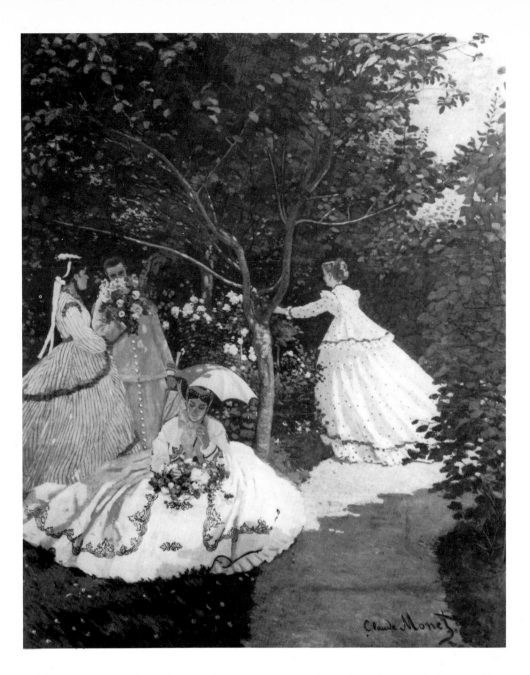

CLAUDE MONET, *Women in a Garden*, 1866–7.
Paris, Musée du Louvre.

Monet's *Women in a Garden* of 1866–7 is exemplary of early French Impression-
ism. Nominally, the subject of young ladies strolling at the shore or in a garden was
one that appealed equally to the French as well as to American painters like Homer
and Eastman Johnson. Bright colors and strong lighting inform the work of all these
painters. Yet even by the late 1860s Monet's vision was moving towards a flattening
out of the picture space and the dissolution of form into patterns of pure light and
color. Thus the details, especially of *Women in a Garden* tend to be read as patches
of paint as much as identifiable figures or objects. Moreover, the broad patterns of
the women's dresses tend to assume an almost two-dimensional surface abstraction
of their own. Any visual thrust into depth is closed off by the flat wall of foliage,
itself brought relatively close to the picture plane. Even the wide pathway in the
foreground seems to lie closer to the flat picture surface rather than receding deeply
into the picture space.

In similar subjects Homer and Johnson carefully define and retain the three-
dimensional qualities of their figures, as well as place them in a deep and ample
space. For example, the figures in Homer's *Croquet Players* of 1865 and his *Long
Branch, New Jersey* of 1869 in the Museum of Fine Arts, Boston, are placed in the

21

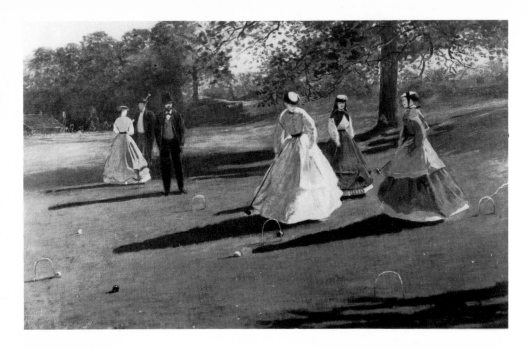

WINSLOW HOMER, *Croquet Players*, 1865.
Buffalo, New York, Albright-Knox Art Gallery.

EASTMAN JOHNSON, *Hollyhocks*, 1876.
New Britain, Connecticut, New Britain Museum
of American Art.

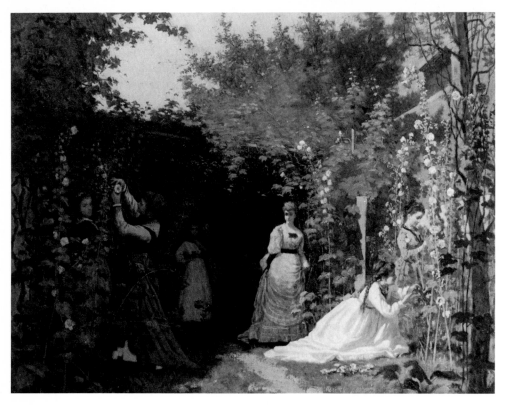

middle ground on a receding diagonal line, and on a platform of ground which leads the eye back swiftly to the horizon. Both Homer, and Johnson in his *Hollyhocks* of 1876, treat their subjects with a full range of tonal contrasts, whereas Monet has replaced almost all shadow and dark areas with bright, fully saturated colors. This effort to eliminate the darks was of course part of Impressionist theory to simulate the brighter intensities of outdoor sunlight. The retention of dark and light contrasts by the American painters reflects partly their graphic approach to painting and partly their desire to define clearly the palpability of form and space. To Monet's version compare Johnson's garden path which sharply recedes into the picture space and leads the eye towards the figures in the deep background. The impulse for retaining and clarifying physical presence is as evident here as in Copley.

22

Another aspect of the American definition of factuality is the frequent combination of art and science in the history of the American arts. Among the most notable in the eighteenth century was Charles Willson Peale, an extraordinary painter, museum founder, scientist, inventor, and patriarch of a prolific family of artists. Equally well known are the varied talents and interests of Benjamin Franklin and Thomas Jefferson, the latter distinguished not only as a statesman but also as an educator, inventor, farmer, and architect. His northern counterpart, Charles Bulfinch, was another man of varied talents and abilities, active both as an architect and politician in Boston.

A number of American painters approached their drawing in a scientific manner, often employing carefully worked out systems of quadrants, perspective, or other mathematical measurements in their renderings, most notably Copley, William Sidney Mount, Fitz Hugh Lane, and Thomas Eakins. In addition, a number of nineteenth-century painters made use of photography, including Lane and Eakins, as well as William Bradford and Winslow Homer. The photographic eye is present in the stopped action of several of Eakins' rowing pictures, as well as in his occasional cropped framing of compositions. Bradford took numerous photographs on his Arctic voyages, using his views later much as pencil sketches or oil studies in the execution of details within large oil compositions.

Like Eakins, the sculptor William Rimmer had some medical training, and his knowledge of anatomy served well in the accurate rendition of the architecture and weight of the human being. And Samuel F. B. Morse led a distinguished career as a painter, although thwarted by lack of recognition, before turning to his more familiar career as an inventor and scientist. Partly, this tradition reflects the American love of gadgets; but it also reveals a tradition of the artist as a craftsman who had to learn certain practicalities before indulging in the practice of art. For many this meant learning the trade of the printmaker; the graphic experience, for instance, is strong in the art of Copley, Lane, Durand, Homer, Bellows, and Rauschenberg. For many, this meant making a living by painting portraits until they were well enough off to paint the landscape or narrative compositions that they pleased. Bingham and Eastman Johnson are but two obvious examples. In fact, American art of the Colonial period was largely portrait painting, but these pictures were not so much thought of as art as they were as likenesses painted quite practically for posterity. The artist, therefore, was very much the craftsman first of all. Art for a long while was viewed by Americans as a frivolous luxury with no practical or physical advantages. Even Harnett's brilliant *trompe l'oeil* deceptions at the end of the nineteenth century were criticized for lacking any moral worth: art had to have a function outside itself to be of value. Significantly, the phrase 'art for art's sake' that is associated with the American-born James A. M. Whistler applies to his work done in the context of modern European art.

Emerson spoke of this practical and factual side of the American temperament when he wrote in 'The American Scholar,' in 1837, that 'action is with the scholar subordinate, but it is essential.' It is equally significant that earlier in his essay he asserted that 'the first in time and the first in importance of the influences upon the mind is that of nature. . . . The next great influence into the spirit of the scholar is the mind of the Past.'[7] Thus, his efforts to establish the distinctiveness of the American mind and character went directly to the heart of those central themes we may discern in the history of American painting: the response to a geography of newness and grandeur; the consciousness of the past as exemplified in European civilization and the consequential impulse to define its own youth in terms of that past; and the necessity of action following from contemplation. The American imagination possesses its own special vitality, which flows through her arts, whether naïve or sophisticated, derivative or original.

1
COLONIAL ART

R. Peter Mooz

COLONIAL ART

I n 1591 Theodore de Bry, a Flemish print maker, published *Voyages en Virginie et en Floride*. This volume contained the earliest reproductions of American colonial art, engravings after the paintings of Jacques Le Moyne de Morgues done in Florida about 1564 and of John White, who lived in Virginia between 1584 and 1593. Other paintings, maps and drawings were made in the New World in the sixteenth century but can hardly be called American art. They are either notations made for topographic records not intended as independent works of art or drawings, by artists trained in Europe, done in a foreign locale without the slightest overtone of transplantation. The works of Le Moyne and White did not stray far from being European art carried as cultural baggage to the New World, but both men depicted Indians, a totally new subject unique to America, and the pictures were the product of direct observation, perhaps the most salient characteristic of American painting. There were no artistic precedents for representing Indians, no rules for drawing previously unknown flora and fauna revealed by a light different from Europe's and surrounded by an atmosphere conditioned not by the expanse of the mollifying Atlantic but by 3,000 miles of prairies and mountains. The selection of subject-matter provided new departures. The Indians' dances were the basis of new poses, and the patterns of body decoration suggested unusual color schemes. Yet one must not be deceived. The predominant style was European mannerism, which had always stressed the strange, unusual, distorted, and anti-classical elements within the basic vocabulary of late-Renaissance art. The tension between the forces of control and chaos which derived from Michelangelo and the sixteenth-century dichotomy between the idealism of Italian art and the naturalism of Northern European art were amply expressed by both White and Le Moyne. The stylistic antecedent of Le Moyne's *Indians of Florida Panning Gold* (c. 1564) was Pollaiuolo's *Battle of the Naked Men* (c. 1470) or Michaelangelo's drawings for the *Battle of Cascina* (1504); White's *Their Manner of Fishynge in Virginia* (1585), anticipates the work of Jacques Callot.

The choice of depicting Indian activities indicated a basic similarity in the two works: both showed an interest in pictorial rather than symbolic art, but the style of the two men was dramatically different. Le Moyne expressed himself through the traditional Renaissance motif of the human figure. The anatomy of the Indians dominated the picture, and the story was told through the action of their bodies. White included figures, but his approach was closer to the northern, late-medieval motif of the bird's-eye view. He readily accepted not only the Gothic tradition of multiple views within one picture but also disregarded logical space by making the fish in the foreground and background the same size – an anti-rational convention which dates to Romanesque miniatures and is alien to the Renaissance point of view.

The first truly American paintings appear after 1664, one hundred years after Le Moyne's voyage. Artists came to America earlier in the seventeenth century; but no American works can be documented earlier than 1664. Art usually emerges after the practical is satisfied. Man always seeks artistic expression and often manages to find it under primitive conditions; but a society must develop to a certain point before resources and energy can be devoted to art. Nevertheless, settlers in America brought examples of European art with them and began to develop their own creativity almost as soon as they had arrived. Aesthetic considerations were always present in America, despite the struggle for survival at first and the iconoclastic religion of New England Puritanism. In fact, America's earliest picture in both Boston and New York celebrated the grand, painterly, opulent Baroque style.

JOHN WHITE, *Their Manner of Fishynge in Virginia*, 1585.
London, British Museum.

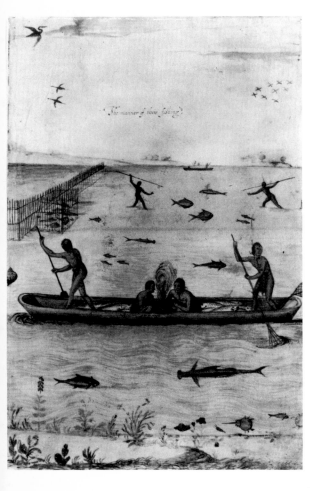

26

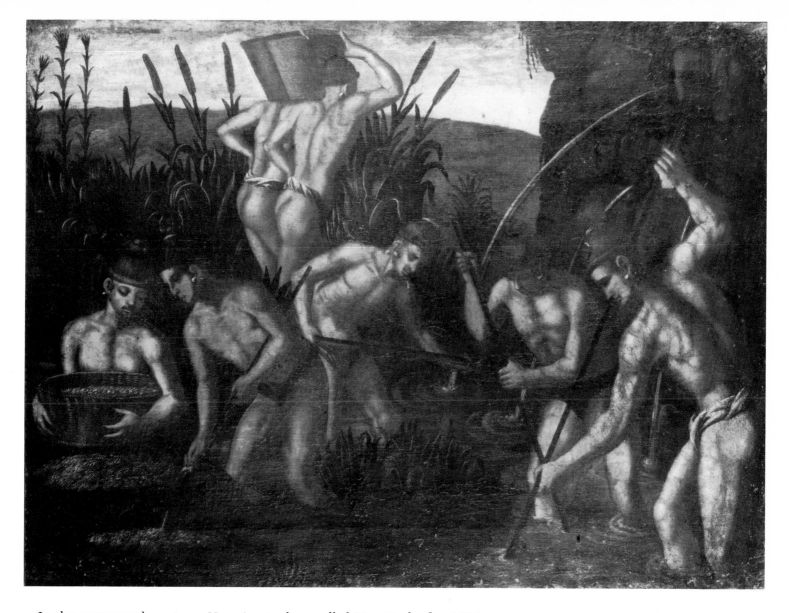

In the seventeenth century, New Amsterdam, called New York after 1664, was the most important artistic center in America, and painting flourished. Evert Duyckinck arrived there in 1638. Contemporary records referred to him primarily as 'glazier,' but he painted on glass as early as 1656 and was called 'Limner of New York' in a deed of 2 November 1693.[1] Jacob Strijcker and Augustine Herrman, both of whose self-portraits survive, arrived about 1651. Jan Dirckzen described as 'painter' lived in New York as early as 1657, and a Frenchman, Hendrik Couturier, was painting portraits in New York before 1663.

These pictures are Baroque and follow the strong Dutch school. In fact, they show the influence of Rembrandt, who was still alive in Holland and was producing his greatest pictures at the time that painting was beginning in New York. For example, the composition of the equestrian portrait of Nicholas William Stuyvesant recalls the rearing horse in a landscape from Rembrandt's *Rider* (1659) in the National Gallery, London, although the colonial has transformed Rembrandt's steed in to a hobby horse. The American portrait, dated 1666 and sometimes attributed to Couturier, was typical of the New York school. The head was convincingly modeled, and the landscape was competently executed. The horse was, of course, ludicrous but might have been an attempt to follow the late-seventeenth-century tradition in Holland of placing the head below eye level so that the top of the head was prominent and the body severely foreshortened. Rembrandt carried on the tradition in *The Man in the*

JACQUES LE MOYNE, *Indians of Florida Panning Gold*, c. 1564.
London, Dawsons of Pall Mall.

27

Above ANON., *Nicholas William Stuyvesant,*
1666.
New York, New-York Historical Society.
Opposite AUGUSTINE CLEMENS, *Dr John
Clarke,* 1664.
Boston, Massachusetts, Boston Medical Library.

Gold Helmet (1646), but the colonial artist was unable to handle the convention which was inappropriate for an equestrian portrait.

The seventeenth-century portraiture of New England had Northern Baroque overtones because it was based on Dutch art, modified and transmitted by English sources. After 1620, Dutch painting strongly influenced English work and supplanted the Flemish and German traditions evident in the style of Holbein a century before. In London, Honthorst, Mytens and other Dutchmen introduced Dutch Baroque realism. Outside of London, East Anglia, a prime supplier of New England settlers, which was closely connected by trade and even culture to Holland, adopted the Dutch manner. Other areas retained their linear, Holbeinesque style or combined it with the new Dutch styles.

The portrait of Dr John Clarke painted before 1664 is the earliest known portrait done in New England and is an example of an English provincial style influenced by the Dutch. The face is sensitively modeled, the color sophisticated, and the skull which Dr Clarke holds displays the typically Dutch interest in still life. The catalogue of seventeenth-century painting by the Worcester Museum of Art (1935) concluded that the picture was thought to have been painted abroad or possibly by 'an artist who visited England briefly;' but astutely added that 'it is not impossible that the painter of the portrait of Clarke may have been the man who first brought to New England the smattering of Anglo-Dutch realism and style. . . .'[2] The latter idea now seems correct. While the portrait was unsigned and the inventory of Clarke's estate listed it without giving the painter's name, it is almost certain that the picture was done in America by Augustine Clemens. Like Evert Duyckinck, Clemens was trained as a decorative glass and heraldry painter. He was born before 1605 and was indentured first to John Miller and then to Edward Newman of Eton, England, who worked in the Dutch manner. Windsor and Eton were important local centers for painting, but Clemens traveled to Reading in December of 1629 when he was paid for painting windows. In 1634 Clemens signed a complaint against several interlopers who were illegally taking his trade. The outcome of the case was not recorded, but in the corporation records of Reading for March 1635 Clemens 'did take the oath of supremacie and allegiance intending to goe to new England.'[3] He sailed with his wife Elizabeth, his daughter Elizabeth, son Samuel, and servant Thomas Wheeler on 5 April 1635, and arrived at Boston on 3 June. At first Clemens lived in Dorchester, but on 20 March 1652, he bought land in Boston and was described as 'painter' in the deed. This document stated that Clemens' land was bounded on the north by the house and land of John Clarke.[4] The connection between Clemens and Clarke was therefore substantial and inevitably led to the speculation that Clemens painted his next-door neighbor's portrait.

The Clarke picture is clearly related to painting in Reading. The portrait of *The Lord Mayor* (1632) in the Reading Town Hall has the same modeling of the face and interest in a treatment of accessories as in a still life. If Clemens was the painter of Clarke, a connection between the Dutch influence on provincial portraiture of England and the early works in Boston is clear. The style of Clarke's portrait was decidedly not indigenous. It was not a vigorous picture. Although sophisticated in technique, the composition was derivative; the shapes and forms, except for the collar, were not distinguished, and the drawing of the hand was unresolved. The best part of the picture was the still life with skull. This vignette was included to show Dr Clarke's instruments and was part of the iconography of the sitter. Nevertheless, the overtones of *memento mori* and the symbolism of the skull would have interested a Bostonian accustomed to seeing the devices on gravestones of the period. In fact, Clemens made the stone for Richard Mather's grave in 1669. Thus, the still life might be related to the American aspects of Clemens' experience. The importance of direct observation from the very beginning of American painting

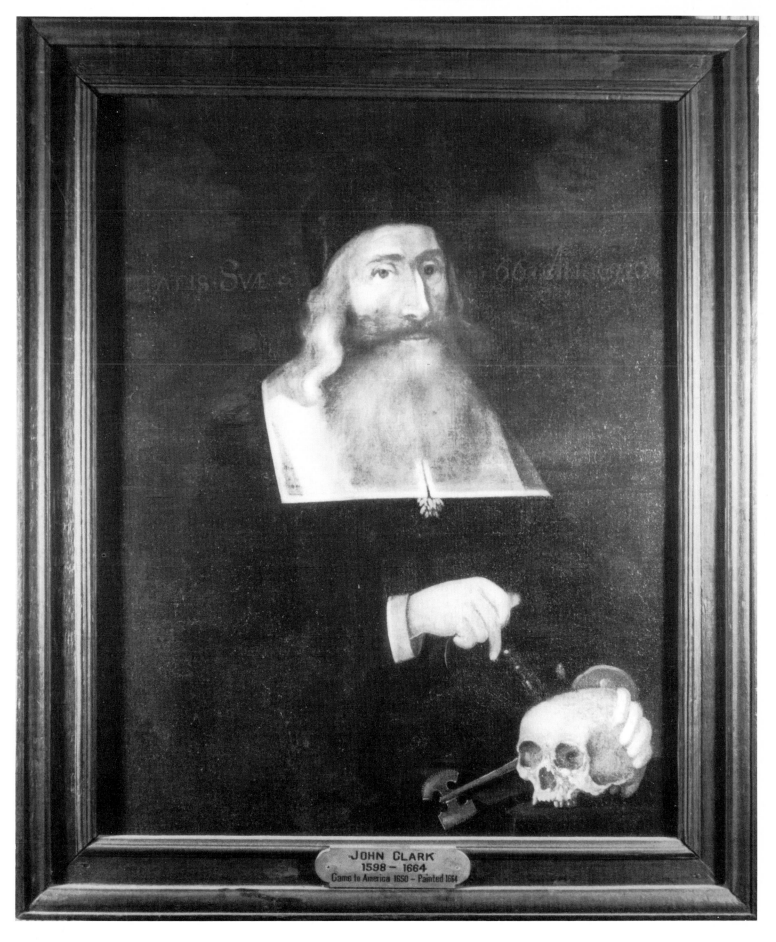

JOHN CLARK
1598 — 1664
Came to America 1650 – Painted 1664

was evident because the still life was not taken from a traditional model and its specificity allows one to identify the tools. But the picture was a reflective one. It was competent, even schooled, yet not native; it remained a provincial English painting in America. The style expressed the sitter's station in life; the iconography was symbolic; the technique European Baroque. There was little adjustment to new American circumstances.

In contrast, an American point of view appeared in the portraits of *Mr John Freake* and *Mrs Freake and Baby Mary*. The style was adjusted to new conditions, and the artist relied strongly on direct observation. The two portraits emphasized line and pattern as seen in late medieval art but they lack the sculptural qualities of that art; they have no religious symbolism or Gothic naturalism. Instead, the diagonal composition emphasis on movement, and draped interior setting indicate a Baroque style. More particularly, the display of material wealth showed the Dutch influence. The linear decorative elements appeared in those places where the training of the artist was wanting, and he developed his own solutions to the visual problems presented in the picture. He dazzled the viewer with tangles of red and black bows, rare and expensive pearls, a gold ring, and European lace. He exploited these passages of visual interest based on direct observation and did not grasp feebly for half-learned professional practices. His solution revealed his natural talent and ability. His adaptations shine through a traditional format as unencumbered expression.

The Freake portraits were painted in 1674. Mr Freake died in an explosion in Boston Harbor on 4 May 1675; and Baby Mary, whose age was inscribed as 6 months on the portrait, was born on 6 May 1674.[5] The artist who painted these pictures may never be known, but the possibility exists that he was Samuel Clemens, Augustine's son. Augustine Clemens himself died in 1674, but in his will he left his paintings to Samuel, in whose will of 1678 they appear. Although Samuel survived his father by only four years, he could have easily painted the Freakes. Samuel lived near them, and is described as a painter-stainer in the Suffolk County deeds. Samuel's style can only be surmised, but it would probably have been based on his father's Anglo-Dutch manner; the loss of modeling and reliance on new solutions would indicate precisely the formula of the Freake pictures. A similar style is found in the portraits of the Gibbs children – Henry, Margaret and Robert. Dated 1670, the paintings are by the same hand as the Freake artist, probably Samuel Clemens. The draped interior, the emphasis on beads, lace and fashion were similar in the Gibbs and Freake pictures. The face of Margaret Gibbs was painted with the same delicacy of Mrs Freake's, and the treatment of sleeves and ribbons in the costume of the Gibbs girl and that of Baby Mary is comparable.

To paint their daughter Alice, Arthur and Joanna Mason did not chose the same artist as Robert Gibbs. Little Alice was not portrayed as a miniature adult. The chubbiness of her face was emphasized, and she mischievously points a tiny finger at the apple she holds rather than stiffly grasping an inappropriate fan as did Margaret Gibbs. The artist of the Mason girl was more sensitive to children and had a different feeling for space. The Gibbs painter created a stage on which the linear, mannequin-like figure was placed before a backdrop. The Mason painter eliminated the drapery, ignored perspective, and established no space. Alice, because she appeared as a three-dimensional solid form, displaced space. Considering this figure–space relationship, the Gibbs and Mason painters could not have been more different.

The Gibbs and Mason portraits show that Bostonians had some choice of painters by 1670. But an analysis of three portraits of ministers – Richard Mather, John Wheelwright, and John Davenport – shows that the demand outran the supply of talent. These were certainly not done by an experienced artist. They appear to be the work of someone pressed into service. All three share techniques usually found

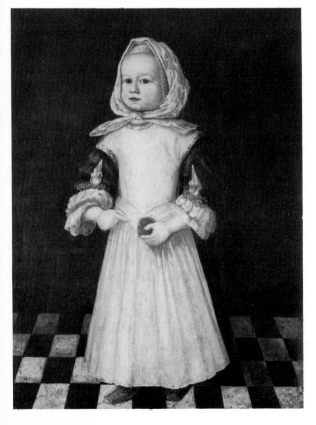

ANON., *Alice Mason*, 1668. Quincy, Massachusetts, Adams Memorial Society.

in the work of a child prodigy. The drawing is instinctive; the primitive image is created by techniques of silhouette; outline and overlapping of edges are the primary means used to produce the form. The pictures employ the simplest vocabulary to represent the figure and are symbols, not artistic realizations of form created from any knowledge of style. In no way should these portraits be considered a conscious reduction of a higher style to a 'plain style' because of Puritan beliefs. Their simplicity is what occurs when the artist is unschooled in any style. The picture is vernacular and does not belong to any stylistic or iconographic tradition or school. The painting appears to be the product of a person who solves each representational problem as he comes to it, without any plan or learned sequence, but this spontaneity is perhaps a redeeming quality. Despite the absence of depth, the pictures have a successful arrangement of shapes on the surface, the area of the artist's primary concern. Probably the pictures were painted by John Foster, who was basically a printer. A woodcut of the Mather portrait appears (*c*. 1670) in a book by Foster.

The portrait of William Stoughton indicates a conscious effort to produce a work of art in an iconographic tradition. Just as Stoughton Hall, the sitter's gift to Harvard College shown in the background, exhibits a deliberate attempt to imitate the buildings of Inigo Jones in the symmetrical façade, string courses, quoins, and alternating dormer pediments, the composition of the picture flirts with academic formulae. The figure is placed at the edge of a wall which bisects the picture and forms a triangular shape in traditional Renaissance practice. The iconography, too, has a long tradition: donor portraits dating to the fifteenth century, when the portrait tradition in the North began. Stoughton is depicted like Jan Vos, who kneels beside a model of his newly constructed church in the *Exeter Madonna*.[6] Stoughton no longer kneels (for Puritan practice would forbid it) but presents his building in the manner of a modern magus. The vista of the curiously alpine landscape is also related to Northern Renaissance altarpieces and Flemish illuminated manuscripts but here may be merely a product of fancy.

Below JOHN FOSTER (?), *Reverend John Davenport*, 1670.
New Haven, Connecticut, Yale University Art Gallery.
Below, right ANON., *William Stoughton, c.* 1690.
Cambridge, Massachusetts, Harvard University Portrait Collection.

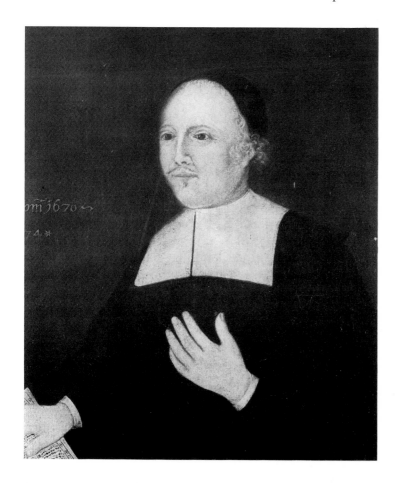

Painting in Plymouth, which was not a part of the Massachusetts Bay Colony until 1670, paralleled Boston developments; but just as cupboards and chests from the South Shore area were different in ornament and proportion from North Shore examples, the portrait of Elizabeth Paddy Wensley, born in Plymouth in 1641, exhibited certain variations. Her costume and the drapery resembled these corresponding items in the portrait of Mrs Freake. The window revealing a landscape was analogous to that in the Stoughton portrait, but the still life of flowers in a bouquet of roses and tulips in a glass vase was a direct descendent of the Dutch flower pieces in which the Protestant Netherlanders specialized. Although the tulip represented resurrection and the rose symbolized both the Virgin and Christ, the meaning of this still life in an American portrait is not clear. These flower pieces, which were considered attributes of the Virgin and were often found on doors enclosing church organs have, like donor figures, become separate from religious scenes on altar pieces. The picture of Elizabeth Paddy Wensley has strong Dutch Baroque overtones, not only in its iconography but also in its formal expression. The drawing of the hands, for example, is much closer to the delineation in the portraits of Captains George Curwin, Thomas Savage, and Thomas Smith, which together are perhaps the most Baroque paintings done in the Massachusetts Bay Colony.

The three portraits of ship captains were not necessarily by the same person, but they all revealed that painters in Puritan Boston knew chiaroscuro, solid form, and three-dimensional space incorporating both foreground and distant views. The picture of Captain Smith (dated 1680–90) appears to be a self-portrait, because the initials 'T.S.,' used as a signature on a poem, are prominently placed in the com-

Left THOMAS SMITH, *Self-Portrait*, c. 1699. Worcester, Massachusetts, Worcester Art Museum.

Opposite SAMUEL CLEMENS (?), *Mrs Freake and Baby Mary*, 1674. Worcester, Massachusetts, Worcester Art Museum.
Overleaf, left ROBERT FEKE, *Isaac Royall and his Family*, 1741. Cambridge, Massachusetts, Fogg Art Museum, Harvard University.
Overleaf, right ROBERT FEKE, *Isaac Winslow*, 1748. Boston, Massachusetts, Museum of Fine Arts, Gift of Russell Wiles.

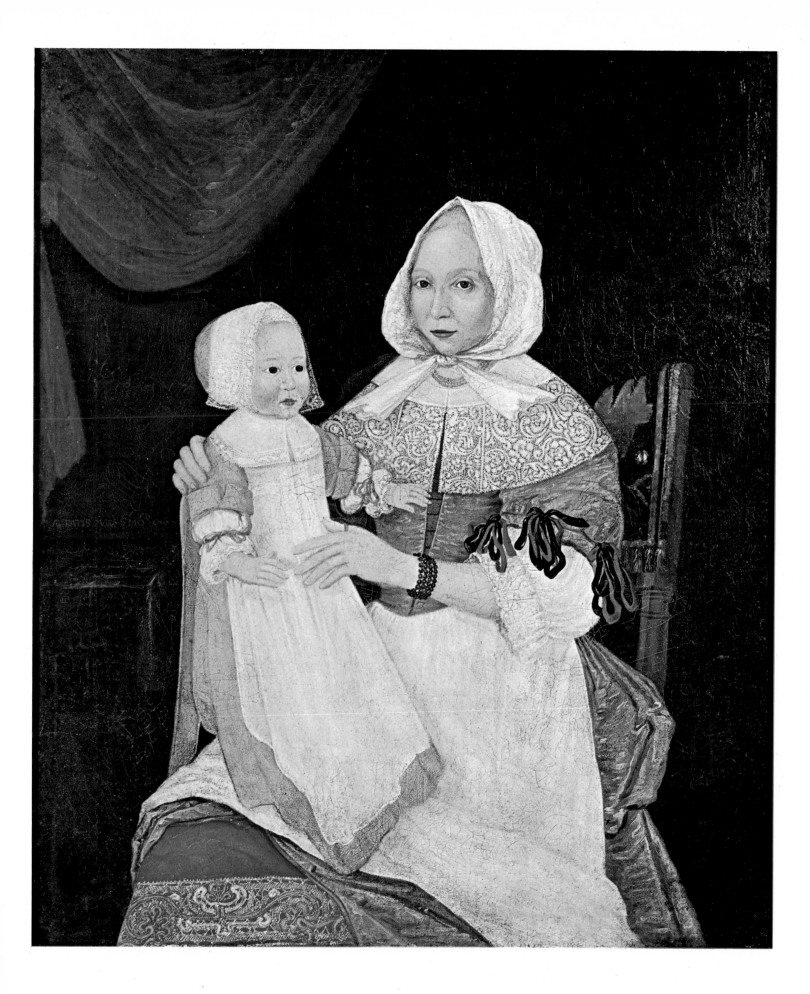

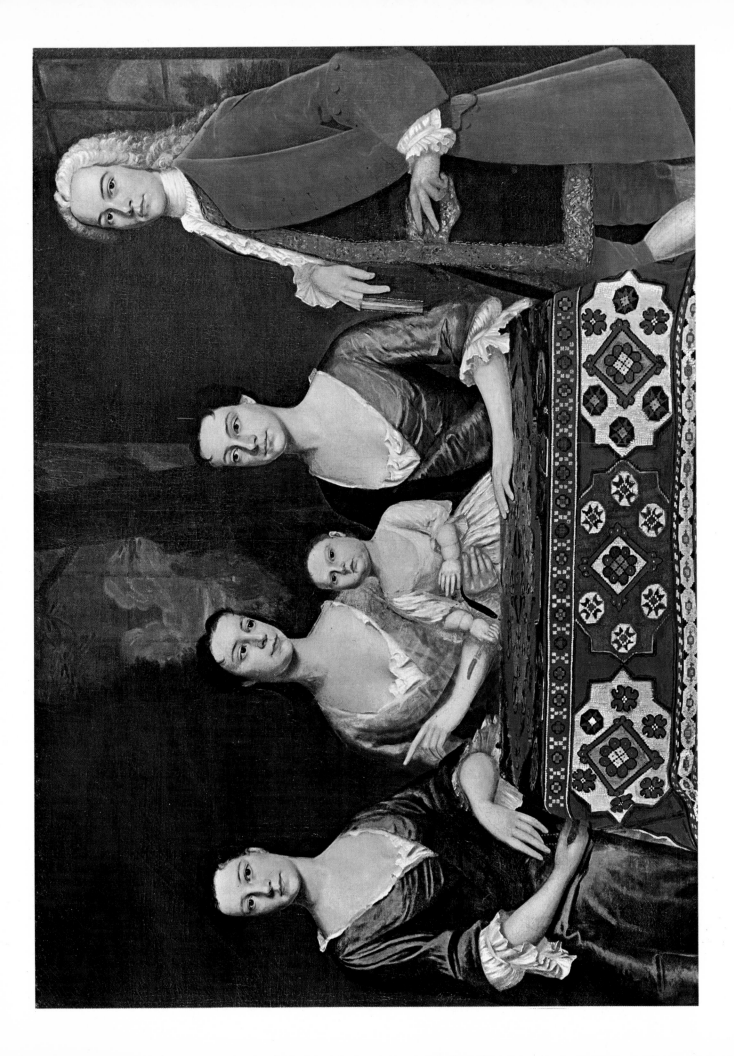

position. The Treasurer's account book for Harvard College contains an entry for 2 June 1680, 'college Pr. to Money pd Major Tho. Smith for drawing Dr. Ames effigies pr Order of the Corporation. L4.4,'[7] and thus indicates Smith was a practicing artist.

The Smith self-portrait was robust and flowing. Sculptural forms and strong patterns of curvilinear movement were created. These elements which connected Smith with Sir Peter Lely, the most high-style court painter in England, indicated that the leading colonial painters in the seventeenth century were not archaic or late-medieval. Smith's picture, while harshly modeled and crudely executed in places, was *au courant* with London painting, just as the contemporary Boston houses of Peter Sargent and Foster Hutchinson proclaimed the Baroque with their curled Dutch gables and the floriated Ionic capitals of Inigo Jones. Perhaps Smith's portrait reflected the combination of Puritan and Anglican thinking brought by the new Royal governors to Boston at the end of the seventeenth century through the use of the *veritas* theme in the skull and poem. But the skull does not represent the iconography of St Jerome and other ascetic saints. It is presented with the poem on the table as a pendant to Smith's personality. Smith's self-portrait anticipated the thinking, brought to its fullest expression by William Hogarth in his portrait of Captain Thomas Coram (1741), that a portrait should not communicate the subject's personality through a pose symbolic of his birth of station but should reveal the man's character through his individual features and a few personal objects which identified his profession and amplified his individuality. In Coram's picture one sees his ships, a globe turned to America where he made his fortune, and the charter of the Foundling Hospital which he established. In Captain Smith's picture one sees in the background a naval encounter with each ship carefully identified by a flag and a fort; on the table next to the sitter is a poem from his hand. Thus American painting in some way previewed the concept of the middle-class portrait which apparently emerged in England later than in America.

Smith's Baroque style had its following in New England although few artists' names are known. Because many pictures of American subjects were by English artists when the sitter was visiting England and some pictures were painted by English artists touring America, it is difficult to analyze American painting in the first decades of the eighteenth century. The portrait of Anne Pollard in the Massachusetts Historical Society, painted in America in 1721, shows the combination of earlier American traditions with the European Baroque style. Perhaps the purest example of this duality is the portrait of the Reverend John Pierpont. Although the painter of this picture was aware of Baroque fashions and struggled successfully to give three-dimensional form, the artist worked with a limited number of elements, just as John Foster had done in his depiction of John Davenport. The linear geometry of the earlier portrait gave way to the new style – not unlike the similar displacement of the strict Puritan theology heralded by John Wise's *Saybrook Platform* of 1710. Several other pictures have been attributed to the Pierpont painter. Surely the portrait of Mrs Pierpont was by the same artist, but in few of the other related pictures was the head placed as high on the canvas or were the faces imbued with the direct but vacant stare of Reverend Pierpont. More rewarding than New England for the study of American paintings in the early eighteenth century are the colonies of Delaware and Maryland and the South, where important developments of this period occurred. Unfortunately there are only a few documented pictures, and they represent Continental rather than English traditions.

On 3 December 1708, 'the Petition of Justus Englehard Ketclon, Painter a German read praying leave a Bill may be brought to naturalize.'[8] From this time until 1717 when he died, he appeared regularly as Kühn in the records of St Ann's Parish, Annapolis. Most of the portraits attributed to Kühn were of members of the family

Opposite WILLIAM WILLIAMS, *Deborah Hall*, 1764.
Brooklyn, New York, Brooklyn Museum, Dick S, Ramsay Fund.

ANON., *Reverend John Pierpont*, c. 1710. New Haven, Connecticut, Yale University Art Gallery.

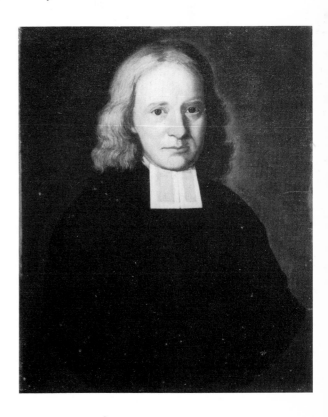

of Charles Carroll The Settler, who was executor of Kühn's estate, and of the collateral families of Darnall and Digges. The only picture signed by Kühn was the portrait of Ignatius Digges, inscribed 'Anno Aetatis Suae 2½ J7J0, E. Kühn, Fecit.' The Darnall pictures were very close to this signed example, but some of the Carroll and related families' pictures departed to greater or lesser degrees from the style seen in the Digges portrait and may not have been from Kühn's hand.

The Digges picture was possibly the most elaborate portrait painted in America at that time. The idea of the small child dressed in his best and acting like a miniature adult had been seen before in the Gibbs and Mason pictures, but the extraordinary surroundings in the Maryland painting superseded anything done in New York or Boston. It was a *tour de force* of symbolism, not unlike the works of Kühn's contemporaries in Germany. The immediate prototypes of Kühn's background were in pictures such as *The Visit* by Theodore Böyermans, in Antwerp, and *The Verbiest Family* by Gonzales Conques, at Buckingham Palace. Both depicted a group of people before a balustrade, fountains or statuary, and a grand vista of gardens and estate. Kühn had reduced the composition to include only one figure. These scenes which used the balustrade motif were derived from the works of Rubens, who was among the earliest artists to show a group of people in a garden with a colonnade

JUSTUS ENGELHARDT KÜHN, *Ignatius Digges*, 1710.
Doughoregan Manor, Maryland, Philip Acosta Carroll Collection (Photo Frick Art Reference Library).

and house. And, going further, Rubens' *Garden of Love* (*c.* 1632–4), was a secular, middle-class adaptation of the *Sacra Conversazione* where the Virgin and Child with Saints were depicted on a series of steps with balustrades.[9] The American conclusion of this portrait type may be in William Williams' New York portrait of *William Denning and his Family* (1772), which contained the same basic iconography.

Five years after the arrival of Kühn, Gustavus Hesselius, a Swedish painter trained in England by Michael Dahl, came to the Maryland area. In the company of his uncle, the Reverend Andreas Hesselius, Gustavus landed at Wilmington, Delaware, then called Christiana, on 1 May 1712. The Old Swedes Church records noted, 'Mons Gustaff Hesselius after a few weeks flyted on account of business to Philadelphia.'[10] Gustavus lived over forty years in America until his death in 1755. More is known about his later than his earlier work, although Gustavus was making some extraordinary paintings, such as a *Last Supper* in 1721 for St Barnabas' Church of Prince George's County, Maryland.[11] In 1735 he was commissioned by John Penn (to whom he had been given a letter of introduction in 1711) to paint portraits of the two chiefs of the Delaware Indians, Tishcohan and Lapowinza;[12] Hesselius treated these subjects with almost scientific realism, eschewing the usual Baroque approach.

Hesselius' allegorical figure subjects, *Bacchus and Ariadne* and *Bacchanalian Revel*

GUSTAVUS HESSELIUS, *Bacchus and Ariadne*, 1726.
Detroit, Michigan, Detroit Institute of Arts.

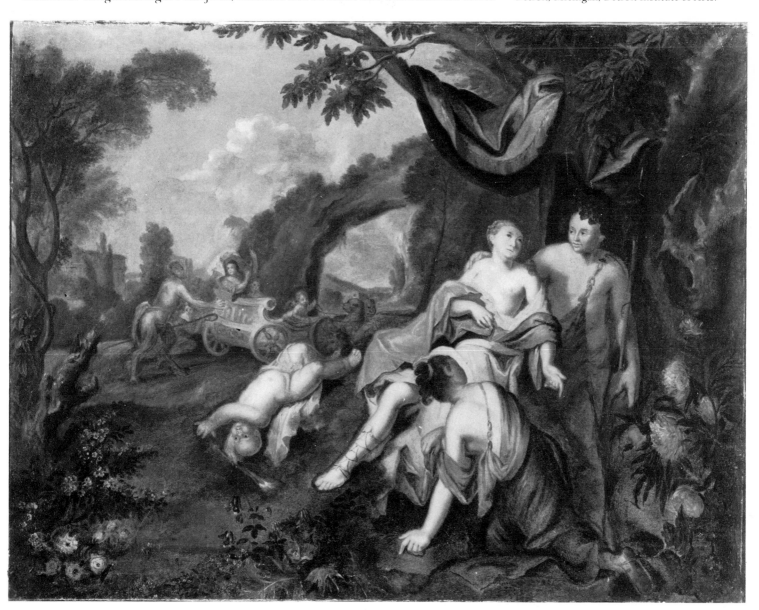

39

(both *c*. 1720) are the earliest known mythological paintings produced in America. They seem to have been done for the artist himself because they descended in his own family, and they were probably executed as exercise. As such, they are also the earliest in a long line of allegorical study pieces by American artists: *The Continence of Scipio* by John Smibert (1722), *The Judgment of Hercules* by Robert Feke (1744), *Galatea, Mars, Venus and Vulcan,* and *The Return of Neptune* by John Singleton Copley (1754), *The Death of Socrates* by Benjamin West (1758), and several others. Only West's *Socrates* passed out of the painter's hands. These mythological works reveal the nature of artists' training in America – copying the Old Masters from engravings. The scarcity of allegorical and historical paintings reports that Americans had little use for such subjects and purchased portraits almost exclusively.

Completing the triumvirate of Continental painters who immigrated to the South was Jeremiah Theus. He came to Charleston about 1739 and, in an advertisement of 1740 in the *South Carolina Gazette,* gave notice that he 'is removed into Market Square, near Mr John Laurens, Sadler, where all Gentleman and Ladies may have their pictures drawn, like wise landscapes of all sizes, crests and coats of arms for

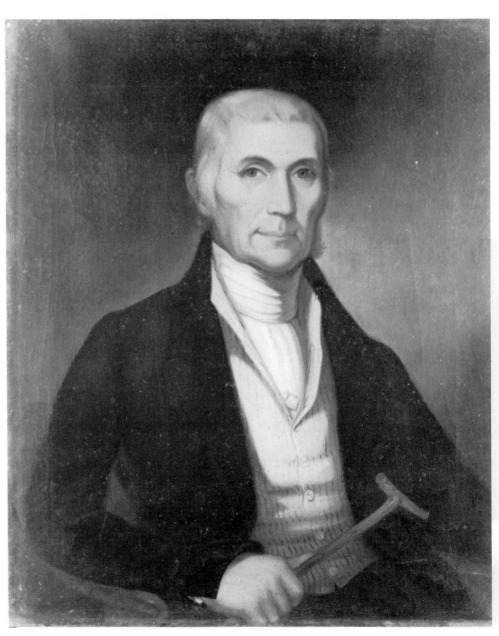

Above JEREMIAH THEUS, *Sarah White*, 1753. New York, Mrs John Campbell White Collection (Photo Frick Art Reference Library).
Right ANON., *William Edward Brodnax*, 1720. Richmond, Virginia, Virginia Museum of Fine Arts, Loan of William Brodnax III.

coaches or chaises. Likewise for the Convenience of those who live in the Country he is willing to wait on them at their respective plantations.'[13] Most of Theus' early works, among which may be the portrait of *Sarah White* initialed 'J.T.' and dated 1753, were continuations of Kühn's painting done before 1717, but he quickly turned to a newer style in portraits such as *Mrs Thomas Lynch* signed and dated 1755. This picture was replete with the delicate appeal of an almost Rococo style and represented the genteel taste of sophisticated Charleston.

Not all painting in the South was so elaborate or done by trained continental artists. Several portraits done in Virginia about 1720 displayed a distinct native strain. One of these was the portrait of William Edward Brodnax. The composition clearly had European pretenses: the billowing drapery and the bird motif were often found in academic pictures. In this painting, however, a distinct flair in the exaggeration of these elements gives vigor and charm to what could have been merely a derivative picture. The Brodnax portrait was not unique. There were many American examples which had the same strong color and harsh lighting and depicted a young boy with a bird. Similar pictures appeared in the West Indies and occasionally in England. Few, however, had as much energy. The Brodnax portrait is related to a number of pictures done in New York between 1710 and 1740, although they were not necessarily by the same hand. There may have been itinerant painters at this time because the portraits of Governor Ward of Rhode Island in the Newport Historical Society and Ariaantje Couymans of Albany in the Albany Institute are so similar; but this connection may only suggest Ward's picture was done in New York and underlines the close artistic ties between Rhode Island and New York.

New York portraits of this period (1715–45) form the first native school of American art. They represent the work of many different painters, most of whom have not yet been identified. Related portraits of the Schuyler, Van Vechten, Van Alstyne and Van Schaick families compose the largest related group and their maker is identified as the 'Aetatis Suae' artist because each work bears that Latin inscription. All were painted in Albany and shared certain idiosyncrasies, such as the sharply curled glove in the left hand, the awkwardly pointing right hand in the men's portraits, strongly lighted drapery forming a V-pattern where the coat is open, and a view into the landscape in the women's portraits. Stylistically these pictures descended from the work of the Dutch painters Maes and Netscher, whose paintings of the 1670s and 1680s grafted Flemish elegance and color derived from Van Dyck onto Rembrandt's Netherlandish realism. Their subjects were often placed against a background of a park containing architecture and sculpture in the international late Baroque vogue. The 'Aetatis Suae' painter, whose work probably included a restricted group of Albany society, appeared to have a Dutch-based style which would have been chosen by the fiercely conservative landholders of the Upper Hudson River Valley. At the same time, other patrons chose a more English style as in certain portraits of the Van Rensselaer family, a *Gentlemen of the Schuyler Family*, *Robert Livingston*, *Anthony Douane*, and *Johannes de Peyster III*. While these portraits were related to the school of Maes, all of them were adopted directly from English mezzotints and appeared to be by a British artist or artists working in New York. The de Peyster portrait had the harsh, broken highlights in the drapery seen in the 'Aetatis Suae' pictures, but there was no similarity between the paintings of de Peyster and Anthony Van Schaick. De Peyster triumphantly, even contemptuously, swaggered through his space; his face and hands are elegant stereotypes. Van Schaick was cramped into his space; he managed a smile but remained brusque and homely. The pictures represent two stylistic poles: the decorative, idealized English court style of the late seventeenth and early eighteenth centuries and the direct realism of the Dutch bourgeois style.

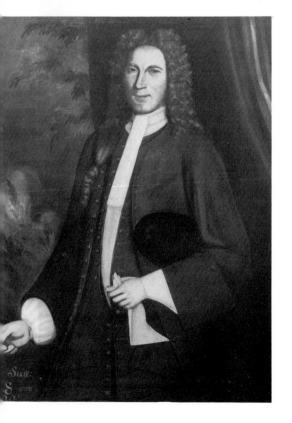

ANON., *Anthony Van Schaick*, 1720. Albany, New York, Collection of the Albany Institute of History and Art.

41

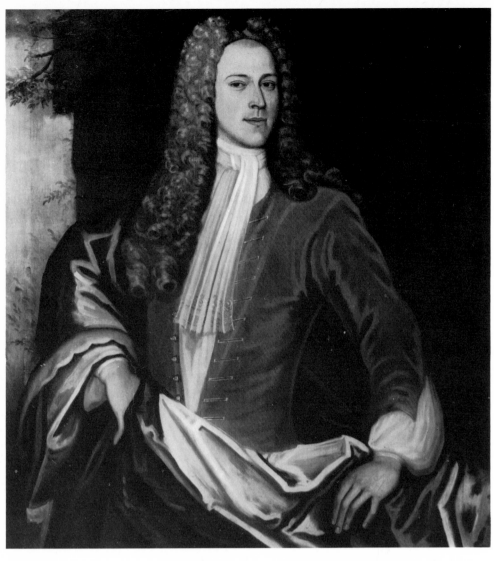

Another important New York group during the 1720s included portraits of persons in the Philipse, Beekman, Proost and Jay families. These half-length pictures emphasized a three-quarter view of the subject with the outline of the nose curving down from the eyebrow. The figures were not placed in a landscape, and the creation of forms in paint was rudimentary. Iconographical accessories were modest. In their lack of sophistication and absence of European stylishness, this group of portraits is linked to an earlier self-portrait of Gerret Duyckinck (1710), whose family of craftsmen-painters had been without direct European contact for several generations. The Duyckincks worked in New York City and nearby Westchester County, where most of the subjects in this group lived.

In the 1730s a second generation of painters seems to be active. One was the painter of Moses Levy, Jacob Franks, the Franks family, and the Crugers. Another was the author of the delightful portraits of the Van Courtland and de Peyster children. He used English mezzotints but infused his pictures with a more personal feeling for design and color than earlier artists who did little more than transfer the outlines of the engravings and tint them. Color in *The de Peyster Boy with Deer* was ingenious. In the central figure the artist used red and blue augmented by pink; in the background he placed the color complementaries, olive and yellow-orange. The proportions of the color masses were carefully considered and set off by the neutral browns and gray of the deer and of the architectural elements. The artist made some compositional changes from the mezzotint prototype, *Lord Buckhurst and Lady Mary Sackville,* engraved by John Smith in 1685 after Godfrey Kneller's painting.

The girl and the garlands of flowers were omitted, but the American added a scroll to the stairs to compensate for the lack of interest created in the lower portion where the deletion of the flowers had left a void. In addition, the elaborate architecture and the scale of the space were reduced. The ashlar articulation of the wall in the print gave way to a plain surface and the trees whose branches are placed very high relative to the boy's head in the mezzotint to give a towering vastness to the park scene are made smaller, lower to the ground, and more in keeping with the natural terrain of the new world.

Architecture played an important role in still another group of New York pictures which included portraits of Cornelius Wynkoop, William Van Berger, Adam Winne, Susan Truax, Magdalena Douw and Matthew Ten Eyck. Pattern, flattened space, whimsy, and the transformation of forms into strong silhouettes and stylized shapes – all elements of so-called American folk art – appear in these works. Matthew Ten Eyck, perhaps unwittingly, appears to be the de Peyster boy's country cousin. The grove of trees in the de Peyster picture became a row of cones, and the already simplified de Peyster architecture was distorted into a play house of caricatured moldings and sharp planes. The Ten Eyck and other similar portraits are linked to one of the most interesting phenomena of the New York School, the religious

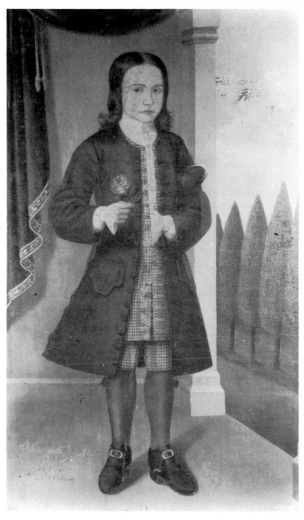

Left ANON., *The de Peyster Boy*, 1738. New York, New-York Historical Society. *Above* ANON., *Matthew Ten Eyck*, 1733. Mrs Frank H. Nowaczek Collection (Photo Frick Art Reference Library).

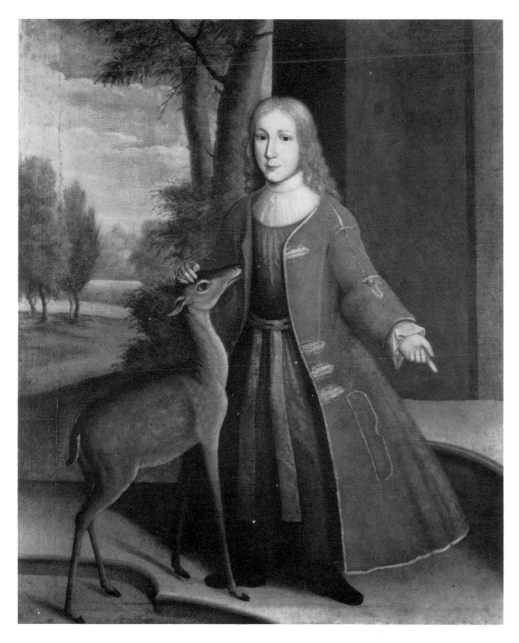

pictures, because the rendering of the architecture, landscapes, and drapery in the religious scenes is so similar to the same elements in the portraits. In the Roman Catholic areas of America, one found occasionally a religious picture, such as the *Last Supper* by Hesselius. And, there were significant religious pictures in the Spanish and French settlements, but in the Protestant settlements paintings like *Isaac Blessing Jacob* were rare outside the Hudson Valley area. When Alexander Hamilton, who had met most of the major artists of America during his *itinerium* of 1744–5, visited Albany, he made particular reference to these pictures stating, 'They affect pictures much, particularly scripture history, with which they adorn their rooms.'[14] Most of these pictures were oil copies from illustrations in Dutch Bibles. Originally the paintings must not have been unusual, but only several dozen have survived. Nevertheless, within the group there are enough versions of one particular scheme to suggest this type of painting was a pastime of untrained artists, perhaps analogous to the needlework pictures and quillwork done by young girls in the Boston area.

A new style developed in New York in the late 1730s. It was thoroughly English, a product of the newly formed school of art developed in the English academies of Kneller, Vanderbank, Thornhill, and Hogarth. Possibly John Watson brought to New York and New Jersey the first inkling of this style, but thus far the portraits included in a 1726 list of Watson's *oeuvre* cannot be identified. Or, the style may have derived from the work of William Chambers, a Scot, who worked in New York about 1734.[15] The English academic style superseded all its predecessors when in the fall of 1740 John Smibert, formerly thought to have worked only in Boston, came to New York, where he painted eleven portraits.

Beginning in 1725 a change in style appeared in most of the colonies as a result of a large immigration of English-trained painters to America. These painters, often Scotsmen, were products of the school of Kneller and worked in an English Baroque portrait style which took form between 1715 and 1725. Sir Godfrey Kneller, a German trained by Ferdinand Bol in Holland and Carlo Maratta in Rome, dominated English portraiture after 1692, when he was knighted and made Principal Painter to William and Mary. He was one of a series of painters, beginning with Holbein, who were born and trained on the Continent, usually in Germany or Flanders, before going to England. Most of these artists overwhelmed British painters and repressed the development of a native school until the early eighteenth century. English painting had been a chronicle of Holbein, Van Dyck and Lely. During Kneller's ascendancy, however, England's native culture grew stronger, continental influences diminished, and an indigenous school emerged. Kneller operated a large portrait factory employing many specialists. The establishment of several academies in London fostered the development of the local talent and formed the first truly English school. The first academy was founded in 1711 with Kneller as its governor. He was succeeded in 1716 by Sir James Thornhill, who resigned in 1720 when he formed his own, unsuccessful school. In 1734, William Hogarth created the St Martin's Lane Academy based on Kneller's foundation, and it was this group which eventually became the Royal Academy.[16]

The earliest practitioner of the Knelleresque style to come to America was probably Peter Pelham, who arrived in Boston in 1726. He was not a trained painter but an engraver; through his medium he was familiar with the prevailing style. Why he emigrated is not clear. Francis Dewing and William Burgis, both English engravers, had come to America in the early 1720s and had been successful. Perhaps Pelham had a similar idea. He quickly found, however, that there was no one painting portraits in America from which he could make mezzotints, and when he did make the first American mezzotint portrait he had to paint the portrait of the subject,

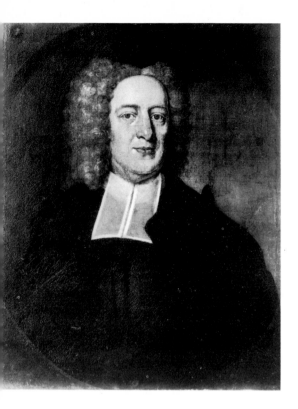

PETER PELHAM, *Cotton Mather*, 1727. Worcester, Massachusetts, American Antiquarian Collection.

Cotton Mather. The style was completely Knelleresque: the composition was based on a series of elegant, elongated, curvilinear shapes with a strong sense of movement. The emphasis on the wig, which dominated the picture, and the direct painting of the face were features derived from Kneller's work, but the American picture lacked the flair for the paint surface and color effects found in English works. Since Pelham was basically an engraver who worked in black and white, it was natural that these painterly elements should be missing from his picture.

Probably to Pelham's delight, new artists moved into Boston, and after 1729 Pelham could rely on others to provide portraits for him to engrave. By far the most important of these was John Smibert, who not only worked in the style of Kneller but also established the earliest museum of painting in America.

Born in Scotland in 1688 and a contemporary of Allan Ramsay and William Aikman, Smibert had been an important painter in London; according to George Vertue, he ranked with Hogarth in the early years of the latter's career. Smibert's training was typical of his generation of native British artists. After an initial apprenticeship as a coach painter in Edinburgh, he went to London in 1709. Two years later he enrolled in Kneller's newly formed academy (just as Hogarth was to do under Thornhill). In 1719 the young Scotsman went to Italy – a journey which had become a prerequisite for any Englishman with aspirations in the arts. After copying a number of works by Raphael and Titian, he returned to London in 1722 and began painting portraits and at least one conversation piece, an avant-garde composition in England at that time. His style was clearly based on Kneller's but modified by the bolder modeling and clearer form of the Italians. Smibert also used the new portrait poses of Charles Jervas, who was appointed Portrait Painter to the king after Kneller's death in 1723. Like Smibert, Jervas had studied with Kneller, been to Italy and copied Italian pictures, especially Raphael's cartoons, now in the royal collections at Hampton Court. Thus, the style of Jervas, as seen in his portrait of Jonathan Swift, in which a geometry of bold shapes, with an emphasis on the oval head, is substituted for Kneller's aristocratic flourishes of brushwork and a more deliberate spatial context replaces his teacher's fluid environments, may have reinforced Smibert's development.

In June of 1726 Smibert painted a portrait of George Berkeley. This painting was to change his life: not because of the picture itself, but because the sitter returned to Smibert in 1728 and persuaded him to go to America as professor of drawing in a college Berkeley had been commissioned to establish in Bermuda.

Smibert's recently discovered *Notebook,* which begins with the date of his first shave in 1705 and continues throughout his career until 1746, tells his story better than any biographer.

In September the 4th 1728 I Set out for Rhode Island from London in Company with the Revd. Dean Berkeley Ec in the Lycy Capn. Cobi and put in to York river Virginia the 6th of January. The 16th of the same month we sailed for Rhode Island where we arrived the 23d, – 1729.

July 30, 1730, I was married to Mary Williams by Dr. Sewell. She being then aged twenty-two years and 6 months, and I forty two years and 4 months.

Then follows mournful entries of the birth of nine children and the deaths of five of them in infancy. Finally on page 21, 'An Accot. of Pictures painted by John Smibert at Boston May 1729,' continued with a list of pictures stating the size and format, the month and year completed, and price paid for each portrait. An incredible document which apparently included every picture Smibert painted, the account showed Smibert had wasted no time in going to Boston where good com-

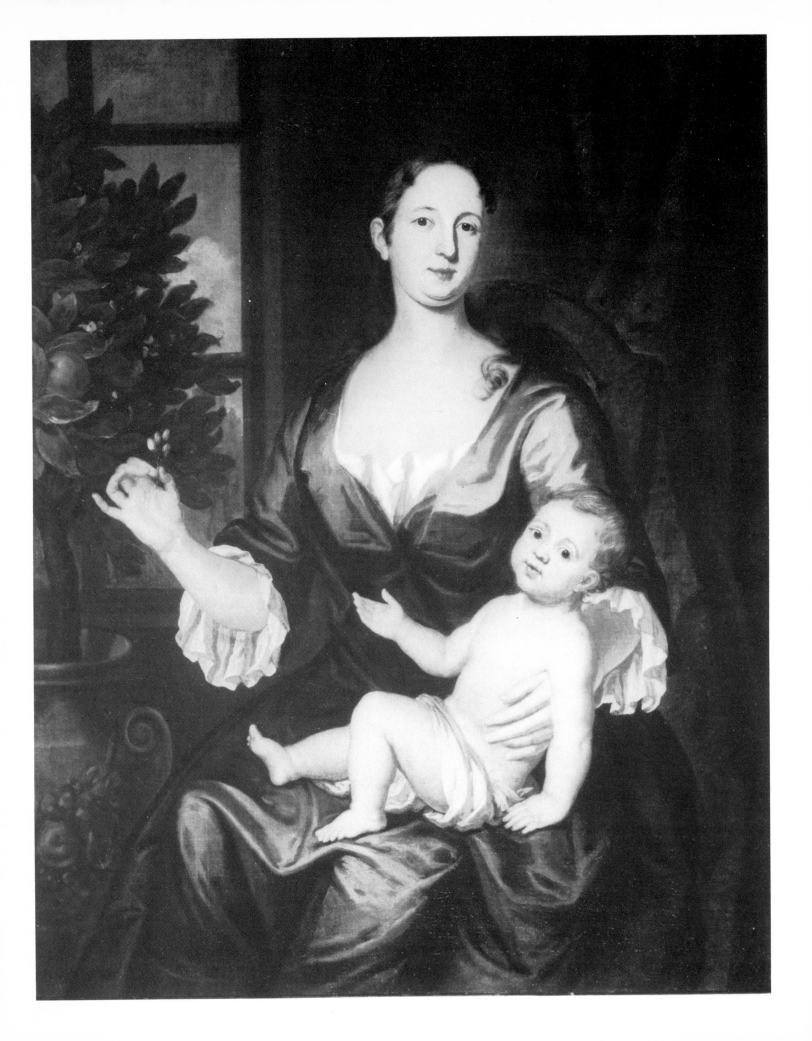

missions could be obtained. He started at the top of society by painting Governor Hutchinson's wife for his first American portrait.[17]

Smibert's clients were all from the leading families of Boston, and most were associated with the governor. The new artist's paintings were the most sophisticated and more *au courant* by London standards than any others in America in the 1730s. Smibert's fifth picture painted in Boston was *Mrs Francis Brinley and her Infant Son*, a companion to the portrait of Francis Brinley, a friend of Berkeley's and one of the wealthiest men in Boston. While Mr Brinley is shown beside a superb landscape of the town of Boston and Beacon Hill in detail (which could be seen from his mansion, Datchet House, built in Roxbury), Mrs Brinley is seated indoors. The basic composition recalls such mezzotint prototypes as *Lady Price* by Sir Peter Lely, but it is derived more directly from Madonna pictures, one of which Smibert brought to Boston. Smibert's style was sturdy and fresh; and although he was never a great colorist, his tones were clear and lively. His technique was typical of English work – a basic red leathery under-painting with green in the shadow areas, a fairly thick layer of scumbled opaque colors to model the forms, and a final glaze of highlight suspended in a translucent medium.

A few months after painting the Brinleys, Smibert held an exhibition of his works, the first art exhibition in America. A Madonna after Raphael, the model for Mrs Brinley and child, was included for it was mentioned in a poem written by Mather Byles to commemorate the epoch-making show. The poem aptly stated, 'Thy Fame, O Smibert shall the Muse Rehearse,'[18] because the pictures in the exhibition later became the nucleus of Smibert's New England museum and an inspiration for nearly every major American painter of the colonial period. John Greenwood, Robert Feke, John Copley, Charles Willson Peale, Mather Brown, John Trumbull, and Washington Allston all knew the studio. Some painted copies of Smibert's works there, Brown and Trumbull rented the premises during their careers.

Between 1730 and 1734, Smibert's income averaged £650 a year, a considerable sum. Among his important commissions was the three-quarter-length portrait of Richard Bill, a prominent merchant. Painted in March 1733, Bill's sympathetically drawn face had a fresh liveliness. His right arm and coat were painted with the fluid, dashing brushstrokes of Kneller. Bill's surroundings were typical of a merchant – a ship seen through the window, a high-backed chair, writing desk, and bill of lading (perhaps an anagram). Other paintings by Smibert included the same props. The chair appeared in the portrait of Mrs Brinley, but only one other portrait, that of Paul Mascarene, painted with full armor in 1729, depicts the subject in a standing posture. Perhaps Smibert thought of the dynamic merchant and military man of action in similar terms.

The year 1734 was marked by three significant developments, all of which occurred in October. First, Smibert opened his color shop on the tenth of the month, when he advertised in the *Boston News-Letter* '. . . All colour, dry or ground, with Oils, and Brushes, Fan of Several Sorts, the best Mezzotints, Italian, French, Dutch and English Prints.'[19] Second, under the entry for Mrs Aliston, Smibert wrote 'att starting and all for the futur Price 9 Ginnes.'[20] This new rate superseded his price of £25 in New England money. Third, he painted two small ministers' portraits in oval spandrel formats. Before 1733 Smibert had depicted no American ministers. Beginning with the picture of the Reverend Joshua Gee, Smibert painted two of the most prominent ministers – Reverend Pemberton and Reverend Rogers. In 1734 he completed four more. These three events suggest a change in his financial picture. The color shop which added a new source of income, the stronger English currency, and the apparent solicitation of ministers' portraits all point to a decrease in commissions and an economic decline of some sort. This supposition is borne out by the entries which follow because Smibert's income drops to £250 for 1735 and 1736.

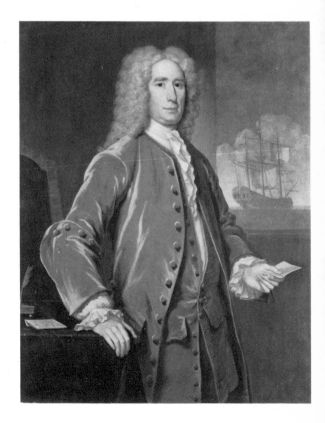

Opposite JOHN SMIBERT, *Mrs Francis Brinley and her Infant Son*, 1729.
New York, Metropolitan Museum of Art.
Below JOHN SMIBERT, *Richard Bill*, 1733.
Chicago, Illinois, Art Institute of Chicago.

Another minister portrait painted in 1735 was of Reverend Thomas McSparran of St Paul's Church in Narragansett, Rhode Island. McSparran was a friend of Berkeley's and knew many important figures in the arts, such as Peter Harrison, the Newport architect, and Gilbert Stuart, whom he baptized. Although formerly thought to have been painted when McSparran visited Smibert in 1729, the picture appears in the artist's notebook under the entry for May 1735; and a letter to Senton Grant of Newport, dated 22 September 1735, states that Smibert was sending a case by the shop of Captain Thorp and 'Mr McSparran's picture is in the case which I desire to inform him of and the reason for its not being sent sooner.'[21] (Smibert explained that the frame maker had not been diligent in his work.) The picture is typical of Smibert's style: oval motifs predominate from the large oval frame to the oval facial features and the oval curls of hair in the wig. While a trifle dull, the painting attempts to capture the emotions by depicting the ageing sitter's puffy face directly.

By 1738 Smibert's financial situation was improving, in part because he painted several pictures of sitters who lived outside Boston: 'Mr. Collins' and 'Mrs. F. Bannister' in Newport, 'Mr. Clark, Jr. of New York,' and 'Mr. Livenston, Albani' (Mr Livingston of Albany).[22] Smibert was also working as an architect and in several

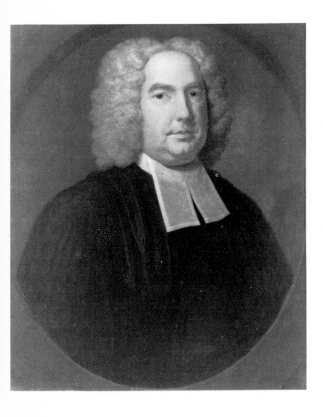

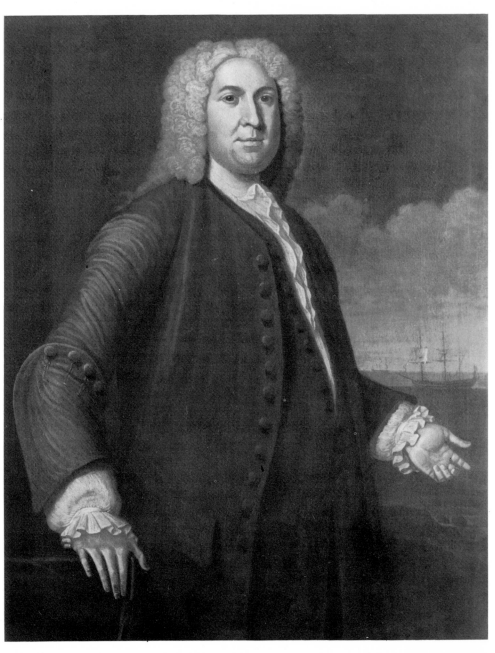

Above JOHN SMIBERT, *Reverend Thomas McSparran*, 1735.
Brunswick, Maine, Bowdoin College Museum of Art, Bequest of Charles Edward Allen.
Right JOHN SMIBERT, *Peter Faneuil*.
Washington D.C., Collection of the Corcoran Gallery of Art, Partial Gift of the Hon. Orme Wilson.

cases, the architectural designs were done at the same time as the patron's portrait. The design of Holden Chapel at Harvard, built between 1742 and 1744 is credited to Smibert, but he probably began in 1738 the architectural work for Browne Hall, Danvers, Massachusetts, which appears in the background of his portrait of Mrs William Brown done the same year. Smibert may also have planned the east façade of a mansion in Medford for Isaac Royall, whose portrait he painted in 1739. The most important of his patrons of this period who commissioned both a painting and architectural work was Peter Faneuil, a wealthy Huguenot merchant-philanthropist, who gave the town of Boston a large sum of money to build a public hall. Smibert designed this hall in 1740 and was asked to paint a portrait to hang in it in 1742, but his association with Faneuil began in 1739 when he painted the merchant's portrait.[23] The earlier picture is similar in pose and iconography to the portrait of Richard Bill (1733); but Faneuil's face is coarse, the parts of the body are misshapen, and the anatomy is misunderstood. Faneuil appears as a clumsy, slightly melted wax figure. Even the ship lacks conviction.

There is no easy explanation for such a staggering change. A clue is obtained by close examination of the famous *Bermuda Group*, now known to have been completed in 1739, the same year as Faneuil's first portrait. The *Bermuda Group* was begun in

JOHN SMIBERT, *The Bermuda Group*, 1739. New Haven, Connecticut, Yale University Art Gallery, Gift of Isaac Lothrop.

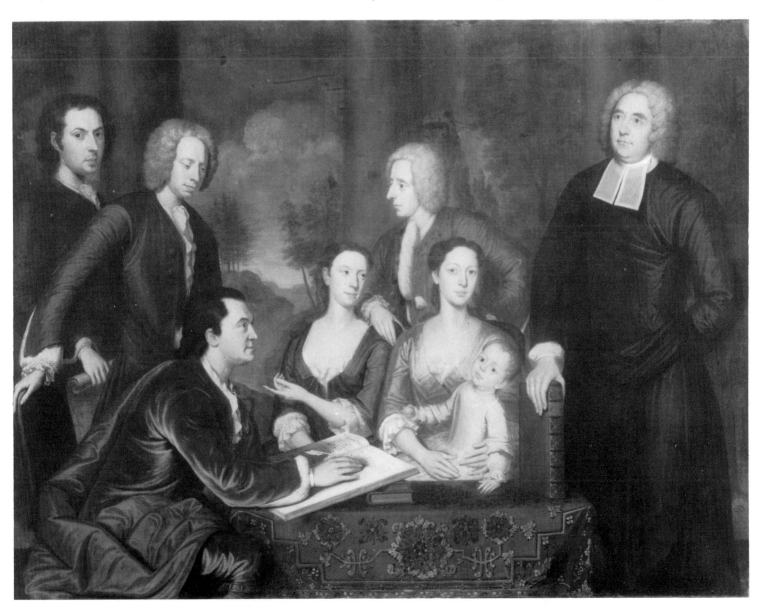

July 1728, before the departure of Berkeley and his entourage. John Wainwright, one of the members of the Bermuda contingent, apparently ordered the painting because Smibert noted: 'A large picture begun for Mr. Wainwright 10 Ginnes rec'd in part.' To the right another notation '10-10 at Boston 30-30-0' suggested that the picture was continued after they reached America.[24] The handwriting of the second entry matches Smibert's handwriting for 1738 and 1739, which is less sure and the individual letters are not so clear as it was in 1728. Also, an inscription on the book in the *Bermuda Group* reads, 'Jo. Smibert fecit 1739.' Radiographs reveal that the composition of the central part of the picture was changed and that the figure of the secretary, Richard Dalton, is painted in a different technique from that of the other figures. Dalton's face is composed of a series of interlocking patches. There is no layering of underpainting, middle tones, and glazes which appear in the figures in the *Bermuda Group* finished previously. In depicting Dalton, Smibert appears to have started with an optical awareness of the face itself and painted the surface of the canvas directly to imitate what he observed. There is no impression of a form built up through the techniques acquired through professional training. The key to Smibert's stylistic change may be his moving toward the type of instinctive painting common with untrained painters – the very methods of self-taught Americans. Did Smibert deliberately adopt this method? Did his new clientèle wish this approach? Or did Smibert fall into a cruder style from lack of competition? An illness which affected his eyes did not occur until the fall of 1740 and thus cannot be the cause of the change. Perhaps it should be thought of as the americanization of Smibert. Other English-trained artists experienced the same transformation. Smibert's contemporary and fellow-Bostonian, Peter Pelham, began with an atmospheric style stressing multiple, broken planes and contrasts in modeling but ended with a flat, single planed, simply lighted style. The same phenomenon occurred in the work of Gustavus Hesselius, Smibert's contemporary in Philadelphia.

In 1740 Smibert made a major trip to New York and Philadelphia. His portraits of sitters from Newport in 1736 and New York in 1737 may have encouraged this undertaking, but the promise of financial gains may have been the primary motivation. Smibert raised his prices significantly, and his income was more than quadrupled. Unfortunately, few pictures done on this trip have been discovered. Of the twenty-seven commissions listed in Smibert's *Notebook*, the location of only the portrait of John Turner of Philadelphia is known.

Immediately after the trip Smibert became ill, as he himself recorded in a letter of July 1743, 'having been 3 years ago recovered from a dangerous illness.'[25] No pictures were recorded for 1741, and only five for 1742. In 1743 Smibert's work returned to its previous volume and continued in the cruder, americanized style of 1738–40. Smibert painted nine portraits in 1744 but only one in 1745. There was a last flurry of activity in 1746 when the *Notebook* recorded six pictures – three of them large whole-lengths – but there were no entries after 1746. Perhaps the illness of 1740 had returned. Smibert mentioned in 1749 that '. . . I grow old, my eyes have been some time failing me, but is [I'm] stil heart whole and hath been diverting my self with some things in the Landskip way. . . .'[26] Smibert must have had difficulty with his eyes after 1745 because his pictures of 1746 showed a marked decline. The portrait of Sir William Pepperrell, done to commemorate the great battle of Louisburg where he was one of the American heroes and was made a Baronet for his efforts, is a travesty. The figure seems about to collapse. The landscape is a cartoon, complete with the trajectory of the cannon balls. None of Smibert's training and competence is evident. This is unfortunate because the importance of this commission and the mezzotints done by Peter Pelham after the portrait have made one of the least of Smibert's works his best known.

The style of Kneller and the English Baroque was also brought to America by

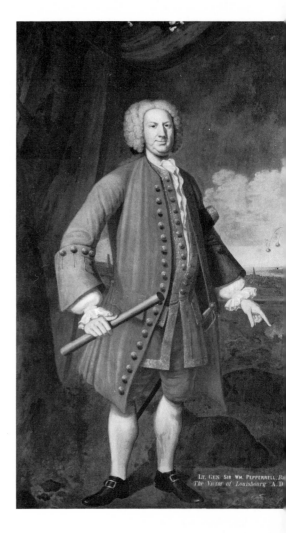

JOHN SMIBERT, *Sir William Pepperrell*. Salem, Massachusetts, Essex Institute.

Charles Bridges, who was called the 'Sergeant Painter of Virginia' by his principal American patron, William Byrd. The portrait of Evelyn Byrd was probably one of the pictures mentioned by her father in a letter of 30 December 1735, to Colonel Alexander Spotswood: 'He has drawn my children & several others in the neighborhood.' Although Byrd continued that 'he have not the Masterly Hand of a Lilly or a Kneller,'[27] Bridges' portraiture displays the same stylistic formula as Smibert's but is more elegant, has less Italian influence and softer brushwork. Bridges, who was already seventy years old when he arrived in 1735 from Bermuda, left Virginia about 1740 after painting the king's arms for the Caroline County Virginia Court. His children stayed in America, and Bridges was alive in England until at least 1746. Other than the Byrd pictures, which are themselves documented only by inference, no other paintings can be attributed to Bridges. His American *oeuvre* is cluttered with misattributed English pictures from Kneller's shop and lesser works of divergent styles.

The manner of Smibert and Bridges predominated in American painting in the 1730s and early 1740s. They did not found a school in the European sense, but American painters, such as William Dewing in Virginia, and Joseph Badger, John Greenwood, and Nathaniel Smibert in Boston, followed the English Baroque style. Portraits by these Massachusetts artists in their early years were darkly modeled and heavy-handed. The poses were taken from Smibert's work and were reinforced by mezzotints.

Robert Feke, born about 1707 in Oyster Bay, Long Island, has also been considered for several reasons a member of Smibert's circle. First, Feke may have seen Smibert's portrait of John Nelson, which was in Oyster Bay after Nelson's death in 1734. Second, he may have met Smibert in New York in either 1737 or 1740, because an inscription on Feke's earliest-known painting, *Phainy Cocks*, dated about 1732 reveals Feke was 'at Judeh Hays at New York.'[28] Third, Feke based several of his early works on Smibert pictures: the portraits of Mr and Mrs Gershom Flagg are based on Smibert's paintings of Reverend and Mrs McSparran and the *Portrait of Isaac Royall and his Family,* dated 15 September 1741, has a version of the *Bermuda Group* as its prototype. These three Smibert portraits used as models by Feke were all in Newport, where Feke lived. (The McSparran pictures hung in Narragansett, Rhode Island. A small conversation-piece version of the larger Boston *Bermuda Group,* was owned by Thomas Moffat, Smibert's nephew, in Newport.)

Despite these contacts with Smibert, a comparison of the *Portrait of Isaac Royall and his Family* to the Newport *Bermuda Group* shows that Feke was independent of Smibert. First, although Feke copied two poses and the pattern in the rug from Smibert, his painting is composed of rather separate three-quarter-length figures in a crowded interior space while Smibert's contains full-length figures placed in a garden setting. Second, Feke did not use the deep red and purples of Smibert but juxtaposed color complementaries, red with green and blue with orange. (This color scheme and the emphasis on the line of the coat recall the New York portrait of the de Peyster boy.) Finally, Feke painted flat, decorative shapes; he stressed contours. Edges and lines created an overall surface design. And a delicate, calculated system of proportions was imposed on the whole scheme to unify and correlate all parts of the picture. The front edge of the table top is on a line precisely one-quarter of the distance from the bottom. The tops of the heads of the three women are correspondingly one-quarter the total height from the top. The edge of Mr Royall's waistcoat and his right hand fall on one of the four vertical lines which divide the width of the portrait into quarters. This system of proportion and the building of his figures from a dark, almost black ground clearly distinguishes Feke from later artists who used white in their preliminary underpainting and from Smibert who used leathery ground colors. In fact, Feke's development from 1741 to 1746 shows an

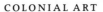

ever increasing divergence from Smibert's work and a marked attempt to create his own new style. Feke's portrait of John Gidley of 1742–4 relies even more strongly on shapes, contour, and the contrast of warm and cool colors; and by 1745 when Feke painted the signed and dated portrait of Reverend Thomas Hiscox, the transformation to his own style was almost complete.

Reverend Hiscox' portrait is a play of shapes and repeated edges. The ovals of the shoulders and the head are opposed to the square bands in which the straight line of the nose is paralleled, and the curve of the shoulders is echoed in the mouth. In comparison to the McSparran portrait where Smibert creates his effects by representing textures and stressing psychological realism, Feke makes his statement through handsomeness of contour and decorative elegance of surface pattern.

In 1746, Feke went to Philadelphia where his career really began. Between 1741 and 1746, he painted only eight known pictures – hardly enough to qualify as a fulltime artist; but, beginning with the Philadelphia trip he painted about twenty each year. In Philadelphia Feke's style, though related to his work of 1745, particularly in the execution of the faces, underwent certain significant changes. Characteristic of the trip are the signed and dated portraits of Mr Tench Francis and Mrs

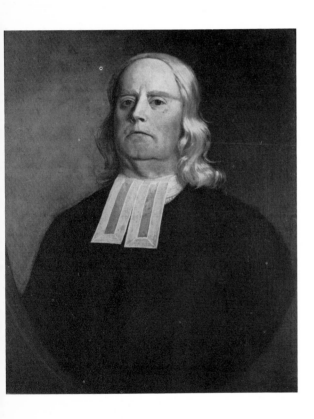

Above ROBERT FEKE, *Reverend Thomas Hiscox*, 1745.
Newport, Rhode Island, The Preservation Society of Newport County.
Right ROBERT FEKE, *Tench Francis*, 1746.
New York, Metropolitan Museum of Art, Maria De Witt Jesup Fund, 1934.

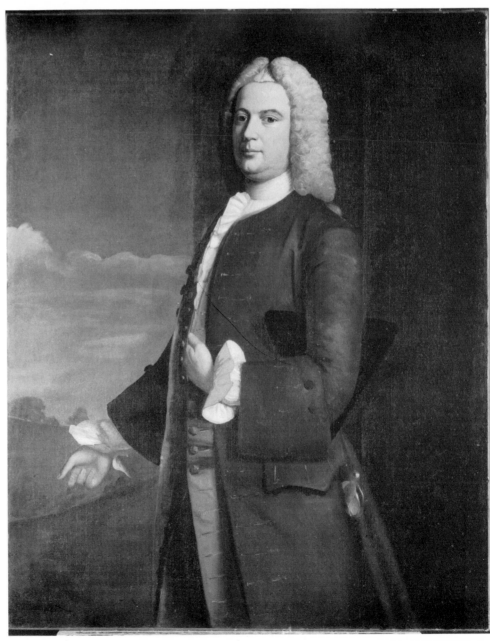

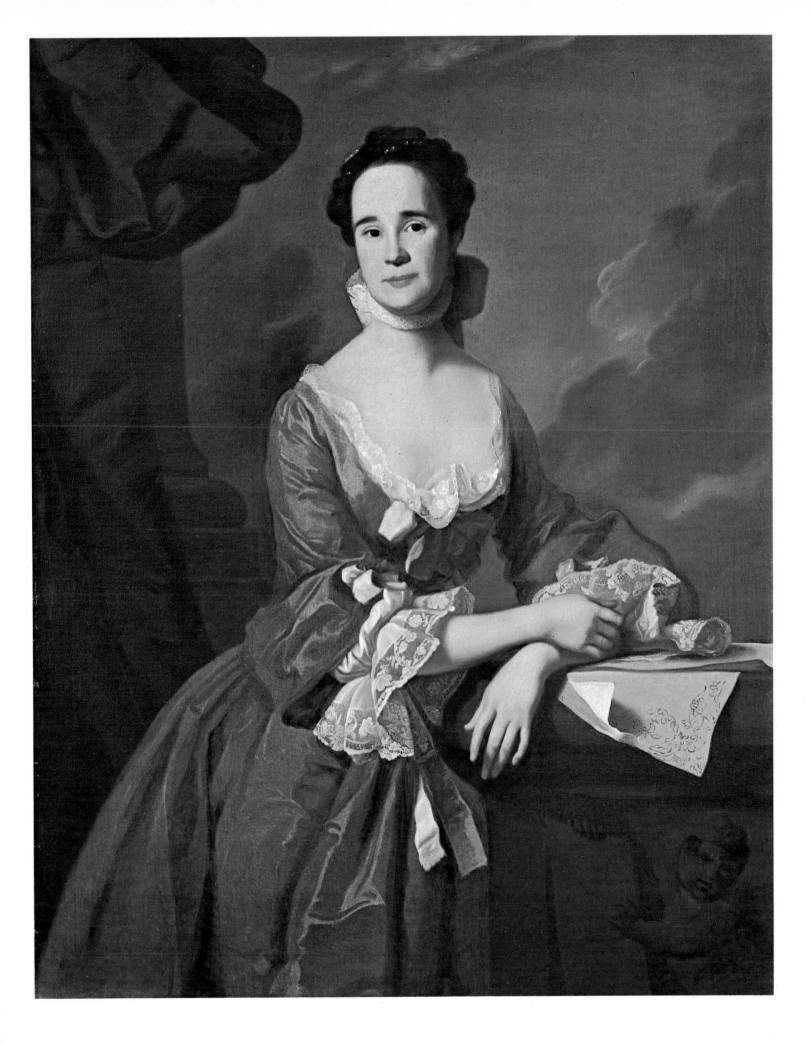

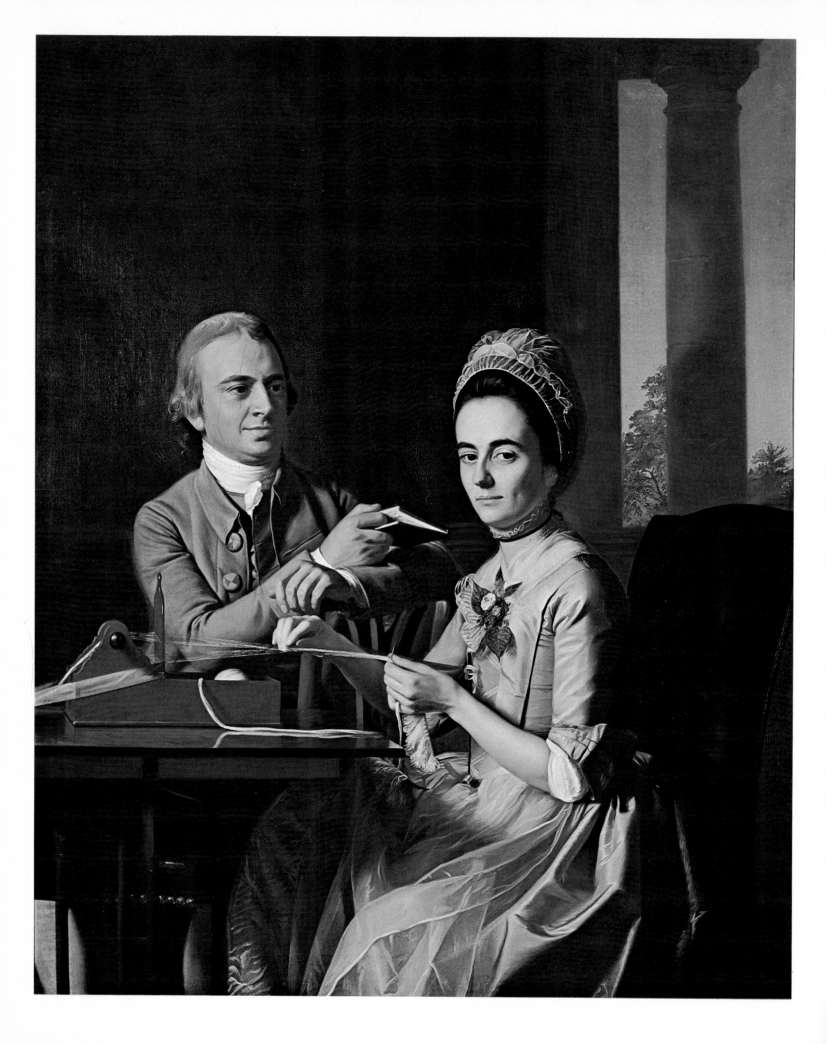

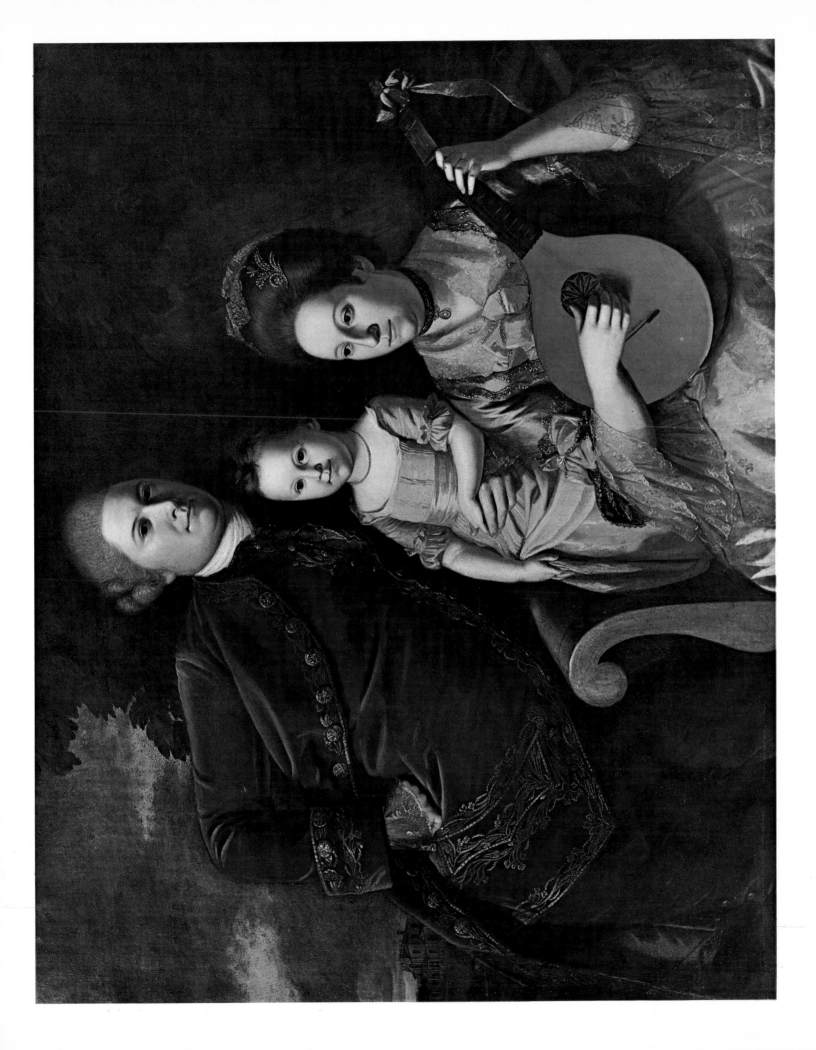

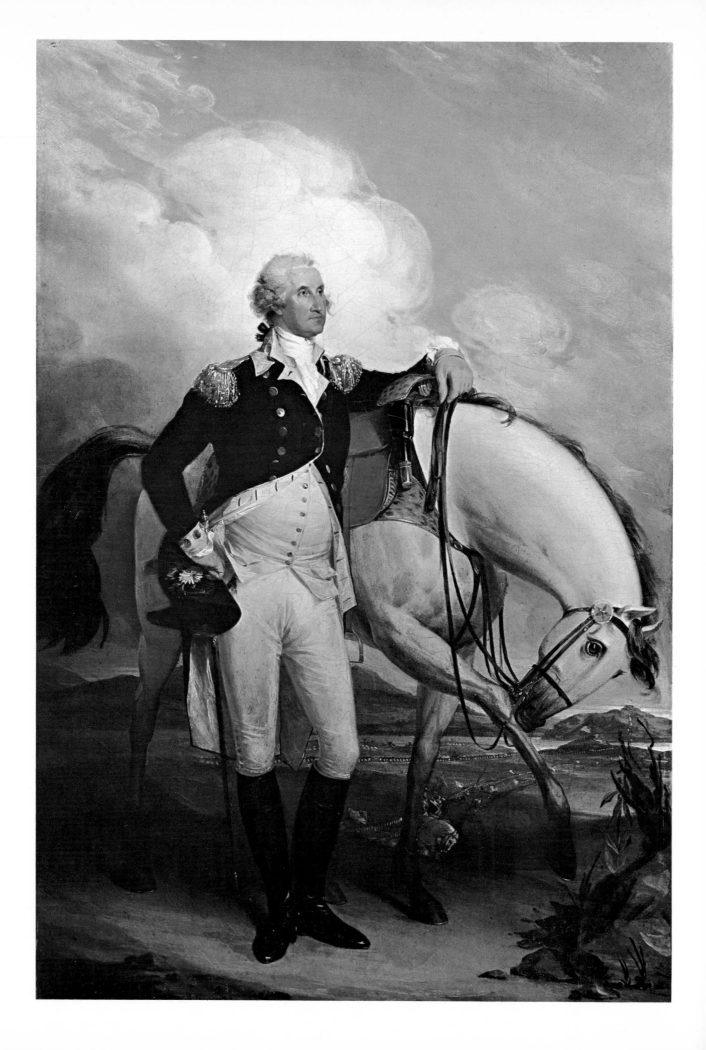

Charles Willing. In most of the Pennsylvania paintings Feke used 50" x 40" canvases and included prominent landscape scenes for the first time. The pictures are masterful pieces of painting and beautiful in coloring – Mrs Willing in a harmony of cool blues, green and gray and Francis in warm sienna browns, gold and salmon pink. Tench Francis was shown by the traditional iconography of an important social and political figure, although Feke made the landscape more topographical than symbolic by trying to suggest Francis' farm in Willingboro, New Jersey. The composition was not unlike that of the Richard Bill painting where the figure formed a triangle with the face and hands at the apexes, and the lines of the garments made vertical elements in the center of the canvas. But, unlike Smibert who ordered mezzotints to use in his portraits of men, Feke, as far as can be determined, did not use poses from prints for his male subjects. Apparently he still used other portraits as his sources for depicting men, and Feke is at his best when not confined to a mezzotint. Starting with the portraits of Mrs Charles Willing and Anne McCall, Feke employed print as prototypes. Perhaps he felt more at ease painting men, or, possibly, the women demanded familiar compositions that immediately suggested portraits of fashionable Europeans. The picture of Anne McCall was taken from John Faber's print, after a portrait of Queen Caroline by Joseph Highmore (c. 1735). Feke copied the pose, the column, the drapery, and the console table. He carefully adapted the iconography by not showing Anne playing with her hair and removing the royal crown and scepter but failed to grasp many sophisticated aspects of the composition. Highmore, for example, silhouetted the column in a lighted area to give the composition atmosphere. He created movement by making an interlocking series of curves in the hand, drapery and costume. Feke gave no feeling of spatial depth and allowed the arms and drapery to fall into rigid parallel lines. Despite these shortcomings, Feke's refined proportion and beautiful painting of the face left a satisfying, lasting impression.

The account book of John Channing reveals that Feke returned to Newport before 29 May 1747, when the artist was paid for a portrait of John Channing. Several stylistically related works, including portraits of Channing's wife and Henry Collins, both seated in a red velvet chair decorated with shells, also date from 1747. That year was one of consolidation and experimentation. These were the first seated portraits since the Royall portrait of 1741. Feke was also experimenting with lighting at this time. His *Self-Portrait* of 1747 was formerly dated between 1725 and 1740, but could not have been done then because Feke's pictures of his earlier period are cruder, more heavily modeled; they neither show the interest in contour and planes, nor employ the unusual lighting scheme seen in the *Self-Portrait*. The light source originates from above the head making the shadows fall below the nose instead of to one side and emphasizing the eyes. This scheme was entirely different from Smibert's self-portrait in the *Bermuda Group*.

Feke may have taken his *Self-Portrait* with him in 1748 when he went to Boston, for it descended with the portraits of his patrons of the early 1740s, Mr and Mrs Flagg, who lived diagonally across from Smibert's color shop. In 1748 Smibert was no longer active. Joseph Badger and John Greenwood were painting inferior portraits in Smibert's style. Bostonians must have been starving for Feke's portraits. And Feke responded by giving them beautiful pictures on which to feast their eyes.

The portrait of Isaac Winslow has the interrelation of figure and landscape, harmony of color scheme, and detail of contour which characterize all his Boston works. Feke skillfully repeated the line of Isaac's shoulder in the tree and the curve of his arm in the dark hill. He established a basic monochrome of blue whose hues are harmonized in the sky, coat and water, and he added a small but intense passage of gold, the color complement of blue. In the center of the composition Feke created an elegant crescent of ivory, a color produced by gold modulated by white, with a

ROBERT FEKE, *Self-Portrait*, 1747.
Boston, Massachusetts, Museum of Fine Arts,
M. and M. Karolik Collection.

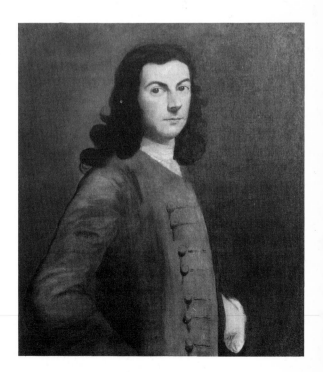

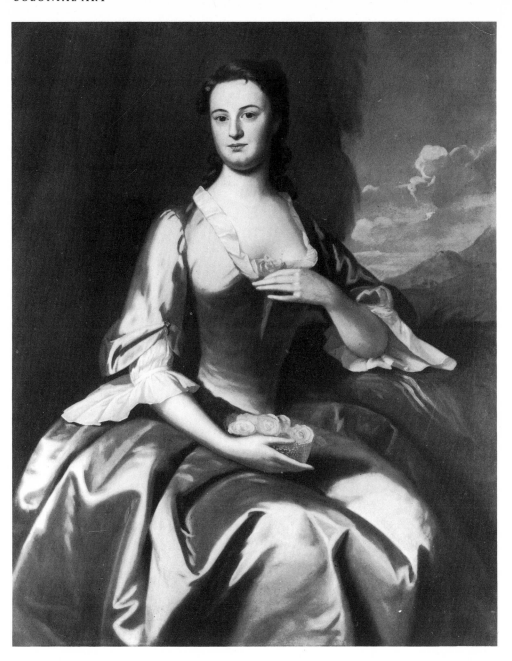

ROBERT FEKE, *Mrs James Bowdoin II*, 1748.
Brunswick, Maine, Bowdoin College Museum of
Art, Bequest of Mrs Sarah Bowdoin Dearborn.

constellation of white in the cuffs and neck cloth around it. Finally, he introduced
in the face some cool greens and warm pinks in the same proportion as the cool blues
and warm gold in the rest of the picture. The details of costume are exquisitely
rendered, just as the gold braid on Royall's coat and Mrs Willing's lace sleeve had
been, but Winslow's embroidery is a virtuoso performance. Besides Feke's success in
the handling of landscape, color and detail, he also achieved his best representation
of form in space. The highlights in the cupped left hand and the edge of the waist-
coat create a convincing depth; the notch in the stone plinth has an almost *trompe
l'oeil* effect. This portrait was perhaps the most brilliant of the decade.

Comparing the portrait of Isaac Winslow to that of Tench Francis makes evident
the strides Feke made in only two years. He went from the Knelleresque Baroque
almost to the Georgian Rococo of Highmore and Knapton, whose style he nearly
equaled by sheer dint of talent.

The portrait of Mrs James Bowdoin II, inscribed 'R.F., 1748,' is one of Feke's best
female portraits done in Boston. It suffers from being too closely tied to its mezzotint

58

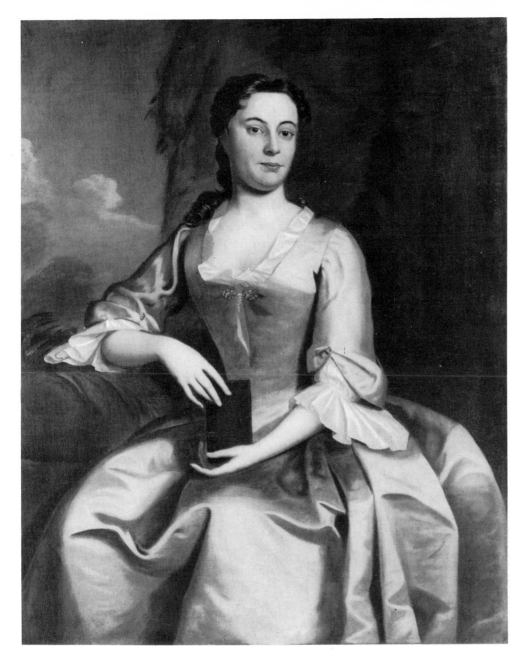

ROBERT FEKE, *Margaret McCall*, 1749.
Philadelphia, Pennsylvania, Philadelphia
Museum of Art, Loan of the Dietrich Corporation,
Reading, Pennsylvania.

source, *Princess Anne,* engraved by Beckett after Willem Wissing's oil. In this case, the substitution of a basket of flowers for the string of pearls leaves a gaping void in the composition. Nevertheless, compared to what Feke's contemporaries in America could manage, the painting is a masterpiece.

Feke returned to Newport in December of 1748 and remained there until the fall of 1749 when he made another journey South. His second Philadelphia trip was recorded by an entry in John Smith's diary which states that Smith visited 'Fewke's the painters' on 7 April 1750, to see a 'few pieces and faces of his painting,'[30] and by a payment in the account book of Samuel McCall of £18 to Robert Feke for a painting on 6 November 1749.[31] The latter was probably for the portrait now identified as that of Margaret McCall. In this portrait Feke carried on the style developed in his Boston works. Margaret's pose was identical to that of Mrs James Bowdoin; the landscape was the same as that in Mrs James Bowdoin's portrait. The poor state of preservation of Feke's last works makes impossible a thorough analysis of his late style, but his development is evidenced by comparing the

zig-zag diagonals in the portrait of Margaret McCall to the triangular composition in the picture of her sister Anne done three years before. The later paintings suggested a general trend toward tighter forms and darker shadows.

Feke's work is basically English, as was his cultural milieu, but his *oeuvre* should not be considered merely provincial painting. He found his models in English prototypes. He borrowed from Wissing, Lely, Richardson, and Highmore. He showed no partiality to any one painter for sources, although he seems never to have copied Hudson. A comparison of Feke's portraits to his contemporaries in provincial England, such as John Heins or James Cranke shows that Feke's works are colonial. The English paintings are a watering down of London style. Feke combines London style with other elements which colonial culture demanded to have expressed. His painting is amended and transformed at certain points to reflect the differences which developed as a result of the quite different conditions in America.

Feke's whereabouts are unknown after 26 August 1751, when he is recorded as a witness to his brother-in-law's wedding in Newport.[32] No pictures appear to date after 1750. Family tradition says he went to Bermuda for his health, but, because a branch of the Feke family lived on Barbados, it is more likely he went there and died. There is an intriguing note in the Barbadian parish records[33] of the death in 1752 of a Richard Feke, a person previously unrecorded on Barbados.

Feke was the founder of the American school of painting. Smibert may have introduced and fostered the mainstream of English art in America, but Feke was the first major artist to paint in a native style, not one merely transported from Europe. His style swept away all others before it not only in New England but also in Philadelphia and possibly in the South. John Greenwood, who followed Smibert at first, completely changed his style after 1748. His *Mrs Welshman*, signed and dated 1749, is modeled on Feke's *Mrs James Bowdoin*. Likewise, Joseph Badger and the young John Singleton Copley followed Feke's lead. Badger's *Mrs Stephen Brown* and Copley's *Mrs Joseph Mann* (1753), derived from Feke's *Mrs James Bowdoin*, but Copley's relationship to Feke is more indirect than Badger's. Comparing *Mrs Bowdoin* and *Mrs Mann*, the latter has a greater feeling for sculptural form. This difference may result from Copley's personal vision which characterizes all his work, but it also can be traced to Greenwood, who is emerging as Copley's teacher. Peter Pelham was Copley's stepfather, and Copley's earliest work – the mezzotint of Reverend William Welsteed shows his indebtedness to Pelham, but the mezzotint is after a Greenwood picture. Also, Copley's earliest portraits, such as *Mrs William Whipple*, seem to have been done in Portsmouth, New Hampshire, in 1753,[34] exactly where Greenwood stopped painting in 1752. The portrait of *Mrs William Whipple*, which is close to Feke, may even have been done under the tutelage of Greenwood because of its similarity to Greenwood's *Sarah Kilby*.

Even more influenced by Feke was John Hesselius in Philadelphia. Again, despite his father Gustavus' reputation and experience in painting, John modeled his early work on Feke. (Notable, too, is the fact that Gustavus' late works such as *Mrs Ericus Unandery* (c. 1750) and *Faithful Richardson* (c. 1754) follow Feke's lead and demonstrate that Feke changed even that established painter's style.) As early as 1749 John Hesselius painted almost side by side with Feke. John's earliest dated picture – *Mrs James Gordon*, inscribed 'J. Hesselius pinx 1750' was a copy in all but execution of Feke's *Anne McCall* of 1746. Hesselius' work was awkward and adolescent but showed Feke's influence. Other works such as Hesselius' *John Wallace* show a similar dependence on Feke. John Hesselius was the major American figure in Philadelphia and the South between 1750 and 1770 and gave the first lessons to Charles Willson Peale, who dominated Middle Colony painting from 1770 to 1815. This debt to the work of Feke is crucial to show the central role he played in establishing a painting tradition in the Middle Colonies and South as well as New England.

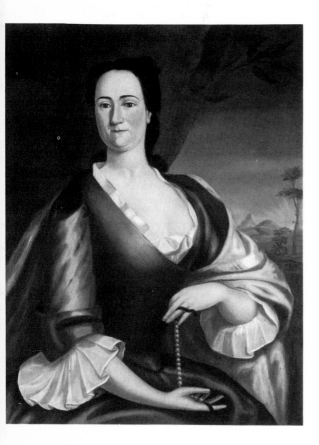

JOHN GREENWOOD, *Mrs Welshman*, 1749. Washington, D.C., National Gallery of Art, Gift of Edgar William and Bernice Chrysler Garbisch.

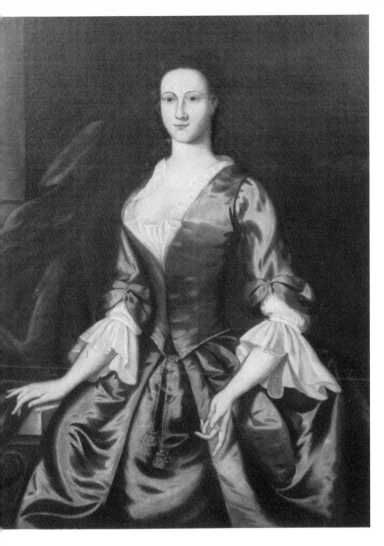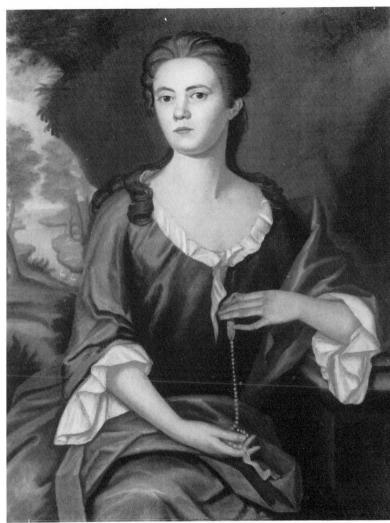

Shortly after Feke's disappearance, colonial newspapers confirm that an increasing number of English artists came to America. Beginning with the advertisement of A. Pooley in the *Maryland Gazette* of 12 October 1752 for painting 'either in the Limning Way, History, Altar Pieces for churches, Landscapes, View of their own Houses and Estates, Signs or any other Way of Painting,'[35] notices of many painters appear. In 1763 Stephen Dwight advertised in New York,[36] and between 1766 and 1769 at least five foreign artists arrived: George Mason and Christian Remick in Boston, Lewis Turtaz, 'from Lausanne in Switzerland,'[37] and Thomas Laidler in Charleston and Alexander Stewart in Philadelphia.[38] While some concentrated on miniatures, Stewart's offer was typical because it included, 'perspective views of gentlemen's country estates for those gentlemen, either in town or country, who have picture panels over their chimney pieces, or on the sides of their rooms, standing empty. . . .' He also reminded his prospective clients that he had 'been regularly bred in the Academy of Painting at Glasgow; and afterwards finished his studies under the celebrated M. De la Cour, at Edinburgh.'

Similar announcements continued to occur in the 1770s and 1780s, noticeably between 1770 and 1774 and again beginning in 1783. These Britishers probably produced many paintings in colonial America although few of their works have been identified. They undoubtedly made contributions to eighteenth-century landscape painting. The most important artists to visit the colonies were portrait painters: John Wollaston, Joseph Blackburn, Lorenz Kilburn, William Williams, and Cosmo Alexander. Of these, Williams and Kilburn advertised, but Wollaston, Blackburn and Alexander were so well received that commissions poured in to them.

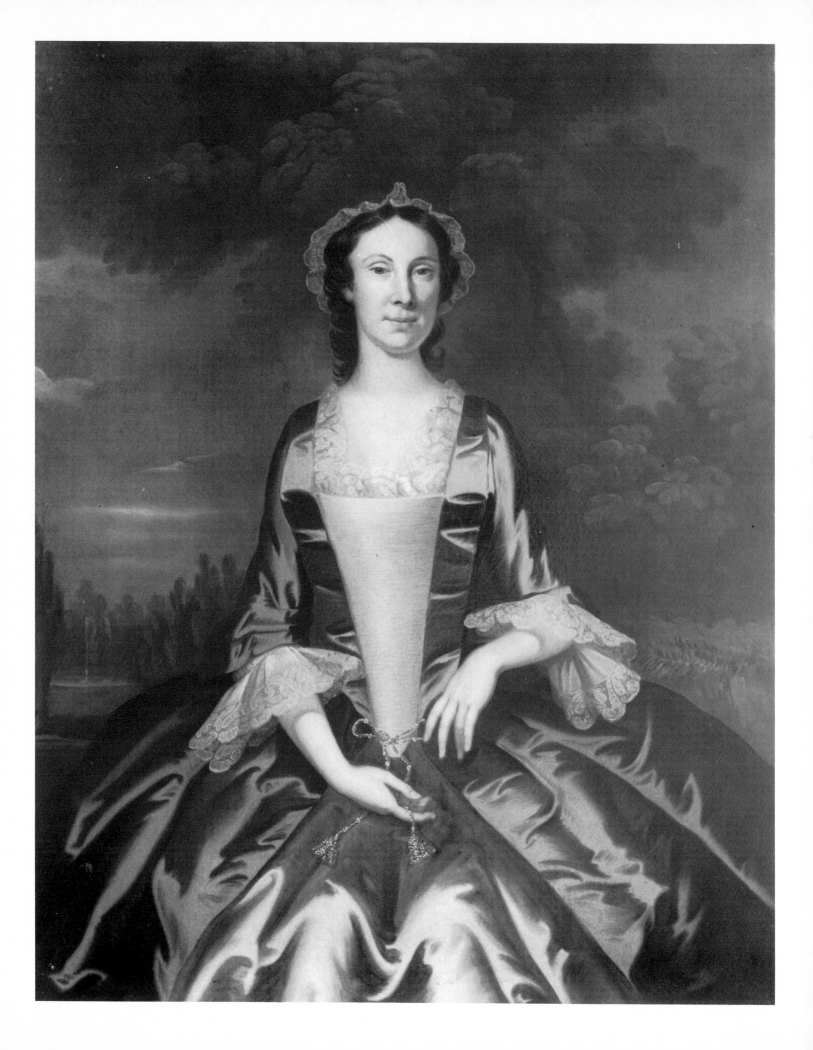

John Wollaston arrived in New York in 1749. He was probably trained by his father J. Wollaston, who was painting in London before 1736. Traditionally Wollaston specialized in the painting of drapery in London, and indeed rendering of costume is his *forte*; but his English work is known primarily from the half-length pictures of Sir Thomas Hales and Thomas Appleford (1746) both now in the New-York Historical Society. Wollaston painted widely in the colonies. From New York he went to Annapolis about 1753, perhaps via Philadelphia, then to Virginia in 1755, to Philadelphia in 1758, and finally to Charleston in 1760 and 1767, after a six-year interim in India. He may even have visited Boston as he painted several subjects from that city. It is difficult to assess Wollaston's work because many of his canvases are now overpainted and his originals are often confused with later copies. His best work is found in the New York portraits between 1749 and 1753, the Philadelphia paintings of 1758, and especially the Charleston pictures of 1767. In the portrait of Mrs William Walton in 1750, appear the hallmarks of Wollaston's work, the beautifully-rendered costume and the almond-shaped eyes, an English convention used in the 1740s by Thomas Hudson and others. Wollaston's compositions are typically based on a large triangle. Here, the panels of the bodice and the folds of the skirt, not unlike the patron portrait of Lavinia Van Vechten, develop the triangle theme. The landscape is delicately painted with a feeling for brushwork and paint surface, a technique introduced into England by the French painters Van Loo and Mercier and incorporated into the style of Hogarth and Highmore, Wollaston's contemporaries in London. Nevertheless, when compared to Feke's portrait of Mrs James Bowdoin, the hands and face appear puffy, distorted and homely. The Wollaston painting lacks the transformation of the pleats of the skirt into an elegant pattern of ripples which in Feke's work cut obliquely across the picture to establish a play of spatial planes.

Wollaston should also be compared to Joseph Blackburn, who arrived in Rhode Island about 1754 after a year or two in Bermuda. In 1755 Blackburn went to Boston and painted there and in Portsmouth, New Hampshire, until 1763. Blackburn's work is far more Rococo than Wollaston's – more nearly reflecting the new, young school of painting that developed after Wollaston's departure from England and included artists such as Thomas Gainsborough. *Mrs David Chesebrough*, painted by Blackburn about 1754, eschews the stiff formality of Wollaston's *oeuvre* and adds the bucolic touch of the Rococo style. The picture features the lace and pearls for which Blackburn was widely admired during his stay in Boston and is beautifully colored in delicate tones of sienna, iridescent green, and yellow. Only the bulbous shape at the end of the nose, as characteristic of Blackburn as is the almond eye of Wollaston, and the too conscious use of a mezzotint inappropriate for the composition, especially in the awkward placement of the crook, reveal the shortcomings which relegated Blackburn to the colonies to make his living.

The artistic vacuum created in New York by the departure of Wollaston was partially filled by Lorenz Kilburn, another European emigré originally from Denmark. Kilburn repeatedly advertised in the *New York Mercury*. The first advertisement announces his arrival 'from London with Capt. Miller' on 2 May 1754; another of 30 March 1761 documents a trip to Albany in the summer of 1761; finally, the last of eight notices published on 17 July 1755, was for the sale of his estate.[39] Kilburn's work was usually bland and uninspired. Like Blackburn and Wollaston, his treatment of fabric was his strongest suit. The portrait of Mrs James Beekman, dated 1761, is one of his finest, and the details of the costume invite comparison with Wollaston's work. In the Beekman picture the lace forms a more insistent pattern, and Kilburn emphasizes concentric curves in the folds and ruffles. He treats his faces in the same way – the curves of the cheek and eyes are repeated in parallel curves, although parts of the face were altered later by John Durand.

Opposite JOHN WOLLASTON, *Mrs William Walton*, 1754.
New York, New-York Historical Society.

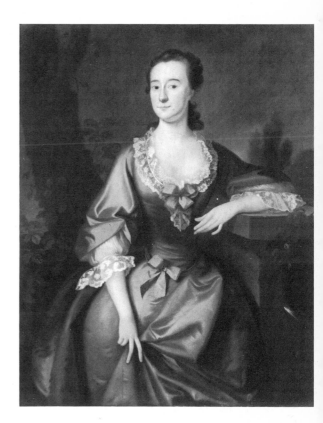

Above JOSEPH BLACKBURN, *Mrs David Chesebrough*, 1754.
New York, Metropolitan Museum of Art, Gift of Sylvester Dering, 1916.

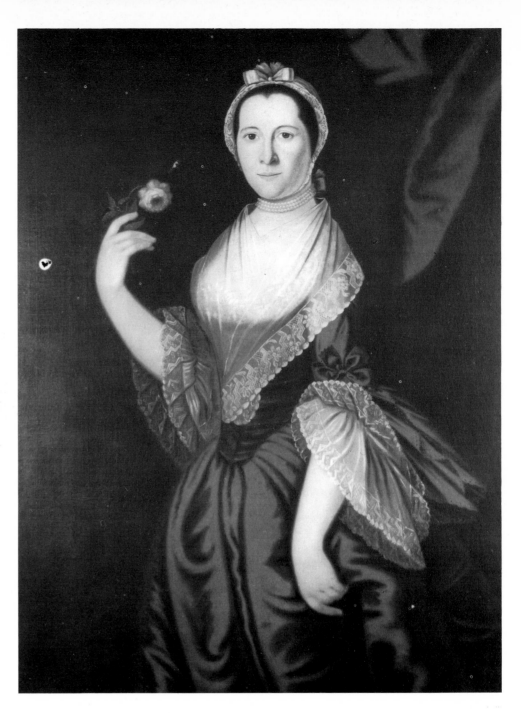

Display of elaborate, fashionable clothing is also an important theme in the portrait of Deborah Hall, done in 1764 by William Williams, another Englishman who painted in Philadelphia. Great confusion exists over the identity of this artist. A William Williams settled in Philadelphia about 1747. He painted some stage scenery and reportedly introduced Benjamin West to landscape painting. An advertisement of 1763 by one William Williams, which states he was 'lately *returned* from the West Indies,' has led to the conclusion that he was the same William Williams mentioned above.[40] The latter Williams is probably the painter of the Hall picture done in Philadelphia a year after the notice, but he may not be the same Williams who influenced West. The situation is further complicated by a William Williams, an artist advertising in New York during the 1770s whose daughter married John Mare, another New York artist. There were several other painters named William Williams working in America at that time. The portrait of Deborah Hall (and those of her brothers, David and William) done for Benjamin Franklin's former printing partner, introduced few new ideas in portraiture. The

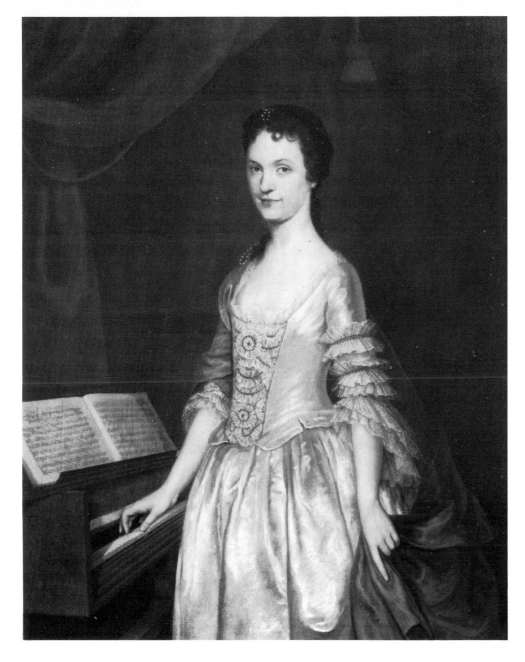

COSMO ALEXANDER, *Catherine Ross Gurney.*
Cambridge, Massachusetts, Fogg Art Museum,
Harvard University.

formal garden and the depiction of a child with a pet dates to Kühn although Rococo influence is seen in the roses and the curved plinth.

The last of these European visitors, Cosmo Alexander, did use a number of new ideas. Trained by his father in Edinburgh, Cosmo came to America in 1766 and painted in New York, Philadelphia, and Newport until 1771. In the latter city Alexander produced his largest number of works. There he was the first teacher of Gilbert Stuart, who accompanied Alexander to Scotland via Virginia and South Carolina.

From the first, Alexander used the type of painting in which the sitter is posed in the setting of his daily life. This type of portrait, developed in France during the Régence, had rarely been used in America before 1766. Feke, in 1747, portrayed Henry Collins seated at a desk with his books; but until the Copley portraits of Paul Revere, Isaac Royall, Isaac Smith, and others in the years between 1766 and 1769, this type of portrait was not common in America. Alexander's portrait of Catherine Ross Gurney is important in that respect. In contrast to the traditional garden

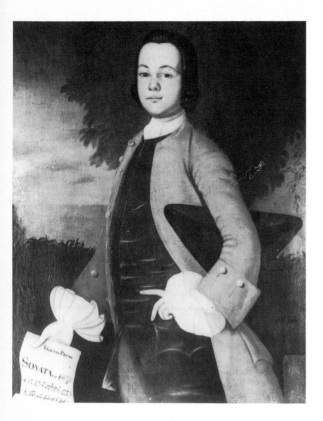

JOHN MENGS, *Self-Portrait*, 1754.
Philadelphia, Pennsylvania, Historical Society
of Pennsylvania.

setting of Deborah Hall's portrait or the mezzotint-inspired formal portraits of Mrs Walton and her sister-in-law, Mrs Beekman, Catherine is shown at her own piano with her favorite music. She is every bit the fashion plate the others are, but she is depicted in an intimate, personal, domestic setting.

These visiting European artists played an important role in American art. Judging from their sitters and the number of paintings produced, they were well patronized and possibly preferred to American painters by the colonial aristocracy. They also had a profound effect on native painting in the 1750s. Pictures such as Joseph Badger's portrait of Timothy Orne (1757) and John Mengs' *Self-Portrait* (1754) are truly native and do not show any effects of the visiting Englishmen. Both are remarkably in the Feke tradition. They have a quality often associated with folk painting, where some particular aspect, unique to the subject, is emphasized or over-emphasized. Badger has almost made a caricature of Timothy Orne's hair and hands which point across the toy landscape to a letter sealed with wax and two boats bobbing in the sea. Mengs makes a similar overstatement of his musical interests in the 'SONATA' he holds. These pictures, while perhaps the more interesting of the decade, are the exception which proves the rule. The majority of American painters after 1750 were influenced by Wollaston, Blackburn, and the others. John Hesselius is a prime example.

Preferring Feke's new, flashy style to his father's Baroque work, John Hesselius continued to emulate Feke through the mid-1750s. After 1757 he adopted the almond-eye convention of Wollaston but the former's pictures have greater clarity of color and less attention to detail than the latter's. A typical portrait is *Samuel Lloyd Chew* (1762). In the year Hesselius painted Chew, the artist married and settled at Bellfield in Anne Arundel County, Maryland. He continued to paint many subjects in Maryland and made occasional trips to Virginia. His latest work was sometimes highly decorative, but he simplified the composition, paid even less attention to detail and concentrated on the face and character of the subject. His very last pictures reveal a great sensitivity to the sitter, and strangely relapse back to Gustavus' pictures of Tishcohan and Lapowinza.

Benjamin West's early career has a similar theme. At first he was influenced by William Williams, and West's earliest picture is a landscape containing fanciful buildings similar to those associated with Williams' work. His first portraits are in the style of Robert Feke which he could have learned either directly from that artist's works or through those of John Hesselius. The Feke inspiration succumbed to Wollaston's, especially after a trip to New York in 1759 when West undoubtedly saw Wollaston's work. The portrait of Elizabeth Peel, done at this time, has the pose, interest in satin, and almond eyes of Wollaston as well as some hint of the blank, stark shapes of Kilburn whose portraits West may also have seen in New York. His last picture done in America, the portrait of Thomas Mifflin, is a beautifully colored work and begins to overcome the stifling effects of the outside influences. Yet a careful look reveals that the picture is an eclectic recapitulation of other influences – a trait seen in most of West's works to the end of his life. The landscape of cool blues and greens is derived from Williams, the pose is based on Feke; the painting of the face, where the folds of the skin are emphasized, and the eyes' almond shape are taken from Kilburn and Wollaston. Only the wonderfully realized gun and the ducks are West's. They save the picture from being a mere compilation of other's works and indicate that, for all his borrowing, West always had an unconventional idea in mind.

One of West's most novel ideas is seen in the *Death of Socrates* of 1756. West had studied du Fresnoy's and Jonathan Richardson's writings. They gave him a feeling for the serious purpose of art and an appreciation for classicism. It may be argued that his *Death of Socrates* derived from those conservative theorists whose views

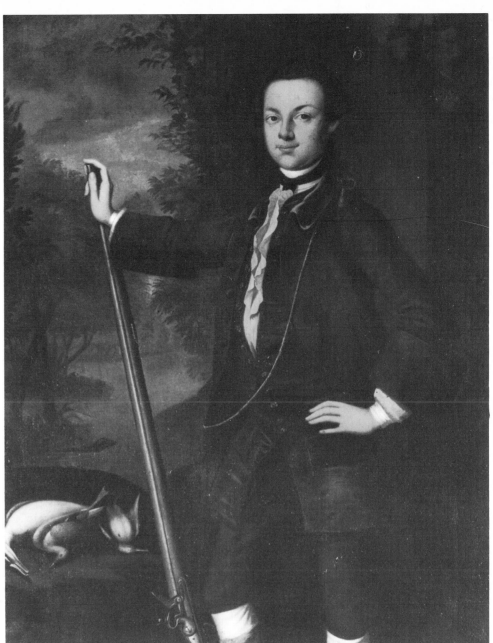

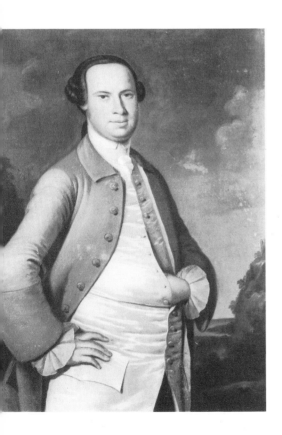

were based on the mid-seventeenth-century classicism of Poussin and the French
Baroque, but West's painting was not *retardataire*. The arches are placed parallel to
the picture plane with the figures set against them in a straight row as in a bas-
relief. No European conceived of this approach until Jacques-Louis David painted
The Oath of the Horatii in 1785, nearly thirty years later. Furthermore, West seems to
have achieved his composition by personal improvisation. The idea for the picture
was taken from the frontispiece to Rollin's *Ancient History*, vol. IV (3rd edition,
London, 1738), because the figure of Socrates is the same in both works. But West
completely changes the Baroque composition with its strong diagonal lines which
organize the figural group and create the pictorial space and includes a nude not
seen in the prototype. Curiously, the most classical motif in the print, the mourning
figure in the lower left foreground, which was copied from an antique statue, is
drastically transformed in West's scene. The figure's face is seen, and he makes a
strong gesture with his upraised hand. This change, combined with the exaggerated
expressions and depiction of crying in other figures, even suggests West anticipated
Romantic thought as well as Neo-Classical.

67

In the final analysis, the expression of these ideas, not the paintings, gives West his place in the art of Western Europe. While his European pictures are technically sound, they are poorly organized sketches of intellectual inspiration. Similarly, it was West's teaching, not his eloquence of style, that has given him his just place in American art. He would never have occupied an important niche in American art based on the few paintings he did there. His students, young Americans who went to London to learn painting, gave West his impact on American art.

West left America in 1760 never to return. Thus in the period after Feke, the most important artist, virtually unrivaled in America, was John Singleton Copley (1738–1815). He was West's contemporary but Copley's art, personality, and temperament were the antithesis of West's. He pursued a more bourgeois career and earned a different place in American art.

Copley's early style was an extension of the work of Greenwood and Feke but was augmented by the painting of classical subjects and the reading of art theorists. Yet Copley's classical subjects, *Galatea* and *Mars and Venus,* show no personal inspiration and remain in the late Baroque tradition. Copley was not impressed with the philosophical overtones of the theorists: to him painting seemed more a way to wealth than a vehicle of scholarly expression. When he matured, Copley yearned to see and to copy the European masters. He expressed dismay at the lack of admiration for art in America, but his displeasure seemed occasioned as much by a desire for higher social standing as by his concern for the status of art.

Copley was buffeted by the same myriad influences as West. As an impressionable adolescent, he clearly borrowed from Greenwood, Pelham, Badger, Feke, and Blackburn; but he quickly integrated their traits into a unified style. The portrait of Joshua Winslow, signed and dated 1755, shows these outside influences. The Rococo landscape, the interest in costume, and the delicacy of the color scheme with its keynote of exquisite crimson are taken from Blackburn. The relationships of line and form in the figure and landscape are based on Feke's portrait of Isaac Winslow, the subject's brother. The linearity and sharp modeling are derived from Greenwood. Nevertheless, Copley forges these three divergent sources into a coherent, integrated picture imbued with an extraordinary personal genius for the representation of physical reality. The picture expresses Copley's innate sense for how Americans visualized their world. As Jules Prown has expressed it,

Copley understood that what New Englanders valued in a portrait above all else was a good likeness. This was a pragmatic society, wedded to the facts of life, more concerned with the material realities of this world than the spiritual potentialities of the next. For this society portraiture was the one acceptable art form because it had a practical social application. A portrait could be sent to family far away as a token of the physical presence of a loved one, or it could descend to family distant in time, providing a kind of material immortality.[41]

This observation is the key to Copley's art: it was not intellectual, filled with complicated allegory and lofty thoughts; it revealed a direct approach and was therefore intensely American. Again in the words of Prown:

His work is clearly stamped by the general as well as artistic values of his society. Copley lovingly delineates textures; not since the Dutch masters of a century earlier had artists lavished as much care on the stuffs depicted. Like his Dutch predecessors, Copley was painting for a Protestant, mercantile, materialistic society, and his art was surely responsive to that society. Indeed Copley's great success as a portraitist lay not only in his ability to depict realistically the external appearances of people and their material surroundings, but also to capture the more profound realism of people as sentient human beings living out their lives in specific social contexts, whether as wealthy merchants, intellectual ministers, fruitful housewives, or characterful elders.[42]

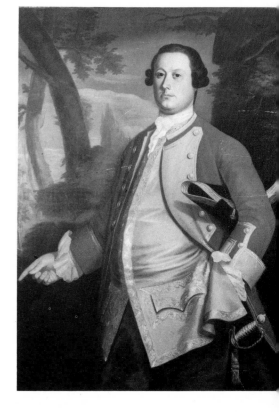

JOHN SINGLETON COPLEY, *Joshua Winslow,* 1755.
Santa Barbara, California, Santa Barbara Museum of Art.

Copley began to reach his stride in the late 1750s with his portraits of Mary and Elizabeth Royall, Epes Seargent, and Thaddeus Burr. In these paintings Copley achieved independence from his earlier influences. The colors are strong, the lighting is bold, the brushstrokes are vigorous. The next decade witnessed Copley's steady advance both socially and artistically. Between 1760 and 1765, Copley's patronage was primarily from the wealthy merchants and landed gentry, and his painting was social portraiture. His pictures grew more sophisticated, opulent, and delicate – the latter possibly because Copley became acquainted with pastels in 1762. A superb picture of this period, *Mrs Daniel Hubbard,* is the epitome of his aristocratic style. The luxurious lace is the leitmotif of the picture, and the landscape agrandizes the subject's status. Probably to be stylish, Copley closely follows John Faber's mezzotint of *Mary, Viscountess Andover* after the painting by Thomas Hudson. As a result, Copley's portrait has areas of dark and light and an overpowering emphasis on line. The drawing of Mrs Hubbard's arm which rests on a plinth is faulty, but the gorgeous color overcomes these defects.

The use of Hudson as a prototype was possibly due to his reputation in London as a specialist of portraits of the social élite. In 1764 Americans would have instantly associated the painting of Mrs Hubbard with the image of position and wealth which Hudson's pictures represented. But Hudson retired in the late 1750s when his pupil, Sir Joshua Reynolds, began to take center stage and introduced new theories of painting. Copley must have been sensitive to this change of leadership; and in the portrait of Mrs Jerethmael Bowers, usually dated 1764 or 1765, Copley seems completely preoccupied with imitating Reynolds' style. Evidently, Copley felt Reynolds was in the ascendency. The Bowers portrait is taken wholesale from James McArdell's print of Reynolds' 1759 painting of Lady Caroline Russell and duplicates the costume, landscape, and lap dog. Copley, always a realist, must have felt close to Reynolds because the latter was replacing the 'fixed stare' of Hudson's sitters with a more sympathetic depiction of the character of his subject, a solution Copley had naturally hit upon himself.

In 1765 Copley's preoccupation with Reynolds became even stronger. Perhaps whetted by a letter received from Thomas Ainslie of Scotland, the Bostonian resolved to paint a picture for the Society of Artists' exhibition in London, where Reynolds might see it. The portrait depicted Copley's half-brother Henry Pelham; he was shown in profile, leaning over a highly polished table and playing with a squirrel. The color combination of red, pink, yellow and black is startling; but Copley's ability to render fur, water, wood, cloth and flesh is superb.

The picture won him an invitation to membership in the Society, and Reynolds was enthusiastic although he 'observed a little hardness in the drawing, coldness in the shades, and over-minuteness, all which example could correct . . . provided you could receive these aids before your manner and taste were corrupted by working in your little way in Boston.'[43] Benjamin West also commented by letter to Copley about the painting.

It is curious that Reynolds was as complimentary as he was, for his style was based on softening the outlines by plunging their edges into dark shadow and relating the figure to the background by establishing a flicker of light in both the figures and the background which visually marries them. Copley uses neither of these devices: the edges are as hard as in any American portrait and the head is set against its backdrop without the slightest integration. Copley's picture is, in fact, *retardataire* and belongs to the French tradition of the *portrait d'apparat* and recalls Chardin's studies of children playing with cards or bubble pipes. In a portrait of Mary Warner Copley tried to correct the faults Reynolds mentioned. This picture is really more in Reynolds' vein, especially when compared to his sentimental pictures such as the *Strawberry Girl.* But Reynolds liked the Warner picture even less; and

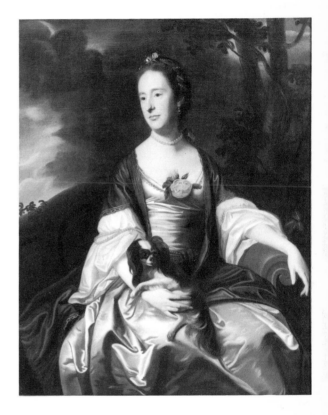

JOHN SINGLETON COPLEY, *Mrs Jerethmael Bowers,* 1764–7.
New York, Metropolitan Museum of Art, Rogers Fund, 1915.

Copley began to explore the possibilities of the Pelham portrait in such works as *Paul Revere, Nathaniel Hurd, Isaac Smith* and others which were actually closer to the style of Reynolds' contemporary, Joseph Wright of Derby.

Culminating the series is the portrait of *Mrs Humphrey Devereaux*, painted in 1771. It depicts the subject in an intimate interior; and while Copley does not place personal effects on the table, he shows Mrs Devereaux sitting in a wing chair generally associated, in the eighteenth century, with the sick and elderly in their private rooms. The closed background parallel to the picture plane in the Pelham portrait has yielded to a dark, blank void; the pictorial effects produced by the polished table top are used with greater finesse not only to create a spatial continuity between figure and viewer but also to heighten the dramatic lighting. The table top finds its luminous counterpart in the darkness of the background and reflects additional light onto Mrs Devereaux' arm and face. The rendering of the face is extraordinary. The tripod-like pose supporting the subject's head was no accident because Copley often requested as many as sixteen sittings of several hours' duration. The portrait is both a brilliant celebration of surface reality and the apogy of the style based on native American vision. The painting makes its statement through line and shape;

JOHN SINGLETON COPLEY, *Mrs Humphrey Devereaux*, 1770.
Wellington, New Zealand, on loan to the National Art Gallery.

it is a translation onto canvas of what the artist saw. There is no hint of a learned academic technique; each passage is its own individual solution to the problem of depicting external appearance.

The picture was commissioned by John Greenwood, Copley's probable mentor. In the years after his departure from Boston in 1752, Greenwood painted in Surinam, went to Holland, and became an art dealer in England. In the spring of 1770 he wrote a letter to Copley which became the basis for the portrait:

It has given me infinite pleasure from time to time, to see your masterly performances exhibited here in London, and hope at the approaching Season to find no disappointment, as it will certainly be a very great one to me, if a Picture of yours is wanting. as it may hapen that subjects may frequently hinder your favoring us with them so often as one could wish, I've tho't of one very proper for your next years Applause, and our amusement; I mean the Portrait of my Hon. Mother, who resides at present nigh Marblehead, but is often in Boston. as I have of late enter'd into conections, that may probably keep me longer in London than I could wish, I am very desirous of seeing the good Lady's Face as she now appears, with old age creeping upon her. I should chuse her painted on a small half length or a size a little broader than Kitt Katt, sitting in as natural a posture as possible. I leave the pictoresque disposition intirely to your self and I shall only observe that gravity is my choice of Dress. I have desired her to write to you to be inform'd when 'twill suit you for her to come to Boston.[44]

Greenwood received exactly what he requested because the picture is painted in grave colors of brown, black and gray. He also obtained one of the most intensely observed portraits of a person 'with old age creeping upon her' ever done.

Greenwood's letter may have had another important result: it apparently rekindled in Copley an interest in the opportunities London offered. In the fall of 1770 he wrote West, after two years' silence, about the picture for Greenwood and asked if it might be exhibited when it arrived. The painting was hung in the 1771 exhibition, and West wrote in June of that year that the picture did Copley 'great honor.' Still, Copley's eye was on success, and he was forestalled from going to London by a letter written in April 1771 by Captain Stephen Kemble, asking him to paint in New York. Copley demanded and was assured high prices for his work – 40 guineas for a full length. With a dozen subscribers awaiting him, Copley opted for the money he would make in New York.

The year 1773 was a crucial one for Copley. He then had much that he wanted – fame, a good income, and a large estate on Beacon Hill – but in January his interest in going abroad was reawakened by another letter from West, who suggested a course of study in Italy. Dr John Morgan, a friend of Thomas Mifflin, Copley's Philadelphia patron, and Thomas Palmer, of Boston, supplied the artist with letters of introduction to their associates in Italy; but Copley refrained from making the final commitment.

Subsequent events must have set his mind. On 16 December 1773, the Sons of Liberty, several of whose portraits Copley had painted, staged the famous 'Boston Tea Party,' and dumped a great quantity of tea into the Boston harbor. Most of the merchandise had been consigned to Copley's father-in-law, and the family suffered a sizable loss. At the end of 1773 Copley resolved to leave but not permanently and not for any particular Loyalist feelings. It would appear the decision was made on financial grounds. Copley foresaw a period of commotion which would restrict his commissions.

Copley set sail on 10 June 1774. In the year before his departure he painted only a few works, although the portrait of Mr and Mrs Isaac Winslow may be counted among the greatest of his American career. It continued the double-portrait format which Copley had revived in the picture of Mr and Mrs Mifflin of 1773. These were the first portraits to include more than one figure since the Royall sisters of 1759

and heralded Copley's European pictures – the Ralph Izards, the daughters of George III, and finally the great historical pictures in which the interrelationship of figures were explored with increasing complexity. The portrait of Mr and Mrs Mifflin is crucial to the understanding of Copley's new interests. It belongs to the *portrait d'apparat* group in Copley's work – the subjects are posed informally, caught as if on an afternoon at home, Mr Mifflin reading a book and Mrs Mifflin making tapes on a loom. As in the other pictures of the early 1770s, intense light and dark play about the picture, and the polished table is present. Copley's picture is successful, but the experimental nature of the composition is revealed in a way he places the intimate figures in an incongruous cavern of space articulated by lofty columns, and fills the center of the picture with a pile of hands which look as though they are from a page of studies. Perhaps the circumstances surrounding the painting of the picture required Copley to portray the two together. The Mifflins came from Philadelphia to have their portrait made, and, by painting them together, Copley may have saved some time. Or, he may have wanted the challenge of a more complicated pictorial problem, a harbinger of his work in Europe.

Copley had no direct pupils, but his style affected two young Connecticut painters, John Trumbull and Ralph Earl. Trumbull was a student at Harvard in 1773 and knew Copley's portraits of Thomas Hollis and Nicholas Boylston which were owned by the college. The young student also visited Copley's studio. When Trumbull returned to Lebanon, Connecticut, he painted in Copley's style. The portrait of his brother Jonathan Trumbull Jr. and his family, is painted in the strong darks and lights of Copley's pictures. The trademarks of Copley – the polished table, the basket of fruit, the meticulously executed Chippendale chair – appear in Trumbull's picture. The book Jonathan holds is taken almost directly from the Mifflin picture. Only the tight edges and the placement of the heads in a single row (as Feke had done in the portrait of Isaac Royall and his family), reveals that Trumbull had not digested Copley's lessons.

Ralph Earl's portrait of Roger Sherman is equally indebted to Copley. The strongly modeled face against the subdued background is taken directly from Copley's

Below JOHN TRUMBULL, *Jonathan Trumbull Jr. and his Family*, 1771.
New Haven, Connecticut, Yale University Art Gallery, Gift of Miss Henrietta Hubbard.
Below, right RALPH EARL, *Roger Sherman*, 1777.
New Haven, Connecticut, Yale University Art Gallery, Gift of Roger Sherman White, 1918.

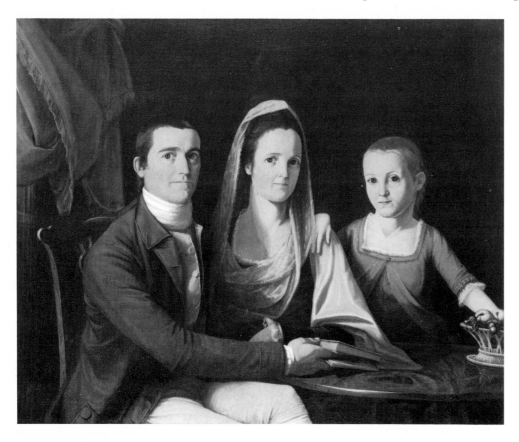

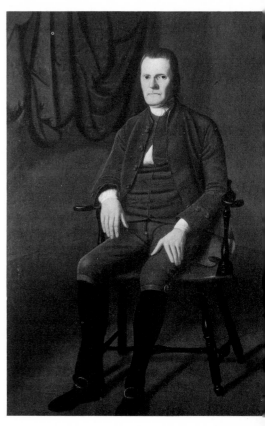

work, and the use of the Windsor chair, a major pictorial motif in the Sherman portrait, appears in several of Copley's works of 1772 and 1773 as in the double portrait of the Winslows. The figure is related to its background by a surface pattern of lines; the line of the floor connects to the edges of the waistcoat, and the corner of the room runs precisely to the crease in his shoulder. These relationships recall Feke, but the Feke-like elements of Trumbull's and Earl's pictures are circumstantial solutions which occur naturally to talented but untrained artists.

Trumbull and Earl had a number of parallels in their lives, although Trumbull was from a more prominent family and had a university education. Both were from Connecticut; both married Englishwomen who never won the approval of their friends and family; both drank to excess; both pioneered in the painting of landscape and abandoned Copley's pragmatic style for training in England, where they studied West's urbane academicism.

Copley had little influence outside of New England. Even his impact on Trumbull and Earl was fleeting. The paintings of Copley therefore seem as indigenous to Boston as that city's *bombé* furniture made during the same period as Copley's later works. In New York and Philadelphia during the 1760s the *portrait d'apparat* was solidly established, but the phenomenon resulted from the simultaneous influence from England on all the principal American painters and not through the influence of Copley. Two striking examples of this style which swept the colonies are John Mare's *Unknown Man* of 1767, done in New York, and James Claypoole Jr.'s *Mr John Pemberton,* painted in Philadelphia the same year. The color in the two pictures is extraordinary. Both have strong hues with a definite Rococo tendency in the palettes. Each subject stands proudly next to elaborate possessions – an expensive 'French Sofa,' very similar to one in Chippendale's *Director,* and an elegantly carved side chair. These articles, representing wealth and social status, vie with the figures for attention and probably were meant to do so.

The careers of Mare and Claypoole are only now becoming known. These men were probably the counterparts of Copley in their respective towns. The major events in American painting however, develop out of the corps of artists returning from West's studio in London: Matthew Pratt, Henry Benbridge, Charles Willson Peale, Gilbert Stuart, John Trumbull, and Ralph Earl. Pratt himself described the studio and West's kindness toward young American artists in one of his letters: 'Mr. Benjamin West had a very elegant house, completely fitted up to accommodate a very large family, and where he followed his occupation in great repute as a Historical and Portrait painter. And where he kindly accommodated me with rooms and rendered me every good and kind office he could bestow on me, as if I was his father, friend and brother.'[45] Pratt's painting of *The American School* (1765) introduces the main American artists after the Revolution. The picture shows the young West, then twenty-seven years old and only three years established in London, giving lessons in his studio. The remaining figures shown in *The American School* have not been identified with certainty but Pratt may be the man seated at the easel and Henry Benbridge the standing student.

Pratt was apprenticed in 1749 to his uncle, James Claypoole, and the young artist also worked briefly in Jamaica. After his return to Philadelphia in 1768, Pratt's work was uneven. He made a trip to New York in 1771 and met Copley, who wrote that Pratt had said, upon viewing the Boston artist's portrait of Mrs Gage, that 'every part and line in it is butifull [sic] that I [Copley] must get my ideas from Heaven, that he [Pratt] cannot paint.'[46] This letter, addressed to Henry Pelham and dated 6 November 1771, reveals that Pratt was certainly aware of his limitations.

Henry Benbridge was a better artist. Born in 1744, he was the stepson of Thomas Gordon, a patron of John Wollaston. After receiving an inheritance of £100 from his

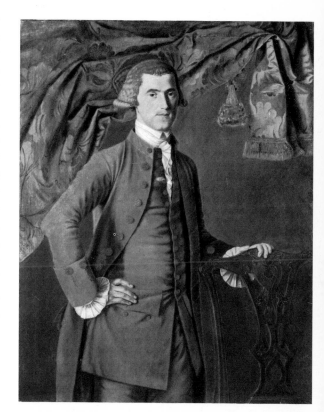

Below JOHN MARE, *Unknown Man*, 1767. New York, Metropolitan Museum of Art, Victor Wilbour Fund, 1955.

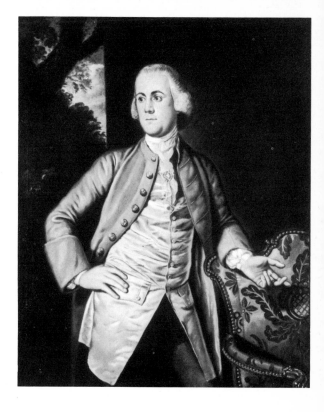

Bottom JAMES CLAYPOOLE JR., *Mr John Pemberton*, 1767. Philadelphia, Pennsylvania, Pennsylvania Academy of the Fine Arts.

father's estate upon attaining his majority, Benbridge went to Europe. By 1765 he was working in Rome, and in 1769 he was probably in London. However, he may have stopped in London late in 1764 and visited Benjamin West at the time Pratt was painting *The American School*. Benbridge returned to America in 1768 and painted in Philadelphia, Virginia, and Charleston. He avoided Boston, where Copley enjoyed a monopoly. A comparison of Benbridge's *Unknown Gentleman* (1771), one of his two signed works, with Copley's *Mrs Humphrey Devereaux*, shows little similarity in technique. The dark background and strongly lit face abruptly recall Copley's paintings done in New York in the same year, but the edges in the man's face are softer (as Reynolds would prescribe), and the shadow flickers about the face without Copley's 'hardness.'

Between Pratt's departure and Benbridge's second visit to London, Charles Willson Peale was West's pupil and the most original and important of West's early students. Born in 1741 in Queen Anne County, Maryland, he was apprenticed to a saddler at the age of nine. By chance Peale became interested in painting; after making a few portraits of his family for practice, he went to Annapolis in 1762 to see John Hesselius, who gave him some painting lessons in exchange for a saddle. Three years later on a trip to Boston to avoid his creditors, Peale visited Copley and studied the paintings in John Smibert's old studio. The pictures Peale painted in New England were at first in the style of Hesselius; but the more informal, naturalistic style of Copley influenced several portraits Peale painted in 1765. Another new inspiration was Sir Joshua Reynolds, whose work Copley had begun to follow in his portrait of Mrs Jerethmael Bowers and *The Boy with the Squirrel*. While in New England, Peale painted a picture based on a print of a Reynolds painting and sent it to Mr Charles Carroll, the barrister of Annapolis. This event was crucial to Peale's career because after seeing the picture, Carroll wrote Peale to return to Maryland. Peale complied and based on this success Peale painted a similar study after Reynolds for Judge Beale Bordley. This picture so impressed Bordley that he organized a group of contributors including many prominent Marylanders to send Peale to England. Equipped with letters of introduction to Benjamin West and to a friend of Alan Ramsay's, the painter to the king, Peale left for England in 1766.

Immediately Peale entered West's studio. He devoured the lessons of London's artists. He bought books on art, including Leonardo da Vinci's treatise in Italian which he could not even read; he went to Reynolds' painting room and painted under West's guidance. His work was in the Neo-Classical style promulgated by West who had just completed his *Agrippina with the Ashes of Germanicus* and was working on *The Departure of Regulus from Rome*, a commission from King George in which Peale posed as Regulus. West advised Peale to specialize in miniatures.

Even more than West, Edward Jennings was the key figure in Peale's career. He arranged commissions in London; and when the time came for Peale to depart in 1769 for America, he ordered several portraits of his American friends to give Peale a start. One was the portrait of Judge Bordley, a huge painting, especially for Peale who was listed as a miniature painter in the Society of Artists' catalogue for 1768. The portrait is closely based on an engraving of William Pitt that Peale made in England after a portrait commissioned by Jennings. He was acting as agent for a gentleman of Westmoreland County, Virginia, who wished to honor Pitt for his stand on the Stamp Act issue. The prominent figure of Liberty to which Bordley points is almost identical to the one in Pitt's portrait. A book of English law is placed symbolically under Bordley's elbow, and the torn paper representing rejection, which reads 'Imperial civil/law – Summary/proceeding,' is placed opposite the deadly American jasmine weed which Peale rendered with botanic accuracy. The allegorical content relates the picture to the Neo-Classical style of painting, but the picture does not carry on West's tradition. It is closer to Reynolds in color and to

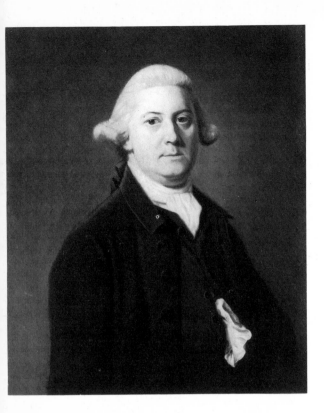

HENRY BENBRIDGE, *Unknown Gentleman*, 1771.
Washington, D.C., National Gallery of Art, Andrew Mellon Collection, 1947.

Opposite CHARLES WILLSON PEALE, *George Washington at Princeton*.
Philadelphia, Pennsylvania, Pennsylvania Academy of the Fine Arts.

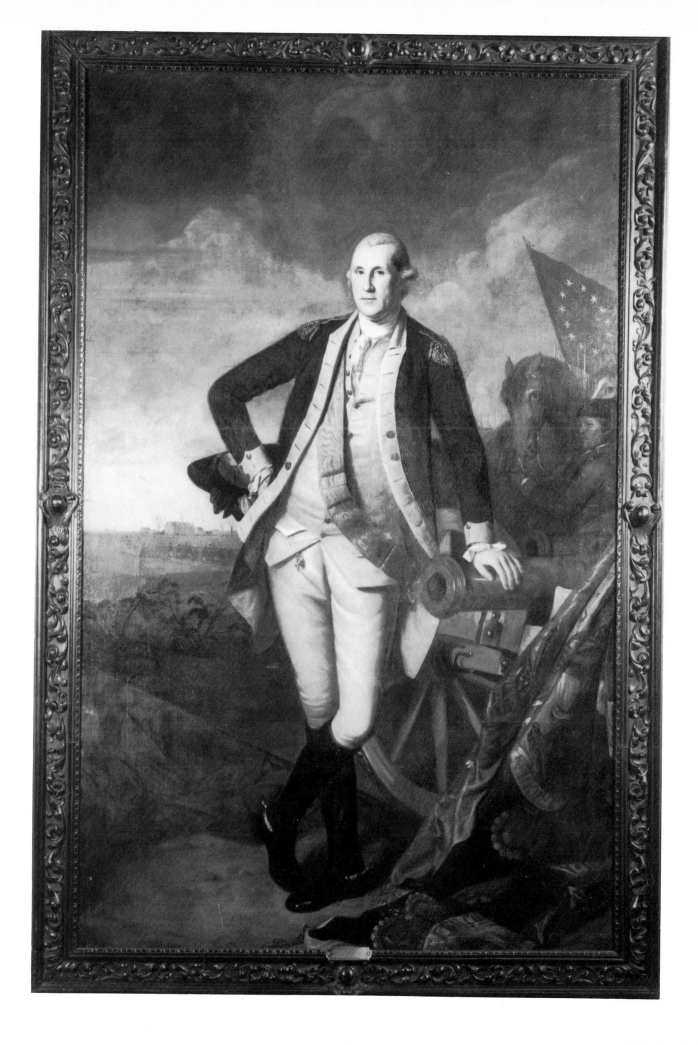

Hogarth in composition. The more avant-garde Neo-Classicism was not successful in America and Peale's engraving of Pitt had no market. The conservative 'line of beauty' espoused by Hogarth was Peale's key to success: the Bordley picture, for example, is dominated by a great curved tree.

Jennings' scheme to promote Peale succeeded, and after his return Peale painted the gentry of Maryland. One of his finest pictures is *The Edward Lloyd Family* (1771). It depicts Edward, his wife, Elizabeth Tayloe Lloyd, and their daughter Anne; but the subject of the painting is really harmony at home and domestic tranquility. This theme dominates Peale's work for many years in distinct contrast to the more bellicose attributes in the pictures of Pitt and Bordley. Again the 'line of beauty' controls the composition. The next year Peale painted a picture of George Washington, whose stepson, John Parke Custis, was a drawing student in an Annapolis boarding school, where Peale taught. The year 1772 marked the beginning of a long association with Colonel Washington. Peale was politically an ardent radical. As the American Revolution approached, he was drawn closer to its center. While carrying on a large portrait business which had finally liberated him from debt, he designed liberty banners, experimented with rifles and gunpowder, finally joined the militia and became a first lieutenant in October 1776. After Copley departed in 1774, Peale was the principal painter in America; and like David in France, he became the 'first painter to the Revolution.' He portrayed many of the prominent people of the time: Adams, Pickman, Hancock, and, of course, Washington. Peale's *George Washington at Princeton* of 1779, is perhaps his greatest painting. The portrait was commissioned by the Supreme Executive Council of Pennsylvania and was hung in the council chambers. Peale cleverly posed Washington leaning with one hand on a cannon, which allowed the painter to use the 'line of beauty' as the central compositional motif. The curves were carefully set against the strong diagonals of the battle flags which frame the figure and represent Washington's victories at Trenton and Princeton. The most remarkable feature of this picture is the trouble Peale took with its accuracy. He traveled to Princeton to make sketches of the exact site of the battle depicted in the background and had a folding easel made so that he could paint Washington in person at his camps at Valley Forge, Monmouth, Brunswick, Trenton, and Princeton. The uniform carefully follows Washington's general orders of 14 July 1775, to wear an identifying light blue ribbon between the coat and waistcoat; the actual flags from the battles of Princeton and Trenton were sent to Peale to be copied. Finally, the proportions of the figure, the arrangement of narrow chest, heavy hips, and thin legs, perfectly reflect Washington's anatomy and compare with Houdon's statue of Washington done from measurements of his body. Such care previews Peale's later painting often related to his scientific experiments or to his depictions of various species of animals and birds in their correct habitat. These culminated in the formation of a museum Peale termed a 'world in miniature.'

Peale's desire to found his museum was especially stimulated by his discovery of some mastodon bones in 1784 and aided by the advent of several portrait painters who slowly took over his portrait trade. First came Robert Edge Pine, an Englishman, followed by his countryman, Edward Savage; Adolph Wertmuller, a Swede; Pierre Charles L'Enfant, Charles Balthazar, Julien Fevret de Saint-Memin, and Pierre Eugène du Simitière, of France; and finally in 1793 Gilbert Stuart then working in Ireland, although originally of Newport, Rhode Island.

Stuart came to Philadelphia to paint Washington, and his pictures have provided the most lasting image of America's first president. Yet how different they are from Peale's portraits of Washington! Peale knew his subject personally and painted him as a human being. Stuart was painting a legend. For example, the Lansdowne portrait (1796) by Stuart could not be further from Peale's *Washington at Princeton*.

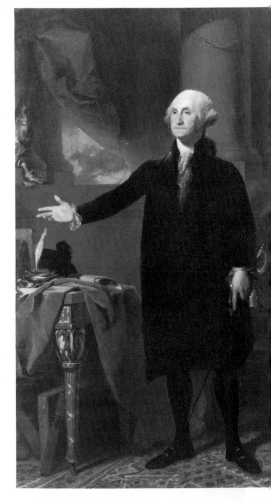

GILBERT STUART, *Lansdowne Portrait of George Washington*, 1796.
Philadelphia, Pennsylvania, Pennsylvania Academy of the Fine Arts, Bequest of William Bingham.

Stuart depicted Washington not as a triumphant soldier but as an executive. Stuart's Washington holds a sword, but the principal gesture directs one's eye to a quill pen and thus reveals an enlightened man who believed the 'pen is mightier than the sword,' and a Cincinnatus, who relinquished his weapons after the battles. Stylistically there is also a great difference. Peale portrayed Washington through intense observation – the epitome of the American approach. Stuart used a mezzotint for the composition and the academic, late Baroque style dominated. Stuart did not even take the figure from Washington but used as a model a man who boarded with him. Peale himself noted the difference, and a letter by his son states, 'On my return to Philadelphia in May 1796, I saw for the first time, in company with my father [Charles Willson Peale] and Uncle [James Peale], Stuart's portrait. We all agreed that though beautifully painted and touched with masterly style as a likeness it was inferior to its merit as a painting. . . .'[47] Stuart knew the difference, too, for George Washington's stepson, Parke Custis, reported that Stuart said, 'I do not pretend to have painted Washington as General of The Armies of Independence; I knew him not as such. I have painted the first President of the United States.'[48] Peale painted the man; Stuart painted the image.

Stuart started humbly enough. He was the son of a Scotsman who had operated a snuff mill in Rhode Island as a partner of Dr John Moffat. Stuart may have been attracted to painting by Moffat, who was John Smibert's nephew, Feke's friend and a collector of paintings; but Stuart's first works were for another Scottish doctor – William Hunter. Through Hunter, Stuart met Cosmo Alexander, who painted portraits of Dr and Mrs Hunter in 1770. Stuart went to Scotland with Alexander in 1771, but Alexander's untimely death in 1772 caused Stuart to return to Newport. The pictures painted by Stuart after his return are similar to Alexander's work, especially in the drawing of the face; but they also show the influence of Copley, who was then producing his greatest American work. Several of his paintings were in Providence; and Samuel Okey, an English artist living in

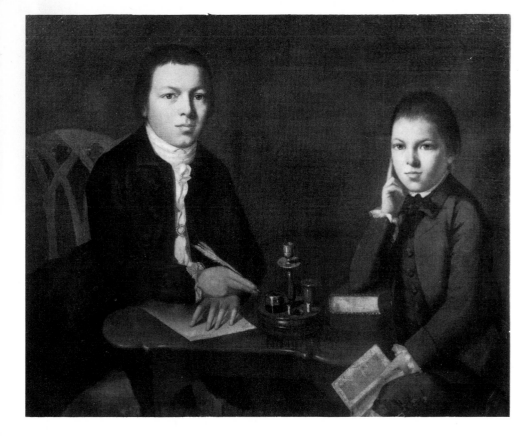

GILBERT STUART, *Francis Malbone and his Brother Saunders*, 1773.
Mrs Francis Malbone Blodget Collection (Photo Frick Art Reference Library).

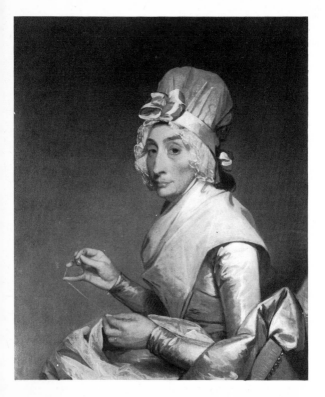

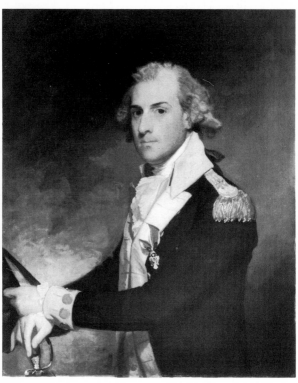

Top GILBERT STUART, *Mrs Richard Yates.*
Washington, D.C., National Gallery of Art.
Above GILBERT STUART, *Matthew Clarkson,*
1797.
New York, Metropolitan Museum of Art,
Bequest of Helen Shelton Clarkson, 1938.
Opposite RALPH EARL, *Daniel Boardman,* 1789.
Washington, D.C., National Gallery of Art,
Gift of Mrs W. Murray Crane, 1948.

Newport published mezzotints after Copley's work in 1770 and 1771. The double portrait of Francis Malbone and his brother Saunders is particularly close to Copley's work in the use of the polished table, small personal objects and the Chippendale chair. Stuart also depicts the reflections on the table top and composes in strong dark and light areas defined by the hard lines so familiar in Copley's paintings. Perhaps this is why after a long sojourn in Europe – first in West's studio in 1775, then on his own in London and in Dublin – his portrait of Mrs Richard Yates, just after his return to New York in 1793, should be so linear. In London Stuart had used all the dashing brushwork of Gainsborough and Lawrence. The portrait of Mrs Yates follows this brilliant application of paint but also can be seen as the successor to Copley's representation of Mrs Mifflin. Both have the same concentrated, taut outline; both are concerned with visual observation above all.

More typical of Stuart's work after his return is the portrait of Matthew Clarkson. This picture of a wealthy and socially prominent New Yorker attests to Stuart's facility with the brush and shows the artist's love of painting uniforms, the images of station. However, the face dominates the picture. Stuart once remarked, 'I don't want people to look at my pictures and see how beautiful the drapery is; the face is what I care about.'[49] Thus, Stuart rarely painted 'past the third button,' as his critics put it.

At the end of the century, Peale and Stuart must share the stage with two other students of West – John Trumbull and Ralph Earl. These two Connecticut painters had been followers of Copley, but in 1800 they were graduates of West's studio and individual artistic personalities in their own right. Trumbull can be compared to Stuart through his splendid portrait of *Washington at Verplanck's Point*. Trumbull's picture of Washington, done as a gift for Martha Washington, has the same deft brushstroke and strongly diagonal movement as Stuart's *Matthew Clarkson*. Yet Trumbull seems to come to his subject with the feeling that he is painting history. His portrait is not one of an image or a person, even though Trumbull had been close enough to Washington to serve as his *aide-de-camp*. The painting is a nostalgic one and shows Trumbull's interest in Washington as the central figure in a sequence of great events.

Earl differs from both. Unlike Trumbull, he was never interested in history painting, although early in his career he made a series of crude pictures of the battles of Lexington and Concord. Unlike Stuart, he was never interested in flashy society portraiture, although he had worked in West's studio along side of Stuart and Trumbull at various times. Comparing Earl's portrait of General Matthew Clarkson to Stuart's reveals their different point of view. Equally dramatic is the comparison of Trumbull's *George Washington* with Earl's *Daniel Boardman*, signed and dated 1789. Obviously the subjects are different, but Earl emphasizes the edges and light and dark contrasts. The perspective is flattened, and objects are treated with visual intensity. Despite this, one element connects the two pictures – landscape. The works of these two Connecticut painters are the prelude to a new era of American painting characterized by landscape which eventually eclipsed portraiture. Even though some conversation pieces, history pictures, and landscapes were painted in the colonial period,[50] the principal vehicle of art was the portrait. Today, in our anti-heroic age, the portrait is not a favored form; but it was very much that in the eighteenth century. That century discovered the individual; the central theme of its history is the triumph of the individual and his rights. In America, portraiture was a natural means of expression for the country was built by a middle-class society acutely conscious of itself. Thus, a people building both new homes and a new nation wanted images of themselves to furnish their buildings, both domestic and public. Portraiture must be seen with renewed eyes, for in these paintings is not only the face of America but also the story of its art.[51]

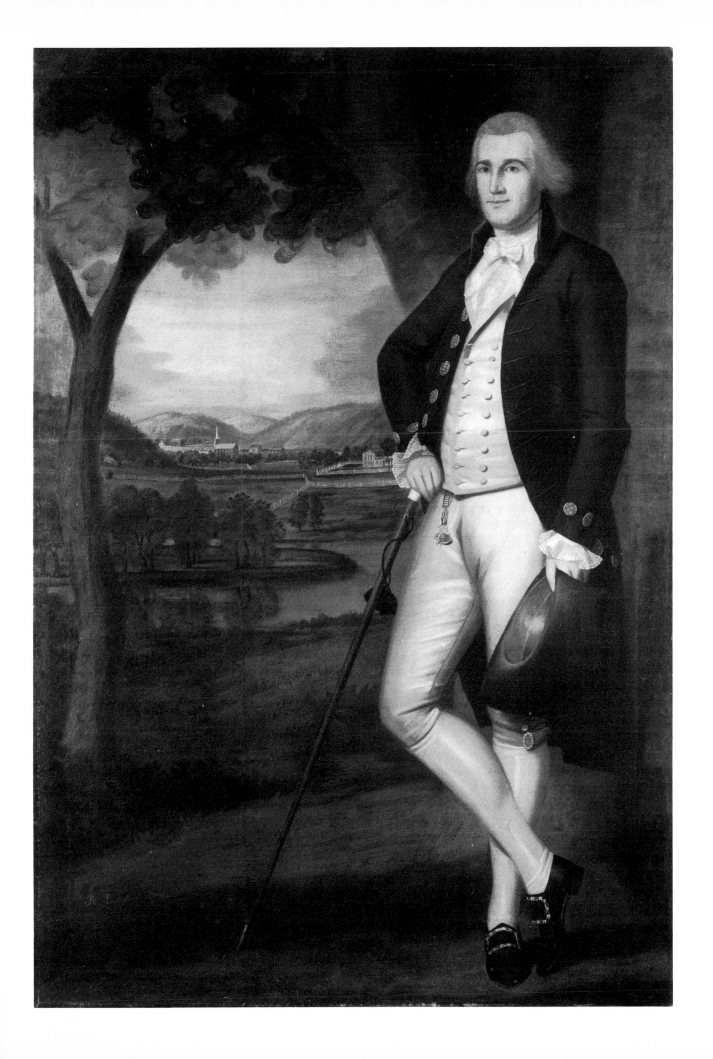

2

THE FIRST HALF OF THE NINETEENTH CENTURY

John Wilmerding

THE FIRST HALF OF THE NINETEENTH CENTURY

A national expression in American art emerges in the closing years of the eighteenth century, concurrently with the formation of the Federal system and later the triumph of Republican Democracy. The gradual shift that was taking place in artistic interest from portraiture and classical history painting to landscape and marine painting, genre, still life, and contemporary history paralleled the rising awareness and pride of Americans in their new nation. Artists and laymen alike took pleasure in their recently elevated status among the community of nations, and consequently sought to define with equal enthusiasm a distinctive national culture. In this light the events and personalities of first the Revolutionary War and later the War of 1812 took on the dignified mantel of instant national history and heroes. Artists seized on both as suitable subjects for their ambitious canvases and aspiring careers. In some instances an untutored or unsympathetic public forced the collapse of a promising career, as in the cases of John Trumbull, John Vanderlyn, and Samuel F. B. Morse. In other cases artists like Thomas Cole well served public taste and expectations by creating an iconography that clearly embodied contemporary views on both the moral functions of art and the special character of the American landscape.

As the new century opened, America's two greatest artists of the colonial period, Benjamin West and John Singleton Copley, were pursuing their later careers in England. But both were to exert a forceful influence over the development of art in America. In the large number of his American portraits Copley had already created an imagery and style that seemed to bear a uniquely native character. The forthright realism, strong physical palpability, clear spatial articulation, and graphic clarity of forms all would contrast with the looser and more elegant style of his subsequent manner cultivated in England. More importantly, those very qualities of directness and factuality in his earlier work would reappear frequently in later American art, from the still lifes of Raphaelle Peale to William Harnett, from the landscapes of Asher B. Durand to Andrew Wyeth, and from the portraits of George Catlin to Thomas Eakins.

Benjamin West had even less of an American career, although paradoxically he was to affect the course of numerous American painters' careers, among them Copley, Gilbert Stuart, John Trumbull, Washington Allston, Charles Willson Peale, Thomas Sully, Samuel F. B. Morse, William Dunlap, and Robert Fulton. To many of these men he gave comfort, shelter, and advice – including artistic and financial assistance – that ultimately permitted them to go their own ways. His patriarchal friendship in England thus gave to a number of younger artists both an introduction to the standards of European art styles and the confidence to create their own manner of painting in the light of that European experience after returning to America. As an influential teacher he plays a select role in the history of American art, not unlike that of Robert Henri in the early 1900s and Hans Hofmann during the 1930s and 1940s. West had already established himself as somewhat of an iconoclast with his *Death of General Wolfe* in 1771, which decisively asserted the artistic validity of recent history and contemporary costume and setting as suitable subject-matter for the painter. Along with Copley's *Watson and the Shark* of 1778 and his history paintings of the 1780s, West's *General Wolfe* was only the beginning of a whole flood of such pictures in the next decades by artists such as Trumbull, C. W. Peale, and Thomas Birch. In different ways these painters began to modify history painting, combining it with portraiture, subordinating it to landscape painting, or blurring it with genre painting.

BENJAMIN WEST, *Death on a Pale Horse* (first oil sketch), *c.* 1787.
Philadelphia, Pennsylvania, Philadelphia Museum of Art.

One major work of West's later years, *Death on a Pale Horse*, was a subject that preoccupied him through several versions done between 1802 and 1817. It was a picture that belonged at once to the English Gothick of the mid-eighteenth century and to the flourishing Romanticism of the nineteenth. In form and content it would assert an influence on Trumbull's historical pictures of the same period and extend to Thomas Cole's monumental canvases of 1836 on *The Course of Empire*. Specifically, West's painting belonged to the so-called 'Dread' or 'Sublime' manner of his mid-career, although continuing into his later work. The style was one that he developed in response to his reading of Edmund Burke's *Philosophical Enquiry into the Origin of our Ideas of the Sublime and Beautiful*, first published in 1756. Burke's theories of the sublime profoundly affected West, who thereafter attempted to visualize the aspects of the sublime in his painting. These included obscurity, privation, vastness, and terror, all of which are present in *Death on a Pale Horse*. The clear stage platforms and rational architectural settings of his earlier work are now replaced by a turbulent and unlimited space, filled with thrashing forms and impending violence. The sublime appears in the rough and irregular, both of which contribute to the sense of pain and difficulty. West's composition writhes in response to the compulsive forces within, enhanced by the vivid contrasts of strong light and shadow. The personification of Death at the center is veiled in obscure shadows, an image of terrible power who wears a crown, hurls belts of lightning, and rushes forward on a powerful white stallion. The dramatic intensity and the romance of transcendent forces of destruction were to become deeply imbedded in later American visions of the wilderness. More immediately, West's interpretation of the sublime had a parallel expression in the Revolutionary panoramas of John Trumbull.

Trumbull was the son of the governor of Connecticut during the Revolution. He went to Harvard where he first cultivated an interest in drawing that ultimately prompted him to undertake some portrait painting. He also met and was influenced by Copley, who was then working in Boston. When war broke out, Trumbull served in the Continental Army as an aide to Washington, rising to the rank of

83

colonel; he occasionally took the opportunity to draw maps and sketches. He resigned his commission in 1777 and a few years later set off for London to study history painting with West, in whose circle he remained through most of the 1780s. Two principal influences seem to have conditioned the development of his work during this period: the first was the large historical canvases by Copley and West then receiving wide attention, and the second was the lively oil sketches by Rubens, the great Baroque master, which Trumbull had studied during visits to France.

Both West and Thomas Jefferson expressed enthusiasm about Trumbull's idea for painting a series of pictures depicting the significant heroes and events of the Revolutionary War. In his *Autobiography* Trumbull called them with some hyperbole 'the noblest series of actions which have ever presented themselves in the history of man.'[1] The eight large canvases that resulted not surprisingly combined the careful drawing and accurate realism of Copley's and West's work with the bright coloring, dramatic lighting, and agitated compositions reminiscent of Rubens. One of the best known among the group at Yale University is his *Battle of Bunker Hill* of 1786. The composition with the dying General Warren in the foreground, with its allusions to a religious *pietà*, comes from West's *Death of General Wolfe*, while the generally diagonal arrangement of figures and waving flags recalls pictures like Copley's *Death of Major Pierson*, in the Tate Gallery, London, completed only two years before. But the fluid brushwork, the intense touches of color in the reds and blues, and the totally restless organization of the pictorial space reflect Trumbull's knowing familiarity with Rubens' Baroque style. On the one hand, then, there is the methodical attention to realism – Trumbull took care to make extensive preparatory sketches of the individuals and the setting to achieve historical accuracy – and on the other hand, there is present the dramatic and romantic presentation of death which West himself was embodying in his Sublime manner.

Trumbull was certain that this noble depiction of noble actions would assure success and favor with the American public. Although he subsequently became head of the American Academy of Fine Arts in New York, he was to preside over the demise of both its and his own fortunes. When the new Capitol in Washington was completed, the United States Congress invited Trumbull to paint some of his Revolutionary subjects as mural decorations in the rotunda. While competent and striking enough, his subjects, so successfully realized earlier, lost something in the enlarged scale. Much of the energy in color, brushwork, and design were diminished in this later series. Furthermore, the public was not particularly impressed; its taste for less heroic and pretentious types of painting only contributed to the ill-temper and bitterness in which Trumbull passed much of his later years.

Some of his later pictures, however, did look more to the future than to the past, most notably his views of Niagara Falls. Trumbull was one of the first artists to travel and sketch in the landscape of upstate New York, and his *View of Niagara from below the Great Cascade, British Side* dates between 1806 and 1808 when he was making several excursions in the area. He has chosen a vantage point of some distance, permitting the spectator a rather detached involvement. Man's insignificance before the face of nature is indicated by the smallness of the two figures in the foreground, while the rainbow arches across the center of the picture as a patent metaphor of optimism. Trumbull actually intended to paint a much larger panorama of the scene now in the New-York Historical Society, for which he had higher ambitions, as his contemporary William Dunlap recorded: 'When Mr. Trumbull returned to England in 1808, he carried with him several studies which he had made of the Falls of Niagara, with a view to have a panorama of that great scene painted by Barker, that species of exhibition being at the time fashionable and profitable in London.'[2]

JOHN TRUMBULL, *View of Niagara from Below
the Great Cascade, British Side*, 1806–8.
Hartford, Connecticut, Wadsworth Atheneum.

The panorama in fact was soon to become an equally popular attraction in the
United States, and in this regard Trumbull forecast a significant development in
nineteenth-century American painting. Both the iconography of a powerful natural
wonder and the panoramic scale were to be recognized as suitable expressions of the
national spirit. In the decades that followed a large number of American artists
made the trek to Niagara to paint there: among them were John Vanderlyn, Alvan
Fisher, Thomas Cole, John F. Kensett, George Inness, and Frederic E. Church, whose
monumental canvas of 1857 became the summary type of this wilderness image and
as such one of the most popular pictures of its day.

Among West's other students was Gilbert Stuart, who for a time served as the
older artist's foremost assistant. Stuart's career also spanned much of the Revolu-
tionary and Federal periods. He was born near Newport, Rhode Island, where as a
youth he met an itinerant portrait painter from Scotland, Cosmo Alexander, who
gave him some instruction and persuaded the young man to go to Edinburgh in
1772. When Alexander died unexpectedly, Stuart made his way back to America,
but unsettled political and economic conditions in the period prior to the outbreak
of Revolutionary War provided no certainty for the portraitist. The day before the
battle of Bunker Hill, with his family having departed for Nova Scotia, Stuart left
for England. In London he worked with West until the early 1780s, mastering the
elegancies of fashionable portraiture. A turning point in his career seems to have
come in 1782. In that year he opened his own studio and also exhibited a portrait
at the Royal Academy that was to establish a firm reputation for him. The painting
was a full-length portrait of his friend William Grant, now best known as *The
Skater*, and so successful was the work that in subsequent years it was mistakenly
taken for a Gainsborough.

Ordinarily, Stuart was best at painting faces and often seemed disinterested or
unconvincing in rendering the rest of the sitter or his setting. Unlike Copley, West
and Trumbull, he cared little for great historical compositions, preferring the prob-
ing intimacy and directness of portraiture. He was obviously less concerned than

they with the creation of a new type of history painting, but addressed his attention to capturing the physiognomic and psychological aspects of his sitters. Building his style on the evanescent brushwork and tonalities of English Rococo painting, Stuart developed a special sensitivity to the different textures and transparencies of flesh and clothing. *The Skater* is the summary of this English period. Not only is the face a strong and convincing likeness, well modeled by the cool precise lighting, but the whole figure of Grant also conveys a believable sense of weight and movement. The generally cool coloring and the rather crisp drawing of the figure's silhouette enhance the mood of winter and the action of skating. Catching the skater poised in the middle of a turn, Stuart gives us an image of both action and contemplation. Similarly, he counterpoints the central symmetry of the vertical figure with the diagonal of the leg, the skating figures behind, and the irregular branches of the tree.

In spite of success, Stuart did not manage his affairs very well; indulgence and imprudence soon brought his creditors down upon him, and he was forced to leave for Dublin in 1787. During the next six years he unfortunately permitted the same pattern to repeat itself. Again a combination of high living and an inability to finish commissioned portraits got the best of him. In 1793 he decided to return to America, taken by the idea of making some money by painting the portrait of that country's most famous living citizen. Of the three occasions when Washington sat for Stuart, the last portrait from life was the best. In 1796 he painted the Vaughn portrait and the following year the Lansdowne portrait, both so-called because of the commissioning client. The first was a bust-length image with Washington facing to the right; although a forceful and direct likeness, Stuart was not pleased with it. The Lansdowne painting was a more ambitious composition, posing Washington full-length in a Roman Imperial stance. But its very scale and complexity tended to dilute the concentration on the individual himself.

Stuart resolved these matters in his third version, *The Athenaeum Portrait of George Washington,* executed in 1796 at the request of Martha Washington. Ironically unfinished, it is the painter's most vivid likeness. Mrs Washington never took possession of the picture, Stuart having recognized that he had a good likeness and determined to use it for the innumerable copies which he then set about manufacturing for public consumption. His 'hundred-dollar bills' he called them, and indeed it has since become America's most familiar national image of Washington. The face is what counts: solid, firmly modeled, clearly lit, deftly colored, impeccably painted. Everything works. The planes of the jaw and face stand out. The sense of life informs the ruddy skin and the deep-set eyes. Not simply an accurate likeness of surface features, it is also an image of dignity and nobility.

Painting until 1803 in Philadelphia, Stuart then moved to Washington with the change in the seat of government. There he continued to paint the country's founding fathers, including all of the first five presidents and many other notable political figures of the day. In 1805 he decided to settle in Boston, where he was to spend his remaining career as a local patriarch to young painters. While outward success continued to attend him, his life was not without personal distractions, pressures, and difficulties. His changes of address during this period seemed to be but one reflection of the current instabilities in his life. One of the attractions in Boston was Sarah Wentworth Apthorp Morton, wife of a prominent Bostonian, Perez Morton, who was a lawyer and statesman. Stuart had already painted one portrait of her before moving to Boston, and at least two other versions are known. The unfinished portrait, *Mrs Perez Morton,* reflects something of Stuart's own inconclusiveness at this time. But its hint of mystery and even melancholy also suggests an awareness of the personal unhappiness that lay in the background of Sarah Morton's life as well.[3] Evidently, Mrs Morton was herself a rather indecisive woman,

GILBERT STUART, *The Athenaeum Portrait of George Washington,* 1796.
Boston, Massachusetts, Museum of Fine Arts, Deposited by the Boston Athenaeum.
GILBERT STUART, *Mrs Perez Morton.*
Worcester, Massachusetts, Worcester Art Museum.

and her portrait intimates this, perhaps unintentionally. Its free and suggestive brushwork and the pale coloring are well suited to the elegiac femininity of the sitter, known because of her verse as the 'American Sappho.' His fresh, direct technique of painting is readily apparent here. As always, he concentrates on the face, gradually building up the form into a solidly modeled image. He sets off the warm tonalities of the face with matching or complementary tints in the clothing and background. Of his technique for rendering the delicate coloring of the flesh tones, Dunlap quoted Stuart as saying that 'Good flesh colouring . . . partook of all colours, not mixed, so as to be combined in one tint, but shining through each other, like the blood through the natural skin.'[4] In fact, the entire painting is one of varying degrees of translucency: not simply the skin, but the veil and dress as well as the background. Ultimately, it is a picture of individual mortality and frailty, both the painter's and the poet's. Such psychological awareness of self would not be made visible again until much later in the nineteenth century when another sympathetic painter, Thomas Eakins, portrayed a poet friend, Walt Whitman.

Thomas Sully was a much younger painter who continued Stuart's tradition well

THOMAS SULLY, *The Student*, 1839. New York, Metropolitan Museum of Art, Bequest of Francis T. S. Darley, 1914.

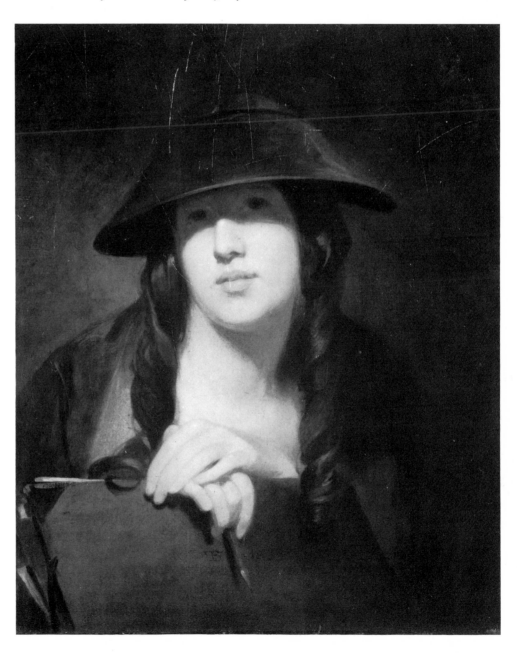

into the nineteenth century. Born in England, Sully was brought to America as a youth. He grew up in South Carolina and made his way north to Boston, where he met Stuart, and to Philadelphia, where he began practicing portraiture. In 1809 supporters helped to send him to London to study. He sought out the ageing Benjamin West and soon came under the influence of Sir Thomas Lawrence. Mastering the latter's fashionable style of delicate coloring and fluent brushwork, Sully earned himself a widely popular reputation. Beginning in the 1820s, he pursued a long and successful career of portrait painting in Philadelphia. Of his more than 2,500 paintings recorded, many seem rather dry and perfunctory. But at his best, as in the rendering of his daughter Rosalie in *The Student*, he was a master of controled and subtle light effects, smooth and delicate textures, and an effect of intimacy that approaches but does not succumb to sentimentality. Clearly responding with a personal warmth to his subject, he treats his daughter with both elegance and informality. Many years later Sully himself wrote in his *Hints to Young Painters*, 'It seems to me that if the refinement of a portrait is carried too far, the identity of the sitter may be lost. . . . The practice of scumbling and glazing may often be repeated with advantage to the picture; it will give softness and depth of effect.'[5]

Opposite GILBERT STUART, *The Skater*. Washington, D.C., National Gallery of Art, Andrew Mellon Collection.

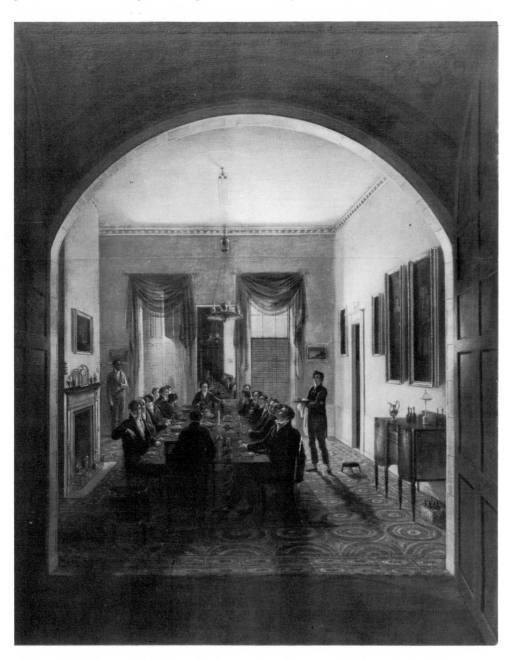

HENRY SARGENT, *The Dinner Party*. Boston, Massachusetts, Museum of Fine Arts, Gift of Mrs Horatio Lamb in memory of Mr and Mrs Winthrop Sargent.

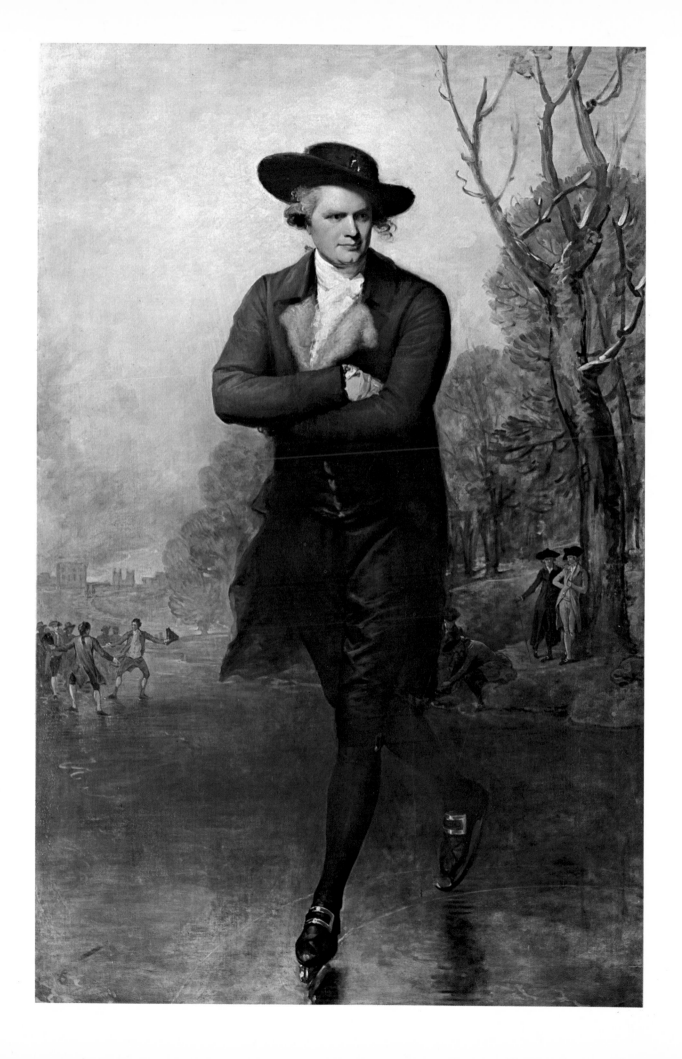

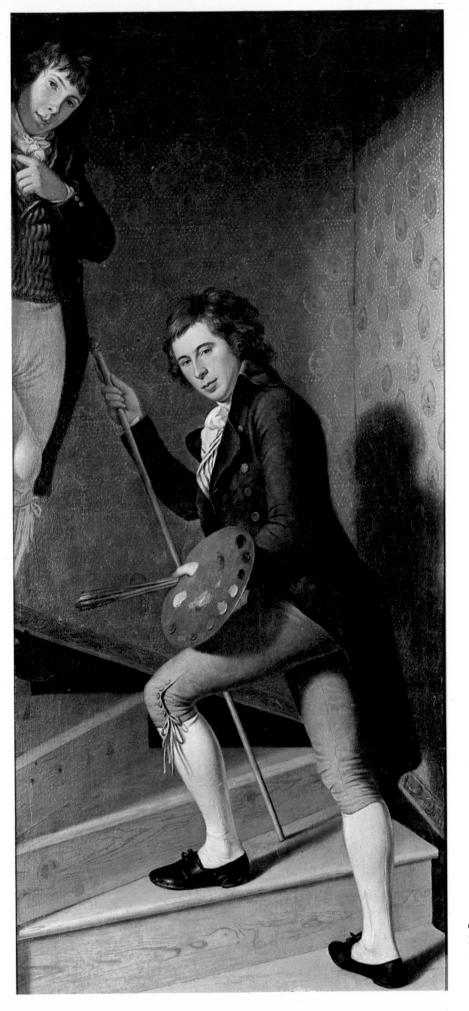

CHARLES WILLSON PEALE, *Staircase Group*.
Philadelphia, Pennsylvania, Philadelphia
Museum of Art, George W. E. Elkins Collection.

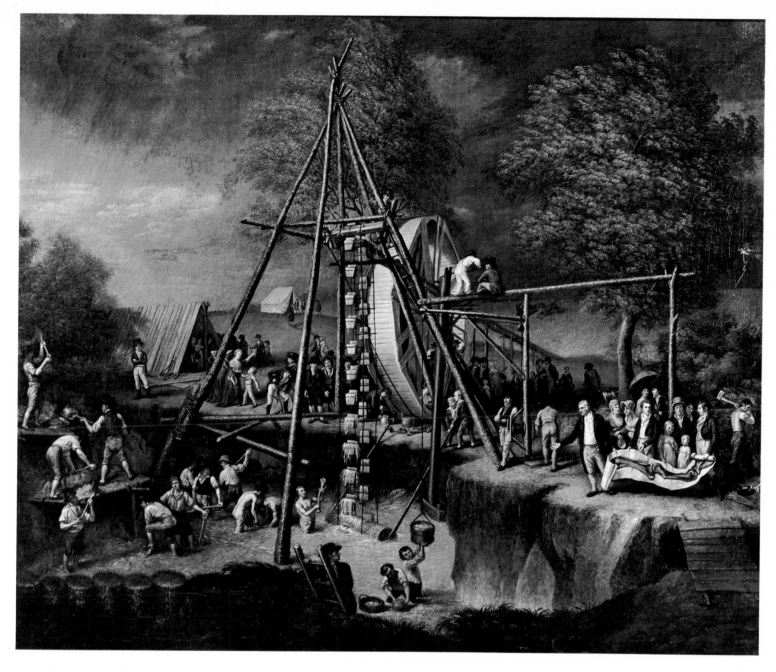

CHARLES WILLSON PEALE, *The Exhuming of the Mastodon*.
Baltimore, Maryland, Peale Museum, Gift of Mrs Harry White in memory of her husband.

Here his technique and his conception happily coincided in a quietly but fully realized work.

Portraits by Stuart and Sully might well have hung appropriately in interiors like that depicted by their contemporary Henry Sargent in his companion paintings of *The Tea Party* in the Boston Museum, and *The Dinner Party*. A native of Gloucester, Massachusetts, Sargent was also drawn to London in the mid-1790s, where he is known to have studied briefly with West and Copley. Back in Boston by the end of the decade, Sargent pursued careers in painting and public service simultaneously. Although his pair of interior scenes date from around 1823, they show the architectural style and furnishings of the turn of the century. Both were probably derived from a rendition of the Capuchin Chapel in Rome executed earlier by the French Neo-Classical painter François Granet. Granet's scene was known in several versions and was notable for its convincing effects of stage-like sp ce and artificial illumination.[6] Sargent appears to have adapted both to his paintings.

The spectator views *The Dinner Party* through the darkened screen of a foreground wall; beyond in almost exaggerated perspective the walls of the room and

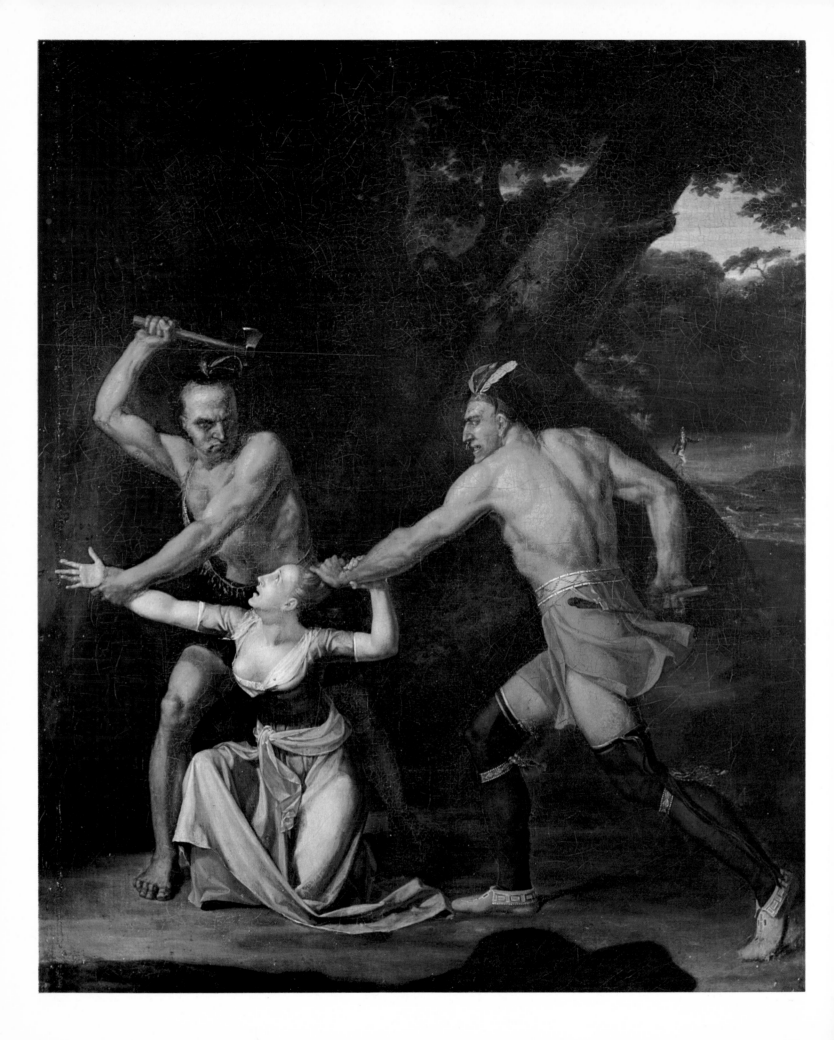

the dining room table recede as if in a tunnel. The slender and chaste proportions of the architecture reflect the popularity of the English Adamesque style in Boston at the end of the eighteenth century. But the severity of forms, especially in the furniture, also bespeaks the rising favor of the Neo-classical manner. In fact, the painting probably shows the interior of a town house in the Tontine Crescent, built by Charles Bullfinch in 1793–4.[7] Based on English models that the architect had seen previously while in Europe, the complex was a graceful and original effort at town planning in the growing city of Boston. It is no surprise that the Crescent should exemplify the latest fashion and that it should provide the subject for a popular painting by a local artist.

Perhaps the remarkable Peale family best represents the artistic variety and developments in the Federal period. The patriarch Charles Willson Peale was versatile enough himself, but he headed a list of more than a dozen painting members of his family over three generations. With a characteristic American optimism he named several of his own children after famous artists, such as Raphael, Rembrandt, Titian, Rubens, and Angelica Kaufmann, or naturalists, Linnaeus and Franklin. Charles Willson came from a humble Maryland background, and rose to success not only as an artist, but was also noted as an inventor, scientist, naturalist, and museum founder. Like Jefferson, he was to some extent a personification of the Renaissance Man in the New World, with wide talents and interests. During his twenties he received some training from John Hesselius and Copley, and then in 1767 preceded the latter to West's studio in London. But if he was one of the first there, he was also one of the earliest to return and make his career in America.

A man of enthusiastic patriotism, Peale served in Washington's army throughout the Revolutionary War. During this time he painted portraits of many noteworthy figures, including Benjamin Franklin, The Marquis de Lafayette, John Paul Jones, and of course Washington himself. Although the relatively cool coloring in some of these pictures may derive from his study of Sir Joshua Reynolds' style while in London,[8] more significant is the clear and solid delineation of form, the insistent retention of physical presence, and the unpretentious realism. The masterpiece of Peale's early maturity was his *Staircase Group* of 1795, which carried realism to the level of illusionism. As such it is an important painting in the history of American art, for it represents a decisive break with the stiff formalities of English portraiture, let alone a rejection of history painting as the primary subject for painters, while it also looks forward to the coming interest in both genre painting and *trompe l'oeil* still lifes.

The Staircase Group shows two of the artist's sons – this family would find continually reliable subjects in each other – Titian above and Raphaelle below. Like Stuart's *Skater* Peale gives us a moment of stopped action, the figures poised between standing still and moving on the stairs. Their direct glances outward establish an immediate rapport with the viewer, who is meant to be further convinced by the life-size scale of the painting. Particularly effective are Peale's subtle effects of lighting across the faces and clothing of his sons as well as on the steps and the staircase walls. Originally titled a deception, the picture was displayed with a doorframe around it and an additional step in front, which, it is said, created a believable enough illusion for Washington to have tipped his hat to in passing. The remarkable achievement, however, is the combination of acute realism with an underlying formal abstraction of design. The asymmetry of the two figures is counterpointed by several interlocking diagonal lines and planes, for example, the stairsteps, Raphaelle's legs, cane, and paintbrushes, and the wallpaper design behind. Thus our admiration for physical veracity should not diminish an appreciation for inherent formal structure, both of which were to reappear during the next century in the work of William Harnett and John F. Peto.

Equally prophetic of future developments was Peale's *Exhuming of the Mastodon*, completed in 1806. Several years before a farmer in upstate New York had uncovered the bones of a supposed mastodon, which Peale purchased along with the rights to further excavation. He promptly undertook an expedition to uncover the remaining bones of the skeleton, aided with the material and moral assistance of President Jefferson. Wrote the President in the summer of 1891: 'I have to congratulate you on the prospect . . . of obtaining a complete skeleton of the great incognitum, ar d the world on there being a person at the critical moment of the discovery who has zeal enough to devote himself to the recovery of these great animal monuments.'[9]

For the excavation itself Peale enlisted a veritable army of assistants. He designed the large wheel by which to lift the buckets of mud and water from the swamp. In short, he saw the occasion as history in the making, and his painting of the scene was therefore a new kind of informal and immediate history painting typical of its American setting. But his picture is more than an historical record: it also combines landscape, genre, and portraiture. In the latter category alone he included some seventy figures within his composition, of which at least twenty were his own relatives, and others were well-known scientists invited to participate. Thus the work becomes an Americanized version of Gustave Courbet's *Studio* of 1855, but here the artist, seen prominently in foreground with his diagram of the mammoth thighbone, is surrounded by his life's work in the midst of nature itself, and an American nature at that. The work becomes both a transcription and a celebration of his calling as artist and scientist; it is a portrait of the painter with his friends and family.

One member of the family, the artist's son Rembrandt, was of a different opinion:

Every farmer with his wife and children, for twenty miles around in every direction with wagons, carriages and horses, flocked to see the operation; and a swamp always noted for being the solitary dismal abode of snakes and frogs, became an active scene of curiosity and bustle; the greater part astonished at the whim of an old man traveling two hundred miles from his home to dig up as a treasure, at incredible risk, labor and expense, a pile of bones which, although all were astonished to see, many believed fit for nothing better than to rot and serve as manure.[10]

Nonetheless, Peale's basically chauvinistic attitude asserted itself, as he made arrangements for the mammoth skeleton to be exhibited in his newly founded museum in Philadelphia. Altogether, he uncovered two partial sets of bones, the second of which he prepared for a traveling exhibition through Europe, presumably to illustrate that America was capable of producing her own archeology (as well as art) equal to that of Europe.[11]

Peale had been a leader in the establishment of the Columbianum Academy in Philadelphia (antecedent of the Pennsylvania Academy of the Fine Arts) in 1795. To its opening exhibition he had contributed his *Staircase Group*. His own natural history collection soon turned into a museum which moved to public quarters in the old State House (Independence Hall) in 1802. It was here that the eighty-one-year-old painter depicted himself in *The Artist in his Museum* (1822). Like the *Mastodon* picture this too was more than a simple self-portrait. It was a justifiably proud testament to his own multi-faceted career. There catalogued before him were the bones of the mastodon, an array of stuffed birds and animals, and portraits of Revolutionary War heroes. In the foreground on either side of Peale himself is the artist's palette and his taxidermist's tools. It is an image of the artist's relation to his public and his country, symbolically hinted in his outward glance and inviting gesture, and may be read as a portrait of personal, cultural and natural history.

In the same year he also produced the more intimate and subtle *Lamplight Portrait* of h; younger brother James. These late works indicate that even after an

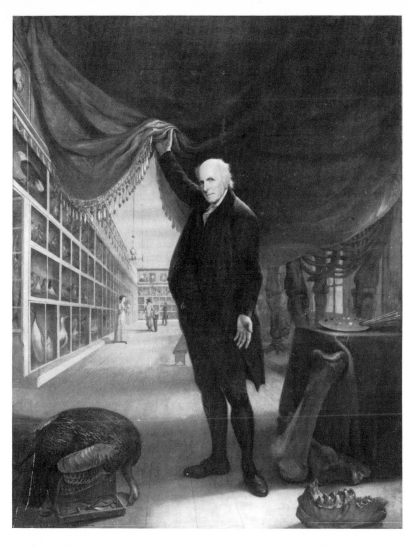

Left CHARLES WILLSON PEALE, *The Artist in his Museum*, 1822.
Philadelphia, Pennsylvania, Pennsylvania Academy of the Fine Arts, Joseph and Sarah Harrison Collection, 1878.
Below CHARLES WILLSON PEALE, *Lamplight Portrait*, 1822.
Detroit, Michigan, Detroit Institute of Arts, Gift of Dexter M. Ferry Jr.

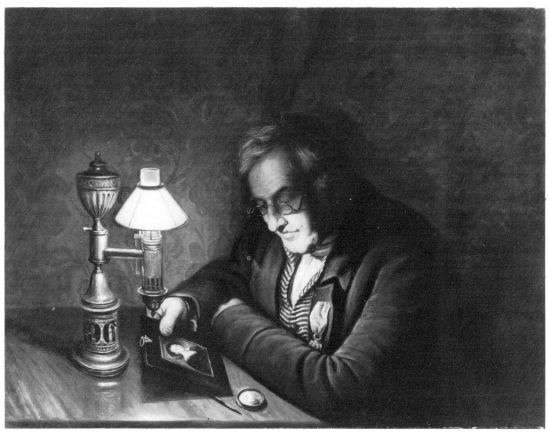

Top RAPHAELLE PEALE, *After the Bath*, 1822.
Kansas City, Missouri, Nelson Gallery of Art.
Above RAPHAELLE PEALE, *Still Life: Lemons and Sugar*.
Reading, Pennsylvania, Reading Public Museum and Art Gallery.

uneven painting career, Peale retained great strength and expressiveness in his style to the end of his life. Possibly learning by this time from his own sons – Rembrandt was then established as a portraitist capable of rendering soft textural and lighting effects – the elder Peale again uses his portrait to reveal more than the physiognomy of his sitter. Boldly employing only the warm yellow glow of the lamp to illuminate his figure, he focuses attention on the contemplative face and the miniature before him. The rich reddish tonalities of the clothing, table, and background add to a unified ambience of self-absorption. One discovers that this is also a portrait of Peale's world of art: James, a painter of portraits and still lifes, holds a miniature in turn painted by his daughter Anna of her niece (and Charles Willson Peale's granddaughter) Rosalba, who by the date of this painting had herself begun to show signs of interest in lithography.[12]

Of Charles Willson's sons the most talented were Rembrandt and Raphaelle. The former was particularly noted for his portraits, of which his most engaging was one of his brother *Rubens Peale with a Geranium*, now in the collection of Mrs Norman B. Woolworth. But it was the oldest brother Raphaelle who excelled at still-life painting, and perhaps his most unusual creation was *After the Bath*, 1822. Continuing the *trompe l'oeil* tradition established by his father in *The Staircase Group*, Raphaelle has created a picture of surprising modernity in its abstraction of plane, light, and line. Of almost life-size scale it was said to have been a cunning illusion to fool the painter's wife who frequently poked around his studio. While one takes note of the hand and feet of the model at top and bottom, it is the powerful shapes of the linen folds which fills the canvas and holds our attention.

More characteristic of Raphaelle Peale's compositions was his *Still Life: Lemons and Sugar*, a subject he constantly enjoyed for its 'skill and wit.'[13] Again there is the delicate balance between acute illusionism and intuitive formal design. Set like most of his table still lifes on a solid platform, the objects stand close to the foreground, though the painter subtly extends the perception of space with the handle of the sugar jar projecting directly towards us and the barely visible highlights of a glass decanter in the shadowy background. Aside from the playful rhythms of light and dark set up across the picture surface, there is an additional variety of oval forms – the sugar jar, lemons, spoon, basket, and decanter – which holds the whole design together. The quiet elegance and grace of such still lifes, their restrained sensuosity, the emphasis on precious tableware and perfect fruit, together reflect something of the aristocratic quality of Federal taste and style, just as much later the darker and more prosaic objects depicted by Harnett seem to intimate the masculine world of Victorian materialism and the Brown Decades.

Meanwhile, the first artist to go to Paris instead of London to study, namely John Vanderlyn, represented another distinctive break from the pervasive tradition of West's studio and style of history painting. Often linked with Washington Allston because of a trip together on the Continent, Vanderlyn's art is often discussed as an expression of Classicism in contrast to Allston's Romanticism. In fact, the division between the two is by no means clear and each artist incorporated something of the other's manner in his own work. Vanderlyn was born in Kingston, New York, where as a youth he came to know Aaron Burr, who made it possible for him to study with Gilbert Stuart and later to go to Paris for additional training.

Vanderlyn left for Paris in 1796, and remained there for the next several years. He immersed himself in the then favored Neo-Classical style, which he initially learned in André Vincent's studio at the École des Beaux-Arts. The great French Neo-Classicist Jacques-Louis David still dominated French style at this time, and his most accomplished follower, J. A. D. Ingres, arrived in Paris the same year as Vanderlyn to enroll in David's studio. Both Ingres and Vanderlyn pursued similar

directions, and some of their portrait drawings and views of this period are almost indistinguishable. The Neo-Classical training in the study of anatomy and clear draughtsmanship made an indelible impression on the young American, as is apparent in his first major picture, *The Death of Jane McCrea* (1804).

Its subject depicts a vivid incident from the Revolutionary War, and Vanderlyn successfully adapts the premises of Neo-Classical history painting to an American context. Scalped on her wedding day by Indians, who were then being employed by General Burgoyne as the British were moving south in 1777, Jane McCrea became a symbol of innocence confronted by evil, virtue crushed by cruelty, civilized man attacked by the savage.[14] It was a topic of high morality and appropriate propaganda, especially suitable to Joel Barlow who had commissioned the work as an illustration for his epic poem *The Columbiad*. The flat relief composition is obviously indebted to antique sculpture as seen through the eyes of West and more immediately David (for example, his *Oath of the Horatii*, 1785, and *The Battle of the Sabines*, 1795) and Ingres, whose *Achilles and the Ambassadors of Agamemnon* had won him the Prix de Rome prize at the École des Beaux-Arts in 1801. But even more noteworthy than the various allusions to classical style and subject-matter are the underlying tones of emotionalism and naturalism, sure signs of the Romantic temperament. The presence of passionate action, sentiments of pathos, along with the expressive colorism and the brooding expanse of wilderness beyond, all remind us that Neo-Classicism itself was but another form of Romantic revivalism.

Between 1801 and 1803 Vanderlyn was briefly back in the United States, where he too sketched Niagara Falls with an eye to marketing an engraving in Europe. Upon his return to the Continent he went to Rome in order to secure a first-hand look at antique sculpture and architecture. Once in residence he undertook an appropriate subject, *Marius amidst the Ruins of Carthage*. It is significant that Vanderlyn's subject is without the moral exemplum of stoic suffering or noble death as depicted by West and Copley in their history paintings. Now the classical absolutes of style and content have yielded to the eclecticism and emotionalism of the Romantic temperament. Marius himself is a melancholy figure of defeat who has fled to Africa, unwelcome. Although partially confined to a frontal posture and planar organization, the anatomy of Marius is largely concealed by elaborate draperies and set off against an asymmetrical recession into depth on the right. Moreover, the ruins in the distance include pieces of the Parthenon, the Villa of Hadrian, and the Claudian aqueduct – all from disparate sources – while the figure of Marius himself derives from a statue of Mercury at Pompeii. The overall mood is threatening, enhanced by the intense coloring of the red toga and the dark storm clouds, which presumably are a reflection of the hero's state of mind. As in *Jane McCrea* Vanderlyn combines classical draughtsmanship and smooth textural details with Romantic lighting and emotional content. However one views this balance, the picture was an immediate success for the artist; Napoleon bestowed the gold medal on it as the best original work among some 1,200 entries in an exhibition at the Louvre, and later tried in vain to acquire the painting for France.

In some respects the female companion piece to this was Vanderlyn's next large canvas, *Ariadne Asleep on the Island of Naxos,* begun in 1809 (as he indicated in a letter to Allston) and completed in 1814. Supposedly the first female nude in American art, the figure of Ariadne was clearly in the tradition of the sleeping Venuses painted by Giorgione and Titian. In fact, Vanderlyn had returned to Paris by this time and was carefully studying the strong coloristic effects in paintings at the Louvre by Titian and Correggio. Again the Romantic landscape setting and rich tonalities suggest a sensual quality beneath the controlled Neo-Classical form. In part, Vanderlyn hoped to succeed with this picture by attracting a disapproving American public in spite of itself. More hopefully, upon his return to the United

JOHN VANDERLYN, *Marius amidst the Ruins of Carthage*. San Francisco, California, M. H. de Young Museum.

97

States he conceived and executed a monumental panorama of the *Palace and Gardens at Versailles,* now in the Metropolitan Museum. He exhibited the three thousand feet of canvas on a specially designed rotunda in New York, aiming for substantial public interest and financial support. Neither proved to be forthcoming. Even though Vanderlyn did undertake a commission to paint *The Landing of Columbus* in 1838 for the U.S. Capitol, his later career was not unlike Trumbull's in its rather sad lack of fulfillment. He ended up like his own Marius, defeated and brooding.

Washington Allston has, in contrast, often been described as America's first full-scale Romantic painter, yet frequently lying within his haunted landscapes and glowing colorism were fully classical subjects. Brought up in South Carolina, Allston studied at Harvard, where he first took an interest in sketching. He was mutually influenced by his studies in classics and his reading of current Romantic literature, two interests which he cultivated in the years following college spent between Rome and Paris. At the Louvre he responded, not to the Titians and Correggios which had impressed Vanderlyn, but to the eighteenth-century seascapes and shipwrecks by Joseph Vernet. They provided the stimulus for his first major work, *The Rising of a Thunderstom at Sea,* which shows man small and insignificant before the sweep of raw nature. Owing some debt to the concepts of vastness and infinity as expounded in the Sublime paintings of West, Allston treats nature even more as an embodiment of mood and feeling. His picture is no call to noble conduct, nor an image of heroic suffering, but suggests man's voyage of life through unknown waters. As such, it looks forward to the universal sentiments abstracted in Albert Ryder's moonlit marines at the end of the century.

During the next few years Allston undertook several large allegorical and religious pictures, among them *The Dead Man Restored to Life by Touching the Bones of the Prophet Elishah*, 1812–13, in the Pennsylvania Academy of the Fine Arts, based on late Renaissance compositions, and *Elijah in the Desert*, 1818. In this latter instance Allston's interest in landscape again comes to the fore, and the complex color relationships and glazes show a deepening debt to the Venetian masters. This direction in his style culminates shortly after his permanent return to the United States in 1818 with his remarkably luminous *Moonlit Landscape*. Now classicism lingers only in the gentle but firm design of repeated verticals and horizontals and the clear planar recession from foreground to background. Otherwise, the scene is one of lyrical reverie, combining the actual details of an observed Italian town with the hazy glow of memory and imagination. More importantly, the warm colors fully express the mood of contemplation and the Romantic sensibility for man's mysterious harmony with nature. Both the subject and the technique anticipate the future development of American painting, especially the Luminist movement led by Fitz Hugh Lane and Martin Johnson Heade at mid-century.

Settled in Boston, like Stuart, a grand old man of American art, Allston introduced his ideas to the rising generation of landscape painters. His pictures were highly popular in Boston, yet his late career is another model of Romantic unfulfillment. Two works symbolize his situation: *Belshazzar's Feast,* known in several studies over many years and a huge unfinished picture, and *Ship at Sea in a Squall* in the Fogg Art Museum, which never got beyond white chalk outlines on a primed canvas. The *Belshazzar* gave him difficulty till the end of his life through constant changes and revisions. Thus the fragile and unresolved qualities of Romanticism came to be literal as well as metaphorical facts of both Allston's art and life.

A young friend of Allston's who accompanied him to London in 1811 was Samuel F. B. Morse. Morse was the son of a well-known minister in Boston and author of one of the first books on American geography. After graduating from Yale, he developed a friendship with Allston which led to their trip abroad together.

WASHINGTON ALLSTON, *Elijah in the Desert.* Boston, Massachusetts, Museum of Fine Arts, Gift of Mrs Samuel and Miss Alice Hooper.

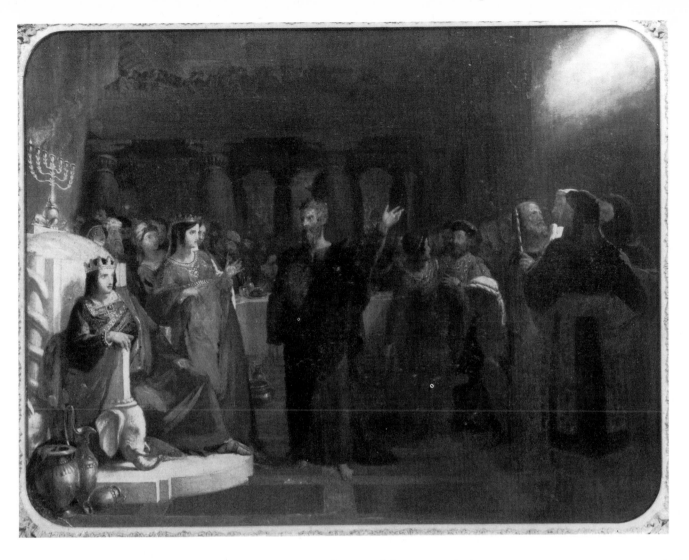

WASHINGTON ALLSTON, *Study for Belshazzar's Feast*. Boston, Massachusetts, Museum of Fine Arts, Bequest of Ruth Charlotte Dana, the Artist's niece.

Morse studied with West, gaining an appreciation for grand history painting as promoted by the Royal Academy. One picture resulting from this period was the large and powerful nude of *The Dying Hercules*, now in the Yale University Art Gallery, but upon his return to America in 1815 he could only find a market for portraits. His ambitions for history painting were only temporarily muted, however, surfacing once more in 1821 in an elaborate scheme for depicting *The Old House of Representatives*. Showing the handsome and capacious Neo-Classical chamber recently completed by Benjamin Latrobe, the picture also includes at least eighty individual portraits of congressmen painted by Morse in adjacent rooms. Just as Jefferson had supported Charles Willson Peale two decades earlier, Morse had the backing of President Munroe for these efforts at recording the workings of American democracy. The hemispherical ceiling and curving row of columns presented Morse with special problems of perspective and spatial illusion, which forced him to redraw the interior three times, but he contrasts the resulting severity of architectural forms rather nicely with the more informal details of the page lighting the central chandelier and the bootblack shining shoes at the right. Regrettably, the picture met with public indifference, giving Morse a foretaste of future disappointments.

Equally ambitious was a similar interior picture, *The Gallery of the Louvre*, done ten years later and destined to meet with little better reception. A document of its times, it showed the American artist's endeavors to transcribe for native audiences the beauties of the great European masters of the past. Visible within the picture are paintings on the wall by Titian, Raphael, and Leonardo, all crowded together

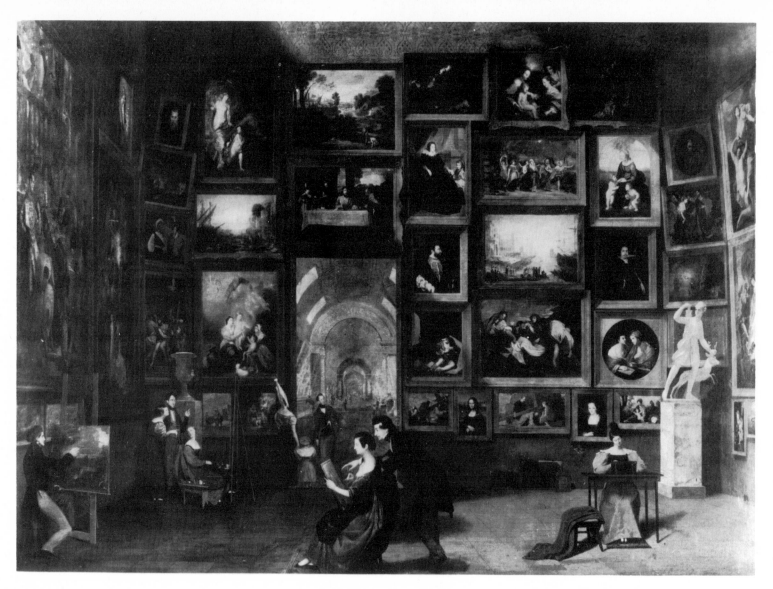

as a backdrop for the amateur and professional painters at work copying in the gallery. Exhibition of this painting proved no more successful than his earlier effort, and Morse again turned to portraiture for a living. Among his more striking images are his *Marquis de Lafayette* of 1824, whose massive figure towers in the foreground, and *The Muse – Susan Walker Morse,* of 1835–7 in the Metropolitan Museum of Art, a warmly-colored portrait of his daughter surrounded by Neo-Classical details. At this time Morse also played an important role as the first president of the National Academy of Design (rivaling the deteriorating leadership of the American Academy of Fine Arts under Trumbull) and as the first professor of art at New York University. Yet his irregular success as a painter, combined with his increasing interest in science – he invented the telegraph in 1832 – persuaded him in mid-career to turn away from art altogether.

Other artists in this period did meet with better luck, but probably because they were more in tune with public taste. For many, images of the American coast and landscape were as representative of pride in the new country as was Morse's *House of Representatives*. When history in action was painted, it was the dramatic events of the War of 1812 which provided subjects for the painter, except that where the figural action would have dominated the composition for an earlier generation, now the action is a harmonious part of a larger seascape. Such is the case with the paintings of Thomas Birch, a Philadelphia artist who had been born in England but brought to America as a youth. He is one of several painters coming

100

to the United States in the opening decades of the nineteenth century – others were Joshua Shaw, Robert Salmon, and Thomas Cole – who helped to establish a native school of American landscape and marine painting. (They are not unlike the immigration of European Surrealists to New York in the 1930s and 1940s who stimulated the Abstract Expressionist movement, America's first major contribution to international art in the twentieth century.) That the foremost interests of artists like Birch and Salmon were topographical illustrates the extent of change that had occurred in American art since the generation of Peale and his contemporaries.

Birch's father was a noted engraver and miniaturist in his own right, as well as a collector of seventeenth-century Dutch paintings and prints. This artistic ambience in which the young Birch developed his own interests naturally drew his attention to the Dutch style of low horizons along with spacious effects of light and atmosphere. He was sufficiently accomplished at both landscape and marine painting, as well as portraiture, to exhibit at the first exhibition of the Pennsylvania Academy of the Fine Arts in 1811. The next year the War of 1812 began to provide him with more than a dozen major subjects, principally naval engagements, which he painted in variations over the next decade or so. Typical is his 1813 version of the *Naval Engagement between the Frigates 'United States' and 'Macedonian'*. While demonstrating careful control in the drawing of such details as the rigging, Birch is no pedant in rendering marine topography. To focus and sustain our interest he contrasts the bright, filled sails of one vessel with the darker, collapsed sails of the other. The highlighted crests of the waves reinforce the exchange of fire between the vessels, while the puffs of smoke are complemented by the cloud formations in the sky above. In other words, Birch has managed to join his depiction of a specific dramatic action with a more generalized seascape setting.

This balance of human or figural interest and the broader topography of landscape characterizes his best work, as may be seen in his later view of *New York Harbor*. With the return to some normalcy after the war artists naturally turned their attention to the bustling harbors of the major cities along the coast. Parallel rises in population, expansion of foreign trade routes, and dramatic increases in shipbuilding made coastal ports like Boston, New York, and Philadelphia places of lively activity. Birch's paintings in the latter two ports show his delight in recording the variety of shipping that made continual passage across the growing skylines of those cities. His attention to light and the spacious expanse of water would reappear in the similarly sympathetic views on the Delaware River by Thomas Eakins.

Much less is known about John S. Blunt who was painting in the Boston harbor area at about the same time. A native of Portsmouth, New Hampshire, he seems to have traveled little beyond coastal New England, although one of his few extant pictures is titled as a Long Island, New York, subject. If and where he might have received any formal training is unknown, but he was established enough by 1825 to offer instruction in Portsmouth. Not long after he was in Boston where he did his winter scene of the harbor. He convincingly renders the feeling of deep space and of cool atmospheric effects with carefully drawn sailboats receding diagonally into the distance and a muted but effective color scheme. Few artists attempted the special monochromatic problems of winter scenes, but Blunt's success belongs with that small group which includes George Durrie, Albert Bierstadt, and Fitz Hugh Lane. Like the latter, however, Blunt perhaps recognized the subtle challenges of such subjects as too time-consuming, for neither he nor Lane painted another winter picture.

Still another artist who looks forward to the subjects painted by Lane is Robert Salmon, an English-born painter who spent almost a full career before the age of fifty working along the coasts of England and Scotland. Probably attracted by the prospects of selling his marine pictures to an appreciative American clientèle and by the opportunities for painting new subjects of vivid interest in an active American

SAMUEL F. B. MORSE, *The Marquis de Lafayette.*
New York, Art Commission of the City of New York.

Right THOMAS BIRCH, *Naval Engagement between the Frigates 'United States' and 'Macedonian'.*
Philadelphia, Pennsylvania, Historical Society of Pennsylvania.
Below THOMAS BIRCH, *New York Harbour.*
Boston, Massachusetts, Museum of Fine Arts, M. and M. Karolik Collection.

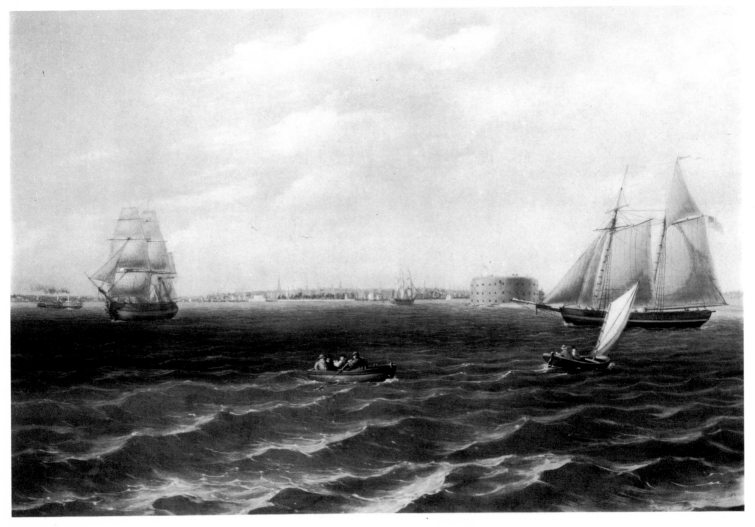

JOHN S. BLUNT, *Boston Harbor*.
Boston, Massachusetts, Museum of Fine Arts,
M. and M. Karolik Collection.

ROBERT SALMON, *Wharves of Boston*.
Boston, Massachusetts, Bostonian Society.

port, Salmon sailed for New York in 1828 and settled for the next dozen years or so in Boston. Unlike his peripatetic career abroad, he evidently traveled little in New England, finding sufficient material for his oils along the wharves and among the islands or beaches of Boston's outer harbor. In addition, he continued to paint scenes, from memory and from sketches brought with him, of English ports and sailing vessels, which he managed to sell regularly at Boston auctions.

Both the *Wharves of Boston* and *Boston from Pemberton Hill* date from just after Salmon's arrival and are characteristic of his best work. Their crisp lighting and clear drawing derive from Salmon's earlier awareness of the tradition of Canaletto's painting established in English art during the middle of the eighteenth century. Salmon's rendering of the Boston shore front documents the topography with a

care and devotion similar to Birch's, while the more aerial view from Pemberton Hill again recalls the popular interest in panoramic painting. Salmon himself for a time worked as a scene painter for stage backdrops, and executed several large canvases (some semi-transparent to allow for dramatic back lighting) of the Battle of Algiers, then a frequent subject for public lectures and entertainments.

Salmon worked in Boston during these years more quietly and doggedly than either Stuart or Allston, but he counted among his continuing clients some of the city's most prominent merchants and politicians. His reputation for topographical and marine painting was unrivaled, although his work did not go unnoticed by younger artists. Salmon's abilities at accurately recording the physical surface of form and landscape as well as the intangible qualities of light and atmosphere found a worthy successor in a native artist from Gloucester, Fitz Hugh Lane. Lane's style was to be firmly grounded in Salmon's achievement, thus assuring the full flowering of an American landscape tradition during the next decades of the nineteenth century.

Joshua Shaw was also an English-born painter, an almost exact contemporary of Salmon's, and influenced by many of the same sources. Both artists had exhibited in London during the early years of the nineteenth century, although Shaw decided to sail to America in 1817, a decade earlier than Salmon. Shaw's major picture of his early career, *The Deluge*, had already received favorable criticism in London, being compared warmly with Turner's version of the same subject. Under West's influence at the time, Shaw not surprisingly has painted an image of the Sublime as exemplified by West's *Death on a Pale Horse*. Present are the same stark contrasts of light and dark, the immanent terror, the wild and turbulent forces of nature unleashed, and humanity abandoned or threatened. For many years *The Deluge* was attributed to Allston, who himself of course had for a time been a student of West's and had painted similar subjects (such as *Tragic Figure in Chains* and *Dead Man Revived*).

When Shaw left England, he brought with him one of West's late religious paintings, *Christ Healing the Sick,* and settled in the older artist's native city of Philadelphia. Almost immediately he began to travel around the United States making sketches of American scenery with an eye to having them published as engravings. Some of these pictures were frankly historical, such as *General Jackson Battling the Indians,* now in a private collection; others were more general and informal views of frontier and Indian life. Characteristic of the latter is *On the Susquehanna,* with its rather poetic view of the Indian hunters resting in a serene and spacious landscape. The change in style from his early work in West's manner is sharp; for the wild and irregular aspects of the earlier Sublime, Shaw has now substituted the evenness and tranquility of the Beautiful, as modified in the direction of the Picturesque. Its primary interest in the landscape recalls the central concern of Shaw's American contemporaries, while the attention to the genre elements of Indian life also finds counterparts in the work of George Catlin and George Caleb Bingham.

By the 1830s nature indeed had become the overriding expression of many American artists, as well as writers, symbolized perhaps by the publication in 1836 of Emerson's important essay on Nature. The generation of painters that was now emerging was too young to be taken into West's circle, to be immersed in ideas of eighteenth-century history painting, or most importantly, to dismiss the American wilderness as their first teacher. For these artists nature was not only a source of inspiration and spiritual nourishment, but a distinct embodiment of American pride and national self-confidence. They discovered and recorded the American wilderness with a sense of mission; their consecration of nature's pristine rawness was in implicit comparison to the age and decay of European civilization. Thus landscape took over from history painting the roles of defining moral order and inspiring moral action.

Opposite JOSHUA SHAW, *The Deluge.* New York, Metropolitan Museum of Art, Gift of William Merritt Chase, 1909.

Opposite JOSHUA SHAW, *On the Susquehanna.* Boston, Massachusetts, Museum of Fine Arts, M. and M. Karolik Collection.

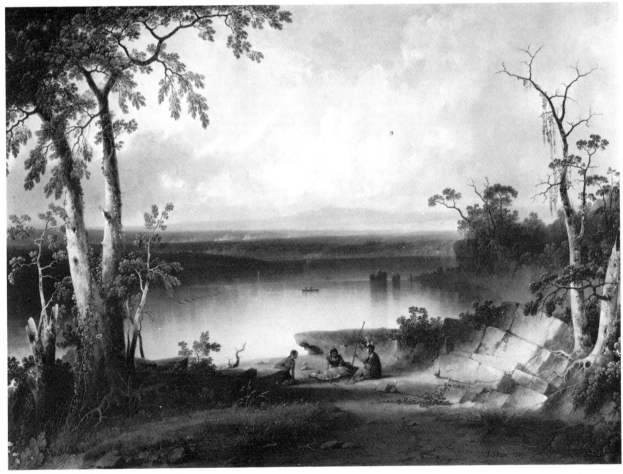

America's first coherent group of landscape painters is the so-called Hudson River School; among the founders Thomas Doughty was the oldest. In his work one can see a synthesis of the two parallel concerns shared by these painters: to record a specifically American countryside and to express the higher spiritual content of the natural world. In fact, Doughty's work was often grouped in exhibitions as done 'from nature,' 'from recollection,' or 'imaginary compositions.' Born in Philadelphia, he took an apprenticeship as a youth in the leather business. 'I attempted three or four paintings in oil,' he wrote later, 'during the latter part of my apprenticeship, but they were mere daubs, inasmuch is I never had received any instruction in oils.'[15] He evidently had some lessons from Thomas Sully, but uncharacteristically, he began his professional career not as a portraitist but painting landscapes directly.

Doughty met with early success: by 1821 he had commissions to paint views of fashionable estates (for example, *Baltimore from Beech Hill*, 1822, now in the Boston Museum of Fine Arts); by the mid-twenties he was regularly exhibiting at the Pennsylvania Academy of the Fine Arts, the National Academy of Design, and the Boston Athenaeum; and by 1834 William Dunlap could write that 'Mr. Doughty has long stood in the first rank as a landscape painter – he was at one time the first and the best in the country.'[16] During his career he sketched from the woodlands of Maine and New Hampshire to the rolling hills near Philadelphia, Baltimore, and

THOMAS DOUGHTY, *House on a Cliff above a Pool*.
Philadelphia, Pennsylvania, Pennsylvania Academy of the Fine Arts, Bequest of Henry C. Carey, 1879.

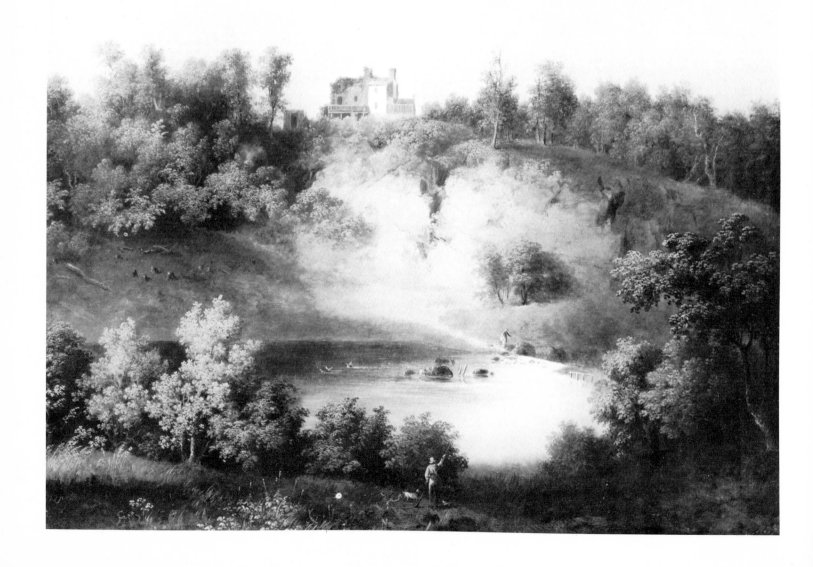

Washington. Typical of his quiet and lyrical interpretations of nature is his *House on a Cliff above a Pool*, with its soft, hazy tonalities and generalized forms. The small figure in the foreground stands dwarfed by but in harmony with the natural setting. The rather tunnel-like composition focusing on the central pool of water was a favorite of Doughty's, one that draws him close in his understanding of the picturesque to Joshua Shaw.

Doughty's painting with its gentle play of nature's irregular shapes and textures also belongs in the context of the emerging gothic revival style and the vogue of picturesque landscape gardening. Many of his views are less specific than *House on a Cliff,* and seem to fall more in the category of 'imaginary compositions,' perhaps 'from recollection.' Such is the case with *Fishing by a Waterfall*. Doughty was an ardent hunter and fisherman himself, and the single figure fishing in the foreground was a frequent hallmark in his views. Using the Claudian formula of framing the figure with the trees at either side and the high cliffs beyond, Doughty generalizes his image of nature, imbuing it with an idealized tranquility and order. The soft curves of rocks, branches, and hills all repeat the bent fishing pole at the center, thus tying man and the various forms of nature together harmoniously.

The aims of depicting actual views from nature and of articulating the broader philosophical content of landscape are most clearly and forcefully present in the work of Thomas Cole, generally recognized as the leader of the Hudson River School. His native Lancashire, England, was an oppressive textile center at the turn of the century, and the young Cole sought release in the surrounding countryside. He cultivated early an interest in the arts, learning engraving, reading widely, playing the flute, and composing poetry. A desire to see the beauties of nature in America was fulfilled when his family decided to move to the United States in 1818. Settled briefly in Philadelphia, they moved on to Ohio, where he began sketching and painting during the 1820s as he wandered about rural Ohio and western Pennsylvania. By 1825 he was in New York, where his landscapes soon attracted favorable and significant attention. That year William Dunlap recalled that Cole had placed three pictures for sale in a shop window:

> Trumbull saw them and purchased one, and the same day called on me, and expressed his admiration of the unknown young man's talent. Durand accidentally came in, and we all immediately went to see the landscapes.
> . . . Trumbull had had the first choice – I had the second, and Durand took the third. Trumbull had previously said to me, 'this youth has done what I have all my life attempted in vain.' When I saw the pictures, I found them to exceed all that this praise had made me expect.[17]

Shortly after this incident Cole set up a studio in Catskill, New York, and began determinedly to wander through the wilderness, making extensive sketches of natural scenery. Many of his pencil drawings are delicate, cursory notations of woodland details, often accompanied by loose, fresh oil studies on small panels. These he brought back to the studio, where he allowed the 'veil of time' to be drawn across them. The artistic act became one, therefore, of contemplation and synthesis – drawing on the incidents and particular aspects of nature to compose the more idealized, moral landscape. The painter's aim was to reveal the higher order of divine creation, and much of Cole's early work is directed either towards literary or religious subjects.

For example, during this period he painted *The Expulsion from the Garden* (Boston Museum of Fine Arts), *John the Baptist in the Wilderness* (Wadsworth Atheneum, Hartford), and *Moses on the Mount* (Shelburne Museum, Vermont). The composition of towering cliffs, distant mountain vista, and small figures facing a stormy wilderness appear to reflect an awareness of Benjamin West's formulas for

THOMAS DOUGHTY, *Fishing by a Waterfall.*
Boston, Massachusetts, Museum of Fine Arts,
M. and M. Karolik Collection.

the Sublime as well as the paintings (possibly known through copies) by the English artist John Martin, whom Cole was to meet a few years later on a trip abroad. Along with these examples of what Cole's biographer Louis Noble calls 'a higher style of art,'[18] Cole also embarked on themes taken from contemporary Romantic literature. The most notable examples were from James Fenimore Cooper, such as the *Scene from 'The Last of the Mohicans'*, showing Cora kneeling before the ancient Indian chief Tamenund to plead mercy for Leatherstocking and his fellow prisoners. The spectacular mountain setting and the massive rock precariously perched behind the figures enhance the human drama depicted. The sympathetic relationship between painters and writers at this time was but one expression of the Romantic movement. (Washington Allston and Samuel Taylor Coleridge had been close friends earlier, and Cole soon struck up a warm association with the nature poet William Cullen Bryant.) In his painting Cole attempts to set the specific narrative incident in the larger context of human action and moral conduct. For him the power of nature's vastness and beauty provides the significant inspiration.

Even his landscapes without any overt literary sources were vehicles of clearly

THOMAS COLE,
Landscape with Dead Tree
Providence, Rhode Island, Rhode Island School of Design.

propounded philosophical content. The *Landscape with Dead Tree* of 1827 is presumably based on actual observations made in nature, but Cole turns the scene into a general one revealing the various forces of nature at work. The presence of a power larger than man is evident in the stark tree trunk in the foreground blasted from some earlier storm, but that power is also a cleansing one, as suggested by the clearing storm in the mountains beyond. Thus the landscape becomes an image of life and death and rebirth, whether seen in the round eroded rocks compared with the distant sharp peaks or in the new shoots of leaves growing from the dead trunk itself. Through an understanding of the natural world the artist intends his spectator to be drawn closer to a higher godly presence.

Already in 1827 Robert Gilmor of Baltimore had become a patron of Cole's work, and with his help the painter set off for Europe in 1829. His departure occasioned Bryant's famous ode which acknowledged that the painter would be tempted by 'the light of distant skies,' but as an American painter he should bear in mind 'A living image of our own bright land/Such as upon thy glorious canvas lies,' and withal 'keep that earlier, wilder image bright.'[19] In London for much of the next two years,

JOHN VANDERLYN, *Ariadne Asleep on the Island of Naxos*, 1814.
Philadelphia, Pennsylvania, Pennsylvania Academy of the Fine Arts.

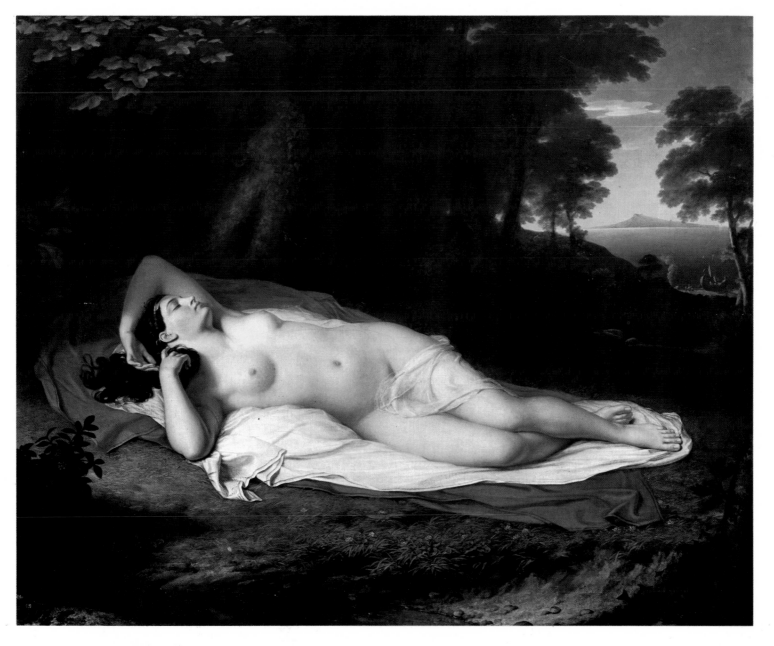

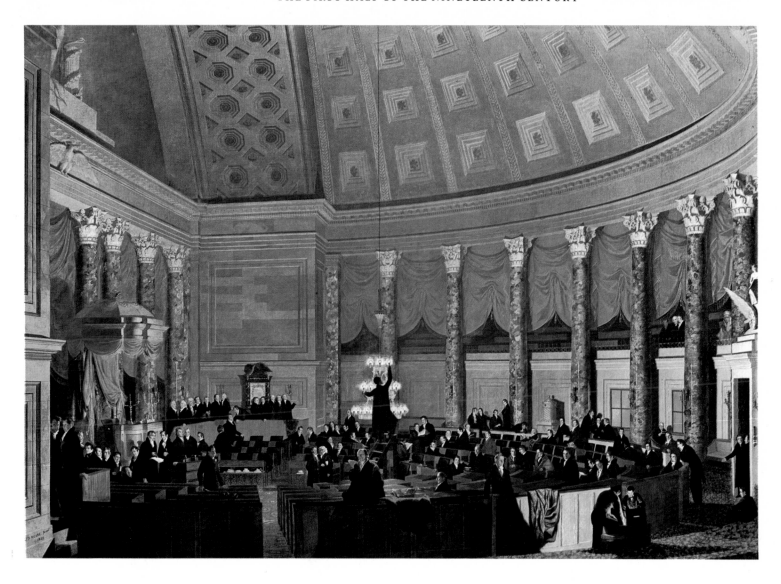

Opposite WASHINGTON ALLSTON, *Moonlit Landscape.*
Boston, Massachusetts, Museum of Fine Arts, Gift of W. S. Bigelow.
Above SAMUEL F. B. MORSE, *The Old House of Representatives*, 1822.
Washington, D.C., Collection of the Corcoran Gallery of Art.

Overleaf, left THOMAS COLE, *The Course of Empire: Consummation.*
New York, New-York Historical Society.
Overleaf, right ASHER B. DURAND, *Kindred Spirits.*
New York, New York Public Library.

he met several prominent English artists like Lawrence, Constable, Turner, and Martin, the last of whom was to influence strongly the composition and style of his next major work, the series on *The Course of Empire*.

After sketching in the museums of England, Cole went on to the Continent, passing through Paris on his way to Italy. There, perhaps recalling Bryant's advice, he wrote back to Gilmor that he had found 'no natural scenery yet which has affected me so powerfully as that which I have seen in the wilderness places of America.'[20] He did find inspiration in the Italian landscape and especially in the ancient ruins, whose contemplation gradually led him to conceive of a new project depicting the history of man's civilization. In part, the crumbling ruins were melancholy evidence of man's past glories, but here too was a source of inspiration for revealing the great moral lessons of man's relationship to nature. When Cole returned to New York in 1832, he had a new patron, Luman Reed, and a firm idea for his new series of pictures.

Cole worked on *The Course of Empire* over the next few years. The finished series consisted of five large canvases, the central one somewhat larger than the rest. They were a grand cycle devoted to man's progress from the primitive to civilized state,

111

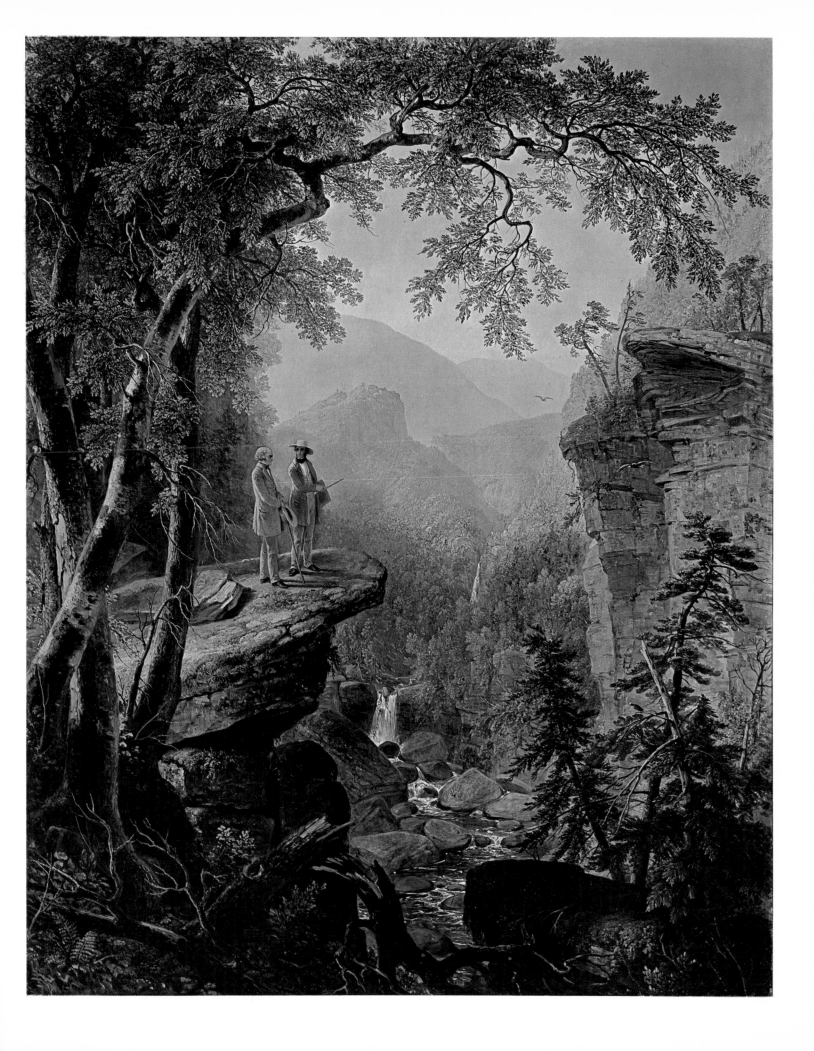

Above JOHN QUIDOR, *The Return of Rip Van Winkle.*
Washington, D.C., National Gallery of Art, Andrew Mellon Collection.
Opposite WILLIAM SIDNEY MOUNT, *Eel Spearing at Setauket.*
Cooperstown, New York, New York State Historical Association.

but concluded with his self-destruction and return to the world of pure nature. The idea of sequential development, one that preoccupied much of Cole's later work, perfectly reflects a century that dwelt on ideas of evolution, perfectability, and rational order. That nature was the fixed point of reference in Cole's series is evident from the mountain in the background, seen from a slightly different vantage point in each painting to suggest the change in time and in man's condition that has taken place. Similarly, Cole shifts the intensity of light and concentration of detail from canvas to canvas to parallel the mood or action.

In the first, *The Savage State,* nature is seen in a virgin state: the lush greens are springlike, the cool thin light is that of early morning, and man's few tents in the distance reflect his innocent dependence on nature. With the second picture, *The Arcadian* or *Pastoral,* man has begun to clear some of the landscape and has built a temple of worship in the background. The time of day is now morning, the earlier mists of dawn now having dissipated; the light is fuller, the mood suggested one of youthful promise. The centerpiece of the series was *The Consummation of Empire*

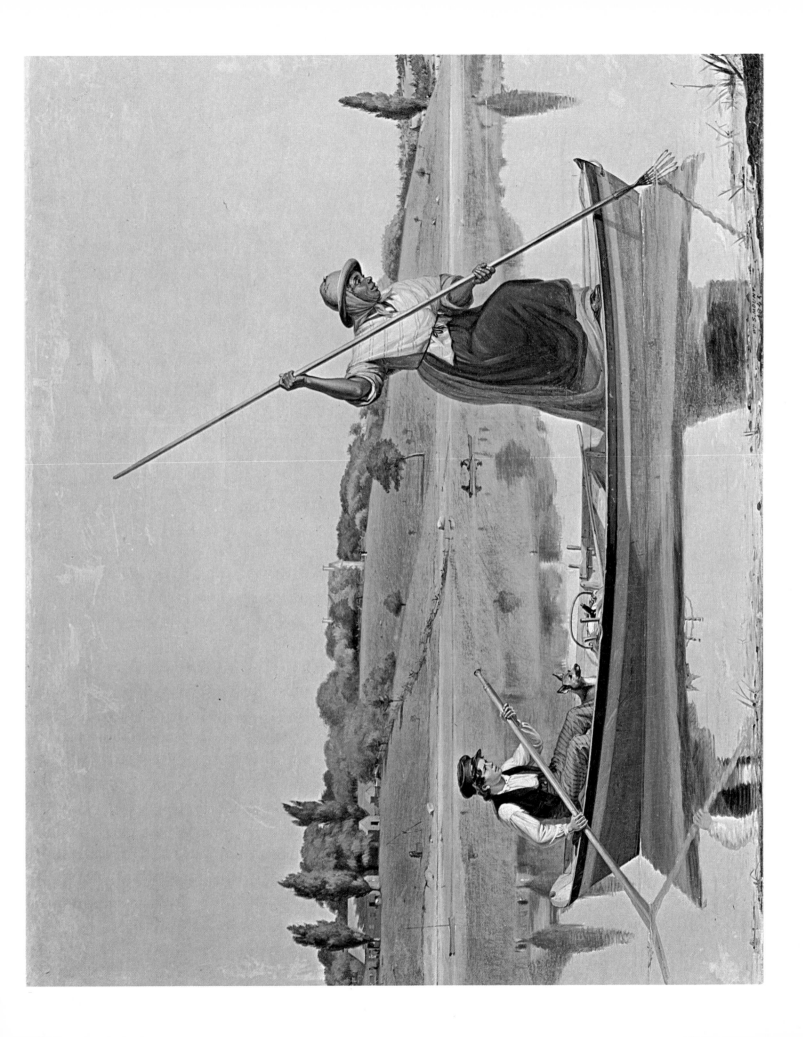

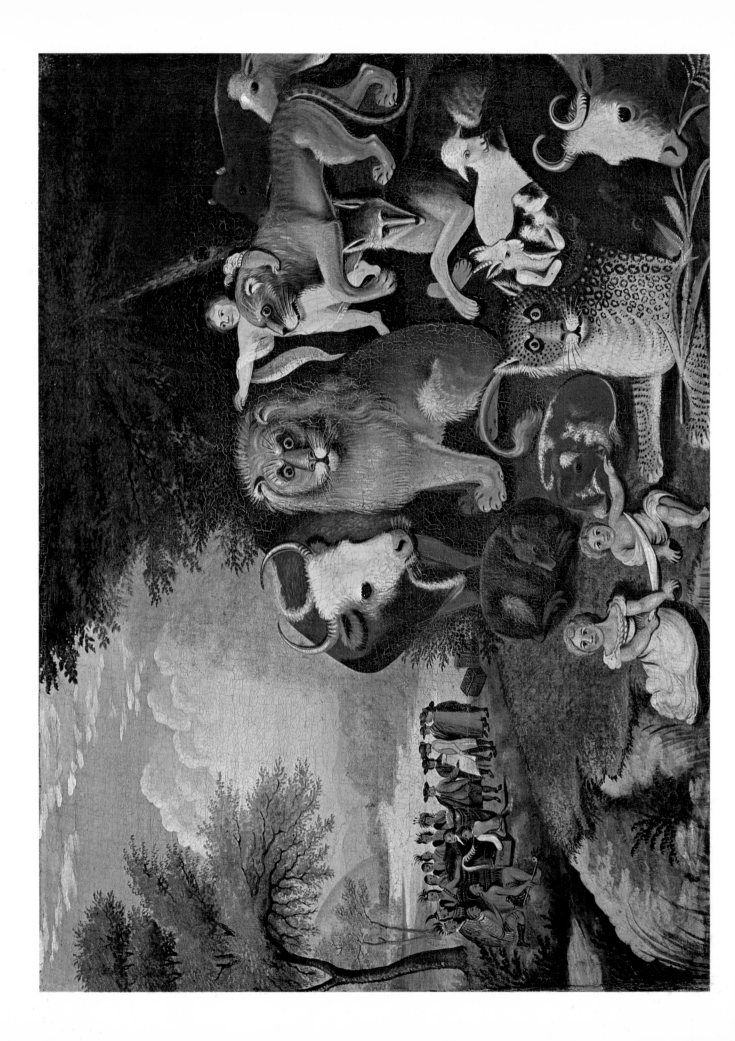

which carries man and his civilization to its maturity. The light is that of midday and man's handiwork fills the composition. Noble described it as 'one of the noblest works of art that has ever been wrought:' 'The dawn of national grandeur is now succeeded by the full blaze. The nation has carried itself forward to the summit-level of its long ascending career.'[21]

Yet implicit in the 'hour of its satiety – the limit of accomplishment' was the intimation of decline and fall, the natural following of death from life, as well as the human following of destruction from pride. Empire's passage for Cole was both a contemplation of past human history and also a didactic lesson for the present and the future. Thus, 'the fourth picture exhibits the Empire in its fall.' Among other things, man's vainglories led him into a discordant relationship with nature, who now unleashes her forces of destruction in revenge. That Cole had in mind both historical and religious implications is made clear in his composition taken from John Martin's *The Seventh Plague of Egypt*, in the Boston Museum of Fine Arts, and in the several stylistic devices inherited from West's *Death on a Pale Horse*. Appropriate to the wild action are strong contrasts of light and shadow, the frenzied loosing of nature's storms, the strong thrust of diagonal space and the setting of details into active motion. The final scene of *Desolation* shows the temples destroyed, the artifacts of man's self service submitted to the overgrowth of nature, with the mood calm and lonely, man not even present, and the moonlight rising in the darkening sky.

1836 was a turning point in many respects for Cole. Besides completing this major series, the artist also got married that year; his patron and friend Luman Reed died, and from that time dates the real beginning of his friendship and association with the painter Asher B. Durand. If *The Course of Empire* represents the culmination of Cole's moral landscapes with their strong allegorical programs, another painting of

Opposite EDWARD HICKS, *Peaceable Kingdom*. Brooklyn, New York, Brooklyn Museum.

THOMAS COLE, *The Course of Empire: Destruction*. New York, New-York Historical Society.

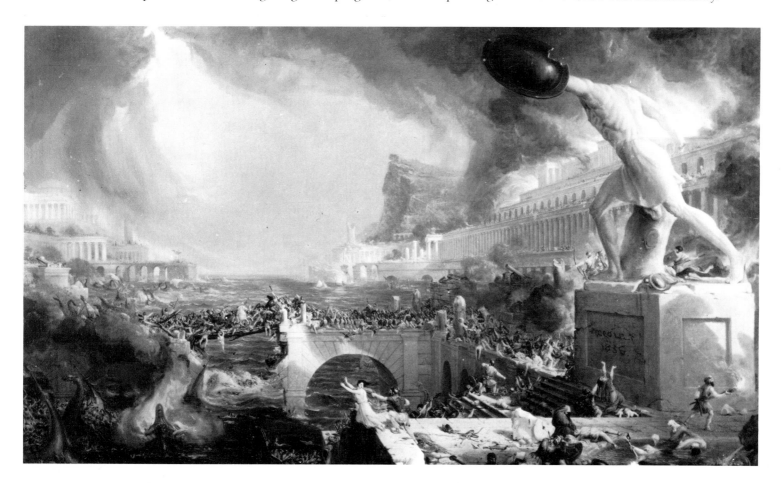

the same year typifies the other aims of the American artist. *The Oxbow* clearly exemplifies that impulse to record identifiable native scenery, in this case the Connecticut River near Northampton, Massachusetts. Yet even here Cole feels the necessity of imbuing the scene with an awareness of nature's loftier power: new shoots spring up around the blasted tree trunk in the foreground, and across the distant hills sweeps a purifying rainstorm. The artist in his role as priest in nature's temple is barely visible with his easel at the lower right; he can only express his awe before such a vast panorama.

After seeing *The Course of Empire*, the New York banker and collector Samuel Ward commissioned Cole to paint another allegorical series, but he did not actually begin what was to become *The Voyage of Life* until 1839. Although painted with a lush sense of color and worked out in similarly related compositions, this series did not quite match the force and balance of the earlier group. Now the program was a

THOMAS COLE, *The Oxbow*.
New York, Metropolitan Museum of Art,
Gift of Mrs Russell Sage, 1908.

THOMAS COLE, *The Voyage of Life* (*Youth*).
Utica, New York, Munson-Williams-Proctor
Institute.

little too obviously stated, and reflecting Cole's deepening return to religion in his later career, somewhat narrowly conceived. Having achieved a tour-de-force in *The Course of Empire,* much of what followed seemed either restatement or elaboration. Thus, *The Voyage of Life* first showed an infant emerging from a rock cavern, guided by an angel into a golden landscape of promise. The second canvas of *Youth* is technically the most varied and interesting of the four. Suggesting an image of promise and expectation, the landscape is full and lush, the light clear and sparkling. Equal attention is given to the youth now taking over the helm of his boat from the guiding angel and to the distant vision in the sky, 'emblematic,' as Cole wrote, 'of the daydreams of youth, its aspirations after glory and fame.'[22]

The last two scenes viewed man about to descend turbulent rapids through a stormy landscape and finally the figure of old age borne out to the ocean where the heavens open up to receive him into eternity. In Cole's last religious works one sometimes senses that the spiritual meaning of nature which he sought to convey was more often imposed on a subject than naturally revealed from within. As he increasingly yielded to expositions of the didactic and literary, it fell to others to give expression to that other, increasingly insistent aspect of American taste, the direct record of native scenery unencumbered by allegorical baggage. The contemporary who best represented this concern of the Hudson River School was Asher B. Durand.

In 1849 Durand had painted a sympathetic testimonial to his friend Cole (who had died the year before) and William Cullen Bryant. *Kindred Spirits* showed the two poets of American nature standing on a rocky precipice overlooking a benevolent woodland vista. The picture was to be a gift to Bryant in appreciation of his recently delivered 'Funeral Oration' to Cole, which had begun, 'For Cole was not only a great artist but a great teacher; the contemplation of his works made men better.'[23] There in the wilderness with Bryant the painter points towards the distance, presumably preaching nature's beauties to his understanding friend. Durand has struck a more even balance than Cole himself ever would have between the scale of man and that of nature; but there is also a gentle harmony established between foreground and distance; among rocks, foliage, sky, and water; between the real and the ideal.

A native of New Jersey, Durand received training early from an engraver in Newark, but soon bettered his teacher and by 1820 was good enough to set up his own shop. He engraved Trumbull's *Declaration of Independence* in Yale University Art Gallery and Vanderlyn's *Ariadne*, a picture he had bought directly from the older artist. These engravings, along with his early portraits, had brought him considerable success by the 1830s when he became interested in landscape painting. His graphic training provided him with a strong sense of line and detail and a disposition for rendering form in terms of tonal values. Both of these instincts carried over into his painting and well suited his temperament for capturing the specific aspects of a locale.

The Beeches is characteristic of his rather tight, precise manner of recording. Durand had been abroad in 1840 and may have used as a point of departure a poem by Thomas Gray. In any case pictures such as this were based on first-hand sketches done from nature, and for all their adaptation to literary overtones or to Claudian modes of composition, they retained much of their sense of individual place. On this point Henry Tuckerman later wrote that 'There is a great individuality in Durand's trees. This is a very desirable characteristic for an artist who deals with American scenery.'[24] In contrast to Cole's descriptions of American landscape in generic terms, Durand talked of noting particular species. For example, forest scenery was significant to Cole, not as specific types of foliage, but as an image of age and growth: '. . . being primitive, it differs widely from the European. In the

Top ASHER B. DURAND, *The Beeches.*
New York, Metropolitan Museum of Art,
Bequest of Maria De Witt Jesup, 1915.

American forest we find trees in every stage of vegetable life and decay. . . .'[25]
But for Durand it was important to 'choose the most beautiful or characteristic of
its kind. If your subject be a tree, observe particularly wherein it differs from those
of other species.'[26] To this end Durand encouraged the cultivation of drawing as the
foremost means of recording such specific aspects of nature. For him the precision
and clarity of the graphic medium learned early in his career perfectly comple-
mented his later interpretation and rendering of nature. His *Lake George* is an even
more exacting record of a favorite attraction for Durand's contemporaries. Its forth-
right naturalism and the increasing devotion to the special qualities of light and
atmosphere forecast the direction taken by the next generation of Hudson River
painters.

Although Doughty, Cole, and Durand together established landscape painting as a
major expression of national consciousness during the first third of the nineteenth
century, the American wilderness was not the only image of the young and optimis-
tic republic. For in the same period and in response to much the same stimuli a
parallel school of genre painters also arose, often equally concerned with literary
and moral themes and primarily aiming to celebrate the plenitude of national life.

Among the group of so-called Knickerbocker artists and writers associated together in New York and the Hudson valley was John Quidor. Along with Cole he drew on Cooper's novels for several of his sources as well as on the tales of Washington Irving. Only some two dozen works by Quidor are now known and information about his life is still incomplete. A native of Tappan, New York, he was for a time a pupil (along with Henry Inman) of the portrait painter John Wesley Jarvis in New York City, but seems to have been influenced by neither. Not disposed to the current manner of precise and often saccharine Neo-Classical portraiture, nor to painting moral landscapes, Quidor sought his subjects in the world of Romantic literature. (Among his earliest pictures is one of *Dorothea*, Brooklyn Museum, taken from *Don Quixote* by Cervantes.)

Quidor's best work of the 1820s centers on incidents from Cooper and Irving, especially those involving dreams or apparitions. One of his favorite subjects was the life of Rip Van Winkle, whose mythic detachment from reality may well have served as a metaphor for the painter's own situation in the New York art world. *The Return of Rip Van Winkle* (1829) presents Rip attempting to discover who and where he is after awakening from his dream. Both time and reality have been disrupted for him, and beneath the lively village scene Quidor poses the more serious theme of self-recognition and identification. Asked who he was by the town elder, Rip replies (in Irving's *Sketch Book*): 'God knows . . . I'm not myself – I'm somebody else – that's me yonder – no – that's somebody else got into my shoes . . . everything's changed, and I'm changed, and I can't tell what's my name, or who I am!'[27] Slouching against the tree at the left is possibly a youthful image of Rip; it is equally apparition and reality. Frequently, Quidor places such a figure off to the side of his compositions, observing or running from the main scene of action.

It is likely, but not certain, that he knew earlier European art through copies or engravings circulating at the New York galleries. It is intriguing to consider if the slouching figure at the left might have come from Michelangelo's *Bound Slave* or the aged figure of Rip from God the Father on the Sistine Ceiling. More obvious inspiration comes from the tradition of seventeenth-century Dutch and Flemish genre painting as transmitted through the engravings and drawings of eighteenth-century English caricaturists like Hogarth and Rowlandson. But Quidor's delight in detailing the variety of postures, gestures, and facial expressions is his own, as are the expressive linear arabesques and warm color translucencies. His paintings are thus not mere literary illustrations, but imaginative re-creations in their own right.

Another painting of equal verve and originality is *Antony Van Corlear Brought into the Presence of Peter Stuyvesant*, done ten years later, although it retains Quidor's familiar warm colors, lively pictorial design, and masterful range of caricatures. There is a witty play between the sound of the trumpet and the visual response of each figure to it. But more than simply a memorable incident taken from Irving's *Diedrich Knickerbocker's A History of New York*, the painting has a complex formal organization of its own. Quidor creates a subtle variety of linear and planar forms, which are in turn placed in the context of the three-dimensional stage-like space of the room. Yet the interior is not the only spatial allusion; it is enlarged literally and metaphorically by the picture on the wall and outdoor scenes framed by the windows. Again the artist alludes to levels of reality not immediately apparent on the surface of his painted anecdote.

In a larger sense the work of Quidor and his contemporaries is an expression of delight in national life: the American landscape and the ordinary activities of everyday life. Now the commonplace becomes the heroic, and the insignificant monumental. Jacksonian Democracy indeed symbolized the ascendancy of the common man, and it was only natural for the American artist to celebrate the energies and exuberance of the self-assured nation. Other painters were less literary than Quidor,

but no less anecdotal. Richard Caton Woodville was a Baltimore painter who first became familiar with Dutch and Flemish painting through the collection of Robert Gilmor and later through first-hand study in Europe. His paintings were mostly interiors, recalling the almost mathematical designs of seventeenth-century Dutch cabinet pictures. Typical were *Politics in an Oyster House* of 1848, in the Walters Art Gallery, Baltimore, and *The Sailor's Wedding* of 1852 with their meticulous lighting, clear textures, strong spatial illusionism, and tight drawing. The latter is also attributable to Woodville's study at this time in Düsseldorf, a center that was to attract a number of American artists and instill in them the sometimes dry style taught there. But the delight in ordinary incidents and people remains American, even though Woodville stayed in Europe for the rest of his short career.

Happily, the two major genre painters of this period had longer and even more productive careers. William Sidney Mount and George Caleb Bingham painted respectively the rural charms of eastern Long Island and the central Mississippi River. Mount moved little from his native Setauket, Long Island, finding subjects throughout most of his life on the farms or coast nearby. During the 1820s Mount did spend some time in New York studying with Henry Inman and visiting the local art galleries. Back in Stony Brook, Long Island, at the end of the decade, he took up portraiture and 'my first design,' *Christ Raising the Daughter of Jairus,* in the Suffolk Museum, Long Island, notable for its rather primitive qualities and for the amusing inclusion of a four-poster bed in the background. Shortly after he began painting scenes of everyday life with a strength of style that grew in expressive power and subtlety as his career proceeded.

One of his finest early works, *Bargaining for a Horse* (1835), celebrates an ordinary episode of Yankee bartering. With bright, clear colors and a firm sense of modeling Mount defines each of the major figures, as well as many minor details, with sure clarity. But he focuses on the narrative of the bargaining with special ingenuity by framing the figures with the architectural forms of the barn and fence behind. The stepped diagonal of the roof and fence lines not only leads the eye across the picture, but also aids in smoothly drawing attention from the foreground into the back-ground. Thus he coherently links together figures and landscape, as well as the organization of picture surface and space. His paintings thereafter possessed this sense of perfect harmony between pictorial content and formal design.

The next year he completed *Farmers Nooning,* now in the Suffolk Museum, another light-filled image of figures relaxing in a hay field. Both this and *Bargaining for a Horse* were subsequently engraved, helping to bring wide popularity to Mount. In 1841 he completed another major work, *Cider Making.* With several distinct groups of figures he depicts the various activities and stages related to making and tasting cider. Each major group has three individuals in it and each is set off by some architectural form: the youths in the foreground next to the barrels, the men pressing cider beneath the shed roof, the further children on the horse-drawn wheel, and at the far right Mount himself with two friends standing below a covered haystack. Thus the picture actually consists of a number of familiar and related incidents, which Mount coherently ties together in this serene Long Island landscape. The warmth of coloring and the full glow of sunlight further comple-ment the mood of ripeness and fulfillment.

Mount's work continued to express this sense of plenitude and harmony, though he gradually de-emphasized patent anecdotal content, relying increasingly on understatement. This subtle change is evident in one of his best-known works done three years later, *Eel Spearing at Setauket.* The rural countryside and individuals are once again Mount's immediate subject, as the artist wrote two years afterwards: 'An old Negro by the name of Hector gave me the first lesson in spearing flat-fish & eels. Early one morning we were along shore according to appointment, it was calm,

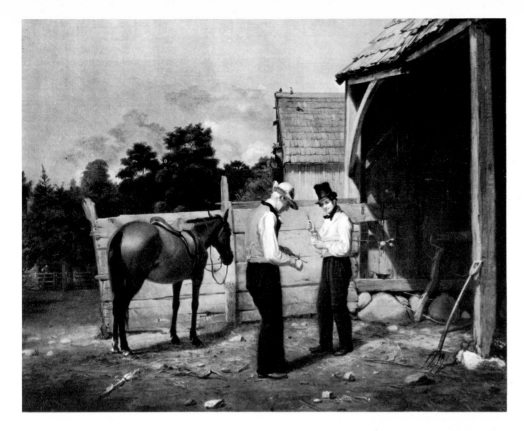

WILLIAM SIDNEY MOUNT, *Bargaining for a Horse*.
New York, New-York Historical Society.

WILIAM SIDNEY MOUNT, *Cider Making*.
New York, Metropolitan Museum of Art,
Charles Allen Munn Bequest, 1966.

and the water was as clear as a mirror, every object perfectly distinct to a depth from one to twelve feet. . . .'[28]

But he of course creates an image of more than momentary narrative action. Through the new simplicity of his stable pyramidal design and the stress on glowing clear light in both the water and the sky the picture takes on a timeless quality. Age and youth are locked together in the stillness of nature's outer calm and inner order.

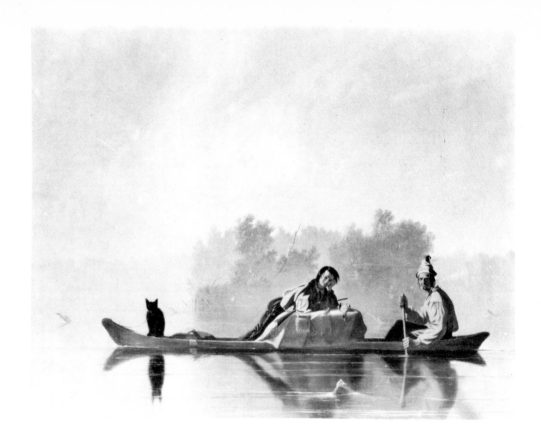

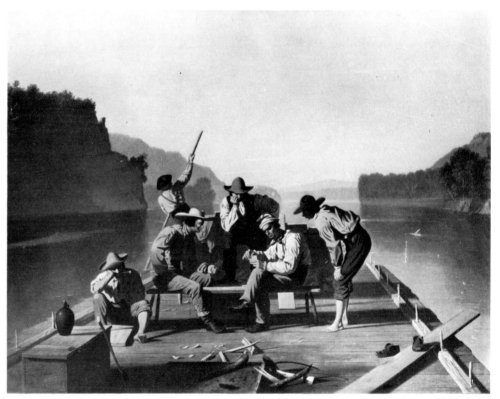

GEORGE CALEB BINGHAM, *Fur Traders Descending the Missouri*.
New York, Metropolitan Museum of Art, Morris K. Jessup Fund, 1933.

GEORGE CALEB BINGHAM, *Raftsmen Playing Cards*.
St Louis, Missouri, St Louis Art Museum.

This process of simplification and evocation marks most of Mount's later paintings, whether with figures (*The Banjo Player*, 1855, Detroit Institute) or without: in *Long Island Farmhouses* there are a couple of children present, but they are small and totally subordinated to the golden landscape. As in *Eel Spearing*, light is the major animating element, here the warm yellow of fall. As an image of momentary and passing time, it looks forward to the photographic stillness of Thomas Eakins'

124

Max Schmidt in a Single Scull, in the Metropolitan Museum of Art, painted two decades later. More immediately, Mount's balanced compositions and light-flooded canvases were to influence the course of his contemporary George Caleb Bingham's work.

Although born in Virginia, Bingham moved as a child with his family to Franklin, Missouri, where he grew up and spent much of his remaining life. He began his career by copying engravings after other American painters, including Sully and Vanderlyn, and probably European artists. By the 1830s he had taken up portrait painting, although these early works are rather stiff and dry. In 1838 he decided to go east for instruction at the Pennsylvania Academy of the Fine Arts and to study at first hand works by artists like Sully and Mount. He also acquired in this period a variety of prints and casts of antique sculpture, which were to provide numerous sources for figures in his own later paintings. During the early 1840s Bingham worked as a portraitist in Washington, D.C., and then returned to Missouri in 1844.

Shortly after his return to the mid-west he began one of his finest genre paintings, *Fur Traders Descending the Missouri,* which probably reflects his recent study of Mount's painting. During the next decade he was to produce a series of monumental and serene boatmen pictures. Like his literary counterpart Mark Twain, Bingham shows his characters and their landscape in a warm and sympathetic way. Although some of these figures are shown self-absorbed, like Mount's, in card-playing, fishing, or story-telling, they are more often looking out directly at the viewer. This unpretentious but compelling directness is typical of his best work. Also like Mount Bingham frequently frames his figures with background forms, as here the soft river foliage echoes the shapes of the two boatmen in the foreground. The balanced design of men and animal, of figures and reflections, of landscape and sky, creates an image of action and contemplation that is suspended beyond time.

In *Raftsmen Playing Cards* Bingham employs a more complex pyramidal design, but continues to counterpoint movement and stasis among his figures. The receding edges of the hills and riverbank softly repeat the diagonal lines of the raft, pole, and boatmen's backs, solidifying that harmony man sought with the natural world so often in the nineteenth century. Bingham changed these solid compositional arrangements little, and one variant was moving his figural group from the center to the side, setting up an asymmetrical balance between the foreground group and the

GEORGE CALEB BINGHAM, *The County Election.*
St Louis, Missouri, St Louis Art Museum.

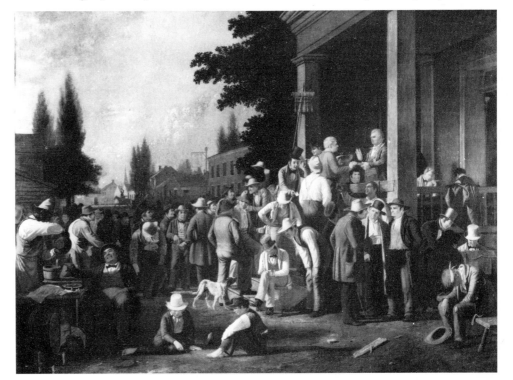

diagonally receding landscape. Such is the case in *Watching the Cargo*, in which he also plays off the postures of the men with the more geometric arrangement of cargo next to them.

Bingham did repeat subjects occasionally with little variation, and generally the second versions are less successful than the first. He also tended to add more figures to his compositions done towards the end of this first creative period, which culminated with his departure for Düsseldorf in 1856. During the early 1850s Bingham embarked on a series of large electioneering pictures: *The County Election, Canvassing for a Vote, Stump Speaking,* and *The Verdict of the People.* The composition and figure grouping for these largely came from Hogarth engravings, with some details taken from antique casts. Bingham himself had by this time become active in local Whig politics, and had won a seat in the Missouri legislature in 1848. Both his personal campaigning experiences and his conception of this subject as a vivid illustration of democracy in action underlie the humor and breadth he brings to these paintings. Thereafter, his style took on many of the mannerisms of the German school – overly tight drawing and detailing, emphatic gestures, and melodramatic treatment of subject.

Bingham's lively images of frontier life were but a part of a much broader interest in the exploration and documentation of the American West. The life of the Indian, and the various types of animals and birds across the continent, also attracted early attention from painters. George Catlin was one of the first and best known recorders of the American Indian. As a youth he had become fascinated with the Indian artifacts and portraits at Peale's museum in Philadelphia, and determined to spend time among the various tribes painting them and their costumes, habits, ceremonies, settlements, and ways of living. To this end between 1830 and 1836 he visited and studied most of the major tribes in the central and southwestern United States. His gradually accumulated 'Indian Gallery' became a comprehensive document possessing an unusual combination of ethnological, historical, and artistic interest. *Chief Kee-O-Kuk* is but one of dozens like it. Although reliable as an accurate record of physiognomy and costume, the figure's proud bearing and stance recall the image of the Noble Savage idealized in the first sketches of the New World by early English and French explorers of the sixteenth century. Behind such images lie the models of ancient Roman statuary, Renaissance reinterpretations of harmonious anatomical proportion, and finally eighteenth-century Romantic notions about primitive man and nature associated with Rousseau. For artist and public alike the raw beauty of the Indian had an appeal no different from that of the American wilderness which he inhabited. The painter recognized the Indian as belonging to an indigenous American iconography. There was a romance both in the discovery of wilderness or landscape and in the missionary pursuit of preserving that imagery through art for posterity.

This combination of art and science was also uniquely embodied in the work of John James Audubon. Born in Haiti of a French naval officer and a Creole mother, Audubon spent most of his youth in France. Before leaving for the United States in 1803 he spent a few months' apprenticeship in the studio of Jacques-Louis David, whose Neo-Classical style was partially to influence Audubon's subsequent work. As he later said, 'The lessons which I had received from the great David now proved all-important to me.'[29] Ostensibly the manager of his father's estate in Pennsylvania, Audubon spent most of his time hunting, sketching, and collecting birds and animals. His collection of drawings gradually grew, and during the 1820s he devoted himself largely to assembling a comprehensive record of the birds in North America. Between 1827 and 1838 the English engraver Robert Havell published four folios of some five hundred colored engravings after Audubon's original watercolors. Subsequently, Audubon made similar expeditions to document the species

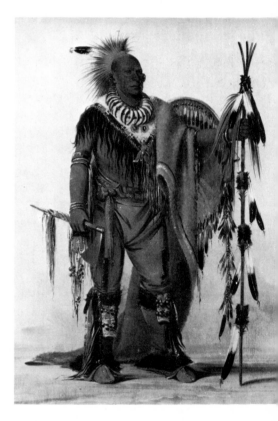

GEORGE CATLIN, *Chief Kee-O-Kuk.* Washington, D.C., National Collection of Fine Arts, Smithsonian Institution.

of animals in America, and this too resulted in published engravings. The artist's best work demonstrates a keen and sympathetic sense for the special qualities of an individual species, whether the bold yet beautiful ferocity of the *White Gyrfalcon* or graceful intimacy of some other bird's character, scale, and habits. Drawing on an innate sense of balance and clarity of outline from his experience with David, Audubon usually juxtaposes the male and the female of a species, one in flight and one at rest, in their natural surroundings. With precise observations he renders appropriate textures and movements, yet his scientific accuracy is always complemented by his aesthetic sense for expressive abstract design.

These inherent formal qualities are closely related to the continuing tradition of American still-life painting, which, while not as popular as landscape or genre during the first half of the nineteenth century, were by no means neglected. In fact, Audubon's carefully designed compositions and closely observed forms may be seen as descendants of the still lifes by the Peale family. Also continuing that tradition at mid-century were painters like John F. Francis and Severin Roesen. Like some of their contemporary genre painters, they were indebted to Dutch sources for their still-life compositions. But their luscious and succulent food or fruit arrangements reflect a change in style from the delicate refinements of Federal taste seen in the Peales' paintings. Now the ripeness and abundance more closely parallel the exuberant self-indulgence of Mount's landscapes and genre pictures.

Still another category of painting that thrived throughout the rise of landscape and genre as national expressions was the work of the folk artist. Although by definition self-trained and unfamiliar with academic painting, he created a vital and continuing American tradition of craftsmanship that was not as separate as is often thought from the work of traditionally trained artists. (One need only recall that American academic painters well into the nineteenth century began their careers essentially as practical craftsmen, whether in painting likenesses or making engravings as a means of livelihood before they could pursue successful and separate careers as professional artists.) The so-called folk artist cultivated his intuitive and conceptual view of the world, unconcerned with rendering things in perspective,

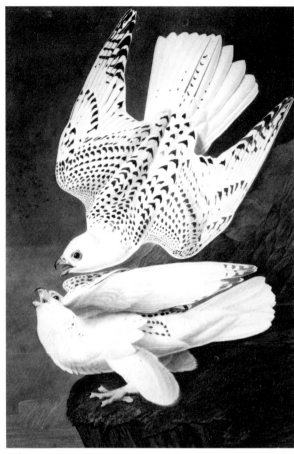

Above JOHN JAMES AUDUBON, *White Gyrfalcon.*
New York, New-York Historical Society.
Left SEVERIN ROESEN, *Flowers.*
New York, Metropolitan Museum of Art, Gift of Various Donors, 1967.

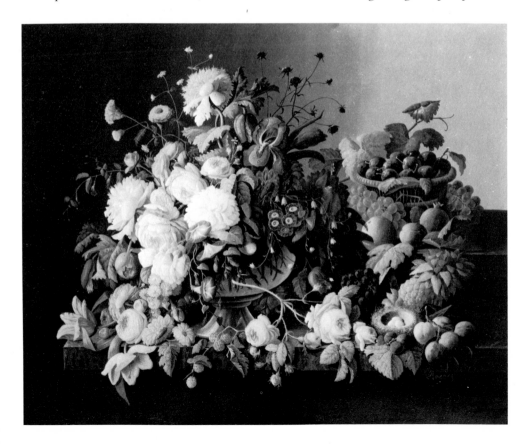

fully modeled, or illuminated with single or consistent sources of light.

His subjects were for the most part the same as those chosen by his academic counterparts: religious and historical topics, portraits, genre, landscape and marines. Often their names are unknown, usually because they did not consider themselves as artists leaving identifiable works for posterity, but rather they pursued their careers as decorators, sign painters, tool manufacturers, or whatever. Some of the more prolific painters are better known: Edward Hicks, Thomas Chambers, Erastus Salisbury Field. But what they most often shared in common was a style of basically two-dimensional abstraction, in which flat patterns, expressive silhouettes, local areas of color or contrasting areas of texture, were the primary means of defining and distinguishing forms. Compare the interest in spatial illusionism and palpable form in Thomas Birch's painting of an event in the War of 1812 with Thomas Chambers' interpretation. The latter stresses bright patterns of color and repeated rhythms of shapes which are more two-dimensional than three. The delight of these artisans in expressing the optimism of national life is parallel to that of the most sophisticated painter, and adds another level to the fabric of artistic activity through this period.

As each of these types of painting reached mid-century, they became modified to suit the needs and reflect the aspirations of their creators. Subtle changes in the direction of each were at work by the late 1840s which would ultimately be clarified during the fifties and sixties. One manifestation of change was the decreasing interest in overt narration in painting, as the direction of Durand's and Mount's work suggests. Both landscape and genre painting seemed to stress the figure less in number and in scale and the landscape itself more and more. But it was not merely a matter of showing more physical amounts of nature, or more details of a given landscape; greater attention was devoted to intangible elements such as the weather and mood enveloping a scene. Even more subtle than this, it involved rendering not so much sky and clouds, but light and atmosphere. Painting became less expository and more contemplative, less prosaic and more poetic.

The artist who best represents these developments was Fitz Hugh Lane, whose career spans the first half of the nineteenth century. A native of Gloucester, Massachusetts, he was like Mount in traveling little from his favorite landscape of Cape Ann. In the latter part of his life he added annual summer cruises along the Maine coast which provided stimulation for refinements in his mature style. Trained as a lithographer in Boston, he learned early the potentialities of the graphic medium and carried thereafter a sense for working in line and in contrasts of tone into oil painting. At work in Boston during the 1830s, he had frequent opportunities to study the marine paintings of Robert Salmon, possibly meeting Salmon himself through their mutual association with the lithographer Pendleton. In any event Lane's early work reflects the older painter's preference for crisp detailing, distinctive effects of light, and capturing the myriad activities along the coast near Boston.

Lane's first mature oil paintings after he had returned to Gloucester at the end of the 1840s were of local views and activities. Their concern with depicting narrative action parallels the work of both Cole and Mount. For example, in *Gloucester Harbor* the foreground shows various incidents related to the process of buying and selling fish, and in other Gloucester views Lane describes the different aspects of shipbuilding along the wharves. By 1850, when he painted his large view of *New York Harbor*, much of this anecdotal material is de-emphasized. To be sure, it is still a picture of much activity and a variety of vessels seen against the city skyline, but if compared to Salmon's rather closed and shallow space in his *Wharves of Boston* of 1829, one becomes aware of Lane's new feeling for spaciousness and calm. In this effort he was partly aided by his examination of engravings and copies after seven-

ERASTUS SALISBURY FIELD, *The Garden of Eden*.
Shelburne, Vermont, Shelburne Museum.

EDWARD HICKS, *The Cornell Farm*.
Washington, D.C., National Gallery of Art.
Gift of Edgar William and Bernice Chrysler Garbisch.

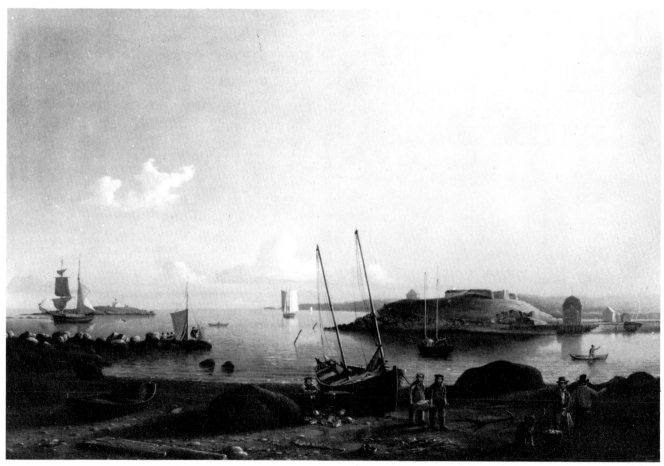

teenth-century Dutch marine paintings, often on view in Boston and New York, which were noted for their low horizons, expansive spatial recession, and sweeping atmospheric effects. In addition, Lane's figures are now much smaller, placed without their earlier prominence in the foreground, and no longer vehicles of any storytelling information.

Lane began his first thorough explorations of the Maine coastline about this time, and the sense of detachment is almost immediately apparent in his painting. Cruising only with close friends, seeking out those lonely but beautiful harbors and islands along the rocky coast, he drew closer than ever to an understanding of nature's transcendental meaning. He attempted in his work to convey his profound feeling for the harmony of the natural world, and man's personal relationship to it, understood more in spiritual than physical terms. Thus his later pictures tend to be with few or no people – pure images of contemplation, in which the surface of geography is merely a means of seeing nature's inner order. *Owl's Head, Maine* is a summary example of his mature work. Although there is a figure in the foreground, he turns from us to gaze across the tranquil scene before him. The light is early dawn, a transitional moment suggesting both the momentary and the timeless – a landscape and a feeling held in suspension. More than half the composition is now open water or sky; the paint itself is very thin, in places translucent, thus perfectly complementing the intangibility of light and thought itself. Lane's development of a new pictorial space and a new feeling for the meaning of light were part of the Luminist movement, a uniquely American development in the middle of the nineteenth century.

A younger generation of painters then emerging carried these developments into the second half of the century. Some were direct followers of Cole and represent a second phase of the Hudson River School; others were more independent, carrying their quest for landscape subjects far afield, first to the Rockies and then to South America and the Arctic. Among those direct descendants of Cole were Jasper Francis Cropsey, Frederic E. Church (Cole's only pupil), and Sanford R. Gifford. The paintings of each artist at mid-century were all indebted to Cole's moral and compositional formulas for landscape painting, especially as exemplified in *The Course of Empire*. For example, the central mountain focus in Church's *New England Scenery*, Cropsey's *Catskill Creek, Autumn*, and Gifford's *Summer Afternoon* are strongly reminiscent of *The Savage and Arcadian States* in Cole's series. Yet they are unmistakably later. While narrative detail is present, space and light play a role parallel to that in Lane's painting of the same period.

Worthington Whittredge and John F. Kensett also emerged out of the Hudson River School tradition and worked largely in New England. Their early work shows the same transition taking place: the former's *View of Cincinnati* and the latter's *Niagara Falls and the Rapids* combine the now familiar accuracy of recording the details of specific scenery with spacious panoramas of light and atmosphere. Even more independent artists like Martin Johnson Heade and George Inness, when viewed in this context, illustrate this underlying coherence of the American vision at this time. Heade's *Rocks in New England* and Inness' *Lackawanna Valley* demonstrate that they began their careers at an important turning point in the development of American art and especially landscape painting. In their different ways this younger group would clarify and modify the meaning of nature in the American imagination over the latter decades of the nineteenth century. But unmistakably American art had emerged into maturity from its colonial inhibitions in a relatively short period of time. European art would continue to attract and challenge Americans, sometimes into imitation and sometimes into rejection and originality. But as the second half of the century began, the course of American art was never more lively or promising.

ANON., *Meditation by the Sea.* Boston, Massachusetts, Museum of Fine Arts, M. and M. Karolik Collection.

FITZ HUGH LANE, *Gloucester Harbor.* Richmond, Virginia, Virginia Museum of Fine Arts.

Top SANFORD R.
GIFFORD, *Summer
Afternoon.*
Newark, New Jersey,
Newark Museum,
Gift of Mr and Mrs Orrin
W. June, 1961.
Left WORTHINGTON
WHITTREDGE, *View of
Cincinnati.*
Worcester,
Massachusetts,
Worcester Art Museum.
Opposite FITZ HUGH
LANE, *Owl's Head,
Maine.* Boston,
Massachusetts, Museum
of Fine Arts, M. and
M. Karolik Collection.

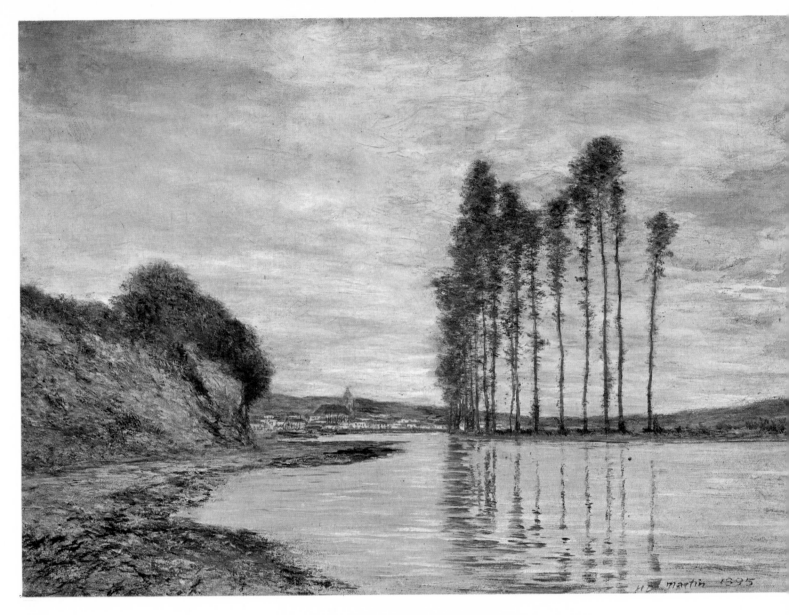

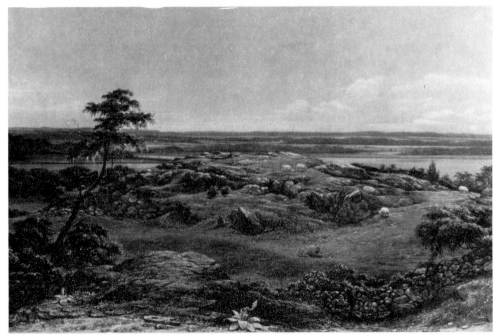

Above HOMER D. MARTIN, *The Harp of the Winds*.
New York, Metropolitan Museum of Art.

Right MARTIN JOHNSON HEADE, *Rocks in New England*.
Boston, Massachusetts, Museum of Fine Arts, M. and M. Karolik Collection.

Opposite FREDERIC EDWIN CHURCH, *Niagara Falls*. Washington, D.C., Collection of the Corcoran Gallery of Art.

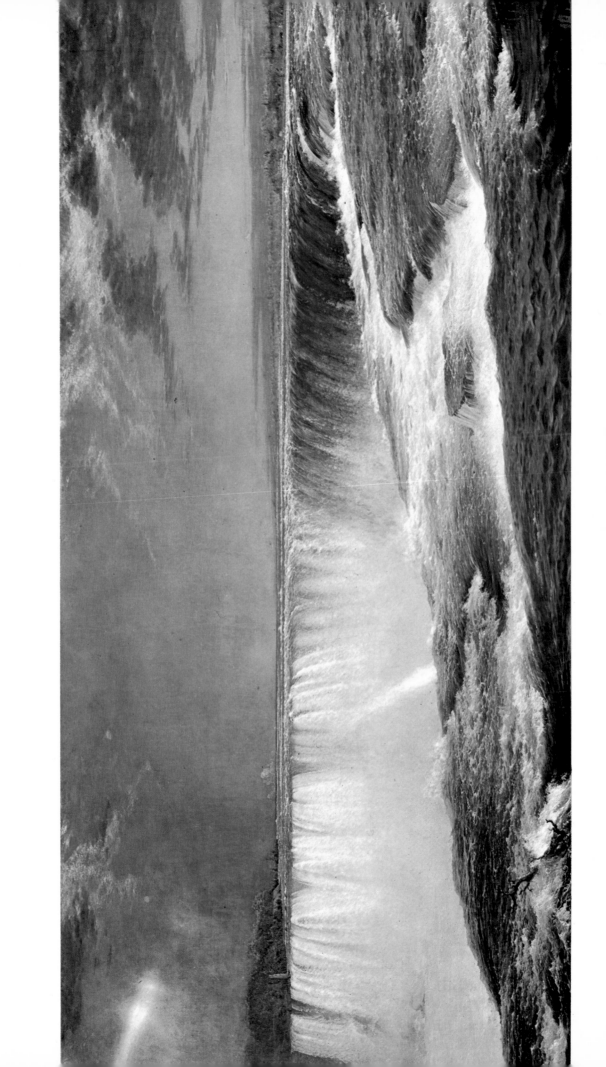

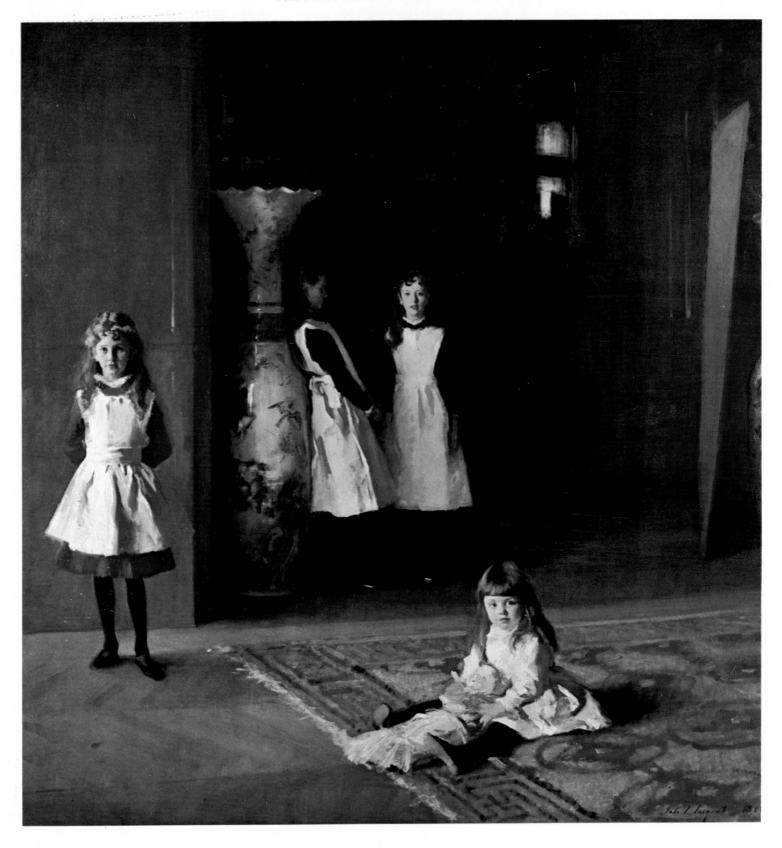

Above JOHN SINGER SARGENT, *The Daughters of Edward Darley Boit.*
Boston, Massachusetts, Museum of Fine Arts.

Opposite, top JOHN F. KENSETT, *Niagara Falls and the Rapids.*
Boston, Massachusetts, Museum of Fine Arts, M. and M. Karolik Collection.
Opposite, bottom GEORGE INNESS, *Lackawanna Valley.*
Washington, D.C., National Gallery of Art, Gift of Mrs Huttleson Rogers, 1945.

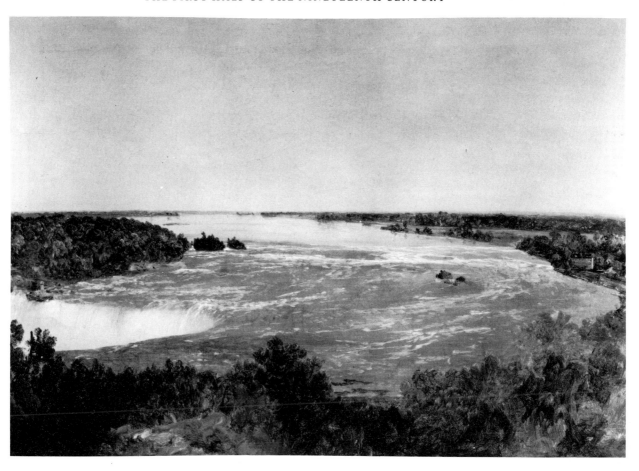

3

THE SECOND HALF OF THE NINETEENTH CENTURY

Richard J. Boyle

THE SECOND HALF OF THE NINETEENTH CENTURY

The underlying coherence in the work of the first and second generations of American landscape painters was based upon the assumptions of Thomas Cole and the forging of a style arising out of the direct confrontation with the American landscape, that 'wilder image.' There was assurance then, and pride. An intense chauvinism was in the air, a truly national style was in the making, and as echoed and articulated in the writing of Ralph Waldo Emerson, American painters were 'self-reliant;' they stood on their own feet. And the public shared their enthusiasm. The 1840s and 1850s seemed to be an ideal time, a time when there was no apparent gulf between the painter and his audience, and American patrons were proud to buy American art.

But beginning in the mid-1860s American society, like that of Europe, underwent serious changes, violent transformations. The apparent simplicity, the cohesiveness of American life and art became fragmented. Artistic directions became uncertain, eclectic and imitative of foreign modes. Once again, as in the eighteenth century, American artists began to look toward Europe, not only for training as they had always done, but for style. However, not all American painters succumbed to a pervasive European influence. Some, like Homer, Eakins and Ryder went their own way; others, like Inness or Harnett, molded a personal manner out of European training and American experience; and still others, Whistler, Chase, Mary Cassatt and Sargent, made of their cosmopolitanism a strong personal statement, and in the case of Whistler, developed an original vision as well. As a result, in the last quarter of the nineteenth century, particularly in that period between the Philadelphia Centennial of 1876 and the World's Columbian Exposition of 1893 in Chicago, the famous 'White City,' American painting became more complex, diffuse and eclectic. The painting of landscape was the primary mode of expression, of course, and it ranged from the cineramic masterpieces of Bierstadt and Church to the poetic solitude of Robert Duncanson; the Luminism of Heade, Gifford and Fitz Hugh Lane, who might be considered the forerunners of such American Impressionists as Robinson, Twachtman and Hassam. There were the painters of Indian life from the documents of Catlin, Stanley and Miller in the 1830s and 1840s to the nostalgia of Henry Farny and Frederick Remington in the 1880s and 1890s; the decorative idealism of Vedder and La Farge; the *trompe l'oeil* still life of Harnett and his followers; the independence of Homer and Eakins, and the extraordinary romantic vision of Ryder. There was the 'art for art's sake' of Whistler, and the sheer love of painting of Duveneck and Chase. Finally in the 1880s there was the overwhelming influence of French Impressionism as represented by Cassatt and Twachtman, Theodore Robinson and Childe Hassam, to name but a few. In the main, however, the dominant artistic thinking in America in the last quarter of the nineteenth century was directed toward Europe, and this trend of thought was woven into the American social fabric as well as its artistic concepts.

Although obviously a part of the West European tradition, there exists in the history of American art an ambivalent attitude toward the culture of Europe ranging from the cultural colonialism of the eastern seaboard in the eighteenth century to the optimistic chauvinism of the young nation in the mid-nineteenth century. From the total embrace of things European after the American Civil War to the isolationism of the 1930s with its emphasis on a 'true' style as interpreted by the painters of the American scene. As America developed from colony to nation, it evolved from the beginning into an open society and the industrial revolution soon made it the first modern one. However these very same forces served to work against the establish-

as known and practiced in Europe.
rything so unprofitable as fine arts.
t part the major stylistic changes in
orbed was modified by a confronta-
cape could not be treated for its own
grounds. Paintings of the wilderness
work and to contemplate them was
inting in America became the domi-
th century and the major outlet for
hicle in which the contradiction be-
d for quiet observation of fact were
f the major characteristics of Ameri-
homas Cole and the Hudson River
and the American Impressionists in
the moral justification of landscape
and the serenity. Landscape painting
was perhaps also an escape as well as a valid path for the artist to take. However as
the country rapidly became more industrialized American painters faced the prob-
lem of how to rationalize this industrial progress with the prevailing image of a
serene and arcadian landscape. For the most part the painters did not really try.
With few exceptions, they ignored the loud intrusions of industry, and also with
few exceptions the city itself was rarely used as viable subject-matter until after
1900, with the advent of Robert Henri and his circle. For the most part the nine-
teenth-century painter concentrated instead upon the isolated, lonely, often nostal-
gic and always romantic aspects of nature. This serenity, however, was not to last
very long and the landscape was soon to be rent by violence as the Civil War
loomed on the horizon. After the Civil War the old Emersonian self-reliance was
gone and Americans became increasingly confused and apologetic about their cul-
ture. No artist, whether painter, sculptor, writer or philosopher could entirely ignore
the changed atmosphere around him, and Henry Adams calls attention to the trans-
formation of life by the 'mechanical development of power, technology, impersonal
and largely uncontrolled, acting upon human events.'[1]

The American Civil War was the first modern war, and the thrust of industrial-
ism and economic change during and after the conflict turned the United States into
the first modern industrial state. By the time of the World's Columbian Exposition
in 1893 it had become one of the world's great manufacturing powers. This coming
age of industrial expansion was strongly emphasized in the Philadelphia Centennial
Exposition of 1876. Although the Exposition was organized to celebrate one hundred
years of American independence, its chief impact was not the focus on a century of
past achievements; instead it gave Americans a glimpse into the future age of
machinery; it gave them their first large-scale look at the arts, artifacts and luxuries
of the old world, and the mechanical wonders of the new. Exhibits were invited
from all over the world, but the center of the Centennial was the huge cast-iron and
glass building containing the industrial displays ranging from Alexander Graham
Bell's telephone to guns from the Krupp Works in Germany. And if this was the
center, the giant Corliss engine, which supplied the power for the whole Exposition,
was the real heart of the show. It was the largest steam engine yet built and it
symbolized the feeling that the United States had become a power in the world.
But the trappings of that power, the outward signs of it, were imported from
abroad. Soon, the symbols of the correct status, found in Europe, began showing up
everywhere. Mock European castles, topped with towers, battlements or the
Mansard roof, stood on city streets or crawled on suburban lawns. Inside they were
furnished with paintings and *objets d'art* ransacked from the estates of Europe.

141

Works of art became a badge of position rather than a means of enjoyment or 'spiritual uplift.' The era of the entrepreneur was on the way, an era which Mark Twain and Charles Dudley Warner called 'The Gilded Age.' The movement toward the democratization of culture at mid-century had been cast aside, and the public came to think that art belonged in the houses of the rich, or in the new museums which were being formed in the 1870s and 1880s. A gulf was created between 'official culture' and popular culture, and the American artist was caught in between. He was ignored in favor of European *chic*.

The art exhibition for the Centennial was held in Memorial Hall, which later became the Philadelphia Museum of Art, and it provided the first experience for many American artists to see what was being done by their contemporaries in Europe, and inspired many to go abroad to study.

The strongest American painting in the Exposition was landscape; and 'the American school of landscape painting,' remarked Edward Strahan in his writing on the Centennial, 'is the only one we can boast of as possessing a strongly marked individuality.'[2] Yet Strahan was afflicted with the taste of his time. He believed that the aim of art was 'to produce a representation of a beautiful human figure, with correctness of design and in a graceful attitude.'[3] He loved Salon pictures, and thought that such an anecdotal horror as George Becker's *Rizpah* was 'probably the most impressive picture in the Exhibition.'[4] Of Cropsey's *The Old Red Mill*, he carped that the water was 'a little too sparkling,' and the work of Corot he understood not at all. Nevertheless the second generation of the Hudson River School was represented in strength and could not be ignored. Homage was paid to the landscapists in the form of retrospective showings for Thomas Cole, pioneer of Hudson River School painting, and John F. Kensett, one of the style's most sensitive practitioners, both of whom were dead by 1876. If the past glories of the Hudson River School were represented by Cole and Kensett, a future style was germinating in the work of Homer D. Martin whose one entry entitled *Adirondacks* looked forward to his celebrated *Harp of the Winds* which, although painted in 1894, is still a proto-Impressionist picture. Just as the exhibit of Thonet's bentwood furniture at the Centennial looked ahead toward the clean lines of modern design, so the presence of Homer D. Martin looked toward the color explosions of Impressionism two decades

JASPER F. CROPSEY, *The Old Red Mill*, 1876. Norfolk, Virginia, Norfolk Museum.

later. But among the most admired artists in the American section were the panoramic painters Albert Bierstadt, and Frederic E. Church, who were commended for 'Eminence in landscape;' and the most popular American artist, whose ten pictures were the greatest number picked by the jury of selection, was the Luminist painter Sanford R. Gifford. Gifford also received the award of 'Eminence in landscape.' Worthington Whittredge was a runner-up with eight pictures exhibited. *A Home by the Sea* was one of these, and is representative of Wittredge's intimate, homey and somewhat prosaic style. It also exhibits a concern for light which was a major interest on the part of painters throughout the western world since the 1850s. It was an interest Wittredge shared with Gifford, Heade and other Luminist painters, along with the qualities of quietness and tranquillity which would become domi-

WORTHINGTON WHITTREDGE, *A Home by the Sea.*
Andover, Massachusetts, Addison Gallery of American Art, Phillips Academy.

nant elements in American painting through the end of the century. A quietist feeling is dominant also in the work of an interesting late Hudson River School artist who was not represented in the Centennial.

Robert S. Duncanson deserves attention, not only because of his poetic interpretation of mid-western American landscape, but because he was one of the first professional black artists this country has produced. He was celebrated in his time, but as was the case with many other nineteenth-century American artists, his reputation dimmed and his work was forgotten. He was born in New York State in 1821, and went to Cincinnati in 1842, where he soon made a name for himself as a painter of still life, fancy pieces and landscapes. A local patron sent him to Europe in 1853, and again during the Civil War when he was lionized in British abolitionist circles. At the height of his career he shuttled back and forth between his patrons in Cincinnati and in Detroit. *Blue Hole, Flood Waters, Little Miami River*, painted in 1851, is Duncanson's most famous painting. In its feeling for space, the careful attention to realistic detail, and in the choice of a quiet and transquil moment to render a bit of 'God's handiwork,' this picture is revealing of some of the characteristics of the Hudson River School; however the modest lyricism, the gentle poetry is more personal to the artist.

Sanford R. Gifford's *Leander's Tower on the Bosphorus*, although not in the Centennial, was painted in 1876 and exhibits those qualities which have come to be known as 'Luminist.'[5] These artists continued the American idealistic landscape tradition,

ROBERT S. DUNCANSON, *Blue Hole, Flood Waters, Little Miami River.*
Cincinnati, Ohio, Cincinnati Art Museum, Gift of Norbert Heerman.

SANFORD R. GIFFORD, *Leander's Tower on the Bosphorus.*
Cambridge, Massachusetts, Fogg Art Museum, Harvard University, Bequest of Mrs William H. Fogg.

seeing in the study of light and its effects another source of wonder in God's world. Their particular emphasis on light, and their personal, almost mystical rendering of its ambiance has given rise to the term Luminism as a description of their style of painting. And it was a style of painting which can be considered a forerunner of American Impressionism. Although their approach, that of a lyrical expression of landscape under specific conditions of light and atmosphere, was similar to that of the Impressionists, the Luminists were not interested in *fracture* or surface texture, or in the disintegration of form. And although Gifford's picture, which was painted two years after the first French Impressionist exhibition in Paris, is reminiscent of Turner who was himself a revelation to the Impressionists, it has none of the agitated colorism which so inspired Monet and Pissarro when they were in London in 1871. *Leander's Tower* remains well within the Luminist format of parallel bands of sky and water dominated by a dramatic and visible source of light, and executed in a smoothly finished style. There is an insistence on the integrity of objects, on the

144

THE SECOND HALF OF THE NINETEENTH CENTURY

quiet observation of fact, evoking a feeling of solitude and calm, an eloquent silence. There is the feeling also that the presence of the artist's hand should not in any way detract from the representation of nature's moods. Luminism was an American style in outlook and attitude, and aspects of that style – the concern for light and atmosphere, the clarity of form and for reticence in handling – later merged with the influence of Monet in American Impressionist practice.

Leander's Tower, with its qualities of quietism, is a contemplative painting. But by 1876 the country was no longer in a contemplative mood. Restlessness was in the air, and it affected artists just as it did everybody else. The push to Europe was on, and in the 1870s and 1880s American artists flocked to Europe as never before. In America railroads were spanning the continent; 'Manifest Destiny' was the political war-whoop of American expansion westward, and Albert Bierstadt was the chief painter of the westward movement. Frederic E. Church, Bierstadt's peer in panoramic painting went further. Church's epic canvases strain for the feeling of trying to grasp the whole, immense universe. If, at the Centennial, Sanford R. Gifford was popular with the jury of selection, Church and Bierstadt awed the public with their gigantic *machines* depicting the wonders of nature on acres of canvas.

Church exhibited *The Parthenon* and *Chimborazo* at the Centennial, and in that same year his *Niagara* was bought by William W. Corcoran for $12,500, quite a price for that time. A pupil of Thomas Cole, Church carried on the 'pious pantheism' of his teacher. Church, however, sought to grasp nature with the thoroughness of a scientist, and the completeness of detail in his work is at once a joyous enthusiasm for the richness of nature and an expression of the factual which was – and is – ingrained in the American mind. In Church's work the morality of Cole had been influenced by a scientific age, but the underlying assumptions, the sense of awe and wonder is still there. Inspired by the writings of the naturalist Alexander von Humbolt, Church acted as though it was the task of the landscape painter to reveal the great enchantment of nature in all its diversity, its infinity and its universality, but at the same time, suggesting its underlying unity. When *Niagara* was first painted it was 'uncontestably the finest oil picture on this side of the Atlantic,'[6] and although for the next two decades, Church painted the 'great enchantment of nature' all over the world, he remained in the minds of his countrymen the first painter to successfully depict the Falls. In Church's later work, in paintings such as *The Parthenon* of 1869, *Jerusalem from the Mount of Olives* of 1870, and *Morning in the Tropics,* painted in 1877, he turned more and more to the kind of light used by the Luminists, and the kind of mood evoked in Gifford's *Leander's Tower.* He had turned from the heroic to the contemplative.

Albert Bierstadt never was contemplative, and his heroic style was operatic rather than real. *Mount Hood, Oregon,* exhibited in the Centennial, is more like a backdrop for a Wagnerian opera than a feeling for the natural grandeur of the West. He was less perceptive than Church and he lacked Church's constant enthusiasm, or his philosophical and scientific bias. But Bierstadt's popularity was immense. The Rocky Mountains were his aesthetic province, and his paintings of the Far West, the rivers, plains, Indian encampments, were highly praised in Europe and America. He had an attractive personality and a natural instinct for publicity. From the early 1860s and for about twenty years thereafter he was very much 'on stage,' and his paintings were fetching anywhere from $5,000 to $35,000, record prices for his day. However by the 1880s his sensationalism was wearing a bit thin. Aspects of his Düsseldorf training, the synthetic combination of vast numbers of tightly-painted details and hard color, became more insistent; his painting became more artificial. Time and change had caught up with Bierstadt and Church.

In the 1870s Church's *Niagara* was looked upon with very different eyes. It was no longer the 'finest oil-picture ever painted on this side of the Atlantic;' instead it

145

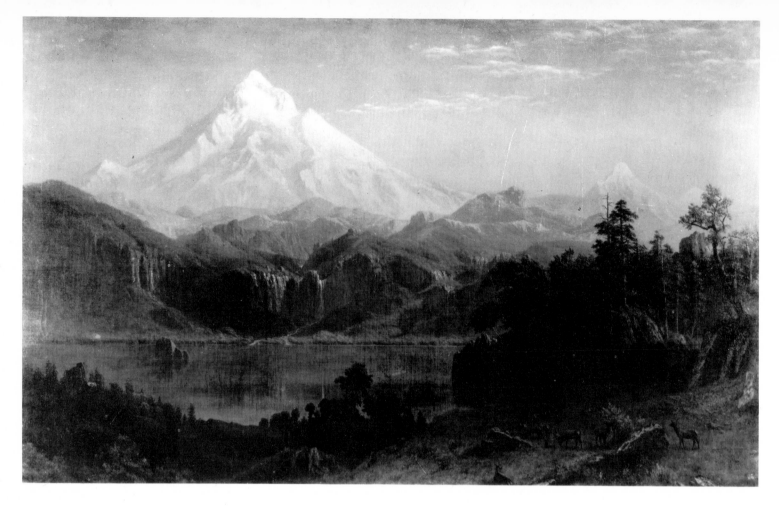

was remarked that, 'We respect the talent of the artist, we admire the picture, but both are without charm; and, as art, the picture has very little we care for.'[7] And in 1889 Bierstadt's *Last of the Buffalo* was rejected by the Paris Exposition Committee. For the younger generation of American artists the older American landscape painting must have seemed a dull and worn-out form, and the picturesque chauvinism, the cineramic masterpieces of Bierstadt and Church interested them not at all. The rush to Europe was on: 'My God,' cried William Merritt Chase, 'I would rather go to Europe than to Heaven.'

The late nineteenth century was an era of cosmopolitanism, and the first, most famous and influential figure among these cosmopolitans, a man who influenced his whole generation, and then some, was James Abbott McNeill Whistler. Whistler was the first and most famous member of that trio of great expatriates, Whistler, Mary Cassatt and John Singer Sargent. He painted in Paris, London, Venice; and moved with ease through an international world of art which he helped to establish. He was born in Lowell, Massachusetts, lived in Russia for six years, studied painting in Paris and died in London. Yet after his death his artistic reputation in his native country suffered. The elegance and fastidiousness of his taste were ignored in favor of a more immediate and direct approach to painting. His work was considered too 'tasteful' and his conception of art as abstraction was often overlooked. Today the assessment of his art is better balanced and there is a renewed interest, not only in his work, but also in his wide sphere of influence. He not only was in the thick of the advanced art of his time, in many respects he went beyond it. As sympathetic as he was with the aims of his Impressionist friends, his mature art has more in common with the Post-Impressionists, with Gauguin, Redon and Maurice Prendergast than with Monet and his colleagues. In the development of his career

146

he started with the realism of Courbet, flirted with Pre-Raphaelism, was interested in the seventeenth-century Spanish and in Manet, until the formal conceptions and subtle nuances of Japanese art ultimately shaped his unique style. He scored his first sensation with *The White Girl* which he exhibited at the Salon des Refusés in 1863. From then on he became a figure to contend with and in the 1880s he began to attract a number of followers. There were few American painters studying in Europe in the 1870s and 1880s who were not in one way or another affected by his art or by his ideas. John Singer Sargent's work in Venice in the early 1880s bears resemblance to Whistler's work of the same period. The spatial relationships, the surface patterning, the tonal values and the quietist mood of Sargent's *Daughters of Edward Darley Boit,* painted in 1882, is highly reminiscent of Whistler's approach. The two men were both in Venice in 1880 and of course, as well-known expatriate artists living in London, they knew each other. William Merritt Chase was one of many artists who admired Whistler before they actually met. He first visited Whistler in 1885 and the two painted portraits of each other. Chase's painting, now in the Metropolitan Museum of Art, captured the flamboyance of the famous expatriate and is painted in Whistler's own style. Chase, always an eclectic artist, painted in a style reminiscent of Whistler at various stages of his career when he felt the moods suited the subject.

Even if there was not a direct influence on American artists Whistler's ideas were pervasive. He was an important member of the aesthetic movement, which held that art is a way of life and that its standards should permeate everything, from painting and sculpture to manufactured goods, from dress to interior decoration; that art is important, a higher ideal. He pursued the aesthetic theory of *l'art pour l'art,* derived from Théophile Gautier, in which he felt that an art object should stand on its artistic merits alone, apart from outside relationships, and should be judged accordingly. He felt that way about *The White Girl,* claiming that it was an exercise in pure painting. He pronounced it a study in subtle color harmony, and for a later exhibition in 1872 he changed the title to *Symphony in White No. 1.* The use of white as a color in itself was something that fascinated him, and his use of white in this picture is indeed subtle, yet there is a great deal of movement in it. In the cool white of the dress, the warm shadows move toward the warmer white background drape, and the warm beige white of the drape takes on a chalky yellow hue until it finally emerges as yellow ochre in the bearskin rug. It is a well orchestrated picture with pink flesh color repeated in the carpet and in the burnt siena color of the girl's hair providing the contrasting notes. Whistler began his series of paintings using the motif of the woman in white in 1861 and the problem continued to intrigue him. He later said of Canaletto that he could 'paint a white building against a white cloud. That was enough to make any man great.' The use of white as a color was – and is – an intriguing problem and it fascinated others as well, possibly through Whistler's influence. A subtle snow scene like *Winter Harmony* by John Twachtman is very Whistlerian in its sensitive relationship between color and mood. The same can be said of the winter scenes by Willard Metcalf and Birge Harrison, of some of the figure pieces by Sargent, Chase and even Mary Cassatt. Thus Whistler's style did have its effect, even on those American painters who brought back from Europe the full panoply of French Impressionist methods.

The White Girl was painted in 1862, eight years after Whistler was expelled from West Point. At the Point he had studied drawing under Robert Weir, the father of J. Alden Weir. Then after working for the United States Coastal Survey etching maps and topographical plans, he decided to become an artist. Accordingly he set out for Paris, arriving there in 1855, in the same year as Pissarro. He was twenty-two then, and although he never came back to the United States, he always thought of himself as an American artist.

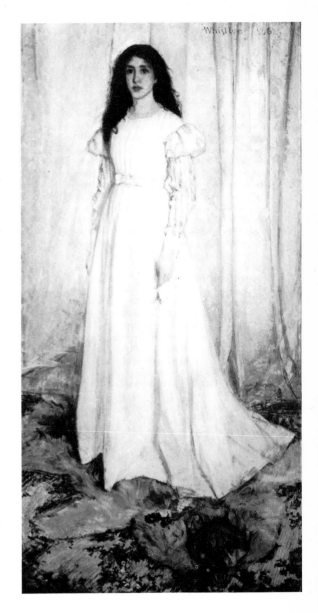

JAMES ABBOTT MCNEILL WHISTLER, *The White Girl.*
Washington, D.C., National Gallery of Art.

147

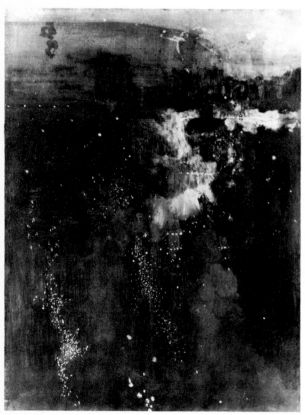

All through the 1860s Whistler was trying to shape his art, to find the direction and to perfect it. Then he discovered Japanese art, in particular the Japanese print. The Japanese print in its simplicity and boldness, its delicacy and strength, its new approach to pictorial construction and its novel presentation of space, provided Whistler with the means to pursue his search for an art based upon 'the science of color and picture pattern.' And in *Valparaiso: Crepuscule in Pink and Gold,* the simplicity of treatment and the evocation of infinite space is oriental in concept.

From 1868 to 1878 Whistler concentrated on making his way in England, and by 1873 he had arrived at the kind of painting for which he would ultimately become famous. He painted nocturnes, harmonies and portraits, and in 1871 he painted his famous *Arrangement in Gray and Black No. 1: The Artist's Mother.* In the next year he followed that with *Arrangement in Gray and Black No. 2: Thomas Carlyle.* The Scottish philosopher was persuaded to sit for Whistler after he had been taken to see the portrait of Whistler's mother. The similarity between the two is obvious; Carlyle is also dressed in black and is shown in profile against a gray background. In its patterning and in the careful asymmetrical balancing of the shapes Whistler's debt to the Japanese is clear and complete. Clear also is the influence of Velázquez in the use of the silhouette and in the subtle and restrained color harmonies. It is a stunning picture, one of his best, and for all its so-called objectivity – the use of the sitter as an object among other objects – Carlyle is depicted with sympathy and respect; the mood of the melancholy Scotsman is captured perfectly.

About 1874, the year of the legendary first Impressionist exhibition in the photographer Nadar's studio in Paris, Whistler painted *Nocturne in Black and Gold: The Falling Rocket.* It was exhibited in 1877 at the opening exhibition of the Grosvenor Gallery, and John Ruskin, who reviewed the show, was so upset by it that he called the artist 'a cockscomb' and accused him of 'willful imposture.' The result was the famous Whistler *vs* Ruskin trial which forced the artist into bankruptcy. The subject of *Nocturne in Black and Gold,* a fireworks display at Cremorne Gardens, was actually very closely observed and it reveals a combination of superb, subtle

color harmonies and a spontaneous freewheeling technique which is reminiscent of the later work of Turner. And it could almost pass as an Abstract Expressionist painting of the 1950s.

After the trial Whistler removed himself to Venice to try to recoup his financial losses by making a series of etchings for the Fine Arts Society, a London gallery. While there he not only produced a large number of etchings, but also watercolors, oils, paintings and numerous pastels for which he devised a new technique. He used a special brown paper which in itself constituted a tone and unified the feathery touches of the other colors and tones. The use of the brown paper was an idea of his own devising and allowed him to make a complete statement with the utmost economy of means. When Whistler returned to England from Venice his attitude was bitter and from the 1880s on he became an energetic pamphleteer and propagandist. This was the period also when he had to seek patronage abroad, on the continent and in America where he was beginning to gain a reputation. American artists began to seek him out and his friendship with most of them dates from this time. They were fascinated by his personality, his reputation and naturally by his technique. Théodore Duret, the well-known art critic and connoisseur whom the artist met in 1863 and who remained friends with Whistler until the latter's death in 1903 recounted his experience of sitting to him. 'It was always his plan to make an arrangement and when that arrangement was completed in his head he sought to realize it upon the canvas. In other words he held that when a painting is completed it should speak for itself.'[8] Whistler felt very strongly about the colors he used and their arrangement on his palette. His range of color was severely limited, but carefully considered, and as he put it, 'scientifically' organized.

Whistler has been the most widely discussed, publicized, and written-about artist in the annals of American art history. He was a flamboyant self-promoter as well. Concerned with developing the 'right' public image, he dressed for the part, and in the same way all of the time. A black frock coat, white trousers, patent leather shoes, top hat, a monocle, and he carried a long cane, his celebrated wand. Appearance to him, the right setting for himself was almost as important as the right setting for his pictures. Here once again he utilized some of the principles of Japanese art in the interior decoration of his house and for the installation of his paintings, both of which were well in advance of his time. For his exhibitions he designed a simple space in which one color predominated, usually yellow, white or gray, complimenting his art and unifying the whole room. The paintings were hung 'on the line,' in other words at eye level with plenty of space in between. His own studio was in tones of gray, and in his sitting-room he used gradations of yellow with notes of blue provided by his collection of blue and white porcelain. Judging by contemporary accounts, all of this must have been quite startling to Victorian sensibilities. Mrs H. O. Havemeyer, the famous American collector and friend of Mary Cassatt, described her visit to Whistler in the early 1880s:

I was so impressed with the lovely yellow light that seemed to envelop us and which began at the floor and mounted to the ceiling in the most harmonious gradations until you felt you were sitting in the soft glow of a June sunset. Near the window stood a blue and white Hawthorne jar which held one or two sprays of long reedy grass and in the center of the room there was a huge Japanese bronze vase. Whistler entered almost immediately. I gave a second glance I was persuaded that Whistler had made that room as a background for himself.[9]

Mrs Havemeyer bought five of his Venetian pastels, which she later presented to the artist's friend and patron, Charles L. Freer.

This self-promotion of his, the flippancy and wit, his theatricality, almost obscured his merit as a serious artist. Yet he was a tireless worker, inventive and willing to take risks. He made his mark, not only for himself, but upon his whole generation.

His celebrated 'wand' touched not only his immediate admirers, but such diverse talents as Sargent and Chase, Twachtman and Birge Harrison, Dewing and Hassam. The 'quietism' of his style is close to that of the Luminists and certainly to the pre-Impressionism of a Dwight Tryon or a Homer D. Martin.

Whistler went to Paris in 1859 and remained in Europe for the rest of his life. Winslow Homer went to Paris in 1867, stayed for less than a year, and returned to America to find his personal expression in American subject-matter based upon certain kinds of American experience. When Homer arrived in France he was already a professional artist, and two of his paintings, *Prisoners from the Front* and *On the Bright Side* ('a couple of little pictures taken from the recent war by Mr. Winslow Homer of New York'), were exhibited in the Fine Arts section of the Exposition Universelle in Paris that year. Not only was Homer's work in that show, but it was probably the first serious consideration of American art by any of the expositions held in Europe. Serious consideration also was given to Japanese art, and the exhibition of Japanese arts and crafts was one of the highlights of the Exposition, as they would be several years later at the Philadelphia Centennial of 1876. Homer was probably aware of Japanese prints before the Paris Exposition, possibly through his friend John La Farge who was interested in them in the early 1860s, and he always had a strong sense of pattern; but this was probably the largest showing of its kind ever assembled in Europe up to that time. Another exciting event in the Paris of 1867 which Homer could have seen was the exhibition of fifty pictures by Édouard Manet. Rejected by the Exposition committee, Manet rented a shed on the Place de l'Alma and exhibited his pictures at his own expense. Although Homer was independent and would not admit to influences, his work was probably affected by his stay in France. After 1867 he developed a more freely-brushed technique, a new feeling for texture, for the fluidity of paint and a stronger sense of immediacy.

Born in Boston, Winslow Homer was self-taught. He always had a strong sense of pattern, and like his younger contemporary Thomas Eakins, a feeling for the life around him. Homer began his career as an apprentice to a Boston lithographer. From there he went into freelance illustrating and soon became one of the best known illustrators in the country. His drawings for *Harper's* of the Civil War were outstanding for their honesty, sense of character and bold realistic draughtsmanship. And the painting which made his reputation, *Prisoners from the Front* of 1866, now in the Metropolitan Museum of Art, was taken from his war experiences. Although this picture gave him recognition, it was painting in the countryside that he liked best. Scenes of rural life, which he started to paint about 1864, predominate in his work during the 1860s and 1870s. At that time also, he depicted the world of fashion, painting and drawing in modish summer resorts on the coast and in the mountains. In most of these pictures it is the women who are shown engaged in outdoor activities, riding, picnicking, playing croquet. In the *Croquet Scene* for example, the atmosphere is idyllic and the ladies are stylish. Yet this is no fashion illustration; there is no sentiment as in Eastman Johnson's *genre* paintings, a tradition in which Homer's early work fits; nor is there a delineation of individual personality as in the work of Thomas Eakins, the one American artist to whom Homer is closest in spirit. Instead *Croquet Scene* painted in 1866, is revealing in its air of detachment and its strong feel for pattern which Homer had before he went to France. It is almost as though he utilized the 'look' of the day, the voluminous skirts, the puffed sleeves, ribbons as an exercise in pure form. And in his use of light he was close to Manet and Monet even before he could have seen their work. In fact Homer was close to Impressionism in many ways. He always paid close attention to the exact effects, not only of light, but of weather and time of day – just as

150

Boudin was doing on the Normandy Coast. Of one of his paintings he wrote: 'The picture is painted *fifteen minutes* after sunset – not one minute before – . . . You can see that it took many days of careful observation to get this. . . .'[10] And George W. Sheldon quotes Homer as saying, 'I prefer every time a picture painted out of doors,' and later, 'you will be glad to hear that I am painting again. I work hard every afternoon from 4:30 to 4:40, that being the limit of the light I represent, the title of my picture being *Early Evening*.'[11] Obviously Homer was concerned with light and he also studied what was then the laws governing color harmony, and he said of Chevreul's celebrated book on color that it is 'my bible' and 'you can't get along without a knowledge of the principles and rules governing the influence of one color on another.' Thus Winslow Homer progressed in his treatment of light from a luminous concept and tight manner of the monumental genre pieces of his pre-Paris days to the Impressionist concept of light through color in the manner of Manet or early Monet. But he never carried that principle as far as the French did, he never obscured form, in fact although he eliminated unnecessary detail, he stuck to that quiet observation of fact which was characteristic of American paintings in the nineteenth century. Although his work early on bore similarities to Impressionist practice he retained his Yankee independence. In other words Homer was a conceptual artist who used elements of Impressionist practice and elements from the Japanese print as a means to an end.

The looseness and fluidity of Homer's later work in oil is also undoubtedly due to his work in watercolor, a medium he began to use in a serious way about 1873. It suited him perfectly, and it was Homer who established watercolor as a major medium in American art, employing it with greater freedom and boldness than most of his European colleagues. And as his art developed he moved away from genre painting as such and began to explore the theme of man against nature. His visit to England in 1881 had a profound effect. He stayed at the fishing port of Tynemouth

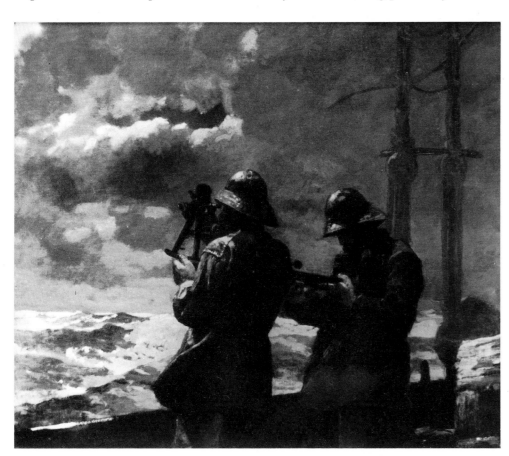

WINSLOW HOMER, *Eight Bells*.
Andover, Massachusetts, Addison Gallery of
American Art, Phillips Academy.

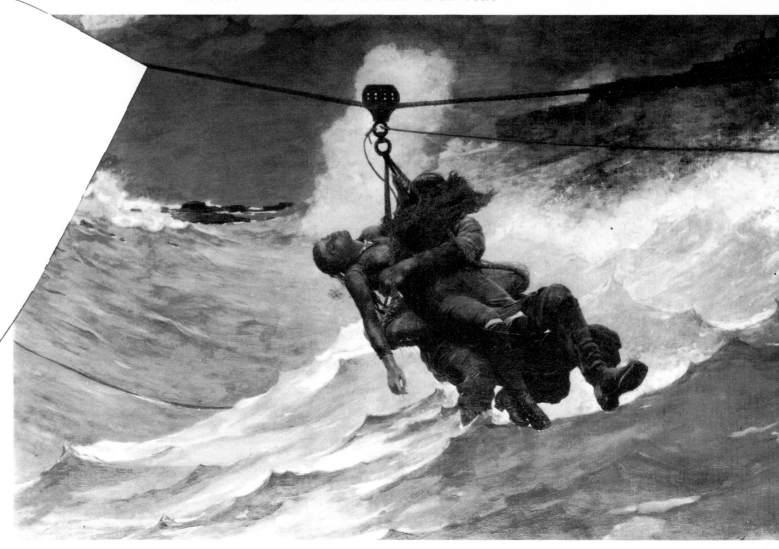

Above WINSLOW HOMER, *The Life Line*, 1884.
Philadelphia, Pennsylvania, Philadelphia
Museum of Art, George W. Elkins Collection.
Left WINSLOW HOMER, *The Wrecked Schooner*,
1910.
St Louis, Missouri, St Louis Art Museum.

Opposite JAMES ABBOTT MCNEILL
WHISTLER, *The Peacock Room*.
Washington, D.C., Freer Gallery of Art (by
courtesy of the Smithsonian Institution).

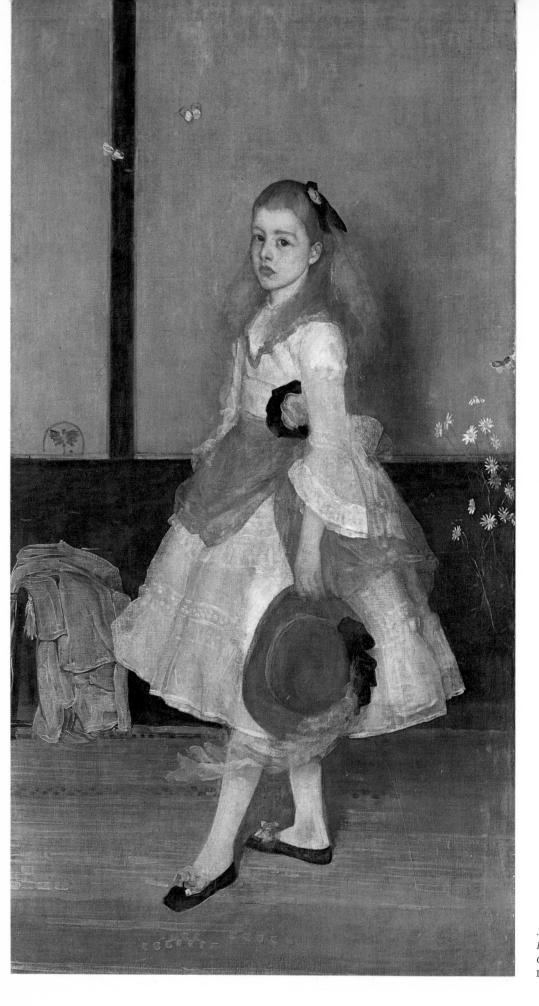

JAMES ABBOTT McNEILL WHISTLER,
*Portrait of Miss Alexander: Harmony in Gray and
Green*, 1872–4.
London, Tate Gallery.

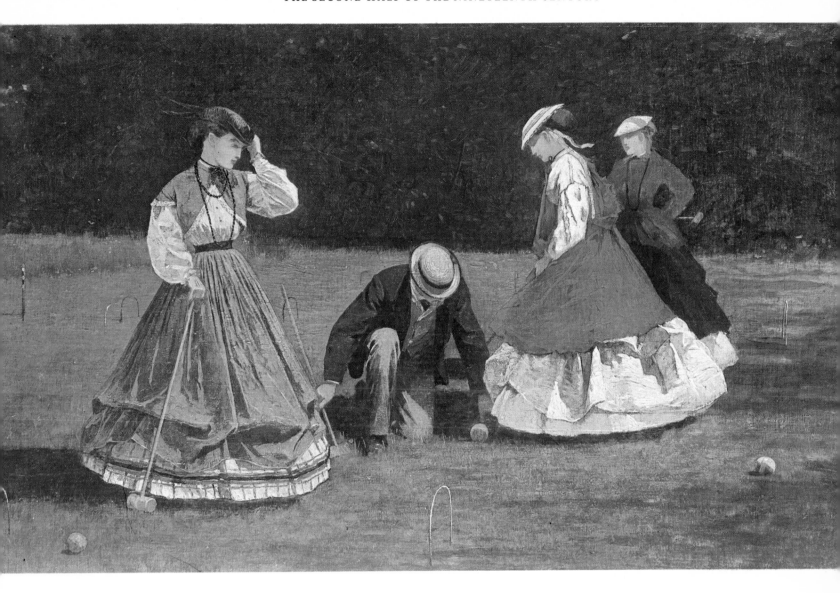

WINSLOW HOMER, *Croquet Scene*.
Chicago, Illinois, Art Institute of Chicago.

where he began to paint the sea and the men and women who had to contend with its every mood. His style changed once again, but this time more radically. Homer had found his subject, his concept and from that point on his work became more dramatic and emotionally charged.

When he returned from England he settled at Prout's Neck, Maine, and gradually became more and more of a recluse, an 'alienated' man in fact. At the very least he withdrew from the art world of his time, painting the isolated lonely aspects of the Maine coast and in particular the stark and challenging drama of the sea.

If *Croquet Scene* is a fine example of his earlier work, then *On a Lee Shore* is a superb example from his maturity. The concentration on the ocean and rocks in the foreground and, breaking on them in the extreme left of the painting, the huge and threatening spray, evokes the powerful presence of the sea. Man is in the background here, symbolized by the solitary sailing ship in the distance. The tiny ship gives the work its sense of scale and adds to the cool, but nonetheless passionate grandeur of Homer's conception.

Yet Homer was not an unpopular artist in the way Eakins was. He did have a market of sorts, albeit at very modest prices. His prices were nowhere near Bierstadt, Church or any of the fashionable Europeans, but he eked out a living. Perhaps the public attitude toward Homer was summed up by Henry James when he wrote:

155

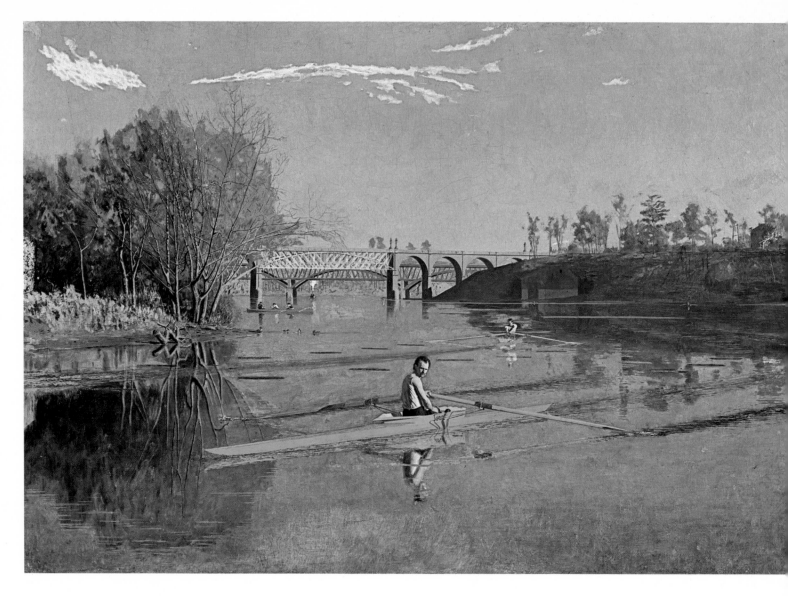

'He is almost barbarously simple, and, to our eye, he is horribly ugly; but there is nevertheless something one likes about him.'[12]

THOMAS EAKINS, *Max Schmidt in a Single Scull.*
New York, Metropolitan Museum of Art.

If Henry James' criticism of Homer was apt in the eyes of his contemporaries, so it would have been for Thomas Eakins, in fact perhaps more so. Eakins, a more important artist, never had even a modicum of the popularity of Homer, with whom he had much in common, and whom he considered the best living American artist.

Thomas Eakins was studying in Paris in the same year that Homer made his brief and sole visit. Eakins was enrolled in the studio of Jean Léon Gérôme then considered one of the best living French painters. Gérôme had developed a style of photographic naturalism, of minutely detailed and ingenuously contrived compositions of anecdotal or imagined dramatic episodes, which were popular in his day. They were greatly admired and brought huge prices. But Eakins was not really interested in Gérôme's subjects; what fascinated him was the Frenchman's controlled academic drawing and modeling, his realization of every detail. However, where Gérôme used his technique to achieve a rather trivial illustration, Eakins used the drawing he learned from him in a very personal and intense search for the truth. 'The big artist,' said Eakins, 'does not sit down monkey-like and copy.' Eakins found his 'big artists' in Spain which he visited in 1869 before returning home. Like Whistler and John Singer Sargent, Eakins was thoroughly impressed by

156

WINSLOW HOMER, *On a Lee Shore*, c.1900.
Providence, Rhode Island, Rhode Island School
of Design.

the Spanish masters. He found in Velázquez not only richness of technique, but a
concern for character rather than 'beauty.' The Spaniard's austere palette, his
marvelous use of blacks, grays and earth tones also struck a responsive chord in
the American painter. Eakins also found an affinity with the stark realism and the
solidity of Ribera. Unlike Whistler and Sargent, who were interested in the Spanish
painters for their decorative qualities and tonal harmonies, Eakins responded to
Spanish realism, its objectivity, thereby placing the three American painters, all of
whom were contemporaries, at opposite poles of American art.

Thomas Eakins was a pronounced individual from the start, and he knew that he
wanted to be an artist when he graduated from high school. He took drawing at the
Pennsylvania Academy of the Fine Arts and at the same time studied anatomy at the
Jefferson Medical College, the same medical college which eventually bought his
masterpiece, *The Gross Clinic*. Eakins was scientific-minded, and in a sense he carries
on or parallels, almost, the interest in science as expressed in the work of Frederic E.
Church, but for different reasons and in different aspects. For example his interest
in anatomy was extremely thorough and almost medical. Even though he disliked
dissection, he considered it essential to 'increase knowledge of how beautiful objects
are put together.' He had a passion for mathematics, and next to painting science
was his major interest.

In 1870 Eakins returned to America and occupied a studio on the top floor of his father's house. He was to stay there for the rest of his life, and unlike most of his fellow artists who returned from travel and study abroad, such artists as Duveneck and Chase for example, Eakins immediately began to paint the life around him; he never went back to Europe again. He painted in his community, the Philadelphia of his time; he painted his family, his friends, people he knew and respected, and he painted them in the midst of their daily activities. The activities Eakins himself enjoyed were anything connected with the out-of-doors, hunting for example, sailing and the popular Philadelphia sport of rowing. *Max Schmidt in a Single Scull*, painted a year after he returned from Euope is one of his best known early paintings. Max Schmidt is not only a portrait of a friend (Eakins himself is sculling in the distance), but a strong painting directly observed with a personality all its own, and with a completeness of vision that reflects the severe self discipline of his approach to art. His pictures are most carefully constructed thus embodying the objective truth not merely of a single momentary episode brilliantly reported, but of a time, a place and an attitude toward life, particularly an attitude toward life. The same totality of purpose runs throughout all Eakins' work, whether it is a small sketch, a large portrait, or a big complex figure composition such as *The Gross Clinic*. *The Gross Clinic,* painted in 1875, embodies his conception of art as well as his passion for science in the same inseparable way they were intertwined in his attitude toward life. In the well of the operating theater Dr Gross pauses, scalpel in hand, to explain a point of procedure. Eakins' use of light which illuminates the surgeon's face is masterful indeed, revealing as it does the thoughtfulness and character of one of the most important medical men in the nineteenth century. An additional element of drama (or melodrama), and a contrast to the atmosphere of scientific seriousness, is indicated by the patient's mother, in the lower left, who hides her face in horror. This is perhaps the one false note in the picture, but the patient might have been a charity case as existing law required the presence of a relative or member of the family in such cases. Nevertheless the painting's utter objectivity overall, the powerful dominating image of Dr Gross, and the complete realization of the artist's idea, the incredible power of expression were completely new and startling in American painting. It was so contrary to the prevailing notion of sentiment in art, that it was rejected by the art jury of the Philadelphia Centennial because its subject-matter was considered unfit for public exhibition. Although some of Eakins' other pictures were included, *The Gross Clinic* had to hang in the medical section. The masterpiece of his early career, it was shown by the Society of American Artists in 1879 and created almost as much fuss as Whistler's *Falling Rocket* in 1877, and later in 1884, Sargent's *Madame Gautreau*.

Eakins continued his scientific studies; he wrote a treatise on perspective and he was an expert photographer. In 1884, under the auspices of the University of Pennsylvania, he worked with Eadweard Muybridge the pioneer photographer, on a series of experiments in photographing horses and men in motion. In the course of these experiments Eakins contributed to the history of motion photography.[13]

At the same time Eakins was conducting his experiments at the University, he was also teaching at the Pennsylvania Academy of the Fine Arts of which he had been made director in 1882. He was a born teacher and he made some radical changes in the Academy. He had no use for the then current practise of drawing and painting from plaster casts; he made the living model, the nude model the basis of his system. 'Our business,' he said, 'is distinctly to do something for ourselves, not to copy Phidias.' Even live horses were used as models. He stressed anatomy, both human and animal, and a dissecting room was set up in the school. He gave lectures on perspective and his students began painting right away, drawing with color. He encouraged the study of sculpture so that painting students could learn to deal

with the solidity and weight of the figure. Altogether it was an extraordinary course of study for an American art school at that time. However he was considered too radical for the directors of the Academy, and in the famous controversy over his insistence on an entirely nude male model in a women's class, he resigned.

Although Eakins was at the height of his influence as a teacher and considered one of the leaders of a new American art, the break with the Academy disrupted his career. That, combined with his lack of sales and portrait commissions, turned him inwardly on himself. His painting was still concerned with humanity, but he concentrated more and more on the individual figure, devoting himself almost entirely to portraiture. It was not fashionable, this portraiture of Eakins', not in the manner of Sargent; nor did it have Whistler's rather more self-conscious elegance of style. Eakins was interested in truth. Beauty to him lay in the power of expression. His figure pieces were portraits of flesh and blood, individuals unique in their time and place. As in *The Thinker,* he sought the physical reality of the individual through his character. Like Dr Samuel Gross and many other portraits of the men and women who interested him, *The Thinker* (Louis N. Kenton, the artist's brother-in-law) is charged with humanity, insight and sympathy. There he stands, this *person*, as fine as anything painted by Velázquez, isolated in thought as he is in outline; but thoroughly three-dimensional, thoroughly solid and solidly alive, his absorption and isolation perhaps echoing Eakins' own. For by 1900, when this picture was painted, he had, it seems, given up making a living by his painting. There were few sitters in Philadelphia, or anywhere else, who dared to face his penetrating eye and the candor of his statement (he could barely *give* his portraits away). The public preferred idealization, particularly of women, or the virtuoso brushwork of John Singer Sargent; and from the late 1880s they preferred the aestheticism of Whistler and the soft, glowing colors of American Impressionism which was becoming increasingly popular in the early 1890s. As a result Eakins suffered from a neglect which was almost total and he slipped into obscurity until shortly after the turn of the century.

And although he had hundreds of pupils, even the impact of his teaching had a delayed effect, and it finally bore fruit after the turn of the century with the advent of Robert Henri and his circle. Henri, who studied with Eakins' pupil and successor Thomas Anschutz, and who went through an Impressionist training, finally realized and acted upon Eakins' strong belief that, 'if America is to produce great painters, and if young art students wish to assume a place in the history of the art of their country, their first desire should be to remain in America, to peer deeper into the heart of American life.'[14] Nobody ever peered deeper than he, and it was not until years later that it was discovered that here was a 'big artist' indeed.

Winslow Homer returned from France in 1867, Eakins in 1870, just before the great migration of American artists to European art schools in the last quarter of the nineteenth century. The styles the succeeding generations brought back, and the attention paid to them drove Eakins into virtual obscurity. During that time, in the late 1870s and 1880s Americans flocked to Europe at an ever-increasing pace, and Munich and Paris soon replaced Düsseldorf – the Mecca of the Hudson River School generations – as the most popular art centers of the day. But from the eighties on Paris became the star attraction; Paris was the place for intellectual ferment and artistic excitement, and above all the place in which to learn craftsmanship, to absorb the sense of dedicated professionalism to which American artists aspired. They came not to seek out the avant-garde, but to pursue the training and 'art atmosphere' they felt was lacking at home. Consequently they sought out the masters of the French Academy, the popular and successful Salon painters of their era. The *ateliers* of such painters as Gérôme, Bonnat and Bouguereau were thronged with

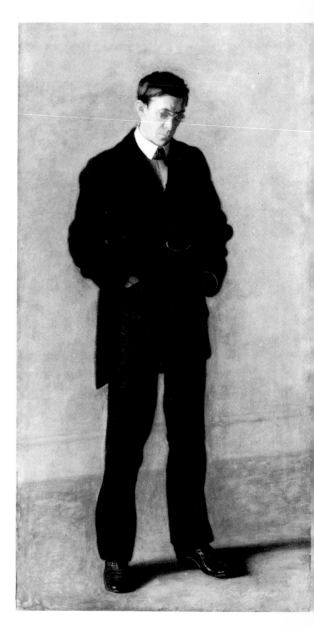

THOMAS EAKINS, *The Thinker, Portrait of Louis N. Kenton.* New York, Metropolitan Museum of Art, Kennedy Fund, 1917.

American pupils; and in 1874, the year of the Impressionists' first group show, and the year before Thomas Eakins painted *The Gross Clinic*, John Singer Sargent enrolled in the Paris studio of Carolus-Duran.

Sargent did not have to rush off to Europe to study painting; he was already there. He was born into a world of expatriate Americans living the life of 'taste' and leisure in Florence. His parents originally came from Philadelphia but they preferred to live in Italy, where Sargent received his first artistic training. He worked by himself at first, attending the Accademia in Florence and then he was accepted in Carolus-Duran's *atelier*. Duran was a skilled, but *chic* portrait painter who, like his friend Manet, was impressed with the work of Velázquez. He was considered very modern in the early 1870s, and he based his teaching on accuracy of vision, a careful control of tonal relationships and a direct, painterly attack on the canvas; all of which suited Sargent perfectly. He already had an exact and clear vision and he quickly absorbed all Carolus-Duran had to offer. Later Sargent too was impressed by Spanish painting, probably inspired by the interest and excitement he found in Carolus-Duran's studio, and reinforced by a trip to Spain in 1880. If *The Daughters of Edward Darley Boit* is somewhat indebted to Whistler, it is also strongly reminiscent of Velázquez. But the dash and *brio* are Sargent's own. He was a precocious painter, and he understood pure technique early on in the game; Impressionist technique for example. Although he was in Paris in the early 1870s when the French Im-

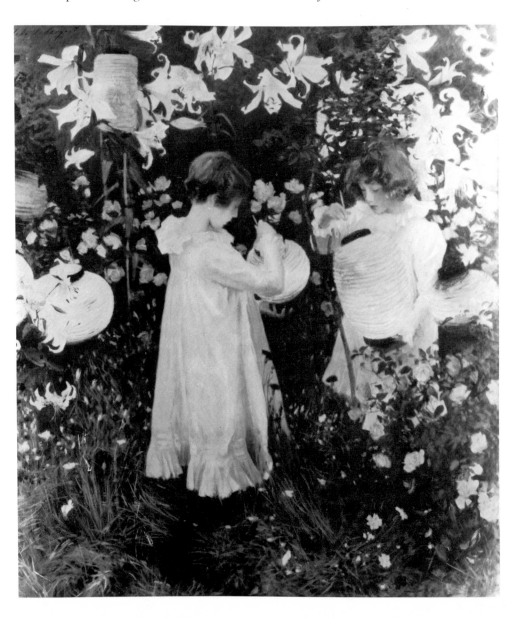

JOHN SINGER SARGENT, *Carnation, Lily, Lily, Rose*.
London, Tate Gallery.

pressionists were news, and even though he was influenced by the new painting to the extent of going through a brief Impressionist period, he was not dedicated to its philosophical premises. He was not in Monet's words 'a true Impressionist.' Sargent, like most American painters, was loath to give up 'the integrity of the object,' loath to fragment, break up form for the sake of an overall light. His use of light was not perceptual as in Monet, but conceptual, illuminatory. In 1885–6 in the artistic community of Broadway in the Cotswolds, Sargent painted a large subject picture of two children in a garden at twilight, with the additional light emanating from a series of Japanese lanterns. Called *Carnation, Lily, Lily, Rose,* it was as Sargent said, 'a fearful difficult subject.' He could only paint on it ten minutes at a time for one thing, yet despite the long period over which it was painted, it has immediacy; and despite the fact that it owes a little to the Pre-Raphaelites and a little to Whistler, the light is acutely observed and it was not painted in the studio. When it was exhibited at the Royal Academy it was probably the first time anything resembling an Impressionist picture had been hung in England. Impressionism broadened his style and enriched his palette, but his most Impressionistic pictures were done when he was off-duty so to speak, when he relaxed from the demands of portrait painting. In the case of *Carnation, Lily, Lily, Rose,* Sargent was sojourning in England where he was possibly recovering from the shock of the furore in Paris caused by his *Portrait of Madame Gautreau.*

A year earlier, in 1884, ten years after entering Carolus-Duran's studio, he had showed at the Salon his now famous full-length *Portrait of Madame Gautreau,* the celebrated Parisian beauty. It was an action that was to have a decisive effect on his career. Sargent probably met Madame Gautreau in 1881 and at once lusted to paint her portrait, writing immediately to a friend to intercede for him. 'You might tell her that I am a man of prodigious talent.' She finally acquiesced although she did not actually commission it and he began work on it in 1883. In the Isabella Stewart Gardner Museum in Boston there is a brilliant little sketch of *Madame Gautreau Drinking a Toast.* The large finished version, however, is more controlled in technique and more formal, even stylized in composition. The unnatural but elegant twist of the arm, the turn of the head, revealing an incisive and compelling profile, the black velvet gown, all combine to make this one of his most striking and important paintings. But nobody liked it. In fact it caused a great outcry and a public scandal. Madame Gautreau disliked it, her friends and family positively hated it, and the critics and public found the mauve color of her skin and her *décolletage* thoroughly shocking and immoral. Madame Gautreau's mother asked the artist to have it removed from the exhibition, but he curtly refused. Instead he removed himself to London in 1885. Thereafter he made London his headquarters, where he became a court painter of the Edwardian era, painting the Anglo-Saxon establishment of his day in both England and America. Like his fellow expatriates, Whistler and Mary Cassatt, John Singer Sargent was a cosmopolitan, moving easily through an international world of art, and of money. In his work he captured the careless elegance, the gilt of the Gilded Age; he used his abundant talent to catch the showy aspects of his era. He most effectively rendered the brightness of sunlight on beach, piazza or villa, the atmosphere out of doors or inside a room, the brilliance of hue in a white gown or the gleam on a polished boot, and, like William Merritt Chase, the glint and glitter of shiny surfaces. It was the kind of thing his patrons loved, a patron such as Lord Ribblesdale perhaps.

Sargent's 'gleam on a polished boot' is nowhere more evident than in his magnificent *Portrait of Lord Ribblesdale.* This portrait of the aristocratic sportsman and author of *The Queen's Hounds and Stag-Hunting Recollections,* is a singular example of what Donelson Hoopes calls Sargent's revival of The Grand Manner.[15] The sitter is dressed in riding attire and standing in front of a tall pilaster and elegant wains-

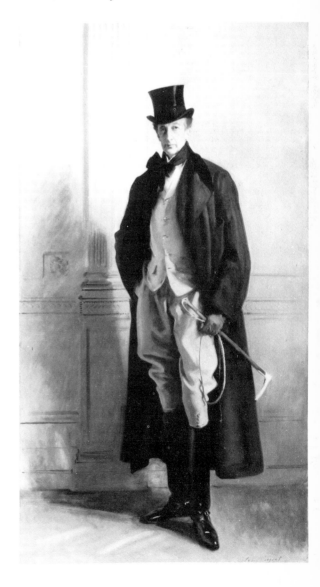

JOHN SINGER SARGENT, *Lord Ribblesdale.* London, Tate Gallery.

coting; the pose is casual yet assured. It is quite a different approach from that of Eakins' *The Thinker* or Whistler's *Carlyle*. The differences among them reveal three separate but concurrent styles influential in American nineteenth-century painting: the aestheticism in Whistler's obvious and self-conscious use of compositional devices – for even though Thomas Carlyle is painted sympathetically – the subject is treated somewhat impersonally and it is the artist's 'arrangement' which is the focus of attention; the realism of Eakins' work where there is a concern for the solidity of a figure occupying space and an objective search for truth of character, for individuality, as well as an attempt 'to peer deeper into the heart of American life;' the portrait painting of Sargent where there is an outward objectivity executed *con brio*, the objectivity of a man who once stated that he never went beyond 'the surface of things.' Eakins' *The Thinker* is a person, whereas *Lord Ribblesdale* is an 'image' in the current advertising sense of that word.

Sargent's combination of honesty of observation and European *chic* made him a success in his lifetime, but after his death he was roundly condemned for his superficiality. The angels were on the side of Thomas Eakins. Today however, there is a revival of interest in Sargent's pictures, not only for his virtuoso manipulation of point, but often for his grasp of character – as in *Madame Gautreau* and *Lord Ribblesdale* – and for his documents of a vanished era.

Frank Duveneck also painted *con brio*, but he was not *chic*. Henry James considered him a boor, but as a painter James admired his grasp of 'palpable reality;' and Sargent called him 'the greatest talent of the brush of his generation.' Duveneck was one of a group of American painters, including William Merritt Chase, John Twachtman, William Harnett and Henry Farny, who studied in Munich. Duveneck, born of German parents in Covington, Cincinnati's Kentucky suburb, was one of the first to go. In any case, Munich would have had a special appeal for American artists of German descent. So Duveneck went to that lively Bavarian city where he studied under Wilhelm von Dietz whose 'radical teaching' encompassed Frans Hals and Gustave Courbet. The Munich style was well suited to portraiture and figure work. A tonal approach, heads and bodies emerge from a dark background to give a startling three-dimensional effect; the forms are built up by planes of impasto and the overall impression is, as Henry James pointed out, one of 'palpable reality.' The *Whistling Boy*, painted in 1872, is all of those things; it is also typical Duveneck, and a typical Munich-style picture.

Like Sargent, Duveneck was a precocious painter. The Munich style suited him right down to the ground and he made it all his own. He was a big success in Munich, but not in Cincinnati to which he returned in 1873. Boston, however, was another story, and his one-man show at the Boston Art Club in 1875, one year before the Philadelphia Centennial, was a major triumph. Henry James was impressed, and said so in his review of the exhibition. Duveneck might have possibly repeated his Munich success in Boston, but he elected to return to Europe instead. It was in Europe at this time that he painted his best pictures and had his greatest influence as a teacher. He opened his own school there, then moved to Venice for the summer. Twachtman was with him for a while in Venice; William Merritt Chase was there and so was Robert Blum, and Whistler arrived in 1879 to lick his wounds after the Ruskin trial.

In 1888 Duveneck came back to Cincinnati to preside over the art academy. His final return to the Queen City was quite a different affair from that of 1873. This time he was an international success, but he did not paint very much and when the vogue for his kind of painting went out of fashion he was lost. The essence of his painting style and the secret of his popularity lay in the combination of the slashing brushstroke with the mellow tonality of an old master. But he was not a terribly intelligent artist and when he could not change, the world passed him by.

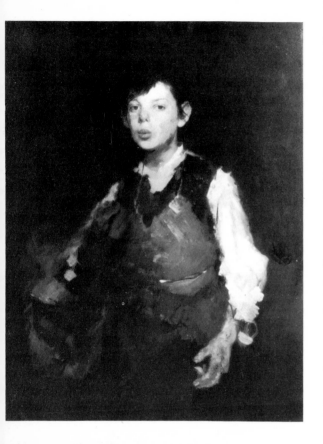

FRANK DUVENECK, *Whistling Boy*. Cincinnati, Ohio, Cincinnati Art Museum, Gift of the Artist.

Nevertheless Duveneck was a brilliant *alla prima* painter who helped change the course of American art; and he was a sympathetic teacher who trained many a good painter. The bluster and bravura of the Munich manner was a minor revolution in its time; it was essentially a tonal style rather than a color style, but the freedom of brushwork very probably helped pave the way for the acceptance of Impressionist painting in America.

William M. Harnett and Henry F. Farny also spent some time in Munich, but like Winslow Homer and Thomas Eakins their best known work was done in America using American subject-matter. But their subject-matter was special; and limited. Although they belong to the broader category of American realism, their concentration, their specialization place them somewhat outside the mainstream of American art; yet like the categories of folk art and the work of artist-naturalists, the *trompe l'oeil* still lifes of Harnett and the paintings of the American West by Farny are important aspects of American artistic expression.

There were quite a few gifted *trompe l'oeil* painters who were working in the last quarter of the nineteenth century, and notable among their number were John F. Peto, John Haberle, Joseph Decker and Richard La Barre Goodwin, but the greatest master working in this style was William M. Harnett. These painters carried the American demand for certain kinds of realism to its ultimate conclusion. The realism of Eakins was hard to take, but the realistic rendering of old books, a pipe, newspapers and Confederate currency gained total acceptance and generated wild enthusiasm. When Homer's best oils were selling for a couple of hundred dollars apiece and Eakins' splendid achievements went unrecognized and unsold, Harnett enjoyed a vogue similar to that of Bierstadt and Church in their salad days.

Like many other painters in this country, Harnett began his career as an apprentice to an engraver and he made a living engraving silver, first in Philadelphia, then in New York. During this time he studied drawing in both cities. He began painting still lifes in 1876 in Philadelphia, and in four years he made enough money to go abroad. But he went there with an American still-life tradition under his belt. Philadelphia, it has been said, had great numbers of talented painters, all of whom belonged to the Peale family. Harnett's early work was inspired by Raphaelle Peale, possibly the most brilliant still-life painter working a half century before Harnett's time. In Europe Harnett stayed mostly in Munich for the next six years and the pictures of this period are filled with German *Kitsch,* meerschaum pipes, elaborate beer mugs and the like; but he improved his technique and he discovered the seventeenth-century Dutch. His style became a composite of all three experiences, with a precision acquired from his training as an engraver. When he returned to the United States he began to paint his most famous pictures, such as *The Faithful Colt* of 1890.

The Faithful Colt is a portrait of an object, an old pistol, and it is painted with fantastic exactitude, from the texture of the rust spots on the metal barrel to the cracks in the ivory handle. In addition to the disturbingly complete degree of realism, there is, in the arrangement of the forms, a strong abstract organization which heightens the intensity of the objects and evokes an air of mystery and nostalgia about commonplace things. It also reflects the materialistic bent on the part of American society. *The Faithful Colt* not only deals with these effects, but is associated as well with the popular category of paintings of the American West.

The art of the American West is another special and perenially popular subject. The major concern of these artists, of course, was the depiction of Indians and Indian life, and although realistically done, the painting of the American Indian provided an exotic element in American art. Along with the exotic there was the knowledge that, as the country moved Westward, the Indian's way of life was doomed, and in the late nineteenth century, the frontier itself would soon be closed. Expeditions

WILLIAM M. HARNETT, *The Faithful Colt.* Hartford, Connecticut, Wadsworth Atheneum, Ella Gallup Sumner and Mary Catlin Sumner Collection.

often included artists in their complement of geologists, botanists and mapmakers, but in the 1830s the first artist of real professional ability to go West was George Catlin. Catlin felt that it was his mission 'to rescue from oblivion' the way of life of the 'native man in America.' He was followed in the 1840s, fifties and sixties by such painters as Alfred Jacob Miller and John Mix Stanley.

There was something of a documentary quality about the work of these men, but after the Civil War and in the era of Westward expansion an air of melodrama, in some cases tinged with nostalgia, crept into the work of the next generation of Western painters. Frederic Remington, Charles Marion ('Charlie') Russell and Henry F. Farny were the best painters of that last phase of Western art when the frontier and the personalities who were the stuff of its legends were rapidly vanishing. Russell was the typical artist-cowboy who himself lived what he painted; and Remington, of course, was the most famous of the three. He was accurate, and he was incredibly prolific, producing over 3,000 pictures.

Henry F. Farny is the least known of the three, but he is by far the best painter. Like Remington's, much of Farny's work, particularly his later painting, comes close to hackneyed illustration; but for the most part Farny looked deeper than the recorded event. And, as in *Toilers of the Plains*, he put the event in the context of art, not theater; he saw the Indians as an integral part of the landscape. And as a landscape painter he was very good indeed. In *Toilers of the Plains*, shown at the Paris Salon of 1882, Indian squaws loaded with bundles of wood wind their way through what appears to be a wintry and desolate landscape, symbolized by the skull of a cow in the lower right of the picture. There is an idea here, and a mood; the texture is rich, the tonal qualities suggest Munich. Farny spent a fair amount of time in Europe, studying at various times in Rome, Düsseldorf, Vienna and Munich. However his eventual subject-matter was obviously and intensely American.

Farny returned from Europe for the last time in 1873, Harnett in 1886 and Duveneck in 1888. All through the late 1870s and 1880s, as American artists returned to America fresh from the art centers and *ateliers* of Europe, armed with craftsmanship and a sense of the European artist's professionalism, they ran into trouble almost immediately. There was no support for one thing: American collectors preferred European paintings or the products of the stiffly conservative National Academy; for another, many of the American painters could not cope with the American environment, and could not forge their European training into a personal point of view. Some of them solved the problem by returning abroad, others made their way to New York, which was the closest city to Europe in atmosphere. They eked out a living by teaching, either at schools like the newly formed Art Students League, or by giving private instruction in their own studios. They pressured the National Academy to change and when it did not, they formed in 1877 the Society of American Artists. Eakins was in the new organization from the beginning, as was J. Alden Weir, Albert Ryder and William Merritt Chase. Chase was involved in the formation of the Art Students League as well; in fact he was involved in just about *everything* in the American art world of his day.

Chase was an outgoing man, ebullient and restless; he was a cosmopolitan man, an international figure who, from about 1878 to his death in 1916, traveled back and forth to Europe as much as he could. He solved the problem of the 'alienated' American artist for himself by his amazing energy, his constant activity in almost every phase of American art. He was a popular teacher, whose approach to art and life was almost as influential as that of Whistler, and certainly more so than that of Eakins, particularly after the latter had left the Pennsylvania Academy. In any case Eakins, though social, was something of a loner and the effect of his teaching did not 'take' until after the turn of the century. And his worth as an artist was not fully felt or appreciated until after his death.

Top HENRY F. FARNY, *Toilers of the Plain*.
Cincinnati, Ohio, Cincinnati Art Museum,
Lent by Edward Foote Hunkle.
Above WILLIAM MERRITT CHASE, *Duveneck Painting the Turkish Page*.
Cincinnati, Ohio, Cincinnati Art Museum.

Chase, on the other hand, was one of the most important artistic personalities in American art in the late nineteenth century. If Mary Cassatt thought J. Alden Weir would start an American school of painting, and if there ever was such a thing, Chase was it. From about the era of the Philadelphia Centennial, to the World's Columbian Exposition in Chicago in 1893, where six of his canvases were exhibited, Chase was the embodiment of nearly every artistic influence exerted on American painters in his time: still lifes and portraits in the manner of the National Academy, the silvery tonalities of Whistler, the bituminous bluster of Munich, the seventeenth-century Spanish and Dutch, the suavity of Manet and Sargent, the bright color and broken brushwork of Impressionism, all of which he utilized at one time or another and, it seems, at one and the same time. He was quite obviously an eclectic; but he was a brilliant virtuoso who, like Duveneck and Sargent, painted in a broad and spirited manner with a sense of elegance and élan. His paintings radiate a love of the *métier*, a love of paint for its own sake.

William Merritt Chase was talented from the start, even back home in Franklin, Indiana, where, at the age of seventeen, he began painting portraits on his own. He then made his way to New York where he studied at the National Academy for a while. When he was twenty-two he set up shop in St Louis, Missouri, where his work so impressed a group of businessmen that they raised the money to send him to Europe, and occasioned his celebrated comparison between Europe and Heaven. So in 1874 Chase went to Munich and entered the studio of Karl von Piloty. Munich and Chase, it seems, were made for each other, and like Duveneck, Chase was a skillful painter who quickly absorbed the Munich manner which he employed with gusto and verve. In 1875 together with Frank Duveneck he opened a studio in Munich where Chase's long and full career really began. At that time he painted *The Turkish Page*. Duveneck did the subject first, then Chase painted Duveneck painting *The Turkish Page*. Chase's version is almost indistinguishable from Duveneck's in its full bluster and bravura of the Munich style. He was offered a teaching post at the Royal Academy in Munich but he declined. Instead he returned to America in 1878 and settled in his famous Tenth Street studio and started teaching, both privately at his own studio and publicly at the Art Students League. He traveled extensively. In 1881 he toured Paris with J. Alden Weir, and at Chase's instigation Weir bought Manet's *Boy with a Sword* and *Lady with a Parrot* for the collector Irwin Davis. Shortly thereafter Davis gave the pictures to the Metropolitan Museum of Art in New York, where they were perhaps the earliest Impressionist pictures to enter an American public collection. In the summer of 1882 Chase was in Spain, France and Holland. He was again in Europe in 1883 and in 1884 he stayed for a while in Zandvoort, Holland, where he experimented with *plein-air* painting in the company of Robert Blum. Also in 1883 Chase painted the *Portrait of Miss Dora Wheeler*, one of his most distinguished efforts, and in the same year he and his friend Carroll Beckwith organized a benefit exhibition of modern French painting for the purpose of raising money for the Statue of Liberty, which was given to the United States by the French government in 1883. The show included a number of French Impressionists and it was the first time prior to Durand-Ruel's major exhibition of French Impressionism in New York in 1886, that their work was seen in depth.

The *Portrait of Miss Dora Wheeler* is painted in an Impressionist style, but the composition is very much Whistler. This picture was shown for the first time in the Paris Salon of 1883 along with Whistler's *Arrangement in Gray and Black No. 1: The Artist's Mother*, to which it bears some resemblance. *Arrangement in Gray and Black* was shown at the Royal Academy in 1872 and later at the Philadelphia Centennial in 1876. However, the strongest influence on Chase at that time was the modified Impressionism of the Belgian painter, Alfred Stevens, whom Chase admired extravagantly. The *Portrait of Miss Dora Wheeler* can be called a

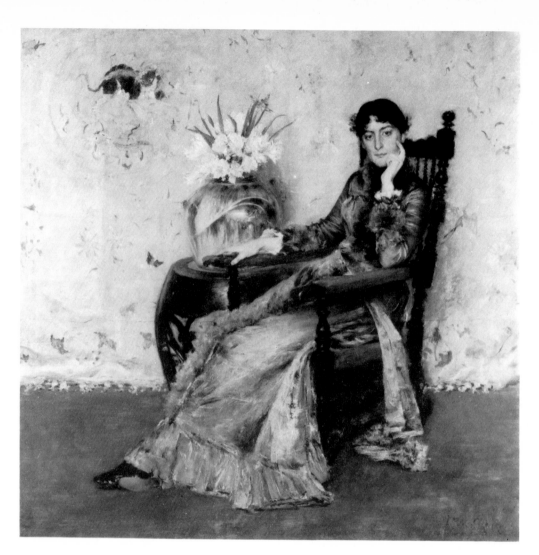

WILLIAM MERRITT CHASE, *Portrait of Miss Dora Wheeler*.
Cleveland, Ohio, Cleveland Museum of Art, Gift of Mrs Boudinot Keith, in memory of Mr and Mrs J. H. Wade.

WILLIAM MERRITT CHASE, *Shinnecock Hills*.
Southampton, New York, Parrish Art Museum.

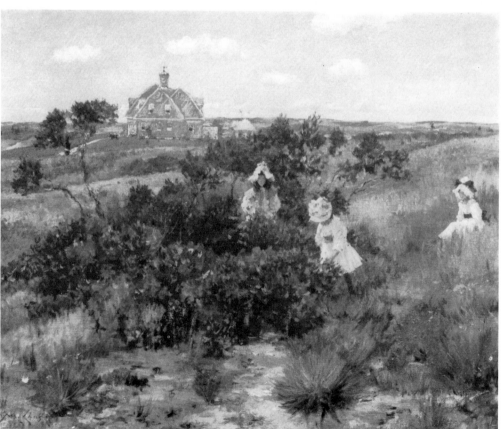

harmony in blue and gold, and with its sympathetic treatment of the sitter, its complex organization, yet clarity of conception, it remains one of the masterpieces of his career. Had Chase seriously pursued the Impressionist style, as Mary Cassatt and Robinson did, he would have been one of the earliest Americans to take that step.

In 1885 Chase developed a friendship with Whistler and his portrait of the great expatriate dates from that time. In 1886, the year of Durand-Ruel's New York show of three hundred Impressionist paintings, Chase was given a one-man show at the Boston Art Club, and like Duveneck's exhibition eleven years before, it was a tremendous success. But then Chase was a success in nearly everything he did. When he embarked on an Impressionist style, in, for example, a picture like *Shinnecock Hills,* he might have been painting that way all his life. In 1892 Chase had built a summer house in Shinnecock, Long Island, and conducted classes there. In *Shinnecock Hills,* against a backdrop of sky, open terrain and his McKim, Mead and White house, three little girls in white play in the fields. Executed with Chase's brilliant and inimitable brush, its charm and sparkle recall Sisley; and it is as good as anything Sisley ever painted.

The year he died Chase was given an honorary degree by New York University, adding to the extraordinary number of honors and awards he had accrued during his career both at home and abroad. With his death the American art world lost one of its most dedicated artists. An artist whose professionalism was sometimes over-shadowed by his theatrical life style. Outside of Whistler, William Merritt Chase was the most flamboyant American artist of his time. And although he was an international figure, New York rather than London was his stage. Chase brought to New York what was then called 'art atmosphere.' He was a star; he wore a pointed beard and a dashing waxed mustache; he would appear on Fifth Avenue wearing a Munich student's cap on his head and walking a huge white wolfhound on a leash. He had the biggest of the celebrated Tenth Street studios and he moved in with his wolfhound, and his birds and jammed it full of exotic bric-à-brac collected on his travels. He had colorful textiles, art pottery and brass pots, musical instruments and oriental screens, all of which were used, at one time or another, as 'props' in his pictures. Dapper and energetic, he was as successful at teaching and influencing taste as he was at making paintings; and as a painter he was a master at what the French call *la bonne peinture.* His realism was tempered by a love of paint and a seductive style. That style, if anything, was eclectic; he borrowed from everybody, and his work, depending on the occasion, is close to that of Frans Hals, Frank Duveneck, Alfred Stevens, Whistler, Sisley, Manet and Sargent. Chase was not an aesthete like Whistler, a philosopher like Twachtman or single-minded like Eakins. Rather, he was pragmatic. He suffered no identity crisis; for all its eclecticism Chase's work is stamped by the benchmark of his strong personality.

William Merritt Chase, though never an expatriate like Whistler, Sargent and Mary Cassatt, was nevertheless a cosmopolitan artist, an internationalist and despite his efforts on behalf of American art (he was president of the Society of American Artists for nearly ten years), he represented the European influence. On the other hand, Harnett and his followers, along with Farny and Remington represent or reflect an American demand for descriptive realism; their art was limited to special categories, *trompe l'oeil* painting and the painting of the Far West, each of which was very American in approach to their respective subjects. However these artists were producing their mature work in the late 1880s and 1890s when the European influence on American painting had its greatest impact since the eighteenth century. This time the impact came not from London but from Paris; French Impressionism had finally reached these shores and submerged the American art scene in its bright and varigated color.

167

But while that last and most influential European style to affect American nine-teenth-century painting was making itself felt, George Inness and Albert Ryder were pursuing their solitary careers as artists working in the imaginative strain, a style which has been a constant but somewhat minor player in the stronger theater of American realism. There are, loosely speaking, two sides to the coin of American imaginative painting, the 'outer-directed' decorative work of Abbott Thayer, John La Farge, Elihu Vedder and Kenyon Cox and the more 'inner-directed' subjective painting of George Inness and Albert Ryder.

The work of Inness and Ryder, along with the moonlight scenes of Ralph Blake-lock, was representative of a later form of Romanticism basically deriving from the work of Allston, Cole and Quidor earlier in the century. George Inness was one of the most gifted landscape painters in the nineteenth century. He transformed the romantic realism of the Hudson River School into a subjective and dreamlike expression. Largely self-taught, he gradually developed a broadly naturalistic approach dissolving the linearism of Asher B. Durand and even the later school of Luminist painters into a pervasive atmosphere expressed by a free, loose handling. He felt that 'a work of art does not appeal to the intellect, it does not appeal to the moral sense, its aim is not to instruct, not to edify but to waken an emotion.' In this sense he repudiates the moral basis of the Hudson River School and its offshoots, substituting personal expression for God's expression, in a manner of speaking. Inness went to Europe frequently, he visited at Barbizon and fell under the spell of Millet and the others who were painting out-of-doors in the picturesque forest of Fontainebleau. In 1870 he spent four years abroad, mostly in Italy where he wandered in the Campagna and painted the Alban Hills south of Rome. After 1875, through the patronage of Thomas B. Clark, Inness' work gained public recognition. At that time his pictures were moody and showed the influence of the Barbizon School, in particular the work of Corot whom he admired. Toward the end of his career, however, he came increasingly under the spell of Swedenborgian mysticism and his style suggested an other-worldly quality. His palette brightened – probably inspired by Impressionism – even though he hated that style. Nevertheless the color and handling of *Near the Village, October,* painted two years before his death, reveal an Impressionist influence. Although Inness' painting was extremely subjective, he used nature as his scaffolding, and onto the structure of a quiet observation of fact, he built his transcendent Swedenborgian vision. Albert Ryder, on the other hand, went much further. Building his pictures from imagination and memory, he was the most original of the nineteenth-century American painters, a true visionary. He would carry an idea around in his head for several years before touching paint to canvas. 'The artist,' he once said, 'must buckle himself with infinite patience, his eyes must see naught but the vision beyond.' His vision grew, and as he worked on his paintings, piling impasto on impasto, his forms developed organically, slowly, until his idea reached its final realization. And his ideas were expressed with deceptive simplicity; that is, the forms are large, simple, direct and closer even to pure abstraction than those of Whistler. *Toilers of the Sea* is free of all anecdotal and irrelevant detail. Moon, clouds, sea and sailboat are, at one and the same time, both shape and sign; almost ideographic in its directness, *Toilers of the Sea* is moody and mysterious as well.

Ryder was born into an old seafaring family in New Bedford, then the greatest whaling port in the world, and the house in which he grew up was right across the street from that occupied by Albert Bierstadt's family. Ryder later moved to New York City, but the sea remained with him all his life, and like his opposite in style, Winslow Homer, the moods of the sea occur again and again in his paintings. Although he was self-taught, he did study at the National Academy. But more important was the informal teaching of William E. Marshall, portraitist and engraver,

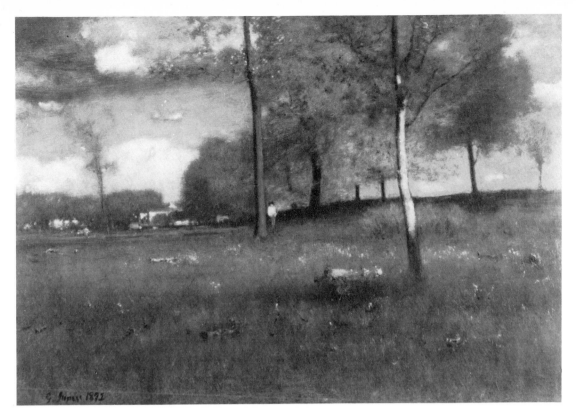

GEORGE INNESS, *Near the Village, October.*
Cincinnati, Ohio, Cincinnati Art Museum,
Gift of Mrs Emilie L. Heine, in memory of Mr
and Mrs John Hanck.

ALBERT RYDER, *Toilers of the Sea.*
New York, Metropolitan Museum of Art,
George A. Hearn Fund, 1915.

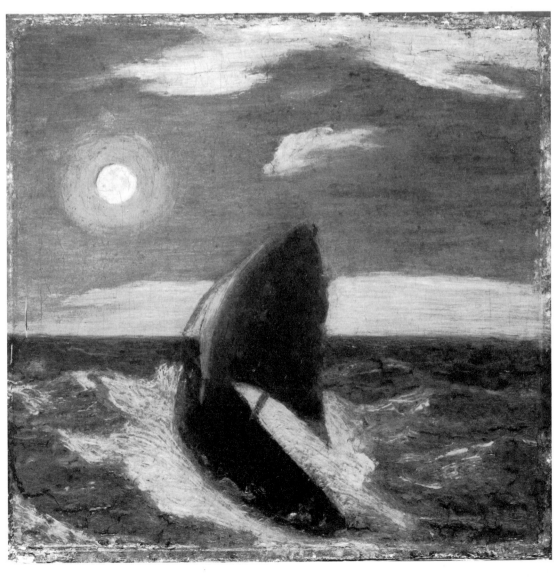

whose paintings of romantic and religious subjects attracted Ryder. However he continued to paint landscape as he had always done, constantly searching for original solutions to his artistic problems. Later in his life he described the turning point of his career. Growing weary with studying the Old Masters, he went out into the fields,

determined to serve nature as I had served art. In my desire to be accurate I became lost in a maze of detail, try as I would my colors were not those of nature. . . . My finest strokes were coarse and crude. 'The old scene' presented itself one day before my eyes framed in an opening between two trees. It stood out like a painted canvas – the deep blue of the mid-day sky – a solitary tree brilliant with the green of early summer, a foundation of brown earth, knarled roots, there was no detail to vex the eye. Three solid masses of form and color, sky, foliage and earth – the whole bathed in an atmosphere of golden luminosity. I threw my brushes aside, they were too small. I squeezed out big chunks of pure moist color and taking my palette knife I laid on blue, green, white, brown in great sweeping strokes. As I worked I saw that it was clean, good and strong. I saw nature springing to life upon my dead canvas. It was better than nature, for it was vibrating with the thrill of a new creation. Exultantly I painted until the sun sank below the horizon, then I raced around the fields like a colt let loose, and literally bellowed for joy.[16]

Ryder's earlier landscape work, a landscape perhaps, like *Pastoral Study* was more naturalistic than his later work, and they are reminiscent of New England scenery, with its old stone walls, rocky pastures, wooded lots. He was able to exhibit only twice at the National Academy, so in 1877 he became one of the founders of the Society of American Artists.

After 1880 he departed from his naturalistic style and began to work more and more in a purely imaginative vein. His landscapes, like those of Gauguin and the Symbolist painters in Europe, were painted from memory and imagination. Familiar forms were transmuted into dream-like elements seen in a softly glowing light. His

ALBERT RYDER, *Pastoral Study.* Washington, D.C., National Collection of Fine Arts, Smithsonian Institution, Gift of John Gellatly.

color was dark and sonorous, his pictures small in size and intensely personal; Ryder's work was definitely a world into itself. His ideas were often inspired by literature and music. He drew on the great poets of the English-speaking world – Chaucer, Shakespeare, Byron, Tennyson, Edgar Allan Poe. One of his sources was the opera of Wagner and another the Bible. But his work was never literary or anecdotal in the way that the Salon paintings were; they were not illustrations. His visual imagination reached for the great themes of literature, his personal conceptions transforming them into expressive form. In his work, whether seascape or landscape, nature plays an essential role. It is never just a backdrop for the human figure in the theater of his mind, but an integral part of his conception. And he used the elements of nature in a very free way, distorting them or discarding them to get to the essence of his idea. The artist, he said, 'should strive to express his thought and not the surface of it.' Thus he anticipated the Expressionist movement. In *Jonah* for example, the power of the waves literally bend the boat, forcing it to conform to their shape. Jonah has been thrown overboard and the whale, in the shape of a giant fish – a monster out of Bosch or Breughel – moves relentlessly toward his victim. But above, near the darkened sun, a Blakian God signifying hope, looks down on the scene. For Ryder, as for Melville and Whitman, the sea was the symbol of eternity; it was infinitely vast, timeless, and like life itself, subject to moods of both terror and peace.

Albert Ryder sold little in his lifetime and as he grew older he became more of a recluse, but he did show at the exhibitions of the Society of American Artists, and through the efforts of the perceptive dealer, Daniel Cottier, he attracted the attention of a small group of discriminating collectors. His reputation was confined to these few collectors and to a couple of dealers and some fellow artists. To the art world at large he was all but totally unknown. In fact so ignored was he that the selection committee for the American art section of the World's Columbian Exposition in Chicago completely passed him by. Yet although his haunting images were virtually ignored in his lifetime, after his death his work was much forged and he influenced generations of younger artists from Marsden Hartley to Jackson Pollock.

At the annual exhibition of the Society of American Artists in 1890, the year Harnett painted *The Faithful Colt*, Theodore Robinson won the Webb prize; it was the first time this most important cash award was given to an American Impressionist painter. In addition there were more Impressionist pictures hanging on the walls than at any of the Society's previous annuals. The acceptance of the Impressionist style was accelerating rapidly until by 1900, the year Eakins painted *The Thinker*, there was hardly a painter in the mainstream of American art who was not in some way touched by its influence.[17]

In 1893, the novelist and critic Hamlin Garland wrote enthusiastically on the art section of the World's Columbian Exposition. 'If the Exposition had been held five years ago,' he observed, 'scarcely a trace of the blue shadow idea would have been seen outside the work of Claude Monet, Pissarro and a few others of the French and Spanish groups.' By that time Impressionism had affected 'the younger men of Russia, Norway, Sweden, Denmark and America.' If the Philadelphia Centennial of 1876, with its early eclectic architecture, its giant Corliss engine, and the impact of European art and artifacts, symbolized a rising interest in the machine and gave expression to an increasing cultural dependence upon Europe, the World's Columbian Exposition could be considered a culmination of that dependence. In the Centennial the Fine Arts section allotted to the United States was dominated by the landscape painting of the 'native school,' the Hudson River School, its adherents and its followers. The exposition in Chicago, on the other hand, was a particular triumph of a generation of Paris-trained American artists – painters, sculptors and architects.

171

Opposite THOMAS EAKINS. *The Gross Clinic.* Philadelphia, Pennsylvania, Jefferson Medical College.

MARY CASSATT, *Mother About to Wash her Sleepy Child.*
Los Angeles, California, Los Angeles County Museum of Art, Bequest of Mrs Fred Hathaway Bixby.

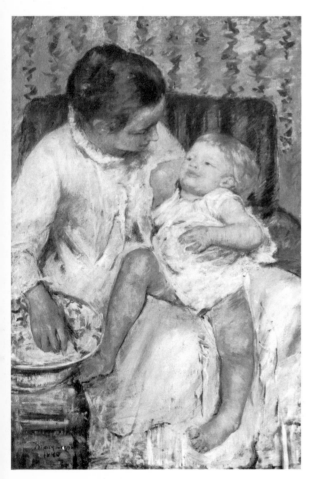

Beaux-Arts historicism, the 'classic' style in all its permutations of Renaissance forms rose in white plaster on the shores of Lake Michigan. It was an outstanding example of what has been called 'the Renaissance complex' in American culture. The leading muralists of the day were called in, as were the leading sculptors, to work with such established architects as Richard M. Hunt, McKim, Mead and White, Burnham and Root. The gathering of the architects alone caused St Gaudens to remark that 'this was the greatest meeting of architects since the fifteenth century.' It was a gigantic French wedding cake, and inside the United States section of the art gallery, with its Ionic order 'of the most refined type,' the wedding ceremony was splendid. Unlike the Philadelphia Centennial, the largest amount of exhibition space in Chicago was reserved for the United States, and the resulting American progeny ranged in style from slick Beaux-Arts Salon pieces, through renditions of the Barbizon Forest, to the homegrown version of French Impressionism which so excited Hamlin Garland.

Of the major American figures to adapt successfully the Impressionist palette and make of it a strong personal statement, Mary Cassatt was the first. She not only absorbed the style but was considered an actual member of the French Impressionist group, to which she was invited by Degas in 1877. She exhibited with them from 1879 until 1886 and she was also the first American Impressionist to exhibit some of her work in her native country. In 1878 she sent three of her paintings to an exhibition held in the Department of Fine Arts of the Massachusetts Charitable Mechanics Association. In 1879 she participated in the annual exhibition of the Society of American Artists and in 1886 her work was included in Durand-Ruel's New York triumph. Yet her early schooling was conventional enough.

From 1861 to 1865 she studied at the Pennsylvania Academy of the Fine Arts. Thomas Eakins was a fellow student, and like Eakins she found the course of study tedious, although she stayed for four years. Then also like Eakins, Mary Cassatt left Philadelphia for Paris in 1866. She returned to the United States during the Franco-Prussian War and in 1872 went to Italy. There she studied with Carlo Remondi of the Academy of Palmer for about eight months, after which she traveled to Spain, to Belgium to look at Rubens and to Holland where she copied Frans Hals. In the same year she had her first picture accepted in the Paris Salon under the name of Mary Stevenson. In 1873 she was back in Paris. Mary Cassatt's early work was strongly modeled and dark in tone after the manner of the Spanish and Frans Hals, but after 1874 her palette brightened. Like Whistler, whose work she respected, Mary Cassatt was a dedicated admirer of Degas. Although she was already working in an Impressionist manner before he asked her to join the group, the work of Degas had always meant a great deal since her arrival in Paris. She also once remarked that she hated conventional art; her 'true masters' were Courbet, Manet and Degas. Degas liked her work from the beginning and they maintained a close relationship for forty years. He criticized her art and even worked on one of her paintings. Throughout the late 1870s and early 1880s Mary Cassatt continued to benefit from Degas' influence and his serious criticism. She used many of his compositional devices derived from the photograph and the Japanese print, the idea of placing figures on the extreme ends of canvas and cutting off portions of the figure which creates an atmosphere of intense immediacy and suggests the feeling of continuous action. In 1880 Mary Cassatt began her celebrated studies on the mother and child theme, and *A Mother About to Wash her Sleepy Child* is one of the first. Thereafter she became known as the painter of *maternité* and to some as a painter of limited imagination who restricted herself primarily to this theme. However, as Adelyn Breeskin points out, there are more portraits and figure pieces in Miss Cassatt's total output than there are of the *maternité* motif.[19] *La Loge* for example, with its juxtaposition of line and painterly method, its interplay of contrasting

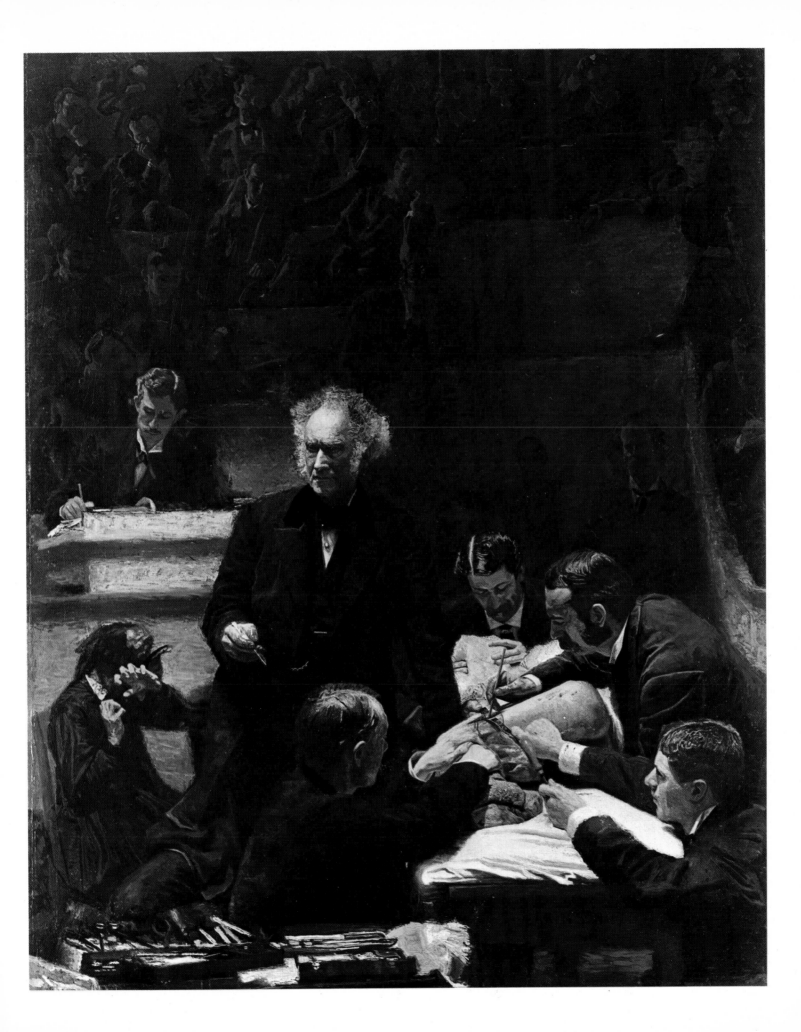

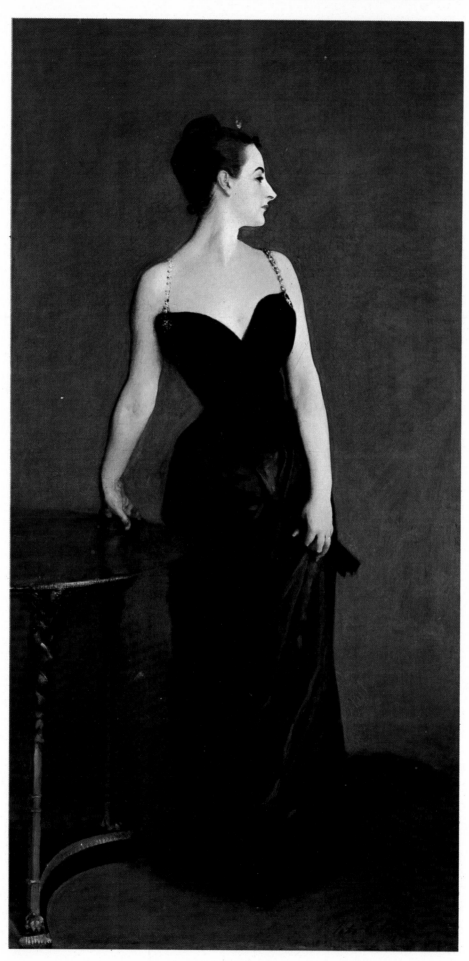

JOHN SINGER SARGENT, *Madame Gautreau*.
New York, Metropolitan Museum of Art.

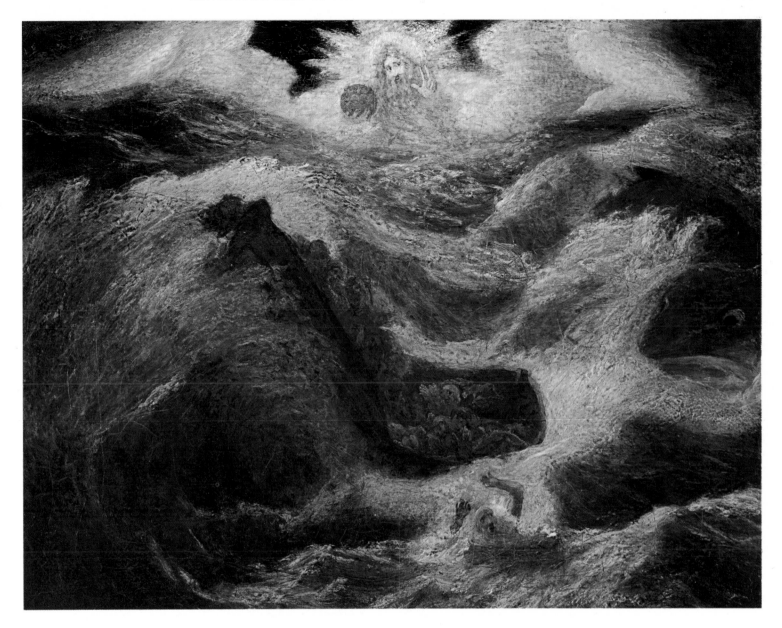

ALBERT RYDER, *Jonah*.
Washington, D.C.
National Collection of Fine Arts
Smithsonian Institution.

textures and organization of form recalls Manet as well as Degas. Even though she might have painted a number of other subjects, she certainly painted enough variations on the theme of mother and child to justify being typecast by the public. Like those artists who were indefatigable self-portrait painters, Mary Cassatt's pattern of development can be traced by way of her mother and child pictures. *A Mother About to Wash her Sleepy Child* was painted in 1880 in a loose Impressionist style. It also somehow has the feeling of Dutch genre painting, of Chardin, and the lovely gradations of the white in the child's frock and the gray in the mother's dress are very close to Whistler.

In the late 1880s and 1890s she departed from a loose Impressionist approach and her style became more linear and schematically inclined. She developed a large, luminous manner, a heightened sense of form and a feeling of permanence such as that evoked in *Emmy and her Child*. Painted in 1889, it is one of the most impressive of Mary Cassatt's mother and child pictures. It recalls Degas of course, but in the arrangement of the shapes and patterns there is also a debt to the Japanese print, elements of which she had begun to use in the 1880s. She was also one of the first artists to admire Persian miniatures.

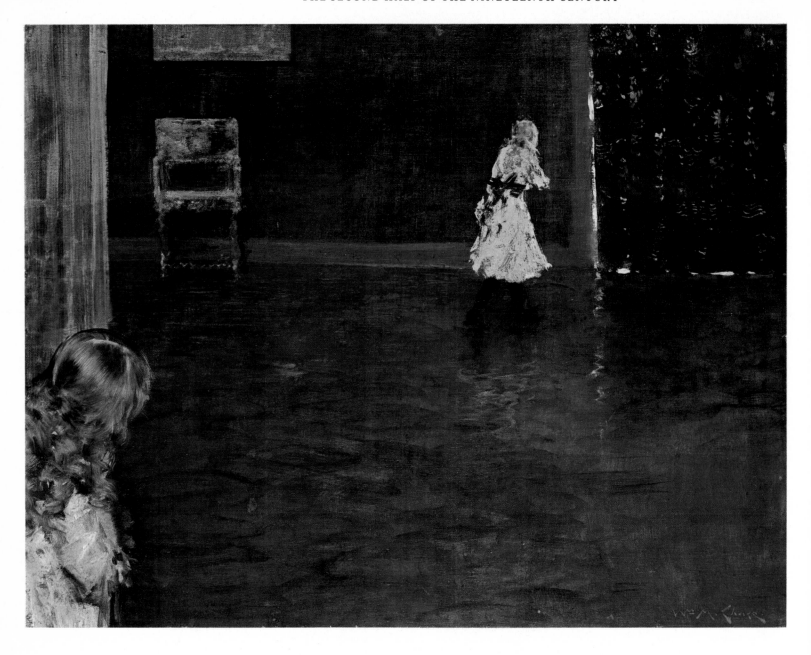

WILLIAM MERRITT CHASE, *Hide-and-Seek*.
Washington, D.C., Phillips Collection.

Like Whistler and John Singer Sargent, Mary Cassatt is also placed in the context of American expatriates cut off from their native soil. But again like Sargent and Whistler, she remained strongly American in her sentiments and always thought of herself as an American artist. Stylistically she was obviously much closer to Degas than to any of the other Impressionists, or to any of her American contemporaries except Whistler. She made the most complete statement of the *maternité* theme in her time and, as in the case of Whistler's nocturnes, any other painter handling the subject would be inevitably compared to Mary Cassatt. Her style was perhaps not as original as Whistler's though it was very personal, indicative of her independence of mind, yet unlike Whistler she never had a following. Her style *per se* was not influential even though she herself was instrumental in introducing French Impressionist paintings into American collections. She persuaded her friends to buy the work of her 'little group of independents,' as she called them.

Mary Cassatt was probably the only American Impressionist to be so strongly influenced by Degas. Édouard Manet was looked at with interest, but the major

176

Above MARY CASSATT, *La Loge*
Washington, D.C., National Gallery of Art,
Chester Dale Collection.

inspiration, the main catalyst for the style that was exported from France in the late 1880s was Claude Monet, and his particular style was brought back by his informal pupil Theodore Robinson.

After Mary Cassatt, Theodore Robinson was the next major American painter to successfully achieve what John Bauer has called 'a wedding of French born Impressionism to American art.'[20] And he was the first to bring it back to the United States. His work was not as well known in his lifetime as that of William Merritt Chase or J. Alden Weir, yet he was one of the pioneers of American Impressionism and one of the most talented artists of the period. Although he often visited Monet and sought his advice, he was never a formal pupil. Robinson was a delicate and individual painter, a master of the quiet, intimate *vue*. Even such a picture as *Panorama of Giverny* is more intimate than sweeping. His work is lyrical, tender, a little diffident, the work of a man who once said that perhaps he was born to make sketches. *Panorama of Giverny* is a beautiful, visual counterpart to his feeling that he must constantly pursue the 'continuous loving study of nature.' He pursued his studies of nature under the watchful eye of Claude Monet on and off from 1877 to his final return to the United States in 1893.

In 1888, Robinson began painting his first fully-realized Impressionist pictures. Before that he had studied at the National Academy of Design in New York, and with Carolus-Duran in Paris. In the early 1880s his paintings were naturalistic, somewhat in the manner of Eastman Johnson and Winslow Homer; like them he was also concerned with light and atmosphere. In 1889 he exhibited a group of his new Impressionist paintings at the Society of American Artists. These were among the earliest American Impressionist paintings exhibited in the United States since Mary Cassatt sent a couple of canvases to the Society ten years before. He relied on the camera extensively for many of his figure compositions, and for the most part he followed the photographic image quite literally. In this he was the opposite of Degas, who made adaptions from the photograph in order to represent a feeling of continuous movement. Robinson on the other hand wanted everything to stand

Right MARY CASSATT, *Emmy and her Child*,
c. 1890.
Wichita, Kansas, Wichita Art Museum, Roland
P. Murdock Collection.

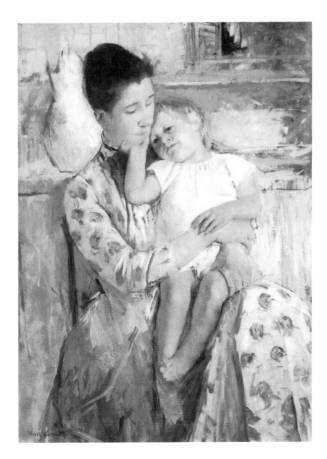

still; 'painting directly from nature,' he wrote in the early 1880s, 'is difficult as things do not remain the same. The camera helps to retain the picture in your mind.' It probably also helped him to husband his time and energy, for he suffered from asthma since childhood and his health was frail.

In 1893 Robinson came back to the United States and visited the World's Columbian Exposition where three of his paintings were on exhibition. But he had difficulty working at home. The 'line' was ragged and the light too harsh. It seems that his art was as fragile as his health; it flowered in France and withered in America. Perhaps he should have become an expatriate and remained in Europe, but he could not. He was concerned with an American style; he wanted to use his French training and knowledge and put it at the service of the American landscape. In 1895 he thought he had found his motif in Vermont, but a year later he was dead. This gentle and lyrical artist died three years after the World's Columbian Exposition and one year before the formation of the Ten American Painters, of which he would have surely been a part.

In 1897 Childe Hassam, J. Alden Weir and John Twachtman resigned from the Society of American Artists. They were joined by seven other sympathetic painters who had become dissatisfied with the huge size and increasing mediocrity of the Society's annual exhibitions; they objected to the stuffy and conservative atmosphere of the Academy and, according to the New York *Times* of 9 January 1898, 'having sympathetic tastes in a certain direction in art, they had withdrawn from the Society of American Artists to work together in accordance with those tastes.' Their first exhibition, called simply 'Show of Ten American Painters,' opened appropriately at Durand-Ruel's New York gallery, and in addition to Hassam, Weir and Twachtman 'The Ten' included Thomas Wilmer Dewing, Willard Metcalf, Edmund C. Tarbell, Joseph DeCamp, Frank Benson, Edward Simmons and Robert Reid. After Twachtman's death Chase was voted in to take his place. The 'sympathetic tastes' they shared was the practise, in varying degrees, of French Impressionist methods. In fact The Ten American Painters were the leading figures in the American Impressionist movement.

Like their original French counterparts the Americans were already experienced artists who had been working fifteen years or more by the time of their first exhibition in Durand-Ruel's New York gallery. Their styles were mature; their influences had been absorbed, and those influences, along with an attitude of mind, make the difference between French Impressionism and its American counterpart. There was the native tradition of landscape, the conceptual and descriptive approach of the Luminists with their regard for light and atmosphere, and their concern for form, for the quiet observation of fact. There was Whistler whose work was a continuing influence in a variety of ways on a number of painters. American work was imbued with the professionalism of French training, and not only from the offical masters. The work of Jules Bastien-LePage, in its combination of studio draughtsmanship with *plein-air* painting appealed to the sense of the factual in American painters, and he was just as important an influence as Monet.

The Ten American Painters, again like their French counterparts, were as different from each other as Monet was from Degas. Just as the label Impressionist as applied to the French covered a wide range of style, from the conceptualism of Degas to the almost pure, perceptual approach of Monet, with Renoir, Pissarro and Sisley in between, so the term American Impressionist as applied to the members of The Ten covers the same wide range, from the conceptual painting of Thomas Dewing to the more perceptual approach of Childe Hassam. Edward Simmons and Robert Reid, to begin with the minor figures of the movement, were essentially muralists, but Reid also painted easel pictures in a muted Impressionist manner. *The Mirror* tends

JULES BASTIEN-LEPAGE, *Joan of Arc*.
New York, Metropolitan Museum of Art,
Gift of Erwin Davis.

ROBERT REID, *The Mirror*.
Washington, D.C., National Collection of Fine
Arts, Smithsonian Institution.

FRANK W. BENSON, *Still Life*.
Washington, D.C., National Collection of Fine
Arts, Smithsonian Institution, Gift of the
Ranger Fund.

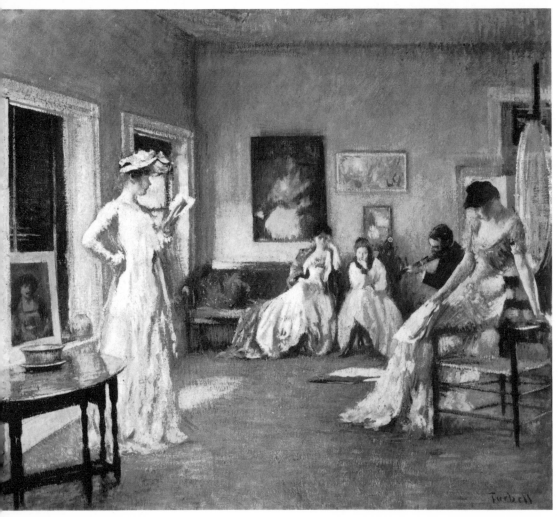

EDMUND C. TARBELL, *A Rehearsal in the
Studio*.
Worcester, Massachusetts, Worcester Art
Museum, Gift of Mr and Mrs Henry H. Sherman

to be decorative, sentimental, and the pose, with its oriental accoutrements is highly reminiscent of Whistler. Benson, Tarbell and DeCamp were known as 'the Boston men.' Of the three Tarbell is the most interesting, but Frank Benson made the most money. He was also the most painterly. *Still Life* is impressive and spirited; and his figure painting, mostly of women, and mostly from his family, such as the delightful *Eleanor,* are painted in a 'frank and cheerful' palette and evoke a holiday atmosphere which was to come to an end with the First World War. Edmund Tarbell became famous for his genre scenes, intimate family groups and figures in interiors. The sense of space in *The Rehearsal in the Studio,* the controlled light, the assured manner of this study of genteel Boston 'art life,' combine to make this handsome picture a little reminiscent of Degas. DeCamp's work was sober and solid, based on craftsmanship, but enlivened by brushwork in the Munich manner. Basically a portrait painter, his Impressionism, like Sargent's was limited to his days off. When he did make use of the style, as in *The Little Hotel*, it tended to be fairly quiet in color.

FRANK W. BENSON, *Eleanor.*
Boston, Massachusetts, Museum of Fine Arts,
Charles Henry Hayden Fund.

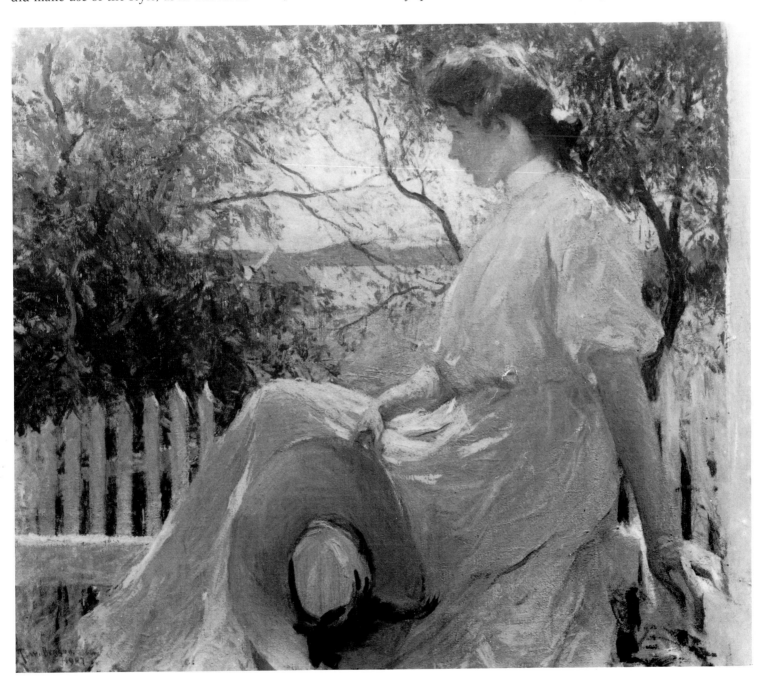

181

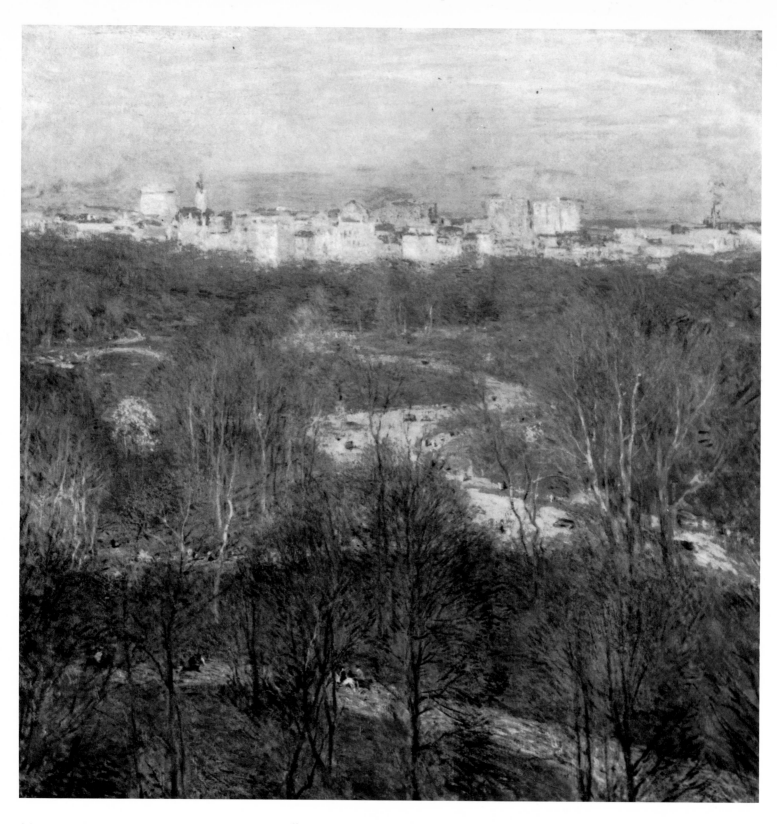

WILLARD METCALF, *Early Spring Afternoon in Central Park*.
Brooklyn, New York, Brooklyn Museum.

Willard Metcalf was also a quiet talent, and he was perceptive. *Early Spring Afternoon in Central Park* is Metcalf at his best, his feathery touch capturing the stillness and lightness of the day and season. Nature is considered paramount, more important than the town, an attitude espoused by most nineteenth-century American painters.

Childe Hassam, J. Alden Weir, John Henry Twachtman, and Thomas Dewing were the strongest painters and the most important members of the group. Hassam was the one artist whose paintings are most closely associated with French Im-

182

pressionism, at least in the public mind. His work was somewhat more superficial than that of Weir or Twachtman, but he was close to Monet in his love of the *métier*. Hassam was a natural born painter, he enjoyed painting more than anything else; his work is particularly fresh and sparkling and his color for the most part is extremely bright and gay. His interest in art began early. It began when he went to work for a wood-engraver in Boston. He went abroad in 1883, and again in 1886. At that time he settled in Paris and came under the influence of the Impressionists. Hassam's early work was basically tonal, the forms modeled in light and shade. Yet during his sojourn in Paris from 1886 to 1889, his handling became broader, more free and perhaps not without the influence of Manet. But in 1889 a picture by Hassam was included in the Paris Exposition and he came back to New York with a bronze medal and brighter canvases; canvases which suggest Monet or Sisley.

New York was his headquarters during the winter, and in the summer New England became his painting ground. He worked in Old Lyme, Cos Cob, Gloucester and in the Isles of Shoals at Appledore. The Isles of Shoals was the favorite watering place of Boston's artistic élite, and it was there that he did his most cheerful and painterly Impressionist pictures. In 1897, the year of the formation of The Ten, Hassam was back in Paris. He returned once again in 1910, and at that time he embarked on the first of his series of flag pictures in which he tried to unify the flags, buildings and the movement of people. He continued this theme more successfully in New York from 1917 to 1919, as in *Flag Day* of 1918. The linear and geometric treatment of flags and buildings as pattern contrasts with the blurred handling of crowds of figures as impression, capturing the essence of the movement of large numbers of people.

Although Hassam is identified as a painter of white New England churches, done in an Impressionist manner, his series of flag pictures represent some of his most distinguished work; and in their pictorial construction they are somewhat prophetic of the early painting of Mark Tobey.

J. Alden Weir was a tireless worker on behalf of American art and Mary Cassatt hoped he would found an American movement. He was not only the key organizer of The Ten, but helped organize the Society of American Artists ten years earlier and was its secretary during 1879 and 1880. He also served as president of the National Academy from 1915 to 1917 and helped his fellow artists no matter what nationality. For Puvis de Chavannes he procured a commission to do the murals for McKim, Mead and White's Boston public library. He was a close friend and ardent champion of Albert Ryder and he was always trying to sell Twachtman's paintings even to the point of refusing a sale of one of his own unless Twachtman's went with it.

J. Alden Weir was born into an artist's family. His brother John was an artist and teacher, and they both received their initial instruction from their father Robert Weir, who taught drawing at the United States Military Academy from 1834 to 1876. Whistler was also one of Weir's students during the former's brief career at 'The Point.' J. Alden Weir studied in New York for a while, and then went on to Paris. At first he studied with Gérôme, but soon became part of the group surrounding Bastien-LePage. In the 1870s Weir believed, with Ingres, that 'drawing is the probity of art.' Consequently he was horrified by the first Impressionist exhibition he ever saw. When he returned to New York in the late 1870s he became involved in 'art politics,' and he started painting portraits which the critics felt were full of 'manly qualities.' His work at this time was relatively tonal, and his portraits, as in the sympathetic portrait of his friend Albert Ryder, stood out from a dark background. But he was developing an eye for modern European painting and his palette began to brighten. However Weir was a dedicated admirer of Ryder and whatever poetry emanates from Weir's gentle prose style, particularly in his land-

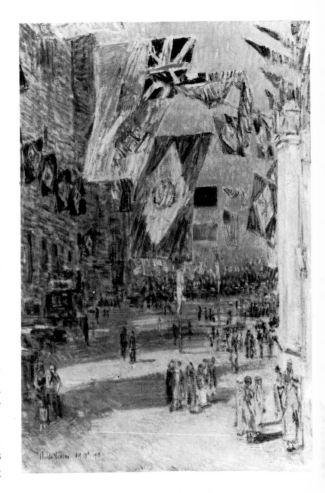

CHILDE HASSAM, *Flag Day, 1918*.
Los Angeles, California, Los Angeles County Museum of Art, Mr and Mrs William Preston Harrison Collection.

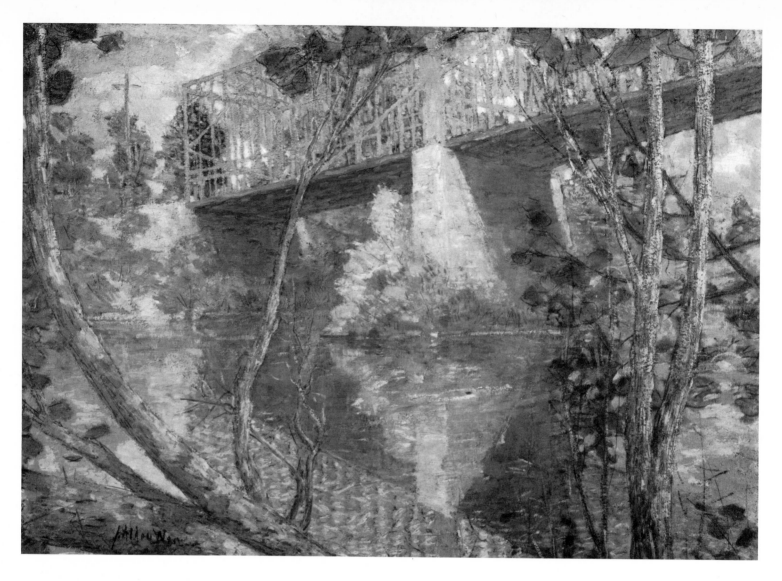

J. ALDEN WEIR, *The Red Bridge*.
New York, Metropolitan Museum of Art,
Gift of Mrs John A. Rutherfurd, 1914.

scapes, probably derives from his intense admiration for the work of that solitary genius. *High Pasture* recalls the spirit of Ryder's early landscapes.

By the 1890s Weir had developed his Impressionist style, and in 1893 he and Twachtman showed together with Monet and Besnard. Also in 1893 Weir was included in the World's Columbian Exposition with eight oils and twenty-six etchings. Thereafter his work became more popular, and his pictures began to sell. *The Red Bridge* is typical of Weir's mature Impressionism. It was painted in 1896, one year before The Ten was organized, yet strong structure and emphasis on draughtsmanship has more to do with the Expressionist tendencies of Ernest Lawson than with anything painted by Monet and his friends.

John Henry Twachtman was the most sensitive and unique of all the American Impressionists. His work was more profound, more searching, and he understood abstraction, the reality of the spirit. At one time he too was influenced by Bastien-LePage, but Twachtman was dissatisfied by the Frenchman's concern with 'the representation of things.' Twachtman was a painter's painter; his colleagues talked of his poetry, but he was not very well known in his lifetime. He was a 'difficult' artist and his work was not easily understood; consequently he did not sell very much and it made him bitter.

Like a number of American painters of the period – Mary Cassatt, for example, Weir and Hassam – Twachtman's work exhibits a dramatic transformation from dark to light – from the bituminous impasto of Munich, where he went with Duveneck in 1874, through his enchantment with Bastien-LePage, to his final Impressionist

184

manner from about 1889. He was a landscape painter from the start, and the few figure pieces he did are not terribly successful. He was more comfortable painting from nature and his attitude toward it was romantic. Landscape to him was not just a *motif*; he felt genuinely close to it, he was part of it. And he lived in the country in order to be closer to nature. It was at his country home, his farm at Cos Cob, Connecticut, that he chose his themes and painted the pictures for which he is best known today, and 'at all seasons of the year.' He painted *The Hemlock Pool* and *The Waterfall* in a series reminiscent of Monet's *Haystacks* or *Rouen Cathedral*. But unlike Monet, Twachtman was not interested in systematically recording optical phenomena, he was not interested in cataloguing changes of light during a specific time of day or season, but to evoke a mood caused by such changes. This evocation of mood is closer to the philosophical subjectivity of a Chinese painter of the Sung period than it is to the almost scientific objectivity of a Monet.

Of all the seasons Twachtman liked winter best, 'that feeling of quiet and all nature hushed to silence.' Winter scenes, such as *Winter Harmony*, constitute a large portion of his work. He could tackle the problem of white as a color, and he could allow himself to be subtle. The formlessness of snow covered shapes gave him an opportunity for a display of pure painting; to *suggest* rather than depict form. It is this approach which baffled the public of the time. For as Hassam said, 'his works

JOHN HENRY TWATCHMAN, *The Hemlock Pool*.
Andover, Massachusetts, Addison Gallery of American Art, Phillips Academy.

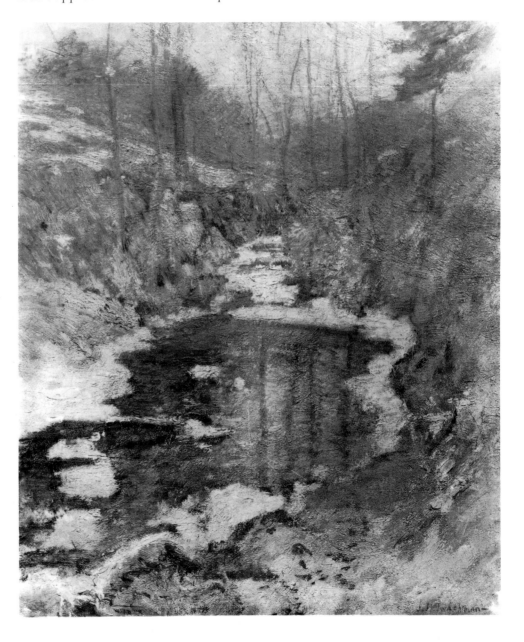

were strong, and at the same time delicate even to evasiveness.' Twachtman was not an innovator, almost none of the American Impressionists were, but he was an original artist who created unforgetable images; an artist who possessed a rare and quiet talent, quietly achieved.

Quietly original and poetic are terms which also apply to the painting of Thomas Wilmer Dewing who was born in Boston in 1851. Next to Hassam, Weir and Twachtman, Dewing was one of the most important members of The Ten American Painters; and he was unique. Drawing was his forte. In Paris he excelled in the draughtsmanship in the French academic tradition, the tradition of Ingres. His pictorial repertoire includes portraits and figure pieces of women and in his precise draughtsmanship he was the Degas of The Ten American Painters. *The Recitation*, with its precision of draughtsmanship, its jewel-like color and enamel surface, his personal expression of space and the odd placement of the somewhat enigmatic women, is classic Dewing. There is a concern with a mysterious light and atmosphere in a spatially ambiguous setting. The draughtsmanship recalls the spirit of Degas, but the mood, the atmosphere and the use of space are very much Whistler.

After his stint in Paris, Dewing painted decorative pictures of 'ideal' female figures in the manner of John La Farge and Abbott Thayer. But after 1887 Dewing became bored with the decorative manner and began to pursue his own style. By 1891, when he painted *The Recitation*, he had discovered the seventeenth-century Dutch. He preferred the 'little masters,' Metsu, Ter Borch, and finally Vermeer. And like almost every modern painter of his time, he was also influenced by Oriental art. His use of the theme of women playing musical instruments, as in *Girl with Lute,* his occasional use of still life and furniture, oddly placed, his use of large areas of empty space, Japanese or Chinese in feeling, all combine to form a private world of his own making. In his portraits and single figures of women he strives for the perfection of technique, and to capture the enigmatic quality of the

THOMAS WILMER DEWING, *The Recitation.* Detroit, Michigan, Detroit Institute of Arts.

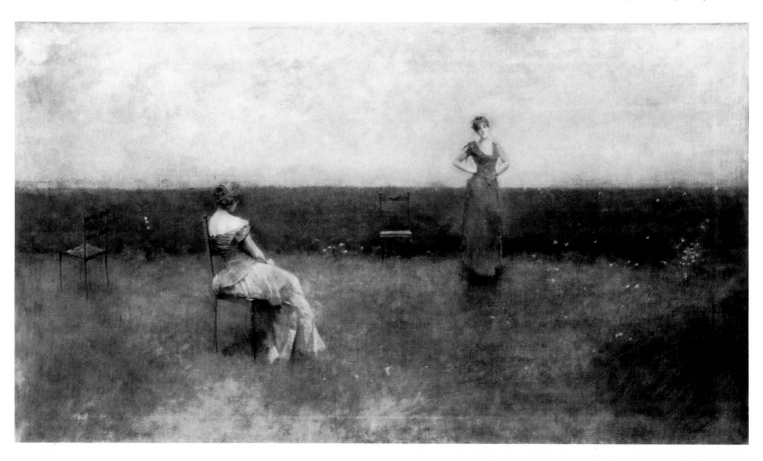

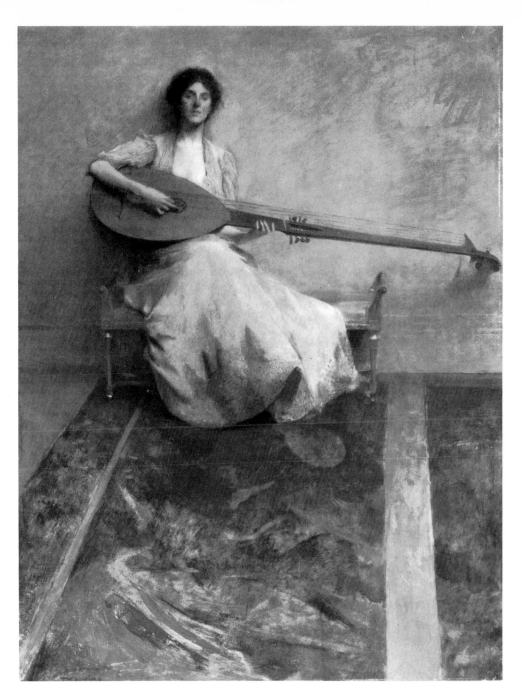

THOMAS WILMER DEWING, *Girl with Lute.*
Washington, D.C., Freer Gallery of Art.

brilliant painter from Delft. The close resemblance between Dewing's *The Necklace* and Vermeer's *Young Lady Adorning Herself with a Pearl Necklace* is astonishing. The gesture of the woman holding the pearls is practically the same in both pictures. Both figures face the same light source. Dewing seems to pay further tribute by including the device of the picture within the picture, also characteristic of Vermeer's work; and the picture on the wall in the upper left might well be a Vermeer.

Dewing's borrowing was not as blatant as Chase's and is representative of a self-conscious concern for the use of 'Art,' not for purposes of training but as a way of acquiring style. Art history for Dewing and for many other painters of the period, John La Farge for example, was more important than 'life.' Yet Dewing painted some of the most sensitive, if rarified, poetic pictures in nineteenth-century American painting.

The Ten was not a radical organization. They were more conservative than their French counterparts. No American ever went as far as Monet in obscuring form; to paint something like Monet's *Waterlilies* was something they could not bring them-

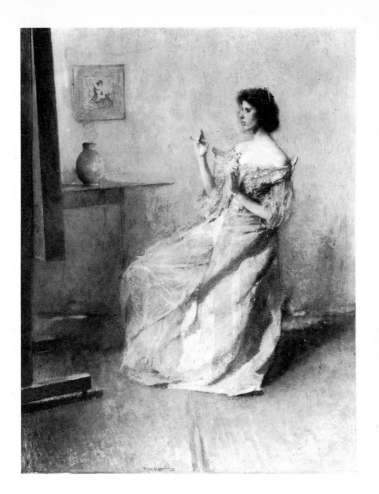
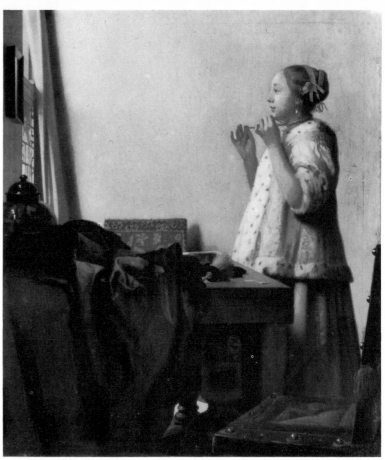

selves to do, it was a step they could not take. If some of them had difficulty in selling their work it was not because they were producing something new or wildly original, but because with few exceptions most collectors were not that interested. Yet The Ten had made their point; in the course of their twenty years' history, they succeeded in showing conspicuously, if not always profitably, and their exhibitions were usually regarded as the hit of the New York season. The Ten American Painters was considered by critics to be one of the most important art organizations of the day. They brought into sharp focus the fact that American painters were capable of making a contribution, of producing not only good but in many cases inspired and inspiring works of art. And they did this more successfully than the National Academy or the Society of American Artists.

By the time of Twachtman's death in 1902 everybody was an Impressionist, and even those who did not espouse the manner were influenced by the impact of the style. However, it was always less robust than its French counterpart. It was more delicate and in some cases more poetic. But in many cases delicacy turned into sentimentality, poetry into decoration or combinations of both. Yet there were artists who clung to the style and tried to instill a new vigor into it. Ernest Lawson was one, and so was William Glackens.

Lawson studied with Twachtman and when he went to France he was already equipped with the methods of a French style which he had learned in America. However in a picture such as *The Hudson River at Inwood* the feeling is more Expressionist than Impressionist.

The painting of Maurice Prendergast takes a bigger step and makes a more radical break with the French Impressionist tradition upon which his work is based. Born in the same year as Georges Seurat, Prendergast also laid on brushstrokes of un-mixed color, however he was not interested in fancy theories of optical fusion, but in the glitter and sparkle of light and movement expressed in a kind of prismatic

Above, left THOMAS WILMER DEWING, *The Necklace, c.* 1907.
Washington, D.C., National Collection of Fine Arts, Smithsonian Institution, Gift of John Gellatly.
Above VERMEER, *Young Lady Adorning Herself with Pearls.*
Berlin, Staatliche Museen, Gemäldegalerie.

ERNEST LAWSON, *The Hudson River at Inwood*, Columbus, Ohio, Columbus Gallery of Fine Arts, Howald Collection.

place of hue against hue. Prendergast was never concerned with the political or social message in his art, nor was his work ever brought before the public via illustration or print. He was essentially a loner and he was original. At the turn of the nineteenth century in America he alone stood for the new direction art was to take in the twentieth. Stylistically he represents the end of American Impressionism and the advent of the truly modern painting in the United States.

The year 1908, the year of Mary Cassatt's last visit to the United States, was a significant one for the arts in America. It saw the adoption of Daniel Burnham's updating of the L'Enfant plan for Washington. Louis Sullivan finished writing his *Democracy: A Man-Search* and designed the National Farmer's Bank, while his Pupil Frank Lloyd Wright built Unity Temple in Oak Park, Illinois, and the Coonley house in Riverside. A whole new group of young Americans were studying and working abroad, mostly in Paris. It was the year of the first showing of Robert Henri and his Group of Eight. In New York Gertrude Vanderbilt Whitney started a small gallery to give encouragement and a chance to unknown painters and sculptors to show their work. The gallery became the Whitney Studio Club and later the Whitney Museum of American Art. It was a key year in the reaction to European influences, a key year in the assertion on the part of American artists to find an American style based upon American subject-matter.

The late nineteenth century was an age of uncertainty in artistic direction which perhaps accounts for the restlessness of John La Farge; it was also an age of borrowing from other styles, which might account for the eclecticism of William Merritt Chase. The question of a national style has always been a difficult one to answer, there were – and are – American experiences, attitudes and ways of thought, but was there an American style? It may be that the answer lies in the example of William Merritt Chase, that eclecticism itself constituted the American style in the last quarter of the nineteenth century.

4

THE FORMING OF THE AVANT-GARDE 1900-30

Irma B. Jaffe

When American art turned the corner to face the twentieth century it was still mainly and officially wearing the cast-off hand-me-downs of Europe for its Sunday Best. It looked, and was, provincial – out of the mainstream that was finding a context structured on Euclid and Descartes inadequate and unacceptable for the task of expressing contemporary sensibility.

The Western search for a way beyond Cartesian rationalism had emerged as a vital aesthetic and intellectual force in Europe during the nineteenth century. Among artists and writers identifying reason with social progress, social progress with industrialization and industrialization with dehumanization, some came to seek reform, as Gauguin did, in going back 'beyond the Parthenon,' to the 'dada' – the hobby horse – of man's childhood. Apprehensive or sick of civilization, and with faith in the naïve and supposedly uncontrolled, Symbolists and Synthetists turned from the surface of appearance to probe the life and art of 'simple' people, of 'primitive' people, in an effort to discover and express pure human feeling. To enter into a pre-rational state of direct, intuitive knowledge through emotion it was necessary, so it seemed, to bypass rationalism. The non-rational or irrational was taken to be rationalism's alternative, and instinct thus replaced reason in the value system of the newly developing epistemology. As industrialism seemed increasingly to threaten the individual with the anonymity of standardization, the senses took on a heightened value as the individual's guarantee of self-consciousness. *I feel, therefore I am* became, for many, the modern affirmation of reality.

Parallel to this development other reforming artists, beginning with Cézanne, searched for essence not in the emotions of man but in the emotional nature of man's response to cosmic nature; Cézanne's 'sensation' was his intuition of order in the physical universe, and for inheritors of this legacy, Descartes' *cogito* could not be so neatly paraphrased in a rhetorical subjective symmetry. Reality was a relationship between subject and object in all possible perspective variations. As such, Cubism was the logical metaphysical solution to Cézanne's frustrated drive to realize what he perceived, just as Fauvism was an equally plausible inference deduced from Synthetism. What gives modernism its seal in our century, what unites the apparently opposed currents of Expressionism and Constructivism, gesture and geometry, is the common thrust to reach the ever-elusive essence of reality.

Modernism is clearly not a single style: there are many 'modern styles,' including figurative as well as non-objective painting. But behind the arbitrary shapes and colors of Fauvism and German Expressionism; beneath the faceted surface and recomposed images of analytic and synthetic Cubism, and the lines of force of Futurism; implicit in the use of materials in collage; explicit in the non-rational juxtaposition of gravity-free objects in Surrealism; assumed in Abstract Expressionism and every style that followed; critical to all primitivizing, is the search for a means to intensify the involvement of the spectator in directly experiencing the work of art. The conception of what is essential in a work of art has varied and some artists have aimed to reveal the essence of the artist's experiencing (sensual, or emotional); others have sought to depict the eidetic essence of the object (chair, figure); others have been concerned with the essence of the media as experienced (color, shape). All, of course, in practice combined such aims. But all along the intention has been to bring the spectator into immediate and sharply realized participation with the essence of whatever is being revealed.

That all great art has the power directly to communicate hardly needs saying, and occasionally in the past, notably in the seventeenth century, art has aimed at

bringing about spectator participation. Even classical, High Renaissance art can be said to speak directly to the viewer. But the levels at which communication is aimed give a different quality to modern communication. Modern art has sought either to synthesize the traditional mind-sense duality through a phenomenological, total grasp of the object or to bypass the rational process completely. Mind-to-mind, soul-to-soul communication has been replaced by visceral resonance. The good, the true, the beautiful have come to be identified with the spontaneous, the uncultivated, and unrehearsed, and this 'unstudied' art of sensation is meant to meet the viewer on equal terms, without regard to whatever previous knowledge he may or may not have about art, or any other subject. On this level, that of cultural preparation, the viewer is expected simply and instantly to react.

Traditional art brings the viewer into a picture space that calls upon sets of common experience and he recognizes the world through the picture. The medium tends to be transparent and the impact is made by an illusion – 'a battle horse, a nude woman, or some anecdote,' as Maurice Denis wrote in a much-quoted statement. Modern art, on the contrary, has striven to make the spectator stop short at the medium. The work of art takes its place among the objects of the viewer's everyday world, no longer providing the illusion of access into another space. For, once another space is presented to a viewer a distance is set up that separates him from that created space, very much like the distance that separates an audience from a stage, and removes theater reality from life reality. No matter how intense the effort, it is only when spatial differences are overcome and removed that the work of art can confront the viewer directly in his own world and something like complete impact can be achieved. This conquest of space in modern art has taken place in several ways: with artists who have aimed to bring the viewer into close contact with the world of people whose emotions and senses are expressed in their life styles; with artists who have wanted to bring the viewer into direct contact with the realm of the unconscious; with artists who have sought to bring the viewer into intuitive contact with Ultimates and Ideal Forms; with artists who have wanted to bring the viewer into an intimate experience of paint, texture, color, form, scale, and pictorial space. This is the level of 'presence,' unmediated in modern art by illusion and thereby creating the condition for the sharp response we call impact.

On the level of interiority, earlier art had cultivated the spectator's capacity to savor – a slow process, involving meditation and memory. It was based on an identification of art with aesthetics, aesthetics with natural beauty, natural beauty with universal harmony, and universal harmony with God. With the disappearance of God, art turned to Experience. It placed its faith in and entrusted its purpose to the meaningfulness of immediate and direct sensual impact. One has only to read what modern artists have said about their artistic aims to find this common thread uniting them, no matter what crucial differences lie between them.[1] What has distinguished modern American art is the literalness with which this faith and purpose have been pursued.

American literalness has frequently been seen as a burden on aesthetic imagination and as a national characteristic has been blamed for the prosaic quality of much of American art. There is undoubtedly some justice in this judgement made as negative criticism, and yet, literalness – telling it the way it is – has in our own time marked off a territory of its own on the playing field of aesthetic impact. The modern game in America began with the painters who went into the streets to report literally the facts of life, the painters who made up what has come to be known as the Ash Can School.

'Back in the nineties our gods were Whistler, Velásquez, and Hals.'[2]

193

When John Sloan sums up in those three names the ideals and aspirations of progressive American painting at the turn of the twentieth century he is recording the most advanced American artists' response to atmospheric color, light-defined, tonal space, and sensitive, energy-charged brushwork, put to the service of realism. For Whistler, as much as Velázquez and Hals, and despite disclaimers, was an observer with his feet on only slightly tilted ground – an American, that is, usually down-to-earth but romantically inclined. Thirty years earlier Manet had discovered in Velázquez and Hals clues to a realism less insistent than Courbet's, and found his way, with Monet's help, to the *Bar at the Folies-Bergère,* a slice of night-life of a kind that would come in time to the aid of Sloan and his fellow observers of contemporary life in the United States. But thirty years is a long time in the modern scale of art history, and in France, in the 1890s, artists born when Sloan was (1871) – Matisse (1869), Rouault (1871) – had available to them the lessons of men who had steadily considered the consequences of aesthetic exploration for an entire century, and in several countries, giving them a comfortable head start in the evolution of pictorial structure that turned out to be one of the most radical developments in twentieth-century art.

It is too often supposed, however, that the progressive element in modern art has only to do with formal problems.[3] Innovations in media and subject-matter have also invigorated painting and sculpture in our time and may eventually be seen to have been at least as significant in forming the character of modern art as the search for picture plane integrity.[4] It is far more a question of sensibility, that peculiar faculty of the imagination located more in the senses than in the mind, that is modernist whether the image is 'mimetic' or 'musical,'[5] and it should be recalled that West's *General Wolfe* gave to art its first success in modernity, won not on formal grounds but in the realm of sensibility, on aesthetic grounds – the realist aesthetic that found its romantic home in America.

Realism requires its own kind of energy: in the United States it has thrived on the dynamism generated by social challenges, and although the current has weakened from time to time it has never died. Romanticism requires place. It is intensely conscious of local color and draws on the specific for its effects, luxuriating in variety. American art emerged at a time when western civilization was sensitized as never before to environment, and such a sensitivity was heightened on this continent by the aggressive, inescapable 'thereness' of enormous land mass. Romantic realism, often verging weirdly on the surreal, was born in Europe but grew up in this country, remaining the single strongest element in American sensibility, always accessible to artists who had use for it, like Robert Henri and his circle, and turning attention away from solutions to artistic problems unrelated to the depiction of living experience.

No American artist has inspired more personal and professional devotion among fellow artists and student disciples than has Robert Henri. His initial influence on an entire generation of contemporary painters was renewed twenty-five years later when 'Ash Can' art was transformed into the American Scene.[6] The vitality of the American environment emerged again, after twenty-five years, in Pop art, and Henri's role in mediating this current in American art gives him and his ideas a significant place in our art history.

Art is the province of every human being [Henri held]. . . . It is simply a question of doing things, anything well. It is not an outside, extra thing. . . . Painting . . . is the study of our . . . environment. . . . War is institutionalism, and institutionalism is the most destructive agent to peace and beauty. When the poet, the painter, the scientist, the inventor, the laboring man, the philosopher, see the need of working together for the welfare of the race, a beautiful order will be the result and war will be as impossible as peace is today.[7]

The tone is familiar. In the early 1890s Henri was reading Edward Bellamy,[8] Hamlin Garland,[9] Tolstoy, Thomas Paine, Emerson, and Walt Whitman. At the same time he was finding confirmation and encouragement for his theories about art in America in William Morris Hunt's *Talks on Art,* a highly influential treatise widely circulated after its publication in the early 1880s. 'Some people have expressed themselves as discouraged in their expectation of finding any art in America, and have long since ceased to hope!' Let us remember that art . . . has always existed, in all nations, and the tradition will probably not die here.'[10]

The nagging worry that it *might* die here, and the confident conviction that salvation lay in 'painting American' had led William Cullen Bryant in 1829 to admonish Cole to 'keep that wilder image bright,' and framed Emerson's American Scholar speech into a manifesto for Ash Can art *avant la lettre*:

The literature of the poor, the feelings of the child, the philosophy of the street, the meaning of household life, are the topics of the time. . . . It is a sign . . . of new vigor when the extremities are made active, when currents of warm life run into the hands and feet. I ask not for the great, the remote, the romantic; what is doing in Italy or Arabia; . . . I embrace the common, I explore and sit at the feet of the familiar, the low. Give me insight into today, and you may have the antique and future worlds.[11]

The history of American art graphs the oscillation of the arrow that pointed now east, now west, depending on whether the aesthetic wind blew across the land or came across the sea. If by land, our art was likely to be earthy; if by sea, it tended to be musty, and dull it remained in the hands of the National Academy of Design in the last quarter of the nineteenth century. These hands busied themselves with Barbizon landscapes, French academics, German genres and Italian Renaissance paintings that crowded the walls of the Academy exhibitions, leaving little space for aspiring newcomers. These would in any case be admitted only by jury choice which automatically insured more of the same since the jury was composed of Academy members who knew what they liked and liked only what they knew. Of course, academic painting in Europe was not much better, and the real fault to find with American painters who went to Paris in the late nineteenth century was that, in their provincial innocence, they were drawn to the glamorous names rather than to the vital artists. What they brought back was already stale when they bought it.

But demerits go, too, to American collectors whose taste depressed any impulse toward innovation in art. New millionaire Americans had built their Hudson River castles, were building their city palaces, and wanted them filled with painting and sculpture that once adorned other castles and palaces in other times, rounding out their collections with 'modern' works certified by academic authority. The less wealthy upper middle class followed suit as best it could, and the academies were thus entrenched, young artists persuaded, and even Robert Henri thought he was happy in 1888 at the Academy Julian, and impressed with Bouguereau, until his art spirit found its real affinity with the French, Spanish, and Dutch realists. Then the Eakins tradition that Henri had absorbed at the Pennsylvania Academy through Thomas Anshutz, with the genre tradition as he had learned it from Thomas Hovenden, reasserted itself, its validity confirmed by the authority of Velázquez and Hals, its vitality evident in Manet. It is worth noting that it did not occur to Henri to seek his roots in John Singleton Copley or in the post-colonial eighteenth century, or in Mount or Bingham; it was in Europe that he readied himself and American art once more to flex realist muscles.

Henri studied the masterpieces of western art in Italy, France, and England; he found Manet in the Luxembourg and Impressionism wherever he looked; and he brought back to American art students an intelligent reading of highroad culture, introducing them to some nineteenth-century names they had never heard, includ-

ing Goya, Daumier, and Degas. He was a born organizer and a teacher with an extraordinary verbal gift, and soon became the acknowledged leader of a group of young artists that included William Glackens, George Luks, Everett Shinn, and John Sloan, all studying at the Pennsylvania Academy, all working as reporter-artists (newspaper photography was about to replace them) for Philadelphia newspapers. Henri's studio at 806 Walnut Street became an informal art center and forum for his philosophy of art, and the newspaper illustrators became artists under the spell of Henri's charisma. Studying, working, and playing, the group found an aesthetic identity that has remained alive in American art history, and in some subtle way has created a magical aura around their collective names.

Gradually, better pay on the *New York Herald* and *World* drew the 'newspaper gang' to New York, where they continued to meet constantly in each others' studios, often with other artists, illustrators and newspaper men at Mouquins, and at James B. Moore's Café Francis, where Henri characteristically held forth on the significance of the life around them for their art. Coming to New York as outsiders, they were perhaps better able than born New Yorkers to absorb the sights the city offered: the immigrant life lived in the streets and on the stoops of lower east side tenements; the elegance of fashionable society driving at night along Fifth Avenue; snowy, blustery gray days along the bleak rivers; men working on the docks or drinking at the bars near the waterfront; women shopping. They were used to sketching quickly, getting the pose and gesture that told the story – their livelihood depended on such skill. Moving from illustration to art they simply shifted their viewpoint from everyday disaster to everyday commonplace, which they saw as proletarian picturesque although, except for Sloan, they were not programmatic Marxists. The French Impressionists had also found some of their subject-matter in everyday urban life, but they had seen that life in bright sunshine or brilliant gaslight. The new American Realists sought out the seamier side, the vulgarly loud, disreputable poor. In France, artists had moved by stages from the Impressionist position to more radical pictorial structures, and had also discovered, some with bite, others with pathos, the bitter or bittersweet flavor of life among the disenfranchised; in the United States, the Realists turned within an Americanized Impressionism to radicalized genre. Artists on both sides of the Atlantic, however, had an equal satisfaction in the rumpus they aroused in the process of radicalizing their country's art and discrediting the credentials of its academics. By 1908, in New York, the rebels were ready to attack.

They were not unknowns, these painters who were about to breach the aesthetic Bastille. James Huneker[12] was even reluctant to see them as the rebels they were, when he discussed in the *New York Sun* the exhibition they organized, with Ernest Lawson, Arthur B. Davies and Maurice Prendergast, that has entered American art history as an event of revolutionary consequences. 'The Eight [are] not gathered together as rebels, for several are members and associate members of the Academy. Nor is this exhibition a protest against academic traditions, a salon of the unhung. Without exception, every man in the group is known to picture lovers at current exhibitions, even at the academy.'[13] But the *World* saw the situation the way most Americans looked at it; on the cover of its Sunday *Magazine* section of 2 February 1908, just before the exhibition opened, it reproduced pictures of the men and their paintings, with a sketch of Henri looking like a wild-eyed, torch-bearing anarchist. There was an art war breaking out, the *World* said: 'The rebels are in arms, their brushes bristling with fight, and the conservatives stand in solid phalanx to resist the onslaught of radicalism.'

The Conservatives should have known they were on the losing side. There were signs; Henri's rising prestige was a barometer of the times. Increasingly active in New York exhibitions, he was elected a member of the Society of American Artists

in 1903, and began to serve on important exhibition juries such as the Pennsylvania Academy of Fine Arts and the Pittsburgh International, Carnegie Institute. In 1906 Henri penetrated the National Academy itself as a full member. His power was growing, and with it, that of his friends. When, in 1907, two of Henri's paintings were subjected to undignified jurying by the Academy, causing him to withdraw them and when he was unable to prevail against the Academy's rejection of Arthur B. Davies, Ernest Lawson, and Jerome Myers, and paintings by Luks, Glackens, Carl Sprinchorn and Rockwell Kent were not accepted for exhibition, Henri was ready to make a major move. Plans were laid for an independent exhibition.

'The Eight' opened at the highly respectable Macbeth Gallery on 3 February 1908. In two weeks eight thousand people visited the exhibition although at the end, only seven paintings were sold.[14] Fortunately, however, the conflict with the Academy aroused wide interest in the newspapers. Some of the criticism was friendly, for the progressive artists had been building up a small, loyal following among the more liberal newsmen in the city. The constant, informal meeting at the Café Francis helped, and probably their own newspaper backgrounds established a sympathetic bond. And, as it happened, the hostile criticisms strengthened the anti-academic forces just as much as the favorable ones, since other vital and imaginative artists were made aware by both sides as to where they could find the kind of guidance they wanted. The meaning of the struggle of The Eight against the intolerance of the art establishment was not lost on those even younger artists such as George Bellows, Edward Hopper, Rockwell Kent, Eugene Speicher, who now came to study with them and join the movement that was searching for an American expression of modern life. Collectors learned about their work, and the curiosity of the public was acutely awakened as a result of the name calling – 'barbarians,' 'apostles of ugliness,' – and colorful descriptions – 'These so-called artists are a black gang who paint half-stripped prize-fighters, barkeepers, dissolute folk of the night, immigrants sipping their coffee in dingy restaurants, children of the streets, cabmen, dockrats and . . . by way of landscapes, . . . the decrepit houses in New York's crumbling East side slums.'[15]

The original Eight never showed again as a group, but two years later when Henri, Sloan, and Davies, joined by George Bellows and Walt Kuhn, rented a three-story vacant house on West 35th Street for one month, and organized the Exhibition of Independent Artists, the memory of 1908 was still sharp; the crowd that jammed the sidewalk waiting to get in was so enormous a police squad had to be called. All three floors were thronged with visitors, and the organizers were understandably exuberant. More than one hundred artists had accepted the invitation to participate, sending in 260 paintings, 20 sculptures, and 219 etchings and drawings.[16] Optimism was high as the crowds continued to come day after day, and disappointment was all the more keen when it turned out at the end of the month there was nothing to count but attendance; almost nothing was sold.

But once again New York was conscious of a cultural leavening, and the artists were learning that it was possible to organize large exhibitions to bring their work before the public. This was a crucial lesson; without it there could not have been the Armory Show, in 1913.

Robert Henri poured his great creative energy into life as a teacher. It was a choice he made time and again, and his art suffered. The extraordinary painting skill that he achieved enabled him ironically to free many of his students but limited him, so that the man's deep personal convictions rarely flow through the artist's brush to become manifest in the image. Some of his best work was done in portraiture, and his *George Luks* is particularly fine for its grasp of personality, the clown-like mask giving the viewer second thoughts about the man casually posed in his comfortable old dressing-gown.

Right ROBERT HENRI, *Portrait of George Luks*,
1904.
Ottawa, National Gallery of Canada.
Below GEORGE LUKS, *Mrs Gamely*, 1930.
New York, Collection of the Whitney Museum
of American Art.

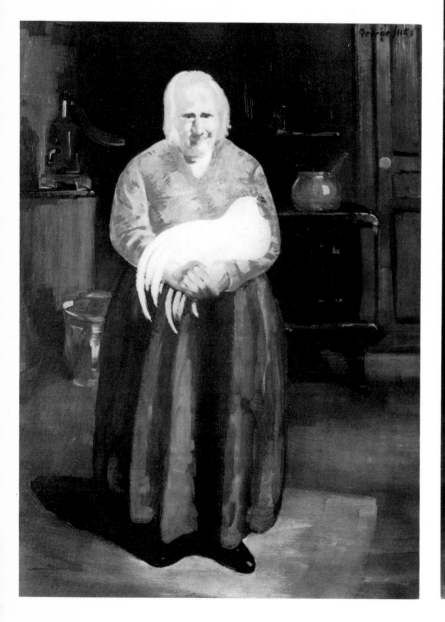

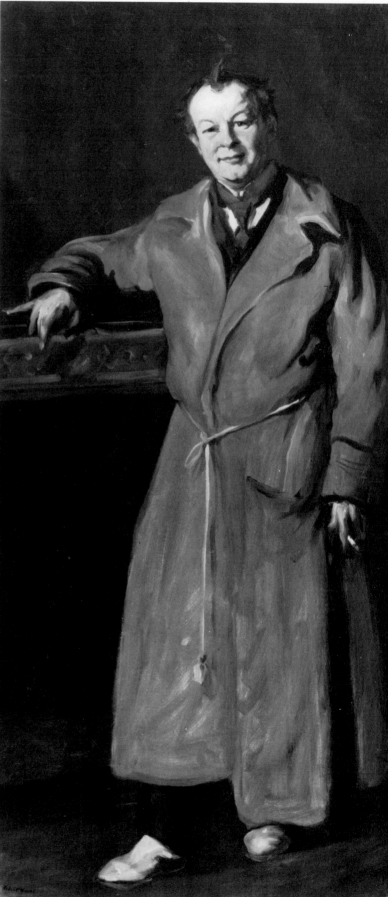

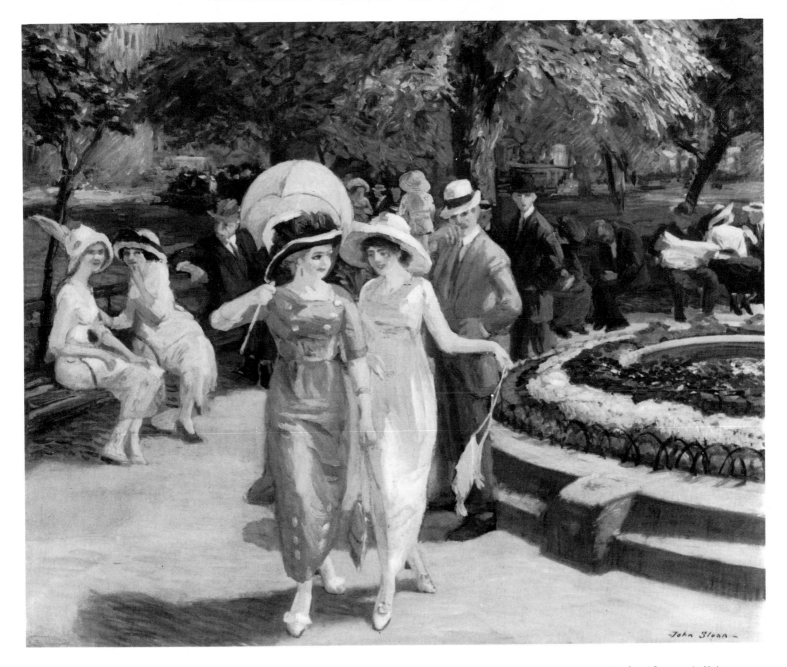

JOHN SLOAN, *Sunday Afternoon in Union Square*, 1912.
Brunswick, Maine, Bowdoin College Museum of Art, Bequest of George Otis Hamlin.

Luks was, in fact, an eccentric, 'a great painter, a great actor, and a fascinating liar,' as John I. H. Baur describes him.[17] If art creates life, as some have said, then Frans Hals created George Luks, a swaggering buffoon who drank too much, bragged too much, and often seems, in his canvases, to be in flight from the physicality he was depicting. Most of his memorable painting was done in the early Ash Can years, but the full strength of his lusty gift surfaced as late as 1930 with *Mrs Gamely*, an old woman posed against the background of a homely kitchen, strangely enigmatic in her hieratic frontality contrasted with the commonplace surroundings.

It is something of a paradox that the artist who worked so slowly that Henri said his name should be 'Slown' captured more tellingly than those with a flying brush the rhythm and atmosphere of New York City life. John Sloan's cliff dwellers are not lonely in their dingy rooms; on roofs amid pigeons flying and clothes drying in the breeze; in modest restaurants and low-class bars; in cheap theaters and dance halls; on the street pausing to window shop or hurrying homeward under the Sixth Avenue 'El' during the rush hour. Clustered in groups or massed, almost always a

few stand out from the crowd, creating a peculiar individuality for all of the anonymous that gives them an air of cheerful busyness: what they do is important to them, even if it is only drying their hair or pausing to look at a passerby who excites their curiosity – and ours. Sloan's strength lay in his graphic sense, and his etchings, among the best in American art, earned him the epithet, 'an American Hogarth.'

Although William Glackens began to move from the Manet–Henri derived style of the City Realists to a higher-keyed Impressionism by 1905, it is evident in his Renoir-influenced *Chez Mouquin* of that year that the Manet of the *Bar at the Folies-Bergère* had not been forgotten. James B. Moore, the earthy proprietor of Café Francis, 'New York's Most Popular Resort of New Bohemia,' and a close friend of some of his artist-literati clientèle is posed in the rival establishment with one of his 'daughters'; the artist's wife and Charles Fitzgerald, a young newspaperman who later became Glackens' brother-in-law, are reflected in the mirror behind them.[18]

Less committed to a social ideology than Sloan or even Henri, Glackens found the

WILLIAM GLACKENS, *Chez Mouquin*, 1905.
Chicago, Illinois, Art Institute of Chicago,
Friends of American Art Gift.

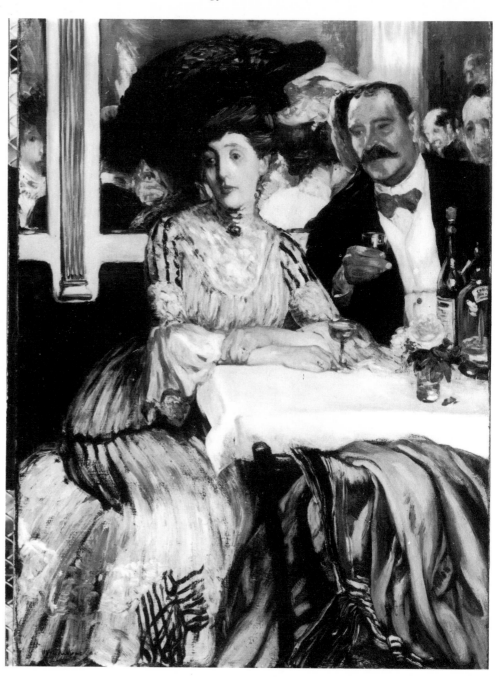

Opposite GEORGE INNESS, *The Coming of a
Thunderstorm*, 1878.
Buffalo, New York, Albright-Knox Art Gallery.

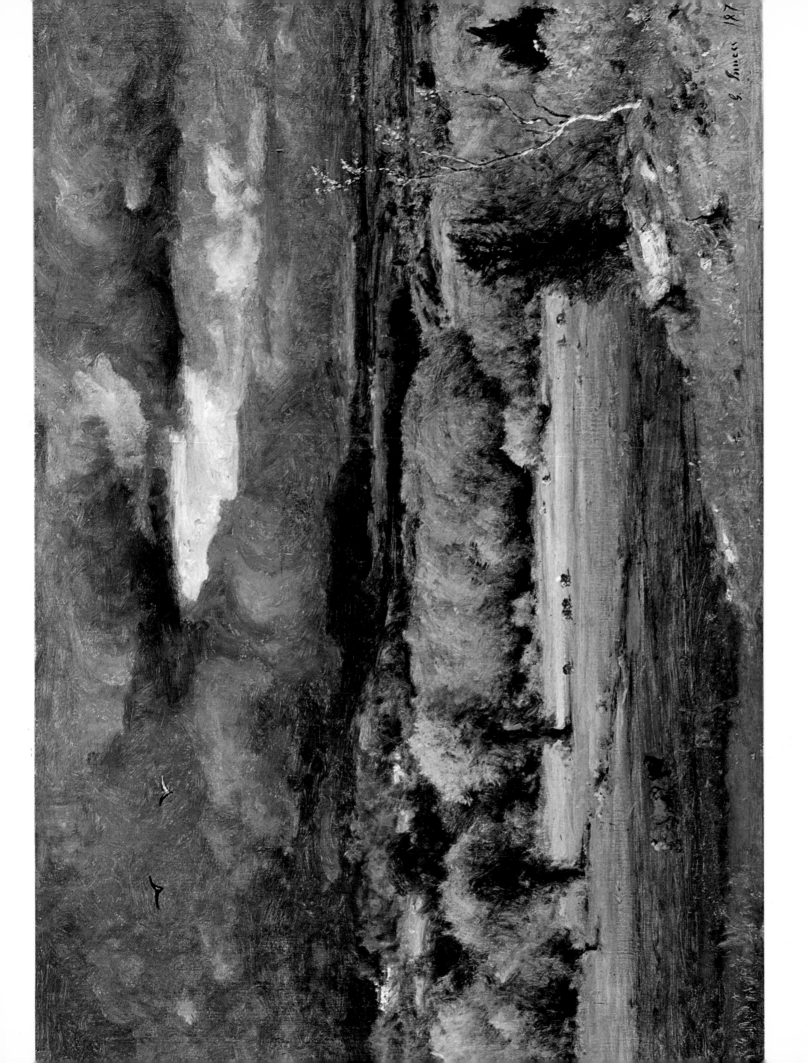

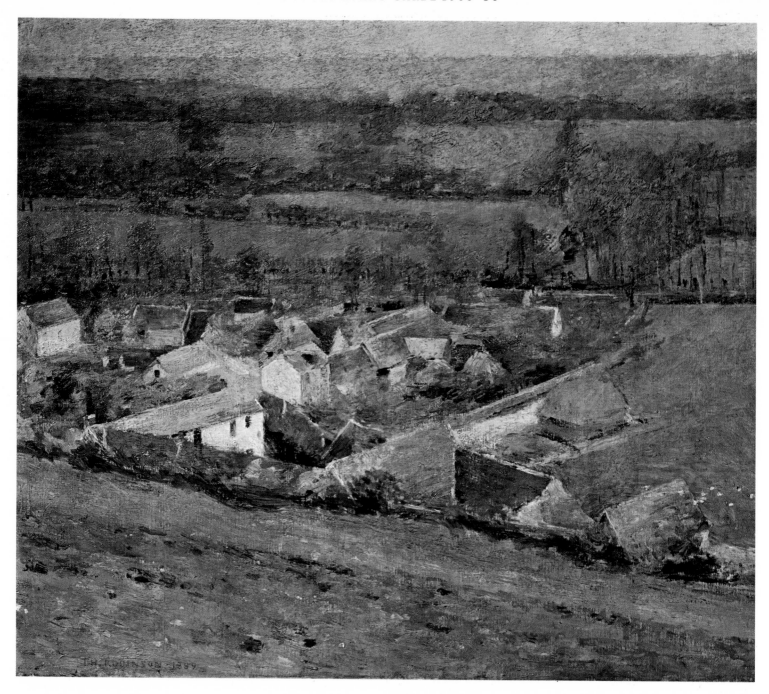

THEODORE ROBINSON, *Panorama of Giverny.*
New York, Metropolitan Museum of Art.

pleasures of middle-class surroundings more congenial than the slum milieu to his artistic sensibilities. His art, based on a secure linear structure and an extraordinary ability to record complex visual phenomena, lifts genre out of its picturesque matrix and often achieves a lyrical color-space reminiscent of the early Bonnard. His debt to Renoir is clear in much of his work, and although he has a tendency to over-elaborate his visual impressions, his buoyant sensuousness often does justice to his master.

Everett Shinn's successful career got under way with the help of the well-known architect Stanford White who arranged his first one-man exhibition at a fashionable Fifth Avenue Gallery in 1902 and made possible his entrée into chic patronage circles. Shinn soon abandoned radical Realist painting for a decorative style well suited to the commissions he received from the world of high society and such theatrical personages as David Belasco, Ethel Barrymore, Sir Henry Irving, and

202

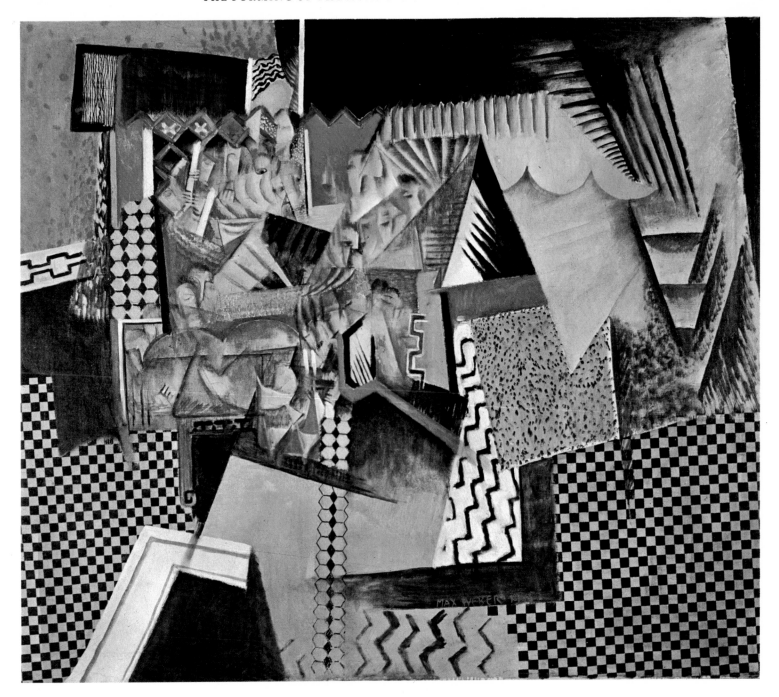

MAX WEBER, *Chinese Restaurant*, 1915.
New York, Collection of the Whitney Museum of
American Art.

Clyde Fitch. In 1902 his *London Hippodrome*, with its oblique view of a crowded
theater balcony, gave promise of a major American painter adapting Degas to the
American Scene. But the Realist impulse was vitiated by the channeling of his gifts
to decorative purposes, and when Shinn tried to revive it in his City Hall mural at
Trenton, New Jersey, he produced an industrial scene that looked as if it had been
designed for the theater. Shinn was a skillful designer and many of his watercolor
sketches have the charm of eighteenth-century Rococo – far from the earnest
realism of his Ash Can beginnings.

In art as in politics, today's revolutionary is likely to be tomorrow's conservative.
Although the style of the Ash Can Realists changed in the course of the first three
decades of our century, none could come to terms with modernist art. Mistaking the
apparent arbitrariness of design for sheer subjective caprice, Henri, Sloan, and
Bellows tended to support their Realist convictions and 'modernize' their painting

203

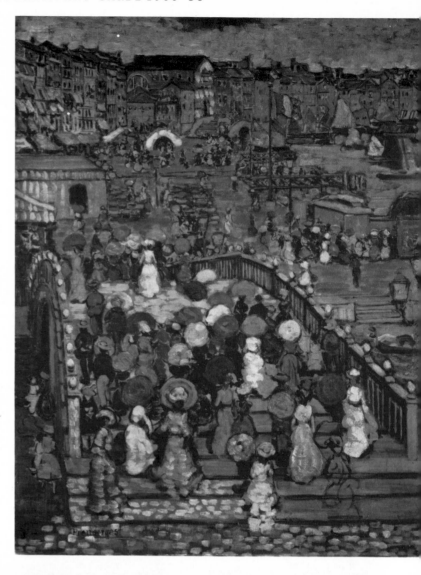

Above ARTHUR DOVE, *The Critic*, 1925.
New York, Terry Dintenfass Gallery.
Opposite MARSDEN HARTLEY, *Portrait of a German Officer*.
New York, Metropolitan Museum of Art.

Right EVERETT SHINN, *London Hippodrome*,
1902.
Chicago, Illinois, Art Institute of Chicago,
Friends of American Art Gift.
Above, right MAURICE PRENDERGAST, *Ponte della Paglia*, 1899.
Washington, D.C., Phillips Collection.

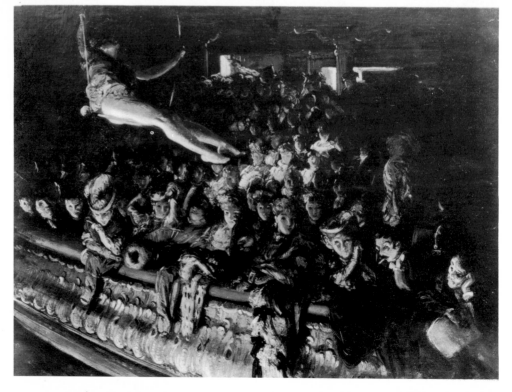

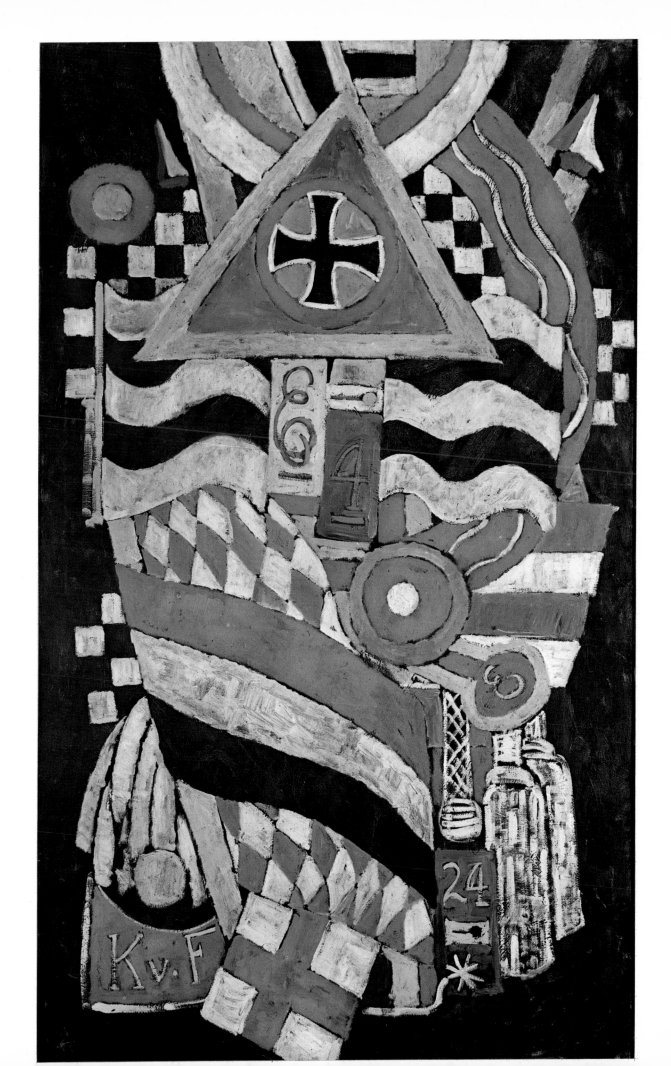

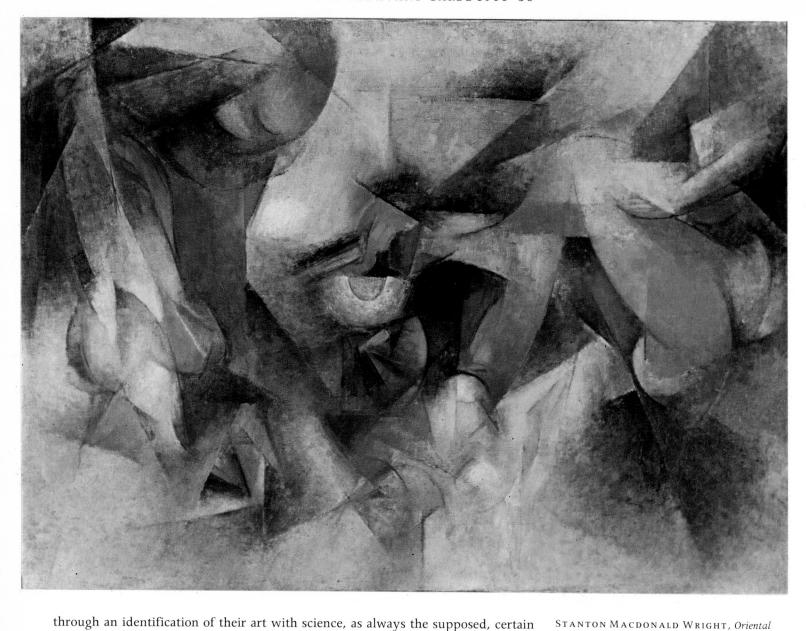

STANTON MACDONALD WRIGHT, *Oriental Blue-Green Synchromy*, 1918.
New York, Collection of the Whitney Museum of American Art.

through an identification of their art with science, as always the supposed, certain basis for objective truth and correctness. From about 1910 they worked enthusiastically with the elaborate color theory of Hardesty Gillmore Maratta according to which color relationships were established formally, like tonal relationships in a musical scale.[19] Around 1917 the Realists, together with a number of art historians and critics, were highly influenced by Jay Hambidge, whose theory, called Dynamic Symmetry, was partly based, as was Maratta's, on the Golden Section proportion thought to be the key to ancient Egyptian and Greek art.[20] Hambidge and his supporters held that Dynamic Symmetry penetrated the secret of nature through the laws of mathematics, but Henri, Sloan, and Bellows had achieved greater penetration through their intuition and the lessons of the European tradition than they won with Hambidge's system. Their best work remains that done in their revolutionary days. It is significant, however, that the Realists attempted, through applied science, to find a method of dealing with absolutes, another facet of the search for essentials.

Of the three painters who joined the Philadelphia group in the exhibition of The Eight, Arthur B. Davies was most absorbed with the idea of art, Ernest Lawson with the physicality of paint, and Maurice Prendergast with painting. The three had little in common with the Realists except the spirit of independence they shared, which

206

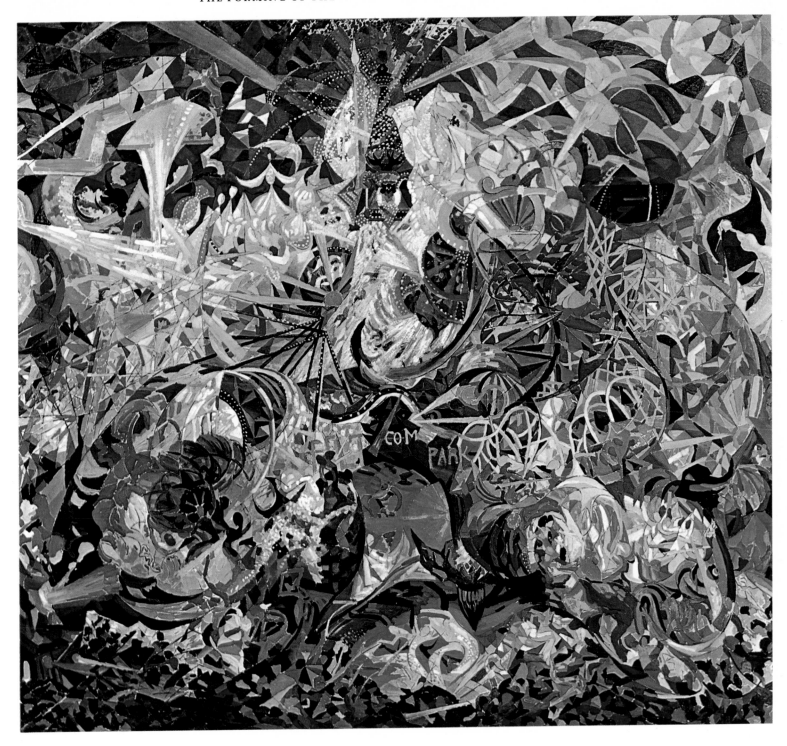

JOSEPH STELLA, *Battle of Lights, Coney Island*, 1913.
New Haven, Connecticut, Yale University Art Gallery, Collection of the Société Anonyme.

led each to go his own way. The measure of Prendergast's originality and modernity is seen in its startling strength when his art is compared to that of John Singer Sargent, his almost exact contemporary. Alone of the Americans who studied in Paris in the heroic days of post-Impressionism Prendergast grasped the significance of Cézanne and Seurat, and paid the price of long-delayed recognition for his precocious vision. In his *Ponte della Paglia* something of post-Impressionist color-structure is combined with the Venetian pageantry of Carpaccio – whose painting had made a lasting impression on him – to create an image so airily gay that its masterly handling of space is apt to be overlooked. His deeper study of Cézanne seems to have been stimulated by the Armory Show, and is revealed in the inter-

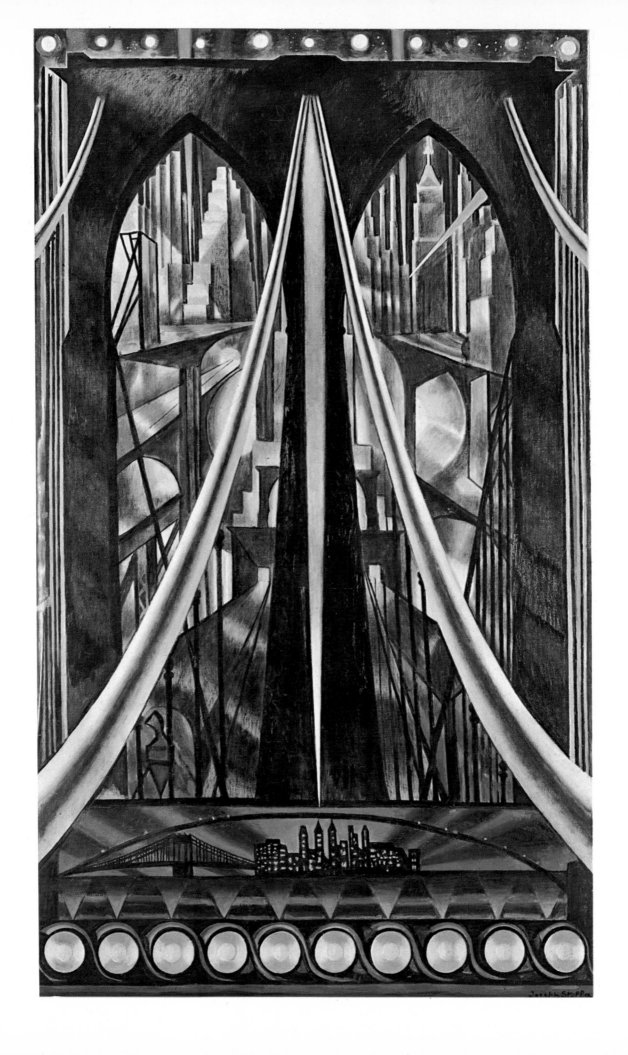

locking forms of his post-1913 paintings such as *Cineraria and Fruit*. Prendergast is ranked with Winslow Homer and John Marin as an American master of watercolor, and his colored monotypes show a highly sophisticated control of this medium as well, achieving softly shimmering effects and often recalling Bonnard. Prendergast's visits to Europe seemed repeatedly to nourish his creative energy, and throughout his life he continued to experiment with new techniques, and new subject-matter, which kept his art always fresh. *Promenade* shows him moving in a new direction;

MAURICE PRENDERGAST, *Cineraria and Fruit*, 1915.
New York, Collection of the Whitney Museum of American Art.

MAURICE PRENDERGAST, *Promenade*, 1922.
Mr and Mrs Meyer P. Potemkin Collection.

the strokes are looser as if the tapestried surface were composed of larger stitches than formerly, with the color more brilliant than his work of a few years earlier. And the deeper quiet suggests that he had still more poetry to paint; had his health not failed, he could have lived to paint it.

In 1893 Ernest Lawson shared a shabby studio with Somerset Maugham in Paris, and was part of the circle of English and Canadian painters in which Prendergast also moved at the same time. Years later he found himself drawn in the character of Frederick Lawson, an artist in Maugham's *Of Human Bondage*.[21] When he joined the Ash Canners, he was setting down views of the East River in bright Impressionist color but with a conservative spatial organization which he handled comfortably. Lawson's use of heavy impasto gives distinction to his interpretation of Impressionism, and is suggestive of the American attitude to paint that became the instrument through which Jackson Pollock led American art to its victory over easel painting in the 1940s.

The heterogeneous nature of the exhibition of The Eight is in no way more evident than in its inclusion of painting by Arthur B. Davies. The only realism in this painter's work is the remembered scenery of his childhood in central New York State, a realism several times removed as it was made to accommodate the artist's response, at various times, to Giorgione, Piero di Cosimo, Ingres, Cézanne, or Picasso.

Until the Armory Show, Davies' figures in their Arcadian fields and woods move in a catatonic state; at its surreal best, as in *Unicorns* with its eerie sense of a floating world, his work evokes the sensation of dream-sound. After 1913, Davies experimented briefly but unsuccessfully with Cubism. His greatest contributions to American art were not to be his paintings but the central role he played in conceiving and organizing the Armory Show, and the part he took in advising American collectors of modern art in this country; in so doing he lay the foundation for the collection of Lillie P. Bliss which in 1931 was bequeathed to the newly founded Museum of Modern Art.

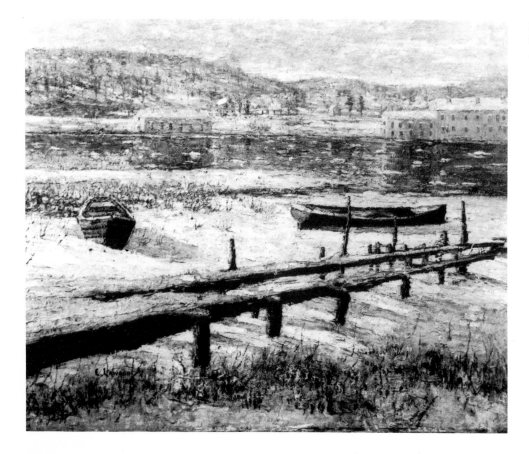

ERNEST LAWSON, *Winter on the River*, 1907. New York, Collection of the Whitney Museum of American Art.

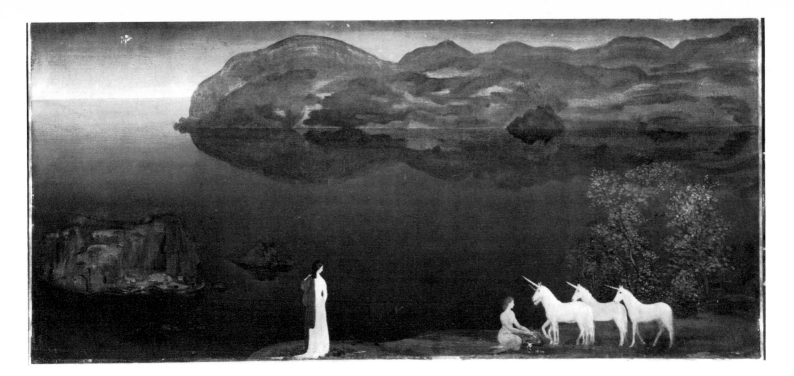

ARTHUR B. DAVIES, *Unicorns*, 1906.
New York, Metropolitan Museum of Art,
Bequest of Lillie P. Bliss, 1931.

Independent of Henri and his friends, a number of other painters of the same generation also found their chief interest in Manhattan's Lower East Side. Jerome Myers' view of slum life was like an eighteenth-century painter's view of peasant life – cheerful and tidy. Considerably more gifted was Eugene Higgins, whose vision was closer to Rembrandt than Hals, and whose New York poor have the look of the disinherited anywhere on earth.

Among those of Henri's pupils who followed in the City Realist tradition, Edward Hopper matured slowly and began to achieve recognition only in the 1920s. George Bellows, on the other hand, born in the same year, won success early. Closely associated with The Eight and Ash Can painting, he was nevertheless, by 1913, at the age of thirty-one, a member of the National Academy and recognized as a major painter by conservatives as well as progressives. Critics saw in him the essence of a national American art, citing brute force, ruggedness and dynamism as characteristics of his style and American society. His purple-orange *Cliff Dwellers* of that year captures those qualities in the realistic atmosphere of a street scene jammed with people escaping from the sweltering heat of their tenement apartments.

Bellows' interest in sports was personal (he had considered becoming a professional baseball player) and led him to turn early as a painter to the boxing matches for which he is probably most famous. His first prizefight pictures, *Stag at Sharkeys* and *Both Members of This Club* were painted in 1907.[22] Eakins' treatment of the subject demonstrates the more baroque tendencies in Ash Can painting contrasted with the earlier artist's serene, classicizing realism.

Less talented than Bellows, but sharing in their earlier style some of his predilection for depicting dramatic aspects of American life, were Rockwell Kent and Gifford Beal, both also Henri students, as was the satirist Guy Pène du Bois, who, although something of an Ash Canner in 1908, did not fully develop his individual style until the 1920s.

Although few of the Ash Can painters and their City Realist associates were programmatic Marxists, the same spirit of rebellion that won them their artistic independence influenced their social sympathies as well, bringing them into the broadly socialist orbit that had grown out of various radical, reform, and utopian tendencies of the nineteenth century.[23] The *Masses*, an influential socialist maga-

211

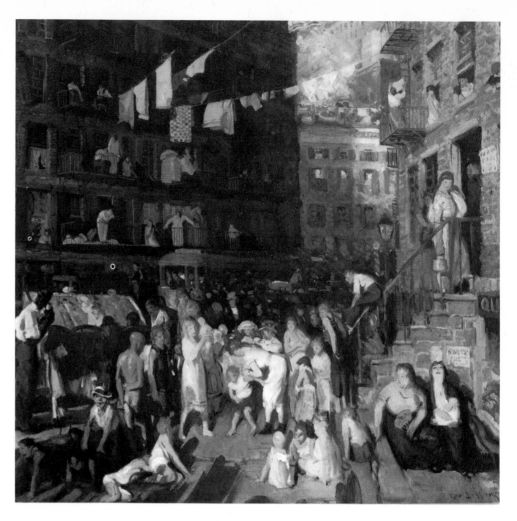

GEORGE WESLEY BELLOWS, *Cliff Dwellers*, 1913.
Los Angeles, California, Los Angeles County Museum, Los Angeles County Funds.

zine from 1911 to 1917, had John Sloan as its art editor and was illustrated by some of the best artists of the day including Henri, Bellows, Arthur B. Davies, Eugene Higgins, Glenn Coleman, Maurice Becker, Hugo Gellert, Henry J. Glintenkamp, Boardman Robinson, and Stuart Davis, together with the sculptors Jo Davidson and Mahonri Young who contributed drawings.[24]

With The Eight and their associates, major American painting settled down in New York. Although measured against contemporary European aesthetic achievements the Realists lagged conservatively behind, they did through their subject-matter, and their attitude towards it, shock cultivated America into a more vivid awareness of life on its overtly sensual levels. Their search for impact gave genuine vernacular expression to the genteel tradition of genre painting. They created a zestful, vigorous life style for the American artist that gave him a public image identified with freedom and progress – too much freedom and too much progress many would have said, although for others the American artist began to take on a glamour he had never before enjoyed. Comparatively few people, it is true, were interested in art or the men who made it, but indifferent and unaware, their vision was nevertheless affected by the victory of the Realists: as in literature, the way of life and the values of people who did not belong to the Puritan tradition were now reflected in American painting, and began to penetrate the consciousness of the country as a whole.

During the years that Henri was leading his vanguard through the streets of the city, Alfred Stieglitz was building an ivory tower right in the middle of it. Unlike most ivory towers, but typically American, this one had an address: 291 Fifth Avenue.[25]

212

In 1902 Stieglitz, already recognized as an important figure in photography, split with the New York Camera Club to found the Photo-Secession movement, explaining, 'In Europe . . . there have been splits in the art circles and the moderns call themselves Secessionists, so Photo-Secession really hitches up with the art world.'[26] The statement summarizes the fundamental orientation and motivation that would shape Stieglitz' leadership in establishing the modernist sector of American art. Since a movement needs a base of operations, Stieglitz found one, and, with Edward Steichen opened the Photo-Secession Gallery in 1905, at 291 Fifth Avenue. Devoted at first to exhibiting progressive camera work, this gallery soon became the heart of the modern art movement in the United States, with *Camera Work*, the journal that Stieglitz published until 1917, reflecting the gallery's views and providing a forum for advanced art.

The move in the new direction began when Steichen, who was in Paris in 1907, wrote Stieglitz suggesting a Rodin show, and early in 1908 the gallery offered to an uninterested public an exhibition of fifty-eight drawings by the acknowledged master among living sculptors. This was followed in a few months by an exhibition of drawings by Henri Matisse. The 'firsts' to be credited to Stieglitz from then on, often with Steichen's help, constitute a truly impressive testimony to this remarkable man's intuition for the significant. Looking back, it seems easy: Matisse, Cézanne, Picasso, Toulouse-Lautrec, Henri Rousseau, Braque, Brancusi, among other European artists, were seen for the first time in America at '291' in the years between 1908–14. Among the gifted and progressive American artists in the Stieglitz circle were Arthur Dove, Marsden Hartley, John Marin, Alfred Maurer, Georgia O'Keeffe, Abraham Walkowitz, and Max Weber. These men were the names that made modern art before it became history. Moreover, it was at '291' that there was held the first exhibition of children's drawings presented as aesthetic works, while other major sensibilities of our century were recognized in exhibiting woodcuts by Utamaro and other Japanese artists, and African sculpture.

Stieglitz' secessionist spirit doubtlessly made him responsive to the avant-garde painters whose cause he came to espouse. Until 1907, however, he had no understanding of modern art, and laughed when, in Paris that year, he was shown a group of Cézanne watercolors. That was the year of Picasso's *Demoiselles d'Avignon*, and the year Stieglitz made what he considered his finest picture, *The Steerage*, a work that brilliantly exemplifies his own aesthetic goals expressed in the remark, 'Photography is my passion. The search for Truth my Obsession.'[27] Henri's Realists would also have responded to the scene that Stieglitz saw on the SS *Kaiser Wilhelm*, but with a different visual priority. 'I saw a picture of shapes,' Stieglitz explained about *The Steerage*, 'and underlying that the feeling I had about life.'[28] Two years later, again in Paris, he met the Steins, saw exhibitions of modernist work and felt himself, as he declared, born into a new world. But it was with the help of Max Weber, whom he deemed to have a knowledge of art 'only equalled in America by Arthur B. Davies,'[29] that his new insight was able to deepen into an abiding commitment to the visual arts of the twentieth century and to some of the artists who founded the American avant-garde.

Only at '291' could Weber find other artists in the United States that shared his interests. After a hostile critical reception at his first one-man show at the Haas Gallery, he joined Arthur Dove, Alfred Maurer, John Marin and Marsden Hartley in 1910 in Stieglitz's 'Young American Painters,' the first group exhibition of modernist art in America. There was comfort in numbers that sustained the group against the scorn of the critics and the indifference of the public that was persuaded not to waste its time on such a 'lunatic' as Max Weber. The artists at '291' were left quietly alone to pursue their aesthetic aims with the unfailing confidence and support of Stieglitz to keep up their courage.

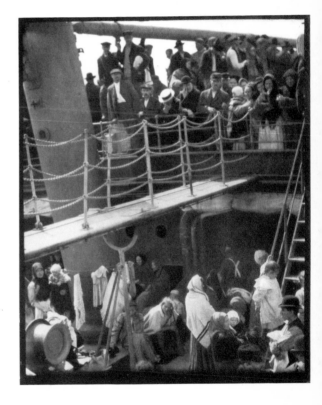

ALFRED STIEGLITZ, *The Steerage*, gravure from *Camera Work*, 1907.
New York, Metropolitan Museum of Art, Alfred Stieglitz Collection.

213

Weber's art at that time reflected the predominant influences of Matisse and Picasso. In the years to follow his style was constantly affected by the explorations of other artists and reveals his gift for applying lessons with skill and imagination rather than for independent self-development, although his fine handling of color constitutes a genuinely individual achievement. His well-known paintings of New York are excellent examples of certain aspects of Futurism, as is also the *Athletic Contest*, with its serially developed rhythmic pattern, its muscular energy, and its subject-matter. *Chinese Restaurant* is a highly accomplished composition in the style of Synthetic Cubism. Around 1917 he began to draw on his Russian Jewish cultural roots for new themes, which around 1921 he expressed in a figurative style that echoes Picasso's classicizing manner of that period. This thematic material remained significant in his work, interpreted in the various transformations of style to which he subjected his art throughout his life.

In a review of Weber's retrospective exhibition at the Museum of Modern Art in 1930 a critic commented that the show seemed to be the work of several artists, but it should be noted that startling changes of style within the *oeuvre* of a single artist are highly characteristic of twentieth-century art. More than ever before twentieth-century artists had available to them a wide variety of formal styles and expressive intentions drawn from many cultures and periods of history which stimulated their imaginations and suggested new artistic problems as well as new solutions to old ones. The art of the Far East, the Near East, the ancient and medieval worlds had penetrated Western aesthetic tradition during the centuries from the Renaissance on, and now the primitivizing sensibility of African, Oceanic, and folk art began to make its impact on artists in search of the pure, the real, the essential. From this quest the major innovators, Matisse, Picasso and Braque, Delaunay, Duchamp, Mondrian, Kandinsky, and the Futurists, established a context of modernism so rich and comprehensive that it has been able to support a world wide movement for our time, providing inspiration for development and experimentation for many artists like Max Weber and others who produced successful paintings in a variety of styles.

Arthur Dove, at once more original and less powerful than Weber, had moved rapidly from illustration, through a Cézanne-Matisse inspired freedom from literal representation, to an abstraction that curiously and independently paralleled that of Kandinsky. In 1911 he found his own method in a series of paintings called, when they were first exhibited, *The Ten Commandments*. One of these was probably *Sails* in which Dove achieves his aim of simplifying through successive stages a motif chosen from nature so that it is in the end transformed from an object 'out there' to a subjective sensation of the object's planes, lines, shapes, colors, and rhythmic patterns. Although never a Futurist in any formal sense, Dove shares with the Italians a concept of lines of force and an interest in synesthetic effects. *Foghorns* suggests muffled sound spreading through a heavy mist hanging over the sea.

Dove's artistic wit found expression in collage. The materials he used were literally associated with his subject – a clock spring, mirror, lens, and steel wool described Alfred Stieglitz, the reflective photographer; newspaper clippings of art news and reviews produced *The Critic*. It is at least possible that *Fog Horns*, too, hides a reference to art critics, since Forbes Watson had characterized some American painting in the 1920s as the 'fog horn chorus of blah.'[30]

Alfred Maurer was Dove's close friend from his Paris days. Winner in 1901 of the Carnegie Gold Medal for the Whistlerian *Arrangement*, he renounced in 1904 the promise of a successful academic career and began to apply himself to the artistic tasks set by the twentieth century. From then on, Maurer seems to have been stalked, like Van Gogh, by an enemy that finally destroyed him: he committed suicide in 1932. It is tempting to read in haunted images like the series of *Two*

Below ALFRED MAURER, *An Arrangement*, 1901.
New York, Collection of the Whitney Museum of American Art.

Left MAX WEBER, *Surprise*, 1910.
New York, Bernard Danenberg Galleries.

Below MAX WEBER, *Athletic Contest*, 1915.
New York, Metropolitan Museum of Art,
George A. Hearn Fund, 1967.

Left ARTHUR DOVE, *Foghorns*, 1929.
Colorado Springs, Colorado, Fine Arts Center,
Oliver James Collection.

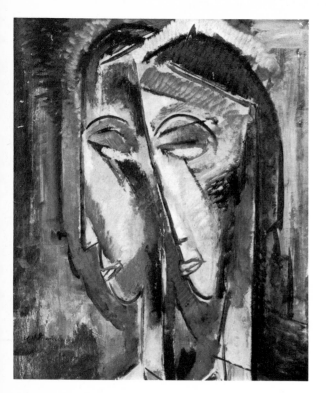

Heads some reference to himself as a tormented, split personality, but evidence is lacking to make such an interpretation authoritative. Aesthetically these paintings are among the most successful modern works in American art. The oscillation between the single head and the two heads is unnerving and compelling.

Maurer was in Europe in 1909 at the time of his first show in America at '291' representing his work of the previous five years. He shared the gallery on that occasion with another newcomer, John Marin, also in Paris at the time, but received more than equal share of the critical attention the show attracted, most of it dismayed, some impressed and sympathetic. 'He is painting pictures that are so extreme, so phenomenal, so miraculous that they could not be given away,' wrote J. F. Chamberlin in the *Evening Mail*; his review went on to make clear he, in any case, would not accept one as a gift. Charles Caffin, on the other hand, one of the few critics as adventurous and sensitive to the modern spirit as the artists themselves, saw Maurer's paintings 'as little creations of color beauty.'[31] Maurer was working at that time in a free, Fauvist style verging close to non-objective. Later he turned to Synthetic Cubism to work out problems in still life, in which he proved himself an able, original composer.

The atmosphere of liberal thought at '291' stimulated independent artists to find their own way rather than provide them with a common language with which to explore formal style. When John Marin met Stieglitz in Paris in 1909 through Edward Steichen and Arthur B. Carles – Weber's fellow-student in Matisse's class – he had just begun to break away from the Whistlerian style that he shared with many other young Americans at the time. His association with Stieglitz gave him the encouragement and financial backing that he needed to complete his breakthrough, and New York gave him the motif through which to express his newly discovered freedom. 'I have just started some downtown stuff,' he wrote in 1911 'and to pile these great houses one upon another with paint as they do pile themselves up there so beautiful, so fantastic'[32] Around 1913 he seems to have found that peculiar view of nature as if seen through a cracked window pane in which the artist, too, is reflected.

No American artist is more present in his images than Marin, and there is, indeed, an eerie face imagery in many of his watercolors (and even in some oils)

Above ALFRED MAURER, *Two Heads*
c. 1930.
Williamstown, Massachusetts, Collection of
Robert V. Godsoe and Harrison Knox.

Right ALFRED MAURER, *Still-Life with Pears*,
1930–1.
Andover, Massachusetts, Addison Gallery of
American Art, Phillips Academy.
Opposite, top, left JOHN MARIN, *St Paul's,
Lower Manhattan*, 1912.
Wilmington, Delaware, Wilmington Society of
the Fine Arts, Delaware Art Center.
Opposite, top, right JOHN MARIN, *Boat and Sea,
Deer Isle, Maine, Series No. 27*, 1927.
Santa Monica, California, The Family of Doris
and Henry Dreyfuss.
Opposite, bottom JOHN MARIN, *Young Man of
the Sea, Maine, Series No. 10*, 1934.
New York, Metropolitan Museum of Art,
Alfred Stieglitz Collection, 1949.

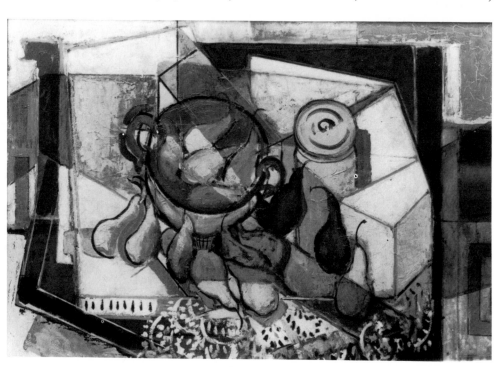

216

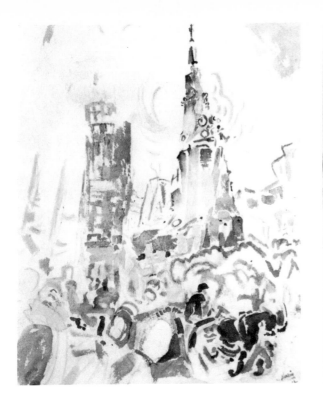

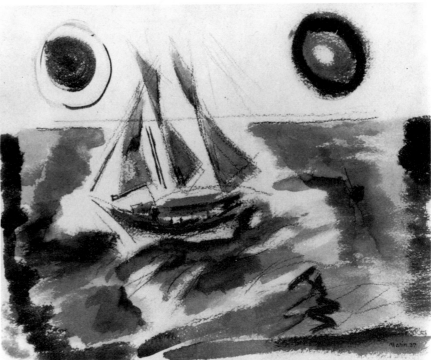

that seems suggestive. Is *Young Man of the Sea* a self-portrait and a clue to the meaning of some of the others? The unique discontinuities, the abrupt stops and starts and switches in direction – the stylistic vocabulary that integrated Marin's selfness is paralleled in his verbal expression:

> As to my doings – my makings – on canvas and on paper – of oil paint – of water paint – of a quiet realized recognition of – of a difference between – of a stretched canvas – as a burden bearer for to tenaciously grip and to hold and to bind its expressing oil paint – of a white paper – of itself – of a quality intrinsic – for to hold – for to show – of itself and its water paint talk. There seems to me a benefit found in the working of these two – each – thereby of a seeing of each thereby.[33]

The theme is oil painting and watercolor. It lies beneath the broken surface of the words just as 'the thing out there,' of which Marin spoke – the boat and sea – exists beyond the canvas with the marks. When America makes poetry it creates it out of facts.

Cézanne and Oriental art helped Marin to understand how 'to say more with less', as Hans Hofmann would later teach his students, and he had use for the Fauves, the Futurists, and the Cubists, while his artistic imagination held the memory of Rembrandt and Tintoretto. But Marin kept his eyes on the earth and sea and sky beyond the window pane, on the 'out-there' that he brought indoors where he experienced the 'inward traveling which throws us back on our haunches again.'

Some painters stay home, others wander, realistically and metaphorically speaking; some settle down in their styles, others move about. Marsden Hartley was the restless kind. The only artist in America to pick up Segantini's Italian stitch, he dropped it in 1909 for Ryder's powerful patterning in which, as he said, he saw his own native Yankee soul.[34] Hartley arrived at '291' that year and exhibited his symbol-laden mountain landscapes for two years, until Marius de Zayas arranged for the first Picassos seen in America to be shown at the gallery. *Landscape no. 32* was 'the first painting [Hartley] made after seeing examples of Picasso's analytical cubism.'[35] Two years later he was in Berlin, after a brief stay in Paris where he moved in the Stein circle, and now Cubist experiment expanded to accommodate the aesthetics of German Expressionism absorbed through contact with Kandinsky and Franz Marc. The most brilliant success of this first German period is the *Portrait of a German Officer*. Back in America at the outbreak of World War I, he was off to Bermuda in 1916 where his style shifted again to large, simple geometric shapes that suggest some knowledge of Casimir Malevich's Suprematism. In 1919, in New Mexico, a new kind of expressionism appears in his work, possibly because of contact with American Indian art, possibly because the memory of Ryder re-emerged. The series of *New Mexico Recollections*, painted in Berlin during 1922–3, is typical of his curvilinear style at this time, in which outlines delimit heavy forms layered like geologic strata that flow lava-like in ponderous rhythms.

In 1928, living in the shadow of Cézanne's Mont Sainte-Victoire, Hartley renounced Expressionism 'forever.' 'I have joined, once and for all, the ranks of intellectual experimentalists,' he declared. 'I can hardly bear the sound of the words, "expressionism," "emotionalism," "personality".'[36] But these were the qualities most natural to his art, and, in the closing years of his life, settled in Maine, Hartley at last found the means to assimilate the experiences of his wanderings. As structured and expressive as a rock, the paintings of the late period, like *Mount Katahdin*, speak in a calm, strong voice resonant with feeling and long memory. 'Nativeness is built of such primitive things,' he wrote in 1937, 'whatever is one's nativeness one holds . . . no matter how far afield the traveling may be.'[37]

American art, for all its romanticism, is rarely lyrical in the way the painting of Matisse is, or that of Marc Chagall. But there are some lyrical passages in American

Above MARSDEN HARTLEY, *Landscape No. 32*, 1911.
Minneapolis, Minnesota, University Gallery, University of Minnesota.
Below MARSDEN HARTLEY, *Movement No. 11*, 1917.
Minneapolis, Minnesota, University Gallery, University of Minnesota.

MARSDEN HARTLEY,
New Mexico Recollection,
No. 11, 1922–3.
New York Babcock Galleries.

MARSDEN HARTLEY,
Mount Katahdin,
Autumn, No. 1, 1930–40.
Lincoln, Nebraska, University
of Nebraska Art
Galleries, Sheldon Art Gallery.

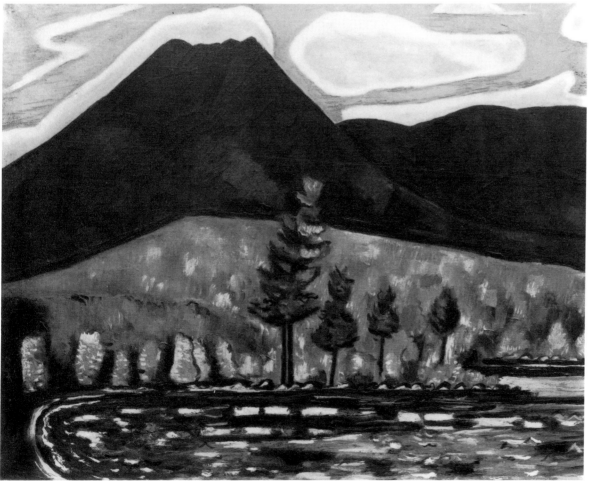

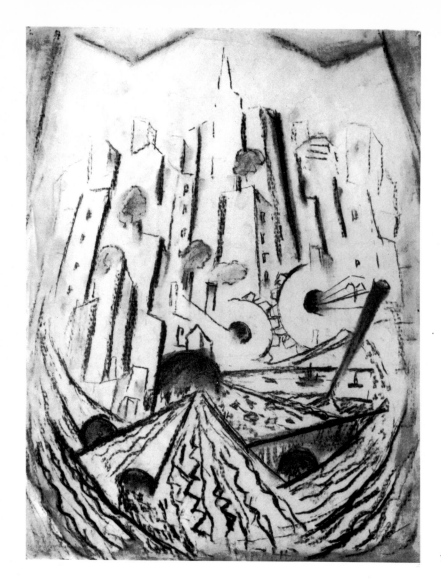

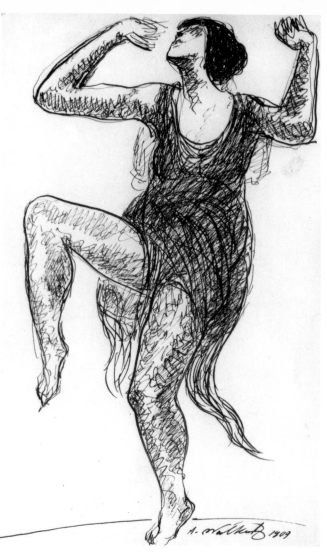

Above ABRAHAM WALKOWITZ, *City Improvisation*, 1916.
New York, Zabriskie Gallery.
Above, right ABRAHAM WALKOWITZ, *Isadora Duncan*, 1909.
New York, Zabriskie Gallery

Modernism and many of them belong to Abraham Walkowitz, whose art shares with Matisse and Chagall that indefinable quality that makes one feel light-bodied as one looks at it. Walkowitz, another artist who first found an audience through '291,' is identified with his countless drawings and watercolors of Isadora Duncan which capture the dancer's arabesque, unlaced, bare-foot style, as shocking in the first decade of the twentieth century as modern painting and for the same reason. Her art carried the message of freedom: from conventional restraints whether they be corsets or correctness of drawing; for self-expression, whether social or aesthetic. Walkowitz's equally uninhibited compositions on the theme of New York are less well known, but the city, no less than Isadora, danced his improvised songs.

The '291' circle was like a tribal family with Stieglitz playing the role of father, brother, and even husband. His relationship to all was formalized in his marriage to Georgia O'Keeffe, who became from the time they met, 'the center of his life and work until his death in 1946.'[38] O'Keeffe came into Stieglitz's life when she marched indignantly into '291' one day in 1916 to demand that he remove her watercolors from exhibition. She had made them to please herself, and a friend had taken them to the gallery without letting her know. Stieglitz won the argument, the paintings stayed up on the walls, and the long, rich professional and personal association began.

Flowers, walls, bones, and sky have constituted the major iconographic elements in O'Keeffe's paintings, and it is with something like awe that one comes to realize how her single-minded artistic purpose, her clear vision of herself and her view of

reality are concentrated in those apparently different motifs. Her *oeuvre* is an immense symphony of creation, death and resurrection expressed thematically in the ambiguity of openings – entrances and exits that divide certainty from uncertainty, that bridge the abyss between unknowing and knowing. Her early abstractions and flower pieces evoke sexual associations in our psychologically-oriented age, despite the artist's disclaimers. The enigmatic walls of Stieglitz' Lake George farmhouse where she spent a number of summers in the 1920s, like those of the adobe house in Abiquiu, New Mexico, where she has lived since the late 1940s, offer mysterious openings into blankness, as if beckoning into a tomb. The bones, sometimes skull-like, sometimes skulls, are often thorn shaped, evocative of pain. In her late paintings of sky and clouds on huge canvases, she draws the viewer into a shared sense of weightless blue and white. Through almost all the range of her art, O'Keeffe has dealt with the paradoxical essence of experience, the strange human intuition of movement, of time and space in an eternal limitless universe.

Stieglitz maintained his leading position as the out-standing defender of modern art in America until 1917, when his exhibition activities were interrupted because the building at 291 Fifth Avenue was razed. It was not until 1925 that he opened The Intimate Gallery, installed in a small room of the Anderson Gallery at Park Avenue and Fifty-Ninth Street, 'uptown' where the art action was developing. But the sense of challenge, the conviction of mission that gave vigor and meaning to 291 before the World War I could never be recaptured, although here, too, and in his last gallery, An American Place, Dove, Hartley, Marin, and O'Keeffe continued to find an ivory tower where they could aesthetically resist the social claims of art made by the Depression, and World War II.

Although the aesthetic movements led by Henri and Stieglitz were utterly different, there are similarities to be noted in the two men, tendencies underlying American culture. Both men were successful partly because of their charismatic personalities, able to inspire the young artists in their circles with belief in themselves, and with the sense of fighting for an underdog cause. Both held a vigorous

Above GEORGIA O'KEEFFE, *Lake George Window*, 1929.
New York, Collection, The Museum of Modern Art, Acquired through the Richard D. Brixey Bequest.

Below, left GEORGIA O'KEEFFE, *From the Faraway Nearby*, 1937.
New York, Metropolitan Museum of Art, Alfred Stieglitz Collection.
Below GEORGIA O'KEEFFE, *Gray Line with Black, Blue and Yellow*, 1923.
Private collection.

anti-academic bias – Henri going to 'the people' for support, Stieglitz developing an intramural elitism – that reflected the common American suspicion of institutionalism as inhibiting individual freedom, but their radicalism was tempered with moderation. 'Institutionalism,' Stieglitz declared, 'is contrary to the spirit of art and the artists . . . rather that all the pictures and museums be burned if they are not used as instruments for the proper end and in the proper spirit.'[39] Henri's comment on institutionalism quoted earlier comes to mind. Compared with the zeal for destruction voiced, at least, by the Futurists, the Americans were mild indeed. Europe felt the heavy burden of tradition and reacted violently to throw it off. America was building. Both Henri and Stieglitz, the former rooted in life, the latter in aesthetics, shared a common commitment to the creation of an American art.

American art was readied by Henri and Stieglitz to make its bid for national and international attention, and opportunity appeared, with a man who recognized it. Standing in the wings, a new hero for the pantheon of American art and art history was waiting for his cue to take the center stage. Arthur B. Davies came forward when he was called to direct the stupendous undertaking that goes down in history as the Armory Show.

A group of American artists including Walt Kuhn, Jerome Myers, Elmer McRae, Alden Weir, and the sculptor Gutzun Borglum had formed the Association of American Painters and Sculptors in 1911, aimed at mounting a large exhibition of contemporary American and European art. Weir was chosen as President. When the anti-Academy position of the group became clear, however, Weir, a loyal Academician, and member of the Academy's Council, resigned and the post was offered to Davies, a well-established painter but not completely identified with any movement, giving him the advantage of non-partisanship over Henri. Into Davies' hands, during the summer of 1912, came the catalogue of the *Sonderbund* exhibition in Cologne, Germany, and from that moment, the Armory Show was born. Walt Kuhn agreed to go to Cologne, and from their traveled through Germany, Holland, France and England, making selections of paintings and sculpture, and arranging for their American showing. Alfred Maurer, Walter Pach, and Jo Davidson were in Paris, providing Kuhn with introductions to the radical artists and to their art. Davies finally joined them to make the final plans, and soon the first huge shipment of modernist European art was sent for exhibition with American art to the United States.

Although the American participants included many of the more progressive artists, their work was stylistically modest compared with that of the advanced Europeans; the latter consequently won most of the publicity when the Show opened on 17 February 1913 at the Armory on Lexington Avenue at Twenty-Seventh Street, although their works accounted for only one-third of the approximately 1,300 paintings, sculptures, and graphics exhibited.[40] The nature of the Armory Show's success is underlined by the public's response to Marcel Duchamp's *Nude Descending a Staircase*: like the *Nude*, the whole show was a 'success by scandal,' and from all reports the curious who came to see the 'explosion in a shingle factory' as Duchamp's painting was called, and the 'hardboiled egg balanced on a cube of sugar,' as Brancusi's *Mlle. Pogany* was described, felt they got their admission money's worth.

The Show was organized with the aim of stressing that the roots of modern art grew out of the nineteenth century, thereby giving the authority of tradition to the avant-garde. With only one painting by Delacroix, two drawings by Ingres, one miniature by Goya, two oils by Corot, one by Courbet; without a single Constable or Turner, the unsophisticated visitor to the show understandably overlooked this didactic intention, and found himself dismayed by still strange Cézannes, Van Goghs, Gauguins; and nervously hilarious by the still stranger Matisses and

Picassos. But if Stieglitz himself had been unable to 'see' Cézanne in 1907, it could hardly be expected that the public could 'see' him or the other Post-Impressionists only six years later, with little opportunity ever to have become familiar with their work. It is extremely doubtful that American criticism, public or professional, was more retarded and more hostile to modern art than was French. Just as some in France were ready to defend the new, here, too, were journalists and historians like Henry McBride, Charles Fitzgerald, James Gregg, Charles H. Caffin, Christian Brinton, J. Nilson Laurvik, among others, to express their understanding and prophetic insight about the new art. Arthur Dove, target of a famous jingle in 1912 in which a critic accused him of painting not the pigeon but the coo.[41] was defended with intelligence and vigor by another critic who saw in his work 'the new energy working here – breaking a way into the untried . . . taking new hold of visual elements.'[42] For every example of harshness, vituperation, and indignant scorn in the American press, one can cite an equal in Paris. It might have helped, at the Show, if the art of some of the non-Western cultures had been included. African and Oceanic sculpture, and Japanese woodcuts had played an important part in shaping modern art, and visitors could have appreciated the obvious formal relationships, and perhaps even have been soothed that the Cubists and Fauves were not engaged in a conspiracy to fool them with meaningless inventions. But the Show's organizers, French-oriented, themselves were not so acutely aware of some of the influences on Matisse, Braque, Picasso, and the German Expressionists. They seemed to have underestimated the last, since only Kandinsky and Kirchner were included, with one work each.

But although the Show was less universal than it might have been – even the Italian Futurists were missing[43] – the stir it created was of great importance for American art. Crowds poured into the Armory and it is estimated that paid attendance reached about 70,000 in the four weeks of the New York exhibition. In Chicago, attendance was even greater, due possibly to some free admission days, with 188,650 visitors in three and one-half weeks.[44] Only the foreign works were shown in Boston, where paid admissions totaled 12,676. Sales in New York came to 235 pictures – by percentage almost four times the number of works sold by The Eight only five years earlier. More people had been made aware of art in this country than ever before, and although it is true that once it was over it was forgotten by the vast majority who saw it, a certain residue of awareness remained to become a permanent part of American cultural consciousness. Important new American patrons, including John Quinn, Arthur Jerome Eddy, Walter Arensberg, and Lillie P. Bliss, were found for modernist – although mainly French – art, and consequently dealers were encouraged to show the new painting and sculpture. Charles Daniel opened his gallery in December 1913 with an exhibition of American moderns, followed by Stephan Bourgeois who presented both traditional and contemporary art by European as well as American artists. The strangeness of modern art gave it publicity value which helped keep it before the public; an exhibition of modern painting at the Montross Gallery in February 1914 was caricatured in the New York *Sun*, showing Walter Pach, Walt Kuhn, Arthur B. Davies, who organized the show, and Joseph Stella all dressed up in their new painting styles. As the movement gained coherence, Walter Arensberg, a supporter of new literary magazines and a poet himself drew together a circle of some of the most brilliant foreign and American artists and intellectuals, and backed the Modern Gallery which opened in 1915 with the critic and caricaturist Marius de Zayas, long associated with Stieglitz's *Camera Work*, as director. The foundations were laid for a thriving art community which, although slowed by the War and Depression, was eventually to become the world center of modern art.

Although it is sometimes – and probably correctly – pointed out that modern art

would have happened here anyway, the Armory Show, as Meyer Schapiro has shown,[45] was a catalytic event of critical moment in the art life of America. And yet – and this is not to reduce its importance – it is difficult to claim for it more than a brief and partial influence on the style of contemporary American painters. Stuart Davis and Man Ray, for example, young artists deeply affected by the Show,[46] absorbed the message of modernity and made their own interpretations, but Man Ray's friendship with Marcel Duchamp whom he met in 1915 was probably more crucial in shaping his development, and Davis moved slowly through Post-Impressionism and Fauvism in the decade after the show before he began to apply the lessons of geometrical abstraction derived from post-Armory Show Cubism. The Realists brightened their palette, stimulated by the brilliant colors of the modernists, but they had already begun to break away from the dark Impressionism of Ash Can painting as a result of Maratta's influence.

Many of the artists who have come to be called pioneers of American modern art had earlier made their commitment to modernism. Marin's *Broadway, St Paul's Church* in the exhibition was about as stylistically advanced as his art would ever be; Weber, not in the show because he was dissatisfied with the small number of his paintings accepted by the committee, continued to develop his Futuristic-Cubist style of 1912 for a few years; Maurer's painting remained essentially Fauve-based during the teens; the changes in Dove's art evolved slowly out of its inherent aesthetic logic. Hartley was in Europe exploring the Cubist grammar that he applied to the language of German Expressionism; Maurice Sterne, not in the show, was in Bali painting the natives and landscape in a Cézanne influenced naturalistic style, vaguely Cubistic, that did not change significantly after his return here in 1915. Other modernists like Arthur B. Carles, Oscar Bluemner, and Samuel Halpert who had gone through the Post-Impressionist-Fauve-Cubist syndrome in Europe, carried on with the compromises they had devised, applying a Cubo-Fauvist fusion to representational painting. Georgia O'Keeffe had not yet arrived on the scene.

On the other hand, many artists did become somewhat more daring as a result of the Show. The measure of modernism was Cubism, and a number of painters began to experiment with angular patterning, although few appear to have grasped to significant depth the meaning of Cubism as a way of dealing with reality aesthetically as revolutionary as the physics of Einstein or the philosophy of Edmund Husserl. Arthur B. Davies and Walt Kuhn do not reveal in their decorative, expressionistic adaptations of Cubism a cool, cerebral method for analysis of form as it is perceived and interpreted by, and related to, a viewer – the Cubism of Braque and Picasso; nor does Walter Pach, who had not learned his Cubism from the Armory Show but already had a thorough knowledge of the theory as practiced and articulated by the Puteaux Cubists, Jacques Villon, Marcel Duchamp, Raymond Duchamp Villon, Fernand Léger, Albert Gleizes, and Jean Metzinger, with whom he had been closely associated in France. The work of the Puteaux group seems to have been, superficially at least, more accessible as well as more attractive to the Americans, to judge by their post-Armory Show painting with its colored patchwork surface, and the greater effect of dynamic Cubism on American painting at this time can also be partly accounted for by the dramatic presence here of Picabia and the scandalous success of Duchamp. Andrew Dasburg, Henry Lee McFee and Arnold Friedman wrestled more energetically with the Cubist problem of translating sculptural form into spatial intervals on the basis of color contrasts, tonal variations, and differences in linear qualities, but McFee and the highly gifted Friedman soon retreated to a milder adaptation of Cubist lessons, while Dasburg remained a convinced convert of limited ability despite his theoretical understanding.

Relatively few Americans had had any preparation for Cubism or non-objective art, and the majority grasped at the straw seemingly held out by the influential

MORGAN RUSSELL, *Synchromy No. 2, To Light*, 1913.
Birmingham, Michigan, Collection of Mrs Barnett Malbin (The Lydia and Harry Lewis Winston Collection).

aesthetician Clive Bell in stating the formalist viewpoint. 'Let no one imagine that representation is bad in itself; a realistic form may be as significant, in its place as part of the design, as an abstract. But if a representative form has value, it is as form, not as representation. The representative element in a work of art may or may not be harmful; always it is irrelevant.'[47] Irrelevance was perhaps a small price to pay for keeping on good terms with nature, and it was not hard to find a rationale for compromise in this position. Bell's tolerance appeared to allow a toe in each door, an awkward pose that possibly accounts in some measure for the clumsiness of some of our pioneer modernist painting.

But even some of the best of our artists were not yet ready to give up the everyday world of appearance. If Charles Sheeler, for example, had been more metaphysically oriented he could have arrived independently at Neo-Plasticism through such work as his *Landscape* of 1915 where figurative elements participate in a geometric dialogue, as in early painting by Mondrian. Instead of moving further in the direction of non-objective composition, Sheeler increased the references to nature and subjected them to a reductive system of geometrized form. Marsden Hartley, on the same road in 1916, took the turn-off to figurative Expressionism.[48] The ground for modernism in this country was too shallow to nourish a full development. The realist tradition with its social foundations was rich and deep and could not easily and quickly be displaced by an imported, logically evolved aesthetic.

It is surely no accident that the only non-objective movement originated by Americans, Synchromism, had nothing to do with America and the Armory Show. The theory and style were developed by Stanton Macdonald Wright and Morgan Russell over a period of five years between 1909–14, while both were in Paris, close to the Stein circle, and associated directly with Robert Delaunay during the period he was working out the color theory that led him to non-objective painting by 1913.

Russell had studied with Henri but rejected dark Impressionism in Europe when he became absorbed with the brilliance of Monet's bright color. He settled in Paris in 1909, after being drawn into the Stein circle, where he met Matisse with whom he worked on a group of sculptures. His study of Cézanne's method of realizing form through color deepened the sculptural tendencies in his painting which always retained a density and solidity quite opposite to the transparent planes that characterize the work of Stanton Macdonald Wright.

Macdonald Wright had also passed, indirectly, through Henri's teaching, learned from Warren T. Hedges who had taught with Henri. Arriving in Paris in 1907 he discovered Cézanne. A natural predilection for scientific theory brought him to study the work of Seurat, and when he met Russell in 1911, both young artists knew Delaunay whose color experiments paralleled their own.

Basing themselves on scientific accounts of color as demonstrated by the French chemist, Chevreul, and the American physicist O. N. Rood, and on their study of Seurat, Signac, and above all, Cézanne, Russell and Macdonald Wright arrived at their theory of color as an optical analogue to music. Their color 'synchromies' were composed with color chords, dominant and subdominant keys, harmonies and dissonances following laws of contrast and intensity. Working with a twelve-tone color wheel analogous to the twelve-tone musical scale with the primaries one hundred twenty degrees apart, Macdonald Wright played his compositions on a piano, 'proving' and adjusting the effects of his tonal combinations.

By 1913 Russell had reached non-objective painting as an implicit demand made by his interpretation of color theory. Since color alone was to generate form and movement, attaching it to recognizable objects which made their own demands of spacial extension led to a possible contradiction, he saw, which, however, could be resolved if one suppressed the object. Russell worked with sculptural, geometrical

forms, and in fact, based one of his first successful synchromies on the rhythms and formal relationships of Michelangelo's *Slave* in the Louvre.[49] Macdonald Wright retained the object until 1914, when he, too finally took the last step into non-objective art with such paintings as *Arm Organization*. This phase of Synchromism was brief, both painters returning to figurative imagery in 1916, Russell to take up his non-objective work again in the 1920s, Macdonald Wright to abandon it until 1954.

Patrick Henry Bruce and Arthur B. Frost had also come into the Delaunay orbit after finding their way through French mainstream painting, rejecting, as had Russell and Macdonald Wright, the teachings of the Chase-Henri school through which each had passed. Their development, too, was independent of American events, since Bruce arrived in Paris in 1904, Frost in 1907. Bruce remained in France until 1936 when he came back to the United States; he committed suicide shortly after his return. His influence was felt here, however, through his friend Frost, who left Europe at the outbreak of the war. Frost disseminated the principles of color theory through his participation in the Penguin Club, formed by Walt Kuhn after the Armory Show, and was instrumental in arranging for the exhibition of Bruce's paintings at the Montrose Gallery in 1917 shortly before his own sudden death at the age of thirty. New York had already seen non-objective color painting at the Synchromist exhibition at the Carroll Gallery early in 1914, and at the Forum Exhibition held in March 1916, organized principally by Macdonald Wright's brother, Willard Huntington Wright, an acute critic of modern art who became the foremost spokesman for Synchromism.[50] The Forum Exhibition marks the high tide of the first wave of modernist painting in America, and the show's catalogue makes explicit the underlying assumptions and aspirations of progressive artists of those years, even if the paintings themselves often fall short of realization of those aims. Willard Wright wrote one of the catalogue's six forewords, in which he explained that the purpose of the exhibition was 'to turn attention for the moment from European art' to focus attention on the American moderns who 'are trying to divest . . . fundamental qualities of all superficial matter, to state them purely . . . so . . . to increase the emotional reaction of the picture.' Purity and essentiality equated with emotional impact was the keynote of almost every statement in the catalogue made by the seventeen[51] artists represented in the exhibition, including those whose work was only slightly reductive. Ben Benn exhibited figurative work and declared, 'I put in my work only the selected essentials of my inspiration desiring above all that my work shall be direct' William Zorach, who did not turn to sculpture until about 1917, was painting in a Matisse inspired style and showed *Spring no. 1*, with the comment, 'It is the inner spirit of things that I seek, the essential relation of forms and colors to universal things. . . .' Henry L. McFee exhibited his Cézannesque-Cubist work with the explanation, 'I am endeavouring by analysis to find the essential planes of the emotional forms of my motif. . . .' Synchromism was represented in the show by its creators, with William Benton and Andrew Dasburg as converts. Russell stated 'I believe that non-illustrative painting is the purest manner of aesthetic expression . . . the emotional effects can be even more intense than if there was present the obstacle of representation,' and Macdonald Wright explained, 'I strive . . . to purify my art to the point where the emotions of the spectator will be wholly aesthetic, as when listening to good music.' William Benton had learned Synchromist principles from Wright, which he applied to figure compositions, expressing his ambivalence about abstract art in the statement, 'I believe that the representation of objective forms and the presentation of abstract ideas of form to be of equal artistic value.' Benton painted some wholly non-objective synchromies for a short time although he later repudiated abstraction as aesthetic soul probing.[52]

STANTON MACDONALD WRIGHT, *Conception Synchromy*. Birmingham, Michigan, Collection of Mrs Barnett Malbin (The Lydia and Harry Lewis Winston Collection).

226

Andrew Dasburg, close to Cubist and Synchromist developments through his friendship with Russell became one of the most sophisticated of American modernists. His most advanced work is represented by his synchromies at the Forum show, thorough-going non-objective compositions that were intended 'to stimulate one's sense of the aesthetic reality.' Arthur Dove wished to set down the essence of the reality of his sensations while Oscar Bleumner echoed Marin's appeal to the 'inner senses' declaring that '. . . a picture ought not to be and cannot be fully explained.' Walkowitz's art also referred, he said, to something beyond words. Charles Sheeler, who had moved far ahead of his Cézanne-Cubist style of Armory Show vintage, ventured 'to define art as the perception through our sensibilities, more or less guided by instinct, of universal order and its expression in terms more directly appealing to some particular phase of our sensibilities.'

Marsden Hartley identified the artist's aesthetic with his experience of reality, . and wondered if 'the individual psychology of El Greco, [Cézanne], Giotto and the bushmen had not more to do with their idea of life, of nature, of that which is essential . . . than any ideas they may have had as to pictural problems.' Alfred Maurer, primarily aware of the direct sensual impact of color, explained, 'I . . . have keyed my pictures in a high articulation, so that the reaction to them will be immediate and at the same time joyous and understandable.' Man Ray wrote that '. . . the marvelous works [of the past] still live for us because of absolute qualities they possess in common. . . . The artist is concerned solely with linking these absolute qualities directly to his wit, imagination and experience. . . . Working on a single plane as the instantaneously visualizing factor, he realizes his mind motives and physical sensations in a permanent and universal language of color, texture and form organization. He uncovers the pure plane of expression. . . .'

The Forum exhibition makes clear the very different conditions of modernism in America as compared with Europe, and suggests why it seems artificial to assign stylistic labels, except to the Synchromists, to modern American artists of this decade. In Europe the Fauves had come together on the basis of shared interests, had worked, theorized, and exhibited together, and had found themselves identified as a group, despite rather wide stylistic differences among them, on the grounds of a generally pervasive formal affinity. So with the Cubists, the Futurists, the Blaue Reiter and the artists of De Stijl. In America, artists had gathered around Henri and forged an identity for themselves as city realists, but among the modernists there was no painter with a vision so compelling, and leadership fell consequently to Stieglitz, whose commitment was to modernism as a concept, rather than to any one modernist style. The situation is illuminated by contemporary American criticism which referred to the modernists as 'Post-Impressionists,' or 'Matisse School,' and employed the term 'Futurist' not categorically in the context of style but descriptively in the context of time, meaning 'the modern age.' The range of styles at the Forum show echoes the viewpoint of Oscar Bluemner's rhetorical question in the catalogue, 'Why . . . should American painting be limited by either old canons or any single new "ism"?' Not only was American painting in general not 'limited'; but neither were most paintings.

The most important artist to undergo a modernist metamorphosis in direct response to the Armory Show was Joseph Stella. One of the finest draftsmen in American art, Stella's work in the early years had been concerned with the human figures which he drew and painted in a conservative style that owed much to his study of Rembrandt in the Metropolitan Museum as well as to his training in the Italian academic tradition before his arrival in New York in 1896, when he was almost nineteen years old. In Italy for a two-year visit during 1909–11 he seems to have had no knowledge of the Futurists who were at that time at the height of their polemical activities, and it was not until he arrived in Paris in 1911 that he came

227

into contact, through Walter Pach, with the modern French movements. He had advanced no further than early Fauvism, however, when he returned to the United States in time to participate in the Armory Show with some sparkling still lifes. It was immediately after the Show, as he records in his *Autobiographical Notes*[53] that he began the work that led within the year to his *Battle of Lights, Coney Island*, the major Futurist painting in American art. Big, bold, dense, *Battle of Lights* drew on Stella's memory of what he had seen in Paris the year before, especially the Futurist exhibition, together with some of Severini's unexhibited work, as seems probable, and Delaunay's *Ville de Paris*, and reflects also what had attracted him at the Show, particularly the decorative and optically stimulating painting of Jacques Villon and Francis Picabia. But none of these influences accounts for the explosive power of Stella's image, making *Battle of Lights* one of the most original and advanced paintings in America when it was exhibited at the Montross Gallery in February 1914.

Although Stella continued to paint in a modernist style for about ten years, very few of his other paintings can be considered Futurist, as such. Superfically there are resemblances to Balla and the other Italians, and to Orphism and Synchromism, too, between 1914 and 1918. But Stella utterly rejected theories as inhibiting the temperament of the artist and thus, like all our progressive artists of the period, he, too, is best seen as a modernist outside of European classifications and schools. His independence often led him astray, but it enabled him also to create his finest

JOSEPH STELLA, *Tree of My Life* (detail), 1919. Des Moines, Iowa, Iowa State Education Association.

works, among which must be counted the first version of *The Bridge*. An early symptom of artistic interest in the American industrial scene, this dark, mysterious, multi-faceted form, and Stella's other industrial scene paintings, have little in common with the Precisionists' interest in the same subject matter that began to develop after the war. *The Bridge* is the pendant to Stella's autobiographical *Tree of My Life*. Both paintings, so different in apparent imagery, symbolize the frustrated longing that underlies his work and the love-hate, fear-courage oppositions at war in his nature.

Stella's most ambitious work is his monumental five-part *New York Interpreted*. A 'symphony' of the modern city, it orchestrates skyscrapers, bridges, and subway tunnels, lights, sounds and smells; an 'altarpiece' for contemporary life, it fuses traditional religious imagery with modern architectural form, as seen for example, in the skyscraper at the center with radiating spokes of light.[54] An uneven painter, Stella's best work, including collages of unexcelled quality, ranks with the highest achievements of his contemporaries and places him among the foremost of those artists who in the second decade of this century created modern art in America.

American art was channelled into modernism largely through the influence of American artists who studied abroad and as a result of European art exhibited here. Furthermore, the presence during the war of Marcel Duchamp, Francis Picabia, and Albert Gleizes brought additional glamour and sophistication to the New York art community. Duchamp and Picabia, moreover, stimulated the first post-Cubist sensibility to be developed here – the nihilist spirit of Dada.[55] Inspired by irreverence and convinced of the power of caprice, Duchamp and Picabia viewed the machine as the sovereign antic devil of a progress-oriented culture. They painted it, gave it in marriage, and erected around it a full panoply of mythology. Dada was a monumental pun comprised of many small puns, like Joyce's *Ulysses*, creating overlapping meanings and images that were paradoxically, – again like Joyce – sharp-focused and precisely edged. In its character of a pun, and because of its emergence at this time, Dada may remind one of Freud's interest in jokes, explicated in his book, *Wit and its Relation to the Unconscious*, published in 1905.[56] The joke, in America, tended most often to be on man and the machine, man the ironically impotent doer, the victim of the greatest of all illusions, that of free will, and in this sense, Dada had its own American roots. Mark Twain had seen man as 'a mere coffee mill,' or 'sewing machine,' a mechanism incapable of creating;[57] and anti-mechanistic sentiment influentially voiced by Ruskin echoed in America into the twentieth century. It had a natural home at 291, and proto-Dadaist activity in New York centered at Stieglitz's gallery.

Benjamin de Casseres, whose art criticism often appeared in *Camera Work*, declared as early as 1913, 'Sanity and simplicity are the prime curses of civilization . . . a kind of lunacy wherein a fixed idea blankets the brain and smooths the admirable incoherence of life to a smug symmetry and proportion.' The mockery of civilization that helped to generate Dada was specific in de Casseres' comment, 'We should mock existence by the perpetual creation of fantastic and grotesque attitudes, gestures and attributes.' Marius de Zayas, also anticipating Dada by several years, announced in 1912, 'Art is dead.'[58]

Picabia gravitated to 291 immediately on arriving in New York for the Armory Show, and later in 1913 had an exhibition in the gallery. In 1915 he participated in founding a publication called *291* for which he made drawing puns: portraits of Stieglitz as a camera, of de Zayas as a pump surmounted by a corset, and one of himself as an automobile horn, referring to his fondness for racing cars.

Marcel Duchamp is one of the most captivating personalities in art history, and as an artist was his own most enigmatic masterpiece. What was often in others not

JOSEPH STELLA, *Skyscrapers*, 1920–2. Newark, New Jersey, Collection of the Newark Museum, Purchase 1937, Felix Fuld Bequest.

much more than a taste for the eccentric was in Duchamp an expression of a vigorous intelligence that seems never to have doubted itself: certain of his existential significance, he transformed a snow shovel or a comb into a work of art by an act of artistic will, rejecting with utter indifference the rational demand for explanations of his works, although willing to argue the validity of his aesthetic position. He defined a work of art as a creation of the artists's choice, on the basis of which definition he could send to the First Annual Exhibition of the Society of Independent Artists in 1917 a porcelain urinal, titled *Fountain,* and signed, 'R. Mutt.' It was a work of art, he explained in *The Blind Man,*[59] because he had chosen to invest it with a new thought and had placed it in a new context – the frame of art. Besides, as he said, plumbing and bridges were the only works of art America had created. The *Fountain* was his homage to America.

The Society of Independent Artists did not see it that way. The Independents, inspired by the French *Salon des Indépendants,* culminated a decade of attempts to find a satisfactory method of holding large exhibitions. The Academy system was obviously obsolete, and for years there had been pressure for a no-jury-no-prize exhibition to take the place of the annual Academy shows. The Society of Independent Artists, seeded by The Eight and the Independents of 1910, committed themselves to this ideal, and immediately betrayed it by refusing to accept Duchamp's *Fountain* which they considered a hoax. This sturdy work escaped the fate of a decorated chamber pot submitted to the show by an anonymous artist. William Glackens, the Society's first president, and some of the members of the executive committee were discussing what to do about the chamber pot. Glackens casually picked it up and 'accidentally' dropped it, thus solving the problem in characteristic direct American style.[60]

The Society did accept about 2,500 works by some 1,300 artists ranging from contemporary masters to amateurs, from conservative to modern. The works were arranged alphabetically, with equal space allotted to each exhibitor. The result was a chaotic assemblage of good, bad, and indifferent which was in a way, ironically, Dada in its choice of non-choice – a gigantic readymade.

Duchamp's masterpiece is *The Bride Stripped Bare by Her Bachelors, Even,* a work in progress over a period of almost ten years, and left unfinished by the artist in 1923. Also called *The Large Glass,* because it is composed of large panels of glass, the work is an elaborate 'modern legend' as André Breton has called it, with male and female roles played by machine parts, acting out erotic activity. *The Large Glass* reflects contemporary ideas of physics and psychology as well as aesthetics, and the viewer looks at, in, and through it into the modern world that is so largely the creation of Einstein and Freud. With this work, art no longer imitates or represents, but mediates life. Shattered by accident, the original *Glass* has remained cracked, as Duchamp preferred, logically consistent always in his belief in the priority of chance in the rule of life. His *Glass* is one of the most significant works of our century up to the present.

With Duchamp frequently the chief attraction, the apartment of the Arensbergs became a kind of displaced French café where he and Picabia, and other Europeans, gathered with American artists, poets, writers, performers, and miscellaneous eccentrics. Here Duchamp would spend the evening playing chess, spontaneously create one of his readymades or otherwise fascinate the other guests among whom were often to be found Man Ray, John Covert, and Morton Schamberg. Encouraged by the Armory Show, Man Ray was further impelled toward a new conception of art through his friendship with Duchamp which began shortly after the French artist's arrival in New York in 1915. In 1916 he produced, by the kind of accident characteristic of Dada, what was to become his best-known painting. Using spectrum-colored paper, he had been trying to sketch a dancer in various positions,

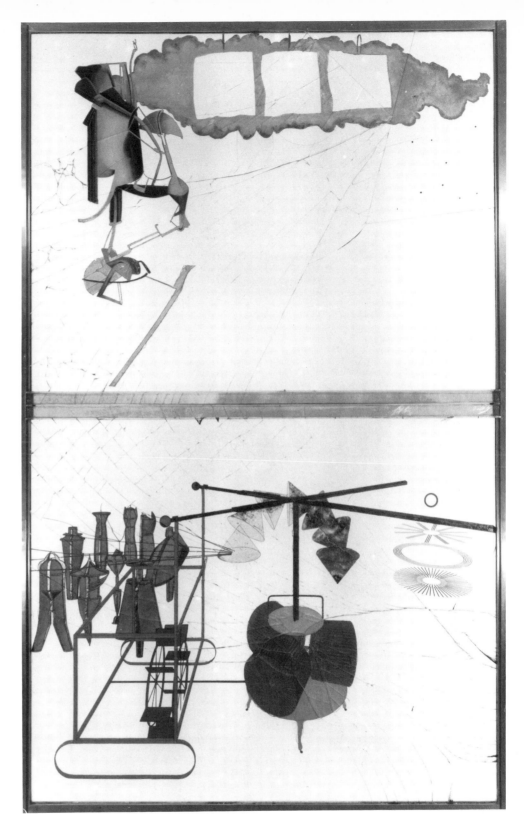

and had cut out the sketches in order to arrange them for his composition. The abstract shapes of the cut-away scraps of bright colored paper that lay on the floor caught his eye and suggested to him the shadows of the dancer he had sketched. Taking his cue from these, he began work on the canvas that he finished with the title written by hand across the bottom, *The Rope Dancer Accompanies Herself with Her Shadows*.[61]

Man Ray was early attracted to the possibilities of mechanical methods to produce art, and used the commercial air brush as a quick way of laying down

231

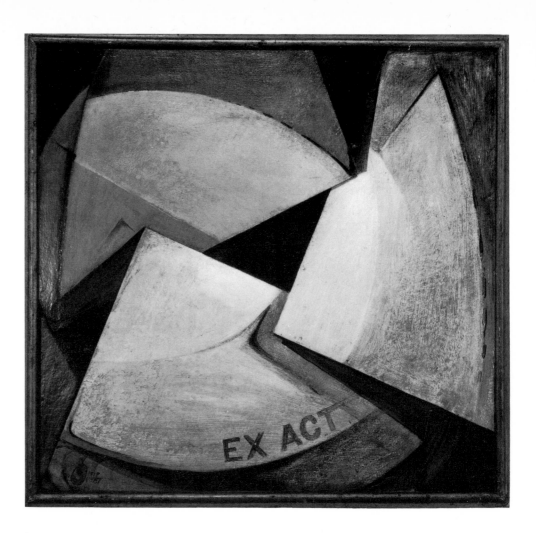

Right JOHN COVERT, *Ex Act*, 1919.
New York, Collection, The Museum of Modern Art, Katherine S. Dreier Bequest.
Below MORTON SCHAMBERG, *Mechanical Abstraction*, 1916.
Philadelphia, Pennsylvania, Philadelphia Museum of Art, Louise and Walter Arensberg Collection.

large areas of color and achieving precise contours. These works he called aerographs. His interest was soon drawn to the camera, however, and by the early 1920s he had given up painting almost entirely, agreeing with Duchamp that 'perhaps in the future photography would replace all art.'[62] Man Ray settled in Paris in 1921, where he has spent much of his life, closely associated with Surrealist artists.

John Covert, after almost fifteen years of conventional painting learned mostly in Germany, turned into a proto-Surrealist and Dadaist with incomprehensible suddenness, in 1915. For about five years some of his weird, witty or simply well-designed compositions were among the best being done in this country. The punning, sexual machine aesthetic is present in a number of his works, such as *Ex Act*, the forms and the word 'exact' suggesting the precision of machinery, but the separation between the letters indicating two words intended, almost certainly *Sex Act*, borrowing from Duchamp and Picabia their double images of sex and the machine. Covert left painting for business about 1920, and disappeared permanently from the American art scene.

Morton Schamberg was one of the first artists in America to use the machine as subject-matter for his paintings. His images are geometrized reductions from a motif usually drawn from the world of everyday mechanical objects, unlike the invented machines of Picabia and Duchamp. Although he shared with his close friend Charles Sheeler an admiration for functional form rendered with extreme clarity that links them both to a vital tradition in American art, Schamberg's work is invested with the anthropomorphizing imagery characteristic of the comic spirit of Dada, entirely absent in Sheeler's art. Schamberg's artistic development was cut short by his sudden death in 1918 at the age of thirty-seven.

232

The short-lived Dada movement is generally held to have been of little importance in affecting American art, and if we view Dada narrowly as an anti-art aesthetic whose method and aim was to shock by means of outrageous gestures and performances and thus create a pure, unreflective response, its influence was indeed brief.[63] But if we also see Dada as bringing to art a new class of subject – technology – rendered with linear precision and emphasizing geometric form and immaculate surface, its effect was far reaching; from such a viewpoint we may interpret Precisionism[64] – or that branch of it concerned with architectural and technological motifs – as a transformation of Dada into a reformed realism.

The Dadaists had used the machine ironically and perversely, but in doing so they helped make the machine and its environment artistic subject matter in its own right. Charles Demuth and Charles Sheeler, the two major artists associated with architectural and technological Precisionism, were part of the Arensberg circle, the latter an intimate friend of Morton Schamberg. Their style matured in the post-Armory Show decade, with the debunking spirit of Dada calling traditional values into question. Aesthetically the value question could be put: if fruit and flowers, trees, hills and valleys have hitherto carried the burden of meaning and metaphor, why not now replace them with machines, smoke stacks, and skyscrapers?[65] Framed in optimism, despair, or irony, the industrial landscape came into prominence as a new painting genre at the end of the decade, and remained significant throughout the 1920s.

Too much emphasis, however, has sometimes been placed on the influence of mechanical forms and the industrial landscape in creating Precisionist style. From the middle teens on, a preference for clearly defined, sharply reduced shapes is apparent among many progressive painters in Europe, and among some Americans, regardless of subject; Hartley's Bermuda abstractions of 1916, and Stella's birds and flowers, beginning around 1917, may be cited. Given such taste, architecture and

Below MAN RAY, *The Rope Dancer Accompanies Herself with Her Shadows*, 1916.
New York, Collection of the Museum of Modern Art, Gift of G. David Thompson.
Overleaf, left CHARLES DEMUTH, *My Egypt*, 1927.
New York, Collection of the Whitney Museum of American Art.
Overleaf, right CHARLES BURCHFIELD, *House of Mystery*, 1924.
Chicago, Illinois, Art Institute of Chicago.

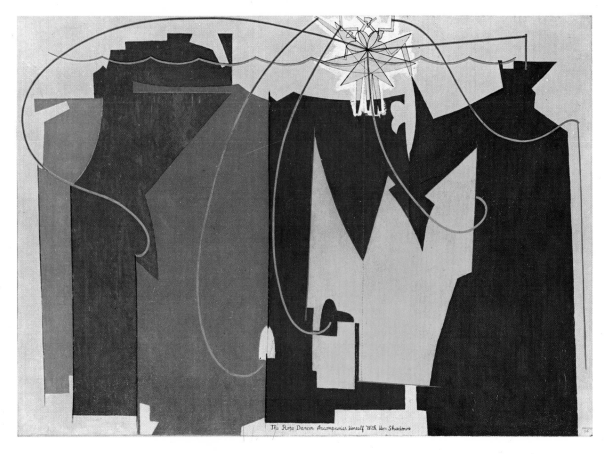

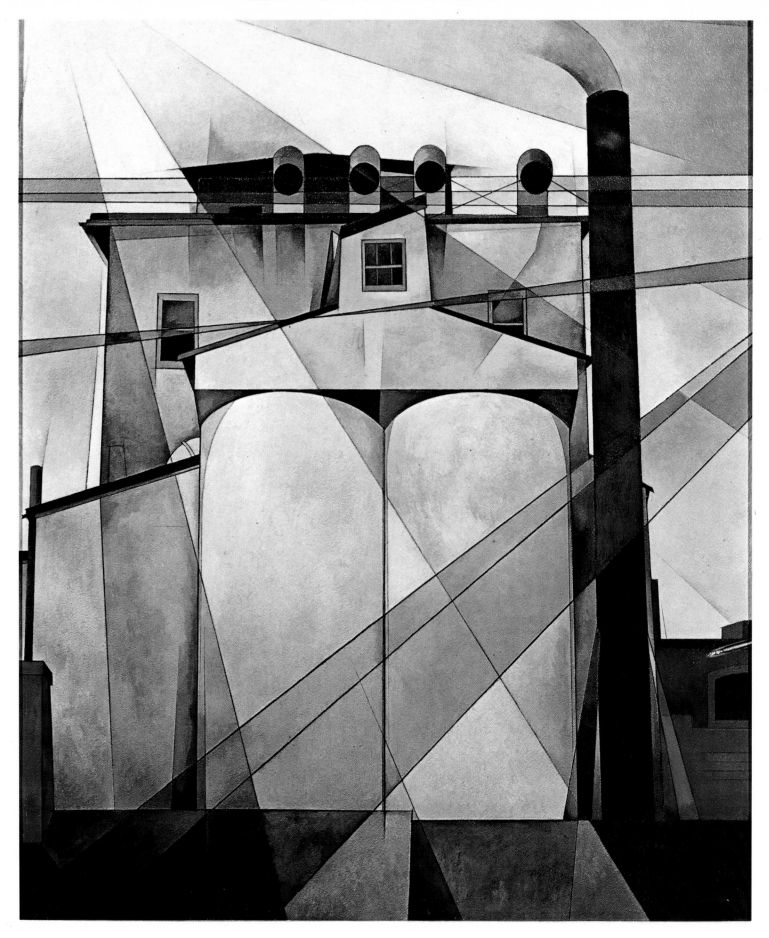

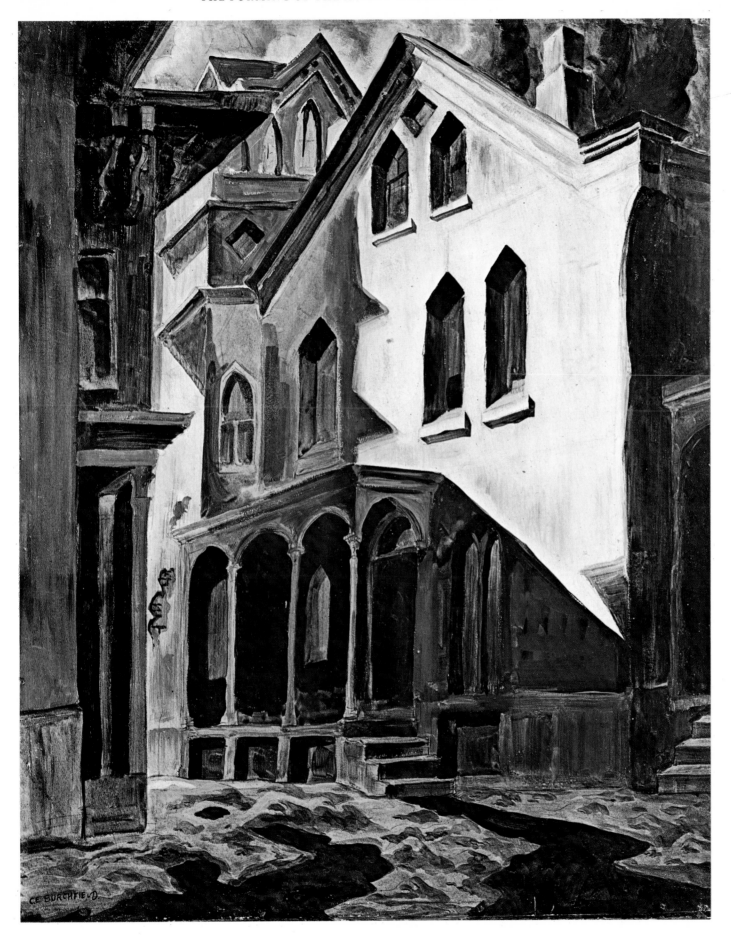

IVAN ALBRIGHT, *That Which I Should Have Done I Did Not Do*, 1931–41.
Chicago, Illinois, Art Institute of Chicago.

functional objects would readily suggest themselves as motifs, but it should be clear that the style preceded the subject: neither architecture nor utilitarian objects in the environment of the late teens and early twenties exhibited the sleekness of design we associate today with modern engineering. The buildings and utilitarian objects appearing in paintings by Sheeler and Demuth, together with George Ault, Stuart Davis, Preston Dickinson, Elsie Driggs, Stefan Hirsch, Louis Lozowick and Nile Spencer are generalizations, more or less sharp-edged, imposed on the motif, just as are the landscapes, flowers, still lifes, interiors, and figures they did and which comprise the themes of other painters of the period such as Georgia O'Keeffe, usually grouped with the Precisionists, Peter Blume, sometimes grouped with them, and Yasuo Kuniyoshi, Guy Pène du Bois, Bernard Karfiol, Gerald Murphy and Rockwell Kent, usually not. Many of Joseph Stella's romantically prophetic technological landscapes, often considered with Precisionist works, are characterized by shifting planes of Cubist *passage* which veils and softens precise edges, while Patrick Henry Bruce, in Paris, drastically reduced shapes and developed them into architectural planes of color out of which he constructed abstract forms that look precisely like tooled objects, are composed like still lifes, and are related to Purism, the contemporary French style to which Precisionism is analogous.

Technological Precisionism, in fact, has little to do with mechanical forms. While life-oriented Dada used mechanical forms – real or invented – as a social critique, and showed the functioning process of the mechanism, Precisionism, when it was concerned with architecture or machinery, focused on those functional parts of the objects that do *not* express the principles and relationships of static and dynamic forces. In transforming the mechanized element in Dada, the Precisionists abstracted function from process, and evolved a formal aesthetic style, which is found only marginally in Dada, and which served for traditional motifs as well.

The most Dada-responsive of the Precisionists was Charles Demuth, an elegant, sophisticated intellectual whose work is penetrated with suggestive overtones of sexuality and double imagery. Converted to modernism by contact with the Stein

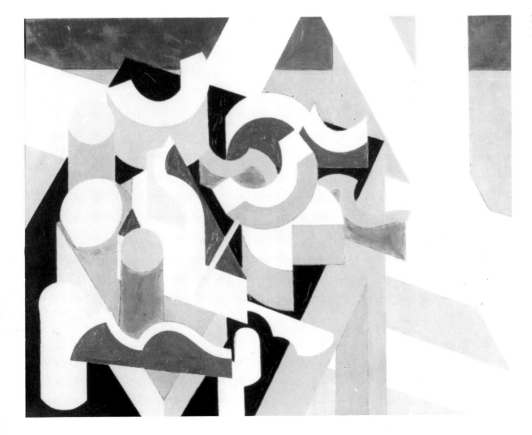

PATRICK HENRY BRUCE, *Forms on a Table*, 1925–6.
Andover, Massachusetts, Addison Gallery of American Art, Phillips Academy, Gift of Mr William Lane.

CHARLES DEMUTH, *Aucassin and Nicolette*, 1921.
Columbus, Ohio, Columbus Gallery of Fine Arts, Howald Collection.

circle in Paris around 1912, Demuth's early interpretation of Cubism combined biomorphic forms with shifting Cubist planes, evoking a weird, transparent world. By 1920 he had developed his unique use of ray lines that seem to owe little if anything to Futurist lines of force, with which they are usually associated. Demuth's rays suggest light, not vectors, and in this his painting resembles that of Lyonel Feininger in the early 1920s, whose art, however, must be seen in the context of Futurist influence which he had assimilated in 1912.[66]

Demuth's Dadaism is explicit. In 1917 his poem, 'For Richard Mutt,' dedicated to Duchamp and the *Fountain*, appeared in *The Blind Man*. A few years later, his Dada perversity and social criticism were expressed in a *Little Review* interview. Asked, 'What would you most like to do, to know, to be . . . ?' he answered, 'Lay bricks. What It's all about. A brick layer.' 'What do you look forward to?' 'The Past.' His paintings often carry joking, mystifying, or whimsical titles whose effects are in part due to a deliberate disproportion or inappropriateness of association, like *My Egypt*, relating American grain elevators to ancient Egyptian architecture, or *Aucassin and Nicolette*, giving to a pair of factory smoke stacks the names of medieval lovers.

Around 1915, Demuth began to make fictional illustrations for French, American, and German writers. His consistent preference in this genre for the weird and menacing, the perverse and erotic, as seen for example, in his watercolors for Henry James's *Turn of the Screw*, underlines a sensibility present in much of his work. Demuth's life-long friendship with the poet-doctor William Carlos Williams is celebrated in *I Saw the Number Five in Gold*, the title drawn from the first line of a poem by Williams. It is not the least of pleasant ironies that, largely within the Arensberg circle, in the Dada hot-bed of anti-art, the arts were brought together to achieve a high moment in the art life of America.

Precise contour, sparkling clarity and surface polish are seen in their purest figurative form in the painting of Charles Sheeler. Like Demuth and Schamberg, he was a Pennsylvanian who had passed through the training of the Academy and of William Merritt Chase. After a joint trip to Europe and a stay in Paris in 1909, both Sheeler and Schamberg returned to the United States with a new vision of art. They took up photography as a means of livelihood and soon made connections with Philadelphia architects for whom they photographed buildings. At the same time they found painting motifs in the Shaker architecture in Bucks County, where, at Doylestown, they established a studio in an old farmhouse.

After the Armory Show, Sheeler and Schamberg began to divide their time between Doylestown, where they sketched, studied local collections of early American furniture and crafts, some of which they acquired, and New York, where they frequented the Arensbergs and participated in New York exhibitions. Through Stieglitz Sheeler came to see the potential of photography as an art medium and in 1917 de Zayas arranged a show of his photographs and paintings together at the Modern Gallery, the first show of its kind in the United States. In his paintings of Pennsylvania barns Sheeler had already begun to realize at this time the vigorous form and economy of means for which his art is noted.

It is often said that photography led Sheeler to his sharp-focus style, but this view overlooks the fact that photography, too, can be, and was, at an earlier time, hazily soft-focused. The sharpness of Sheeler's images should be put down to the period's stylistic tendencies, and it is likely that throughout his career his photography was as much influenced by his painting, as the other way around. His *Church Street El* of 1920, an imaginative study in perspective and surface pattern is stylistically not only like his own contemporary photography and that of Paul Strand, but also like some Purist and Constructivist painting in Europe. Although camera work preceded brushwork in some of the industrial landscapes of the 1930s

CHARLES DEMUTH, *At a House in Harley Street*, illustration for *The Turn of the Screw* by Henry James, 1913.
New York, Collection, The Museum of Modern Art, Gift of Abby Aldrich Rockefeller.

CHARLES SHEELER, *Church Street El* 1920. Philadelphia, Pennsylvania, Mrs Earle Horter Collection.

based on photographs commissioned by the Ford Motor Company in 1927, stylistically the paintings have much in common with the period's American Scene Realism. That Sheeler's stylistic changes were registered contemporaneously in both media indicates the issue concerns the complex problems of the psychology of vision and its relation to other formative factors in cultural sensibility rather than the relatively simple historical matter of which came first.

Top CHARLES SHEELER, *Objects on a Table*, 1924.
Columbus, Ohio, Columbus Gallery of Fine Arts, Howald Collection.
Above CHARLES SHEELER, *Upper Deck*, 1929.
Cambridge, Massachusetts, Fogg Art Museum, Harvard University.

After Schamberg's death in 1918, Sheeler left Bucks County to settle in New York. In 1920 he collaborated with Paul Strand to make a film, *Manahatta*, a poetic homage to New York's architecture, acclaimed by the Dadaists who showed it in Paris, and in the following years worked as a commercial photographer for *Vogue* and *Vanity Fair* while he continued to paint and exhibit architectural landscapes as well as still lifes and interiors. *Objects on a Table* illustrates that peculiar quality whereby intense realism takes on the aspect of surrealism, as if reality wants to discourage such possessiveness by disappearing before our eyes.

The significant features of Sheeler's style at its best are its directness, its uncompromising austerity, and its insistent aestheticism based on the identification of beauty with function. With Georgia O'Keeffe, Demuth and Sheeler represent the continuation at its highest level of that realist current in American tradition found in the airless purity and glistening polish of Copley.

Charles Daniel, the bartender-café-owner turned art dealer was one of the strongest supporters of the new immaculate style that in 1954 Henry McBride recalled noticing in the 1920s.[67] In 1914 Ferdinand Howald visited Daniel's new gallery where he saw paintings by Edward M. Manigault.[68] and began the great collection of American art that includes many works by the Precisionists which he continued to acquire, frequently from Daniel, through the 1920s. Prominent among the artists associated with Daniel, besides Demuth and Sheeler, were Nile Spencer, Preston Dickinson and Elsie Driggs who were often but not exclusively drawn to urban and industrial motifs. Their various interpretations of this theme reveal the richness and range of the style. Spencer's painting is characterized by strong construction that he learned from his study of old masters, especially Giotto and Piero della Francesca, and new ones, particularly Braque and Gris, during his trip abroad in 1921, studies that prepared him for the influence of Sheeler and Demuth on his return to the United States. Dickinson's admiration for Oriental art is reflected in the oblique perspective treatment of his architectural landscapes and still lifes, as well as the peculiar insubstantiality of the objects he depicts as if they floated in space an effect also found in some of Sheeler's work such as *Offices* of 1922, in the Phillips collection. Driggs, like Stella, saw the steel mills of Pittsburgh with a romantic imagination, and effectively silhouetted vertical smoke stacks and looming factory buildings against a smoky sky.

Other important artists at Daniel's gallery included the young Peter Blume and Yasuo Kuniyoshi, whose Precisionism was less concerned with architecture and technology. Blume's interest in broad simplifications of figural elements and odd spatial organization at that time created images that suggest the closed, reality-suspended world of folk myth, and adumbrates his Surrealist work in the following decades, while in Kuniyoshi, too, one finds a dreamlike suspension of naturalistic space that links Precisionism with Surrealism. In *The Swimmer* the irrational scale produces a symbolic rather than real relation between the swimmer and the island.

The Dada-Surrealist-Precisionist connection is strikingly summarized in the work of Gerald Murphy, some of whose paintings closely resemble Sheeler's work in later years. His *Portrait* is a geometric jigsaw of human features in a variety of scales, with the problematical meaning of size and proportion wittily underlined by the representation of rulers used as space dividers. Murphy, the inspiration for F. Scott Fitzgerald's hero in *Tender is the Night*, was active as a painter for only ten years, the decade of the 1920s. Like Covert, he, too, after a brief but significant career, became a businessman.[69] The Precisionists' feeling about urban and industrial America ranged from admiring to hostile. Some frequently regarded their motifs simply as formal problems; in others one often senses a double-edge of admiration for its functionalism, and scoffing criticism for its materialism. Occasionally the antipathy is explicit as with Stefan Hirsch who recalled, years later, his 're-

coil from the monstrosity that industrial life had become in ''megalopolitania''.[70] Hirsch's *Lower Manhattan* looks like an arrangement of piled up cardboard cartons, and suggests he might have updated Cennino Cennini's advice to fourteenth-century artists, 'If you want to acquire a good style for mountains . . . get some large stones . . . and copy them . . .'[71] For George Ault, too, geometry seems to have been a metaphor for dehumanization, while Louis Lozowick, on the other hand, optimistically saw 'order and organization . . . in the rigid geometry of the American City.'[72]

As an expression of American style, Precisionism illuminates with particular clarity an important difference between the conceptual frameworks of European and American artists, as far as such differences can be generalized. Cubist and post-Cubist painting in Europe developed as a metaphysical search for the underlying structure of reality; the Precisionists interpreted the period's concern with essence

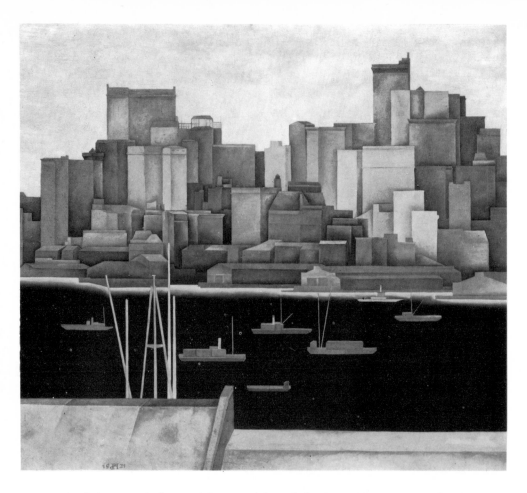

in terms of the morphology of forms. Although both problems were solved by the method of reduction, in Europe reductiveness tended to abstraction and non-objectivity, while American art remained strongly committed to ordinary common-sense appearance.

The brilliant exception to this generalization was Stuart Davis, who synthesized his early training and association with Henri and the American Realists with the most advanced European painting, to achieve a wholly modernist style that penetrates to the core of American life in the first half of the twentieth century. Immensely impressed by the Gauguins, Van Goghs, and Matisses he saw at the Armory Show, he began immediately the slow, patient work that, with the help of Cubism, led to his abstract Precisionist style of the late 1920s developed in the famous *Egg Beater* series. During 1927–8, Davis set up on a table a still-life arrangement of an egg beater, an electric fan, and a rubber glove. Again and again he painted this still life, studying color and space relationships, until he arrived at completely non-objective imagery. His liberation from the object did not occur as a sharp, irreversible break, however, for he continued to represent appearance, albeit rearranged and more or less abstracted, for the next twenty years.

Davis' art in the 1920s reflects the artistic and thematic concerns that were to emerge in the advanced non-objective and figurative art of the 1960s, and provides, with that of Demuth and Sheeler, one of the most important links in the creation of a truly self-conscious American art tradition.

Progressives and conservatives alike felt the obligation set by the period to deal with essentials, with absolutes, by reducing, primitivizing, or otherwise purifying art. The archaic classicizing realism of Kenneth Hayes Miller and the 'Fourteenth Street School' artists of the 1920s, including Reginald Marsh and peripherally Raphael and Moses Soyer, can be seen as attempting to get back, after the modernist spree of the teens, to the origins of the great tradition of Pure Art. Miller carried on

Above, left STEPHAN HIRSCH, *New York, Lower Manhattan*, 1921.
Washington, D.C., Phillips Collection.
Above STUART DAVIS, *Egg Beater No. 2*, 1927.
New York, Collection of the Whitney Museum of American Art.

242

Henri's role as an influential teacher and became the leader of the new City Realist movement; he represented his figures, often women shopping in the Fourteenth Street area known as Union Square, in broadly realized forms and poses quoted from the standard repertory of classical sculpture and painting. Miller's student, Reginald Marsh, drew his city types – strutting street-walkers and bowery characters – with the lustiness, if not the genius, of Rubens. Moses and Raphael Soyer also found subject-matter in the marginal, socially disenfranchised city-dwellers but in the traditions handed down through Delacroix and Ingres. Curiously, their work was influenced by Jules Pascin, a Bulgarian painter of the School of Paris who spent some years in the United States, and Edgar Degas, both of whom took an ironic and often bitter view of their favorite theme, women, while the Soyers painted office workers, dancers, shopgirls, and prostitutes with sympathy, enveloping them in a soft, sad, atmospheric haze. These artists, twin brothers, were less interested in social documentation, however, than were other Fourteenth Street painters and often drew on the world of the artist for inspiration, as seen in the double portrait by Moses Soyer of the sculptor Chaim Gross and his wife.

The decade of the 1920s, although less dramatic than that of the Armory Show, produced a rich and varied art, and continued the work of building a modernist American School that could include progressive figurative, abstract, and non-objective styles. The conservative American Scene movement of the 1930s began to develop in the twenties not only in Precisionism, but in the work of Charles Burchfield and Edward Hopper, who came to artistic maturity in these years.

Burchfield's early painting and watercolors, beginning about 1916, were eerie fantasies, with houses, trees, flowers, and other innocent commonplaces inhabited by spooks. By 1924 these fairytale ghosts had become Americanized, and ordinary

Above KENNETH HAYES MILLER, *Shoppers – Department Store.*
New York, Zabriskie Gallery.
Left RAPHAEL SOYER, *Two Girls, c.* 1933.
Chicago, Illinois, Earle Ludgin Collection.

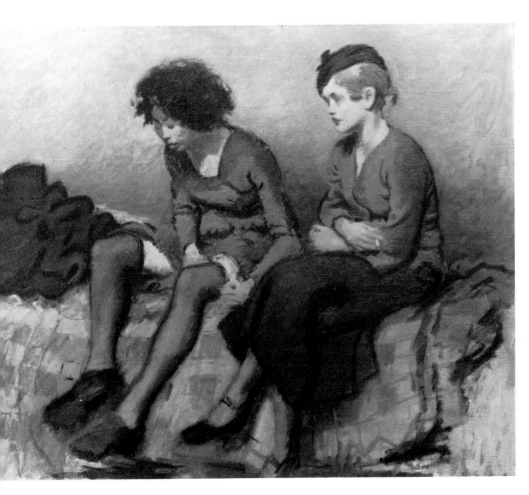

Victorian houses in Buffalo, New York, where he had gone to work for a wallpaper company, became haunted with Burchfield's sinister imagination. Reminiscent of Van Gogh, Burchfield was filled with love and sympathy for the world around him and yet expressed in his paintings a desperate loneliness; there is an almost audible, beseeching cry to escape from this world where idiot eyes and grasping claws lurk in every window and behind every bush.

In 1929, Burchfield gave up his wallpaper company job to paint full time. During the 1930s his moody interpretation of the industrial landscape brought him national recognition as a major painter of the American Scene.

Edward Hopper worked from the beginning as if he knew he would live to an ever-productive ripe old age. He took his time, absorbed what was useful to him

MOSES SOYER, *Chaim and Renée Gross in the Studio of Chaim Gross*, 1929.
New York, Mr and Mrs Chaim Gross Collection.

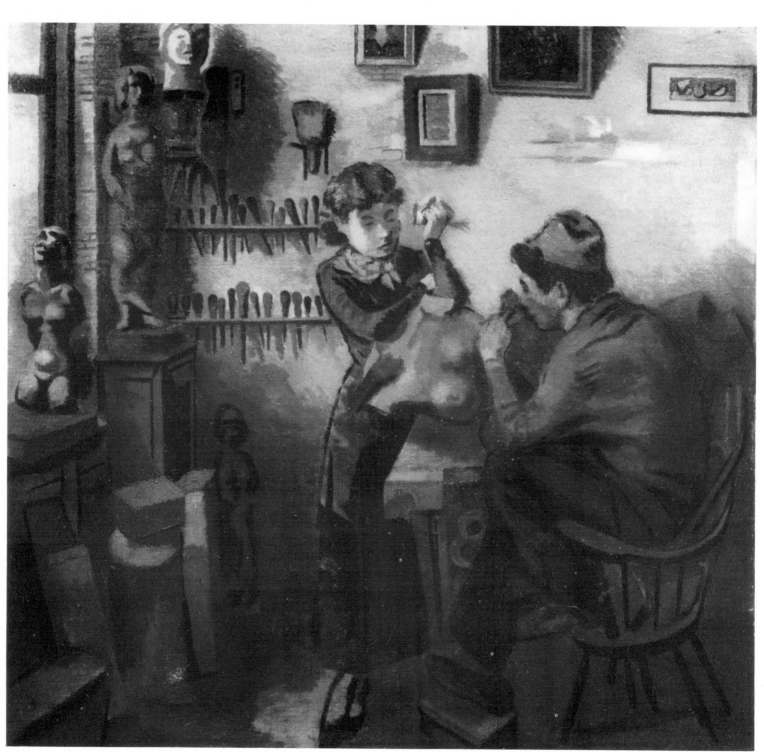

from Impressionism in Paris in the first decade, hardly noticed the Armory Show, formally, and went on his steady, extraordinary way to become a major figure in the conservative tradition, an acknowledged master of American art in the twentieth century, admired by all sectors of the critical spectrum.

His subject was loneliness, his raw material urban and provincial America, and his instrument was light, cold and uncompromising, leaving the figure – human or architectural – stripped bare. Hopper gets to the heart of the matter not like a poet but a sensitive novelist. The famous *House by the Railroad* is like a saga, telling the stories not only of the people that lived in it, but of America with its social pretensions, its railroad building; its property values destroyed, its class relationships altered; it is all there in a single, immediately perceived image.

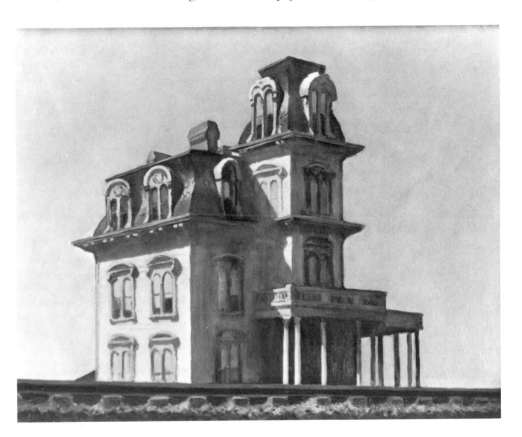

EDWARD HOPPER, *House by the Railroad*, 1925. New York, Collection of the Whitney Museum of American Art.

EDWARD HOPPER, *Early Sunday Morning*, 1930. New York, Collection of the Whitney Museum of American Art.

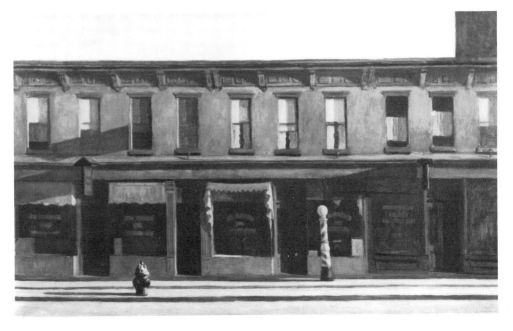

After his third trip to Europe in 1910, Hopper settled into the United States. He sold one painting at the Armory Show, and not another until 1923. During the teens he worked as a commercial artist and illustrator, and painted in his leisure time. About 1915 he took up etching and in this medium developed the ideas that matured, in painting, during the twenties. A peculiar masculine hardness in his handling of the female figure, seen at this time in the etching *Evening Wind*, remained characteristic of his style. By 1930 Edward Hopper had fully discovered what he wanted to say, and how to say it.

The traditional double nature of American art, its Americanism and its Europeanism, was given embodiment at the end of the 1920s in the establishment of the Whitney Museum of American Art and the Museum of Modern Art, both institutions predominantly concerned with art of the modern period. Gertrude Vanderbilt Whitney had established in 1914 the Whitney Studio where unknown artists were given opportunities to exhibit, and in 1917 she established the policy of purchase prizes instead of cash awards, making acquisitions for her personal collection from almost every show. In 1918 she started with Juliana Force, her assistant at the Whitney Studio, the Whitney Studio Club, a social and exhibiting center with a membership that quickly grew to hundreds and included most of the prominent artists in America. Gradually she realized the need for a museum devoted to exhibitions and encouraging American art 'unhampered by official restrictions' and in 1931 the Whitney Museum of American Art opened to the public. Mrs Whitney gave about five hundred works she had acquired over the years to start the collection of the new museum.

Katherine S. Dreier established in 1920 the Société Anonyme, with the help of Marcel Duchamp and Man Ray, international in scope and aimed at promoting an understanding of modern art in America. Installed in a brownstone house near Fifth Avenue, the Société Anonyme organized exhibitions of works by leading Europeans and Americans including Juan Gris, Constantin Brancusi, Wassily Kandinsky, André Derain, Francis Picabia, Kurt Schwitters, Joseph Stella, and Marsden Hartley, arranged lectures and published pamphlets on modern art. Miss Dreier, her sister Dorothea, and their friends carried most of the financial burden of the society and made acquisitions on its behalf to form the excellent collection given in 1941 to the Yale University Art Gallery where it is still housed. But it was left to other proponents of modern art, also, curiously, women, to establish a permanent institution for its exhibition and encouragement. Lillie P. Bliss had bought several French paintings from the Armory Show, advised by Arthur B. Davies, and with his continued advice, and that of Walt Kuhn, her collection grew. In the 1920s Miss Bliss joined Mrs John D. Rockefeller Jr., and Mrs Cornelius Sullivan in creating a plan for a museum of modern art.[73] The Museum of Modern Art thus opened in an office building at 730 Fifth Avenue in 1929 with the Bliss paintings, almost entirely French, as the nucleus of its collection. Its first purchase, however, was Edward Hopper's *House By the Railroad*.[74]

Rounding out this brief account of American art in the first three decades of our century mention should be made of two artists, Louis Eilshemius and Ivan Albright, whose work separates them from the mainstream of development. The former, a super-visionary-*naïf*, the latter a super-realist, together, by their stretching of the normal range of romantic realism, call attention to the consistent, underlying tendency in American art towards the surreal. Eilshemius, who with Vincent Canadé, Émile Pierre Blanchard, and John Kane eventually won recognition when the taste for primitivizing emerged in the 1930s, was one of the strangest eccentrics in American history, a 'self-styled Parnassian, Mightiest All-Round Man, Transcendent Eagle of Art, inventor of electric belts, homeopathic procedures, and hypnotic spells.'[75] His paintings are wish-fulfillments and re-enacted nightmares,

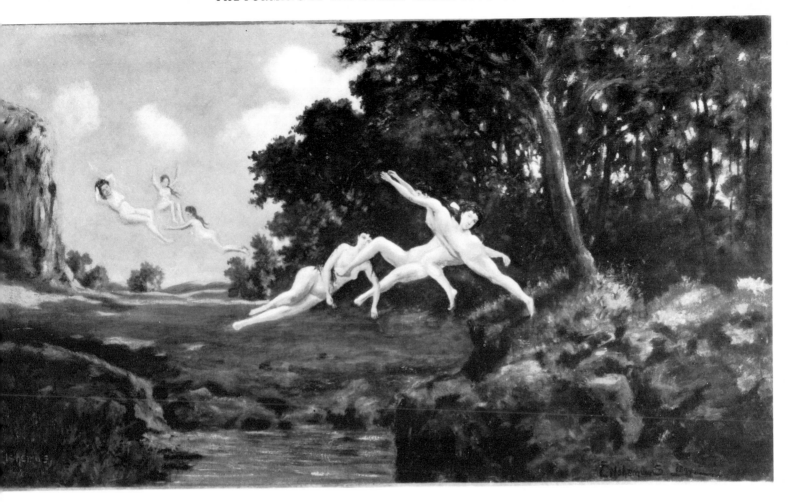

LOUIS EILSHEMIUS, *Afternoon Wind*, 1921. New York, Collection, The Museum of Modern Art.

but their fantasy is compelling and creates a believable world of dreams. Eilshemius was not a *naïf* in the usual sense of 'untaught'; he knew the European tradition and had studied with that arch-academician Bouguereau in France in 1886. But his childlike, mystical nature is reflected in the early idyllic landscapes with figures such as *Afternoon Wind*, painted with assured brushwork and engaging color.

Ivan Albright's family lineage included doctors, gunsmiths, and an artist father who studied with Thomas Eakins, a lineage in which meticulous craftsmanship was a highly respected family tradition; Albright's obsessive concern with the exhaustive recording of minutiae may be put down, in part, to this tradition. But the high visual pressure of his painting seems to have its source in Albright's poetic feeling about the impossibility of seeing the real, 'In this eternal smog-land, if the real truth appeared, it would blind us . . . as the sun would blind . . . on close approach. We are shadows of the real but not the real; we live by half-truths and half facts;'[76] in his view of objects as 'philosophical toys,' and in his sense of the human body as a tomb. Albright began to consider himself seriously as an artist when he received Honorable Mention at the 1926 Annual American Exhibition at the Art Institute of Chicago. His style developed rapidly to its mature manner, carrying well its burden of Episcopalian symbolism, as in *Heavy the Oar to Him Who Is Tired, Heavy the Coat, Heavy the Sea*, a portrait of a fisherman. The title of Albright's masterpiece, *That Which I Should Have Done I Did Not Do* is taken from an Episcopalian prayer.

By 1930 the task of creating an American art commensurate with the leading political and economic position of the United States was well on its way to accomplishment, with little recognition on the part of the government of its responsibilities in this effort. For this there was needed the Depression.

247

5

THE
1930s AND
ABSTRACT
EXPRESSIONISM

Harry Rand

THE 1930s AND ABSTRACT EXPRESSIONISM

The reasons for the emergence of American art from its conventionally understood provincialism to international predominance are as puzzling and exciting a set of issues as any in history. When we consider that this transition took place in the stormiest of times, but was not itself linked to any single agent or event, the appearance of our artistic maturity grows, in unpartite hugeness, more splendid, and its causes inextricably complex. For those artists who moved through them, the times were debilitating. Rather than understanding their art, soliciting their talents and rewarding their growth, the period drained force from the lives of the men that molded it. Few of the generation of the Abstract Expressionists received commensurate praise in their lifetimes. Few eked out more than a meager living. With but very few exceptions, the contented, prideful, and well-deserved status of the old-master eluded these artists. Brutal tragedy robbed these painters of their earned rank.

No previous generation of American artists was so castigated, even as these very painters elevated the level of national art beyond what had ever been achieved. Prior and subsequent generations of artists would know living success and economic security surpassing any that was experienced by the artists of the 1930s and 1940s.

The first of the irresistible facts that shaped the period was the Depression, announcing, along with the new decade, an unsuspected era of tremendous consequence. Not only throwing the country into havoc, the failure of the stock market called all old values into question. No assumptions were free from the vigor of the new inquisition: the sources of the disaster were being searched out. The Depression underlined the vacancy and indeed bankruptcy of the competing artistic movements, each of which owed, in some degree, its values to the establishment responsible for the ruin of the society. Some thought the native culture to be essentially sound but to have been rendered impotent by a foreign corruption and every one of the disputing modern movements seemed indebted to Europe to some extent. Most of modern American art of the 1920s seemed steeped in European bohemianism, the avant-garde, or one of the 'inexplicable' aesthetic doctrines of Dada, Surrealism, or one of the Cubist camps. This was a debt that could not be eradicated quickly in the hard suspicion born of calamity. The arts were implicated in either an entrenched effectism, or a chaotic and radical anarchism; both were thought to be symptomatic of the causes of the Depression. Nowhere was there an artistic program offering order, timelessness, human responsibility and spiritual satisfaction.

In America only a very narrow band of artistic investigation remained untainted by the debacle of universal collapse. The Precisionists had taken what essentials they needed from modern Europe and transformed those tenets into a purely native and highly refined art. All through the 1920s, they experimented with the treatment of appearance; at the outset of the Depression, the Precisionists held a firm understanding of the capacities of their art. During the thirties, the Precisionists involved themselves in an ever more literal transcription of the characteristic appearance of portrayed objects. This deep preoccupation with objective appearance can be thought of as a typically American trait, the unique quality of which is an estrangement of reflexive emotions, and of the contemplation of psychology. So established, the group was released from any sense of involvement in the causes of the Depression. Theirs, an art of the highest order, progressed blameless through the Depression.

As early as 1929, Charles Sheeler, the greatest master of this rankly presentational mode, was intellectually equipped to paint one of his masterpieces, *Upper Deck*.

Sheeler, a participant in the Armory Show of 1913, was already thoroughly schooled in Cubism in the first two decades of the century. Absorbing the most decisive knowledge of modern Europe, Sheeler made what could only seem to an American the advance of investing his understanding of the arrangement of the picture in the service of depicting aspects of the world of objects. *Upper Deck* epitomizes the Precisionist proposition of actualization. Sheeler suffused the environment itself with the relationships that had until so recently, in French Cubism, been forcibly distilled from the furnishings of tangibility.

Like so much else of the Precisionist art, the choice of subject-matter in the *Upper Deck* is calculated to use objects whose structures bore a distinct plastic identity without attaching to those objects any pseudo-narrative implications. Singular objects were depicted to display plastic relationships without specific associational intent.

If this painting, and other like it, seems to beckon, however feebly, to a world of events and consequences, it is by a suspension of transitional states rather than by a depiction of causal relationships that these works' allure wells up in the viewer. The objects depicted are not transformed from the state of their outright lineaments. This confidence, resident in the object, marks Sheeler's Precisionism, more securely than any previous modern statement, as a Classical position.

Typical of this style, the light suffusing the scene is an even, pearly, sourceless glow indicating neither time of day nor the season. The objects show no signs of wear or decay. A denoted eternal immutability is approached; everyday objects invite metaphysical and lyric speculation. Without relying on the sentimental specter of their own imminent or future deterioration and extinction, these objects elicit emotion. The Precisionists were in fact making painting-objects of the same concrete and imperturbable state as the Synthetic-Cubists, but, as Americans, they relied on the visible sustaining scaffold of the objective and communally verifiable world. Not only a poet but a frequent writer on art, William Carlos Williams may have caught the spirit of this position when he wrote: 'Say it, no ideas but in things'[1]

Like the Cubist, the Precisionist world is one of arrested evolution in which objects have arrived at a state of balance between their virtual appearance and their position in a system of plastic relationships. The Cubist scheme was typified by a peeling-up of surface to locate and present a total of plasticity, while the Precisionists exhibited the external surfaces of objects as the limiting expression of their complete morphology. Cubism and Precisionism represented two extrenes of treating visual material.

Contrary to every but the basically representational assumption of the Precisionists arose two other, mutually opposed doctrines. The Regionalist and the Social Realist groups both came into being in direct response to the all-pervading fact of the Depression.

Unlike the Precisionists whose art, while descriptive, was never narrative, the Regionalists were decidedly narrative and even anecdotal. Curiously, both the Regionalists and the Precisionists considered themselves a cleansing return to pictorial essentials. Additionally, the Regionalists understood their conservatism to be a matter of portraying a moral climate and depicting situations with paradigmatic content.

The Regionalists attempted to ressurrect an agrarian past, but beyond the sense of locale or even 'region', the Regionalists proffered a set of values which they hoped could be conserved and elevated to a once more dominant and formative role in the society. While superficially true to think of the Regionalists as conservative, protecting a system of values which may or may not have ever actually had a vital currency, their position as hermetic preservers, keeping intact against the external forces of decay, seems more appropriate. The Regionalists' was essentially

251

a self-ordained holding action, a most untenable position for an artform. As Barnett Newman wrote of them:

What was this America that artists were to paint? Was it a certain national character one was to express, a point of view, a taste, a cultural nuance? Not at all. Even if these qualities could have been evoked they were not wanted. To the isolationist artists, America was the geographic life around them. The crassest philistinism. A complete reversion to the exhaltation of subject matter.[2]

The world the Regionalists presented to a public unsure of any of life's necessities was one of stability, a secure world physically beyond the parched middle American farmland and of genial human scale compared with the oppressively soaring and unresponsive life of the city. Neither the international threat of rising Fascism nor the fact of the otherwise all-pervasive Depression disturbed the quiet of the Regionalists' vistas. What was offered was an alternative to pressing reality, a world in its own way as removed from the invasions of urgent necessity by the manipulation of the political past and present as the Precisionists had removed their world by absenting the flow of time or processes of decay and as remote as the Surrealist psychoscape was from outside intrusions. The world of the Regionalists was pre-presented with no uncertainty as the obvious comparison to be drawn between the

Opposite ARSHILE GORKY, *The Artist and his Mother*, 1926–9.
New York, Collection of the Whitney Museum of American Art, Gift of Julien Levy for Maro and Natasha Gorky in memory of their father.

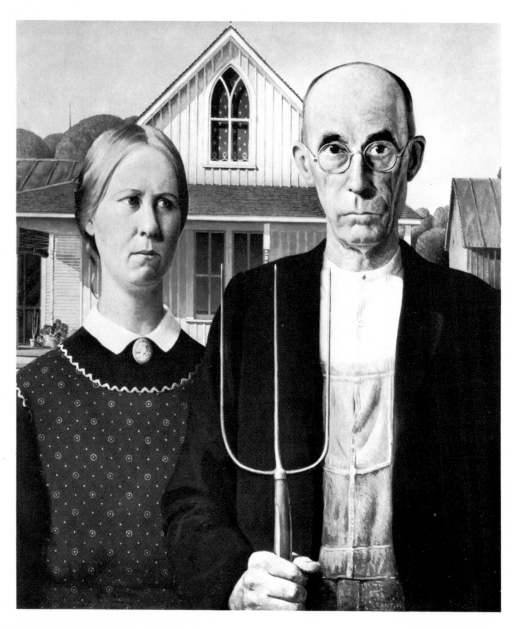

GRANT WOOD, *American Gothic*, 1930.
Chicago, Illinois, Art Institute of Chicago, Friends of American Art Collection.

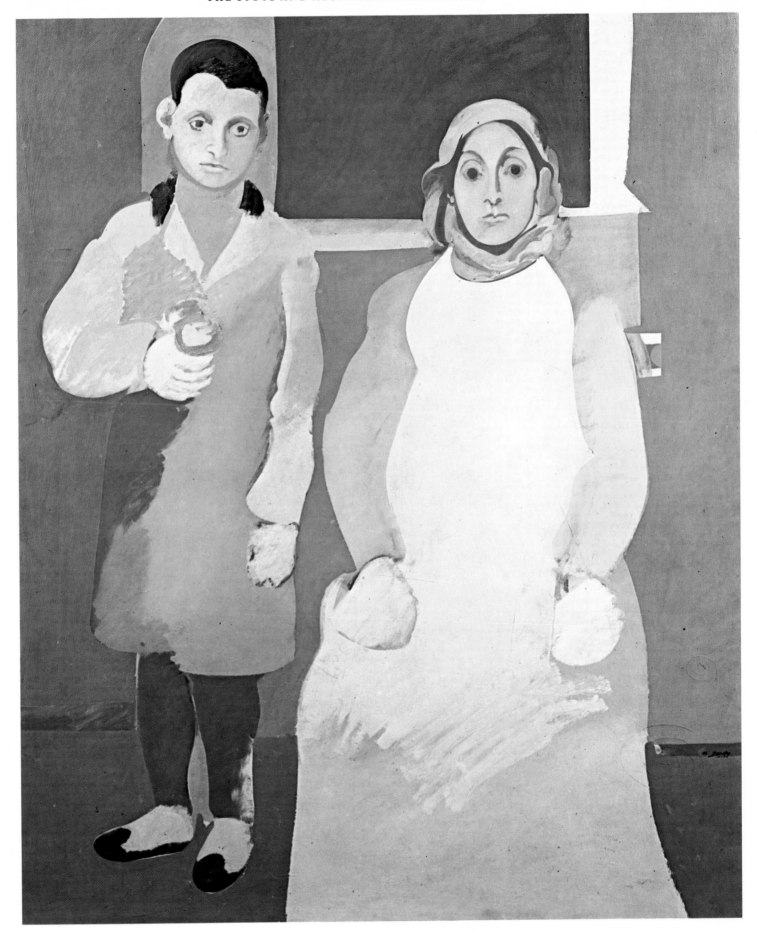

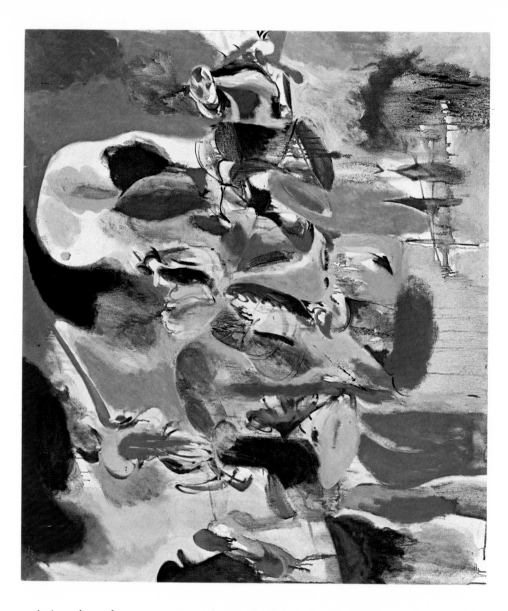

ARSHILE GORKY, *Water of the Flowery Mill*, 1944.
New York, Metropolitan Museum of Art, George A. Hearn Fund.

Opposite JACKSON POLLOCK, *Eyes in the Heat*, 1946.
Venice, Peggy Guggenheim Foundation.
Overleaf, left WILLIAM BAZIOTES, *Cyclops*, 1947.
Chicago, Illinois, Art Institute of Chicago, Walter M. Campana Memorial Prize.

artistic values that were part and parcel of the collapse of the world's production facilities and the older values of Land and Home and Family that these artists ladeled out. The Land was to be *America*, as were the Family and Home to be understood to be *American*. Thomas Hart Benton explains:

> John Steuart Curry and Grant Wood rose along with me to public attention in the thirties. They were very much a part of what I stood for and made it possible for me in my lectures and interviews to promote the idea that an indigenous art with its own aesthetics was a growing reality in America[3]

The effect of the Regionalists' retreat from the international scene, from the economic reality, and from current artistic speculation (not one of the three major Regionalists was in the least ignorant of the artistic investigations going on around them, and in fact as a group they were rather well-informed) was a structured and severe art which resembled a good deal of the 'intellectual' work the Regionalists railed against. Their desire for a stabilized world finally came home, strongly organizing their pictures. Far from an earthy impetuosity, which is sometimes found in the work of Benton, the Regionalists made paintings of a refinement that now can be seen to reflect an underlying revulsion at a disordered world.

254

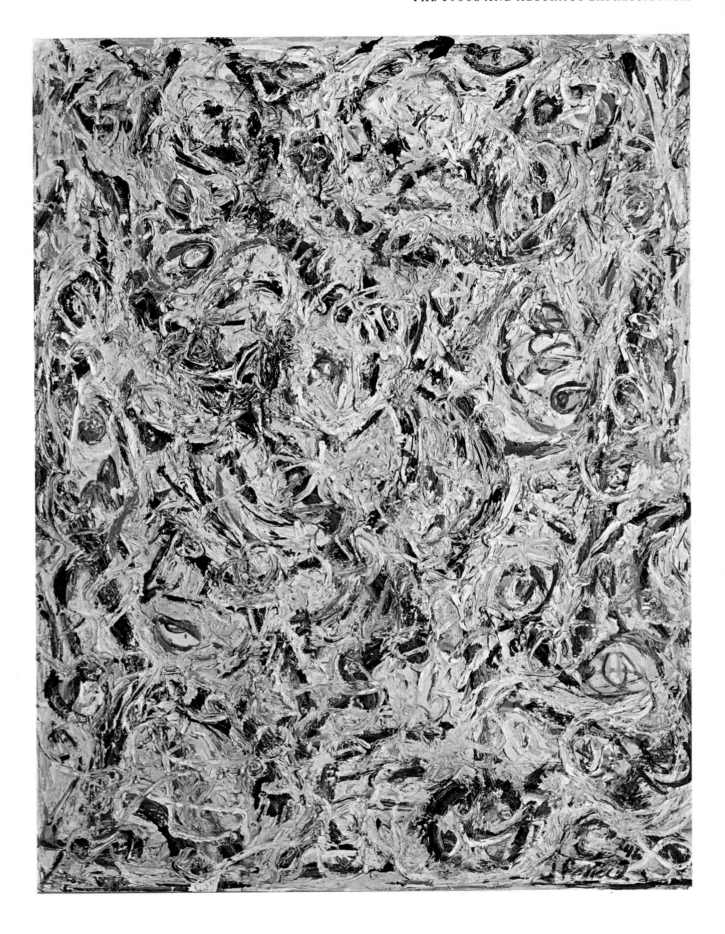

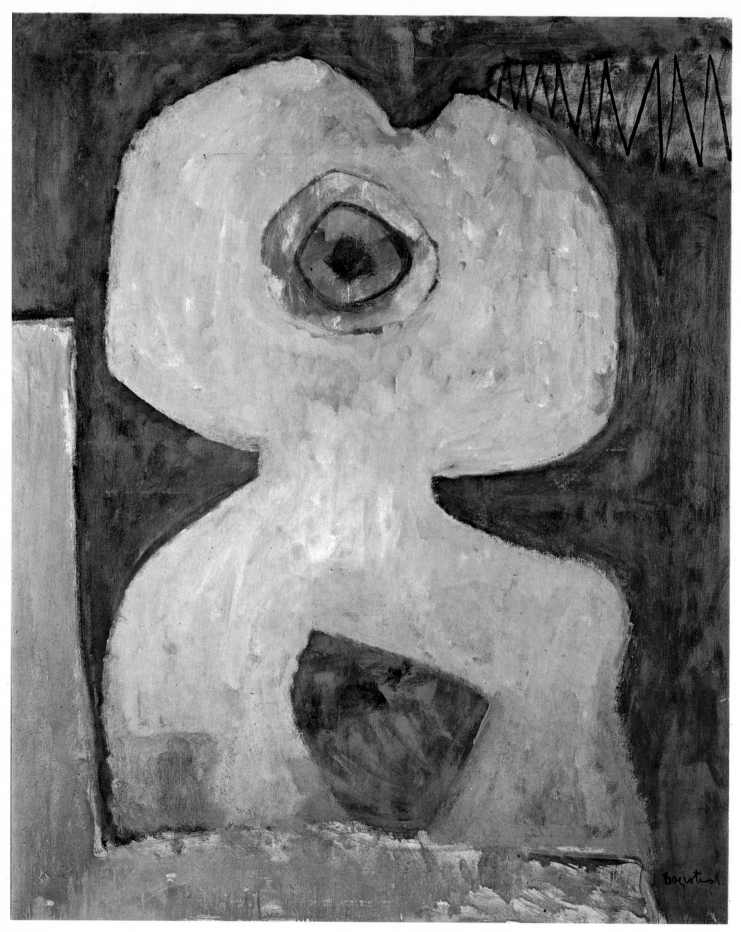

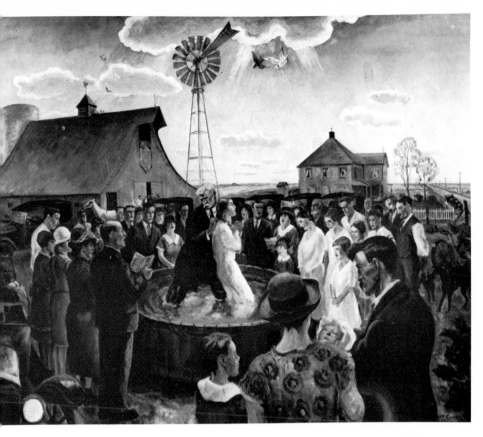
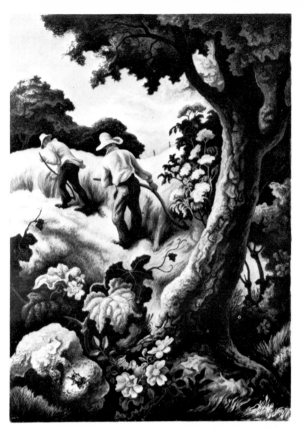
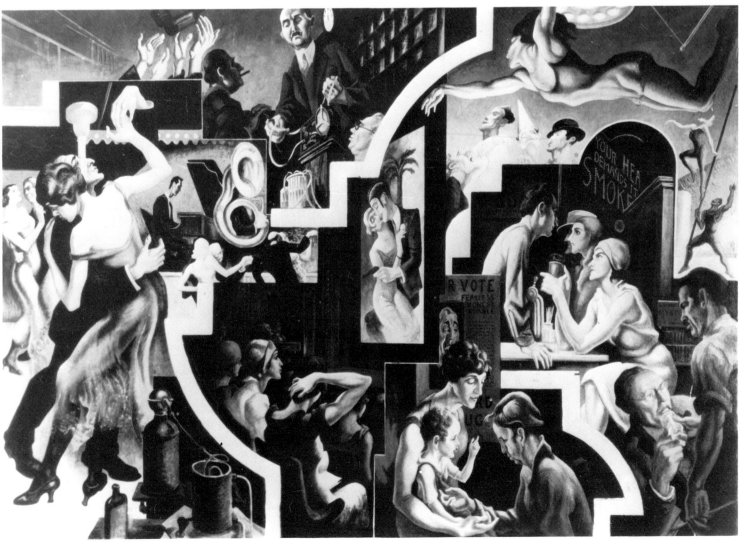

Grant Wood's famous *Stone City, Iowa* of 1930 is an exemplary case. One sees in this painting a care for the contrapuntal arrangement of the surface of the picture that approaches the lean, ornamental dignity of Renaissance architecture at its clearest and most refined. Shapes echo across the picture and bloom back into deep space. Were it not for the pulsing life sprouting up in the foreground or the trees bulging with an untold harvest, this ordered world might be but a fertile extension of *Upper Deck*, painted a year earlier. Though Wood painted this as a paean to one locale, the reoccurring sequences of points ascend to the realm of geometry, over-reaching all national borders.

Often nominally but erroneously classed as Regionalist, Charles Burchfield's work was usually more specifically descriptive of localities than even the Regionalists'. His work was never anecdotal, and his renditions of actual locations, while precise depictions of the lay of the land and its features, were meant to serve as entries into a rêverie of nature and not a moral lesson in service to the nation. This personalizing of the images that shape the life of the painter serves as a clear precedent for the transformations cherished images by the Abstract Expressionists.

In marked contrast to the preservationist instincts of the Regionalists, another group of artists arose and was fostered by the Depression. The Social Realists attempted to depict the class struggle, its participants, emblems and scenes. Typical of the artists who never entirely abandoned at least the outward trappings of this kind of art was Ben Shahn.

Shahn, journeying through this period and across the country as a photographer for the Farm Security Administration, saw at first-hand the depth of suffering. He eventually jettisoned any hope of an ideological salvation, becoming instead a humanitarian. His art, chastened by visions of thorough misery, often reached in succeeding years a subdued and intense emotional pitch which not only signaled the zenith of quality in the movement but wrought an apparently permanent touch-stone of human proportion in an age where human scale was often the first among fugitive values.

Previous page: Top right THOMAS HART BENTON, *July Hay*, 1943.
New York, Metropolitan Museum of Art, George A. Hearn Fund, 1943.
Top left JOHN STEUART CURRY, *Baptism in Kansas*, 1928.
New York, Collection of the Whitney Museum of American Art (Photo Geoffrey Clements).
Bottom THOMAS HART BENTON, *City Activities with Dance Hall*, 1930.
Mural for the New School for Social Research, New York.

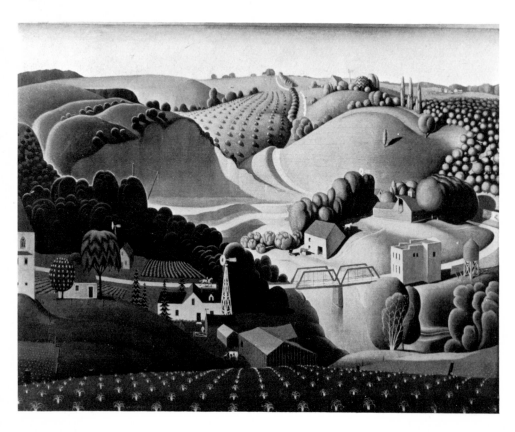

GRANT WOOD, *Stone City, Iowa*, 1930. Omaha, Nebraska, Joslyn Art Museum.

Shahn's art principally upheld the humanity of the individual and personal wants before any prescriptive system. If he was a slightly atypical Social Realist in coming to this revelation, it is also probably the central reason for his art's continued vitality. Not concerned with simpering class caricature, or mammoth and bizarre emblems, Shahn's work can reach audiences unacquainted with the minute details of particular political betrayals. His was generally a plea for a dignification of life and its necessities.

Many of the Social Realists proposed and executed gargantuan projects suitable only for funding by the state, occasional tycoons, or established institutions. In contrast, Shahn painted in 1927 a series of twenty-three gouaches on the Sacco-Vanzetti case, produced specifically to be bought by working people. Surprised when his fellow Brooklynites showed little interest in buying them, he was scandalized when presented with a bribe in exchange for not showing his work at the Museum of Modern Art. He had touched a nerve and, having found it, never left it out of his sight. After seeing the Sacco-Vanzetti gouaches, Diego Rivera hired Shahn as an assistant on the Rockefeller Center Murals in 1932.

In contrast to Shahn's often sadly lyrical work is the bitter satire of Jack Levine. This Boston-bred artist centered his attention on the generally corrupt state of society and in particular on the venal motives of all classes. *The Feast of Pure Reason* and *The Gangster's Funeral* are of course caricatures, but it is a viable question as to whether, by the sheer strength of painterly intentions, these works are elevated to the level of a ritual incantation of sin. Levine's pictures, medallions of shame, are gorgeously painted. This luxury of paint was as necessary to elevate his work beyond caricature as the same magnificence of handling would be irrelevant to the virtue of a portrayed Madonna.

The rise in popularity of the Social Realists – as well as the reasons for their cohesion as a recognizable element in the art of the period – is the inescapable fact of the Depression. Had this disaster not taken place it is very doubtful that such a movement would have arisen, or that, had it come into being, it would have accrued such a sense of urgency to its program. By plainly stressing that art was but one of the tools of a healthy, self-critical society, the Social Realists hoped to attract not only the newly destitute but also the wealthy and influential to paintings which were critical of social institutions, which had brought on the fundamental chaos.

Before the Depression the artist stood at the periphery of American society. A slightly suspect character, producing goods of questionable worth and unsure function, the artist and his manliness could easily be called into question in pre-Depression America. Consequently the self-respect of artists rose with their submergence in the common struggle. The lot of the artist became that of every other worker and the isolation of a real or imagined Bohemian exclusion wavered in the attempt to unify the society. However, unity and comradeship were not always the rule, even for a practicing Social Realist, as Reginald Marsh recalls:

Having mounted the scaffold without a colored smock and a Tam O'Shanter resulted in many employees asking when the artist was coming along. This happened even after I had completed full-length figures, In all the time I was there no one asked me my name.

One or two had heard of Rockwell Kent – three or four had heard of Grant Wood, and about a dozen of a Mexican who had trouble with Rockefeller Center. One had heard of Michelangelo.

Many volunteered to tell me that Cubism angered them.

Many wanted to know if there were new jobs in store for me and always looked at me in a pitying way.

Most of them ventured that I must have been born that way.[4]

If the workers were ambivalent about the role of the artist in a floundering

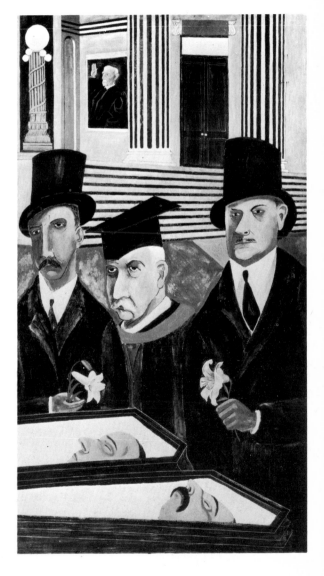

BEN SHAHN, *The Passion of Sacco and Vanzetti*, 1931–2.
New York, Collection of the Whitney Museum of American Art.

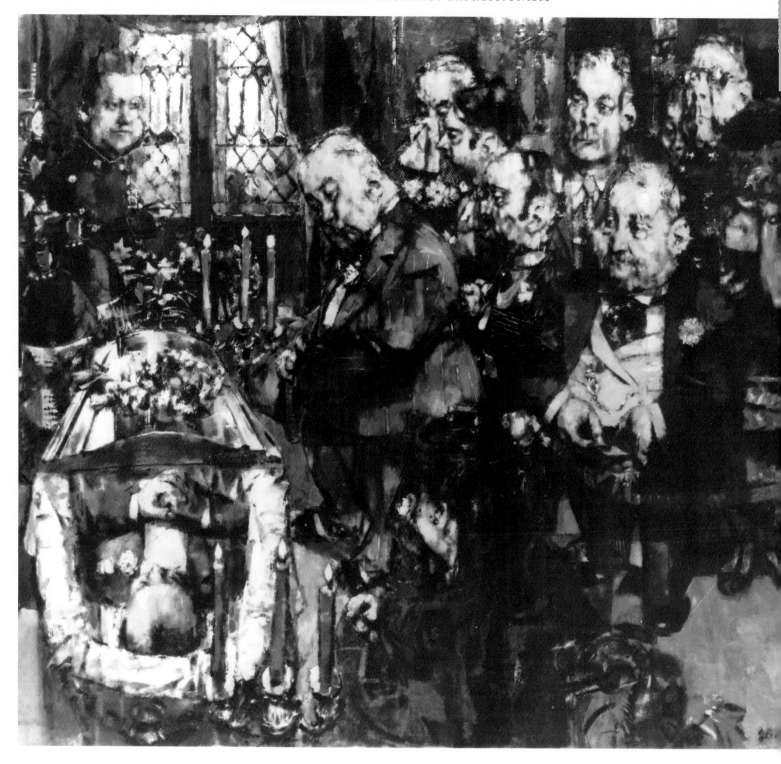

JACK LEVINE, *The Gangster's Funeral*, 1952–3.
New York, Collection of the Whitney Museum of
American Art.

society, the government was luckily more firmly committed. Recognizing for the
first time, the legitimate place of the artist in America, the government extended
coverage of federal assistance to the cultural professions. Like most shifts in govern-
ment policy, this change of heart was not brought about without pressure from the
affected parties – in this case the artists themselves. In 1933, the Unemployed Artists
Group was founded principally to get professional funding from the administration.
The group was later transformed into the Artists' Union, whose short-lived maga-
zine *Art Front* published some of the earliest writing by, and on, figures later to
become enormously important.

260

The government's reply to the artists' pressure was the Public Works of Art Project which started operation in December 1933, employing nearly four thousand artists. For the first time the National Government hired artists not on a piecework basis for specific and limited commissions arranged by patronage or reputation, but on a wholesale basis. The government was fully appreciative of the precedent it was establishing: artists as other workers have a right to their chosen job. In the five months that the Public Works of Art Project was in existence, 15,633 works of art were produced and, satisfied with the results, the government extended its coverage in August 1935, under the Works Project Administration (WPA) in the form of the Federal Art Project ('The Project').

The Project extended coverage to artists of lesser stature then those previously given financial aid. Painters, sculptors, teachers, designers, photographers, craftsmen of every variety – almost 5,500 people were employed. With this more inclusive support, many of the younger artists who had not yet made a deep professional impression, or those that had been forced by circumstance to practice their art on a part-time basis, were now covered. They could eat and practice with at least the confidence of knowing that a meager income was guaranteed. Some of those that were underwritten at this time were James Brooks, William Baziotes, Willem de Kooning, Philip Evergood, Arshile Gorky, Adolph Gottlieb, Philip Guston, Jackson Pollock, Lee Krasner, and Mark Rothko. Delivered to some extent from the pressures of the market place and raw survival, these young artists matured at the pace that suited them best and in whatever style they preferred.

What mural commissions were available from the government were usually taken by the Regionalists and Social Realists, because they were usually the senior painters; moreover they welcomed the chance to present their messages. This left other young artists time to work at easel painting. The easel painting division of The Project required only one canvas for ninety-six hours work, or every four to eight weeks. This had the double-edged effect of affording a leisurely pace of work while assuring a steady production. Not established as an academy for young painters, no more felicitous arrangement can be imagined to foster invention, considering the poverty of the land and the depth of committment of the recovery programs. In exchange for their work the artists were given $85–$100 a month and shows could be arranged at the WPA Federal Art Gallery. The artists working in New York were luckier than others in having Burgoyne Diller as district supervisor. Diller, having come through the massively formative influence of Piet Mondrian's Neo-Plastic style, was not only favorable to the latest innovations, but was himself the practitioner of a severely modern style.

BURGOYNE DILLER, *Second Theme*, 1937–8. New York, Metropolitan Museum of Art, George A. Hearn Fund, 1963.

The first painter associated with The Project to both bloom as an artist and then, tragically, to die, thus setting the grim pattern for the titans of his generation, was Arshile Gorky. Almost all the evidence about his early life and even the details of his maturity are shrouded in contradictory descriptions. Gorky was born in 1905, Vosdanig Manoog Adoian, at Khorkom Vari, Hayotz Dzore, in Turkish Armenia. His family had been priests in the Gregorian Apostolic Church for generations; Gorky's father, a merchant, fled to America in 1908 to escape military service. In 1920 his son arrived with a party of immigrants and joined his father in Providence, Rhode Island; then, after moving to Boston, Gorky made his way to New York in 1925.

Throughout the late 1920s and early thirties, Arshile Gorky, as he now called himself in apparent deference to the writer, apprenticed himself to and became submerged in the personalities of a number of masters. That some were dead did not apparently deter him; he gained access to them through their works. Schooling himself in Cézanne, Gorky painted works which do not merely emulate the outward appearance of a Cézanne but spring from an understanding of the fundamental urges that structure the Frenchman's work. It might be true to say that Gorky's

journeyman works are not modeled on Cézanne's painting, but *are* Cézannes painted by another hand; of course an exaggeration of the visual evidence, this is no inflation of the intent and intensity of Gorky's investigation.

When he had finished 'being with' Cézanne – and this is how Gorky talked of his studies – he 'was with Picasso'. Gorky sought out all that was beckoning to him in Picasso's and Braque's Synthetic Cubism and again immersed himself in study. Once more his works reflected to a marvelous degree his understanding of his chosen masters. In these works, however, his own fixation on the personalities of objects that touched his life never allowed for the complete merging of the objects' identities into the larger corporate entity of the picture. This identifying trait in his early work was to be a peculiarity Gorky could work from and realize as a strength in his mature painting.

In 1926 Gorky embarked on a project that was to occupy him intermittently for a full decade. In a variety of media and in countless versions he enlarged, reproduced, then refined, replicated and analyzed a single image that tied him to his childhood in Armenia.

ARSHILE GORKY, *The Artist's Mother*, 1930.
Chicago, Illinois, Art Institute of Chicago.

In 1912 his mother had a local photographer make a portrait of herself with her son standing beside her. This scrap furnished the cherished image, rendered almost without change to the essential details, that became *The Artist and his Mother*. Bringing to bear everything he had learned. Gorky applied his studies to successive versions of this theme; if he was not yet a master when he undertook the project, at its completion he could be reckoned to be among the greatest draughtsmen of all time. Gorky simplified each of the forms, reducing the edges to lines which clearly bounded the interior of the form, distinguishing it from exterior space. This line, though often likened to the quality of Ingres', is less self-conscious or parochial a triumph. The identity of the thing portrayed rests unwaveringly behind the line that manifests it. The line itself skates energetically over the surface of the paper.

Gorky heeded a loving separation of each of the objects that composed the catalogue of the picture; each had its attendant meaning for him, and he supposed that each would set off a sympathetic resonance in the viewer. If the objects themselves do not awaken such delicious feelings in the spectator at the very least the loving concern of the rendering does. Gorky, apotheosizing one component of the double portrait, entitled one of his later pictures *How My Mother's Embroidered Apron Unfolds in My Life* (1944), and all during his years of painting, riddled as they were by tragedy, objects of his affection, whether from his life or from literature, made their appearance in his work. In 1941 Gorky said of his method work:

I might add that though the various forms all had specific meanings to me, it is the spectator's privilege to find his own meanings here. I feel that they will relate or parallel mine.

Of course, the outward aspect of my murals seemingly does not relate to the average man's experience. But this is an illusion! What man has not stopped at twilight and on observing the distorted shape of his elongated shadow conjured up strange and moving and often fantastic fancies from it? Certainly we all dream and in this common denominator of every one's experience I have been able to find a language for all to understand.[5]

Looking at the dignity and simplicity of *The Artist and his Mother* we might keep in mind that Gorky's words apply to his later art and that those images, however camouflaged they are compared with this simple double portrait, are equaliy cogent. The elegance that attends the drawings and paintings of this series springs from the same strong care that suffuses his entire body of work, regardless of the terror that themes held for the artist or our relative inabilities to decode his meaning. The root of Gorky's assessment as a master of painting's formal means lies in the demanding grace of his images. The care attendant in the rendering of those images reflects the

wealth of the meaning which the artist felt such pictures had.

Gorky joined the faculty of the Grand Central School of Art a year after he exhibited three works in the Museum of Modern Art's 'An Exhibition of Work of 46 Painters and Sculptors under thirty-five Years of Age' in 1930. This was his first showing in a museum. In 1934, Gorky's first one-man show, at the Mellon Galleries in Philadelphia, did little to alleviate his crushing poverty. The painter consistently made his destitution worse by habitually spending his spare change in whatever art shops he chanced upon while walking. In the depths of the Depression his hoard of materials was legendary among New York painters. Paradoxically, at one point in the early thirties, Gorky found himself short of canvas and paints and had to curtail easel painting in favor of drawings for projected later works. By 1935, his impoverishment had progressed so far that after begging friends to purchase his work, partly to defray a $600 unpaid bill for art supplies, Gorky joined The Project; at about the same time his first, short-lived marriage dissolved.

The WPA Project assigned him, after a brief competition, a set of murals. Originally intended for mounting at Floyd Bennet Field in New York, these murals, entitled Aviation: *Evolution of Forms under Aerodynamic Limitations* consisted of ten canvases and were eventually installed in Newark Airport. The murals sagged because of defective glue applied by a technician and are thought to have been destroyed when the Army took over the airport during the war.

Gorky based the murals on a set of photographs and collages made from photographs, of airplanes and selected gear from the airman's world. The elements were chosen to represent the constituent and invariable parts of the mechanics of flight. 'These symbols, these forms,' Gorky wrote, 'I have used in paralyzing disproportions in order to impress upon the spectator the miraculous new vision of our time.'[6] Gorky's choice of words is arresting; in particular the phrase 'paralyzing disproportions' seems to be more than another one of Gorky's typically ornate verbal embellishments. If the spectator's vision was to be 'paralyzed,' Gorky's means were the arrangement of his elements without regard for their logical display in a rational space. One's vision would be arrested by the sense of speed suggested by the shapes of the airplane's components. Thus speed could be appreciated by paralyzing its actual effects; rapid passage was frozen by distilling from the implements of speed their contributory visual suggestions. Speed was captured by emphasizing enforced stillness.

Gorky had carried over from the portrait of his mother to the world of machines the interest he lavished on the emotions vested in objects. A dimension of the airplanes's utility and effect on its users is an ever increasing desire for rapidity and a connoisuership of speed, and it was that aspect that Gorky emphasized. He composed his picture using the selection and visual weighting of elements by their location in the field and 'paralyzing' non-naturalistic size.

At about the same time that Gorky was working on the Newark Airport murals, another young artist, Jackson Pollock, started his employment with The Project's easel painting division.

Paul Jackson Pollock was born in Cody, Wyoming, in 1912, the youngest of five sons in a family of ranchers; inexplicably and without any encouragement from their parents, all the brothers eventually became professionally involved in art. In his early years the family moved several times in the West, settling in 1925 just outside of Los Angeles, in Riverside, where Jackson attended high school. He shared classes with Philip Guston, later to become one of the figures in the artistic movement Pollock spearheaded. The following fall Jackson's older brother Charles registered in New York's Art Students' League as a pupil of Thomas Hart Benton, while the youngest Pollock was being expelled and readmitted to Manual Arts High School in Los Angeles. For several years Jackson avidly followed the art world at a

JACKSON POLLOCK, *The Flame*, c. 1937.
New York, Marlborough-Gerson Gallery.

distance in the magazines that his brothers sent from New York. He became acquainted with Rivera's work by 1929, and practiced painting, drawing and clay modeling through the next year. In the autumn of 1930 Jackson Pollock – he had now dropped 'Paul' from his name – came to New York and registered in Thomas Hart Benton's class at the Art Students' League which dealt with life drawing, painting and composition.

Unquestionably Pollock discovered a vigor and energetic rhythm in Benton's work which he absorbed, and which became a constituent of his own art more than a decade later. Benton's mural work inculcated an understanding of large, sprawling scale, a space characteristic of Pollock's classic work and which reflected the spaces of his western upbringing. In 1932 Benton left the League to undertake a set of murals for the State of Indiana, but this was not to be the end of Pollock's apprenticeship to the older Regionalist. In 1935 Benton left New York again to live on Martha's Vineyard and Pollock visited him there all through the summers of the thirties and in 1937, also visited him in Kansas City for Christmas. The two artists kept in touch by occasional telephone calls right until Pollock's death. There can be little doubt that the style practiced by Benton formed the core of Pollock's sensibilities even if in contrast to Benton's idea of a purely autoctonous art. Pollock thought: 'The idea of an isolated American painting, so popular in this country during the thirties, seems absurd to me, just as the idea of creating a purely American mathematics of physics would seem absurd. . . .'[7]

264

Benton's art did not infiltrate Pollock's as a body of uninvestigated beliefs; but rather Pollock saw his teacher's art 'as something against which to react very strongly.'[8] Speaking of Benton on another occasion, Pollock said, 'He drove his kind of realism at me so hard I bounced right into non-objective painting.'[9]

But Pollock was not entirely, or even basically non-objective even in his most daring speculations. The Social Realists – with whom Pollock was aligned for a time in his early years – the Regionalists, the Precisionists, all of these preceding major groups of American artists, in contrast to the European Cubist and Surrealist masters, involved themselves in the portrayal of objects for their personally evocative qualities. Objects were seen as the containers of the world's emotional as well as physical reality. These earlier groups showed the way to a more volatile and personally revelatory use of images. Arrangement of surface, not the primary goal of painting, succumbed to the need for innovational compositions to display the personal image. Gorky's concern for the images of his life were no less manifest than Pollock's. The last year of his life Pollock remarked on his use of subject-matter:

I don't care for 'abstract expressionism' . . . and it's certainly not 'nonobjective,' and not 'nonrepresentational' either. I'm very representational some of the time, and a little all of the time. But when you're painting out of your unconscious figures are bound to emerge.[10]

Pollock's wife, the painter Lee Krasner, amplified these remarks with a specific reference to his painting, proving, if nothing else, how much at a loss we are at in describing his work when the source of his imagery is both unrecorded and obscurely personal

B. H. Friedman: What about the imagery? Did Jackson every talk about it?
Lee Krasner Pollock: I only heard him do that once. . . we were looking at *Portrait and a Dream.* . . . In response to . . . questions Jackson talked for a long time about the left section. He spoke freely and brilliantly. I wish I had had a tape-recorder. The only thing I remember was that he described the upper right-hand corner of the left panel as 'the dark side of the moon.'[11]

Both Gorky and Pollock excavated images from their pasts and from visions

JACKSON POLLOCK, *Portrait and a Dream,*
1953.
Dallas, Texas, Dallas Museum of Fine Arts,
Gift of Mr and Mrs Algur H. Meadows and the
Meadows Foundation, Inc.

critical of their lives, but the changes these images underwent all but eliminated public accessibility to the world of these private signals. The painters moved in intimate surroundings: their own envisioning. The very untranslatability and inaccessibility of their images contributed to their triumph in the period of the middle thirties to the end of the war.

The international aspect of the approaching World War worked against the parochial and representational Regionalist. Their narrow aesthetic of isolationism was held in lower and lower esteem, becoming finally untenable in the face of the dawning monstrosity of Fascism. At the same time that the idea of a native American art was flagging, the hatred of the Nazis fostered a natural endorsement of the styles the Fascists repudiated, notably Expressionism. As the Expressionists were ejected from their homelands they flocked to welcoming shores, and their art sometimes preceded them or acted as their surrogates in flight. Between 1936 and 1939, Kirchner, Nolde, and Schmidt-Rottluf were each given their first one-man show in America.

Expressionism itself, while it may imply an attitude toward the artist's materials and a basic procedural response to his activity, is not native to any one cultural tradition, though it may surface more strongly from time to time in a given style. Manifesting itself as a particular distortion or emphasis, or even in the applied sense as the clustered characteristics of modern Germanic art, but by and of itself, Expression does imply a list of technical means. It does not entail any particular and unique catalogue of preconceptions about the way a work is to be executed. Thus if we understood that to a large degree Abstract Expressionism was not based on a non-objective program of ever more rarified speculations about the arrangement and deployment of the picture surface, but was mainly concerned with the private delectation of secret signs, and if we understand that it was not mainly submerged in the 'pathology' of high Expressionism, we can use the term with its conventional meaning understood and intact. Abstract Expressionism refers to a movement and ethic that were at best multipartite, if not the literary amalgam of a host of personal, though related, contemporary inventions.

The Expressionists themselves did not form the major part of immigrant artists. In 1930, Hans Hofmann began teaching in California, establishing himself in New York in 1932, and becoming a citizen in 1941. He was one of the most important teachers of art in the period; the critics Greenberg and Rosenberg came under his influence and about half of the original members of the American Abstract Artists group were his students.

A broad coalition of non-objective painters, the American Abstract Artists, were instrumental in the success of Abstract Expressionism. Banding together, they held their first group show in New York in 1937 and in succeeding years their lectures and exhibitions paved the way for an understanding and acceptance of abstract art. Their gallery space was nearly the only way, aside from the WPA Project, that non-representational painting could be shown.

As the war continued, celebrated artists arrived along with all those who could make good their escape. The ranks of the European masters in New York were swelled by the arrivals of André Breton, Marc Chagall, Salvador Dali, Max Ernst, Fernand Léger, Jacques Lipchitz, André Masson, Roberto Matta, Piet Mondrian, Amédée Ozenfant, Kurt Seligman, Yves Tanguy, Pavel Tchelitchew, and Ossip Zadkine.

New York, which had been a local outpost for the world of painting, became during the course of the war the undisputed center of the art, wresting the title and pre-war vitality from Paris. The painters of New York experienced first-hand the presence of masters drawn from all of Europe's capitals. Painting in New York lost forever its provincialism.

266

This geographic shift accounts for the occasional use of the value-neutral term, 'New York School' in reference to the Abstract Expressionists. The New York School grew on the diversity of hybrid vigor. Pollock, Motherwell, Still and Guston came from the West; Kline and Baziotes from Pennsylvania; Gorky, Rothko, and John Graham were natives of Armenia and Russia; and de Kooning from Holland. Gottlieb and Newman were the only New Yorkers in this gathered invention. The 'School' itself has often been seen as divided into several trends, Action or Gestural painters, Color Field painters and Ideographic painters. Not many major artists fall neatly into any one of these types, and these classifications do not sufficiently distinguish between the different operative assumptions about painting. While one or more of these terms may overlap in the work of a given artist, in the greatest masters of the school, good argument could be presented for subscribing all of these divisions to a single work. Only in the work of the earliest exponents of the school can all these variables be seen to be acting with incipient and egalitarian vigor.

Gorky is the overture figure to Abstract Expressionism. His work embodies, in a condensed and germinal condition, the characteristics of the later broad developments. Tragically he was to die at precisely the moment when these elaborations began unfolding.

For all his personal strength and charm, it is very doubtful that Gorky would have been remembered if his painting had stopped developing with the WPA murals. In the late thirties and early forties his system of personal signs in a deep floating space continued to evolve. By 1941, in a series of not less than five paintings and numerous sketches, he had arrived at his *Garden in Sochi* motif. It was in such works that he resurrected images of his childhood home and the magic of the archaic and unchanging world-view of the peasantry.

Each canvas of the series layers countless similar versions painted one atop of the other; thus the total number of times that Gorky painted this scene is incalculable. His use of a single broad background color, anticipating the Color Field painters, is inflected by forms placed to create a deep parabolic space coming closest to the picture surface at the lower edge; the main objects float in the center. These images were simplified, reduced by repetition to approximate in Gorky the sublimation of lines to the level of a muscular response, approaching the Surrealist's 'automatic writing.' The reduction of the number of each form's components approached the Ideographic immediacy of Gottlieb and Baziotes.

Gorky's forms became freer as he learned to balance a painterly and draughtsman-like approach to his art. Paint itself was applied with great freedom, requiring less conscious attention at the moment of execution, his strokes being rooted in a deeply rehearsed familiarity with the images. It was the personal worth, the content of these images that justified such an hypnotic subservience to their every contour. Unlike the Surrealists who dredged their unconscious for surprising and revelatory images, Gorky committed to his unconscious those shapes which were emblematic of his vision of himself and his past. More than any other painter, Gorky produced blazing signs, almost chapter headings, for both his psychological states and the plateau of his life. His artistic effort did not describe a corresponding progress of ascending celebrity. Every attempt at recognition turned sour. His work was shown in New York in 1938, but his first important one-man show came only in March of 1945, at the Julien Levy Gallery; the catalogue carried a foreword written by André Breton. (In that show a painting called *They Will Take My Island*, anticipated by fully fifteen years, if not more, the image of the 'island' that was to arrest literary thinking of the fifties.) Since 1937 no major museum had made a cash purchase of one of his paintings. None was to do so again during his lifetime. The painter's woes increased and the appreciable effect on his style was to drive his strokes ever more quickly and frantically across the canvas. The underlying armature of images

267

frequently appeared to dissolve in slashed, dripped and glazed paint, his eloquent line keeping all in harmonious check. Not till the maturity of Gorky's friend, fellow-student, and one-time disciple, Willem de Kooning, in the late forties, would the armature of supporting shape be reunited with a paint-laden surface.[12]

Gorky's luck continued to fail. In 1946, his studio burned down completely; it contained at that time a staggering trove of work: fifteen canvases painted in 1945, two versions of one of his later masterpieces *The Plow and The Song*, several portraits of his wife, in all a total of twenty-seven paintings and countless drawings were burned to ashes. Only a short time after the fire, cancer was diagnosed in the artist and surgery performed in February 1946. The year following the operation, as if to make up for time lost to sickness and for paintings destroyed by fire, Gorky worked with feverish intensity executing a score of paintings and about three hundred drawings. Julien Levy scheduled Gorky's fourth one-man show for June 1948. The painter was now garnering some measure of praise, but this success too was short-lived. On June 28 Levy and Gorky were involved in an automobile accident. The artist's neck was broken. On 21 July 1948, unable to paint, success eluding him, his body wracked and marriage failing, Arshile Gorky hanged himself in his home in Sherman, Connecticut.

The first master of the new style died at the very moment that the seeds buried in his art began to blossom in the paintings of various artists. A year previously, his art congested with paint, superimposed images overlapping and forced to the very limits of the traditional technical repertoire, Jackson Pollock began his dripped paintings.

Pollock stayed with the WPA Project through 1942, after being rejected by the Army largely due to the alcoholism that plagued him through his life, with but one highly productive interregnum, 1948–50. In 1942 he met, through William Baziotes, Robert Motherwell, who urged him to experiment with the Surrealist 'automatic writing.' Already acquainted with automatism, Pollock did on several occasions participate in this with Motherwell and Baziotes. Motherwell also worked with Pollock on the collages which were to be displayed in Peggy Guggenheim's Art of this Century Gallery in the spring of 1942.

Miss Guggenheim, married to the European Surrealist master Max Ernst, opened her gallery as a haven for Abstraction and Surrealism. Art of this Century Gallery had an interior designed by the architect Frederick Keisler (who published the first article on Arshile Gorky). Keisler equipped the gallery with remarkable chairs that could also serve as sculpture bases, and curved walls which projected forward toward the viewer, heightening the atmosphere of surreality depicted in the paintings. At the urging of Howard Putzel, the perspicacious manager of the gallery, Pollock signed his first contract with a gallery, Miss Guggenheim's. The year-long agreement called for a 'salary' of £150 a month against the amount his paintings actually brought at sale during the year, with the gallery acquiring paintings to make up any difference. Pollock was to get a one-man show at the gallery in November of that year and the commission for a mural in Miss Guggenheim's house.

Between the time in mid-summer of 1942 when the contract was arranged and late December or early January, this great eight by twenty feet mural remained a blank canvas. Pollock would often come to stare at the huge area and leave without having made a mark, then sometime around the new year he painted it all in one exhausting burst.

During the following year, Pollock showed work several times at the gallery and began receiving some favorable notice from several sources. Mostly, however, he was the recipient of ardently negative criticism. Pollock's first one-man show displayed his deep concern for non-discursive aspects of symbolism. He struggled to

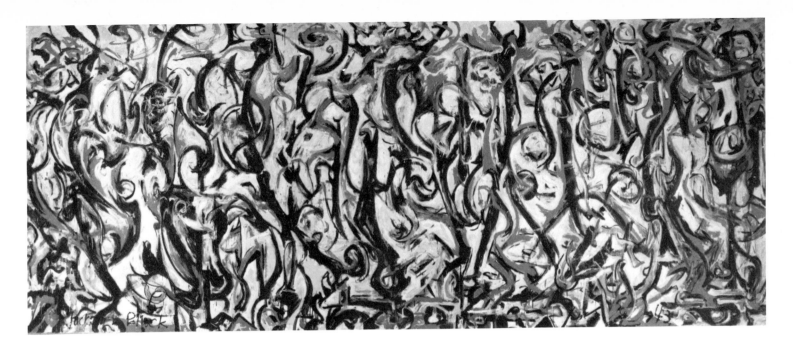

JACKSON POLLOCK, *Mural*, 1943.
Iowa City, Iowa, Collection of the School of Art,
University of Iowa, Gift of Peggy Guggenheim.

coax images from the unconscious to the level where they could win a space for themselves, vigorously occupying area. The titles of that exhibition reveal clearly that the role of recollection was a fundamental concern. The catalogue of those début paintings reads like a primer on mythography: *The She-Wolf*, *The Guardians of the Secret*, *Male and Female*, *The Moon-Woman*, *Conflict*, *The Magic Mirror*, and so forth. From this first exhibition Pollock's supremely refined sense of color operated. There is no question that had his work never evolved past this point, had his career even ended at that moment, the value of these paintings would have eventually established itself. These paintings distill the American love of the transcendental expressed in a gritty native argot of images directly frontal to the viewer, fully cognizant of the underlying debt to Surrealism.

For the next few years, Pollock continued to work very much in this vein, his paintings becoming ever denser, the figures more obscure as he became more familiar with both his subject and the limits of his imagery. Increasingly Pollock's compositions became more centrifugal, occupying the outermost corners of the canvas with the same tenacity as the middle images claimed their position. His painting remained basically figurative through 1946. Pollock never entirely abandoned figuration and images recognizably surfaced in his painting inter-mittently. By 1946 however, the shapes of the constituent images were lost in the frenzy of painting going into each work.

In *Eyes in the Heat* of 1946, paint has been stacked up so thickly that the brush left its traces in the still wet, underlying paint. The brushstroke and the action that went into its course have been frozen in the same way an animal's prints can be-come fixed in lithified mud, preserving the fossilized record of that passage into our day and into our natural history museums.

Such energy in paint could not long be accommodated by the conventional, laboriously slow and limited means of the brush and palette. The next year, Pollock began to drip paint from cans, or sticks, or the tips of paint-hardened or hairless brushes, to canvases laid flat across the floor. This mode of painting, gestural painting, was dubbed 'action painting,' by Harold Rosenberg: 'At a certain moment the canvas began to appear to one American painter after another as an arena in which to act – rather than as a space in which to reproduce, re-design, analyze, or "express" an object, actual or imagined. What was to go on the canvas was not a picture but an event.'[13]

Remarkable as this idea was, its painted and not its written expression was the

new presence in America. As early as 1915 Willard Huntingdon Wright had supposed when discussing painting that '. . . energy is the ultimate physical reality;'[14] Rosenberg, cautioning the viewer on the aesthetics of the new painting, recommends: '. . . the spectator has to think in a vocabulary of action: its inception, duration, direction – psychic state, concentration and relaxation of the will, passivity, alert waiting. He must become a connoisseur of the gradations among the automatic, the spontaneous, the evoked.'[15]

Neither was this new to America; an aesthetic of action and its appreciation had preceded the cult of the action painter. Long before the gestural paintings themselves appeared, Robert Henri addressed his class: 'The brushstroke at the moment of contact carries inevitably the exact state of being of the artist at that exact moment into the work, and there it is, to be seen and read by those who can read such signs . . . he paints, and whether he wills it or not each brush stroke is an exact record of such as he was at the exact moment the stroke was made.'[16]

Not to depreciate Rosenberg's grandiloquence, for he hit the nail squarely, but this idea has had a long, healthy life in American painting. What the gestural painters did innovatively was to drive a wedge effectively between what images had been used to generate the picture and the surface organization of the work's appearance. The action painter was neither purely concerned with his images nor was he purely a formalist; but neither function, the depictive nor the kinesthetic and formal, would ever win the upper hand.

Even in comparison with Gorky's last, cursory disposition of paint, Pollock's drip was a radical departure that raised numerous technical questions. Though Gorky's color was often thinned to the merest wash floated over the surface, Pollock's lashed paint exposed the raw material of the canvas itself. The sequence in which paint was applied became crucial and an inseparable part of the image itself. In fact the image, the picture, was a creation of the irrevocably ordered sequences in which a color was applied, mitigated only by the quality of the draughting. The unique picture that each painting represented reflected the order of events that brought it to fruition; no longer could an image evolved early in the making of a work be 'saved', seeming to float on the same finished surface as the last strokes were applied. Pollock's technique risked more than it was possible to risk in a painting by other means. There could be no repainting.

Rather than cut a given length of canvas to a predetermined size before the painting began, Pollock rolled his material across the floor and proceeded painting down its length, raising the option of where to draw the edge in a picture. Where should a painting end? Pollock did not work out to a deliberately preconsidered edge in these drip paintings. He allowed the progress of the picture to define its own limits. The painting was then cut from the roll or from the center of a painted area in the roll. The relationships of paint-to-edge could thus vary from a dense and intimate relationship with much paint hugging the limits of the painting all the way to a single suspended area freely floating in the center of a rectangle of raw canvas.

Once the painting had been cut from the canvas bolt, the decision for a vertical or horizontal format had to be made. The strength of a vertical picture, allusive of the force of gravity acting against a mass erected in air, can animate the picture through the implied stress on its components. There is a heroism in the struggle of forms to remain upright, their thrust playing off against gravity. The horizontal format, allusive of lanscape's repose, has its own strengths and lyricism. Pollock, the westerner-moved-east, could use these differences to play off his feeling about the land and architecture.

Color in Pollock's painting was not often 'pretty.' The lacy network of whipped lines would quickly make pleasant and comfortable colors gratuitously insipid.

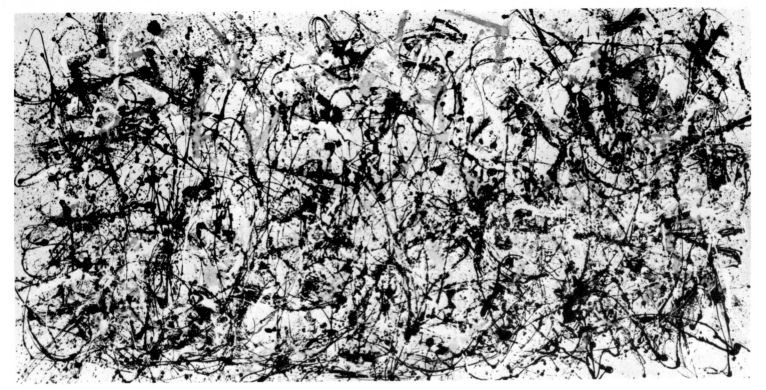

JACKSON POLLOCK, *Autumn Rhythm*, 1950.
New York, Metropolitan Museum of Art,
George A. Hearn Fund.

Pollock's color has its own rewards which are the gift of a precarious balance of individually harsh hues. He established elegant and sophisticated harmonies, hardly relying on the vocabulary of previous painters; often he used rich earthy tones against black or a Byzantine silver.

It is, however, on Pollock's draughting, that attention must be focused in the last analysis. Negating everything tradition had elevated to signal quality. Pollock raised the thorny question of what the art of draughtsmanship finally entailed. No particular technical vocabulary or rendering virtuosity, but the appreciation of the life of line itself seemed the crucial issue. Gorky had employed every masterly device to vary the thickness of his line, its direction, and texture. Just as Gorky's suave line sprang from his sophistication as a draughtsman, Pollock's dripped line evolved naturally out of his weakness in rendering. Nevertheless, the fundamental quality of Gorky's and Pollock's drawing shows the direction painting had taken in the short time between the crests of their two maturities.

Pollock's dripped paint thickened, becoming a clotted shape, then swept off again as the thinnest line. Quickening or slowing the pace at which the paint raced over the canvas, the man dancing behind the hand imparted gesture sometimes broadly from the shoulder or with great delicacy from the tips of the fingers. The area bounded by Pollock's line is usually elusive; rarely can single figures be isolated from the tangled web of his drips. At the beginning and end of his career, Pollock worked in clear figuration and the temptation to read out patterns of the dripped paintings as whole or partial scenes is tantalizing. The strength of the imagery of the last five years of Pollock's life reflects back on the rest of his painting, cautioning the careful viewer to keep distance between the artist's invention and the free-play of the viewer's unconscious.

It is the sum of the variables of color, format, the use of the canvas' edge, the quality of draughting, the sequence of the application of hues, the choice of scale, and its propriety to the other variables that operated uniquely for Pollock. The force with which these elements combined in a convincing declaration of the individuality of the arrangement, the degree of palpability the picture's personality attained in its appearance, are finally the means toward a discussion of relative quality in this artist's work.

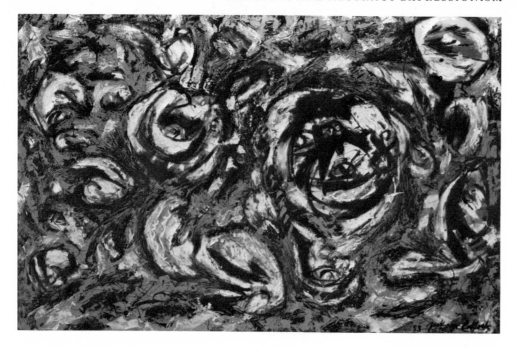

JACKSON POLLOCK, *Ocean Grayness*, 1953. New York, Solomon R. Guggenheim Museum.

In the last two and a half years of his life, Pollock succumbed to both broadly negative and overly expectant criticism. His recurring bouts of alcoholism allowed him to work less and less. Between 1954 and 1956, it is possible that he did not even approach painting. Pollock put on weight, becoming excessively depressed. In the winter of 1952 he was in an automobile accident; in the summer of 1954 he broke his ankle. He began to grow a beard and to sink into a deeper despondency. On 10 August 1956, driving toward his home on Long Island over a road he knew well, only a quarter mile from his house, his car ran off the road killing him instantly.

Pollock secured from the deep concerns of his own life and struggles images which anchored in his paintings, but he did not attempt to prune those images of particular autobiographical content to make them 'universal.' His forms, emerging from the net of their own development, were not studied and perfected as an appeal to any prototypical behavior. Other artists had slightly different approaches to the invigoration of the painting's content, and painters of the 1940s positioned themselves between the extremes of a fully fluid and immediately responsive technique and a way of freezing the image for a public delectation. Gorky chose a method of sublimation through repetition, Pollock the spontaneity of an immediate technique and instantaneously extensible exposition of clusters of freely-related symbols. At the time there seems to have been little alternative to the assumption of an extreme position with regard to the uni-dimensional range of spontaneity or repetition. Each painter had to mediate some balance between the demands of a dynamic, gestural meeting of the canvas, and a reliance on the structure of the image, the picture. Painting resisted picture-making; the urge to make pictures had to legitimize itself in the act of painting. The outer limits of a spectrum were thus delimited.

Another of the notable solutions to this dilemma of extremes came from Adolph Gottlieb. Born in New York in 1903, he studied at the Art Students League with John Sloan and Robert Henri, and had his first one-man show in 1930. During the thirties, Gottlieb became interested in, and began collecting primitive art. These works gestated as a potentiality in his art through the decade, while he was in the WPA Project after 1936, and finally emerged in his pictographic painting of 1941.

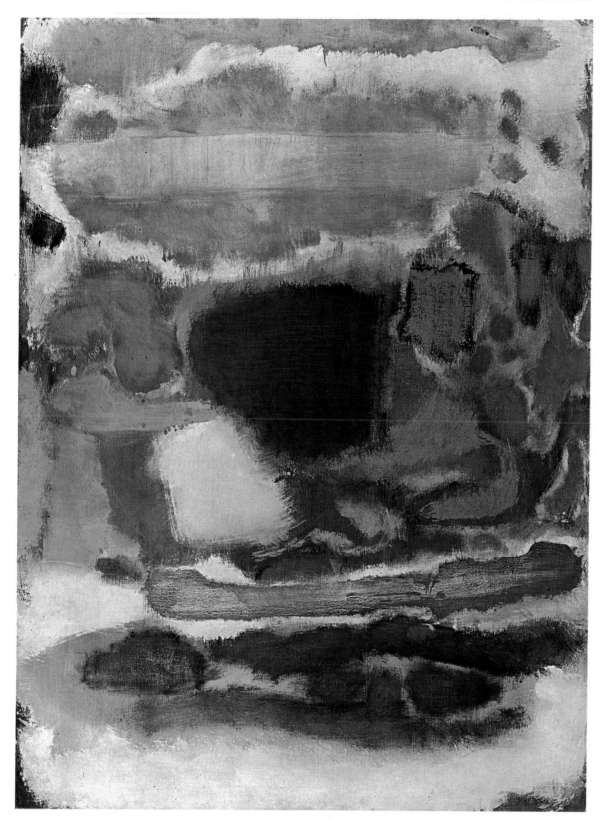

MARK ROTHKO, *Number 26*, 1947.
New York, Mrs Betty Parsons Collection.

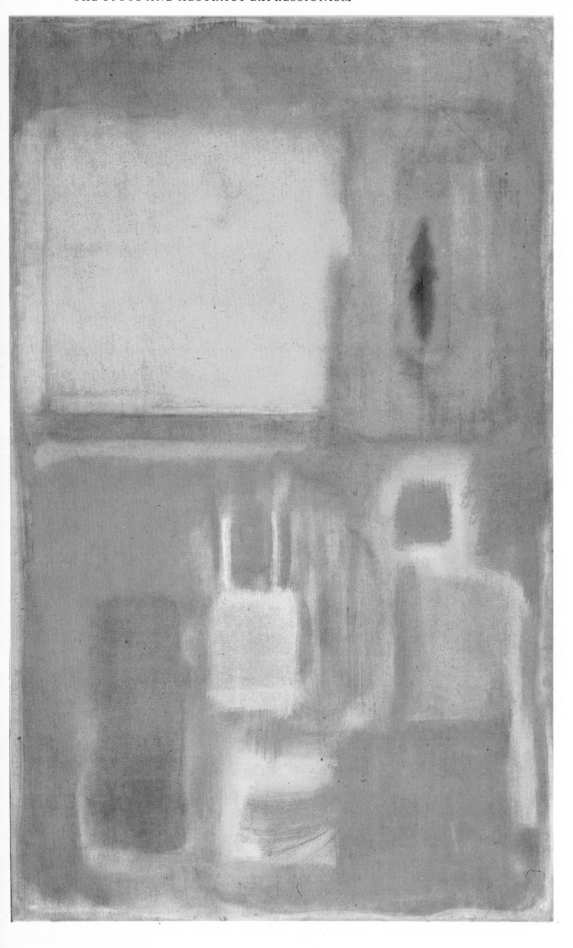

Left MARK ROTHKO, *Golden Composition*, 1949.
Private Collection.
Opposite ROBERT MOTHERWELL, *The Emperor of China*, 1947.
Provincetown, Massachusetts, Chrysler Art Museum.

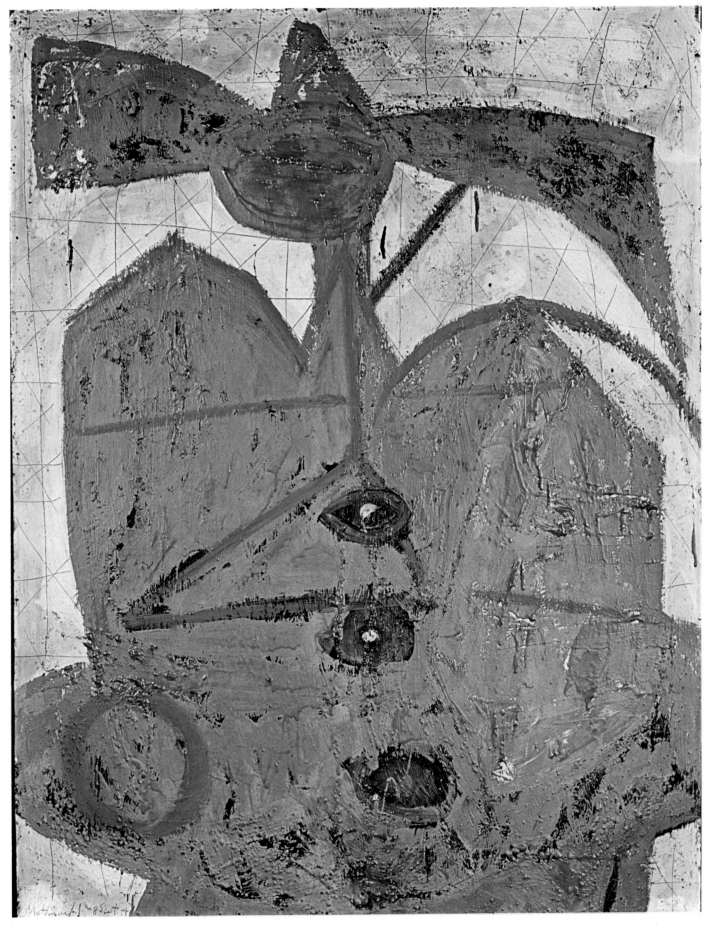

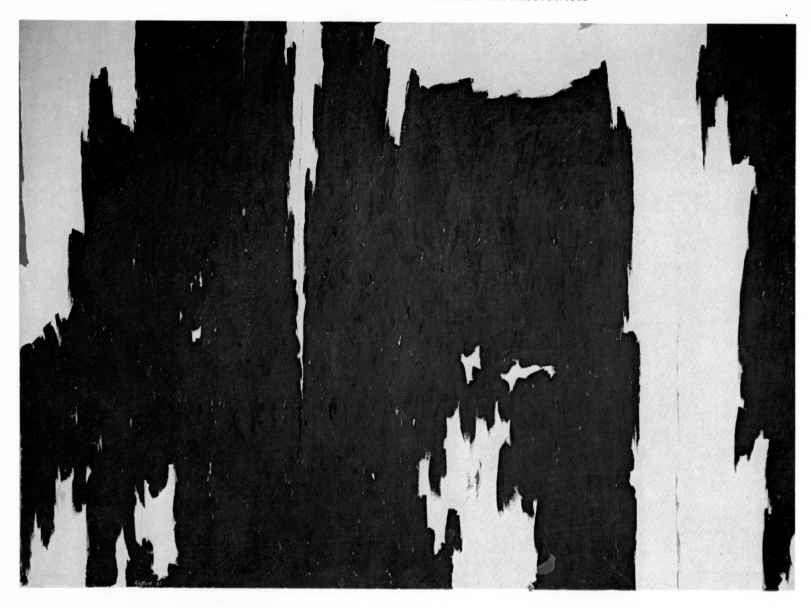

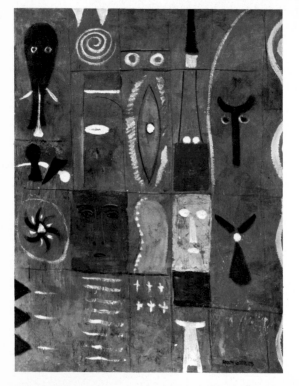

Speaking of the role of the primitive element in modern art, Gottlieb and Rothko said: '. . . It is not enough to illustrate dreams. While modern art got its first impetus through discovering the forms of primitive art, we feel that its true significance lies not merely in formal arrangement, but in the spiritual meaning underlying all archaic work.'[17]

Gottlieb saw very clearly the dichotomy between the static elements of pictorialization, the need to freeze a configuration to establish para-syntactic relationships and hence the force of meaning, and the dynamic fecundity of ideation. The question which arises with especial force in his art, and which engenders even today so much discussion, is the question of identifying the fundamentally plastic element in a system: is it the syntactic, the ordering, or the overtly contentual, the semantic coordinate.

Whether the two functions are even separable or are merely superficial classifications is problematic, and Gottlieb in his investigations owed a debt to those who had already, achieving greater or lesser success, grappled with the problem. Paul Klee, Piet Mondrian, and Joaquín Torres-García each had – Mondrian the obvious extreme case – seen the viability of syntax as itself evocative.

Gottlieb's pictographs can be seen as being divided by their grids into active

276

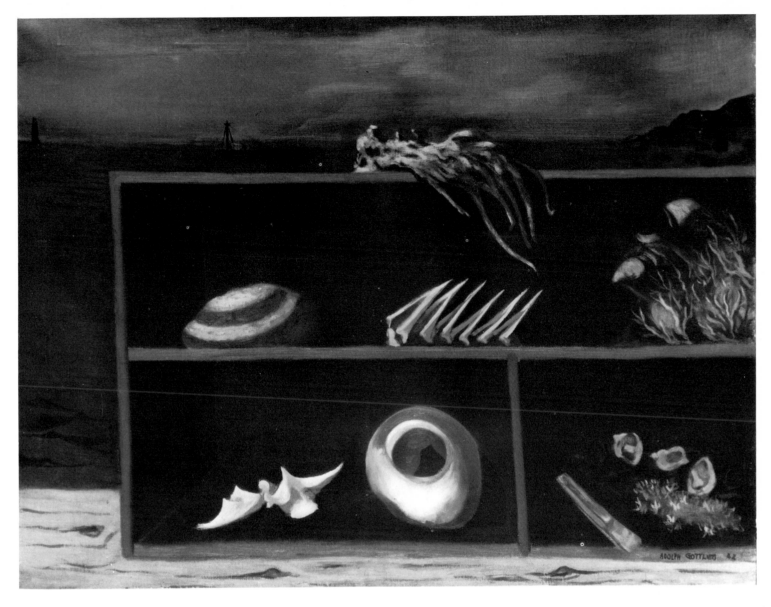

components, if the arrangement of horizontal tiers and vertical rows are the mean-ing-lending grammatical device, elevating otherwise static images. The opposite view that the compartmentalized images are meaningful hieroglyphics divided by grids only to enhance, emphasize, or inflect their meaning is also fully viable. The mute images, appearing to alternate between a pictorial and an idiogramic identity summon deep stirrings, of unexpected proportion to their stable, placid arrange-ment. Gottlieb's hieroglyphic expanses were in fact an attempt to arouse haunting recollections of the epics of proto-history, not the specifics of any narrative. Gottlieb worked more or less in this vein, mitigating the active and passive elements of his picture until the evolution of his images took a dramatic turn.

In 1957 the basic arrangement of his 'bursts' paintings occurred to Gottlieb and his art appeared to take a radical departure. Instead of a picture whose surface was divided across its expanse in a metaphor of inscription or record keeping, a funda-mental simplification had taken place. The size of the canvas increased dramatically, the range of colors became broader and stronger, and the number of shapes in-volved fell off to a minimum of two. These two shapes played up the essential difference between the active – the verb – and the passive – the noun. Presentational – and the dynamic elements were always present – but their location in set,

appropriate shapes was not fixed into a single reading. The hovering disc-shape could be seen as the active element working on the lower passive terrestrial shape. Alternatively, the geometry frozen above can be viewed as an object of arrested evolution while an active metamorphosis continues beneath it. The 'cloud,' by its clearer and tighter outline, reflects a more controlled kind of painting than the flamboyant and energetically brushed black. Additionally, the force of the lower forms seems muted by its opacity while quivering possibility lurks in the translucent sphere.

These alternating interpretations do not by any means exhaust the roles played by the two major shapes in Gottlieb's work. The location of the canvas' white surface through its transition under the hovering circle shape to the edges of the black form can hardly be the same unmodulated space throughout. The kind of space we are dealing with is limited in its possibilities only by the quality of associations that the whole configuration recalls in the viewer, the initially stark appearance of these two forms floating in or on their space gradually yields to a richer and less defined view of the configuration rooting it in the flow of time, through our kinesthetic feel of the painting, and through our associations with the wealth of situations this diagram satisfies. The true economy of Gottlieb's solution is only fully understood against the background of his earlier work and the realization that although both sets of solutions appear disparate they nevertheless present a single cogent and respectful view of the profundity of human response, its ultimate sources and prototypes. Gottlieb's ideogramic works evolved from hieroglyphs, that is, symbolic recording, much like the suggestive shapes and grammatical references of Klee and Torres-García, into more energized diagrams of forces and objects.

William Baziotes' art represents another studied route of access to associational responses to images. Baziotes was born in Pittsburgh in 1912; in 1933 he moved to New York where, between 1936 and 1938, he was a teacher in the Federal Arts division of the WPA. From 1938 to 1940 he painted in The Project's easel division. In 1944, one year after Pollock's first one-man show, Baziotes debuted, also at Peggy Guggenheim's Art of this Century gallery. His work in the late thirties was heavily influenced by Cubism and in the forties he practiced an art marginally associated with Social Realism. Like many painters whose art had been flavored by Cubism, Baziotes employed – as had Gottlieb – a grid system. Unlike Gottlieb, however, Baziotes' early work is not concerned with the historical epic, but the mechanisms of the modern world fitted into the pattern of verticals and horizontals.

Gradually this grid system lifted from Baziotes' painting and in 1946 he began to describe 'biomorphs' in his work. Instead of the gesture toward the recorded ideograph of Gottlieb, Baziotes sought to instill his forms with the apurtenances of life and the eeriness of alien life's mutual distrust and respects. He essayed this theme from the late forties until the end of his career. In 1948, along with David Hare, Robert Motherwell, Barnett Newman, and Mark Rothko, Baziotes helped found the 'Subjects of the Artists' School in New York. As the title of the short-lived experiment (Clyfford Still removed himself even before the school's opening) implied, these artists all believed that modern art indeed had subject-matter.

The subjects that Baziotes chose to a large extent determined the look of his painting. Painting slowly, refining his image in the reworking of each picture, Baziotes calmed the frenetic dialogue that Pollock had established. Reciprocating for a protracted assault on the picture, the act of painting, though vital as ever, decelerated and the stilled image came into clearer focus. Baziotes deliberately closed his forms' contours, rendering them distinct from their backgrounds. Often fragile beings, his forms could also mass as an aggressive bulk near the foreward plane of the picture, presenting a threatening and alluring immediacy. The picture

plane holds back and gives a view into a contained and impenetrably dense, possibly submarine world. Baziotes' images appear to be seen through a congested atmosphere in an horizonless world stretching up from the bottom of the picture and folding back into extreme depth at the center. The picture plane serves as a surface through which we peer at a world of dappled and shifting light softly mottling the surfaces of what rests behind. One senses that his figures are neither stolid and weightily immovable nor given to rapid movement. The mode of action in this world is gliding.

The personality of Baziotes' creations is not expressed by the character of reaction, since this is a world basically without movement, and thus without the main quality of the epic – response. His forms' personalities result from the interplay between color and the character of outline. The basic issue, in this Cambrian or post-civilization age, seems to be the struggle of survival; 'beauty' is what is granted to the uninvolved spectator. This painting's ethical element is contributed not by the sum of conflicts but by the precise location of critical variables.

If Baziotes' art was not spontaneous, in the sense of a flurried action, it continued even further to slow as a process. In the forties his work was at its most fluid and free, while in the fifties each painting became more labored, each a more calculated and precise evocation. His work became ever more methodical as the act of painting,

279

its chain of responses, went into gracefully slow suspension. In the fifties Baziotes produced but a handful of canvases a year, but every painting became more polished, more clearly and tightly defining the compact emotional territory staked out.

Unquestionably his was a legendary world in which the painter had chosen to portray the mundane aspects of the bizarre, the enchanting and the repulsive, in a non-narrative situation only intimating movement and the possibility of myth-making enterprises. It is this scaling-down of the constituents of the fantastic that awakens a sense of primordial recognition and deep associations. Thoroughly convincing and probable, this world was won by painting out the slightest irrelevancy. Like so many others of his generation, William Baziotes died young, at the age of fifty.

Where Baziotes scaled down his vision, Mark Rothko enlarged it; if Baziotes' forms exist behind a screen, Rothko's float before one. Individuality of identity, a function of shape in Baziotes' painting, is only a scent, a tinge, represented by irreducible differences of hue in Rothko's painting. If Baziotes' painting has even slight implications of gliding motion, Rothko severely absented everything but an instantaneously durable and self-renewing immobility. Yet it is accurate to say that, compared with the implications of real physical activity in Gottlieb's painting, Baziotes and Rothko share distinct overtones and goals.

Mark Rothko was born in Dvinsk, Russia, in 1903 and came to America in 1913. Between that time and 1947 when he began to come to his mature style he experimented with a discontinued formal education at both Yale and the Art Students' League. Passing through a succession of artistic innovations, he began to purge his work of all referential content around 1945. In 1950 Rothko arrived at the point where his pictures were occupied by unique and faceless rectangular personages.

Below MARK ROTHKO, *Vessels of Magic*, 1946–7.
Brooklyn, New York, Brooklyn Museum.
Below, right MARK ROTHKO, *Four Darks in Red*, 1958.
New York, Collection of the Whitney Museum of American Art, Gift of the Friends of the Whitney Museum of American Art, Charles A. Simon Fund, Samuel A. Seaver, Mr and Mrs Eugene Schwartz.

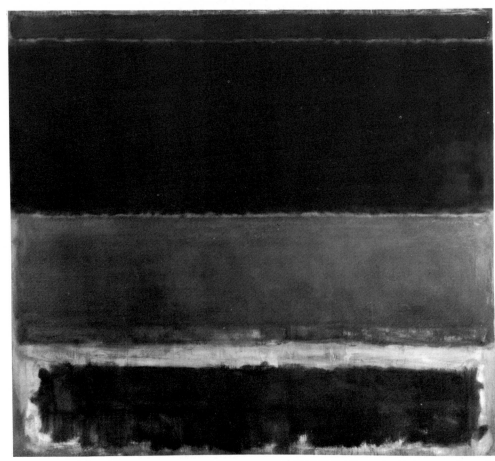

This signature configuration had inherently a host of implications and effects characteristic of a vast heroic remove. Against the flat, pulsing background color of each of his works, cloudlike rectangular shapes announce their presence continually, in an immense sky-like space. Against this limitless exterior, forms blare piercing awareness of their own invulnerable expanse. This is an unidentified proclamation, an annunciation without consequence, whose reception has been prepared by the life of the unconscious. There is no sense of equality with these looming forms; their domination hints at neither threat nor assistance but the blank unsmiling possession of limitless power.

If the immediate effect on seeing a Rothko is one of viewing forms inaccessible by virtue of infinite remove, it is because the painter has paradoxically forced the shapes forward by placing them in front of a congested background plane. This bedecked iconostasis, immediately near, alternates rapidly with an enormously deep sky space into which vision falls trackless. Thus to some extent these pieces seem to be pictures of themselves; they depict entities that can have no life outside of depiction. As the scale changes from the manageable to the huge the viewer first sees the small picture of a being, then the image dilates and the viewer is in that very presence. The difference is the difference between a space that one shares with another entity and complete submission. Shifts in color, the number of forms, and their placement only modify the quality of that submission.

The glowing luminosity of the forms bespeak an undecaying alertness, much as the even light of the Precisionists had hinted at these same metaphysical consequences. Rothko's shapes seem anchored, almost riveted, in frontal attention. Painting had become for Rothko a way of depicting without denoting. For Rothko ceased to combine in painting elements derived from other sources into a synthetic visual whole. Nothing like a memory of the world as it appears in everyday reality is called upon to make veridical the response to these pictures. A common agreement on the quality of this work seems to imply a homogeneity of human response at a level which signals the repository of emotions often held suspect: the mystic. Rothko expressed something of this when he said: 'To paint a small picture is to place yourself outside your experience, to look upon an experience as a stereopticon view or with a reducing glass. However you paint the larger picture, you are in it. It isn't something you command.'[18]

Dealing with such forces was a precarious, demanding venture, and one can only guess what it required of the painter, what humility and constant daring. Mark Rothko took his life, in New York in 1970, at the height of his powers.

Gottlieb, Rothko, and Baziotes are sometimes associated under the banner of the myth-makers, but they were certainly not the only painters of the period to experiment with configurations meant to suggest the archetypal. Just as certainly as theirs was a shift from the personal mythology that preceded them in the Surrealism-imbued work of Gorky and Pollock, they anticipated with Barnett Newman the severe configurations of a geometric, but no less suggestive art.

What these approaches seemed to demand in different proportions was an admixture of resonant imagery and an alertness to the condition of painting. More even than Pollock's dedication to the painting of paintings, there came about an interest in painting pictures and to the same degree that all previous generations of artists had been interested in making pictures. This distinction, though ungainly in writing, is nevertheless the crucial one. In a joint statement Rothko and Gottlieb said simply, '. . . There is no such thing as a good painting about nothing.'[19] The immediacy of the process of painting, that act that combines the sum of learned and personal traits, was never to be sacrificed in their art for the sake of the wrought image alone. This sought after delicate balance, almost as proof of its own elusiveness, sometimes did not come off. The attempt became exciting and as the means

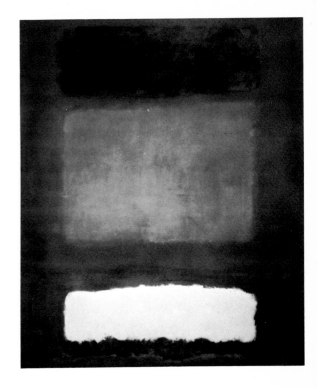

MARK ROTHKO, *Red, White and Brown*, 1957. Basle, Öffentliche Kunstsammlung.

MARK ROTHKO, *Red and Brown*, 1957. Milan, Giuseppe Panza di Biumo Collection.

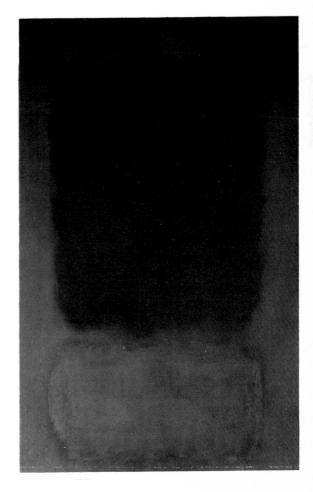

281

became more and more refined the continued assaults on the goal began to resemble each other more closely.

Against the grandiose and bloated spectacles of the Fascists the Abstract Expressionists might have found their own scale and ecstatic involvement suspect unless carried out by the most scrupulous means. The smallest distinction between individual paintings meant the greatest difference in the identity of the finished work. In the world of Pollock, and certainly in that of Rothko and Gottlieb, the repeated image denotes a search for the perfected object embodying, if not reconciling, all disputing demands of the picture. The serial art of the sixties finds its precedent in these works.

By 1945 the Surrealist-fostered and enhanced *self* seemed exhausted as the sole locus of observation. Even before the war had long faded, an art of somewhat greater objectivity, not of the artist's concerns or seriousness, but of imagery evolved.

This newer objectivity did not rely any more than the other Abstract Expressionist work did not overt representation, but its concerns were less the life of the man that made it, and more with executing an object of public delectation. A painted monument whose space became more and more a question of public proclamation and not private entry.

Robert Motherwell more than any other painter epitomizes the transitional position. For him: '. . . the extraordinary English artists of the 19th century are Dickens, Turner, and Hopkins; in America, Poe, Melville, Whitman, Ryder and Eakins. But one has to wait until the 20th century to talk about modern art in clusters: in this sense, in our century the enterprise is more sociable, less desperate.'[20] In a certain sense, of all the painters of the period only Motherwell could have authored such a statement.

Born in 1915 in Aberdeen, Washington, Motherwell attended from the age of eleven the Otis Art Institute of Los Angeles on a scholarship; in 1932 he studied for a short time at the California School of Fine Arts. That same year he entered Stanford University, was dissatisfied with the art department and majored in philosophy. In 1937 Motherwell entered the Department of Philosophy at Harvard as a graduate student; in 1938 he studied through the summer at the University of Grenoble and in 1939 spent some time at Oxford University. Motherwell moved to New York in 1940, entering the Department of Art History and Archaeology at Columbia University at graduate level. It was at Columbia that Professor Meyer Schapiro introduced the young student to the exiled Surrealists living in New York. Under Schapiro's influence, Motherwell himself was encouraged to paint.

Submerged in the artistic life of the city, Motherwell continued to work through 1943 when he, Pollock and Baziotes were asked to contribute collages to Peggy Guggenheim's Gallery. He and Pollock worked together on their pieces at Pollock's studio; the two painters' friendship dated from the previous year when they, with Baziotes, joined in making 'automatic' poems. Motherwell's deep empathy for the Surrealists and for French literature significantly helped foster the general tone of partiality this art found in New York in the mid-forties. If he was not the prime source of this influence, after the Surrealists living in America, he was certainly the principal intermediary between the ruggedness of the native art and the courtly perversity of French Surrealism. In Motherwell's painting the two distinct tastes can be reconciled.

When Motherwell referred to a 'sociable' enterprise, the designated community is probably the entire Atlantic and even the Mediterranean community. In the service of that community, and of art as a vital and public enterprise, he has worn many mantles. His influence as a teacher, author, panelist, lecturer and especially as an

ROBERT MOTHERWELL, *Joy of Living*, 1943.
Baltimore, Maryland, Baltimore Museum of Art,
Saidie A. May Collection.

editor have shaped to some extent a healthy investigation of the sources, as well as
the implications, of modern painting. Motherwell seems to be a man longing for an
artistic community and its concomitant supporting traditions and identity; he said
of his early years that he '. . . knew nobody in New York – nearly died of loneliness,
at how hard and cold and overwhelming it seemed to me. . . .'[21] The great community
he sought was fashioned as the war drove many artists to New York and predisposed
the Americans toward the foreigners by their sense of involvement in the very real
struggle. Motherwell was the liason between the two mentalities and his art bridged
the division. His painting was vast and gestural but refinements were introduced
as anxiety was funneled away. Organizing his painting is a living synthesis of the
art of the past with a relational stance to the newest innovation in Europe and
America, a huge undertaking in which his strongest bond to the new art of the
French Surrealists was his lifelong fascination with psychoanalytic theory. Mother-
well's roots in the West contributed something of that region's burly scale.

In his work gravity is overcome not through the actual energy of painting as it
was by Pollock, but through the knowledge that it could be bested; his is a know-

283

ledgeable and not an especially muscular art. Motherwell's mural-size canvases are careful and considered works, delicately steering clear of risks that might undiplomatically reveal excesses of reserve force. In his large rambling paintings the weight of size sometimes evaporates in lyricism; shapes mediate between the clear, hard edges of contained forms and a painterly, soft line. Though gravely occasioned and somber, his paintings do not appear threatened. They are wrought with an elegant and precisely delimited vocabularly. Motherwell's evolution as a painter brought many influences and effects perceptibly into play, though his is not essentially an eclectic position.

Gorky had used black to cover extensive areas of his pictures, and it had been used as a color by Pollock mainly for linear ends. In 1943 Motherwell, like Gorky, introduced black into his works for its non-linear effect as shape, and though Gorky's last work favored black, Motherwell used it as an unprecedented expressive too.

Elevating his active interest in collage to the status of his painting, Motherwell incorporated torn papers directly into his painting. Cubism's tilted views and Mondrian's Neo-Plasticism had their combined geometric effects in his painting, but were not employed without an injected sense of nostalgia and rage. The *Little Spanish Prison* could be an aerial view of a grave in a field, or a slot in some restraining barrier, but in any case the sense of containment makes itself felt. This same tragedy and nostalgia born or restraint underlies the double portrait of the sombrero-clad and blood-spattered *Pancho Villa, Dead and Alive*. The stress of an oval set tangent to a straight line shows up in Motherwell's works of this period and marks the entrance of the principal motifs of his career, the one for which he is probably best known.

In 1948 while illustrating a book of Harold Rosenberg's poems, Motherwell hit on the motif of the 'elegies to the Spanish Republic,' a brooding, dark, and brutal image that neither distinctly hovers on the surface of the canvas nor implies any pictorial depth. These shapes, like bars, contain the viewer's vision in the space in which he stands outside the painting. The series of elegies which was to occupy him on and off for the next twenty years, in over one hundred versions, quickly grew to a mural-size whose looming black forms gave expression to Motherwell's revulsion at the events of the Spanish Civil War. Rage proved also to be a fertile wellspring for painting. Motherwell's distant approach to the forensic was basically an enraged exclamation. These glowering paintings both clearly expressive and

ROBERT MOTHERWELL, *Little Spanish Prison*, 1941.
New York, Collection of the Artist.

ROBERT MOTHERWELL, *Elegy to the Spanish Republic, 70*.
New York, Metropolitan Museum of Art, Anonymous Gift, 1965.

dedicatory are about as close as modern painting after Social Realism would come to social polemics before the advent of Pop.

Where Rothko's forms suggested a sublimity, Motherwell's forced reality back as a sickening possibility tempered only by compromise. The blackness of the paintings – and black is used here for its distinctly associative value, unlike its diagramatic and architectural utilization by Kline – is the principal access to these works. It is the wake-like immobility of forms unrefreshed by an annunciatory role and forced into presence by exhaustion of alternatives, as a corpse, that ranges the shapes out across the canvas. Here Motherwell's refined brushwork invests angry listlessness in shapes robbed of all energy and potential for change. The perfected-object proposition of serial painting reflected in the repeated forms, signals his paintings' abandonment to keening and despair. While these paintings are certainly monuments they are erected out of a sense of hopelessness and emotional fatigue rather than any rising expectation or common exultation. They show that hate, even when smoldering and impotent, is a vital source of art.

Black as an expressive color was used by Motherwell throughout his work. Its appearance in any quantity signals the artist's dedicatory and occasional intentions, sometimes for the broadest situations, as in the effusively titled *Africa*.

Less involved with the specifics of any human event, the other great monument-painter is Clyfford Still. Still came from the West, as did Pollock and Motherwell; he was born in North Dakota in 1904, and spent his childhood studying painting, art history and music. In 1924 he made the journey to New York to peruse the city's museums and galleries. His reaction was decisive and swift: he repudiated almost everything he saw, disappointed with its vacant and meaningless speculations.

. . . Having seen and studied deeply the works and acts of those men of art presented in museums and books as masters, I was brought to the conclusion that very few of them merited the admiration they received and those few most often achieved true worth after they had defied their means and mores. The galleries held almost exclusively a collection of works selected to reflect the quality of minds dedicated to aesthetic peurilities and cultural pretensions.[22]

After a single class at the Art Students' League, Still cut short his trip and returned to the West to finish his degree and to take up a career of teaching. Painting in rapid succession in those years through the major styles of the twentieth century,

ROBERT MOTHERWELL, *Africa*, 1965. Baltimore, Maryland, Baltimore Museum of Art, Gift of the Artist.

285

he arrived in the early 1940s at a stark, mysterious, and basically figurative art. His first one-man show in 1943 was a retrospective exhibition in California, and in February 1946, he had his first New York one-man show at the Art of This Century Gallery. In 1947 his mature style of work emerged, a totally non-figurative painting. The following year, as a prescience of his later pieces, he added almost totally black painting to his repertoire of techniques.

Still worked paint into a thick and crusty surface of interlocking, jaggedly contoured shapes. There is little sensation in his paintings of either foreground or background but rather a procession of enmeshed pieces or zones drifts across the field apparently at some distance from the viewer. Neither a horizontal or vertical horizon is present or implied in most of Still's paintings and there is no indication of the tilt of the field with regard to the viewer; often a logical supposition is that the spectator is suspended above the depicted terrain. These painted plates of surface do not dematerialize. They suggest masses rather than an ethereal world like Rothko's. The scale of Still's pictures is vastly geologic in comparison with Baziotes' biology.

In his dry and graceless pictures Still, more than any other Abstract Expressionist, repudiated the past and its sources. His is an anti-hedonistic art without easily conversant shapes, luscious paint, or pleasant colors. His palette is mostly earth tones: bleached yellow, masses of parched red and blues, at high intensities and low values. Just this catalogue of colors accurately suggests his anti-mechanistic bias and penchant for dreary planetscapes, the scene of a relentless, dour testing and probing of intentional strength. Still's ragged shapes and scabrous surfaces challenge and defy investigation by the viewer.

From 1950 onward, Still's pictures grew huge, their size more like walls than

Below CLYFFORD STILL, *Painting – 1951.* Detroit, Michigan. Detroit Institute of Arts. *Below, right* CLYFFORD STILL, *1950 – H, No. 1.* New York, Marlborough-Gerson Gallery.

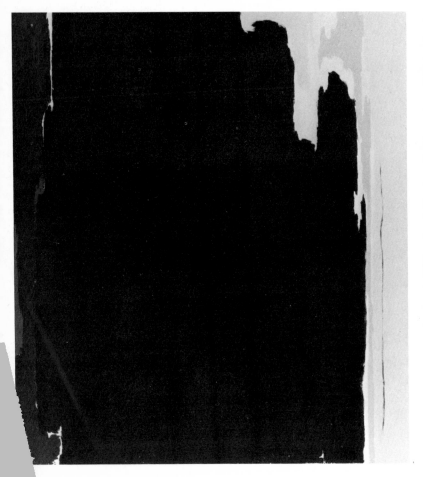

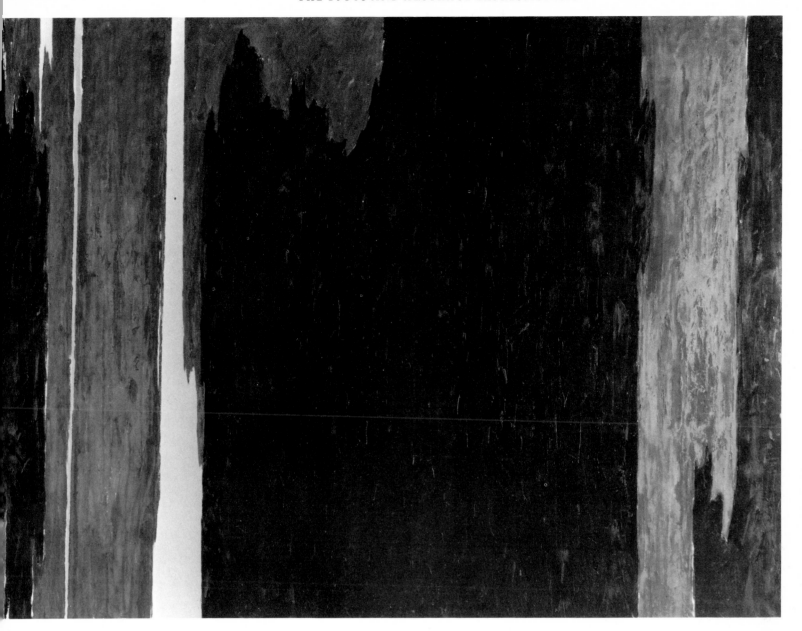

CLYFFORD STILL, *1954.*
Buffalo, New York, Albright-Knox Art Gallery,
Gift of Seymour H. Knox.

painted canvases. Some of his works are entirely covered with a crusty paint while in others, relatively few forms float in the center of almost untouched material reminiscent of Pollock's exposed canvas. Neither of these extremes of handling suggest a program of hierarchies by which the problems of painting can be categorized and attacked in sequence; they are rather two disparate approaches, occurring as the issues arose for the painter. No general dogma can or should be solicited from the penchants for various solutions that run through Still's fiercely individual painting: 'the elements of my paintings, ineluctably co-ordinated, confirmed for me that liberation of the spirit.'[23]

If anything can be drawn from Still's work beside the exaltation of expanses and the challenge of limitless space, it is a song in praise of individual freedom fully cogniscent of the lethal responsibility of decision. The right to failure and the specter of inhospitable vastness greets the viewer. The hardiness needed for survival and triumph are the implicit health and joy of these pictures.

In the face of a corrupted art and a devastated world, Still offered the alterna of a virgin but ruthless vision in stern opposition to a superficially social or private psychological view. In Still's typically turgid language, 'witless p

287

are displayed as evidence of social artistic commitment ... the impudence and sterility which so hypnotically fascinate the indifferent, perform a sordid substitute for responsibility. . . .'[24]

The elusive character of Americanness depends on the reactions of the dual forces of influence and native character. In Clyfford Still's art a conscientious effort to purge all the peculiarities of foreign invention, retaining only the inspiration of found quality, without its manners, has rendered up an art stripped of all but personal ideolect and native flavor. The totally appropriate scale of his mammoth paintings and the rude, crusty surfaces of meshed brute shapes bespeak inheritances of full promise.

No other painter has examplified simultaneously in each work and in the whole course of his career so many of the general attributes which make up the broad range of styles grouped under the term Abstract Expressionism as does Willem de Kooning. It is the look of his paintings and in particular the look of his paint which most clearly comes to mind when the term Abstract Expressionism is brought up. In part de Kooning's lengthy career, stretching through the major developments of the period, accounts for his being associated, rightly, with much of the activity in the art of New York starting in the late 1930s. De Kooning's was a circuitous route through this extended and tumultous era.

Born in Rotterdam in 1904, the artist received the most extensive formal training in art. For eight years he attended classes in academic drawing, painting, anatomy, perspective and color theory in the disciplined classical tradition. He came to New York in 1926 and liked the atmosphere. Having almost no command of English, he decided to stay on, earning his living doing house-painting, store-window decorations and murals. In the following year he came to know, through John Graham, Arshile Gorky, who was to become his friend and mentor until Gorky's death in 1948.

WILLEM DE KOONING, *Standing Man*, 1942. Hartford, Connecticut, Wadsworth Atheneum, Ella Gallup Sumner and Mary Catlin Sumner Collection.

More than any other of the Abstract Expressionists, de Kooning rooted his painting in the European traditions of subject and execution in an attempt to bring something new from the heritage. To de Kooning, the tradition was still vital. Like Gorky, he used images from the visible world as an armature from which his paintings depended, though his relationship to specific images is looser than were Gorky's rich autobiographical pictures. The whole of de Kooning's career, if it can be seen as a unit without oversimplification, describes, first, a widening breach from the originating figure to the image arriving on the canvas, and then a gradual reunification of the two. The image undergoes in his painting a successively more intense dismemberment as the body is disintegrated, almost distilled, into its elemental shapes and identifying gestures. The catalogue of these pictures is informed almost wholly from human shapes and the spatial bulk of the world infiltrates the surface arrangements of his shapes, suggesting a relief of shifting contours.

A free and improvisatory approach to painting marks de Kooning's work. In the 1940s his images and brushwork became more active as increased automatism, employed as a mechanism with no particular obligation to the Surrealists, typified his work. Experimenting with paints, de Kooning discovered his own mixtures of pigments and mediums which allowed him to work and rework his paint for days while the slow-drying compounds remained semi-liquid.

A master of rendering the closely observed figure, de Kooning nevertheless preferred to essay more general gestural possibilities and quick-drying paint hampered this investigation by forcing him to remain close to the first, naturalistic image that appeared. Unlike Gorky, now tragically his predecessor, de Kooning preferred to analyze his images, removing them from the specific conditions from which they sprang. Though clearly a gestural painter, like Pollock, de Kooning preferred to

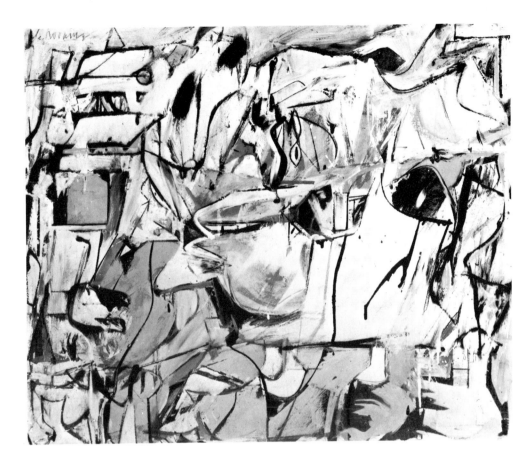

Left WILLEM DE KOONING, *Ashville*, 1949. Washington, D.C., Phillips Collection.
Below WILLEM DE KOONING, *Excavation*, 1950.
Chicago, Illinois, Art Institute of Chicago, Gift of Mr Edgar Kauffman Jr. and Mr and Mrs Noah Goldowsky.

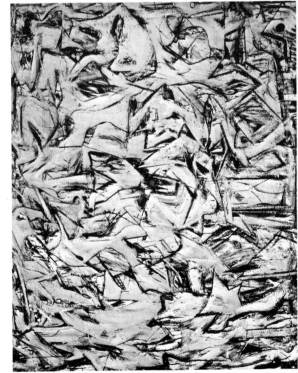

rework his paint, allowing selected passages to emerge rather than choosing his images context after the painting's completion. In this, and his choice of materials – brush and oil paint – he associated with the tradition of the worked, rather than the serial, canvas. His images rise from the depth of the painting rather than sequentially from the dialogue between painter and last picture. If his pictures look frenetically painted, the energy involved is a reasonable, less therapeutic outpouring than in even the quieter 'mythologizing' Abstract Expressionists. Clement Greenberg has admirably described the look of de Kooning's figures:

The supple line that does most of the work in de Kooning's pictures, whether these are representational or not, is never a completely abstract element but harks back to the contour, particularly that of the human form. Though it is a disembodied contour, seldom closing back upon itself to suggest a solid object, it continues in the great tradition of sculptural draughtsmanship that runs from Leonardo through Michelangelo, Raphael, Ingres and Picasso.[25]

While Gorky had always drawn the full figure and presented his figures as entire, unmoving, even frontally iconic units, de Kooning closed in on the specific elements of gestures and the particles composing the language of a unique pose and its expressive meaning, injecting and yielding more energy in his work. When this potential for energy came into do Kooning's painting, the weight of Gorky's static, frozen and frontal images had to be sacrificed.

Other gestural or action painters of the New York School often arrived, no matter what the process involved, at serene or at least unmoving images; not so with de Kooning. His painting explored the collision of shapes and implied in the strongest possible terms a motion beside that generating the shapes inside the picture. With this motion came an understanding of relative speeds, of speed itself, and of violence.

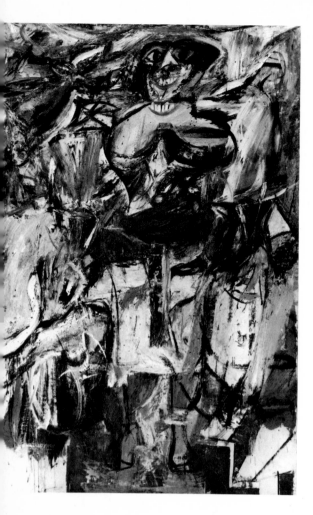

WILLEM DE KOONING, *Woman and Bicycle*, 1952–3.
New York, Collection of the Whitney Museum of American Art.

Rather than hinting or even declaring the possession of power or an unlimited threat, these paintings portrayed definite quantities of energy. In comparison Rothko's is a world of gigantic forces, but forces held in momentary suspension; Pollock's is a record of activity post; the world of Baziotes, while populated with veiled treachery, is mute; Gorky's is a frozen if terrible vision. De Kooning alone made paintings of genuine, grinding violence.

Between 1946 and 1948, the year of his first one-man show, de Kooning worked mainly in a style of black and white painting, which exposed only the edges and highlights of shapes. In the next year these shapes would begin to slide over one another forcing edges which had formerly been slightly wedged into the background to tile the buckle even more, indicating a higher level of activity across the whole picture and greater charges within each form.

Between 1950 and 1955, de Kooning's figurative elements which had been tending to disintegrate toward the common integer of the brushstroke, began regrouping around the central armature of the figure. Dispersed pictorial elements restored themselves, the brushstrokes reconstructing a figure. Lines which had come from observed contours, the planes of the body, the colors of flesh and dirt, reconstituted a figure in the palpable rendition of a form in space and, significantly for de Kooning, often in gestural motion. This series of works was titled *Women*.

Much has been made of the editorial caricature that appears in these figures, and the genuine furore of the scandal that greeted the works cannot be ignored. Not since the Fauves in Europe or the Armory Show in America, did the public and reviewers feel so assaulted by the vision presented to them. Speculation on the meaning of these works was, and indeed still is, rampant. The character of the man and the society that could produce these paintings was called into close question. Agreement was general on the repulsive, aggressive, vulgar and lurid quality of these ladies. Few cared to think that such a strong reaction spoke of the accuracy and potency of the stimulus which de Kooning had discovered. The paintings were especially reviled in Europe, which had received the Abstract Expressionists with, at best, distrust and usually with some ridicule. The force and implications of the young Americans' repudiation of European tradition was clearly felt on the Continent. De Kooning was the one American artist most closely associated with that tradition and still his *Women* were greeted with disgust and contempt.

Having reassembled his basic naturalistic armature painting in his *Women*, de Kooning continued to simplify his images in the late 1950s to early sixties. His paint began to regroup in larger and larger areas at the center of the canvas. Eventually the flurry of paint which had marked his earlier work subsided as a tight and clear architecture emerged. His work of the late 1950s epitomizes the clearest expression of gestural painting, excepting the work of one man – Franz Kline.

The emergence of Franz Kline and his untimely death bracket the central period of Abstract Expressionism. The death of Morris Louis three years after Kline proved to be the only event of equal magnitude in the decade.[26] Kline rocketed into eminence out of the deep obscurity of his career as a mildly successful Realist. His first one-man show in 1950 at the Egan Gallery in New York marks a line of very precise distinction between this artist's oblivion and deserved recognition. In that show he presented for the first time the clear black-and-white paintings which were to become his autographic style. Not only was Kline to appropriate black-and-white for himself but the effect of this choice, resulting from the expertise with which he handled his chosen colors, was to make black-and-white painting his own, though among the Americans, Pollock, de Kooning, Motherwell, Newman, and Gorky had preceded him in painting series of black pictures.

Born in Wilkes-Barre, Pennsylvania, in 1910, Franz (Joseph) Kline studied painting in Boston and London, coming to New York in 1938 where he exhibited in the 1939 Washington Square Outdoor Show. Between 1938 and 1950, Kline worked, when he could, as a scenic designer and as a designer for a department store. In the 117th Annual at the National Academy in 1943 and the following year, he was awarded $300 in prize money. In the years that followed, when money got really scarce, he did quick-sketch portraits in bars in lower New York.

In 1949, Kline limited himself to working in a loose, black and white technique on paper. Often he worked on the yellow pages of telephone directories, not being able to afford any other paper. This early work was mainly linear, the black appearing as a line on the field of the paper, but calligraphy as an end in itself was not Kline's central concern. His work grew in size and complexity through the 1950s and the black which had initially looked mainly linear began blossoming into shapes. Toward the end of his career the addition of a range of grays transformed these shapes into forms, and then into forces. In the last of Kline's paintings, the brilliantly cogent architecture of levered masses played off against beam and limb gives way to a slow, majestic unfolding of forces directly distinguishable from de Kooning's swiftly colliding shapes.

In Kline's canvases, which have outer dimensions smaller than the viewer's height, a sense of domination still inheres, hinting that the shapes are but depictions

Below FRANZ KLINE, *Composition*, 1952. Cambridge, Massachusetts, Fogg Art Museum, Harvard University, Gift of Mr G. David Thompson in memory of his son, G. David Thompson, Class of 1958.
Below, right FRANZ KLINE, *Accent Grave*, 1955. Cleveland, Ohio, Cleveland Museum of Art, Anonymous Donor.

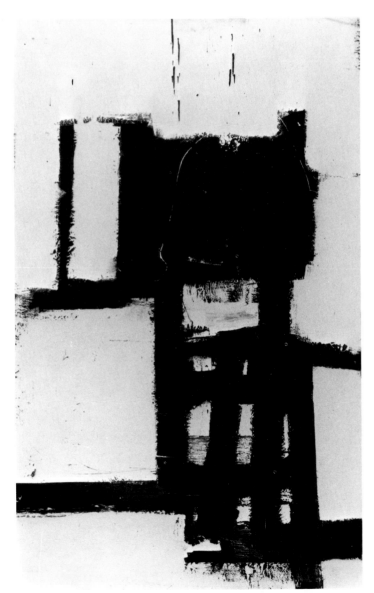

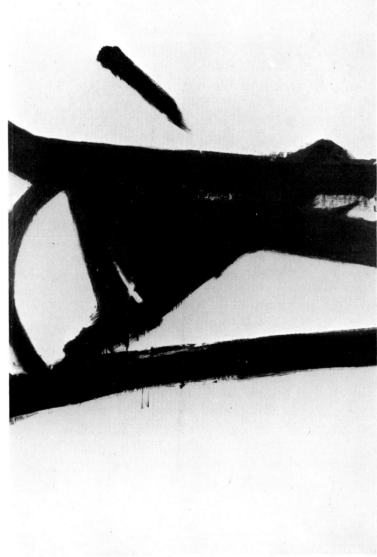

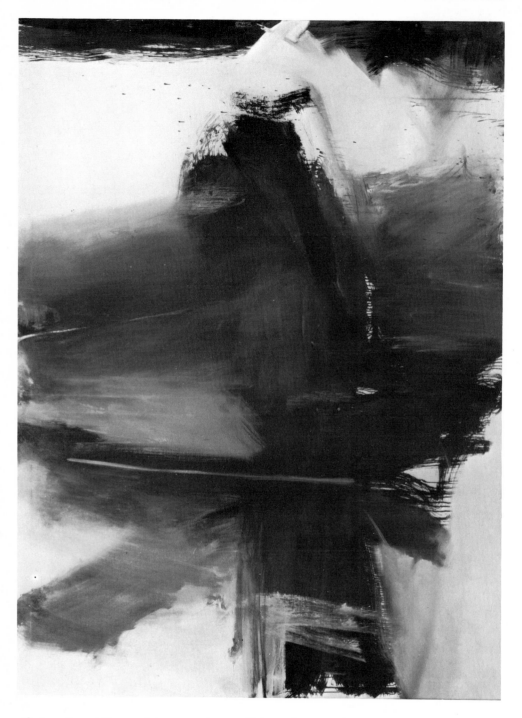

FRANZ KLINE, *Black, White and Gray*, 1959.
New York, Metropolitan Museum of Art,
George A. Hearn Fund, 1959.

of gigantic artifacts, objects or the rendition of tremendous events. Space in these canvases, not solely generated by the virtual extent of shapes, is given form by strong associational factors. Spaces between shapes, either black or white, may be read as emerging from the apparently empty limits of the canvas rectangle. The size of this rectangle was not determined by the requirements of rendering the image, but by the appropriateness of scale to a given gesture. As the image emerged, the considerations of painting and paint-quality fixed the character of the evolving force and its temperament. Testimony for the size of the picture is evidenced by the process of painting, is established seemingly by the image, though that image takes shape on pre-stretched canvas. Unlike Pollock, who cut his canvas to fit the requirements of an image, Kline's pictures sprung autoctonously from a predetermined size and shape, arriving at internal appropriateness to match external scale.

Opposite WILLEM DE KOONING, *Door to the River*, 1960.
New York, Collection of the Whitney Museum of American Art, Gift of the Friends of the Whitney Museum of American Art and purchase.

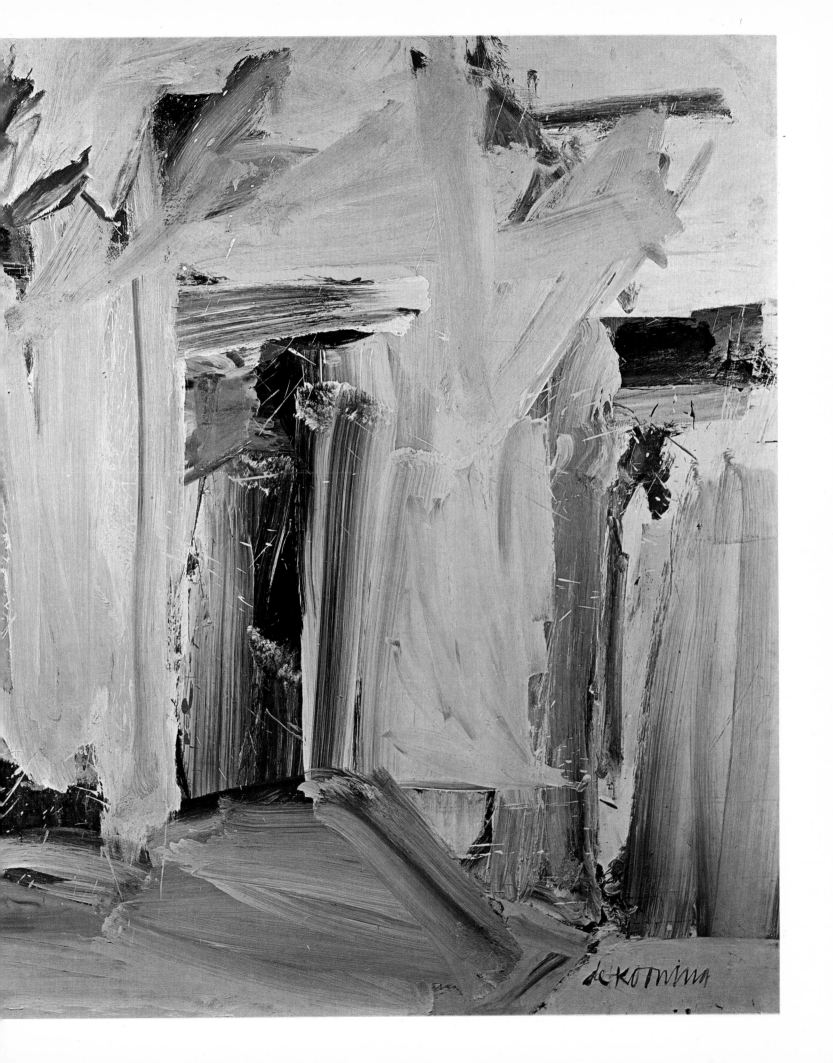

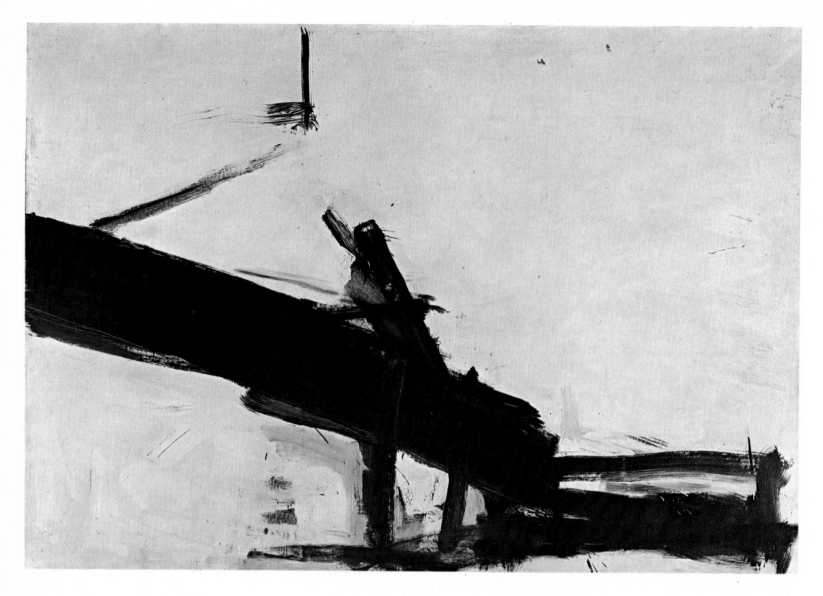

FRANZ KLINE, *Monitor*, 1956.
Milan, Giuseppe Panza di Biumo Collection.

While Kline started his pictures with some painting gesture in mind in order to set the limits for the canvas, the dialogue between painter and developing picture finally determined the appearance of the presented act. The look of either spontaneity or predetermination suggested in his work is contrary to the hard-won and slowly wrought images that constitute the body of Kline's painting. Underlying the impression of spontaneity is the fact of the immediacy of choice that went into shaping each of the works' stages.

I don't like to manipulate the paint in any way in which it doesn't normally happen. In other words, I wouldn't paint an area to make texture, you see? And I wouldn't decide to scumble an area to make it more interesting to meet another area which isn't interesting enough. I love the idea of the thing happening that way through the painting of it, the form of the black and white comes about in exactly that way plastically.[27]

Kline's choice of the size of the canvas is a choice of the appropriateness of an area to a gesture. This allowed proper expression to the brush's play: its detail and focus.

Though Kline is a gestural painter, it is problematic whether his careful technique qualifies him as an action painter. His pieces were worked out in many sessions, often several pictures being balanced and corrected at once. Nor for that matter

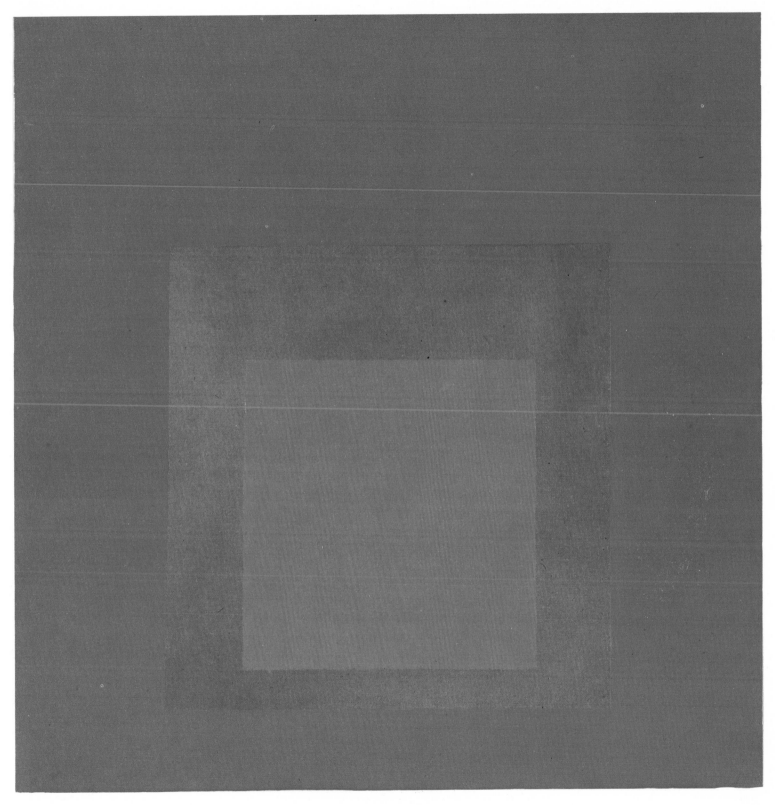

JOSEF ALBERS, *Homage to the Square*, 1962.
New Haven, Connecticut, Carrol Janis Collection.

should we fall into the easy trap of thinking of action painting as a deed accomplished without reflection. The images of his work may have been derived from landscape arrangements or a pictorial idea, but direct references are gone when the painting stands completed. Most often his images seem to rest at a distance inside the canvas, a safe distance from which to investigate Kline's tremendous explosions or huge structures.

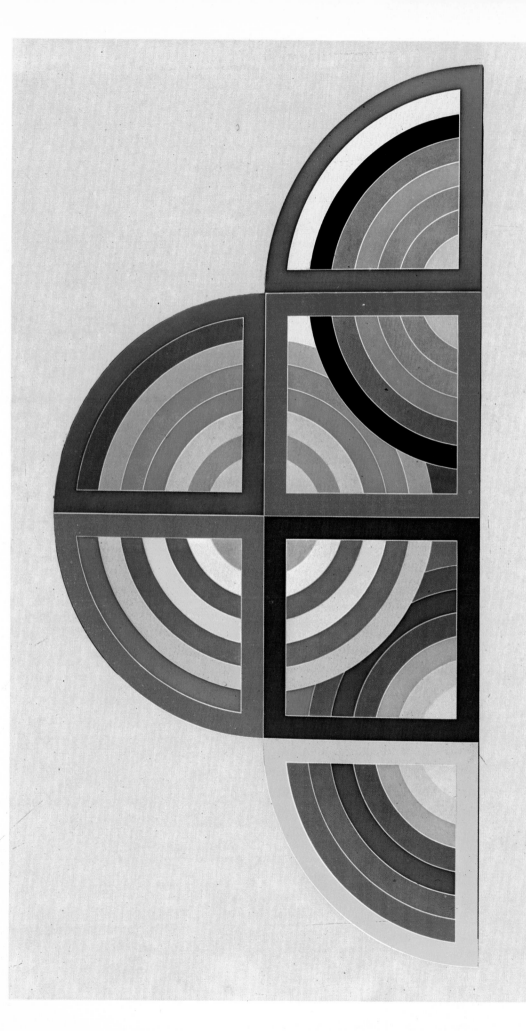

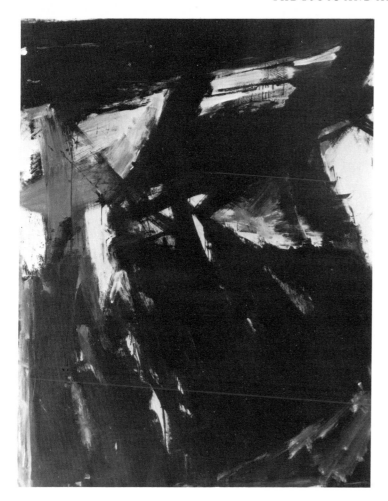 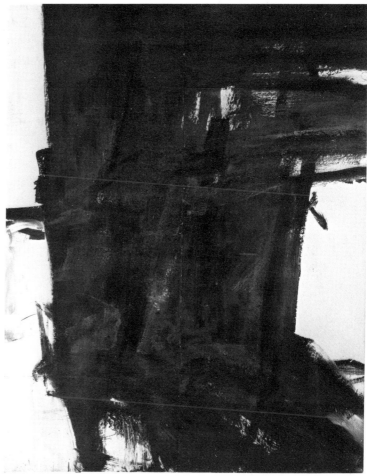

Above FRANZ KLINE, *Siegfried*, 1958.
Pittsburg, Pennsylvania, Museum of Art,
Carnegie Institute.
Above, right FRANZ KLINE, *Mahoning II*,
c. 1961.
New York, Marlborough-Gerson Gallery.

As the range of grays broadened in his work, shape which seemed to work close to the surface became form wrapped in space, truly monumental because of its fleeting tri-dimensionality, and distinguishing Kline from a calligrapher. In the late 1950s Kline introduced color in his work, at first just as tints of black or gray. Color allowed more complex sets of relationships to be worked out than could be done with values of a single hue. Gradually, these tints broadened into a brilliant range of searing, pure color.

While these late color works are sometimes of disputed quality, Kline's abilities as a colorist, purely on the basis of his black-and-whites is firmly established. Starting with the most limited of palettes, he made brillant choices, weighting shades along the fine divide between hot and cool blacks. This limited vocabulary yielded to him a universe that does not bespeak its severe limitations but seems to contain every possibility from patrician elegance to wild abandon. He allowed the eye to wander back into deep spaces or range across the canvas, feeling out the balance of his shapes and gauging their strengths for suggestions of compression and sheer, allusive of weights in vast industrial landscapes.

Kline repeatedly proved himself a master of color by abstaining from soliciting color's resources and resolving seemingly chromatic problems with limited means. Through his method of playing off the simple colors of black and white against each other, shapes came to occupy two or more successive positions and orientations in space, molding the volumes around them. Flat white forms are sometimes absorbed internally into large shapes; at other times, thrust outside shapes, white becomes open area. Consciously limiting his position, rather than deploying varied resources, Kline proved a master of color. His precise calculation of means never hints that the

Opposite FRANK STELLA, *Hatra II*, 1968.
St Louis, Missouri, Joe Helman Collection.

two hues he chose were in any way rendering a subdued version of compositions better realized in colors. If a great colorist is recognized by a judicious use of color, heightening our perception of color itself, Kline, paradoxically, must be ranked with the finest and most revered color masters. By limiting any gesture toward *coloring* he established himself as colorist. Franz Kline succumbed to heart disease in May 1962, at the early age of fifty-one, after only twelve years as a masterful painter with all his resources at the disposal of his mature style. But the internal space that he generated was a space fit for the grandest constructions, a massive space unlike the field composition of Pollock's canvases.

The great vitality Abstract Expressionism showed in the late 1940s attracted to it painters who had previously hovered outside the movement. Some of these individual and dramatic transformations were the result of a personal revelation, as was Kline's. Other drastic stylistic changes may have resulted from something like a conversion, but in any case these changes took place in the work of artists intellectually alert to, and emotionally responsive to, the attractions of the new proposition.

One such painter was Bradley Walker Tomlin who, like Gottlieb and Baziotes, had his art deeply flavored by Cubism. Unlike the other two painters, Tomlin utilized the grid, not to enclose hieroglyphic symbols of the antique, but to call up visions of three-dimensional antiquity itself. The idyllic and mythological was also his idea and between 1939 and 1947 his paintings reflected his desire to employ visions of that content in painting. He was, during that time, completely aware of the speculations that raged about his own, perhaps hesitant, inquiries. Between 1948 and 1949 he shared a studio with Robert Motherwell and this vigorous influence may have had a catalytic effect on his work. In the late 1940s, his palette was already dominated by cool blues, greens and black, which were eventually to become the mainstays of his tonal range. Slowly, as the grid disappeared into his work, its framework could more and more be identified with the blocky movement of the brush itself. Tomlin devolved the broad range of his content down to a limited and delicate gestural vocabulary of lines and dots.

Mark Tobey came to be identified in some minds with Abstract Expressionism, though his development took place mostly outside its geographic centers, and was unindebted intellectually to the movement. Having first established himself as a commercial artist, he studied in New York with Kenneth Hayes Miller. Between 1923 and 1924 he was introduced to what was to become the real molding force in his art – Chinese calligraphy. In the following years he traveled and studied throughout the world, specifically in Shanghai and Japan. From these esoteric studies came his 'white writing,' a light brushwork on a dark field, which permeated his work, from the most meticulously representational to the refinements of his open, sprawling, almost gauzy fields.

Most closely associated with the painters of the New York School, and himself a major influence while he moved in its circles is Philip Guston. In the years from about 1940 and 1951, Guston slowly, but without relapse, purged the images of magic realism from his painting. If his early realistic work was haunting, full of unresolved visions, and indistinct moods, his gestural paintings would show the same degree of mortal wonder. One usually and spontaneously thinks of huge glowering forms when the action painters come to mind: Kline and Pollock, Rothko, the later de Kooning, and even Barnett Newman.[28] Guston's painting was full of hesitation and revision. Tentativeness only heightens the shimmering loveliness of his canvases, making them lyric to the full extent that they are anything but heroic. His short brushstrokes seem polite and courtly; their genuine humility added a dimension to the whole movement. Guston's colors were equally soft and often

Opposite top BRADLEY WALKER TOMLIN, *No. 11*, 1952–3.
New York, Metropolitan Museum of Art, Purchase, Arthur H. Hearn Fund, 1958.

Opposite bottom BRADLEY WALKER TOMLIN, *Burial*, 1943.
New York, Metropolitan Museum of Art, George A. Hearn Fund, 1943.

Opposite, bottom far right MARK TOBEY, *World Dust*, 1957.
New York, Metropolitan Museum of Art, Purchase, Arthur H. Hearn Fund, 1958.

merged like visions of an autumnal pond with a grayed-out high-value neutral tone at the edges of the canvas.

Between Pollock's opening of the painting field and his invigoration of action painting, inherent in American painting but previously only deeply latent, and the demise of Kline, American painting expressed enormous grandeur and realized sublime visions. Spaces unlike those hinted at by the previous history of European painting, a position fecund beyond reckoning, was the gift of this one generation to its successors. Clyfford Still's jagged, desolate picturescapes offer an invitation to struggle. Kline presents nothing to the viewer but subjugation, though often an ecstatic one and the triad of Baziotes, Gottlieb and Rothko represent a spectrum of increasing ethereality, acted out inside spaces that vary from the biologic to the gigantic. Time, a crucial component of Abstract Expressionism, varies from the instantaneous recognition of the wrought mark on the canvas to connotations of an unreckonable expanse.

Comprehending fully their American and continental predecessors, the Abstract Expressionists, as a group, sheared off from predictable routes of picture-making. They concerned themselves neither with a mechanistic or a grossly exhibitionist psychological approach. Instead they strove to root their art's legitimacy in the developing act of painting, rather than in an *a priori* sanction of pictorial organization. While it is true that Pollock and a few others typified the all-over field composition the idea of the field itself, a wider area in which to act, was the common foundation of the school. Charles Olson on this point:

PHILIP GUSTON, *If This Be Not I*, 1945. St Louis, Missouri, Collection, Washington University Gallery of Art.

PHILIP GUSTON, *The Room*, 1954–5.
Los Angeles, California, Los Angeles County
Museum of Art, Contemporary Art Council Fund.

(there is always a field,
for the strong there is always
an alternative)

But a field
is not a choice, is
as dangerous as a prayer, as death, as any
misleading, lady[29]

The responsibilities of the painter become manifold as his art jetisoned conventions of depiction for conventions of procedure. Painting became a clear paradigm of ethical conduct. Painting referred with less frequency to events outside of its own generative associations. In Olson's words again, 'for the problem is one of focus, of the field as well as the point of vision: you will solve your problem best without displacement.'[30]

Abstract Expressionism was not a style, or even a cluster of related styles, but an ethical position assumed before realizing the painting. Only by understanding that this attitude was present before any marks were initiated on the canvas by the painter can the disparate phenomena of the period be understood to have shared anything more than mere contemporaneity.

6

FROM THE 1960s TO THE PRESENT DAY

Dore Ashton

FROM THE 1960s TO THE PRESENT DAY

The mood of enthusiasm that prevailed during the rise of the Abstract Expressionists, particularly in the 1950s, was greatly altered during the next decade. The young successors of the 1960s found distasteful the emotional and philosophical rhetoric that had accompanied Abstract Expressionist successes. They tended rather toward a stance of irony, or matter-of-factness. The traditional revolt against the fathers was played out during the 1960s in varied ways, but in all cases represented a rejection of what were felt to be overly exalted claims for painting. To the claims of sacredness in the painting act, the artists of the 1960s responded, as Rauschenberg put it: painting is no more important than any other human endeavor. To the claims of emotional intensity and the lived act, they replied that a painting was an object or fact perceived, no more no less. To the claims of philosophic or psychological subject-matter in the Abstract Expressionist work, they replied with praise for commonplace and direct popular imagery. Whether they pursued pure art, in the wake of Ad Reinhardt and Barnett Newman, or figurative art in the wake of Robert Rauschenberg and Jasper Johns, or even more traditional figurative modes, the artists of the 1960s were determined to be cooly objective.

They also obeyed what appeared to be a modern imperative, cyclically invoked, to strip modern art to its essentials. Since the nineteenth century, as Paul Éluard once observed, painting had expressed the truth of art rather than that of reality. Cézanne, he said, had made painting independent of the object it represented, and above all, had exposed his means. 'Formerly, the painter hid his means,' Éluard said. 'The Golden Section in one of the occult means. Few people could have said why a painting was beautiful. Since Cézanne, painting has become clear, because the painter exposes his means.'

Once the means were exposed, modern painting hurtled into a sequence of reductions based very often on the isolation of one or another of the traditional means in painting. One by one color, line, point, plane were separated and studied exclusively. The reductive tendency, so often considered the distinctive trait of twentieth-century painting, worked inexorably, and more than once in the twentieth-century history, arrived at the final reduction to zero. Almost every decade has witnessed progressive astringency, and the decade of the 1960s was notable for it. It was not accidental that for the 'younger rejective artists, inertia has become esthetically desirable as dynamism once was,' as Lucy Lippard wrote in the mid-1960s.[1] They were rounding the cyclical curve of reduction which represented more than a mere revolt against the motional dynamics of the Abstract Expressionists.

A will to reduction is evident in the proliferation of 'movements' during the 1960s. Although in the light of time, these manifestations will probably not be seen as movements, but as aspects of a prevailing mood, they functioned effectively during the 1960s. Reduction is reflected even in the diction: the brief moment of interest in painting which depended on physiological responses of the eye was quickly reduced to Op Art. Painting which drew on the resources of public imagery found itself called Pop Art. And painting of the more sober reductive abstract tradition was characterized as hard-edged, minimal, systemic, primary and ABC. In all of these designations, the desire to avoid speculative and philosophical divagations, such as had flourished in the 1950s, was apparent.

Suddenly, the mysterious pronouncements of Ad Reinhardt, who in 1960 established the five-foot square black canvas as his final decision, began to seem highly significant to his younger colleagues. If he said, 'The one, eternal, permanent revolution in Art is always a Negation of the use of Art for some purpose other than

its own,'[2] they understood him to mean that a painting had an objective existence, independent of either readable motif or interpretation. Reinhardt himself thought of his work during the 1960s as a 'clearly defined object, independent and separate from all other objects and circumstances . . . whose meaning is not detachable or translatable.'[3]

In reducing his own endeavor to the replication of black canvases measuring five feet square, in which a cruciform division resulted in nine interior squares, Reinhardt served as a powerful model. As stern as his formula was, though, the paintings were carefully prepared, and worked with brushes so that the variations in light values were considerable. When he exhibited these paintings first in 1960, they overwhelmed viewers who were obliged to stand quietly within their aura and wait until the lineaments of the surface revealed themselves. Although many younger painters admired primarily the self-discipline Reinhardt's renunciations represented, they could not fail to be moved by the mysterious cohesiveness of feeling from painting to painting, and to ask themselves the meaning of it, despite Reinhardt's disclaimer of meaning.

The new appetite for objective painting made it possible for another older figure to emerge again as a model. During the early 1960s, Josef Albers became prominent after years of eclipse during the Abstract Expressionist era. What Reinhardt achieved by eliminating color, Albers achieved by using color exclusively. His formula of the square within the square was aimed at the revelation of a single means of expression – that of color alone. Though, he said, the underlying symmetrical and quasi-concentric order of squares remains the same in all paintings – in

305

proposition and placement – these same squares group of single themselves, connect and separate in many different ways. Albers' aim was to make an unequivocal declaration of color autonomy. Given the mood of younger artists during the 1960s, it was not surprising that his teachings became once again significant.

BARNETT NEWMAN, *Who's Afraid of Red, Yellow, and Blue III*, 1966–7. Amsterdam, Stedelijk Museum.

The third artist whose attitudes assumed importance during the 1960s was Barnett Newman. Of all the Abstract Expressionists, only Newman appeared to offer a viable tradition out of which the new generation could work. An exhibition in 1959 introduced by Clement Greenberg proved to be a crucial event. As Thomas B. Hess writes, it was a revelation to many painters and critics. 'The general tendency in the late 1950s toward larger, more simple forms and toward a quieter, more objective surface suddenly was confirmed and in a sense defined in ten-year-old paintings. The flat, clean, objective look of the 1960s was established before the decade opened.'[4] Hess suggests that Newman's work offered a firm precedent to the younger painters since 'it opened doors which seemed to have been locked by Mondrian and the Constrictivists and painted over by Abstract Expressionism.'

Not all the doors beckoned to the new generation. In general they shunned Newman's metaphysical pronouncements about his work, and were unwilling to assume, as Newman always did, that there could be a philosophical content in any abstract work where an ethical conscience was engaged. They took his idea to be that expressed in one of his first important pictures, *Onement* of 1948, in which the picture surface was rendered as nearly as possible as a whole space articulated purely in terms of color. The vertical lines in many of his paintings were seen not as intrusions in the wholeness of the image, but rather as agents pointing to wholeness and flatness. Newman could say that his paintings were not about space at all, but about a certain 'sense of time' but his followers were intent on the spatial lessons inherent in these vastly simplified canvases.

The gathering forces of reduction found enthusiastic critics, one of whom applied the term 'hard-edge' to the new work, a term quickly adopted by Lawrence Alloway who defined it as: 'the new development which combined economy of form and neatness of surface with fullness of color.'[5] He qualified the term further by suggesting that in previous geometric art, forms were used as units of a composi-

306

tion, whereas in the new 'hard-edge' painting, 'the whole picture becomes the unit; forms extend the length of the painting or are restricted to two or three tones.'

This description fits the work of a number of the newest younger painters, one of whom, Frank Stella, made a sensational entrance into the art history of the 1960s. In the 1959–60 'Sixteen Americans' exhibition at the Museum of Modern Art, Stella, then aged 24, arrested the attention of many painters and critics with his severely uncompromising variations on charcoal-black canvases scored with slender white lines. He was introduced in the catalogue by a fellow young artist, Carl André, who maintained that 'Frank Stella has found it necessary to paint stripes. There is nothing else in his paintings. Frank Stella is not interested in expression or sensi- tivity. He is interested in the necessities of painting. . . . His stripes are the paths of brush on canvas.'[6]

The grim aesthetic expressed here, undoubtedly with Stella's acquiescence, sum- marized the skeptical attitudes of many painters of Stella's generation. In their insistence on the 'objectness' of painting, they hoped to evade the immediate past. They found many expositors for their position, among them the critic Michael Fried who, basing his conclusion largely on Stella's early work, elaborated a whole theory of 'deductive structure' from their rectilinearity. Fried's idea that Stella had revealed the importance of the literal character of the picture-support for the determination of pictorial structure fed into the aesthetic of many of the painters who were considered minimalists during the early 1960s.

Stella, however, illustrated Fried's thesis only for a time. Until around 1965, he worked in series which he planned beforehand, usually with the intention of minimizing the role of color. There were aluminum canvases in 1960; copper in 1961, and magenta metallic works in 1963. He began to experiment with different canvas formats – as did a few others – in which he would leave out the corner, or break his rectangle with notches, or work with a squared U-shape, or a modified X-shape. These were stretched on thick carriers which stood well out from the wall, giving the notion of the 'shaped canvas' the quality of 'objectness' which Stella had long advocated.

Toward 1965 Stella extended his scepticism to his own previous works and re- nounced both the rectilinear patterning and his dependence on monochrome. He built eccentric stretchers based on interrupted triangles, intersected cirlces and rhomboids, within which he played complicated games with color and illusionistic overlap. 'Deductive structure' was much harder to rationalize in these baroque extensions of Stella's position. Rather, the canvases, which grew more and more colorful and aggressive toward the late 1960s, reflected Stella's unwillingness to reverse his decision to regard a painting as an inexpressive object which is organized in self-referring terms. The apparent disjunctions in both form and color in the work of the late 1960s reflected, as well, the general attitude of rejection, since nearly everything previously associated with painting is challenged, above all, composition. The 1960s, as Stephen S. Prokopoff observed, were characterized by 'an awareness that nothing exists in isolation and that connections obtain regardless of how tenuous they may initially appear.'[7] Such faith in a simplified notion of systems and interrelationships underlay many of the minimalist experiments, and also, many other attempts to divest painting of all its previous associations.

So marked was this faith in interconnections, no matter how tenuous, that Lawrence Alloway was able to summarize the impulse in an exhibition at the Guggenheim Museum in 1966 which he called 'Systemic Painting.' The paintings he included were characterized mainly by the fact that 'the end-state of the painting is known prior to completion.' Alloway further qualified his inclusions by suggesting that the conceptual order displayed by these artists was just as personal as the autographic

tracks produced by the previous generation of Abstract Expressionists, and that their repeated configurations led toward system, or 'an organized whole the parts of which demonstrate some regularites.' Since many of the artists he included tended to repeat motifs in 'runs, groups or periods' Alloway was tempted to call their art One Image art, citing Kenneth Noland's repeated use of chevrons, Thomas Downing's grids and Reinhardt's crosses.

Alloway's apologia for the serialization of painting heartened many young artists who had felt an absence of sustaining tradition and theory. The recognition of the fact of the canvas, divested of previous associations, in which significance was not to be sought in specified ways, left them free to produce objects in which the conception of repetition was invested with a value. The artists included in the show tended to make catalogue statements of self-conscious factualism: Jo Baer: 'These paintings form part of a series of twelve. There are four colors in the series: blue green, purple, yellow.' Robert Mangold: 'Pieces follow in series in similar formal structures and similar color ranges.' Larry Zox: 'Once the proportions and outside scale of the painting are determined, the interior structure is established. Inverted V's or triangles repeat four times to become the structure upon which the final dimensions depend.'

Despite the strong 'object' bias of the period, several of the artists represented fit only obliquely into the systemic thesis. The older painter Agnes Martin, for instance, whose pale cream canvases were scored with penciled graphs, sought in delicate brushwork and reticent linear accents to convey a lyrical ambiguity that scarcely suits the cool factualism of the theory. Will Insley, who later went on to do frankly metaphysical drawings and sculptures, made use of geometric elements

AGNES MARTIN, *Drift of Summer*, 1965. New York, Robert Elkon Gallery.

in grid spaces, but only 'to protect visual force beyond the material thing.' Larry Poons' optically active ovoid shapes laid along the grid flirted with the ambiguities that had once inspired the Expressionists, and indeed, his work of the late 1960s went toward a full, tactile Expressionism. Jack Youngerman whose free, flowing forms had always referred back to the lyricism of Matisse fits the theory only insofar as he worked with clean colors and hard edges, while Al Held, who always relished a painterly surface, could only relate in his simplification of roughly geometric forms. The one artist who wholly satisfied the theory was Ellsworth Kelly, who, toward the mid-1960s, began to make series of monochrome canvases in color sequences that were meant to be read as nearly as possible as a whole. Kelly's absolute symmetry, and his total rejection of form in favor of color, satisfied the definition of systemic art. For the next two or three years, scores of young artists were to endeavor to reduce their surface to single colors, sometimes even reduce still further to single tones. Brice Marden, for instance, dimmed his colors and brought their intensity so low that the eye would have strained to capture the nuance. In the densely opaque, smooth surface, Marden concealed an inner source of very restrained light, and rejected the velleities of light in the environment.

Critical theory took on new dimensions during the 1960s. In the previous postwar years, there was avid discussion, but rarely did a critic attempt to systematize his views. The openness and liberties associated with Abstract Expressionism did not encourage a strictly structured aesthetic. All the same, one of the major critics of that period moved steadily toward closure, and became a powerful voice in the 1960s. Clement Greenberg, who had long questioned the premises of such painters as de Kooning and Pollock, eventually rejected their position in favor of that of Barnett Newman. In very strong language, indicating his basic dislike for the amorphorous character of Expressionism, Greenberg reordered his priorities in the October 1962 issue of *Art International*. With characteristic aplomb, he called the

article 'After Abstract Expressionism', thereby diminishing his previous association with it, and proceeded to lay down the new lines for painting: 'By now it has been established, it would seem, that the irreducible essence of pictorial art consists in but two constitutive conventions or norms: flatness, and the delimitation of flatness; and that the observance of merely these two norms is enough to create an object which can be experienced as a picture . . .' The importance of modern painting had become, to Greenberg, the expression of something he referred to as 'color-space' – a notion he had explored earlier in relation to Newman who, he said in the late 1950s, painted 'fields.'

The punctillio with which Greenberg dismissed the Expressionist aspect of Abstract Expressionism delighted the young artists who were enacting their rites of passage. But in practise, Greenberg stretched his point. Two years later he staged an exhibition called 'Post Painterly Abstraction' in which he expanded his definitions. Using Wölfflin's terminology – the doublet of painterly and linear – Greenberg declared again that painterly abstraction would be replaced by something 'as genuinely new and independent as Painterly Abstraction itself was ten or twenty years ago.'[8] That 'something' would have a physical openness of design and linear clarity 'more conducive to freshness in abstract painting at this particular moment than most other instrumental qualities are – just as twenty years ago density and compactness were.' He still insisted that the relatively geometric regularity of drawing in most of the artists he chose was because the 'trued and faired edge' calls less attention to itself as drawing, and thus 'gets out of the way color.' The real intention – to establish color field painting as the sole legitimate direction – reads through Greenberg's essay even though his choice of artists, among them John Ferren, Helen Frankenthaler and Sam Francis, seems to belie his thesis.

The artist of whom Greenberg wrote most attentively during the late 1950s and early 1960s was Morris Louis. Greenberg's theory was possibly influenced by Louis' rapid movement from Pollock-like abstractions, painted rather densely, to the thinly stained works of the mid-1950s, in which spatial illusion depended on layer upon layer of extremely thin paint, read like transparent veils. Toward the late 1950s, Louis' paintings took on a somber, formal quality of true originality. Huge monolithic bunches of muted colors – greenish rust, acid oranges, purples – filled the surfaces of his canvases and seemed to move upward in slow cadences. Register marks of each layer of color at the extreme edges of his forms made Louis' paintings luminously readable. Early in 1960, Louis swerved away from somber color and took up saturated, high-keyed colors which at first he used in dense bunches causing them to be referred to as 'florals.' These seemed to demand opening out, and early in 1961, Louis began a remarkable series of paintings, first of vertical columns of saturated stripes in which the canvas was impregnated with high color, and later, of what were called 'unfurls.' In certain of these, Louis left an extremely wide central void which was defined by streamers of color spilling inward from the extreme edge. The powerful effect of attrition gained by the irregular pressure from the side was unique to Louis, although other painters, notably Sam Francis, were experimenting with the central void during the same period, and could be related very reasonably to the prior experiments of Rothko and Still.

Louis' final paintings, before his death in 1962, were sometimes composed of just a few vivid stripes of color hanging from the top edge of his canvas. This purified rendition of color attracted the interest of many young painters. The critic Brian O'Doherty suggested that Louis' method of conjugating his color bands could be called a sort of color grammar – a goal that had long been pursued. When Louis was given a memorial exhibition at the Guggenheim Museum in 1963, Daniel Robbins wrote enthusiastically about the artist's originality, and stressed Louis' indifference to the format of his paintings. To him, Robbins wrote, it did not matter where the

BRICE MARDEN, *Point*, 1969.
New York, Bykert Gallery.

Far left HELEN FRANKENTHALER, *Blue Atmosphere*, 1963.
Dayton, Ohio, Mr Jesse Philips Collection.
Opposite MORRIS LOUIS, *Alpha Pi*.
New York, Metropolitan Museum of Art, Arthur H. Hearn Fund, 1967.

311

painting began or ended. His attitude was 'anti-compositional.' Here again, Louis' stance proved important, for in subsequent years the challenge to composition was taken up again and again, and many younger artists declared themselves in favor of something they like to call 'non-hierarchical' composition.

Louis' friend Kenneth Noland was also widely remarked for his 'direct and candid means of presenting color,'[9] as Barbara Rose put it, and his progress from concentric ring paintings in the late 1950s, to stripes in the early 1960s was praised by a number of critics following Greenberg's dicta. The other younger artist most frequently signalled by Greenberg, Jules Olitsky, followed a similar quick course in reduction, moving in the late 1950s into stained, asymmetrical images on large fields, and from there, in the mid-1960s, to large fields defined at the extreme edges by minor forms, and from there to stained and sprayed fields almost entirely free of individual forms and divisions.

The coolness and scepticism evident in the abstract painting of the early to mid-1960s was burlesqued by those artists who pressed forward with popular imagery with remarkable success. The phenomenon of Pop Art burst upon the American art scene early in the 1960s with a number of practitioners, all of whom abjured any pretensions to social criticism, and many of whom played the public role of the *eiron* – he who pretends he knows not. By coming forward with bald statements concerning the furniture of American life – such things as elaborate plumbing, Coca-Cola, and comic strips – these artists on the whole pretended that they were doing nothing more than making objects, or rather, paintings as objects. They shared with the minimal abstract painters a will to ignore the Abstract Expressionist tradition of philosophical speculation. While their public statements were redolent with irony, their works tended more toward the parodic or the burlesque. The subtleties of irony were too much reminiscent of the ambiguities at the heart of the Abstract Expressionist aesthetic.

Just as the minimal painters had found progenitors in Newman and Reinhardt, while not accepting their attitudes completely, so the Pop Art painters found a progenitor of the older generation, Richard Lindner. His sudden access to fame was coincident with the Pop movement and aided by the intense interest in his work exhibited by his younger colleagues. It had become increasingly clear that the so-called Pop movement could not be defined merely on the basis of the motifs selected and emphasized by the Pop artists. As Robert Rosenblum pointed out, 'If Pop Art is to mean anything at all, it must have something to do not only with *what* is painted, but also with the *way* it is painted; otherwise, Manet's ale bottles, Van Gogh's flags and Balla's automobiles would qualify as Pop Art.'[10] He continues with a satisfactory description of Pop Art's characteristics: 'The authentic Pop artist offers a coincidence of style and subject, that is, he represents mass-produced images and objects by using a style which is also based upon the visual vocabulary of mass production.'

In Richard Lindner the new generation found a curious precedent. Lindner, when he first arrived in the United States in 1941, had earned his living as a magazine illustrator. He was thoroughly conversant with the styles and techniques demanded by the slick magazines. Moreover, he had come from a rebellious tradition which offered a parallel with the American situation. His youth had been dominated by the German Expressionist idioms which he rejected at an early age. The reaction, the *Neue Sachlichkeit*, or New Objectivity, had been closer to his temperament, and he had for years painted with rather sharp, flat colors. His subjects, it is true, were nearly always drawn from the traditional Expressionist literature – the mythical siren, the housemaid, the maladroit lover and the sinister visitor. But gradually, as he worked in New York, his figures changed, or at least their outer guises changed. As one of his younger admirers, Robert Indiana, noticed: 'Now, given the buxom,

RICHARD LINDNER, *The Actor*, 1963. London, Fisher Gallery.

312

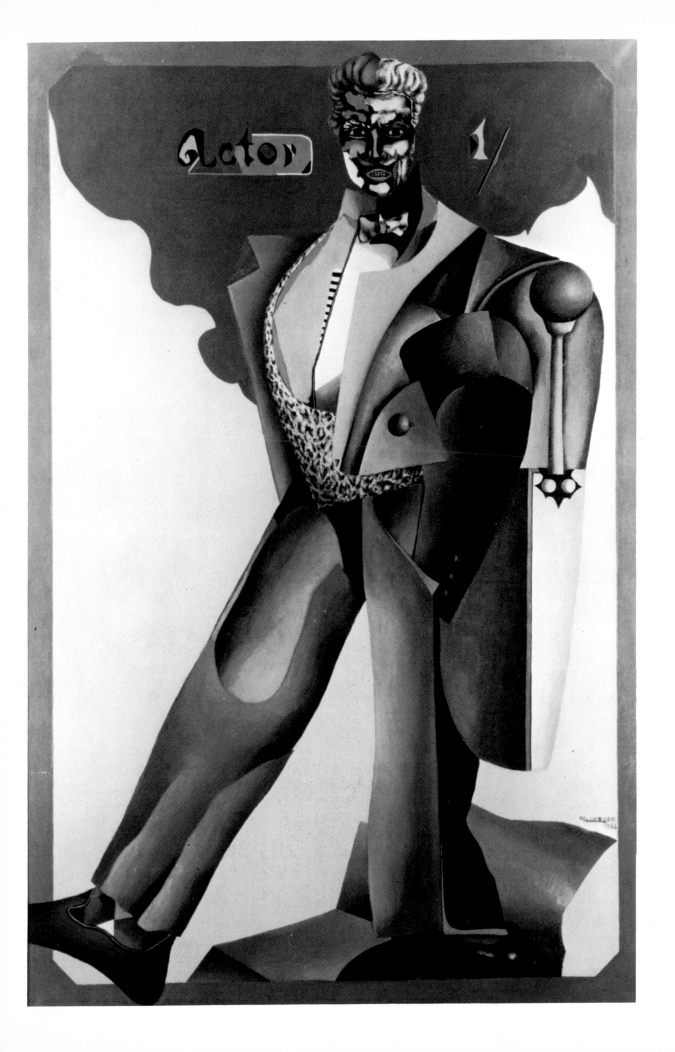

brazen B-girls of his '60s work, I think he has moved from a European to an American feeling. I know his inspiration is from Broadway and 42nd, not Soho, the Champs-Elysées, nor the Via Veneto.'[11]

Indiana's observation was based on the paintings of New York in which Lindner's drawing became much sharper; his figures were dressed in contemporary modes (though the women still had their corsets and garters underneath) and his colors heightened to match the new intensity of synthetic colors used in commercial printing and signs. Not only did Lindner meet the criterion of a 'coincidence of style and subject,' but he also delved into the sources which interested the younger artists so much. Many of his images of the mid-1960s seemed beholden to girlie magazines, comic strips, and toymakers' catalogues. He offered them up in a coldly precise manner, exhibiting a great detachment, completely in keeping with the ideals of the younger artists whose dearest hope was to evade the emotional clichés they felt endemic to Expressionism.

Indiana, whose flatly painted groups of signs and emblems were greatly admired in the 1960s, could easily relate to Lindner's adaptation of typography and emblems in his paintings. His notion of objectivity was clearly stated in an interview with Gene Swenson in 1963: 'Pure Pop culls its techniques from all the present-day

ROBERT INDIANA, *USA 666*.
New York, Collection of the Artist (Photo Eric Pollitzer).

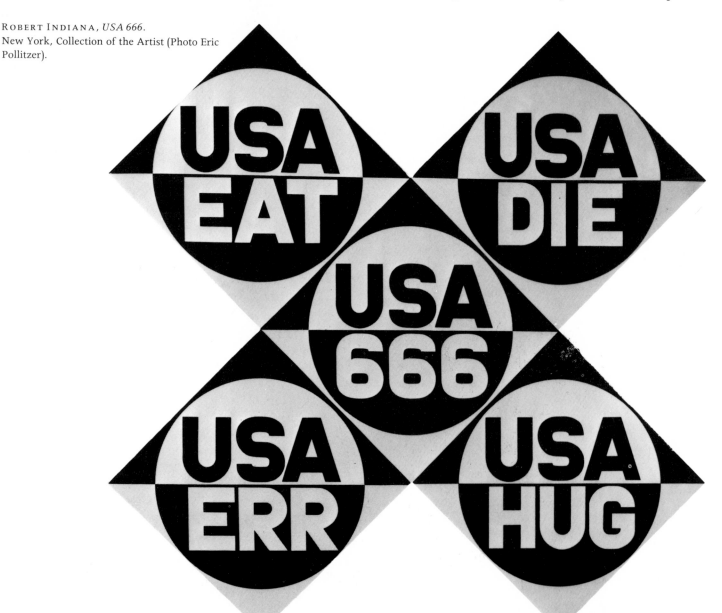

communications processes: it is Wesselman's TV set and food ad, Warhol's news-paper and silk-screen, Lichtenstein's comics and Ben Day, it is my road sign. It is straight-to-the-point, severely blunt, with as little "artistic" transformation and delectation as possible. The self-conscious brushstroke and even more self-conscious drip are not central to its generation.'12

All the same, the initial impetus for the Pop Art movement clearly derived from the wide success of two young artists who had been well schooled in Abstract Expressionist attitudes. Both Robert Rauschenberg and Jasper Johns, who had won wide admiration in the late 1950s, were cordial to Abstract Expressionist tech-niques and theories when they commenced painting. Rauschenberg, in his earliest paintings, had made extensive use of the equivocal interplay between the defined and the barely defined form. When he began to insert allusions to the absurd, such as a stuffed bird perched atop an Expressionist painting, or a set of Coke bottles inserted in the composition, he still clung to the manners of the Abstract Expres-sionist painter. His attitudes, however, clearly indicated a rebellion. He may have begun with an old Expressionist tenet, as he does in his Museum of Modern Art statement for the 'Sixteen Americans' show: 'Any incentive to paint is as good as any other. There is no poor subject,' but he goes on with a statement characteristic of the 1960s: 'Painting is always strongest when in spite of composition, color, etc. it appears as a fact, or an inevitability, as opposed to a souvenir or an arrangement.'13 His determination to regard painting as a fact rather than an 'arrangement' endeared him to his slightly younger colleagues who had eschewed composition as an aesthetic value. When he went on to say that painting relates to both art and life, and that he tried to act in the gap between the two, he opened the way to many disaffected young artists who were only too willing to let 'life' dictate their aesthetic choices, and by 'life' they most often meant the common visions of American life in its vulgar context.

Rauschenberg's friend Jasper Johns, had enjoyed a rapid rise in New York art circles during the late 1950s, based largely on his provocative renditions of the American flag. Johns' versions of the flag, often rendered in meticulous encaustic techniques imitating the impastoed surfaces of the Abstract Expressionists, challenged his viewers who could not understand his choice of banal motif. His explanation, in the same 'Sixteen Americans' catalogue, was not easy to decipher either, since he insisted that he was opposed to painting which is concerned with conceptions of simplicity. Why then, the critics asked, does he do flags, or suites of numbers, or targets, which all seem so simple? The question alone seemed to gather significance in the early 1960s. 'Once it was realized that the question "Is it a flag or is it a painting?" had no answer – was not important – the way was wide open to Pop Art,' writes Lucy Lippard who, in her essay on New York Pop recognized only five 'hard-core' Pop artists: Andy Warhol, Roy Lichtenstein, Tom Wesselman, James Rosenquist and Claes Oldenburg.14

The de-emphasis of the traditional painting, with all its implications of serious-ness and profundity, went rapidly in the Pop era. Its most devastating advocate was Andy Warhol, whose early career as a commercial artist had prepared him to use new mass-media techniques in his campaign against high art. Warhol's flamboyant personality equipped him with possibilities to reach a broad public that few artists could match. When he stated that the reason he adapted the repeated silk-screen image in his paintings was because he wanted to be a machine, the news was reported in the popular press, even in the gossip columns. When he set Marilyn Monroe or Jacqueline Kennedy in identical silk-screen series on canvas, he made his way into the homes of many who had never thought about painting at all. His most famous sally was the rendition of the Campbell Soup Can, exactly as it was. This demythicizing of painting was clear to everyone, and met with hilarity and appre-

ciation. Collectors who had long since grown bored with their Abstract Expressionist acquisitions hastened to acquire these emblems of negation. As late as 1970, Warhol's 1962 *Campbell's Soup Can with Peeling Label* brought $60,000 in an auction at Parke-Bernet Galleries in New York.[15]

Warhol did not linger very long in the purlieus of painting – just long enough to insert a sardonic commentary – but there were others who confined themselves to the two-dimensional canvas in their campaign to change the character of American painting. Probably the most celebrated was Roy Lichtenstein who, around 1960, began to be noticed for his paintings based on such popular comic stripes as *Dick Tracy*. By 1962 Lichtenstein had modified his approach, bringing it into line with the new technocratic ideals: he projected images from the comics onto his canvas in large segments which he filled in by means of stencils with the Ben Day dots typical of newspaper reproductions. In this he often used helpers, one more gesture of defiance against the autographic myths of Abstract Expressionism. (The abstract painters of the 1960s in the minimal group also made use of assistants, broadcasting their heresies loudly with evident satisfaction.) Lichtenstein's dry humor, and his obvious talent for design made it possible for him to hold the attention of several critics. His sorties into historicism, which he spoofed in take-offs on Art Nouveau, or Léger, won their approval, as did his manufacture of various household objects screened with his images.

Where Lichtenstein drew upon the newspaper for his stylistic approach, Tom Wesselman and James Rosenquist looked to the billboards, Wesselman tended towards greatly enlarged details, painted crudely, and frequently reflecting the salacious undercurrent in American advertising. He claimed that the billboard picture excited his imagination in the way others were excited by other kinds of images. He also incorporated real objects in some of his paintings in order to stress his scorn for the sanctity of the old oil painting, and to reinforce his point about the subjects suitable for an American artist.

Rosenquist, who had the distinction of having been a professional billboard painter, never used three-dimensional objects, but often rendered them on canvas in the manner of the billboard painter. His works of the early 1960s reflected an interest in the closeup, as once Léger had spoken of it, as an arresting method of transforming the most commonplace motif. Despite the ordinary objects in Rosenquist's paintings – the stuffed armchairs of lower middle-class living rooms; automobile interiors, typewriter keys and womens shoes or men's socks – they almost always suggested an aspiration toward something more than the mere representation of the objects encountered in daily life in America. His ambition became obvious when, in 1965, he exhibited *F-111*, a huge mural consisting of inter-related segments carefully designed to refer back to the overwhelming fact of the F-111, a controversial war plane. Rosenquist's allusions to the plane, to an atomic mushroom, to masses of enlarged spaghetti and to a child under a hairdryer, could easily be interpreted as allusions to the vices of American life. At the same time, his handling of enormous spaces, composing passage to passage coherently, indicated a willingness to take composition and illusion quite seriously, despite their un-popularity with so many other painters. The way Rosenquist dealt with contem-porary allusions was related more nearly to Rauschenberg's method of montage than to the general run of Pop artists' approach. So impressive was Rosenquist's mural that the Metropolitan Museum, some months later, made the unprecedented gesture of showing it prominently and speaking of it with utmost respect.

While Pop Art brought figurative painting back into the good graces of the art world in a 'straight-to-the-point' mode, there were signs in the 1960s that hetero-geneity would be tolerated, and that figurative painters of various persuasions would

find at least modest acceptance. In 1959, the Museum of Modern Art had staged an international exhibition called 'New Images of Man.' The choice of images was largely accented by the basically Existentialist attitude of the curator Peter Selz. He was interested in artists who dealt with 'the human predicament' and painted 'the disquiet man.' The younger Americans – Richard Diebenkorn and Nathan Oliveira for instance – had come out of the Abstract Expressionist epoch and clung to the loose brushwork and spatial ambiguity characteristic of the Expressionists. Both of these artists were working on the West Coast, and had resisted the currents of objectivity wafting westward from New York. (The so-called California School which included, beside Diebenkorn, Elmer Bischoff, and David Park, withstood the changes in taste successfully for many years.) In their emphasis on the lonely, isolated, and often shadowed figure, all of these artists seemed intent on prolonging the speculative, Existentialist assumptions that had been so salient in the 1950s.

This was particularly marked in the case of Richard Diebenkorn who had first attracted attention in the mid-1950s with exuberant abstractions in which a hint of Western landscape was always evident. When he shifted into a figurative idiom, he continued to work with large, loosely brushed areas, ambiguous edges, and the little erasures and revisions associated with the style of de Kooning. But his real reference seemed to be to Matisse, whose curious elisions of inner and outer space seemed to haunt Diebenkorn. He translated these preceptions into large, often bleak images of one or two isolated figures, whose features were always in shadow, and whose stance indicated loneliness, withdrawal. In the early 1960s, Diebenkorn re-newed his interest in landscape, this time painting California vistas – great sprawling views of stucco cottages and palm trees descending toward the sea. They were rendered with dry realism, but were haunted still by the earlier vision of flowing spaces. When finally, toward the mid-1960s, Diebenkorn came full circle, and returned to abstract motifs, he had enriched his vocabulary and carried into his new paintings the echoes of the sensibilities he had called into play in the figurative works. His ruminations on the character of lived spaces were now enlarged to include ruminations on the character of generalized spaces.

Others never returned to the abstract idioms. Lester Johnson, for instance, who had begun his exhibiting career in the mid-1950s with an exhibition of abstract paintings, soon became absorbed with the problem of presenting the human figure in a language reflecting the period. Retaining the thickly worked impastos of Abstract Expressionism, Johnson developed a hieratic vision of grouped figures, often nearly identical. Most often they were males, suggestive of the dispossessed that haunted the streets near Johnson's downtown New York studio, and most often they stared frontally from the canvas. Johnson brought these lineups of figures close to the picture plane and used glaring gray backgrounds to give an impression of a cold, impersonal place. The looming, nameless figures in his paintings had an intense effect of fixation, and were far removed from conventional approaches to figurative painting.

There were others, however, who emerged in the late 1960s, who did not shrink from convention. The only painter of any prominence who had made use of the human figure during the 1950s had been Willem de Kooning. His conventions were adapted by many young artists during the 1950s, but proved to be so much saturated with de Kooning's personality that they could not be easily transformed by others. The painter Louis Finkelstein, in an article on Charles Cajori, one of the few younger artists who had concentrated on drawing and painting from the model, stated the dilemmas of the young artists: 'For the generation of painters who had grown up during the flowering of Abstract Expressionism, several strategies have been available. These include: tagging along, working within the license or liberties it has created (depending on how you look at it), rejecting it via "return to the figure",

RICHARD DIEBENKORN, *Ocean Park*.
New York, Marlborough-Gerson Gallery.

317

Hard Edge, Neo-Dada and Pop Art, or revaluing it.'[16] The process of revaluing Abstract Expressionism was to be deferred until the late 1960s and early 1970s, and the 'return to the figure' was a strategy which attracted more and more artists.

The return, however, was not to the figure as conceived by the Expressionist, who sought to express states of the soul in its lineaments. The intense desire to be 'objective', reflected in most painting tendencies in the 1960s no matter how divergent in approach, dominated the figure painters. Probably the most effective proponent of the objective study of the human model was Philip Pearlstein. Emerging from the Abstract Expressionist tradition of the loaded brush, and turbid color, Pearlstein began, in 1962, to work directly from the model. The discipline of looking, gauging, placing, worked to clarify his palette and technique. In a very short time he developed the blanched tones and systems of thin shadows which still characterize his work. He was quickly celebrated as *chef d'école* of what came to be called The New Realism. This, too, was seen as a response to the excesses of Abstract Expressionism. Almost all the critics dealing favorably with Pearlstein's

PHILIP PEARLSTEIN, *Two Female Nudes with Red Drape*. 1970.
New York, Allan Friemkin Gallery (Photo Eric Pollitzer).

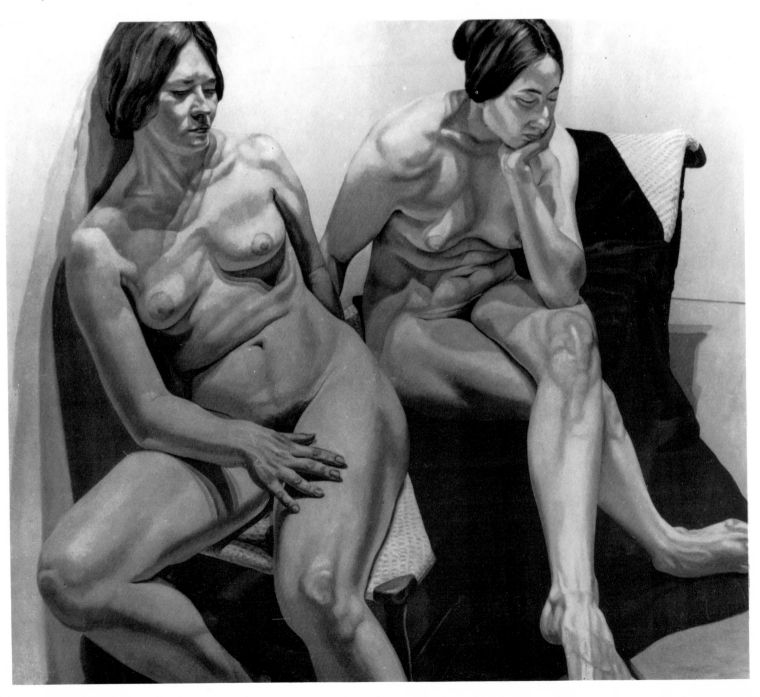

work hastened to point out its timeliness, its sympathy with the general aesthetic tendencies of the 1960s which were sharply opposed to the previous rhetoric of Expressionism. The most brilliant critic writing about Pearlstein, Linda Nochlin, stressed again and again his 'scrupulously empirical' attitudes. 'Anti-imaginative, anti-sociological, anti-symbolic, anti-expressionist, anti fun-and-games, Pearlstein is the most recent and articulate spokesman for the anti-rhetorical mystique at the heart of Realism,'[17] she wrote in 1970. And she noted that 'Pearlstein seems to share in the cool self-effacement characteristic of so much of today's art.'

Pearlstein's 'self-effacement' was seen by many sympathetic viewers in the un-inflected way he rendered his nudes, sometimes in groups of two. His study of form in harsh light was unrelentingly precise, and indifferent to the psychological dimensions of either sitter or viewer. Like many previous realists, he experimented with cropping and truncating in a way that could only recall photographic realism. The exaggeration of members such as feet or hands frequently referred to the snapshot. Pearlstein was admired for his willingness to deal harshly with the figure when such problems of perception as the close-up and the cut-off arose. 'For Pearlstein,' Nochlin writes, 'unlike the Impressionist, the cut-off, the so-called "brutal" cropping of the figure functions as the paradigm of the artist's decision as an image-maker, not of his artfulness as a spontaneous moment catcher. This static, frozen, deadpan immobility is characteristic of the New Realism generally considered in its temporal dimension.'

Pearlstein's clearly stated position of empiricism did much to gain attention for younger artists dealing with the figure. During the late 1960s, many artists turned to sober versions of photographic realism, some going so far as to limit their activities entirely to the imitation of the photograph. In an ultra-sophisticated vein, Chuck Close painted meticulously detailed, huge closeups of faces in which the dialogue with the old philosophical questions of illusion and reality was quickly sensed by the critics, and for which the phenomenological approach to perception and philosophy was mobilized in critical diction. In Close's excessive scanning of molecular detail bordering on the grotesque, the Realists moved close to the conundrums posed by the Surrealists. Others, less extravagant in their finicky empiricism, such as Richard Estes whose studies of crowded still life, as in drugstore displays, were greatly admired, seemed to be resurrecting high traditions of illustration rather than philosophical dialogue with the problems of realism. For them, as for Pearlstein, epithets of admiration most frequently invoked were 'deadpan', 'static', 'anti-expressive' and 'factual.'

CHUCK CLOSE, *Portrait of Robert Israel.* Robert Feldman Collection.

If the salient tendencies, figurative and non-figurative, of the 1960s were objective and anti-expressionist, they existed in curious tension with the older lyrical modes. The 1960s was a decade of official appraisal, when older members of the painting community were honored with large retrospectives, and several were still accessible to students. Large numbers of young painters withheld allegiance both from the scepticism inherent in objective positions and from the romanticism they found uncomfortable in older, more subjective positions. They followed the mature work of the established masters attentively so that, toward the end of the decade, the revaluing Louis Finkelstein had predicted came about.

The first important retrospective, offered in 1961, presented the works of Mark Rothko at the Museum of Modern Art. Aside from the genesis of Rothko's move into pure abstraction, the exhibition pointed to Rothko's increasing preoccupation with ensembles of canvases. Rothko, in fact, fulfilled his deepest aspiration, and in many critics' view, made his most important contribution during the 1960s. The young painters, particularly in New York, were very much aware of him and his work, and frequently debated his merits. In this sense the 1960s were not precisely

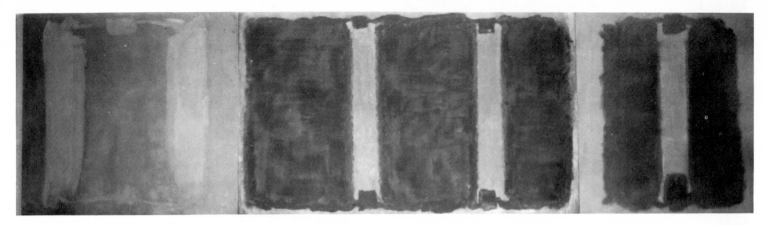

comparable to previous decades in which the old masters were decisively pushed into the background. Unlike Monet, for instance, whose eclipse for young artists lasted throughout his old age when he, too, was painting his most glorious ensembles, Rothko was very much on the minds of the young until his death on February 25, 1970.

In the 1961 exhibition, they were able to see Rothko's first suite of murals, originally intended for the dining room of the new Seagram building on Park Avenue. Rothko had actually produced three suites of murals for this commission, and when he had finished, as Peter Selz wrote in the catalogue, it was clear to him that these paintings and the setting did not suit each other. In the sketches and a few of the finished sections, viewers were to see radical changes in Rothko's approach. The measured cadences of his previous paintings, with their frequent division into three parts, were abandoned. Instead Rothko sought absolutes of luminosity working often with a simple fiery rectangle within a red-brown ground, or a suspended U-shaped dark spectre on a deep-hued ground. The aspiration to make an enveloping cycle of which Rothko had spoken long before he undertook its realization was to become his ruling passion in the 1960s.

Soon after the exhibition, Rothko was again at work on a mural cycle, this time for the Society of Fellows of Harvard University. As in the first commission, Rothko worked feverishly, producing dozens of sections before he worked out the scheme of five sections which were installed in a dining room at Harvard in the Spring of 1964. Again, Rothko worked with very deep reddish tones, heightening the ensemble with a single panel in which a fiery orange-red form is suspended like a flaming hoop in purple space. This was to be his last obviously dramatic gesture for, soon after, Rothko began to concentrate on the lowest range of value contrasts – a period of experimentation which was often mistakenly assumed to be Rothko's bow in the direction of the flat, objective tendencies.

Almost as soon as the Harvard murals were complete, Rothko was deeply involved in what he thought of as the culmination of his life's work – a cycle of fourteen murals for a chapel commissioned by Mr and Mrs Jean de Menil in Houston, Texas. During the several years he was absorbed in this surpassing problem, he received many visitors, and many fellow-painters had seen fragments of the whole. During this time, there was much talk about 'environmental art' in New York, and astute younger painters understood that Rothko was a prime source for environmental theory. He had long maintained that his paintings must envelop the viewer, and his final masterwork of the jointed scheme for the chapel was a definitive statement of his belief that his own painting, at least, must create and control a total, inescapably emotional environment. Rothko wanted to create awe in his murals, and awe was an ingredient which many young artists thirsted after in the rather cynical 1960s. Rothko's presence was felt, his moral example remarked, by a number of

MARK ROTHKO, *Tryptych 1, 2, 3,* mural in Harvard University, Cambridge, Massachusetts (Photo Fogg Art Museum).

320

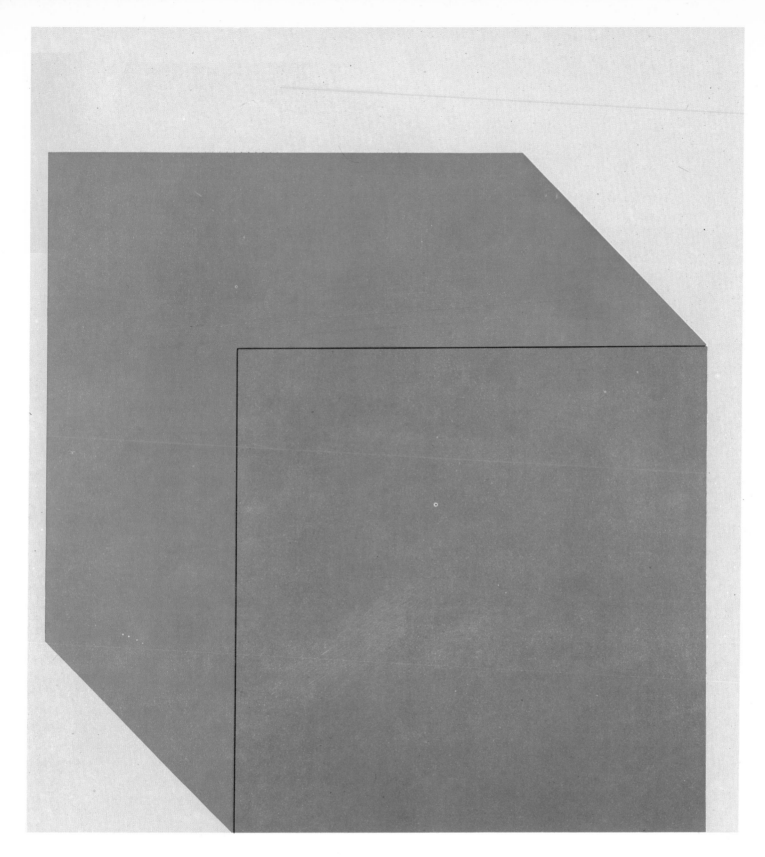

young artists who were to emerge in the last year of the decade.

The Museum of Modern Art followed up its decade of retrospectives with an exhibition of the work of Hans Hofmann in 1963. The reputation Hofmann enjoyed until the end of his life in 1966 was based both on his extraordinary personality as a teacher, and on his ability to refresh his work. The exhibition stressed his recent works, in which Hofmann had combined freely the rectilinear forms derived from

ELLSWORTH KELLY, *Blue-Green*, 1968. New York, Collection of the Artist (by courtesy of the Sidney Janis Gallery).

321

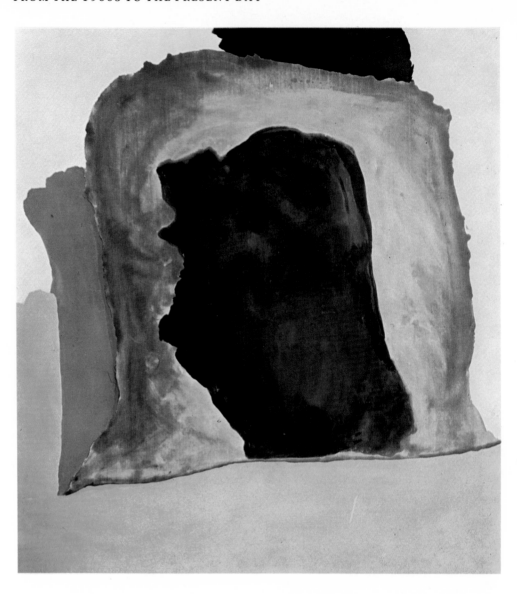

constructivism and the free forms he had always found so congenial. Hofmann's exuberance and his willingness to experiment with all aspects of his art were unfailing sources of encouragement to the young, generations of whom had passed through his school.

Another artist whose presence was inescapable to any serious young artist was Robert Motherwell. Not only did Motherwell exhibit frequently during the 1960s, but he also taught at Hunter College (and occasionally at many other universities), where several artists who would later gain prominence were exposed to his keen analysis of the problems inherent in modern art. Motherwell's progression from his earlier dedication to the principles of analytic Cubism to his mature experimentalism was noted by himself when he exhibited *The Voyage: 10 Years After* painted in 1961, in the Guggenheim Museum's exhibition that same year titled 'American Abstract Expressionists and Imagists.' The 1961 *Voyage*, unlike earlier voyages, was an exceptionally long painting in which a single vertical bar, interrupted by a softly flowing, protoplasmic form was the sole anchor for the impression of boundless space. The loose spatters of color modify only the central portion of the canvas, while the extremities are completely bare. This mural vastness preoccupied Motherwell during the early 1960s, and when the Museum of Modern Art gave him a retrospective in 1965, several startling murals almost twenty-feet long attested to

322

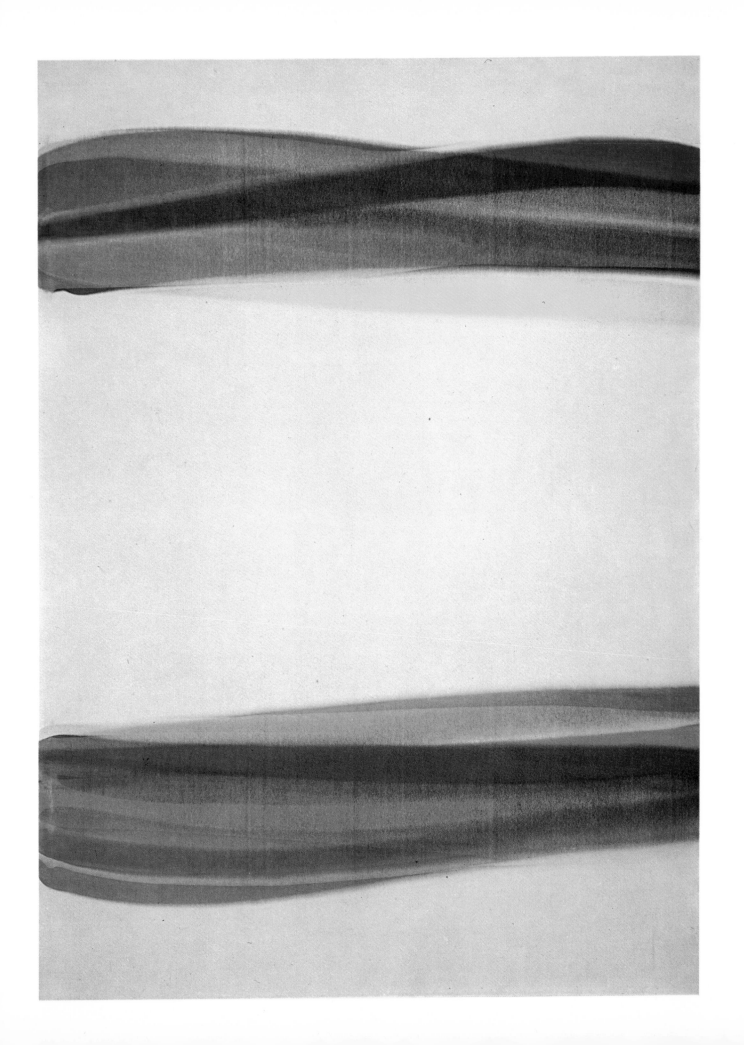

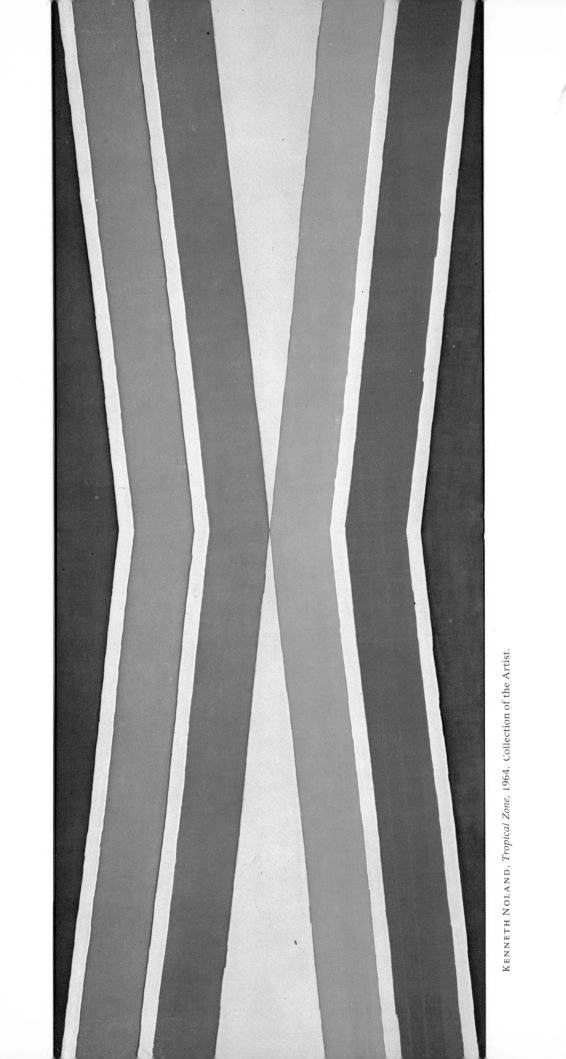

KENNETH NOLAND, *Tropical Zone*, 1964. Collection of the Artist.

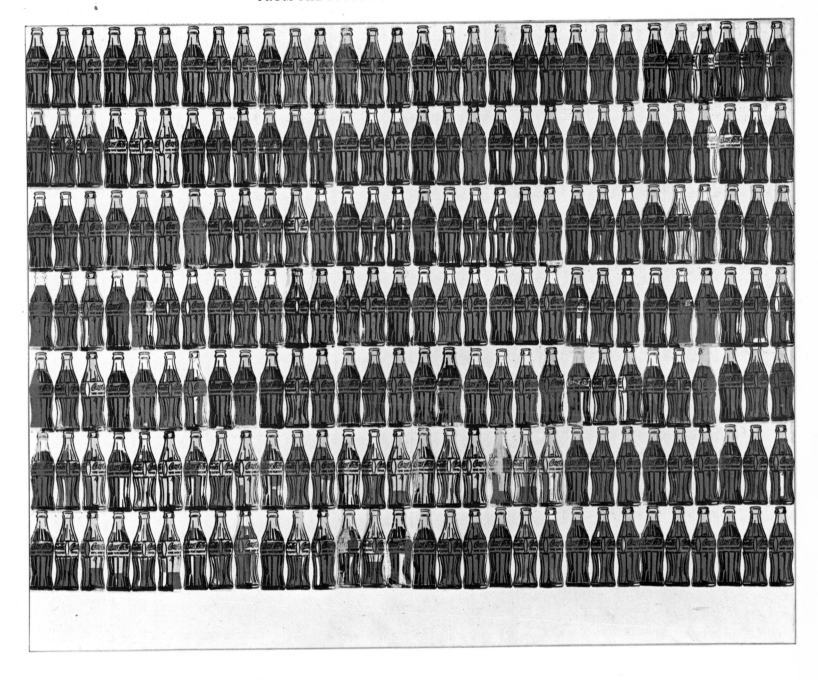

ANDY WARHOL, *Green Coca-Cola Bottles*.
New York, Collection of the Whitney Museum of
American Art.

Motherwell's shifting interests. These canvases were kept largely flat, with large areas of blue or red laid on with surprising little variation. Where a sign, or a flourish of calligraphy appeared, it, too, lay rather flat on the surface, as if to remind the viewer that these murals were meant to be read along a horizontal axis which was inexorable, and that Motherwell could deal with the same 'temporal' problems which preoccupied a painter like Newman. While the immediate impact of Motherwell's work was not evident in 1965, it becomes clear now that the free improvisation which always invigorates Motherwell's painting meant a great deal to other painters who were not eager to take the long trip to nullity that so many generations of twentieth-century artists had made. When, in the last year of the decade, so many young painters broke free from the rules of post-painterly abstraction, Motherwell's example gained new significance.

Another artist of the Abstract Expressionist generation who had not one but two museum exhibitions during the 1960s was Philip Guston. The first was a full-scale

325

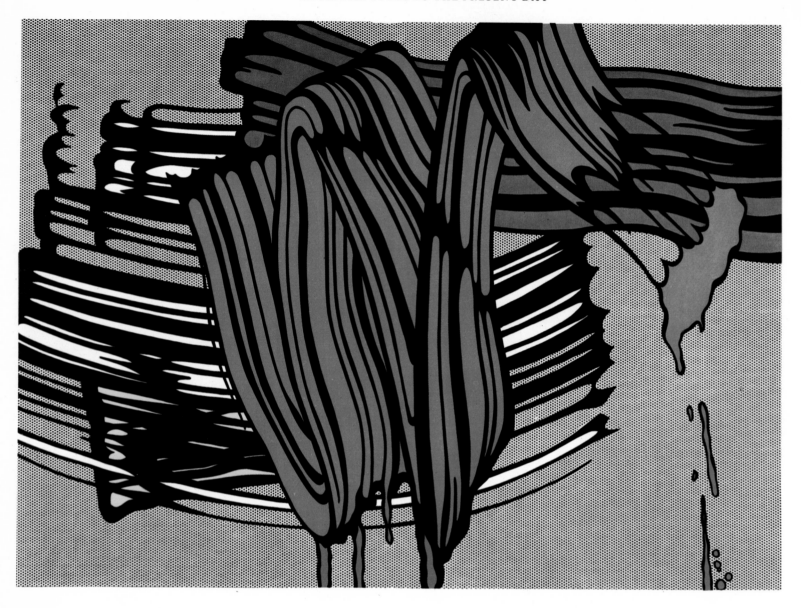

Above ROY LICHTENSTEIN, *Big Painting 6.*
New York, Robert C. Scull Collection.
Opposite JAMES ROSENQUIST, *Waves*, 1960–1.
Milan, Private collection.

retrospective at the Guggenheim Museum in 1962, and the second, a very large show of recent paintings and drawings at the Jewish Museum in 1966. Except for reactions from a faithful, select group of admiring painters, both exhibitions met with reserve. The Jewish Museum show was dominated by Guston's darkest, most turbulent abstractions in which his muddied grays and blacks and huddled, un-distinct forms flew in the face of the new tendencies and were rudely dismissed. However, a few discerning viewers noticed in the drawings and a few of the paintings a distinct reference to specific shapes – heads, feet, pots, fruits. Soon after, Guston began to eliminate the equivocal spaces and forms that had dominted his paintings for more than a decade, and in the fall of 1970, he shocked admirers and foes alike with a group of paintings that rejected abstract canons and dealt with easily discernible (although not easily interpretable) materials.

This exhibition inaugurating the 1970s for Guston, came at an historical moment of confusion. For two years American life and had been fraught with eruptions of a political nature. Quite aside from the war in Vietnam which had long been a source of malaise for every intellectual, including the painters, theere had been killings at Jackson State and Kent State – both universities, and traditionally exempt from such 'police actions'. Indigenous revolutionary movements, such as the Black

326

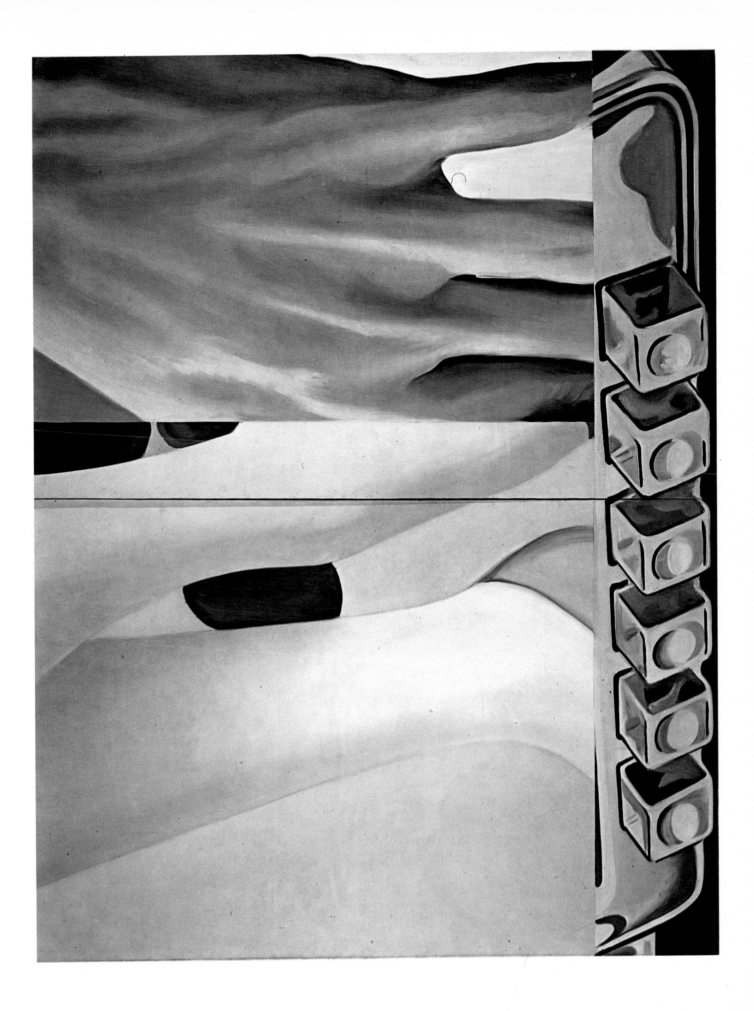

Right ROBERT MOTHERWELL,
The Scarlet Ring,
1963.
Private collection.

Opposite ROBERT INDIANA,
Serigraph.
Private collection.

PHILIP GUSTON, *Courtroom*, 1970.
New York, Collection of the Artist.

ADJA YUNKERS, *A Human Condition*, 1966,
mural at Syracuse University, Syracuse,
New York.

Panthers, has been subject to terrible persecution and, on the foreign horizon, the Nixon régime was every day expanding its bellicose interventions. For some years already, there had been a steady widening of interest in politically pertinent art, although it stayed largely within the boundaries of social propaganda. Such artists as Adja Yunkers, Allen d'Arcangelo, Joe Raffael and Robert Rauschenberg had made topical references to the war in their work, but few artists had attempted to make a profound art with political content. Aside from the Yunkers mural at the University of Syracuse, which was highly abstract and symbolic, rather than specific, there had not yet been any political statement of consequence on recent American history.

When Guston's exhibit arrived in 1970, the shock was enough to set the journalistic critics off on wild denunciations. Guston had doubled back to his very

beginnings, when he had painted such subjects as Ku Klux Klan members on lynching errands. But in 1970, the Klan figures were rendered in a fierce satiric mode, and their tasks were generalized. Piles of boots and dismembered bodies alluded to atrocities of all time, and bloodied hands were everywhere. In these paintings, which referred not only to the American cartoon style of drawing, but also, to the principles governing modern abstract art, many viewers found Guston's insistence on subject-matter obtrusive. But other felt that at least, America had spawned a genuine political artist worthy of being placed in the tradition of Goya's atrocity paintings and Picasso's *Guernica*.

The 1960s saw, too, the first comprehensive retrospective of the works of Willem de Kooning. In March, 1969, the Museum of Modern Art at last opened its exhibition – an exhibition that had been discussed for many years, and had been eagerly awaited by a generation of young artists who were not familiar with de Kooning's *oeuvre*. For nearly thirty years de Kooning had been considered a painter's painter, a kind of *chef d'école* hovering behind most of the shifts in style and taste and always capable of attracting interest. Even when in the early 1960s the reaction against his peculiarly energetic Expressionism was strongest, de Kooning had remained a charismatic figure.

The retrospective was thorough, showing his origins in purely academic Dutch still-life painting; his vacillation between Cubist and Surrealist modes in the late 1920s and 1930s; his strong interest in Picasso, and his emergence in the 1940s as an abstract painter of authentic originality. In addition, there were paintings from the mid-1960s in which de Kooning's interest focused once again on the human figure, particularly, as he told David Sylvester, on 'flesh-colored' women. These latest de Koonings generated much discussion. As always, he was denounced by the journalistic critics, who saw in the tremendously active surfaces of these paintings only a confusion of brushstrokes and wayward color and who lamented his exacerbated Expressionism.

In fact, during the mid-1960s, de Kooning was exploring the human form in a radically different way. His autographic hookline strokes were still there, his great sweeping erasures were still there, and his palette of oranges, pinks, greens and high reds were still there. But they were in the service of a different vision. Now the figure was brought up very close to the picture plane, and generally filled the entire surface with its frontal presence. The bodies seemed splayed and sprawling, and their features distorted, but their characteristics were expressed unfailingly. De Kooning had gone up very close and examined the surfaces of his figures as a topologist might. Their rubbery twistings and turnings were remarked, as were their dimensions in a space teeming with mobile forces. The staccato respiration of these topologically extended figures was entirely different in rhythm from the heaving breaths of his earlier women. The differences were noted, assessed, and praised or condemned widely during the late 1960s, when de Kooning continued to be a vivid source for critical discussions of art.

Probably the most compelling argument in favor of the abstract expressionist generation's abiding power among the young was the increasing asperity demonstrated by the young. The late 1960s were certainly a turning point, and a time for a shift from the values of objectivity that had so forcibly shown up in the first half of the decade. A case in point: Darby Bannard, an extremely and intelligently articulate painter, who had first been associated with the rise of minimalist painting (his 1965 *Green Grip* was praised by Barbara Rose for its simple geometric motifs set forth 'with a new coolness and sophistication'[18]) began, toward the late 1960s, to break most of the post-painterly abstraction rules, and especially the rule about knowing the outcome of the painting beforehand. When the de Kooning exhibition required a reviewer, *Artforum*, which in the 1960s had become the leading art

magazine for the new generation, invited Bannard to do the job. He set to work with zest, expressing all the hate-love that had been stored up by members of his generation. The meticulous analysis Bannard undertook, even though it was negative, was a measure of the importance de Kooning still held for the younger artists.

In the review, Bannard wrote that unlike his contemporaries, whose works had a 'non-art' look, de Kooning was still 'an old-fashioned figure-ground draftsman.'[19] Bannard accused de Kooning of falling into mannerism with his slashes and drips and frenzied brushwork. In order to effectively dispose of de Kooning, Bannard devised a formula: 'large-scale small-piece all-over expressive Cubism' to cover de Kooning's attitude toward painting, and unceremoniously referred to his definition throughout the article with the initials LAPSAC. The seeming disrespect demonstrated in this article was only superficial. It was the last war whoop of a decade's rebellion against the fathers. Soon after, Bannard himself began to use the masked, ambiguous tonal areas and fluid, painterly techniques which had originated with the de Kooning generation, as did a host of young painters who had begun their careers in the stern canons set forth by Clement Greenberg and his critical admirers. The harvest of reactions against the stiff formalism that had dominated the middle-1960s began to be evident in the 1969 and has continued in a healthy expansion. In addition, an open interchange amongst generations, both in practice and theory, became evident. When Jack Tworkov, for example, showed his paintings of the late 1960s, in which he developed a rhythmic structure by means of a grid, while still retaining the spatial ambiguities inherent in Abstract Expressionism, younger artists were able to understand his transition as the product of interaction. The strict boundaries that had hedged in the proliferations of 'isms' in the 1960s were being assailed by those who craved openness.

The undeniable variety of idioms was stressed in a mammoth exhibition staged by the Metropolitan Museum in its Centennial celebrations during 1970. In 'New York Painting and Sculpture: 1940–1970', curator Henry Geldzahler assembled 408 works of art by forty-three artists who had at one time or another been identified with the so-called New York School. In fact, there was little to suggest anything so cohesive as a school in the exhibition, but there was an important anthology of works by major figures in the Abstract Expressionist movement. Young artists who had never seen more than one or two paintings at a time by such artists as Arshile Gorky, Adolph Gottlieb, Jackson Pollock, Barnett Newman and Willem de Kooning had an opportunity to see a large ensemble of works.

Side by side were works representing every idiom that had flourished since the late 1950s, including a large group by Ellsworth Kelly, Frank Stella, Morris Louis and Kenneth Noland, as well as large selections of works by most of the prominent Pop artists. Geldzahler's ecstatic claims were felt by most critics to be embarrassingly exaggerated (for instance, 'Not even at the height of the High Renaissance, Impressionism or Cubism has anything like the number of these artists finally seemed crucial to the development of the art of their time'), but the scale of the exhibition certainly offered a perspective on the greatly amplified energy of the painting world.

Robert Motherwell has characterized the 1960s as a period of irony and parody. Painting, he said, is fragile and very vulnerable, and did not stand up well to the ravages of the period.[20] His concern with the destiny of painting was shared by a new generation of young artists who had suffered cold winds of objectivity, with all the stringent rules set forth during the early 1960s, and who yearned for a more open situation. The Abstract Expressionist position began, again, to seem more viable for a painter. Young artists undertook to study the works of the older generation; to

JACK TWORKOV, *Partitions*, 1971.
New York, French & Co., Inc.

speculate on their values, and to allow themselves to experiment in various open modes. As a result, the press, ever eager to coin a phrase, began to talk about Lyrical Expressionism as though it were a new movement. While it could hardly be called a movement in the formal sense, in the literal sense it was a movement away from the confines of 'post painterly abstraction' to the open spaces and free compositions associated with lyrical painting.

The genesis of the movement toward openness, and reintegration of Abstract Expressionist principles was fairly rapid in the case of several young painters who started out in the mid-1960s. A typical case history is that of Jake Berthot, one of the most promising of the present generation lyrical painters. He studied first with one of the Abstract Expressionists, Milton Resnick, but while still a student, he had the feeling that 'painting was falling apart.' This was during the mid-1960s, and his feeling was that 'the Pop scene had taken over.' He was keenly aware, as were most young artists of his generation, of the accelerated pace of marketing and the cynical dependence on public relations that had overtaken the art market. He resented what he called 'the star system,' particularly as it worked to destroy cohesion in the art community. Longing for the kind of community which had become legendary during the high moments of Abstract Expressionism, he gravitated to a group of other young artists who were in full rebellion against the Abstract Expressionist position, and who constituted a group within the Park Place Gallery. For two years he worked, as did his confrères, to reach a disciplined, non-commital, quasi-geometric idiom. But, toward 1968, he felt constricted, uneasy.

Berthot had pondered Wölfflin. He had been attracted to 'the discipline of the Baroque' but he had also been drawn to the beauties of classicism as sketched by Wölfflin. Although he felt the two could not successfully be joined, he nevertheless took a decision: to follow his feelings wherever they would lead him. 'I felt I just wanted to put paint down. Before there had always been a denial somewhere.' He, like many of his acquaintances in the artists' quarter of SoHo in downtown New York, no longer wished to deny themselves any experience in painting, and there was a notable turning away from the problem of style.

Berthot thoughtfully looked back. The artist who seemed to move him most deeply was Mark Rothko. Unquestionably, Berthot's first accomplished paintings in his new manner during 1969, had derived direction from Rothko's work of the mid-1960s when the dark reds and silvery blacks had come to predominate in his work. Berthot commenced to work with double panels with notched corners to express a tense, drawn-out central space. He worked with layer upon layer of thin paint, building up resonances, allowing irregularities and breathing spaces, but holding his composition within a bilateral, framed situation. His choice of earth reds and dusky browns and greens was in keeping with his emotional interest in creating a mood. The ambiguities of edge created illusions of recession that would have scandalized the orthodox post-painterly abstractionist. His indifference to the general principles holding together the various 'movements' that had flourished during the 1960s fed Berthot's work, and allowed him to mature slowly. He, and many others, had learned the hazards of 'movements', and were preparing a new climate of individualism more in keeping with the climate of the 1950s.

The presence of the younger British painter John Walker in New York was also helpful to a number of young Americans. Walker came to New York early in 1970 with the intention of establishing a dual studio situation – some of his time in London, some of his time in New York. However, he remained in New York for nearly two years, and was quickly integrated into the community of younger painters. Walker's great value to them was his unabashed admiration of the old masters, particularly Matisse, and his serious appraisal of the American Abstract Expressionists, particularly Pollock. In his own work, which was seen by a number of his acquaintances

in SoHo long before he exhibited in the Spring of 1971, Walker showed great indpendence.

His study of the Abstract Expressionist generation had left him with the feeling that 'the best of the period had a huge spiritual content.' In his own work, he strove to achieve a sense of spiritual content equivalent to that he felt in the older painters' works. He worked on large, sometimes horizontal canvases, some twenty feet long. He established huge areas of atmospheric extension which seemed to flow well beyond the confines of the canvas, as had the spaces of Still and Pollock before him. He invented a method of enlivening his surface by applying his paint through the grid of a chicken-wire or large screen. He was attentive to detail, working now thick, now thin, now with emphatic relief, now with runny trills. He was not in the least concerned with the flatness of the picture plane, and when the fancy took him, allowed amorphous areas to sink into a cloudy distance.

What distinguished Walker's large paintings especially was his interest in shape – specific, sometimes almost geometric shape. It had been a long time since painting had permitted the exploration of specific shape in an abstract painting. Walker's shapes, which sometimes resembled stones, were usually placed in startling juxtapositions. There might be two identical stone-like shapes planted firmly on the very bottom of the canvas; or, there might be three such shapes, two nearly moving out of the extreme edges of the groundline and one incongruously perched on a plane at eye level in the middle of the painting. Overtones of Surrealism, as well as Abstract Expressionism, enlivened Walker's work. Moreover, unlike the generation of systemic painters, Walker saw each painting as distinct. There was no question of serial development. For him, each mood, each image had its particular solution, its own ambiance, and the problem was to convey how seriously he meant to project a 'spiritual' content. The strong imaginative tide in his work, and his evident control, was to be remarked by many younger painters. His attitude itself was tonic: he confirmed in his positive and confident stance, the feelings many others had entertained at the turn of the decade.

In interviews and general assessments published during the year 1970, it began to be obvious that the new generation of painters had made a declaration of independence which they took very seriously. They no longer wished to be bound by any allegiance, either to a gallery or to a group style, and they no longer regarded painting as the solving of stylistic, historically-conditioned problems. The profusion of approaches evident in galleries during 1970 and 1971 confirmed this fresh attitude. Not only were many individual obsessions viewed with sympathetic tolerance, but artists, among themselves, insisted on the right of their fellows to view painting according to their own lights. A painter such as Harvey Quaytman, who pursued a vision of expression primarily through color was not dubbed a 'color' painter by his friends. On the contrary, they recognized that in establishing a single-hued canvas, with many tremolos articulated in the way the color is laid on, and by relating that colored surface to a swift, narrow, almost calligraphic flourish beneath the rectangle, Quaytman was not adjusting to the rules of either color painting or shaped canvas painting. He was, rather, seeking the keenest lyrical expression of a vision of color and light. The support he found amongst his peers had nothing in it of the categorizing glibness that marred most contemporary criticism.

Similarly, the harsher but emotionally charged abstractions by William Williams, found approval and understanding. Williams, probably the foremost young black painter, had begun with the cold factualism in abstraction proposed by Frank Stella. But as he gained experience and confidence, he increased the intensity of his colors, complicated his compositions, and attempted to make strident statements of his complicated feelings about being a black artist. Unquestionably the frenetic pace of merchandising in the 1960s, and the concomitant loss of hierarcnical distinctions

HARVEY QUAYTMAN, *Second Cupola Cappellas*, 1970. New York, Paula Cooper Gallery.

had posed deep problems for the younger artists embarking on professional careers in the 1970s. Writing in 1962, Leo Steinberg remarked about the rapid domestication of the outrageous, noting that 'at the present rate of taste adaptation, it takes about seven years for a young artist with a streak of wildness in him to turn from *enfant terrible* into elder statesman.'[21] By 1972, probably, the seven years Steinberg allowed had shrunk to a mere two or three, and many younger artists were bitterly aware of the hazards of quick recognition. The slow maturation pace permitted years before were truncated. Even universities, which had become the principal source of the artist population, had bowed to various sociological pressures and granted their students the status of artists. 'Every student is an artist' advertised one West Coast college. If the student is no longer a student, but a professional artist, he is left very little time to explore, discard, probe. He must find a style instantly, and try to register it through the numerous public modes available.

Such pressures were keenly felt. In the 1970 Whitney Annual, for instance, there were countless paintings by artists who seemed to be grabbing wildly from the groaning board of recent art history; whose haste was symbolized by their use of the spray-gun, and whose images seemed willfully incomplete. But on the whole, the annual had an air of exuberance and variety that had been missing in the annuals of the 1960s. There were some younger artists exploring the impact of textured monochrome painting, such as David Diao; there were some who were combining the grid structure of the 1960s with the amorphous paint structures of the 1950s, such as Darby Bannard; and some who, like Ed Ruda, took up earlier challenges implicit in Morris Louis's work, using a rough system of paralleled swaths of color in extremely loose configurations. What became clear during the 1970–71 season (for art has its seasons in New York, geared to the demands of the market), is that all the shibboleths that had flourished during the 1960s had been refused by the new generation – all those ideas about the integrity of the picture plane, the integrity of the 'field', the color value of so-called 'color painting', the dangers of illusion, the probity of the rectangle – all were energetically challenged by the young. The survival of painting seemed assured.

Notes

Introduction

1 William Dunlap, *History of the Rise and Progress of the Arts of Design in the United States*, New York, 1834; and Henry T. Tuckerman, *Book of the Artists*, published 1867, reprinted New York, 1966.
2 Lorado Taft, *History of American Sculpture*, New York, 1903; and Samuel Isham, *The History of American Painting*, New York, 1905.
3 See Barbara Novak, *American Painting of the Nineteenth Century*, New York, 1969, chapters 7 and 10; and Axel von Soldern, *Triumph of Realism*, Exhibition catalogue, Brooklyn, New York, 1967.
4 See John W. McCoubrey, *American Tradition in Painting*, New York, 1963, introduction and chapter 5.
5 See Novak, *op. cit.*, chapters 5 and 6; and J. Wilmerding, *Fitz Hugh Lane*, New York, 1971.
6 Novak, *op. cit.*, chapter 1.
7 *The Writings of Ralph Waldo Emerson*, New York, 1949, pp. 47–8.

1 Colonial Art

1 Waldron Phoenix Jr. Belknap, *American Colonial Painting*, Cambridge, Mass., 1959, p. 64.
2 Louisa Dresser, *XVIIth-Century Painting in New England*, Worcester, Mass., 1935, p. 53.
3 Sidney and Cummings Gold, Abbott Lowell, 'A Study in Early Boston Portrait Attributions,' *Old Time New England*, January, 1968, vol. LVIII, no. 3, p. 64.
4 *Ibid.*, p. 74.
5 Dresser, *op. cit.*, p. 83.
6 Panofsky, Erwin, *Early Netherlandish Painting*, Cambridge, Mass., 1953, vol. I, p. 188.
7 Dresser, *op. cit.*, p. 135.
8 J. Hall Pleasants, 'Justus Englehart Kühn,' *Proceedings of the American Antiquarian Society*, October, 1936, p. 8.
9 Mario Praz, *Conversation Pieces, A Survey of the Informal Group Portrait in Europe and America*, London, 1971, p. 113.
10 Christian Brinton, *Gustavus Hesselius*, Philadelphia, Pa., 1938, p. 10.
11 *Ibid.*, p. 11.
12 Roland E. Fleischer, 'Gustavus Hesselius: A Study of His Style,' *American Painting to 1776: A Reappraisal*, Charlottesville, Va., 1971, p. 126.
13 Margaret Simons Middleton, *Jeremiah Theus, Colonial Artist of Charles Town*, Columbia, S. C., 1953, p. 33.
14 Dr Alexander Hamilton, *Gentleman's Progress*, ed. Carl Bridenbaugh, Chapel Hill, N. C., 1948, p. 72.
15 William T. Whitley, *Artists and Their Friends in England, 1700–1779*, London and Boston, 1928, vol. I, p. 67.
16 Ellis Waterhouse, *Painting in Britain 1530–1790*, London, 1953, p. 123.
17 John Smibert, *The Notebook of John Smibert*, Boston, Mass., 1969, p. 87.
18 Henry Wilder Foote, *John Smibert, Painter*, Cambridge, Mass., p. 54.
19 *Ibid.*, p. 76.
20 Smibert, *op. cit.*, p. 93.
21 Foote, *op. cit.*, p. 84.
22 Smibert, *op. cit.*, p. 95.
23 Smibert, *op. cit.*, p. 96.
24 R. Peter Mooz, 'Smibert's Bermuda Group – A Reevaluation,' *The Art Quarterly*, Summer 1970, vol. XXXIII, no. 2, p. 148.
25 Foote, *op. cit.*, p. 86.
26 Foote, *op. cit.*, p. 100.
27 Henry Wilder Foote, 'Charles Bridges, Sargeant – Painter of Virginia 1735–1740,' *Virginia Magazine of History and Biography*, January 1952, vol. 60, no. 1, p. 11.
28 Henry Wilder Foote, *Robert Feke*, Cambridge, Mass., 1930, p. 137.
29 Newport, Newport Historical Society, *Channing Daybook*, Vault A, no. 396.
30 John Smith, *Hannah Logan's Courtship*, ed. Albert Cook Myers, Philadelphia, Pa., 1904, p. 290.
31 R. Peter Mooz, 'New Clues to the Art of Robert Feke,' *Antiques*, November 1968, p. 703.
32 R. Peter Mooz, 'Robert Feke: The Philadelphia Story,' *American Painting to 1776: A Reappraisal*, Charlottesville, Va., 1971, p. 181.
33 Foote, *Robert Feke*, p. 99.
34 Belknap, *op. cit.*, p. 293.
35 Alfred Coxe Prime, *The Arts and Crafts in Philadelphia, Maryland and South Carolina, 1721–1785*, Topsfield, Mass., 1929, p. 7.
36 Rita Susswein Gottesman, *Arts and Crafts in New York, 1726–1776*, New York, 1938, p. 3.
37 George Francis Dow, *The Arts and Crafts in New England, 1704–1775*, Topsfield, Mass., 1927, p. 2.
38 Prime, *op. cit.*, pp. 5–11.
39 Gottesman, *op. cit.*, pp. 3–6.
40 James T. Flexner, 'The Amazing William Williams,' *Magazine of Art*, November 1944, vol. 37, p. 276.

41 Jules David Prown, *American Painting: From its Beginnings to the Armory Show*, Cleveland, Ohio, 1970, p. 31.

42 *Ibid.*, p. 32.

43 Jules David Prown, *John Singleton Copley*, Cambridge, Mass., 1966, vol. I, p. 48.

44 Prown, *John Singleton Copley*, p. 77.

45 Albert Ten Eyck Gardner, *American Paintings, A Catalogue of the Collection of the Metropolitan Museum of Art I*, Greenwich, Conn., 1965, p. 20.

46 *Ibid.*, p. 21.

47 William T. Whitley, *Gilbert Stuart*, Cambridge, Mass., 1932, p. 95.

48 John Hill Morgan, *Two Early Portraits of George Washington, Painted by Charles Willson Peale*, Princeton, N.J., 1927, p. 28.

49 Edgar P. Richardson, *Gilbert Stuart*, Providence, N.J., 1967, p. 24.

50 Frances Ann Miner, *Landscape in Eighteenth Century America and its European Sources*, Unpublished Masters Thesis, Winterthur Program in Early American Culture, University of Delaware, 1969, in *passim*.

51 The author wishes to acknowledge the able editorial assistance of Mrs Karol Grubbs Schmiegel and the helpful comments of Messrs William Oedel, Richard Saunders and Gilbert Vincent. In addition to the books cited in the notes, the author is indebted to the following:
William Dunlap, *History of the Rise and Progress of the Arts of Design in the United States*, New York, vol. I, 1834:
Oskar Hagen, *The Birth of the American Tradition in Art*, 1940;
Edgar Richardson, *Painting in America, From 1502 to the Present*, 1956;
John W. McCoubrey, *et al.*, *The Arts in America, The Colonial Period*, 1966.

2 The Early Nineteenth Century

1 John Trumbull, *Autobiography, Reminiscences and Letters*, New York, 1841, p. 159.

2 William Dunlap, *History of the Rise and Progress of the Arts of Design in the United States*, New York, 1834, I, p. 372.

3 Its date has been given as both about 1802 and 1807. See J. Howat and J. Wilmerding, *19th-Century America: Paintings and Sculpture*, New York, 1970, no. 3; and C. M. Mount, *Gilbert Stuart*, New York, 1964, p. 276.

4 Dunlap, *op. cit.*, p. 217.

5 Thomas Sully, *Hints to Young Painters*, reprinted New York, 1965, pp. 31, 34.

6 See Howat and Wilmerding, *op. cit.*, nos. 26 and 27.

7 Harold Kirker, *The Architecture of Charles Bullfinch*, Cambridge, Mass., 1969, pp. 78–85.

8 Jules D. Prown, *American Painting from its Beginnings to the Armory Show*, Cleveland, Ohio, 1970, p. 53.

9 Quoted in Howat and Wilmerding, *op. cit.*, no. 11.

10 Source unknown.

11 A full account of the excavation and the picture is in Charles Coleman Sellers, *Charles Willson Peale*, New York, 1969, pp. 293–304.

12 See Charles H. Elam, ed., *The Peale Family, Three Generations of American Artists*, Detroit, 1967, pp. 10, 43, 129.

13 *Ibid.*, p. 90.

14 See Samuel Edgerton's discussion in 'The Murder of Jane McCrea,' *Art Bulletin*, December 1965, pp. 481–92.

15 Dunlap, *op. cit.*, p. 380.

16 *Ibid.*, p. 381.

17 *Ibid.*, p. 360.

18 L. L. Noble, *The Life and Works of Thomas Cole* (ed. by Elliot S. Vessell), Cambridge, Mass., 1964, p. 60.

19 John W. McCoubrey, *American Art 1700–1960* (Eaglewood Cliffs, N.J., 1965), p. 96.

20 Noble, *op. cit.*, p. 101.

21 *Ibid.*, pp. 167, 171.

22 *Ibid.*, p. 215.

23 McCoubrey, *op. cit.*, p. 96.

24 Henry T. Tuckerman, *Book of the Artists*, reprinted New York, 1966, p. 193.

25 McCoubrey, *op. cit.*, p. 106.

26 *Ibid.*, p. 110.

27 John I. H. Baur, *John Quidor*, Exhibition catalogue, Utica, New York, 1965, p. 24.

28 Alfred Frankenstein, *Painter of Rural America: William Sidney Mount*, exhibition catalogue, Washington, D.C., 1969, p. 37.

29 Maria R. Audubon, *Audubon and His Journals*, New York, 1897, p. 38.

3 The Second Half of the Nineteenth Century

1 Henry Adams, *The Education of Henry Adams,* New York, 1931, chapters 25–9, pp. 379ff.

2 Edward Strahan, 'The Fine Art of the International Exposition,' *Illustrated Catalogue, The Master-pieces of the Centennial Exposition,* Vol. I, Philadelphia, Pa., 1876, p. 248. There is an undercurrent of sarcasm in Strahan's remarks, even while complimenting the American landscape painters.

3 *Ibid.,* p. 5. Here Strahan quotes Benvenuto Cellini to support his claim that figure painting is the highest goal of art.

4 *Ibid.,* p. 66.

5 The term 'Luminist' was coined by John I. H. Baur to describe a group of painters who were quite different from the Hudson River School in their approach to atmosphere and light. See John I. H. Baur, 'American Luminism,' *Perspectives,* USA, no. 9, Autumn 1954.

6 David C. Huntington, *The Landscapes of Frederic Edwin Church: Vision of an American Era,* New York, 1966, p. 2.

7 *Ibid.,* p. 102.

8 Quoted from Charles L. Borgmeyer, 'A Few Hours with Duret,' *Fine Arts Journal,* March 1914, pp. 109–10.

9 Louisine W. Havemeyer, *Sixteen to Sixty; Memoirs of a Collector,* New York, 1961, pp. 205–6. It was Mary Cassatt who suggested that Mrs Havemeyer visit Whistler, and she was largely responsible for the direction of the important Havemeyer collection of Impressionist paintings now in the Metropolitan.

10 Quoted from Lloyd Goodrich, *Winslow Homer,* New York, 1959, p. 25.

11 George W. Sheldon, *Hours with Art and Artists,* 1882, pp. 136–41.

12 Quoted from 'On Some Pictures Lately Exhibited' (originally published in the *Galaxy,* July 1875) from *The Painter's Eye, Notes and Essays on the Pictorial Arts* by Henry James, selected, edited and with an introduction by John L. Sweeney, London, 1956, p. 96.

13 For a discussion of Eakins' use of photography, and for a good discussion, in general, on photography and the artist, see Van Deren Coke, *The Painter and the Photograph,* Albuquerque, 1964.

14 Quoted from Lloyd Goodrich, *Thomas Eakins, A Retrospective Exhibition,* National Gallery of Art, Art Institute of Chicago, Philadelphia Museum of Art, 1961, p. 30.

15 Donelson F. Hoopes, 'John S. Sargent and the Revival of the Grand Manner Style in Late Nineteenth-Century Portraiture,' (lecture', Pennsbury Manor Americana Forum, 28 September–1 October 1967, Pennsbury Manor, Morrisville, Pa.

16 Quoted from Lloyd Goodrich, *Albert Ryder,* New York, 1959, p. 13.

17 Information on the American Impressionists and on the development of that style in America was taken from Richard J. Boyle, *The Rise of American Impressionism,* unpublished manuscript, 1972.

18 Hamlin Garland, 'Impressionism,' *Crumbling Idols,* 1894. New ed., edited and with an introduction by Jane Johnson, Cambridge, Mass., 1960.

19 Adelyn D. Breeskin, *Mary Cassatt: A Catalogue Raisonné of the Oils, Pastels, Watercolors and Drawings,* Washington, D.C., 1970.

20 Quoted from John I. H. Baur, *Theodore Robinson,* Exhibition catalogue, New York, 1946, p. 51. Baur's sensitive appraisal of a sensitive artist is still the standard work on Robinson.

4 The Forming of the Avant-Garde, 1900–30

1 Documentation for this interpretation of modern art is vast. The reader may browse through Herschel B. Chipp, *Theories of Modern Art,* Berkeley, Los Angeles and London, 1971; Lionello Venturi, *History of Art Criticism,* New York, 1936. A convenient survey of twentieth-century aesthetics is found in William F. Hare, Earl of Listowel, *A Critical History of Modern Aesthetics,* London, 1933. For the most recent expression of aesthetic aims and assumptions, *Art Forum,* monthly since 1963. One of the clearest early statements of the position is found in Clive Bell, *Art,* London, 1914, section I, chapter I: 'For, to appreciate a work of art we need to bring with us nothing from life, no knowledge of its emotions . . . we need . . . nothing but a sense of form and color and a knowledge of three-dimensional space.'

2 John Sloan, *Gist of Art,* New York, 1939, p. 15.

3 The term 'progressive' is used in this essay as a neutral adjective, like 'modernist,' to describe art that moved in a direction now apparent as we look back from the present time; it carries no aesthetic value judgment, since some progressive, modernist art is moving, some is dull.

4 Picture plane integrity refers to the recognition of the canvas, or any ground, as a two-dimensional surface, with the consequent obligation to avoid, as far as possible, illusionistic effect.

5 Meyer Schapiro, as quoted by William Homer, *Robert Henri and His Circle,* Ithaca and London, 1969, p. 176.

6 The term 'Ash Can,' applied to the art of the Henri Realists, became current after 1934 when Holger Cahill and Alfred Barr Jr used it in their book, *Art in America,* according to Bennard Pearlman, *The Immortal Eight,* New York, 1962, p. 202.

7 Robert Henri, *The Art Spirit,* Philadelphia, Pa., and New York, 1960 (originally published 1923), pp. 15, 116, 145.

8 Edward Bellamy's *Looking Backward,* published in 1888 when Henri was twenty-three years old, was only one of the large number of utopian works published in this country as he was growing to maturity. An avid reader, Henri very likely read this book that reached a larger public than any American novel since *Uncle Tom's Cabin* (Vernon Parrington, *Main Currents in American Thought,* New York, 1930, vol. 3, p. 302).

9 Hamlin Garland's art credo was published in book form under the title of *Crumbling Idols* in 1894. 'Art,' Garland insists, 'is an individual thing – the question of one man facing certain facts and telling his individual relations to them.' Henri's emphasis on the environment as material for art is also found in Garland: 'Write of those things of which you know most, and for which you care most.' (Parrington, *op. cit.,* pp. 293–4.) The note of optimism sounded by Henri and echoed by the Ash Can artists is struck by Garland as well; it is in sharp contrast to the stark tragedy of Theodore Dreiser with whom the Realists are often and too simply compared.

10 Quoted in Bennard Perlman, *op. cit.,* p. 61.

11 Ralph Waldo Emerson, *The Complete Essays and Other Writings of Ralph Waldo Emerson,* New York, 1950, p. 61.

12 James Hibbon Huneker, 1860–1921, American essayist and music, art, and drama critic for the New York *Sun, The Times,* and the *World.* His biography by Benjamin de Casseres appeared in 1925.

13 Leslie Katz, 'The World of the Eight,' *Arts Yearbook,* no. 1, 1957, p. 76.

14 Four of the works sold, including Henri's *Laughing Child* and Luks's *Woman with Goose,* both now in the collection of the Whitney Museum of American Art, went to the young sculptor Gertrude Vanderbilt Whitney, whose steady support of American art created the collection on which the Museum was founded in 1931.

15 Unidentified newspaper clipping where the Brooklyn Museum exhibition of *The Eight* (1943–4) is reported, with references to reviews that appeared at the time of the original exhibition. See below, note 17.

16 William Homer, *op. cit.,* p. 153.

17 Brooklyn Museum, *The Eight,* exhibition catalogue, Brooklyn, 24 November 1943–16 January 1944. Foreword by John I. H. Baur.

18 Ira Glackens, *William Glackens and the Ashcan Group,* New York, 1957, p. 54.

19 Maratta was a painter from Chicago who went into the manufacture of pigments to be used according to his color theory. In New York, in 1909, he interested Henri in his system, and worked with the Realists on its development in the following years. It is similar in many respects to the theory of the Synchomists (see below) who, however, accepted its abstract implications, which the Realists did not. (See Homer, *op. cit.,* pp. 184–9.)

20 Hambidge was a Canadian artist-illustrator who became a writer-theorist and teacher at Yale and Harvard after World War I. (See Homer, *op. cit.,* p. 192.)

21 Henry and Sidney Berry-Hill, *Ernest Lawson,* Leigh-on-Sea (England), 1968, p. 23.

22 Tom Sharkey was an ex-sailor and ex-pugilist who operated a 'social club' to get around the New York law which made prizefighting illegal; the fighters were signed up as club members, hence Bellows' title.

23 Between 1912–18 Henri, Bellows, and probably Sloan, taught at the Modern School of the Ferrer Center, named for Francisco Ferrer Guardia, a Spanish anarchist executed in 1909 for his alleged part in a military rebellion (See Donald Drew Egbert, *Socialism and American Art,* Princeton, 1967, p. 96). The school was sponsored by such leading radicals as Emma Goldman and Hutchins Hapgood, and attracted as lecturers Elizabeth Gurley Flynn, Lincoln Steffens, Upton Sinclair, and other outstanding socialists, anarchists, and muckrakers. The Marxist emphasis on freedom appealed to many artists, and Henri applied this principle at the Ferrer School, as he always had, by rejecting systematic, imposed methods of teaching.

24 *Ibid.,* pp. 96–7, and *n.* 184.

25 See *History of an American, Alfred Stieglitz: "291" and After.* Philadelphia, 1944.

26 Beaumont Newhall, *The History of Photography,* New York, 1964, pp. 105–106.

27 *Ibid.,* p. 113.

28 *Ibid.,* p. 9.

29 Dorothy Norman (ed.). *Twice a Year,* no. 1, Fall–Winter 1938.

30 Quoted in Barbara Rose, *American Art Since 1900,* New York and Washington, D.C., 1967, p. 111.

31 Chamberlin quoted in *Camera Work,* no. 27, July 1909, p. 43: Caffin, 'The Maurers and Marins at Photo–Secession Gallery,' *ibid.,* p. 32.

32 Los Angeles County Museum, *John Marin,* Los Angeles, Calif., 1970, p. 9.

33 *John Marin* (Contributions by William Carlos Williams, Duncan Phillips, Dorothy Norman, MacKinley Helm, Frederick S. Wight) Berkeley and Los Angeles, Calif., 1956.

34 Museum of Modern Art, *L. Feininger, M. Hartley*, New York, 1944, p. 61.

35 Elizabeth McCausland, *Marsden Hartley*, Minneapolis, Minn., p. 19.

36 Museum of Modern Art, *L. Feininger, M. Hartley, op. cit.*, p. 61.

37 *Ibid.*, p. 65.

38 Lloyd Goodrich and Doris Bry, *Georgia O'Keeffe*, New York: Whitney Museum of American Art, 1970, p. 11.

39 Norman, *op. cit.*, no. 1, Fall–Winter 1938, p. 89.

40 Milton W. Brown, *The Story of the Armory Show*, New York, 1963, p. 89.

41 Frederick S. Wight, *Arthur G. Dove*, Berkeley and Los Angeles, Calif., 1958, p. 31.

42 *Ibid.*, p. 33.

43 Gino Severini writes that Walter Pach invited the Futurists to participate but at the behest of Marinetti they refused. 'Today it is clear what a mistake we made in not being represented in that magnificent international exhibition,' Severini comments (Gino Severini, *Tutta la Vita di un Pittore*, Milan, 1946 I, pp. 165–166).

44 Brown, *op. cit.*, p. 173.

45 Meyer Schapiro, 'Rebellion in Art,' in *America in Crisis* (ed. Daniel Aaron), New York, 1925. See especially pp. 229–42.

46 Man Ray, *Self Portrait*, Boston, Mass., and Toronto, 1963, p. 30; James J. Sweeney, *Stuart Davis*, New York, 1945, pp. 9–10.

47 Clive Bell, *Art*, London, 1914, Section I, Chapter I.

48 See Hartley's *Abstraction, c.* 1916, Collection Mr and Mrs Hudson Walker, University Gallery, University of Minnesota. Illustrated, A. C. Ritchie, *Abstract Printing and Sculpture in America*, New York, 1951, p. 55.

49 William C. Agee, *Synchromism and Color Principles in American Painting*, New York, 1965, p. 20, Compare Hardesty Maratta's theory, mentioned above.

50 The Wright brothers collaborated on several books: *The Creative Will: Studies in the Philosophy and Syntax of Aesthetics*, New York, 1916; *The Future of Painting*, New York, 1923. Willard Wright's *Modern Painting* is the fullest statement of Synchromist aesthetics, and aims to establish the style as a universal principle of art.

51 *The Forum Exhibition of Modern American Painters*, New York, 1916. The publisher, Kennerley, published the monthly *Forum*, with W. H. Wright as art critic. The catalogue for the show, held at the Anderson Galleries, carried a preface, 'In Explanation,' stating, 'out of fifty names of the most deserving very modern American painters, the Committee [Christian Brinton, Robert Henri, W. H. De B. Nelson, Alfred Stieglitz, John Weichsel, W. H. Wright] has selected sixteen names here represented.' There were, in fact, *seventeen* names listed: William and Marguerite Zorach were printed on one line and William's statement, written in the first person singular, presumably speaks for himself and his wife. Marguerite, the only woman artist in the exhibition, was left out of the count after all.

52 Thomas Benton, *An Artist in America*, New York, 1937, p. 46.

53 Published as 'Discovery of America: Autobiographical Notes,' *Art News*, November 1960, pp. 41–2, 64–7.

54 Irma B. Jaffe, *Joseph Stella*, Cambridge, Mass., 1970, pp. 64–80. See especially pp. 69–70.

55 Dada was officially founded and named in 1916, in Zurich, by Tristan Tzara, Richard Huelsenbeck, and Hans Arp, giving the coherence of a movement to what was already a widespread attitude among artists and writers in Europe and America.

56 The sociological explanation of Dada – its rejection of rational bourgeois society – must be placed in a broader context that takes account of the new consciousness of a radical shift in the conception of the nature of reality, a consciousness related in part to the translation and diffusion of Freud's writings between 1910–13.

57 John I. H. Baur, *Revolution and Tradition in Modern American Art*. Cambridge, Mass., 1958, p. 26.

58 De Casseres, *Camera Work*, 1913, no. 42, p. 17; De Zayas, *ibid.*, 1912, no. 39, p. 17.

59 *The Blind Man* was a short-lived journal financed by Walter Arensberg and Henri-Pierre Roche, a wealthy young French friend of Duchamp.

60 Glackens, *op. cit.*, pp. 187–8.

61 Ray, *op. cit.*, pp. 66–7.

62 *Ibid.*, p. 82.

63 One of the more famous Dada incidents in New York occurred at the First Annual Exhibition of the Society of Independent Artists. Arthur Cravan, an ex-pugilist, self-claimed nephew of Oscar Wilde, and 'deserter of seventeen nations,' arrived drunk to deliver a lecture on modern humor. The only sounds he uttered, according to André Breton, were loud belches, which he delivered while undressing himself on the stage. The police dragged him away, not quite naked, the reports say. (See Maurice Nadeau, *The History of Surrealism*, New York, 1965, pp. 29 and 55.)

64 The origin of the term 'Precisionism' is not known. In 1942 Jerome Mellquist refers to the artists now associated with the style as the 'delicates.' Milton Brown in his *American Painting From the Armory Show to the Depression* of 1955 still does not use the term, referring to these artists as

Cubo-Realists. John I. H. Baur in his *Revolution and Tradition in Modern American Art* of 1951 refers to them as 'Immaculates,' and uses the term precisionist with a small *p*.

65 The catalogue of the Schamberg Memorial Exhibition at the Knoedler Gallery in 1919 comments, 'It seems absurd to say that Schamberg has evolved structures as beautiful as flowers from mechanical forms, and yet there is no other way to express the fact that beauty is the result.'

66 Feininger was born in the United States in 1871 but settled in Germany in 1887, where he decided to be a painter. He did not return to this country until 1937 and cannot be considered as part of the development of American art in the first quarter of the twentieth century.

67 *Art News,* March 1954, p. 21.

68 Manigault was a gifted artist who died in 1922 of self-imposed starvation at the age of 37: he believed starvation enabled him to see colors previously invisible to him. (Marcia Tucker, *American Painting in the Ferdinand Howald Collection,* Columbus, Ohio, 1969.)

69 Douglas MacAgy, 'Gerald Murphy, "New Realist" of the Twenties,' *Art in America,* vol. 51, April 1963, pp. 49–57.

70 Martin Friedman, *The Precisionist View in American Art,* Minneapolis, Minn., 1960, p. 35.

71 Quoted in Elizabeth Holt, *A Documentary History of Art,* New York, 1957, vol. 1, p. 148.

72 Louis Lozowick, 'The Americanization of Art,' quoted in Friedman, *op. cit.,* p. 35.

73 Eloise Spaeth, *American Art Museums and Galleries,* New York, 1960, p. 70.

74 *Ibid.*

75 Baur, *op. cit.,* p. 112.

76 Frederick A. Sweet, *Ivan Albright* (A retrospective exhibition), Chicago, Ill., 1964, p. 17.

5 The 1930s and Abstract Expressionism

1 William Carlos Williams, *Paterson,* Book I.

2 Barnett Newman, a typescript of 1942, reprinted in *Barnett Newman,* by Thomas B. Hess, New York, 1971, p. 35.

3 Thomas Hart Benton, *An Artist in America,* Kansas City, Mo., 1951.

4 Reginald Marsh, 'Poverty, Politics, and Artists, 1930–45,' *Art in America,* volume 53, August–September 1965.

5 Arshile Gorky, from an interview in the *New York Sun,* 22 August 1941.

6 Arshile Gorky, 'The WPA Murals, Aviation: Evolution of Forms Under Aerodynamic Limitations,' a description written for the Works Project Administration by Gorky as a prospectus for the mural venture. Reprinted in Harold Rosenberg; E. K. Schwabacher.

7 Jackson Pollock, *Arts and Architecture,* February 1949.

8 *Ibid.*

9 Jackson Pollock, 'The Talk of the Town,' *The New Yorker,* 25 August 1950.

10 Jackson Pollock in Seldon Rodman's *Conversations with Artists,* New York, 1957.

11 Marlborough-Gerson Gallery exhibition catalogue, New York, March 1969.

12 The idea of describing de Kooning, himself a master, as Gorky's disciple is meant with no pejorative intent whatever. When one considers to whom Gorky apprenticed himself, the tradition in which de Kooning is but the most recent avatar is one of the most glorious in western art. Nor should it be thought that de Kooning himself did not see his profound debt to Gorky:

In a piece on Arshile Gorky's memorial show – and it was a very little piece indeed – it was mentioned that I was one of his influences. Now that is plain silly. When about fifteen years ago, I walked in Arshile's studio for the first time, the atmosphere was so beautiful that I got a little dizzy, and when I came to, I was bright enough to take the hint immediately. If the bookkeepers think it necessary continuously to make sure of where things and people come from, well then, I come from 36 Union Square [Gorky's studio]. (Willem de Kooning, Letter to the Editor, *Art News,* January 1949.)

13 Harold Rosenberg, 'The American Action Painters,' *Art News,* vol. 51, September 1952.

14 Willard Huntington Wright, *Modern Painting,* 1915.

15 Rosenberg, *op. cit.*

16 Robert Henri, *The Art Spirit,* New York, 1923.

17 Adolph Gottlieb and Mark Rothko, *The Portrait of the Modern Artist.*

18 Mark Rothko, *Interiors,* vol. 110, May 1951, p. 104.

19 Mark Rothko and Adolph Gottlieb, *New York Times,* letter, 14 June 1943, sec. 2, p. 9.

20 Robert Motherwell in a letter to Frank O'Hara of 18 August 1965, reprinted in *Robert Motherwell,* exhibition catalogue, Museum of Modern Art, 1965, p. 70.

21 Museum of Modern Art Catalogue, p. 9, and see bibliography no. 38 in that catalogue.

22 *Clyfford Still: Thirty-three Paintings in the Albright-Knox Art Gallery,* 1966, p. 16.

23 *Ibid.,* p. 17.

24 Letter from Clyfford Still to Gordon Smith, 1 January 1959, reprinted in *Paintings by Clyfford Still* catalogue of exhibition held at the Albright-Knox Gallery, Buffalo, New York, 5 November–13 December 1959.

25 Clement Greenberg, foreword to exhibition catalogue for de Kooning retrospective, Workshop Art Center, Washington, D.C., 14 June–3 July 1953, reprinted in *Willem de Kooning,* by Thomas B. Hess, New York, 1968, pp. 138–9.

26 While Louis is generically referred to as a 'Color Field' painter, I do not think this precludes his consideration as one of the later Abstract Expressionists. If one but thinks of the role that the application of paint has in generating his pictures, the flow of paint and its rate of absorption actually determining the kinds of paintings he could produce, and if one then thinks of the dominant role of shape itself in his pictures, his position as an Abstract Expressionist becomes clear. While it is currently fashionable to see in the work of Morris Louis a new era being ushered in, his work seems more cogent and more easily accessible if he is allied with the painters of the New York School, perhaps as its last great exponent.

27 Franz Kline, 'Interview with Franz Kline,' *Living Arts,* Spring 1963.

28 Barnett Newman, a contemporary of the Abstract Expressionists, and usually thought of as one of their number, and both a precursor and standard bearer for the Color-Field painters, is rarely thought of as an Action Painter. Lately this assessment has come in for a strong reevaluation. Thomas Hess has written: 'Looking back on the situation twenty years later, it seems to me the only real "act" in terms of Action Painting, was Newman's decision to interrupt *Onement I.*' (Thomas B. Hess, *Barnett Newman,* New York, 1971, 65.)

29 Charles Olson, 'In Cold Hell in Thicket,' in *The Distances: Poems by Charles Olson,* New York, 1960, p. 31.

30 Charles Olson, 'To Gerhardt, There, Among Europe's Things of Which of Which He has Written Us In His "Brief An Creely Und Olson",' *op. cit.,* p. 43. This poem, together with the preceding one (*see* note 29) is also reprinted in *Archaeologist of Morning,* 1970. 'In Cold Hell in Thicket' appeared first in *Golden Goose,* ser. 3, 1, 1951. 'To Gerhardt . . .' first appeared in *Origin* 4, Winter 1951.

6 From the 1960s to the Present Day

1 Lucy R. Lippard *Ad Reinhardt,* New York, 1967.

2 Ad Reinhardt, 'The Next Revolution in Art', *Art News,* vol. 62, February 1964.

3 Lippard, *op. cit.*

4 Thomas B. Hess, *Barnett Newman,* New York, 1971.

5 Lawrence Alloway, *Systematic Painting,* New York, 1966.

6 Dorothy C. Miller ed., *Sixteen Americans,* New York, 1959.

7 Museum of Contemporary Art, *Six Sculptors,* Chicago, Ill., 1971.

8 *Post Painterly Abstraction,* an exhibition organized by the Los Angeles County Museum of Art in 1964.

9 Barbara Rose, *American Art Since 1900,* New York, 1967.

10 Robert Rosenblum, 'Pop Art and Non-Pop Art', *Art & Literature,* Summer 1964.

11 Letter to the author, 1967.

12 Gene Swenson, 'What is Pop Art', *Art News,* Vol. 62, November 1963.

13 Miller, *op. cit.*

14 Lucy Lippard, *Pop Art,* New York, 1966.

15 *The New York Times,* 16 May 1970.

16 Louis Finkelstein, 'Cajori, the Figure in the Scene', *Art News,* vol. 62, March 1963.

17 Linda Nochlin, *Philip Pearlstein,* Atlanta, Ga., 1970.

18 Rose, *op. cit.*

19 Walter Darby Bannard, 'On de Kooning', *Art Forum,* April 1969.

20 Lecture at the Cooper Union, December 1971.

21 Leo Steinberg 'Contemporary Art and the Plight of its Public', *Harper's,* March 1962.

Bibliography

General

Baigell, Matthew, *A History of American Painting*, New York, 1971.
Barker, Virgil, *American Painting, History and Interpretation*, New York, 1950.
Benjamin, Samuel G. W., *Art in America: A Critical and Historical Sketch*, New York, 1880.
Burroughs, Alan, *Limners and Likenesses, Three Centuries of American Painting*, Cambridge, Mass., 1936.
Dunlap, William, *History of the Rise and Progress of the Arts of Design*, 3 vols., rev. ed., New York, 1965.
Feder, Norman, *American Indian Art*, New York, 1972.
Fielding, Mantle, *Dictionary of American Painters, Sculptors and Engravers*, Philadelphia, Pa., 1926.
Gardner, Albert Ten Eyck, *History of Water Color Painting in America*, New York, 1966.
Gerdts, William H. and Russell Burke, *American Still Life Painting*, New York, 1971.
Green, Samuel, *American Art: A Historical Survey*, New York, 1966.
Groce, George C. and David H. Wallace, *The New-York Historical Society's Dictionary of Artists in America, 1564–1860*, New Haven, Conn., 1957.
Harris, Neil, *The Artist in American Society: The Formative Years*, 1790–1860, New York, 1966.
Hayes, Bartlett H., Jr, *American Drawings*, New York, 1965.
Isham, Samuel, *The History of American Painting*, New York, 1936.
Jarves, James Jackson, *The Art-Idea*, new ed., Cambridge, Mass., 1960.
Larkin, Oliver, *Art and Life in America*, 2nd ed., New York, 1960.
McCoubrey, John W., *American Tradition in Painting*, New York, 1963.
——, ed., *American Art, 1700–1960: Sources and Documents*, Englewood Cliffs, N. J., 1965.
McLanathan, Richard B., *The American Tradition in the Arts*, New York, 1968.
Mendelowitz, Daniel, *History of American Art*, 2nd. ed., New York, 1970.
Miller Lillian B., *Patrons and Patriotism: The Encouragement of the Fine Arts in the United States, 1790–1860*, Chicago, Ill., 1966.
Pierson, William H., Jr and Martha Davidson, eds, *Arts of the United States: a Pictorial Survey*, New York, 1960.
Prown, Jules D., *American Painting from its Beginnings to the Armory Show*, Geneva, 1969.
Richardson, E. P., *Painting in America*, New York, 1965.
Rose, Barbara, *American Art Since 1900: A Critical History*, New York, 1967.
——, *Readings in American Art Since 1900: A Documentary Survey*, New York, 1968.
Tuckerman, Henry T., *Book of the Artists, American Artist Life*, new ed., New York, 1966.
Whitehill, Walter Muir, Wendell D. Garrett, and Jane N. Garrett, *The Arts in Early American History*, Chapel Hill, N. C., 1965.
Wilmerding, John, *A History of American Marine Painting*, Boston, Mass., 1968.

1 Colonial Painting

American Paintings at the Museum of Fine Arts, Boston, 2 vols, Greenwich, Conn., 1970.
Baigell, Matthew, *A History of American Painting*, New York, 1971.
Bizardel, Yvon, *American Painters in Paris*, New York, 1960.
Barker, Virgil, *American Painting: History and Interpretation*, New York, 1950.
——, *A Critical Introduction to American Painting*, New York, 1931.
Bayley, Frank W., *Five Colonial Artists of New England*, Boston, Mass., 1929.
Belknap, Waldron Phoenix, Jr, *American Colonial Painting*, Cambridge, Mass., 1959.
Bolton, Charles K., *Portraits of the Founders*, Boston, Mass., 1926.
Brinton, Christian, *Gustavus Hesselius, 1682–1755*, Philadelphia, Pa., 1938.
Burroughs, Alan, *Limners and Likenesses; Three Centuries of American Painting*, Cambridge, Mass., 1936.
——, *John Greenwood in America 1745–1752*, Andover, Mass., 1943.
Croce, George C., and Wallace, David H., *The New-York Historical Society's Dictionary of Artists in America 1564–1860*, New Haven, Conn., 1957.
Dresser, Louisa, *Seventeenth Century Painting in New England*, Worcester, Mass., 1935.
Dunlap, William, *A History of the Rise and Progress of the Arts of Design in the United States*, 2 vols, New York, 1834.
Foote, Henry Wilder, *Robert Feke, Colonial Portrait Painter*, Cambridge, Mass., 1930.
——, *John Smibert, Painter*, Cambridge, Mass., 1950.
Flexner, James Thomas, *America's Old Masters*, New York, 1939.
——, *First Flowers of Our Wilderness, American Painting*, Boston, Mass., 1947.
Gardiner, Ten Eyck and Feld, Stuart, *American Paintings, A Catalogue of the Metropolitan Museum of Art*, Vol. I, New York, 1965.
Goodrich, Laurence B., *Ralph Earl: Recorder for an Era*, Yellow Springs, Ohio, 1967.
Hagen, Oskar, *The Birth of the American Tradition of Art*, New York, 1940.
Harris, Neil, *The Artist in American Society*, New York, 1966.
Larkin, Oliver W., *Art and Life in America*, New York, 1949.
Lee, Cuthbert, *Early American Painters*, New Haven, Conn., 1929.

Little, Nina Fletcher, *American Decorative Wall Painting, 1700–1850*, Sturbridge, Mass., 1952.

Middleton, Margret Simon, *Jeremiah Theus, Colonial Artist of Charles Town*, Columbia, S.C., 1953.

Mooz, R. P., *American Painting to 1776: A Reappraisal*, ed. Ian M. G. Quimby, Charlottesville, Va., 1971.

Morgan, John Hill, *Early American Paintings*, New York, 1921.

———, *John Watson, Painter Merchant and Capitalist of New Jersey 1685–1768*, Worcester, Mass., 1940.

Oliver, Andrew, *Faces of a Family*, Portland, Me., 1960.

Park, Lawrence, *Joseph Blackburn, A Colonial Portrait Painter*, Worcester, Mass., 1923.

Pleasants, J. Hall, *Two Hundred and Fifty Years of Painting in Maryland*, Baltimore, Md., 1945.

———, *Justus Engelhardt Kuhn, An Early Eighteenth-Century Maryland Portrait Painter*, Worcester, Mass., 1937.

Prown, Jules D., *John Singleton Copley*, 2 vols, Cambridge, Mass.,

———, *American Painting, From Its Beginning to the Armory Show*, Cleveland, Ohio, 1970.

Richardson, Edgar P., *Painting in America, From 1502 to the Present*, New York, 1956.

Sadik, Marvin, *Colonial and Federal Portraits at Bowdoin College*, Brunswick, Me., 1966.

Sawitzky, William, *Matthew Pratt, 1734–1805*, New York, 1942.

'The American Work of Benjamin West,' *The Pennsylvania Magazine of History and Biography*, October 1938.

———, *Catalogue, Descriptive and Critical of the Paintings and Miniatures in the Historical Society of Pennsylvania*, Philadelphia, Pa., 1942.

Sellers, Charles Coleman, *Charles Willson Peale*, New York, 1969.

———, *Benjamin Franklin in Portraiture*, New Haven, Conn., 1962.

Shearman, Frederic Fairchild, *Early American Painting*, New York, 1932.

Shelly, Donald A., *Catalogue of American Portraits in the New-York Historical Society*, New York, 1941.

Sizer, Theodore M., *The Works of Colonel John Trumbull, Artist of the American Revolution*, Rev. ed. with assistance of Caroline Rollins, New Haven, Conn., 1967.

Smibert, John, *The Notebook of John Smibert*, ed. R. E. Wood, Boston, Mass., 1969.

Stewart, Robert G., *Henry Benbridge (1743–1812)*, Washington, D.C., 1971.

Sutton, Denys, *American Painting*, London, 1948.

Washburn, Gordon Bailey, *Old and New England: An Exhibition of American Painting of Colonial and Early Republican Days, Together with English Painting of the Same Time*, Providence, R.I., 1945.

Waterhouse, Ellis K., *Painting in Britain, 1500–1790*, Baltimore, Md., 1958.

Whitley, William T., *Gilbert Stuart*, Cambridge, Mass., 1932.

———, *Artists and Their Friends in England*, Vol. 1, London and Boston, 1928.

2 The First Half of the Nineteenth Century

Adams, Alexander B., *John James Audubon*, New York, 1966.

Baur, John I. H., *John Quidor* (exhibition catalogue), New York, 1965.

Black, Mary C. and Jean Lipman, *American Folk Painting*, New York, 1966.

Biddle, Edward and Mantel Fielding, *The Life and Works of Thomas Sully, 1793–1872*, Philadelphia, Pa., 1921.

Bloch, E. Maurice, *George Caleb Bingham*, 2 vols, Berkeley, Calif., 1967.

Callow, James, *Kindred Spirits: Knickerbocker Writers and American Artists, 1807–1855*, Chapel Hill, N.C., 1967.

Cowdrey, Bartlett and H. W. Williams, *William Sidney Mount, 1807–1868, An American Painter*, New York, 1944.

Dickson, Harold E., *Arts of the Young Republic*, Chapel Hill, N.C., 1969.

Durand, John, *The Life and Times of A. B. Durand*, new ed., New York, 1970.

Elam, Charles H., ed., *The Peale Family, Three Generations of American Artists*, Detroit, Mich., 1967.

Flexner, James Thomas, *That Wilder Image*, Boston, Mass., 1962.

Frankenstein, Alfred, *Painter of Rural America: William Sidney Mount* (exhibition catalogue), Washington, D.C., 1969.

Gerdts, William H., *Thomas Birch* (exhibition catalogue), Philadelphia, Pa., 1966.

Haberly, Lloyd, *Pursuit of the Horizon: The Life of George Catlin*, New York, 1948.

Harding, Chester, *My Egotistography*, Boston, Mass., 1866.

Howat, John K., *The Hudson River and its Painters*, New York, 1972.

———, and John Wilmerding, *19th-Century America: Paintings and Sculpture*, New York, 1970.

Lawall, David B., *A. B. Durand* (exhibition catalogue), Montclair, N.J., 1971.

Larkin, Oliver W., *Samuel F. B. Morse and American Democratic Art*, Boston, Mass., 1954.

Lindsay, Kenneth C., *The Works of John Vanderlyn, from Tammany to the Capitol* (exhibition catalogue), Binghampton, N.Y., 1970.

Lynes, Russell, *The Art Makers of Nineteenth Century America*, New York, 1970.

Mount, Charles Merrill, *Gilbert Stuart, a Biography*, New York, 1964.

Noble, Louis Legrand, *The Life and Works of Thomas Cole*, new ed., Cambridge, Mass., 1964.

Novak, Barbara, *American Painting of the Nineteenth Century*, New York, 1969.

Richardson, E. P., *Washington Allston, A Study of the Romantic Artist in America*, new ed., New York, 1967.

Sears, Clara Endicott, *Highlights Among the Hudson River Artists*, Boston, Mass., 1947.

Sellers, Charles Coleman, *Charles Willson Peale*, new ed., New York, 1969.

Sizer, Theodore, *The Works of Colonel John Trumbull, artist of the American Revolution*, rev. ed., New Haven, Conn., 1967.

Sweet, Frederick A., *The Hudson River School and the Early American Landscape Tradition*, Chicago, Ill., 1945.

Wilmerding, John, *Audubon, Homer, Whistler and 19th Century America*, New York, 1972.

 , *Fitz Hugh Lane*, New York, 1971.

 , *Robert Salmon, Painter of Ship and Shore*, Boston, Mass., 1971.

3 The Second Half of the Nineteenth Century

Born, Wolfgang, *American Landscape Painting: An Interpretation*, New Haven, Conn., 1948.

Coke, Van Deren, *The Painter and the Photograph*, 1964.

Flexner, James T., *That Wilder Image: The Painting of America's Native School from Thomas Cole to Winslow Homer*, Boston, Mass., 1962.

Havemeyer, Louisine W., *Sixteen to Sixty, Memoirs of a Collector*, New York, 1961.

Hoopes, Donelson F., *The American Impressionists*, New York, 1972.

Isham, Samuel, *The History of American Painting* (with supplemental chapters by Royal Cortissoz), New York, 1936.

Jarves, James Jackson, *The Art Idea*, 1864.

Kouwenhoven, John A., *Made in America: The Arts in Modern Civilisation*, New York, 1962.

Larkin, Oliver, *Art and Life in America*, New York, 1949.

McLanathan, Richard, *The American Tradition in the Arts*, New York, 1968.

Mather, Frank Jewett Jr, *Modern Painting*, New York, 1927.

Novak, Barbara, *American Painting of the Nineteenth Century*, New York, 1969.

Richardson, Edgar P., *Painting in America*, New York, 1956, (revised edition, 1965).

 , *The Way of Western Art*, New York, 1939, (reissued in 1969).

Rourke, Constance, *The Roots of American Culture*, New York, 1942.

Saarinen, Aline, *The Proud Possessors*, New York, 1958.

Sheldon, G. W., *Hours with Art and Artists*, 1882.

Strahan, Edward, 'The Fine Art of the International Exhibition', *Illustrated Catalogue, The Masterpieces of the Centennial Exposition*, Philadelphia, Pa., 1893.

4 The Forming of the Avant-Garde

Agee, William C., *Synchromism and Color Principles in American Painting*, New York, 1965.

Anderson Galleries, New York, *The Forum Exhibition of Modern American Painters, March 13 to March 15, 1916*, New York, 1916.

Baur, John I. H., *Revolution and Tradition in Modern American Art*, Cambridge, Mass., 1958.

Bell, Clive, *Art*, Section I, Chapter I, London, 1914.

Benton, Thomas, *An Artist in America*, New York, 1937.

Berry-Hill, Henry and Sidney, *Ernest Lawson*, Leigh-on-Sea (England), 1968.

Brooklyn Institute of the Arts and Sciences, *The Eight*, New York, 1943.

Brown, Milton W., *American Painting From the Armory Show to the Depression*, Princeton, N.J., 1955, (paperback edition, 1970).

Brown, Milton W., *The Story of the Armory Show*, New York, 1963.

Camera Work, 1903–17.

Celender, D. D., *Precisionism in Twentieth Century Painting*, University Microfilms, 1964.

Dreier, Katherine S., *Western Art and the New Era; An Introduction to Modern Art*, New York, (c.1923).

Egbert, Donald Drew, *Socialism and American Art*, Princeton, N.J., 1967.

Friedman, Martin, *The Precisionist View in American Art*, Minneapolis, Minn., 1960.

Glackens, Ira, *William Glackens and the Ashcan Group*, New York, 1957.

Goodrich, Lloyd, and Baur, John I. H., *American Art of Our Century*, New York, 1961.

Goodrich, Lloyd, and Bry, Dorothy, *Georgia O'Keeffe*, New York, 1970.

Henri, Robert, *The Art Spirit*, Philadelphia, Pa., and New York, 1960.

Homer, William I., *Robert Henri and His Circle*, Ithaca, N.Y., and London, 1969.

Jaffe, Irma B., *Joseph Stella*, Cambridge, Mass., 1970.

Katz, Leslie, 'The World of the Eight', *Arts Yearbook*, no. 1, 1957.

Larkin, Oliver W., *Art and Life in America*, rev. ed. New York, 1964.

Los Angeles County Museum, *John Marin*, Los Angeles, Calif., 1970.

MacAgy, Douglas, 'Gerald Murphy, "New Realist" of the Twenties,' *Art in America*, vol. 51, April 1963, pp. 49–57.

McCausland, Elizabeth, 'A Selected Bibliography on American Painting and Sculpture,' in *Who's Who in American Art*, IV, pp. 611–53. Washington, D.C., 1947. (First published in *Magazine of Art*, XXXIX (November 1946), pp. 329–49.)

———, *Marsden Hartley*, Minneapolis, Minn., 1952.

Mellquist, Jerome, *The Emergence of an American Art*, New York, 1942.

Museum of Modern Art, *Lyonnel Feininger and Marsden Hartley*, New York, 1944.

Nadeau, Maurice, *The History of Surrealism*, New York, 1965.

Newhall, Beaumont, *The History of Photography*, New York, 1964.

Norman, Dorothy ed., *Twice a Year*, 1938.

Perlman, Bennard P., *The Immortal Eight*, New York, 1962.

Ray, Man, *Self Portrait*, Boston, Mass., and Toronto, 1963.

Ritchie, Andrew C., *Abstract Painting and Sculpture in America*, New York, 1951.

Rose, Barbara, *American Art Since 1900*, New York and Washington, D.C., 1967.

Schapiro, Meyer, 'Rebellion in Art,' *America in Crisis*, Daniel Aaron, ed., New York, 1925.

Sloan, John, *Gist of Art*, New York, 1939.

Stella, Joseph, 'Discovery of America: Autobiographical Notes,' *Art News*, November 1960, pp. 41–2, 64–7.

Sweeney, James J., *Stuart Davis*, New York, 1945

Sweet, Frederick A., *Ivan Albright*, Chicago, Ill., 1964.

Tucker, Marcia, *American Painting in the Ferdinand Howald Collection*, Columbus, Ohio, 1969.

University of California, Los Angeles, Calif., *John Marin*, Berkeley and Los Angeles, Calif., London, 1956.

Wight, Frederick S., *Arthur Dove*, Berkeley and Los Angeles, Calif., 1958.

Wright, Willard H., *Modern Painting; Its Tendency and Meaning*, New York and London, 1915.

5 The 1930s and Abstract Expressionism

Alloway, Lawrence, *Baziotes*, Exhibition Catalogue, Solomon R. Guggenheim Museum, New York, Feb. 1965; introduction and comprehensive bibliography.

Arnason, H. H., *Philip Guston*, Guggenheim Museum, ex. cat., May–June 1962; bibliography.

Ashton, Dore, *Philip Guston*, New York, 1960.

———, 'Philip Guston, the Painter as Metaphysician', *Studio International*, Feb. 1965, pp. 64–7.

Benton, Thomas Hart, *Tom Benton's America: An Artist in America*, New York, 1937; an opinionated and interesting autobiography.

Blesh, Rudi and Janis, Harriet, *De Kooning*, New York, 1960.

Craven, Thomas, 'An American Painter', *Nation*, Jan. 7, 1925, p. 22.

Dawson, Fielding, *Emotional Memoir of Franz Kline*, New York, 1967.

Fried, Michael, 'New York Letter', *Art International*, May 1963, pp. 70–2.

Friedman, B. H., *Jackson Pollock: Energy Made Visible*, New York, 1972; a biography and comprehensive bibliography.

Friedman, Martin, *Adolph Gottlieb*, Walker Art Center, Minneapolis, Minn., ex. cat. June 1963; bibliography.

Geldzahler, Henry, *New York Painting and Sculpture: 1940–1970*, The Metropolitan Museum of Art, New York, 1969; reprinted critical essays, bibliographies on the artists.

Glassgold, C., 'Thomas Benton's Murals at the New School for Social Research', *Atelier*, April, 1931, pp. 399–403.

Goldwater, Robert, *Franz Kline*, ex. cat. Marlborough Gallery, New York, 1967.

———, 'Reflections on the Rothko Exhibit', *Arts*, March 1961, pp. 42–45.

Gordon, John, *Franz Kline*, ex. cat. Whitney Museum of American Art, Oct.–Nov. 1968.

Greenberg, Clement, *Adolphe Gottlieb and the New York School*, Paris, April, 1959.

Hess, Thomas B., *Willem De Kooning*, New York, 1959; bibliography.

Hunter, Sam, *Hans Hofmann*, 1963.

Janson, H. W., 'Benton and Wood, Champions of Regionalism', *Magazine of Art*, May 1946, pp. 184–6; 198–200.

Levy, Julien, *Arshile Gorky*, New York, 1966.

O'Connor, Francis V., *Jackson Pollock*, ex. cat. Museum of Modern Art, New York, March–May 1967.

———, 'The Genesis of Jackson Pollock', *Artforum*, May 1967, pp. 16–23.

O'Hara, Frank, *Robert Motherwell*, ex. cat. Museum of Modern Art, New York, Sept.–Nov. 1965; chronology and bibliography, extensive quotations from the artist's writings.

Robertson, Bryan, *Jackson Pollock*, 1960.

Rosenberg, Harold, *Arshile Gorky: The Man, the Time, the Idea,* New York, 1962; bibliography and reprinted statements by the artist.

Sandler, Irving, 'Baziotes: Modern Mythologist', *Art News,* vol. 63, no. 10, Feb. 1965, pp. 28–31.

, *The Triumph of American Painting,* New York, 1970; a history of Abstract Expressionism.

Schwabacher, Ethel, *Arshile Gorky,* Whitney Museum of American Art, 1957; preface by Lloyd Goodrich; introduction by Meyer Schapiro, bibliography and quotes from the artist's letters as well as statements by contemporaries.

Seitz, William C., *Arshile Gorky: Painting, Drawings, Studies,* ex. cat. Museum of Modern Art, New York, 1952.

, *Hans Hofmann,* Museum of Modern Art, New York, 1963.

Tuchman, Maurice, *New York School: The First Generation;* revised edition, individual bibliographies on artists, statements by painters, reprinted critical essays.